# DISFIGURING

# RELIGION AND POSTMODERNISM

a series edited by Mark C. Taylor

# Mark C. Taylor

# DISFIGURING

## Art, Architecture, Religion

THE UNIVERSITY OF CHICAGO PRESS

Chicago and London

MARK C. TAYLOR, Preston S. Parish Third
Century Professor of Religion at Williams
College, is the author of *Erring: A Postmodern
A/theology* (1984) and *Altarity* (1987), and the
editor of *Deconstruction in Context: Literature
and Philosophy* (1986), all published by the
University of Chicago Press.

Research for this book was supported by a
generous grant from the Graham Foundation
for Advanced Studies in the Fine Arts.

The University of Chicago Press, Chicago 60637
The University of Chicago Press, Ltd., London
© 1992 by The University of Chicago
All rights reserved. Published 1992
Printed in the United States of America

01 00 99 98 97 96 95 94 93 92  5 4 3 2 1

ISBN (cloth): 0-226-79132-7
ISBN (paper): 0-226-79133-5

Library of Congress Cataloging-in-Publication Data

Taylor, Mark C., 1945–
    Disfiguring : art, architecture, religion / Mark C. Taylor.
       p.      cm.—(Religion and postmodernism)
    Includes bibliographical references and index.
    1. Art and religion.  2. Aesthetics.  I. Title.  II. Series.
BR115.A8T39    1992
261.5′7—dc20                  91-39655
                                  CIP

For M.-D. S. T.

*And do you not see that the poor in having the religious also have the aesthetic, and that the rich, insofar as they have not the religious, have not the aesthetic either?*
—SØREN KIERKEGAARD

*Our experience of the divine is our experience of its desertion. It is no longer a question of meeting God in the desert: but of this—and* this *is the desert—we do not encounter God, God has deserted all encounter.*
—JEAN-LUC NANCY

# CONTENTS

List of Illustrations    |    xi

**1.    PROGRAM**    |    1

**2.    THEOESTHETICS**    |    17

**3.    ICONOCLASM**    |    49

**4.    PURITY**    |    97

**5.    CURRENCY**    |    143

**6.    LOGO CENTRISM**    |    185

**7.    REFUSE**    |    229

**8.    DESERTION**    |    269

**9.    A/THEOESTHETICS**    |    309

*Abbreviations and Editions*    |    *321*

*Notes*    |    *325*

*Index*    |    *341*

# ILLUSTRATIONS

**PLATES**  (following page 178)

1. Caspar David Friedrich, *The Cross in the Mountains* (1807–8)
2. Claude Monet, *Rouen Cathedral, the Façade in Sunlight* (1894)
3. Paul Cézanne, *Mont Sainte Victoire* (1902–6)
4. Georges Braque, *Rooftops at Céret* (1911)
5. Pablo Picasso, *Landscape at Céret* (Summer 1911)
6. Annie Besant and C. W. Leadbeater, *Key to the Meanings of Colours* (1911)
7. Wassily Kandinsky, *Black Lines No. 189* (December 1913)
8. Wassily Kandinsky, *Composition 8* (1923)
9. Piet Mondrian, *Composition with Red, Blue, and Yellow* (1937–42)
10. Kasimir Malevich, *Suprematist Painting*
11. Barnett Newman, *Vir Heroicus Sublimis* (1950–51)
12. Barnett Newman, *Dionysus* (1949)
13. Mark Rothko, *Untitled* (Black and Grey)
14. Pablo Picasso, *Still Life with Chair Caning* (1912)
15. Kurt Schwitters, *Merzbild 32A, "The Cherry Picture"* (1921)
16. Robert Rauschenberg, *Retroactive I* (1964)
17. Jasper Johns, *Target with Plaster Casts* (1955)
18. Andy Warhol, *192 One-Dollar-Bills* (1962)
19. Andy Warhol, *Atomic Bomb* (1965)
20. James Stirling, *Staatsgalerie, New Building and Chamber Theater* (1977–83)
21. Michael Graves, *The Portland Building* (1980)
22. Charles Moore, *Piazza d'Italia* (1975–78)
23. Michael Graves, *Walt Disney World Dolphin Hotel* (1987)
24. Bernard Tschumi, *Le Parc de la Villette*
25. Peter Eisenman and Jacques Derrida, *Choral Work*
26. Peter Eisenman, *Wexner Center for the Visual Arts,* aerial view
27. Peter Eisenman, *Wexner Center for the Visual Arts,* exterior
28. Michelangelo Pistoletto, *Man Seen from the Back: The Present* (1961)
29. Michelangelo Pistoletto, *Division and Multiplication of the Mirror (The Divided Table)* (1975–79)
30. Michelangelo Pistoletto, *The Time of the Mirror* (1986)
31. Anselm Kiefer, *Ways of Worldly Wisdom: Arminius's Battle*

32. Anselm Kiefer, *Resurrexit* (1973)
33. Anselm Kiefer, *Painting = Burning* (1974)
34. Anselm Kiefer, *Father, Son, and Holy Spirit* (1973)
35. Anselm Kiefer, *Shulamite* (1983)
36. Anselm Kiefer, *Zim Zum* (1990)

## FIGURES

2.1. Caspar David Friedrich, *Monk by the Sea* (1808–10) / 19
3.1. Piet Mondrian, *Composition I-A* (1930) / 51
3.2. Kasimir Malevich, *Suprematist Composition: White on White* (1918) / 51
3.3. Ad Reinhardt, *Abstract Painting* (1963) / 51
3.4. Jakob Böhme, *The True Principles of All Things* / 53
3.5. Georges Braque, *Houses at L'Estaque* (1908) / 60
3.6. Pablo Picasso, *Cottage and Trees* (1908) / 61
3.7. Wassily Kandinsky, *The Last Judgment* (1910) / 67
3.8. Annie Besant and C.W. Leadbeater, *An Inspiration to Enfold All* / 68
3.9. Annie Besant and C. W. Leadbeater, *The Logos Pervading All* / 68
3.10. Wassily Kandinsky, *Lady in Moscow* (1912) / 69
3.11. Piet Mondrian, *Composition No. 10, The Sea* (1914) / 75
3.12. Kasimir Malevich, *Suprematist Composition Conveying the Feeling of a Mystic "Wave" from Outer Space* (1917) / 78
3.13. Kasimir Malevich, *Analystic Investigation of Form Development in the Pictorial Cultures of Cezanne, Cubism, and Suprematism* / 81
3.14. Barnett Newman, *Zim Zum I* (1969) / 91
3.15. Mark Rothko, *Chapel* / 95
3.16. Insignia of the Aryan Theosophical Press. / 95
4.1. Bruno Taut, *Sketch for Alpine Architecture* (1919) / 107
4.2. Le Corbusier, *Villa Savoye* (1929–31) / 111
4.3. Le Corbusier, *Villa Savoye*, cross section / 111
4.4. Le Corbusier, *La Tourette* (1960) / 111
4.5. Le Corbusier, *Dom-Ino House* (1919) / 112
4.6. Le Corbusier, *A Contemporary City* (1922) / 112
4.7. Theo van Doesburg, *Composition XXI* (1920–22) / 116
4.8. Theo van Doesburg and J. J. P. Oud, *De Vonk House* (1920) / 116
4.9. Theo van Doesburg, Cornelius van Eestern, and Gerrit Rietveld, *Model, Private Villa, Paris* (1923) / 117
4.10. Theo van Doesburg, *Color Construction: Project for a Private House* (1923) / 117
4.11. Gerrit Rietveld, *Schröder House* (1924) / 118
4.12. Kasimir Malevich, *Architectonics* (1922–25) / 119
4.13. El Lissitzky, *Proun Space* (1965 reconstruction of the 1923 original) / 120
4.14. Walter Gropius, *The Fagus Shoe-last Factory* (1911) / 122
4.15. Walter Gropius, *The Bauhaus* (1926) / 124
4.16. Adolf Loos, *Steiner House* (1910) / 127

4.17. Mies van der Rohe, *Friedrichstrasse Office Building Project* (1921) / 135

4.18. Theo van Doesburg, *Rhythm of a Russian Dance* (1918) / 136

4.19. Mies van der Rohe, *Brick Country House* (1924) / 136

4.20. Mies van der Rohe, *German Pavilion at International Exposition* [Barcelona Pavilion] (1929) / 137

4.21. Mies van der Rohe, *Lake Shore Drive Apartments* (1948–51) / 138

4.22. Mies van der Rohe, *Farnsworth House* (1946–51) / 139

4.23. Mies van der Rohe, *Seagram Building* (1954–58) / 140

5.1. Thomas Nast, *A Shadow Is Not a Substance* / 151

5.2. Thomas Nast, *The Survival of the Fittest* / 153

5.3. Thomas Nast, *Milk Tickets for Babies, in Place of Milk* / 153

5.4. J. S. G. Boggs, *$10 Bill B28021991B* (1991) / 159

5.5. Marcel Duchamp, *Tzanck Check* (1919) / 162

5.6. Marcel Duchamp, *Fountain* (1917) / 162

5.7. Kurt Schwitters, *Cathedral of Erotic Misery* (ca. 1933) / 165

5.8. Robert Rauschenberg, *Monogram* (1955–59) / 169

5.9. Jasper Johns, *Painted Bronze* (1960) / 172

5.10. Jasper Johns, *Flag* (1954–55) / 172

5.11. Jasper Johns, *Three Flags* (1955) / 174

5.12. Jasper Johns, *Gray Numbers* (1958) / 175

5.13. Jasper Johns, *No* (1961) / 176

5.14. Andy Warhol, *Campbell's Soup Cans* (1965) / 180

5.15. Andy Warhol, *Van Heusen (Ronald Reagan)* (1985) / 184

6.1. Joel Bergman, *The Mirage Hotel* (1989) / 187

6.2. Skidmore, Owens, and Merrill, *John Hancock Building* (1969) / 195

6.3. Robert Venturi, *Vanna Venturi House* (1963–65) / 198

6.4. Robert Venturi, Denise Scott Brown, John Rausch, *Gordon Wu Hall* (1982–84) / 199

6.5. Philip Johnson, *Glass House* (1949) / 200

6.6. Philip Johnson, *University of St. Thomas* (1957) / 200

6.7. Andy Warhol, *Thirteen Most Wanted Men* / 201

6.8. Philip Johnson, *New York State Pavilion* (1964) / 201

6.9. Philip Johnson, *Republic Bank Center* (1981–84) / 203

6.10. Philip Johnson, *PPG Corporate Headquarters* (1979–84) / 203

6.11. Philip Johnson, *AT&T Corporate Headquarters* (1979–84) / 204

6.12. Philip Johnson, *AT&T Corporate Headquarters*, lobby / 204

6.13. James Stirling, *Engineering Building* (1959–63) / 205

6.14. James Stirling, *Staatsgalerie, New Building* / 207

6.15. Michael Graves, *Benacerraf House* (1969) / 209

6.16. Michael Graves, *Snyderman House* (1972) / 209

6.17. Michael Graves, *Plocek Residence* (1982) / 210

6.18. Charles Moore, *Indiana Landing* (1980–82) / 216

6.19. Charles Moore, *Wonderwall* (1982–84) / 216

6.20.  Michael Graves, *Walt Disney World Resort Hotels*  /  221

6.21.  Michael Graves, *Walt Disney World Dolphin Hotel* (1987)  /  221

7.1.  André Masson, *Acéphale*  /  237

7.2.  André Masson, *The Labyrinth*  /  239

7.3.  André Masson, *Dionysus*  /  241

7.4.  André Masson, *Massacre*  /  241

7.5.  Bernard Tschumi, *Le Parc de la Villette* (1985)  /  243

7.6.  Adrian Fainsilber, *La Cité des Sciences et de l'Industrie* (1986)  /  244

7.7.  Bernard Tschumi, *Superimposition: Points/Lines/Surfaces* (1982)  /  249

7.8.  Peter Eisenman, *House No. III*  /  257

7.9.  Peter Eisenman, *Romeo and Juliet* (1986)  /  259

7.10.  Peter Eisenman, *Wexner Center for the Visual Arts*, interior (1989)  /  262

7.11.  Peter Eisenman, *Wexner Center for the Visual Arts*, aerial view  /  263

7.12.  Peter Eisenman, *Wexner Center for the Visual Arts*, exterior passage  /  264

7.13.  Peter Eisenman, *Doorhandle*  /  267

8.1.  Michael Heizer, *Double Negative* (1969–70)  /  271

8.2.  Michael Heizer, *Negative Painting* (1966)  /  275

8.3.  Michael Heizer, *Rift* (1968)  /  275

8.4.  Michael Heizer, *Double Negative* (1969–70), aerial view  /  277

8.5.  Michelangelo Pistoletto, *The Cage of the Mirror* (1978–82)  /  284

8.6.  Michelangelo Pistoletto, *Division and Multiplication of the Mirror* (1979)  /  286

8.7.  Michelangelo Pistoletto, *The Shape of the Mirror* (1975–78)  /  287

8.8.  Anselm Kiefer, *Icarus: March Sand* (1981)  /  295

8.9.  Anselm Kiefer, *Germany's Spiritual Heroes* (1973)  /  297

8.10.  Anselm Kiefer, *Iconoclastic Controversy* (1980)  /  299

8.11.  Anselm Kiefer, *To the Supreme Being* (1983)  /  304

8.12.  Anselm Kiefer, *Departure from Egypt* (1984–85)  /  306

# 1

*By "modernity" I mean the ephemeral, the fugitive,*
*the contingent, the half of art whose other half is the eternal*
*and the immutable.*
—CHARLES BAUDELAIRE

# PROGRAM

# 1 □ PROGRAM

**T**HE MOMENT has arrived when it is not only possible but, in a certain sense, necessary to reconsider the complex interplay of art, architecture, and religion. Religion and the visual arts currently are at war. Art, we are repeatedly told, is not only corrupt but also corrupting. Many representatives of the religious and political right assume that it is their God-given mission to purge the polis of this catastrophic disease. The struggle resulting from this confrontation of religion and art harbors implications that reach far beyond the exigencies of the present situation.

Hostility toward the arts is not, of course, anything new. Ever since Plato banned poets from his ideal city, Western philosophy and religion have suspected that art has the power to mislead the young and corrupt otherwise upright citizens. Within the Jewish tradition, the Second Commandment raises serious questions about the proper role of images. The transcendence of Yahweh tends to render all forms of figuration problematic. Insofar as Christianity is, in Nietzsche's terms, "Platonism for the masses," many theologians and believers share Plato's misgivings about the arts. From the radical dualism of early Gnostic "Christians" and eighth-century iconoclasts to the asceticism of the Reformers and the purism of the Puritans, Christians have been wary of potentially errant forces operating in artistic figures. To attempt to represent the unrepresentable is, in effect, to corrupt the divine. Obviously, contrary tendencies are also at work in the Christian tradition. In many periods, doubt about images is balanced by a deep appreciation for the spiritual significance and pedagogical value of the visual arts.

Throughout the twentieth century, Christian theologians and philosophers of religion have been, for the most part, either critical or dismissive of the arts. With the publication in 1918 of Karl Barth's epoch-making book *The Epistle to the Romans,* cultural achievements of every kind came under a cloud of suspicion. Instead of offering signs of humankind's spiritual development, Barth and his followers argue, culture provides an index of human corruption. Returning to his Swiss Calvinist roots, Barth developed a dialectical theology in which the affirmation of God presupposes the negation of nature, history, and culture. From this point of view, God, who is "wholly other," can never be revealed through natural events or human activity. To assume that cultural expression is spiritually significant is to become more deeply mired in the sinfulness from which God alone can provide deliverance.

There are exceptions—though few—to this dominant theological perspective. Most notably, Paul Tillich formulated a theology of culture in which the arts play a constructive role. In a suggestive essay entitled "On the Theology of Fine Art and Architecture," Tillich observes, "It was natural for a theologian to raise the question: 'How is the aesthetic function of

the human spirit related to the religious function? How are artistic symbols—and all artistic creations are symbols, however naturalistic their style may be—related to the symbols in which religion expresses itself?' " [1] In advancing responses to these questions, Tillich does not develop a sustained analysis of the relationship between religion and art. Rather, he presents a series of separate studies intended to disclose the way in which particular paintings and works of architecture can be interpreted as expressions of ultimate concern. Apart from Tillich's scattered reflections, twentieth-century theologians and philosophers of religion have virtually ignored modern art. [2]

The situation is no less problematic when viewed from the perspective of art criticism. In his highly influential essay "Modernist Painting," Clement Greenberg writes, "I identify Modernism with the intensification, almost the exacerbation, of this self-critical tendency that began with the philosopher Kant. Because he was the first to criticize the means itself of criticism, I conceive of Kant as the first real Modernist. The essence of Modernism lies, as I see it, in the use of the characteristic methods of a discipline to criticize the discipline itself—not in order to subvert it, but to entrench it more firmly in its area of competence." So understood, modernism is, as Jürgen Habermas never tires of repeating, an extension of the Enlightenment project. To be enlightened is to be not only rational but critical and, more importantly, self-critical. "The task of self-criticism," Greenberg continues, "became to eliminate from the effects of each art any and every effect that might conceivably be borrowed from or by the medium of any other art. Thereby each art would be rendered 'pure,' and in its 'purity' find the guarantee of its standards of quality as well as of its independence. 'Purity' meant self-definition, and the enterprise of self-criticism in the arts became one of self-definition with a vengeance." [3]

Another term for the purity that is supposed to be established by self-criticism is "autonomy." An art form is pure when it is clearly delimited from other types of artistic expression and thus is completely self-determined. The autonomy of a particular style or work of art is defined by establishing its difference from other styles or artworks. In philosophical terms, autonomy involves a complex interplay of opposites in which identity defines itself in relation to that which is different from itself. Relation to apparent otherness, therefore, is actually a reflexive self-relation that establishes rather than negates autonomy. According to Greenberg, pure autonomy results from a gradual process of abstraction in which everything that is regarded as extraneous to a particular medium is progressively removed. Greenberg's most influential student, Michael Fried, explains that "the enterprise in question involve[s] testing a wide range of norms and conventions in order to determine which [are] inessential, and therefore to be discarded, and which on the contrary constitute the timeless and unchanging essence of the art of painting." [4] From this point of view, the development of modern art follows an "inexorable logic" that

leads from figuration and ornamentation to abstraction and formalism. This process of abstraction reaches closure when the work of art becomes totally self-reflexive and transparently self-referential.

> The history of avant-garde painting is that of a progressive surrender to the resistance of its medium; which resistance consists chiefly in the flat picture plane's denial of efforts to "hole through" it for realistic perspectival space. In making this surrender, painting not only got rid of imitation—and with it, "literature"—but also of realistic imitation's corollary confusion between painting and sculpture. . . . Painting abandons chiaroscuro and shaded modelling. Brush strokes are often defined for their own sake. . . . Under the influence of the rectangular shape of the canvas, forms tend to become geometrical—and simplified. . . . But most important of all, the picture plane itself grows shallower and shallower, flattening out and pressing together the fictive planes of depth until they meet as one upon the real and material plane which is the actual surface of the canvas; where they lie side by side or interlocked or transparently imposed upon each other.[5]

The "timeless essence" of painting is captured in the "ineluctable flatness" and irreducible "two-dimensionality" of the painterly surface. When painting becomes transparent to itself in brush strokes executed for their own sake, all vestiges of mimesis are removed and every trace of representation is erased. The history of art becomes a series of formal revisions and innovations in which painting is concerned with nothing other than itself. In sum, *painting is about painting.*

Painting that is essentially about painting seems to leave little room for religious and spiritual concerns. Having defined the terms of debate for many critics, Greenberg effectively obscures the self-confessed spiritual preoccupations of the very artists whose work he analyzes. All of the major abstract expressionists were deeply interested in religion and actively incorporated spiritual concerns in their work. Moreover, such involvement with religion is not limited to postwar American art. From the beginning of modern art in Europe, its practitioners have relentlessly probed religious issues. Though not always immediately obvious, the questions religion raises lurk on or near the surface of even the most abstract canvases produced during the modern era.

One of the most puzzling paradoxes of twentieth-century cultural interpretation is that, while theologians, philosophers of religion, and art critics deny or suppress the religious significance of the visual arts, many of the leading modern artists insist that their work cannot be understood apart from religious questions and spiritual issues. In this book, I will attempt to create a dialogue between religion and the visual arts by developing an interpretation of twentieth-century art and architecture from a theological or, more precisely, an a/theological perspective. A/theology explores the middle ground between classical theology and atheism. In this interstitial space and intermediate time, we find the possibility of refiguring the polarities and oppositions that structure traditional religious thought.[6] My purpose in bringing together religion and the visual arts is not to present a comprehensive history of modern painting and architecture.[7]

Nor am I particularly interested in works of art that are religious in a direct or straightforward way. Rather, I develop an a/theologico-philosophical *argument* that is intended both to establish the implicit and explicit spiritual preoccupations of leading twentieth-century painters and architects and to disclose the religious significance of their work. This approach inevitably places limitations on the investigation. The structure of the argument makes it necessary to exclude many noteworthy artists and works. It is my hope, however, that once the opportunity for a dialogue between religion and the visual arts has been created, it will be possible to extend the discussion to include contributions of other artists and architects.

It is important to stress that my primary concern in this study is the interplay between religion and the visual arts and not the relationship between religion and aesthetics. While interest in the arts is as old as philosophy itself, the discipline of aesthetics is a relatively recent invention. Alexander Gottlieb Baumgarten, a German Wolffian philosopher, introduced the term "aesthetics" into philosophical discourse in his two-volume work *Aesthetica Acroamatica* (1750–58). In Baumgarten's philosophical system, aesthetics is the branch of empirical psychology devoted to the study of knowledge derived from sense experience rather than from conceptual reflection.[8] "The distinction that the term 'aesthetic' initially enforces, in the mid-eighteenth century, is not one between 'art' and 'life,' but between the material and the immaterial: between things and thoughts, sensations and ideas, that which is bound up with our creaturely life as opposed to that which conducts some shadowy existence in the recesses of the mind."[9] For Baumgarten and those who follow him, one of the most important sources of such "empirical" knowledge is the experience of beauty. Through a gradual process of refinement and revision, "aesthetics" eventually came to designate theoretical reflection on artistic phenomena. The pivotal chapter in the emergence of modern aesthetics begins with Kant's critical philosophy and ends with Hegel's absolute idealism. As we shall see in later chapters, the notion of *l'oeuvre d'art* formulated in post-Kantian idealism is concretely embodied in the work of a variety of twentieth-century painters and architects. I shall consider aesthetic theory only insofar as it illuminates specific artistic practices.[10]

My interest in art and architecture, however, is not simply analytic. The larger purpose of this book is constructive or, perhaps more accurately, reconstructive. Though theological reflection in our century has tended to dismiss the visual arts, nineteenth-century theologians, philosophers, and artists insisted upon the inseparability of art and religion. I am convinced that certain developments in contemporary art and architecture provide untapped resources for religious reflection. The result of a reconsideration of the interplay between religion and art is not a return to conclusions reached during the last century. To the contrary, a thoughtful exploration of some of the most provocative art of our time opens an alternative space for the a/theological imagination. Into this space I shall

wander at the end of this study. It would not be inaccurate to understand this venture as an effort to rethink the interrelation of Kierkegaard's three spheres of existence: the aesthetic, the ethical, and the religious.

Toward this end, I develop a quasi-Hegelian argument comprising three nondialectical "epochs." In each epoch, I consider parallel developments in art and architecture. If one insists on historicizing these epochs by interpreting them as "moments" or "stages" of development, they might be understood to approximate modernism and two contrasting versions of postmodernism. Of course, "modernism" and "postmodernism" are notoriously problematic terms whose meaning shifts from context to context and discipline to discipline. Confusion is compounded because what is usually understood as postmodernism is actually an extension of modernism. Postmodernism *sensu strictissimo* subverts both modernism and "modernist" postmodernism as if from within. I will reconsider the modern/postmodern debate in the visual arts in the hope of clarifying the issues at stake in the rapidly developing discussion of religion and postmodernism.

Instead of approaching these epochs as historical periods, it is more fruitful to understand them as three alternative strategies of disfiguring. Disfiguring might appear to be an unlikely notion around which to organize a study of the visual arts, but on close examination *disfigure* proves to be a complex and suggestive word with many layers of meaning. On the most obvious level, *to disfigure* means "to mar the figure or appearance of, destroy the beauty of; to deform or deface." In less common usages, *to disfigure* also means "to disguise" or "to carve." By extension, *disfigurement* designates a defacement, deformity, blemish, or flaw. Additional dimensions of *disfigure* appear when the word is broken into its constituent parts. The prefix *dis-* denotes "negation, lack, invalidation, or deprivation." Among the many meanings of *figure,* which is both a noun and a verb, the most relevant for my purposes include "form, shape; an embodied (human) form; a person considered with regard to visible form or appearance; the image, likeness, or representation of something material or immaterial; an arrangement of lines or other markings forming an ornamental device; one of the devices combined into a decorative pattern; to form, shape; to trace, mark; to be an image, symbol, or type; to adorn or mark with figures; to embellish or ornament with a design or pattern." When taken together, the two parts of *disfigure* suggest the negation or deprivation of form, image, likeness, or representation; the removal of symbol, ornament, design, or pattern. But *figure* also means "to calculate; to take into consideration; to solve, decipher, or comprehend"—as when I figure something out.[11] Accordingly, *disfigure* suggests the negation of calculation, deprivation of solution, and lack of decipherment or comprehension—as when I fail to figure something out. Disfiguring can figure a disguise whose efficacy is measured by the failure to decipher or comprehend it.

Further semantic layers are suggested by the German translation of *disfigure*—*entstellen* (*ent-*, "im-, de-, dis-" + *stellen*, "put, place, set, stand, position"). In addition to disfigure, *entstellen* means "to deform, deface, mutilate, mar, spoil; distort; garble; and misrepresent." *Entstellung* (disfigurement, distortion, misrepresentation, deformation, defacement, deformity) is the term Freud uses to describe the overall effect of dream work. In the development of the dream, "latent thoughts are transformed into a manifest formation in which they are not easily recognizable. They are not only transposed, as it were, into another key, but they are also distorted in such a fashion that only an effort of interpretation can reconstitute them."[12] Freud's account of *Entstellung* discloses the strange logic of disfiguring, for disfiguring enacts what Freud elsewhere describes as *Verneinung*. Though usually (mis)translated "negation," "denial," or "disavowal," the term "denegation" better captures the irresolvable duplicity of *Verneinung,* in which affirmation and negation are conjoined without being united or synthesized.[13] *Verneinung* is at once an affirmation that is a negation and a negation that is an affirmation. To de-negate is to un-negate, but un-negation is itself a form of negation. More precisely, denegation is an un-negation that affirms rather than negates negation. The affirmation of negation by way of denegation subverts the specious dialectical effort to affirm negation merely by negating negation.

Disfiguring enacts denegation in the realm of figure, image, form, and representation. As such, disfiguring is a formation that is a deformation and a deformation that is a formation. In the process of disfiguring, revelation and concealment as well as presence and absence are interwoven in such a way that every representation is both a re-presentation and a de-presentation. From this perspective, disfiguring is what Georges Didi-Huberman describes as *une fonction déchirée.*

> A torn function—that is to say, a function including the power of the negative within it—thus presides, as *work,* in the intense or evanescent visuality of the images of the dream. How to understand such work? Beyond the same metaphor proposed in the paradigm of the rebus, Freud puts us on guard against the attempt to "represent to ourselves in a plastic manner our psychic state at the time of the formation of the dream." . . . The problem is to be able to envision only on the basis of that which . . . *presents itself*—and it is not by chance that Freud begins to problematize the notion of *Traumarbeit* by insisting on the presentation of the dream, which with its character of *fragments put together* is so often lacunary. What presents itself crudely at first, what presents itself and what refuses the idea, is the tearing or rending [*la déchirure*]. It is the image outside the subject, the image as image of the dream. It only imposes itself here by force of the omission (*Auslassung*) or the abridging of which it is, strictly speaking, the *vestige:* that is to say, the unique survival, at the same time sovereign remainder and trace of effacement. A visual operator of disappearance.[14]

The "trace of effacement" is the "visual operator of disappearance" through which the impossibility of presenting both presence and presen-

tation is "presented." The *fonction déchirée,* which allows dis-appearance to appear, dis-figures in the sense of figuring the very impossibility of figuring. In different terms, disfiguring figures the unfigurable in and through the faults, fissures, cracks, and tears of figures.

From this complex semantic web, three strands emerge that serve to structure the analysis developed in the following chapters. In the first place, to disfigure is to de-sign by removing figures, symbols, designs, and ornaments. Second, to disfigure is to mar, deform, or deface and thus to destroy the beauty of a person or object. Finally, disfiguring is an unfiguring that (impossibly) "figures" the unfigurable.

Though involving an extraordinary array of diverse styles and schools, twentieth-century art and architecture, until recently, have been characterized by two dominant tendencies: abstraction and figuration (or refiguration). During most of this century, art and architecture have tended to gravitate toward either the abstract and formal or the concrete and figurative. While the stakes of abstraction and figuration vary from artist to artist and from architect to architect, shared questions and concerns inform contrasting artistic practices. Most important, both abstract and figurative artists and architects have regarded representation as problematic. The emergence of the problem of representation parallels the development of the question of language in twentieth-century philosophy, and indeed these two issues are really different twists of a common problematic. Whereas language traditionally has been understood to be representational, representation has gradually come to be interpreted in terms of language. Paradoxically, the more self-conscious philosophers, artists, and architects become about the media they use, the more opaque language and representation themselves become. Instead of a window on, or mirror of, reality, language and representation increasingly seem to form a screen or veil that obscures more than it reveals. As vision becomes questionable, representation changes from an ideal to be realized to a difficulty to be overcome.

In view of the important role linguistic metaphors have played in recent cultural studies, it is illuminating to recast the issue of representation in semiotic terms. As Saussure, among others, insists, every sign is formed by the interplay of a signifier and signified. Depending on the semiotic theory, the understanding of the signified varies from a specific entity in the world to a concept or mental construction. The signifier, by contrast, constitutes the mark (written, verbal, or otherwise) that stands for a particular signified within a given sign system. While the relation between signifier and signified usually is regarded as arbitrary, the function of the signifier is to re-present the signified. The aim of signification is the formulation of a perfect sign that effectively erases itself by becoming completely transparent to the signified. So understood, the structure of signification not only harbors the possibility of union (i.e., the conjunction of signifier and signified that issues in the fullness of truth) but also inevitably implies the prospect of division (i.e., the fragmentation of sig-

nifier and signified that issues in the impossibility of truth). To avoid the fragmentation occasioned by the fault of the sign, various strategies are developed that are intended to resolve the dilemmas posed by entanglement within the net of representation. In the realm of art and architecture, two alternative approaches to questions of representation emerge: some artists and architects attempt to elide the signifier in an effort to allow the signified to shine forth clearly, and others try to collapse the signified into the signifier in order to secure the self-referentiality of signs.

As abstraction and refiguration run their course, many artists insist that these two alternatives are overly reductive and therefore inadequate for dealing with the complex artistic, religious, and social problems of our day. Thus, some of the most creative contemporary painters and architects are seeking a third way that falls *between* abstraction and figuration. In this interstitial site, figure is neither erased nor absolutized but is used with and against itself to figure that which eludes figuring. Torn figures mark the trace of something else, something other that *almost* emerges in the cracks of faulty images. This other neither is nor is not—it is neither being nor nonbeing, fullness nor void, immanent nor transcendent. It is more radically other than the other that is the other *of* the same. I improperly "name" this unnameable other "altarity." Never present without being absent, altarity approaches by withdrawing and withdraws by approaching. This unimaginable approaching withdrawal and withdrawing approach occurs in "events" that transpire in images that represent nothing.

> To live an event as an image is not to remain uninvolved, to regard the event disinterestedly in the way that the aesthetic version of the image and the serene ideal of classical art propose. But neither is it to take part by a free decision. It is to let oneself be taken: to pass from the region of the real, where we hold ourselves at a distance from things the better to dispose of them, into that other region where distance holds us—the distance that then is profoundly lifeless, an unmanageable, inappreciable remoteness that has become something like the sovereign power behind things. (L, 261)

It should be clear that the three epochs of painting and architecture reflect and enact the three strategies of disfiguring. Abstract or nonobjective art and high modern architecture disfigure by removing figures, symbols, designs, and ornaments. The goal of such disfiguring is the presentation of pure form, which is often indistinguishable from pure formlessness. In the wake of abstract expressionism and the international style, when figuration returns in pop art and postmodern architecture, artists and architects disfigure by deforming, defacing, or corrupting the purity of modernist canvases and buildings. If your aesthetic is ascetic, figures are disfiguring. The critique of modernism in what is traditionally defined as postmodernism is, however, a reversal that is less significant than it initially appears. As Kierkegaard once observed, to do the opposite is also a form of imitation. To disrupt and dislocate the shared presuppositions and conclusions of modernism and modernist postmodernism, one must think what modernism leaves unthought by trying to figure a dis-

figuring that struggles to figure the unfigurable. It is to this endless task that certain contemporary artists and architects call the a/theologian. To heed this call is to approach the possibility of refiguring the sacred by rethinking the interplay of art, ethics, and religion.

As I have noted, modernism is defined differently in various domains of cultural expression. While modern philosophy is usually thought to have begun with Descartes's turn to the subject in the seventeenth century and modern theology is generally acknowledged to have started with Schleiermacher's romantic apology for religion at the end of the eighteenth century, there is far less agreement about the beginning of modern art. For some, the closing decades of the nineteenth century—which were marked, inter alia, by Van Gogh's solar sensualism, Manet's transgressive eroticism, Monet's brilliant impressionism, and Cézanne's geometric rigor—signaled the advent of modernism. According to others, artistic modernism is a product of the twentieth century. In his suggestive book *The Banquet Years,* Roger Shattuck observes that "by 1900 old-world gaiety had taken on an aspect of methodical demonstration. Montmartre and the Latin Quarter do not merely provide a colorful backdrop for these years. Their cabarets and cafés represented a new aesthetic. The banquet called for gaiety and scorn of convention, and also for an assimilation of popular art forms and a full aliveness to the present moment. This was the setting for a great rejuvenation of the arts."[15]

The heart of modernism is, in Shattuck's apt phrase, a profound longing for "a full aliveness to the present moment." The aim of diverse modernist practices in art, architecture, and theology is the enjoyment of "total presence" *here and now.* Perhaps nowhere is the desire for presence more vividly portrayed than in the closing lines of Joyce's *Finnegans Wake.*

> Lff! So soft this morning, ours. Yes. Carry me along, taddy, like you done through the toy fair! If I seen him bearing down on me now under whitespread wings like he'd come from Arkangels, I sink I'd die down over his feet, humbly dumbly, only to washup. Yes, tid. There's where. First. We pass through grass behush the bush to. Whish! A gull. Gulls. Far calls. Coming, far! End here. Us then. Finn, again! Take Bussoftlhee, mememormee! Till thousendsthee. Lps. The keys to. Given! A way a lone a last a loved a long the[16]

Within the modernist economy, the immediate presence of "Lff," "taddy," . . . , *ici et maintenant* provides "the keys to" a Kingdom that dawns here and now. For true believers, modernity is, in effect, the realization of the Kingdom of God on earth. Fulfillment is not delayed or deferred but is available in the present as a presence that knows no absence and a fullness that experiences no lack.

Baudelaire's classic formulation captures the significance of the "full aliveness to the present moment": "by 'modernity,' I mean the ephemeral, the fugitive, the contingent, the half of art whose other half is the eternal and the immutable."[17] Whereas Baudelaire consistently emphasizes the fugitive and contingent, modern artists and architects depict not only the

ephemeral but also the eternal and immutable that they believe is implicit in, and the structural foundation of, the passing moment. As a matter of fact, the two rhythms that Baudelaire so concisely describes accurately characterize the first two strategies of disfiguring I have defined. While the activity of abstraction searches out the eternal and immutable, the gesture of figuration seeks immersion in the ephemeral, fugitive, and contingent. Whether through abstraction, directed toward the eternal, or immersion in the transitory play of signs, the goal of disfiguring remains the same: to establish an *immediate* relation with that which is believed to be (the) real. In "Art and the Structuralist Perspective," Annette Michelson writes,

> Art tends increasingly to posit "formal statements" which are positive and nonambiguous, their reductive or nonrelational character resisting denial, debate, and qualification. Statements of this sort we term "apodictic." And the ultimate statement of this kind, the height of immediacy, is reached by the work whose formal statement is merely "I am that I am." The Utopian ideal of this century is, indeed, as Lévi-Strauss has suggested, the construction of a sign system on a single level of articulation. It is a dream of absolute immediacy pervading our culture and our art, which replaces, in a secular age, a theology of absolute presence. The dream is figured on the reverse side of the idealist coin.[18]

For the modernist, the dream of immediacy envisioned in "a theology of absolute presence" comes true. Or so it seems.

As these remarks indicate, modernism is irrepressibly utopian. Incredible though it now appears, for many people living during the decades of transition from the nineteenth to the twentieth century, unprecedented social, cultural, and, most important, technological changes seemed to herald a new age in which human suffering could be overcome and wants satisfied. The Eiffel Tower, completed in 1889 for the Paris World's Fair commemorating the one-hundredth anniversary of the French Revolution, stands as a lasting monument to the confidence in technology to usher in the millennium. In words that mix irony and awe, the poet-critic Guillaume Apollinaire effectively sacralizes Alexandre-Gustave Eiffel's remarkable engineering feat.

> At last you are tired of this old world.
> O shepherd Eiffel Tower, the flock of bridges bleats this morning
> You are through with living in Greek and Roman antiquity
> Here, even the automobiles seem to be ancient
> Only religion has remained brand new, religion
> Has remained simple as simple as the aerodrome hangers
> It's God who dies Friday and rises again on Sunday
> It's Christ who climbs in the sky better than any aviator
> He holds the world's altitude record
> Pupil Christ of the eye
> Twentieth pupil of the centuries he knows what he's about,
> And the century, become a bird, climbs skywards like Jesus. (SN, 11)

Roland Barthes correctly points out that the Eiffel Tower is a "pure—virtually empty—sign . . . *because it means everything.*"[19] Not only the fu-

turists but artists of widely differing persuasions filled this vacuous sign with their hopes for the imminent arrival of the eschaton. In this epochal moment, the artist-architect does not remain a passive observer or recorder of unprecedented events but is a prophetic—indeed, a messianic—figure who bears the enormous responsibility of providing what Friedrich Schiller describes as "the aesthetic education of man." Without the guidance of visionary artists and architects, entry into the Promised Land is believed to be impossible.

But the Kingdom does not arrive. Like a mirage on the distant horizon, the Promised Land always withdraws as one approaches it. The modernist project failed miserably and tragically. The apocalypse became a holocaust that left Western culture in ruins. Within a few short years, the dream of modernity became a nightmare from which we are still struggling to awaken. The association of modernist art and the sociopolitical disasters of this century is not entirely accidental. For reasons that will become evident in the course of this study, there is a disturbing complicity between modernism and fascism. This claim might initially seem implausible, for many Fascist leaders were extraordinarily hostile to modern art. Indeed, some of the most creative twentieth-century artists and architects were ruthlessly persecuted by Fascist governments. Nonetheless, there is a subtle and undeniable ontological and ideological relationship between certain strands in modern aesthetics and art on the one hand, and, on the other, authoritarian and totalitarian forms of sociopolitical organization.

As yet another millennium draws near, it appears that the tragic end of modernism is unavoidable and inevitable. Its failure does not, however, mean that modernism is over. To the contrary, the modern will *always* be present. Despite its complexity, the presence of modernism can be understood as, among other things, the conviction that presence is realizable in the present. Such belief necessarily tends toward the repressive, for it attempts to remove, erase, or wipe away everything that disrupts the utopian dream of presence. If the twentieth century teaches us anything, it is that our dreams often become nightmares and that utopia can turn into hell. It is an old, perhaps ancient, tale: the repressed does not go away but always returns. The question that pursues us and that calls for pursuit is whether this eternal return opens the space-time of a postmodernism that repeatedly subverts the modernism we can never completely escape.

In the endless wake of modernism, the destiny of art and religion must be not only rethought but refigured. To undertake this daunting task is to retrace the disturbing question raised by Maurice Blanchot: "But where has art led us? To a time before the world, before the beginning. It has cast us out of our power to begin and to end; it has turned us toward the outside without intimacy, without place, without rest. It has led us into the infinite migration of error. For we seek art's essence, and it lies where the nontrue admits of nothing essential. We appeal to art's sovereignty: it ruins the kingdom. It ruins the origin by returning it to the errant immensity of an eternity gone astray" (L, 244). In this uncanny no place, we cannot avoid erring.

As I have stressed, in venturing into this forbidding territory I shall be more concerned with art than with aesthetics. Nonetheless, it is impossible completely to separate theory and practice in modern art and architecture. With characteristic wit and irony, Tom Wolfe writes,

> What I saw before me was the critic-in-chief of *The New York Times* saying: In looking at a painting today, "to lack a persuasive theory is to lack something crucial." It didn't say "something helpful" or "enriching" or even "extremely valuable." No, the word was *crucial.*
>
> In short: frankly, these days, without a theory to go with it, I can't see a painting.
>
> Then and there I experienced a flash known as the *Aha!* phenomenon, and the buried life of contemporary art was revealed to me for the first time. The fogs lifted! The clouds passed![20]

Elaborating a latter-day version of Hegel's theory of the development of art, Arthur Danto makes Wolfe's point with less humor but more philosophical sophistication.

> Now if we look at the art of our recent past . . . what we see is something which depends more and more upon theory for its existence as art, so that theory is not something external to a world it seeks to understand, so that in understanding its object it has to understand itself. But there is another feature exhibited by these late productions, which is that the object approaches zero as their theory approaches infinity, so that virtually all there is at the end *is* theory, art having finally become vaporized in a dazzle of pure thought about itself, and remaining, as it were, solely as the object of its own theoretical consciousness.[21]

To interpret the history of modern art as passing from material object to immaterial theory is a theoretical translation of the strategy of disfiguring that characterizes one—but only one—strand in twentieth-century art. From Danto's perspective, the "progression" from abstract expressionism, through minimalism, to conceptual and performance art fulfills Hegel's prophecy of the end of art.

Within this developmental scheme, abstract and nonobjective art is regarded as advanced, while painting that does not conform to a purist aesthetic is viewed as ideologically regressive. Such painting, it is argued, resists the progress of technological society and avoids the implications of electronic media by attempting to reinvest both the creative artist and the work of art with what Walter Benjamin describes as their "aura."[22] Commenting on Barbara Rose's *American Painting: The Eighties,* art critic Douglas Crimp observes,

> The revivalism of current painting . . . depends, of course, on reinvesting those strokes with human presence; it is a metaphysics of the human touch. "Painting's quasi-miraculous mode of existence is produced . . . by its mode of facture. . . . *Through the hand:* this is the crucial point." This faith in the healing powers of the hand, the facture that results from the laying on of hands, echoes throughout Rose's catalogue text, which pays special homage to Hennessy's attack on photography. The unifying principle in the aesthetic of her painters is that their work "defines itself in conscious opposition to photography and all forms of mechanical reproduction which seek to deprive the art work of its unique 'aura.'" For Rose, elimination of the human touch

can only express "the self-hatred of artists. . . . Such a powerful wish to annihilate personal expression implies that the artist does not love his creation." What distinguishes painting from photography is this "visible record of the activity of the human hand, as it builds surfaces experienced as tactile."[23]

Rose's privileging of painting over photography is as one-sided and problematic as Crimp's privileging of photography over painting. The movement toward abstraction and mechanical modes of reproduction is always checked by countermovements. Despite the efforts of critics like Greenberg and Danto, modern art cannot be forced into the straitjacket of linear development. Any such account of the history of modern art is an extension of some of the most basic and problematic presuppositions of modernism. A more responsible approach to the art and architecture of this century requires an openness to patterns of change that cannot be synthesized to create a comprehensive totality. Nor is the rejection of nonabstract[24] painting for being ideologically regressive entirely justifiable. One need only recall the unholy alliance between certain aspects of modernism and fascism to which I have alluded to realize that "advanced" art can be ideologically, politically, and socially "regressive." There is nothing intrinsically advanced about nonobjective art any more than there is anything inherently regressive about nonabstract painting. Indeed, in the context of postmodern theory and practice, it is no longer clear that it is possible to make sense out of terms like "advanced" and "regressive."

It is, however, undeniable that throughout this century, theory has increasingly come to play a constitutive role in the *production* of artistic and architectural objects. Artist-sculptor-critic Robert Morris explains that "the history of the development of abstract art is also one of the repression of words. That is, the demand for an autonomous art was a demand for the excision of contaminating literature within it. However, language thus repressed was merely displaced into the realm of theory."[25] In modern art, figure and discourse as well as image and text become involved in a complex interplay that establishes lines of association between two ostensibly diverse domains.[26] During the first half of this century, words tend to be absent from the surface of the canvases of many of the most thoughtful artists. Since the 1950s, however, words have emerged to "contaminate" the painted surface. But, as Morris notes, even when words seem to have been erased, they remain "present" in their "absence." Displaced beyond the limit of the work, words become theories that "frame" the object by establishing its context. What is distinctive about modernism is the propensity of *artists* and *architects* to develop theories to accompany their works.

It would be a mistake to approach the figure/discourse, image/text, or object/theory relation in terms of the classical binaries like work/commentary and theory/exemplification or illustration. Figure and discourse combine to form a heterogeneous constellation in which one is necessary,

though not reducible, to the other. Image and text are bound by the strange logic of parasitism in which each is for the other "le dedans du dehors et le dehors du dedans."[27] Text no more explains object than object exemplifies text. The practices of explanation and exemplification remain captive to an economy of representation that can no longer remain unquestioned. When text does not explain and object does not exemplify, figures become textual and texts become figural. Writing, art, and architecture intersect in a textual practice that might be termed archetextural.

*Le dedans du dehors et le dehors du dedans* marks the margin of representation. It is toward this limit that the following pages seek to draw the reader. The journey to the boundary is not always easy; *le pas au-delà* is hardly reassuring. At the limit, something other approaches. Though not precisely unnameable, this other cannot be properly named; though almost unfigurable, this other can be figured only by a certain disfiguring.

**2**

# THEOESTHETICS

*The unity of the material and the transcendental object, which constitutes the paradox of the theological symbol, is distorted into a relationship between appearance and essence. The introduction of this distorted conception of the symbol into aesthetics was a romantic and destructive extravagance that preceded the desolation of modern art criticism. As a symbolic construct, the beautiful is supposed to merge with the divine in an unbroken whole. The idea of the unlimited immanence of the moral world in the world of beauty is derived from the theosophical aesthetics of the romantics.*

—WALTER BENJAMIN

# 2 □ THEOESTHETICS

**I**N THE FALL of 1810, Caspar David Friedrich exhibited *Monk by the Sea* at the Berlin Academy (fig. 2.1). It is a haunting work in which a diminutive figure stands at land's edge beside a dark sea and immense sky. The mood of the painting is somber, its colors muted. The land is ashen and barren, the sea more black than blue, the sky steel-gray with a hint of rose light in its midst. The tiny human figure, clothed in a black robe, fades almost imperceptibly into the sea. There is a profound ambiguity in the monk's relation to the earth, water, and air. He is both overpowered by the forces of nature and absorbed in a totality that infinitely surpasses the isolated individual.

Living in Berlin at the time of the academy's exhibition was the person who is generally acknowledged to be the founder of modern Christian theology: Friedrich Schleiermacher. In the early years of the nineteenth century, hostility toward Christianity was widespread in Berlin. There is no way to know whether Schleiermacher saw Friedrich's painting. It is clear, however, that they faced a common problem. "Friedrich's dilemma," Robert Rosenblum argues,

> his need to revitalize the experience of divinity in a secular world that lay outside the sacred confines of traditional Christian iconography was . . . an intensely personal one. Yet it was also a need that was shared, on different levels, by many of his contemporaries who responded to the eighteenth century's repeated assaults upon traditional Christianity and who hoped to resurrect or to replace the stagnant rituals and images of the Church. Friedrich's intentions, in fact, are closely paralleled in theological terms by the writings and preachings of another German Protestant of his generation, Friedrich Ernst Daniel Schleiermacher, who was born just six years before the artist. . . . Schleiermacher hoped to revive Christian belief in drastically new terms. In 1799, he published *On Religion: Speeches to Its Cultured Despisers,* a plea to preserve the spiritual core of Christianity by rejecting its outer rituals and by cultivating a private experience of piety that could extend to territories outside Christian dogma.[1]

In their efforts to reinterpret religious themes in nontraditional terms, Friedrich and Schleiermacher both turned from orthodox symbols and ideas to the domains of nature and art. This strategy is not, of course, without precedent. Influenced by Edmund Burke's *Inquiry into the Origin of Our Ideas of the Sublime and the Beautiful* (1756), early romantic artists and writers sought religious inspiration in the natural environment. The Irish romantic poet Thomas Moore expresses the feelings of many of his contemporaries in his response to Niagara Falls, recorded in a letter to his mother dated July 24, 1804.

> I felt as if approaching the very residence of the Deity; the tears started into my eyes; and I remained, for moments after we lost sight of the scene, in that delicious absorption which pious enthusiasm alone can produce. We arrived

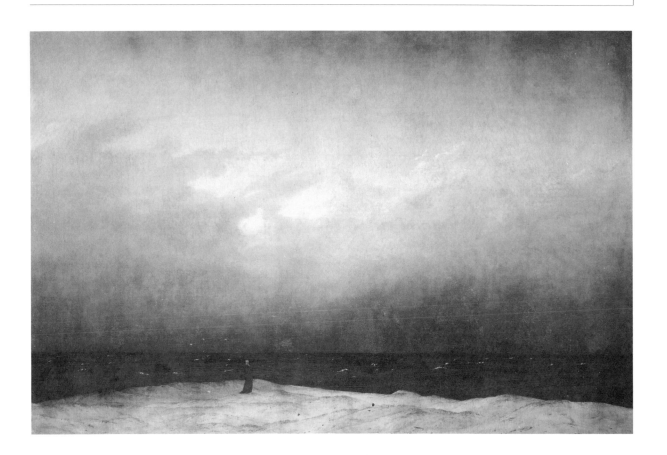

**2.1 Caspar David Friedrich,** *Monk by the Sea* **(1808–10). Staatliche Museen Preuβischer Kulturbesitz, Nationalgalerie, Berlin. Photograph: Jörg P. Anders.**

at the New Ladder and descended to the bottom. Here all its awful sublimities rushed full upon me. My whole heart and soul ascended toward the divinity in a swell of devout admiration, which I never before experienced. . . . We must have new combinations of language to describe the Fall of Niagara.[2]

Friedrich's works depict precisely the kind of scenes that fill Moore with awe. In some paintings, nature seems harmonious and tranquil (*Woman in Morning Light* and *Village Landscape in Morning Light (Lone Tree)*; in others, nature appears vast, empty, and mysterious (*Sea with Sunrise* and *Mountain with Rising Fog*); while in still others, nature's violence is vividly portrayed (*Arctic Scene* and *The Polar Sea*). For Friedrich and his fellow romantics nature is, in Rudolf Otto's terms, numinous—it is the source of both attraction and repulsion, consolation and fear. This irreducible ambiguity renders the experience of nature sublime.[3]

For Friedrich and Schleiermacher, nature's healing powers always outweigh its destructive force. On numerous canvases, Friedrich explicitly weds the natural and the religious. In a work like *The Cross in the Mountains*, God disappears from the heavens of eighteenth-century Deism and reappears in nature, which now is deemed divine (plate 1). William Wordsworth's "Lines Composed a Few Miles above Tintern Abbey" might well have been written after stumbling upon Friedrich's *Abbey under Oak Trees* (1810).

> For I have learned
> To look on nature, not as in the hour
> Of thoughtless youth; but hearing oftentimes
> The still, sad music of humanity,
> Nor harsh nor grating, though of ample power
> To chasten and subdue. And I have felt
> A presence that disturbs me with the joy
> Of elevated thoughts; a sense sublime
> Of something far more deeply interfused,
> Whose dwelling is the light of setting suns,
> And the round ocean and the living air,
> And the blue sky, and in the mind of man;
> A motion and a spirit, that impels
> All thinking things, all objects of all thought,
> And rolls through all things.[4]

The seeds of the theoesthetic vision that emerges in Wordsworth's poetry and on Friedrich's canvases were sown in Germany during the closing decade of the eighteenth century. Throughout the 1790s, a remarkable group of artists, writers, and philosophers gathered in the small town of Jena in the duchy of Weimar.[5] Among those who were drawn to Jena at this time were Herder, Goethe, the Schlegel brothers, Novalis, Tieck, Fichte, Schiller, Hölderlin, Schelling, Schleiermacher, and Hegel. Out of the creative tumult of these years comes a vision of "Weimar *Kultur*" whose influence extends into this century in the search for a *Gesamtkunstwerk* that characterizes artistic endeavors as diverse as the *Festspiel* of Bayreuth and the modern design of the Bauhaus. Goethe's young Werther suggests the continuity of interests and sensibilities between the Jena romantics and nineteenth-century artists and painters when he records his response to the untamed landscape: "I felt myself exalted by this overflowing fullness to the perception of the Godhead, and the glorious forms of the infinite universe stirred within my soul! Stupendous mountains encompassed me, abysses yawned at my feet, and cataracts fell headlong down before me; rivers rolled through the plains below, and rocks and mountains resounded from afar."[6]

This vision of the creative power of nature, however, is counterbalanced by a pervasive recognition of the destruction wrought by modern sociocultural developments. M. H. Abrams points out that "no thinker was of greater consequence than Friedrich Schiller in giving a distinctive Romantic formulation to the diagnosis of the modern malaise, and to the overall view of the history and destiny of mankind of which the diagnosis was an integral part."[7] For the generation of poets and philosophers that came of age in Jena, Schiller's *On the Aesthetic Education of Man* (1795) provided the definitive interpretation of the personal and social problems created by the industrialization and commercialization endemic to modern society. Drawing on a wide range of sources, Schiller forges a comprehensive argument in which he maintains that the distinctive feature of

modern experience is its fragmentation. In a world governed by the competitive laws of an industrial economy, class divisions emerge that create conflict among and within individuals. In a particularly penetrating passage, Schiller describes the consequences of the disintegration typical of the age. "Eternally chained to a single little fragment of the whole, man himself develops into nothing but a fragment; with the monotonous noise of the wheel he drives everlastingly in his ears, he never develops the harmony of his being, and instead of putting his stamp of humanity upon his own nature, he becomes merely the stamp of his occupation, of his specialized knowledge" (AE, 40). Jena romantics sought to cure the personal and social ills of the era by healing the wounds, mending the tears, and closing the faults brought by modernity. Art and religion constitute the heart of the therapy they prescribed.

Jean-Luc Nancy and Philippe Lacoue-Labarthe suggest that the artists and writers who came together in Jena during the latter half of the 1790s constituted what was, in effect, "the first 'avant-garde' group in history" (LA, 8). Most interpreters overlook the important role religion played in the genesis of modern and postmodern artistic movements. In a letter to Novalis, Friedrich von Schlegel, who was one of the most creative and influential members of the Jena group, went so far as to declare, "I am thinking of founding a new religion or at least of helping to preach it. Perhaps you are better qualified to make a new Christ—if so, he will find in me his St. Paul."[8] The person who was, in fact, best qualified to found "a new religion" was neither Schlegel nor Novalis but Schleiermacher, whose passionate defense of religion, *On Religion: Speeches to Its Cultured Despisers*, opened the modern era of religious reflection.

As his title indicates, Schleiermacher's purpose in *On Religion* is avowedly apologetic. He seeks to present an interpretation of religion that responds to Enlightenment criticisms by avoiding, as much as possible, orthodox Christian dogma. Reflecting the interests and preoccupations of his day, Schleiermacher rereads religious faith in terms of artistic awareness.[9] In the crucial second speech, he defines "the essence of religion" as "the sensibility and taste for the infinite" (SR, 103).

By approaching religion in terms of art, Schleiermacher draws upon and criticizes Kant's philosophy. Whereas Kant attempts to relocate religion from the realm of theory or thought (the First Critique) to the domain of practice or action (the Second Critique), Schleiermacher situates religion squarely in the province of sensibility or affection (the Third Critique). The insistence on the close relation between religion and artistic awareness reflects a common eighteenth-century tendency to associate aesthetics with perception and sensation instead of reason and conceptual thought. Religion, however, is not just any sensation but involves a unique intuition in which the "original" unity of subjectivity and objectivity is apprehended. Schleiermacher describes this primal oneness as the "first mysterious moment that occurs in every sensory perception, before intui-

tion and feeling have separated, where sense and its objects have, as it were, flowed into one another and become one" (SR, 112). This primal moment of unity is "immediate consciousness."[10]

For many of his critics, Schleiermacher's "immediate consciousness" is illusory. Inasmuch as consciousness presupposes a distinction between subject and object, it would seem to rupture every form of immediacy. Schleiermacher indirectly admits as much when he sighs regretfully that to express or even to indicate religious intuition is to "desecrate it." Since religious awareness slips away in the very effort to grasp it, the unity or identity it portends can only be "present" as "absent." The unavoidability of loss and the inaccessibility of immediacy lend a melancholy tone even to Schleiermacher's most exalted moments. One way of reading his text is as a prolonged struggle to deny what he nonetheless admits. This denial takes the form of the *affirmation* of his unity with the universe in its wholeness or totality. Like Friedrich's monk who fades into elemental nature, Schleiermacher's religious enthusiast totally identifies with the universe. In religious intuition, "the universe as a whole exists in uninterrupted activity and reveals itself to us every moment. Every form that it brings forth, every being to which it gives a separate existence according to the fullness of life, every occurrence that spills forth from its rich, ever-fruitful womb, is an action of the same upon us. Thus to accept everything individual as a part of the whole and everything limited as a representation of the infinite is religion" (SR, 105).

To perceive the re-presentation of the whole in the part is to grasp the finite as a moment or member of the infinite. Schleiermacher's totality is an *organic* whole in which "everything is *ornately* connected and intertwined" and hence "all diversity and all opposition are only apparent and relative" (SR, 118, emphasis added). This intricate whole is nothing other than an "eternal work of art."

> Thus the outlines of personality that appear so definite to you disappear from my standpoint. . . . Like an atmosphere filled with dissolving and magnetic forces, this circle fuses and unites everything and, through a lively diffusion, places even what is most distant in active contact; it busily scatters the emanations of those in whom light and truth dwell independently so that they penetrate some people and illuminate the surface of others in a brilliant and striking manner. That is the harmony of the universe, the wondrous and great unity in its eternal work of art. (SR, 123)

The beauty of this *oeuvre d'art* issues from the harmonious interrelation of its parts. Within the plenteous (maternal) body of the whole, division and fragmentation are overcome; every need is met and all desires fulfilled.

For Schleiermacher, religious intuition does not merely apprehend a universe in which God is immanent, but, in the final analysis, is actually divine. In a remarkable statement, he declares that "divinity can be nothing other than a particular type of religious intuition" (SR, 136). The divine and the human meet in the creative activity of the imagination. No longer a transcendent Creator or Demiurge, God now appears concretely

in the imaginative process by which worlds arise and pass away. Schleiermacher identifies three principal modes of imaginative activity. In the first, "the universe presents itself as a unity in which nothing manifold is to be distinguished, as a chaos uniform in its confusion, without division, order, and law, and from which nothing individual can be separated except by its being arbitrarily cut off in time and space" (SR, 137). While it is unclear how this "dim instinct" differs from religious intuition in which subjectivity and objectivity remain indistinct, it is obvious that Schleiermacher regards this kind of sensibility as both rudimentary and inadequate. At another level of imaginative activity, "the universe presents itself as a multiplicity without unity, as an indeterminate manifold of heterogeneous elements and forces whose constant and eternal conflict determines its manifestations" (SR, 137). In contrast to the first form of awareness in which unity represses multiplicity, the second is characterized by a recognition of multiplicity that excludes unity. In Schleiermacher's organic vision, neither of these alternatives is adequate. What is needed is a comprehensive viewpoint in which the one and the many are effectively integrated. This synthesis is produced by a third form of imaginative activity. "Now let us climb still higher to the point where all conflict is again united, where the universe manifests itself as totality, as unity in multiplicity, as *system* and thus for the first time deserves its name. Should not the one who intuits it as one and all thus have more religion, even without the idea of God, than the most cultured polytheists?" (SR, 137, emphasis added). The person who ascends this height is like the pilgrim in Friedrich's *Wanderer over the Sea of Mist* who gazes out from a lofty mountaintop upon a world with which he completely identifies.

The three stages of Schleiermacher's spiritual ascent anticipate the three moments that structure the dialectical system of his eventual colleague and often hostile critic at the University of Berlin—Hegel. Though the positions of Schleiermacher and Hegel are usually regarded as antithetical, Hegel's philosophy actually answers the call for a system that Schleiermacher issues in *On Religion*. The way from Schleiermacher to Hegel, however, passes through several of the most demanding thinkers in the Western tradition. To deepen our understanding of the nineteenth-century interpretation of the relation between religion and art that culminates in Hegel's system, it is necessary to consider aspects of Kant's critical philosophy, Schiller's aesthetic education, and Schelling's philosophy of art.

Clement Greenberg, as noted above, dubs Kant "the first real Modernist." The basis of this claim is Greenberg's insistence that Kant develops a method of criticism in which the purity or autonomy of different disciplines and arts can be securely established. According to Kant, the quest for autonomy defines the Enlightenment project. In an important essay entitled "What Is Enlightenment?" he argues, "Enlightenment is man's emergence from his self-incurred tutelage. Tutelage is man's inability to make use of his understanding without direction from another. Self-

incurred is this tutelage when its cause lies not in lack of reason but in lack of resolution and courage to use it without direction from another." [11] Because the French Revolution was but five years away, it is impossible to ignore the political implications of Kant's position. But, while Kant is not uninterested in politics, his primary concern is philosophical rather than political. For Kant, freedom and reason are inseparable. Reason enables a person to overcome bondage by progressing from heteronomy, that is, determination by another, to autonomy, that is, self-determination. This movement toward autonomy takes place in both the theoretical and practical spheres of experience.

To be an autonomous human being is to be a self-legislating person. Such an individual gives himself or herself the laws, rules, and principles through which to think and to act. While in the theoretical domain these rules are the a priori forms of intuition and categories of understanding, in the practical realm the law is the categorical imperative according to which individuals are supposed to treat each other not merely as means but also as ends in themselves. Though *substantially* different, theoretical and practical reason are *formally* identical. In both its theoretical and practical deployments, reason involves a unity of universality and particularity: the governing rules and laws are general or universal, and the experiences they order are particular or idiosyncratic. As theoretical faculties, reason and understanding bestow unity and coherence upon the confusing manifold of sense data; as a practical faculty, reason integrates the personality by subjecting multiple and conflicting sense inclinations to the directives of the moral law.

Two aspects of Kant's argument are particularly important at this point. First, since reason (be it theoretical or practical) is autonomous, the rational subject is self-reflexive. In relating to the law of reason, the subject is not bound to something other or alien but relates to that which forms his or her own essence. Thus relation to "other" is not external but is internal and self-constitutive. Second, insofar as reason is universal, there is *one* reason at work in *many* subjects. In other words, different subjects can be understood as *particular* embodiments of a *universal* reason. Universality and particularity join to form a concrete universal that is inherently rational. So understood, Kant's analysis of reason anticipates the notion of the "system-subject" [12] that emerges in post-Kantian romanticism and idealism. This system-subject, Josiah Royce argues, is the "virtual self" that is inherent in every human being. "All our possible experience must be viewed as connected and as interrelated, by virtue of the very fact that it is to be defined as the experience of one virtual self. . . . 'There is,' said Kant, 'but one experience,' and all experiences are to be viewed as part of this one experience. . . . The knowing self which is viewed as the one subject of experience must at least virtually be viewed as the self of mankind, rather than as the transient intelligent activity of any mortal amongst us." [13]

The move from this virtual self to the actual system-subject of romanticism and idealism is made possible by Kant's interpretation of the imagination. It is somewhat misleading to insist that reason alone orders sense data and sensuous inclinations. Inasmuch as reason is universal and sense experience is particular, Kant found it necessary to invoke a supplementary mental capacity that has the ability to synthesize the categories of understanding and the sensible manifold. This mediating faculty is the imagination. As early as the First Critique, Kant identifies the imagination as "art concealed in the depths of the human soul." The artistry of the imagination is its creativity. Within Kant's architectonic, the imagination is essentially the synthetic capacity that is the condition of the possibility of subjective and objective experience. As such, the imagination is transcendental. The transcendental imagination is not merely reproductive but is also productive.

> The reproductive function enables the mind to connect the diverse impressions of the senses by reinstating a preceding perception alongside a subsequent one, thereby forming a sequence of perceptions. But this reproductive role is, in turn, guided by a more fundamental role which provides the "rule" according to which certain "combinations" of perceptions are preferred to others, independently of their empirical order of appearance. And it is this *autonomous* act of synthesis which Kant describes as the productive imagination.[14]

The synthesis through which the imagination enables objects as well as subjects to become *present* or *self-present* is threefold: "the *apprehension* of representations as modifications of the mind in intuition, their *reproduction* in imagination, and their *recognition* in a concept. These point to three subjective sources of knowledge that make possible the understanding—and consequently all experience as its empirical product" (CPR, 130–31). When taken together, these three moments constitute the process of representation, which creates the unity and establishes the identity of subjects and objects. Kant maintains that "the order and regularity in appearance, which we entitle nature, *we ourselves introduce.* We could not find them in appearances, had not we ourselves or the nature of our mind originally set them there" (CPR, 147).

Since there is neither subject nor object prior to the activity of the productive imagination, "this very power of synthesis points to a primordial unity of sensation and understanding brought about by the imagination prior to the functioning of either faculty. The synthetic role of imagination, presupposed by both faculties, is indeed so primordial that it operates behind our backs, as it were unconsciously."[15] This original unity, which is the source of thought and action, anticipates Schleiermacher's religio-aesthetic intuition as well as Schelling's *Indifferenzpunkt.* With this insight, Kant approaches the abyssal power of the imagination. If the condition of the possibility of consciousness and self-consciousness cannot itself be rationally comprehended, autonomy is impossible. Self-

reflexivity presupposes something it cannot incorporate and thus is determined by a certain exteriority.

At some point between 1781 and 1787, Kant realized the unsettling implications of his argument. With this recognition, what had seemed to be the unifying ground of understanding and intuition became a fathomless abyss. Heidegger points out that "by his radical interrogation, Kant brought the 'possibility' of metaphysics before this abyss. He saw the unknown; he had to draw back. Not only did the imagination fill him with alarm, but in the meantime [i.e., between the first and second editions of the *Critique of Pure Reason*] he had also come more and more under the influence of pure reason as such." In the second edition of the First Critique, the task of synthesizing intuitions and concepts is taken over by understanding. In other words, Kant erases the synthetic third and replaces it with a binary opposition in which one term (understanding) is privileged over the other (intuition). The imagination "is no longer a 'function' in the sense of an autonomous faculty, but is now a 'function' only in the sense of an operation of the faculty of understanding. While in the first edition, all synthesis, i.e., synthesis as such, arises from the imagination as a faculty not reducible either to sensibility or understanding, in the second edition, the understanding alone assumes the role of origin for all synthesis."[16] Kant can only return to the imagination by severely restricting the role it plays in human experience. He defines and explores the limits of the imagination three years later in the Third Critique. The seminal decade of the 1790s opens with the publication of *The Critique of Judgment*.

The Third Critique is supposed to resolve the tensions within each of the first two critiques as well as to unite the analyses of theoretical and practical reason. As Derrida points out,

> The first two Critiques of pure (speculative and practical) reason had opened an apparently infinite gulf. The Third could, should, should have, could have thought it: that is, filled it, fulfilled it in infinite reconciliation. "Already the Kantian philosophy not only felt the need for this point of union [*Vereinigungspunkt*] but recognized it with precision and furnished a representation of it." The Third Critique had the merit of identifying in art (in general) one of the middle terms (*Mitten*) for resolving (*auflösen*) the "opposition" between mind and nature, internal and external phenomena, the inside and the outside, etc. (TP, 35)

As the synthetic third that unites the opposites articulated by theoretical and practical reason, *The Critique of Judgment* is itself something like a work of art. This unifying mean (*Mitte*) serves as a bridge across the abyss that Kant encounters in the First Critique. "The analogy of the abyss and of the bridge over the abyss is an analogy that says that there must be an analogy between two absolutely heterogeneous worlds, a third term to cross the abyss, to heal over the gaping wound and think the gap. In a word, a *symbol*. The bridge is a symbol, it passes from one bank to the other, and the symbol is a bridge" (TP, 36).

The symbol that "heals the gaping wound" is *beautiful.* The beautiful is, in Kant's well-known definition, "purposiveness without purpose" (*Zweckmässigkeit ohne Zweck*). Kant identifies two primary examples of such purposeless purpose—one natural, the other cultural: the living organism and the work of art. To argue that the living organism is characterized by purposiveness without purpose is to insist that the end, purpose, or goal of the organism is nothing other than the organism itself. In "The Analytic of Teleological Judgment" Kant explains, "This principle, the statement of which serves to define what is meant by organisms, is as follows: *an organized natural product is one in which every part is reciprocally both end and means.* In such a product, nothing is in vain, without an end, or to be ascribed to a blind mechanism of nature" (CJ, 24–25). In contrast to mechanical relations in which means and end are external to each other, in the living organism means and end are internally related in such a way that they are mutually constitutive. This reciprocity creates a harmonious accord that insures the vitality of the organism. The internal relation of means and end creates the "inner teleology" that constitutes the organism. When inner teleology is translated from the natural into the cultural domain, it appears as a beautiful work of art. The idea embodied in the living organism is re-presented in artistic activity. In his analysis of the work of art, Kant attempts to discern the original unity of theoretical and practical reason through which the identity of nature and reason can be secured and thus truth and freedom established. The demonstration of this primal oneness establishes the *possibility* of overcoming fragmentation and alienation by recovering the unity of experience that has long been lost or hidden. The work of art opens the way to this original accord.

Since artistic activity is, according to Kant, "production through freedom," the artist cannot be subjected to extraneous influences or determined by anything other than himself or herself. The artist, in other words, is self-determining or autonomous. Artistic autonomy freely embodies the inner teleology naturally present in the organism. If the work of art is to reconcile subject and object, the spontaneous activity of the artist cannot be imposed upon a nature that is alien to it and to which it is alien. The self-determination of the artist must not disrupt the integrity of nature. The unity of nature and reason in the work of art is possible only if subjectivity and objectivity are implicitly one. As the artist relates to himself or herself in and through the object, so nature relates to itself in and through artistic activity. The subjectivity of the artist realizes itself objectively, and the objectivity of nature comes to completion in subjective artistic production.

Kant maintains that the identity of nature and freedom is present in artistic genius. Genius is *natural* talent. In creating the work of art, the genius acts naturally or spontaneously. Such spontaneity is not random, contingent, or arbitrary. To the contrary, the genius acts according to the rules, principles, or ideas with which he or she is naturally endowed. While the genius need not be conscious of the principles by which he

creates, his work is always governed by rules. *"Genius,"* Kant contends, "is talent (natural endowment) that gives the rule to art. Since talent, as an innate productive faculty of the artist, belongs itself to nature, we may put it this way: *Genius* is the innate mental aptitude (*ingenium*) through which nature gives the rule to art" (CJ, 168). Nature, in other words, gives rules to the artist who in turn gives rules back to nature. These natural rules are not alien to the artist but, as innate, are constitutive of his or her own subjectivity. Consequently, the artistic production of genius is *formally* parallel to the theoretical and practical exercise of reason. In this autonomous production, all vestiges of heteronomy are overcome. Since original artistic activity is both natural and free, it is the self-realization rather than the violation of nature. As nature presents itself through the artist, so the genius presents herself to herself in her work.

The autoaffective character of artistic activity is mirrored in the autotelic nature of the work of art. The art of genius is fine art, which, like the organism, is "intrinsically final." Never pointing beyond itself, the work of art reconciles means and end in a self-contained totality that is, in a certain sense, purposeless. This purposelessness is the source of Kant's insistence that art, as well as aesthetic judgments, must be disinterested. If the art object and the accompanying judgment about its beauty express interests, they serve an ulterior purpose and thus point beyond themselves. Any such external reference interrupts the inner teleology that defines *l'oeuvre d'art.* [17]

The most complete form of fine art is poetry. Poetry—*poiesis*—is a making that is essentially productive and creative. Kant prepares the way for the theory of poetry espoused by many romantics when he suggests that the original activity of the poet mimes the creativity of divine *poiesis.* This interpretation of poetry shifts the problematic of imitation from the subject-object relation to the sphere in which freely acting subjects interrelate. In the "art of an author-subject, and, one could even say, of an artist-god, *mimesis* displays the identification of human action with divine action—of one freedom with another." [18]

At this juncture, the limitations that Kant places on imaginative activity emerge clearly. In the first place, the notion of inner teleology or autoaffection that characterizes the natural object and the object of art is a "regulative" idea of reason rather than a "constitutive" concept of the understanding. A regulative idea functions as a guide for reason in its effort to organize experience derived from sensation and preliminarily ordered by understanding. Such heuristic devices do not, however, convey knowledge about the actual constitution of objects and subjects in the world. This restriction points to the second limitation of the imagination. Aesthetic judgment is not a matter of knowledge. Instead of stating a relation between subject and object, as does every cognitive assertion, aesthetic judgments articulate contrasting relations of the subject to itself. More precisely, different forms of aesthetic judgment reflect different relations among the mental faculties of intuition, sensibility, imagination,

understanding, and reason. Kant identifies two basic types of aesthetic judgment: beauty and sublimity.

Beauty "conveys a finality in its form, making the object appear, as it were, preadapted to our power of judgment, and thus constitutes in itself an object of satisfaction" (CJ, 91). Form is apprehended by the imagination and *presented* to understanding. A judgment of beauty reflects a harmonious accord between imagination and understanding in which the form of the object appears to be "preadapted" (*vorherbestimmt*) to the judging subject. It is essential to recognize that the harmony discerned in the judgment of beauty is inescapably intrasubjective. "The object enters, as it were, into the judgment only as form, through the apprehension of its form in imagination, that is, in and through the operation of the imagination. Hence, the relation between the object and the faculties is not a simple external relation of the object to the subject but rather is a relation in which one faculty, namely, imagination, is already involved. Thus, to say that the object is in harmony with the faculties is already to refer to the harmony between those faculties, that is to say, to the preeminent sense of harmony."[19] The preeminent sense of harmony that constitutes beauty grows out of "the free play of cognitive powers." Play is free when the player is unaffected by anything other than himself or herself. In aesthetic judgment, the subject plays with itself by representing itself (as imagination) to itself (as understanding). The harmony of such autoaffection is expressed in the judgment of beauty, which is the occasion for the judging subject's experience of pleasure. Pleasure, in other words, is the subject's experience of its own *internal* accord.

Since the object of aesthetic judgment is not external to the judging subject but is its own representation, the subject relates to itself in the object that appears other than itself. Jean-Luc Nancy underscores the self-reflexivity involved in the judgment of beauty and its accompanying experience of pleasure. "The only beauty, or beauty alone, isolated for itself," as he explains,

> is the form in its pure accord with itself or, to say the same thing, in its pure accord with imagination, with the faculty of presentation (or formation). Beauty alone, without interest, without concept, or without Idea is the simple accord, which by itself is a pleasure of the thing presented with its presentation. At least modern beauty has tried to be such; a successful presentation without remainder, in tune with itself. . . . The beautiful is the figure that figures itself in accord with itself, the strict accord of the contour with its outline [*tracé*].[20]

Kant's idea of the beautiful implies the romantic idea of symbol as well as the idealistic idea and reason. Beauty, however, is not abyssal; thus, it can be enjoyed without fear and trembling. If, as Heidegger suggests, Kant's quest for the foundation of reason leads to an abyss from which he withdraws, the imagination must approach something other than beauty. The other that is beyond beauty is sublime.

While the beautiful presupposes inner harmony that is experienced as

pleasure, the sublime interrupts harmonious autoaffection and issues in what Kant describes alternatively as "a negative pleasure" or "a feeling of displeasure, arising from the inadequacy of the imagination."

> For the beautiful is directly attended with a feeling of the furtherance of life, and is thus compatible with the charms of a playful imagination. On the other hand, the feeling of the sublime is a pleasure that arises only indirectly, being brought about by the feeling of a momentary check to the vital forces, followed at once by a discharge all the more powerful, and so it is an emotion that does not seem to be play, but deadly earnest in the affairs of the imagi-nation. Hence charms are repugnant to it; and, since the mind is not simply attracted by the object, but is also alternately repelled thereby, the satisfaction in the sublime does not so much involve positive pleasure as admiration or respect, which rather deserves to be called negative pleasure [*negative Lust*]. (CJ, 91)

The pleasure of beauty, we have observed, derives from the harmony be-tween the imagination and understanding that is released when the form of an object is apprehended. The sublime, by contrast, *exceeds* every form and *escapes* all formation. In Kantian aesthetics, "the beautiful in nature is a question of the form of the object, and this consists in limitation [*Begren-zung*], whereas the sublime is to be found in an object even devoid of form, so far as it immediately involves, or else by its presence provokes, a representation of unlimitedness [*Unbegrenztheit*], and yet its totality is also present to thought" (CJ, 90). While the presentation of form to under-standing in the judgment of beauty reveals the *unity* of intuition, imagi-nation, and understanding, the presentation of unlimitedness to reason in the judgment of sublimity discloses *differences* among intuition, imagina-tion, and reason. Kant explores these differences through a consideration of the two modalities of the sublime: mathematical and dynamic.

The sublime erupts at the *limits* of human consciousness. Indeed, the sublime might be understood as the experience of limit as such—if limit as such could be experienced. Paradoxically, limit is encountered in and through the experience of the unlimited. In the "Analytic of the Sublime," Kant identifies two orders of excess: magnitude, described as the mathe-matical sublime, and power, defined as the dynamic sublime.

The mathematical sublime marks the boundary between reason's de-mand for totality and the imagination's inability to deliver it. In seeking to satisfy reason's desire for "absolute totality," the mind is "pushed to the point at which our faculty of imagination breaks down in presenting the concept of a magnitude, and proves unequal to the task" (CJ, 101). The fault of the imagination is the opening of the sublime. Kant cites two examples of the mathematical sublime—the Egyptian pyramids and St. Peter's in Rome. In both cases, one is forced to admit that comprehen-sion is never complete, and hence the totality of reason is repeatedly de-ferred. When this occurs, one suffers the feeling "of the inadequacy of his imagination for presenting the idea of a whole within which the imagi-nation attains its maximum" (CJ, 100).

Something can be *de trop* not only because of its excessive magnitude but because of its excessive power. According to Kant, the dynamic sublime is encountered in the overwhelming power of nature. "In the immeasurableness of nature and the insufficiency of our faculties for adopting a standard proportionate to the aesthetic estimation of the magnitude of its realm, we find our own limitation" (CJ, 111). The dynamic sublime traces the difference between natural power and the human capacity to master it. As in the case of the mathematical sublime, reason seeks a totality that the imagination cannot present. Instead of an endless series of forms, the dynamic sublime exceeds all form. Kant argues, "In what we are accustomed to call sublime in nature, there is such an absence of anything leading to particular objective principles and forms of nature corresponding to them that it is rather in its chaos or its wildest and most irregular desolation, provided size and might are perceived, that nature chiefly excites in us the ideas of the sublime" (CJ, 92).

Kant's interpretation of the beautiful and sublime points to related, though distinguishable, philosophical and artistic developments in the nineteenth and twentieth centuries. His immediate successors focus on what they see as the shortcomings of Kant's account of beauty. Since the Kantian idea of beauty is ideal rather than real, the reconciliation of opposites it figures remains imaginary. For many later theologians, artists, and philosophers, Kant's refusal to regard *Zweckmässigkeit ohne Zweck* as constitutive of the world and human life provides further evidence of the deep divisions that fissure modern experience. In the final analysis, Kant's critical philosophy fails to deliver the cure it promises. To overcome this impasse, leading writers and artists attempt to translate Kant's ideality into reality.

The first significant effort to achieve this end is Friedrich Schiller's *On the Aesthetic Education of Man.* Schiller regards the aesthetic ideal formulated in the Third Critique as prescriptive rather than descriptive. The aim of Schiller's aesthetic education is to realize the Kantian ideal concretely by establishing an aesthetic state in which individual members are harmoniously related in an organic social totality. By defining the role of the artist-philosopher as the aesthetic educator who leads humanity to the ideal state, Schiller defines the notion of the avant-garde that informs twentieth-century artistic and architectural practices.

Kant was not, however, the only influence on Schiller's formulation of the principles of aesthetic education. Firmly rooted in Weimar *Kultur,* Schiller was also deeply indebted to Goethe and, more important, to Johann Joachim Winckelmann. Winckelmann, who heard Baumgarten's lectures on aesthetics in Halle, developed an "aesthetic paganism" that influenced all later German thought and culture. For Winckelmann, the "nobility and simplicity" of Greek life embodied an ideal order that has never since been realized. Within the Hellenic social setting, outer harmony is reflected in an inner equilibrium that Winckelmann designates "gaiety." "Balancing feeling and reason, this gaiety, originally physio-

logical, passes into the intellectual and spiritual capacities that are pre-supposed by the higher pursuit of beauty. When nature and human being in this manner dwell together in beauty, the moment of 'festival and play' occurs. This festive state allows the human being to dwell in his or her own beauty, both as a living artwork and as the highest manifestation of nature's own character" (AS, 19).[21] In Winckelmann's Hellenism, as in Kant's critical philosophy, the natural organism provides the model for the beauty that ideally represents fulfillment for individuals as well as society. While Kant insists that this ideal remains not only unrealized but unreal-izable, Winckelmann believes it was once actualized—in the Periclean republic. The brief period from 421 to 413 B.C.E. formed what Winckel-mann describes as "the most sacred" era of human history.

In contrast to Kant's unrealizable ideal and Winckelmann's idealized past from which we have fallen, Schiller regarded the aesthetic state as a realizable Kingdom toward which we can progress. The Protestant pietism that pervaded Schiller's native Württemberg during his youth left a lasting impression on him. In his mature reflection, Schiller rewrites theological doctrine in his aesthetic ideas. While sin is, in effect, the fragmentation brought by modern society and culture, salvation is the reintegration of opposites prefigured in art. In Schiller's diagnosis of personal and social ills and prescription for a cure, conflict is not simply something negative. The antagonism of opposites is necessary for the development of human-kind's "manifold capacities." Far from a total disaster, the fall is a *felix culpa* rendering possible a future Kingdom that surpasses the lost Garden. In this progression, the hand that inflicts the wound holds the cure. Cul-ture not only fragments and divides but, in the form of art, also integrates and unites.

The power of art to mend the tears sundering society and experience is a function of its capacity to unite sensuousness and reason. For Schiller, as for Kant, art is a *Mittelkraft* that is actualized in free *play*. Schiller de-veloped his influential analysis of the *Spieltrieb* by bringing together Kant's account of the "free play of the powers of representation" and Fichte's theory of the drives (*Triebe*) governing behavior. Human experience, Schiller argues, is suspended between the "sensuous drive" (*Sinntrieb*), which chains individuals to nature, and "formal impulse" (*Formtrieb*), which "proceeds from man's absolute existence or from his rational nature, and strives to set him at liberty, to bring harmony into the diversity of his manifestation" (AE, 66). If fragmentation is to be overcome and integration achieved, neither the sensuous nor the rational side of experi-ence can be repressed. The *Spieltrieb* "sublates" (*aufgehobt*) [22] the *Sinntrieb* and *Formtrieb* in such a way that they are reconciled without losing their specificity. Schiller concludes, "Man plays only when he is, in the full sense of the word, a man, and *he is only wholly man when he is playing*" (AE, 90, 80).

The integration of sensuality and rationality accomplished in Schiller-ian play repeats and extends the pleasurable equilibrium of the subjective

faculties wrought by Kantian aesthetic judgment. Like Kant's creative genius, Schiller's player reunites necessity and freedom to form a "living shape" that is essentially *beautiful*. Directly echoing Kant, Schiller contends that "beauty reflects all things as self-purposive." That which is beautiful is "not-determined-from-outside" and thus represents what Schiller describes as "heautonomie" (AS, 80). Heautonomie mediates heteronomy and autonomy in such a way that determination-by-an-other is at the same time self-determination. Since the heautonomie actualized in aesthetic play transforms external determination into internal determination, Schiller concludes that "it is through beauty that we arrive at freedom" (AE, 27). To be free is to be determined by no one and no thing other than oneself.

In Schiller's educational theory, the aesthetic is not an abstract realm that is simply separated from and opposed to the sociopolitical sphere but is the prefiguration of the ideal society toward which we are obliged to move.

> Though need may drive man into society, and reason implant social principles in him, beauty alone can confer on him a *social character*. Taste alone brings harmony into society, because it establishes harmony in the individual. All other forms of perception divide a man, because they are exclusively based either on the sensuous or on the intellectual part of his being; only the perception of the beautiful makes something whole of him, because both his natures must accord with it. All other forms of communication divide society, because they relate exclusively either to the private sensibility or to the private skillfulness of its individual members, that is, to what distinguishes between one man and another; only the communication of the beautiful unites society, because it relates to what is common to them all. (AE, 138)

The artist is the prophet who leads his people from bondage to the Promised Land. The aesthetic educator's decree, which carries the weight of a demand, is "There shall be beauty!" To affirm beauty as an obligation commanding action, however, is to deny that it is a present reality that can be immediately enjoyed.

Despite his differences from Kant, Schiller remained a utopian idealist for whom the beautiful society defines the goal of human striving. This idealism lends a progressive trajectory to history. Inasmuch as the fall from primal harmony is a fortunate fall, the end toward which the human race is moving exceeds the origin from which it derives. Unlike Winckelmann, who nostalgically longed to return to the simplicity of Periclean Athens, Schiller looked forward to a more complete state in which freedom is *self-consciously* realized. In this expectation, Schiller's aesthetic education anticipates Hegel's speculative philosophy. Between Schiller's aestheticization of politics and Hegel's aestheticization of reason, however, lies Schelling's philosophy of art. Schelling transposes Schiller's utopian idealism into an absolute idealism in which beauty actually constitutes the original essence of reality.

In a manner reminiscent of Kant's Third Critique, Schelling constructs a transcendental idealism to bridge the gap between nature and reason. From Schelling's point of view, the bifurcation of subjectivity and objectivity can be healed neither theoretically nor practically. In the theoretical exercise of reason, concepts are forced to conform to objects, and in the practical employment of reason, objects are forced to conform to concepts. What is needed, Schelling argues, is a middle way that lies *between* theory and praxis. This mean is not merely a regulative idea or sociopolitical ideal but constitutes the identity of being itself. Hölderlin, who was once the roommate of Schelling and Hegel at the Tübingen *Stift,* goes so far as to assert that "Being expresses the joining of subject and object. Where subject and object are absolutely unified, one can speak of *absolute* Being, as in the case of intellectual intuition."[23] For Schelling, the intellectual intuition that apprehends the identity of being as the unity of subject and object is fundamentally aesthetic. Schelling's aesthetic intuition, on the one hand, is a refinement of the notion of the primordial unity of sensation and understanding that Kant formulates in the first edition of the First Critique and, on the other hand, is strictly parallel to the aesthetic intuition with which Schleiermacher identifies religious awareness.

In the winter semester of 1799/1800, the year Schleiermacher published *On Religion,* Schelling presented his first lectures on the philosophical foundation of art. During the previous summer, he had lectured on the organic doctrine of nature. Eventually appearing in Schelling's *Sämtliche Werke* in 1859, *The Philosophy of Art* forms a crucial chapter in the development of post-Kantian idealism and plays a significant role in the emergence of the aesthetic that informs modernism. Schelling insists that his inquiry is "not directed toward the cultivation of the empirical intuition of art, but rather of its intellectual intuition" (PA, 3). The philosopher is better able than the artist to apprehend the essence of artistic activity. Philosophical speculation brings the practice of the artist to transparent self-consciousness. Forecasting the flight of Hegel's legendary owl of Minerva, Schelling maintains that theoretical reflection emerges only with the waning of a creative era. "When such a fortunate age of pure production has passed," he writes, "reflection enters, and with it an element of estrangement. What was earlier living spirit is now transmitted theory" (PA, 10).

There is, however, gain as well as loss in the rise of theory, for "only philosophy can reopen the primal sources of art for reflection" (PA, 11). The primitive origin that philosophy uncovers constitutes the inner bond uniting art and religion. In the context of transcendental speculation, every source other than the absolute is penultimate. When traced back to its true beginning, art is the *mise-en-forme* that is essential to the absolute itself. Schelling's absolute is nothing other than the "point of identity" that Hölderlin identifies as "*absolute* Being."

> This point of indifference, precisely because it is such a point and because it is absolutely one, inseparable and indivisible, inheres necessarily in its own

turn within every *particular* unity (also called potence). This, too, is possible only if within each of these *particular* unities all unities, and therefore *all potences,* are also present. . . . We always know only the absolutely one or absolute unity, and this absolutely one only in particular forms. Philosophy is concerned . . . not at all with the particular as such, but rather immediately only with the absolute, and with the particular only to the extent that it takes up the entire absolute within itself and represents it in itself. (PA, 15)

Excluding every difference, the *Indifferenzpunkt* is the One that underlies the many. Within Schelling's absolute, as within Schleiermacher's organic totality, every particular re-presents the whole of which it is an integral member.

As the primal identity that is antecedent to all differentiation, the absolute forms the original *archē* rather than the final *telos*. The goal of human striving, therefore, is not to progress to the anticipated end but to return to the remembered origin. Though Schelling remains reluctant to use psychological categories, the longing for the origin expresses the *desire* to return to the primal or primitive condition of oneness in which all needs and wants are satisfied. The Eden from which we have fallen is the womb to which we forever want to return. From a Freudian viewpoint, Schelling's entire philosophy can be read as a dissimulation of the most primitive drives governing human life. The psychoanalytic framework suggests that the philosophy of history implicit in this philosophy of art is *regressive*. In contrast to Schiller, who, as I have stressed, points toward an end that surpasses the beginning, Schelling posits a beginning that is unsurpassable.

Throughout *The Philosophy of Art,* Schelling insists that art and religion are inseparable. When approached from a theological perspective, the absolute appears as God. In the opening thesis of his argument, Schelling claims, "*The absolute or God is that with regards to which being or reality follows immediately from the idea, that is, by virtue of the simple law of identity,* or, *God is the immediate affirmation of himself*" (PA, 23). This assertion is actually a reformulation of the ontological argument for the existence of God in which God and Being appear to be One. To be is to be one, and One is God. This identification of God, Being, and Oneness is typical of what Heidegger labels "Western ontotheology." Though usually interpreted philosophically or theologically, ontotheology implicitly informs many modern aesthetic theories and artistic practices.

Inasmuch as Being is divine, the God of Schelling's absolute idealism is in no way transcendent but is immanent in the universe as a whole.

> As absolute identity, God is immediately also absolute totality, and vice versa.
> Elucidation. God is a totality that is not a multiplicity but rather absolute simplicity. God is a unity that itself is not conditioned in contrast to multiplicity; that is, he is not singular in the numerical sense. Neither is he simply the One, but is rather absolute unity itself, not everything, but rather absolute allness itself, and is both of these immediately as one. (PA, 24)

Two points in this thesis deserve emphasis. First, God is the absolute totality and *the absolute totality is God*. Elsewhere, Schelling makes explicit

the conclusion that is implicit in the immanentism that characterizes his philosophy: "God and the universe are one, or are merely different views of one and the same thing. God is the universe viewed from the perspective of identity. He is *everything,* since he is the only reality; outside him there is nothing. The *universe* is God viewed from the perspective of totality" (PA, 14–15). When expressed in these terms, Schelling's absolute idealism and Schleiermacher's religious vitalism are virtually indistinguishable. Second, inasmuch as the absolute is God and God is "absolute unity itself," multiplicity, plurality, and difference are epiphenomenal. Everything *is* only to the extent that it re-presents the One. To apprehend truth is to see through the particular to the universal. The possibility of this vision is created by art. *"The indifference of the ideal and the real as indifference manifests itself in the ideal world through art,* for art is in itself neither mere activity nor mere knowledge, but is rather an activity completely permeated by knowledge, or in a reverse fashion knowledge that has completely become activity. That is, it is the indifference of both" (PA, 28). By insisting that art is the indifference of thought and action, Schelling attempts to locate the originary point of theory and praxis that Kant identifies in his preliminary account of the imagination. The work of art, which preoccupies philosophy, is not the product of a finite creator but is, in the final analysis, the entire universe, which not only issues from but continues to reside within the infinite Creator. "The universe is formed in God as an absolute work of art and in eternal beauty." When philosophically comprehended, "art is *the science of the All in the form or potence of art"* (PA, 13, 16). What Schelling describes as "the potence of art" is its capacity to "present" the absolute in "a *reflex* or *reflected image."* The reflexivity of the image *mirrors* the autotelic nature of *l'oeuvre d'art.* As the reflecting subject gazes into the reflected object, she gradually disappears before her own eyes. Two become one in an identity that allows no difference. This experience is "sublime." Recalling Kant by misquoting Schiller, Schelling describes the sublime:

> Sublimity within nature takes place in one of two ways: "We refer it either to our *power of apprehension* and are defeated in our attempt to form an image of its concept; or we refer it to our *vital power* and view it as a power against which our own dwindles to nothing." Examples of the first case would be colossal masses of mountains or cliffs whose peaks our vision cannot reach; the wide ocean that is surrounded only by the vault of heaven; the immensity of the earth itself in its boundlessness, for which every possible human standard is found to be inadequate. (PA, 86)

In this ocean surrounded by the vault of heaven, we return to Friedrich's lonely monk standing by the sea. For Schiller, the philosopher faces the same dilemma that Friedrich posed for the artist: how to give "form" to the formless. "Here, too, form, as always, is the finite element, except that here the condition has been added that it must appear relatively infinite, and from the physical perspective must appear absolutely colossal. This, however, negates the *form* of the finite, and we now see how it is precisely

formlessness that most immediately acquires the character of *sublimity* for us, that is, that most immediately becomes the symbol of the infinite as such" (PA, 87). In Schelling's absolute idealism, the culmination of human experience is the loss of difference that makes it possible to enjoy the fullness of identity.

The criticism of the notion of the absolute as formless and of human fulfillment as the enjoyment of unity at the expense of multiplicity serves as the point of departure for Hegel's speculative reflection. In the opening pages of *Phenomenology of Spirit,* Hegel levels a broadside at Schelling's position.

> Nowadays we see all value ascribed to the universal Idea in this nonactual form, and the dissolution of all distinct, determinate entities (or rather the hurling of them all into the abyss of vacuity without further development or any justification) is allowed to pass muster as the speculative mode of treatment. . . . To pit this single insight, that in the Absolute everything is the same, against the full body of articulated cognition, which at least seeks and demands such fulfillment, to palm off its Absolute as the night in which, as the saying goes, all cows are black—this is cognition naively reduced to vacuity. (PS, 9) [24]

Hegel's criticism of his erstwhile friend and seminary roommate is the product of more than a decade of reflection. Though he arrived in Jena in 1801, after the heyday of romanticism had passed, his early work is deeply influenced by late eighteenth-century Weimar *Kultur.*

Looking back at these formative years from the perspective of his mature philosophical system, Hegel acknowledges the importance of the task of reconciling sensuousness and reason as defined by Schiller. For Schiller, Hegel writes, "the beautiful is thus pronounced to be the mutual formation of the rational and the sensuous, and this formation to be genuinely actual" (FA, 62). Hegel proceeds to underscore the pivotal role played by Kant's *Critique of Judgment* in defining the goal of the philosophical enterprise. In an early effort to identify "the difference between Fichte's and Schelling's systems of philosophy," Hegel defines what he regards as the fundamental task of philosophy throughout his entire career. Recalling Schiller's analysis of the fragmentation plaguing modern society, Hegel maintains that "bifurcation is the source of *the need of philosophy.* . . . When the might of union vanishes from the life of men and the oppositions lose their living relation and reciprocity and gain independence, the need of philosophy arises." [25] In the Third Critique, Hegel points out, Kant glimpses the unification of the opposites that rend human experience. "Now what we find in all these Kantian propositions is an inseparability of what in all other cases is presupposed in our consciousness as distinct. This cleavage finds itself cancelled in the beautiful, where universal and particular, end and means, concept and object, perfectly interpenetrate one another. Thus Kant sees the beauty of *art* after all as a correspondence in which the particular accords with the concept" (FA, 60). But for Hegel, as for Schiller and Schelling, Kant's analysis is inadequate insofar as

beauty remains an unrealized ideal or, in a strikingly contemporary phrase, is "steadily deferred to infinity." "This apparently perfect reconciliation," Hegel stresses, "is still supposed by Kant at the last to be only subjective in respect of the judgment and production [of art], and not itself to be absolutely true and actual" (FA, 57, 60).

To make the transition from the limited domain of subjectivity to the sphere of the absolutely true and actual, we must move from Kant's critical philosophy to Schelling's absolute idealism. Not until Schelling does philosophy arrive at the absolute standpoint toward which it has been progressing since its beginning in ancient Greece.

> This *unity* of universal and particular, freedom and necessity, spirit and nature, which Schiller grasped scientifically as the principle and essence of art and which he labored unremittingly to call into actual life by art and aesthetic education, has now, as the *Idea itself,* been made the principle of knowledge and existence and the Idea has become recognized as that which alone is true and actual. Thereby philosophy has attained, with Schelling, its absolute standpoint; and while art had already begun to assert its proper nature and dignity in relation to the highest interests of mankind, it was now that the *concept* of art and the place of art in philosophy was discovered. (FA, 63)

As we have seen, however, Schelling failed to complete what he initiated. Though he effectively translated Kant's idea of the beautiful from ideality into reality, Schelling did not articulate the idea in such a way that the universal is joined to the particular as such. Hegel attempted to effect the final movement of reconciliation in his all-encompassing philosophy of spirit.

From the outset, Hegel's reflection was guided by the aesthetic ideal formulated in *The Critique of Judgment.* In "Earliest System-Programme of German Idealism," a brief but seminal document dating from 1796 whose authorship has been attributed not only to Hegel but also to Hölderlin and Schelling, Hegel makes it clear that the philosophy of spirit is necessarily an aesthetic philosophy.

> The Idea that unites all the rest [is] the Idea of *beauty* taking the word in its higher Platonic sense. I am now convinced that the highest act of Reason, the one through which it encompasses all Ideas, is an aesthetic act, and that *truth and goodness only become sisters in beauty*—the philosopher must possess just as much aesthetic sense as the poet. Men without aesthetic sense is what the philosophers-of-the-letter of our times are. The philosophy of spirit is an aesthetic philosophy. One cannot be creative [*geistreich*] without aesthetic sense.[26]

In his philosophy of spirit (*Geist*), Hegel takes up the challenge Schiller issued by developing what is, in effect, an "aesthetic education of man." In Hegel's pedagogy, the artist-turned-philosopher is "the teacher of mankind" (*Volkserzieher*) who leads his followers from slavery to freedom. This is not simply an aesthetic or a philosophical undertaking but actually a *religious* calling. Hegel concludes the *Systemprogram* by proclaiming, "No power shall any longer be suppressed, for universal freedom and equality

of spirits will reign!—A higher spirit sent from heaven must found this new religion among us, it will be the last [and] greatest work of mankind."[27] In a series of writings that remained unpublished until 1907, Hegel developed the intricate interplay between religion and art that forms the structural foundation of his mature philosophy.[28]

The place of art in Hegel's system is particularly complex. On the one hand, art is the specific form of cultural expression with which human awareness begins the final stage in its ascent to complete self-consciousness. As such, art must be subjected to the same rigorous dialectical analysis as all other natural and spiritual phenomena. On the other hand, the autotelic structure defined by Kant and developed by post-Kantian idealists is isomorphic with the self-reflexive concept that grounds Hegel's entire philosophical edifice. The notion of the beautiful or the beautiful notion, in other words, is simultaneously part and whole. Thus the work of art functions as something like a synecdoche for the Hegelian system. In different terms, art is implicitly philosophical and philosophy is inherently aesthetic.

In his essay "The Spirit of Christianity and Its Fate," the youthful Hegel goes so far as to assert that "truth is beauty intellectually represented."[29] The far-reaching implications of this claim did not become clear for several decades. Between 1820 and 1829, Hegel developed a philosophy of fine art in his university lectures. Published posthumously in 1835, these lectures present a detailed analysis of previous aesthetic theories and chart the historical development of different art forms.

Hegel opens his lectures by arguing that since art is "born of the spirit," it must be placed "in the same sphere as religion and philosophy." Art, religion, and philosophy define alternative ways in which the human mind "expresses the *Divine*" (FA, 2, 7). It is clear from the outset that Hegel agrees with Schelling's claim that, though the form varies, the content of art, religion, and philosophy is the same. "Art's vocation," Hegel argues, "is to unveil the *truth*."

> Art shares this vocation with religion and philosophy, but in a special way, namely by displaying even the highest [reality] sensuously, bringing it thereby nearer to the senses, to feeling, and to nature's mode of appearance. What is thus displayed is the depth of a suprasensuous world that thought pierces and sets up at first as a *beyond* in contrast with immediate consciousness and present feeling; it is the freedom of intellectual reflection that rescues itself from the *here* and *now*, called sensuous reality and finitude. But this breach, to which the spirit proceeds, it is also able to heal. It generates out of itself works of fine art as the first reconciling middle term between pure thought and what is merely external, sensuous, and transient, between nature and finite reality and the infinite freedom of conceptual thinking. (FA, 7–8)

The absolute, which is divine, is the self-developing totality that forms the essence of everything. In order to realize itself, this essence *must* appear. Thus the absolute necessarily manifests itself first in natural processes and then in the gradual unfolding of history. The development of human self-

consciousness recapitulates the evolution of the natural and historical totality. In its sensuousness, art is the most rudimentary experience of the highest form of self-consciousness.

In order to avoid misunderstandings, it is important to note that for Hegel sensuous "appearance itself is essential to essence." While appearance is obviously dependent on essence, essence also *needs* appearance in order to become itself. Sensuousness, therefore, is in a certain sense essential. And yet, it is nonetheless *superficial.* Never true in itself, the sensuous becomes true only when it is apprehended as the appearance of essence.

> Now it follows from this that the sensuous must indeed be present in the work of art, but should appear only as the surface and as a pure appearance of the sensuous. . . . Thereby the sensuous aspect of a work of art, in comparison with the immediate existence of things in nature, is elevated to a pure appearance, and the work of art stands in the *middle* between immediate sensuousness and ideal thought. It is *not yet* pure thought, but, despite its sensuousness, it is *no longer* a purely material existent either, like stones, plants, and organic life; on the contrary, the sensuous in the work of art is itself something ideal, but which, not being ideal as thought is ideal, is still at the same time there externally as a thing. (FA, 38)

The dialectic of "no longer" and "not yet" defines the intermediate space and time of art. In theological terms, the space of art lies between the Garden and the Kingdom; its time is the meantime.

As the product of creative spirit, the work of art is elevated above the purely natural realm. The relation between artist and work exemplifies both the design of the divine totality and the internal structure of the artwork itself.

> The universal and absolute need from which art (on its formal side) springs has its origin in the fact that man is a *thinking* consciousness, i.e., that man draws out of himself and puts *before himself* what he is and whatever else is. Things in nature are only *immediate* and *single*, while man as spirit *duplicates* [*verdoppelt*] himself, in that (i) he *is* as things in nature are, but (ii) he is just as much *for* himself; he sees himself, represents himself to himself [*sich vorstellt*], thinks, and only on the strength of this active placing of himself before himself is he spirit. (FA, 30–31)

So understood, the relation between artist and work is thoroughly specular; the creative subject sees itself reflected in the created object. Recalling Kant's analysis of inner teleology, Hegel maintains that for the artist what initially appears to be external and other is, when properly understood, internal and constitutive of his or her own being. This specularity can also be expressed in terms of the self-reflexivity of the subject and object in artistic activity. In self-reflexivity, relation to an other is mediate self-relation that is necessary for self-realization.

As I have noted, the specularity embodied in artistic activity exhibits the structure of the absolute itself. It is precisely this specularity that renders philosophy *speculative*. *Speculum* is, of course, the Latin word for mirror. The speculum is what makes reflection and its extension in speculation possible. Speculation is not abstract musing but the careful and de-

liberate reflection through which the knowing subject attempts to achieve self-consciousness by apprehending its internal relation to everything else that is. Though no longer *immediate* sensuousness, art is not yet speculative thought. For Hegel, as for Kant and Schelling, the artist does not fully understand what he or she accomplishes and thus cannot comprehend the truth of what he or she creates. In Hegel's speculative system, the work of art "points through and beyond itself, and itself hints at something spiritual of which it is to give us an idea" (FA, 9).

To grasp the spiritual idea at work in art, it is necessary to understand what Hegel means by "the concept." The Hegelian concept (*Begriff*) is not merely a subjective construct but the formal groundwork of all subjectivity and objectivity. In contrast to what he describes as Kant's subjective idealism, Hegel systematically develops the absolute idealism anticipated by Schelling. In absolute idealism, the concept is both epistemological and ontological; it is the foundation of thought as well as being. When concretely embodied in nature and history, the concept is the *idea* that is not simply ideal but also real.

> In the products of art, the spirit has to do solely with its own. And even if works of art are not thought or the concept, but a development of the concept out of itself, an estrangement [*Entfremdung*] into sense, still the power of the thinking spirit lies in being able not only to grasp itself in its proper form as thinking, but to know itself just as much in its *externalization* in feeling and sense, to comprehend itself in its other [*in seinem Anderen*], because it changes into thoughts what has been estranged and so reverts to itself. And in this preoccupation with the other, the thinking spirit is not false to itself at all as if it were forgetting and abandoning itself thereby, nor is it so powerless as to be unable to grasp what is different from itself; on the contrary, it comprehends both itself and its opposite. For the concept is the universal that maintains itself in its particularizations, overreaches itself and its opposites, and so it is also the power and activity of sublating the estrangement in which it gets involved. (FA, 12–13)

The structure of the concept outlined in this text comprises three dialectically related moments: universality, particularity, and individuality. As the synthesis of universality and particularity, individuality is what Hegel also describes as "concrete universality." These three moments define the three major stages in the development of art. "The forms of art," Hegel argues, "are nothing but the different relations of meaning and shape, relations that proceed from the idea itself and therefore provide the true basis for the division of this sphere. For division must always be implicit in the concept, the particularization and division of which is in question" (FA, 75). When philosophically comprehended, the self-manifestation of the absolute in the work of art falls into three divisions: symbolic, classic, and romantic. In the course of his analysis of these stages, Hegel charts the development of particular art forms. The progression from architecture to poetry by way of sculpture, painting, and music repeats the advance from materiality to spirituality that characterizes the overall progression of art.

Symbolic art is the moment of *abstraction* in which the artistic idiom has yet to find concrete expression. "Being indeterminate, [the work of art] does not yet possess in itself that individuality that the ideal demands; its abstraction and one-sidedness leave its shape externally defective and arbitrary. The first form of art is a *mere search* for portrayal rather than a capacity for true presentation; the idea has not found the form even in itself and therefore remains struggling and striving after it" (FA, 76). Seeking but not finding proper form, symbolic art remains essentially formless. Following Kant and Schiller, Hegel labels such formlessness *sublime*. In philosophical terms, the sublime involves a universality that cannot be represented in particularity. "In the incompatibility of the two sides to one another, the relation of the idea to the objective world therefore becomes a *negative* one, since the idea, as something inward, is itself unsatisfied by such externality, and, as the inner universal substance thereof, it persists *sublime* above all this multiplicity of shapes that do not correspond with it" (FA, 77). By overcoming the two basic defects of symbolic art, artistic representation becomes "the free and adequate embodiment of the idea in the shape peculiarly appropriate to the idea itself in its essential nature" (FA, 77). The *sensuous* form that is most adequate to the idea is the human body. When artistically depicted, the human body is no longer merely an empirical existent but is "the natural shape of spirit." Classical art, however, cannot translate the particularity of the idea into universality.

While symbolic art emphasizes universality at the expense of particularity and classical art stresses particularity but ignores universality, romantic art synthesizes universality and particularity to create an *organic* work of art. As the culmination of artistic development, romantic art forms the point of transition to religious awareness. Since he regarded the content of art and religion as the same, Hegel was able to draw a schematic parallel between the three forms of art and three stages in the history of religion. While symbolic art is the correlate of Eastern religions and classic art represents Greek religion, romantic art marks the meeting of East and West in the Christian religion. "Abandoning this [classical] principle, the romantic form of art cancels the undivided unity of classical art because it has won a content that goes beyond and above the classical form of art and its mode of expression. This content . . . coincides with what Christianity asserts of God as a spirit, in distinction from the Greek religion that is the essential and most appropriate content for classical art" (FA, 79). The spiritual essence of Christianity is revealed in the doctrine of the Trinity.[30]

In contrast to art, which sensuously figures the concept, religion represents the concept at the level of human consciousness. The Trinity is the *Vorstellung*—the re-presentation—in which the *conscious* subject places (*stellt*) the absolute notion before (*vor*) itself in the shape of *self-conscious* individuality. As Father, Son, and Holy Spirit (*Geist*), God is the "act of distinguishing or differentiating, which at the same time gives no difference and does not hold on to difference as permanent. God beholds Him-

self in what is differentiated; and when, in His other, He is united only with Himself, He is there with no other but Himself, He is in close union only with Himself, and beholds *Himself* in His other [*in seinem Anderen*]" (PR, 18).[31] In himself, apart from incarnation, the Father remains abstractly universal. Through the otherness of the Son's particularity, the Father sublates this abstract indeterminacy by assuming specific existence in which he achieves self-actualization. In orthodox christology, the Father and the Son are two but one—*both* identical *and* different. The bond joining Father and Son is the *third* member of the Trinity: Spirit or Holy Spirit. Always united in and through the synthetic third, Father and Son are forever spiritual. So understood, spirit is "concrete universality" or individuality that is realized by the activity of self-differentiation and self-reconciliation. This process is the "movement of retaining self-identity in its otherness." In abstract terms prefigured by theological language, "the three forms indicated are: eternal being in-and-with itself, the form of universality [*Allgemeinheit*]; the form of appearance, being-for-other, particularization [*Partikularisation*]; the form of return from appearance into self, absolute individuality [*Einzelheit*]. In these three forms, the divine idea explicates itself. Spirit is the divine history, the process of self-differentiation, diremption, and reappropriation" (PR, 2).

Though religion surpasses art by moving from sensuous awareness to consciousness, the religious believer fails to achieve full self-consciousness. To reach this end, it is necessary to transform religious *Vorstellungen* into philosophical *Begriffe*. While Hegel regards the sensuous embodiment of the idea as necessary, it is nevertheless penultimate. The completion of humankind's spiritual journey requires the progression from religion to philosophy. Philosophical reflection discerns the rational idea hidden beneath the sensuous surface of art and incarnate in religious representations. In this sense, philosophy is nothing other than the *dis-figuring* of art and religion. Within Hegel's system, such disfiguring marks the end of both art and religion. This conclusion leads to Hegel's notorious claim that "art, considered in its highest vocation, is and remains for us a thing of the past" (PA, 11). Hegel's point is not, of course, that art and religion simply disappear. However, inasmuch as the highest vocation of both art and religion is to unveil the Absolute, these two forms of figural representation inevitably give way to the conceptual presentation formulated in philosophy.

Hegel develops his purest statement of the rational structure of the absolute idea in the first part of his philosophical system, *Science of Logic*. As I have observed, the concept is ontological as well as epistemological. Consequently, *Science of Logic* articulates both the structure of thought and the logos of being. In this work, as in the system as a whole, Hegel reinscribes the tripartite structure of Kant's critical philosophy. He begins the concluding chapter, which simultaneously brings *Science of Logic* to fulfillment and prepares the way for *Philosophy of Nature* and *Philosophy of Spirit*, by arguing,

> The absolute idea has shown itself to be the identity of the theoretical and the practical idea. Each of these by itself is still one-sided, possessing the idea itself only as a sought-for beyond and an unattained goal; each, therefore, is a *synthesis of striving,* and has, but equally has *not,* the idea in it; each passes from one thought to the other without bringing the two together, and so remains fixed in their contradiction. The absolute idea, as the rational concept, which, in its reality, meets only with itself, is by virtue of this immediacy of its objective identity, on the one hand the return to *life;* but it has no less sublated this form of its immediacy, and contains within itself the highest degree of opposition. (SL, 824)

In a manner analogous to *The Critique of Judgment,* the absolute idea synthesizes the opposites between which thought and action are suspended. Furthermore, Hegel's idea replicates the autotelic structure of Kant's aesthetic ideal. From this point of view, Hegel's entire system can be interpreted as an intricate work of art that is characterized by *Zweckmässigkeit ohne Zweck.* The end—that is to say, both the completion and the goal—of philosophy is the *self-conscious* realization of the concrete universal in which each individual is internally related to all other individuals.

With the emergence of transparent self-consciousness, the *particular consciousness* of religion becomes the *universal self-consciousness* of philosophy. In Christianity, which for Hegel is "the absolute religion," the Son recognizes his identity with the Father. But the followers of Jesus do not realize that, in the object of their faith, they see their own self-consciousness objectified. In other words, the self-consciousness of the Son is universal; what is true of Jesus is true of everyone. Each person—indeed the entire natural and historical process—is an incarnation of the divine. When the universal is transparent in every particular, absolute self-consciousness becomes real. This reality is the end toward which history progresses from its beginning.

In his account of "The Realized End" in *Science of Logic,* Hegel describes the formal structure of the idea that is the alpha and omega of the world process.

> The *content* of the end is its negativity as *simple particularity reflected into itself,* distinguished from its totality as *form.* On account of this *simplicity* whose determinateness is in and for itself the totality of the concept, the content appears as the *permanently identical* element in the realization of the end. The teleological process is the *translation* of the concept that has a distinct concrete existence as concept into objectivity; this translation into a presupposed other is seen to be the meeting of the concept *with itself through itself.* Now the content of the end is this identity that has a concrete existence in the form of the identical. In every transition the concept maintains itself. . . . The end possesses, therefore, in externality *its own moment;* and the content, as content of the concrete unity, is its *simple form,* which not merely remains *implicitly* self-identical in the distinct moments of the end—as subjective end, as means and mediating activity, and as objective end—but also has a concrete existence as the abiding self-identical. (SL, 748)

The "externality" of the end must be understood in at least two ways. In the first place, every particular notion analyzed in *Science of Logic* is a specific determination of the all-inclusive concept. In the second place, when completely unfolded in the absolute idea, this concept forms the basis of all reality. Externality in both of these guises is internalized through the process of re-collection in which specific determinations are comprehended as integral members of the generative totality. Unlike Schelling's absolute, which, as we have seen, is a "point of indifference" where differences collapse into identity, Hegel's absolute is an identity-within-difference in which opposites are reconciled without being erased. For those with eyes to see and ears to hear, the oneness-in-threeness of the Trinity becomes the unity-in-plurality of the uni-verse. This unifying vision is the goal of philosophical reflection.

In Hegel's *aesthetic* education, knowledge is salvific. Since thought and being are essentially one, to think differently is to become a different person. More precisely, philosophical speculation enables one to recognize the implicit truth about oneself. This truth is immanent rather than transcendent; it lies near at hand waiting to be dis-covered. For Hegel, this discovery takes place neither in feeling nor intuition but in thought. "Thinking is the meeting of the self with *itself* in the other. This is a *deliverance* that is not the flight of abstraction, but consists in what is actual having itself not as something else, but as its own being and creation in the other actuality with which it is bound together by the force of necessity. As existing for itself, this deliverance is called *I*; as unfolded to its totality, it is *free spirit*; as feeling, it is *love*; as enjoyment, it is *blessedness*." [32] Contrary to Kant, Hegel insists that this blessedness *is not* "steadily deferred to infinity." Salvation . . . fulfillment . . . satisfaction is at hand *here and now*; the Kingdom *is present as presence*. This presence is a *total presence*, which, by negating all absence, actualizes the perfect *self-presence* of God, self, and world. Following the course plotted by Schiller, Hegel believes the salvation realized in his philosophical Kingdom surpasses the fulfillment experienced in the primordial Garden. Within Hegel's speculative narrative, history becomes a theodicy in which the fruits of the fortunate Fall eventually are enjoyed by everyone. The system ends at the point anticipated in the closing lines of *Phenomenology of Spirit*.

> The *goal*, absolute knowledge, or Spirit that knows itself as Spirit, has for its path the recollection of the Spirits as they are in themselves and as they accomplish the organization of their kingdom. Their preservation, regarded from the side of their free existence appearing in the form of contingency, is history; but regarded from the side of their comprehended organization, it is the science of knowledge: the two together, comprehended history, form the inwardizing and the Calvary of absolute spirit, the actuality, truth, and certainty of his throne, without which he would be lifeless and alone. Only from the chalice of this realm of spirits foams forth for Him his own finitude. (PS, 493)

When taken together, the aesthetic theories formulated by Kant, Schiller, Schelling, Schleiermacher, and Hegel interpret religion—*religare*—as a binding that is a rebinding—*re-ligare*. This rebinding is supposed to bind together what has fallen apart. As such, religion promises to heal the wounds, mend the tears, cover the faults, and close the fissures that rend self, society, and world. Casting a glance back toward the ancients, Schleiermacher writes, "It was religion when they rose above the brittle iron age of the world, full of fissures and unevenness, and again sought the golden age on Olympus among the happy life of the gods; thus they intuited the ever-active, ever-living, and serene activity of the world and its spirit, and beyond all change and all apparent evil that only stems from the conflict of finite forms" (SR, 105). For the theologians, philosophers, and artists whose thought was shaped by the discussions and debates that took place in Jena during the last decade of the eighteenth century, traditional forms of religious expression seemed vacuous. Nevertheless, many remained convinced that the problems of modernity were unsolvable apart from the infusion of a renewed spiritual sensibility. In an effort to fashion a therapy suited to the ills of the times, some of the most creative individuals of the era conceived a theoesthetic in which art and religion join to lead individuals and society from fragmentation and opposition to integration and unification. For some, the longed-for harmony was the faint memory of an ancient past; for others, an enthusiastic hope for an approaching future; and for others, a present reality waiting to be disclosed.

But in the midst of the choruses celebrating the dawning of harmonious accord, there is a disruptive undercurrent that usually remains muffled. The melancholy that Schleiermacher cannot avoid haunts the words of all who proclaim the imminence and immanence of the Kingdom. Hegel, in whose speculative system theoesthetics receives its most complete expression, ends his famous Berlin lectures on the philosophy of religion on a "discordant note" by conceding that the reconciliation his philosophy decrees has not, after all, materialized. Confronted by a world in which "individual opinion and conviction without objective truth have assumed authority, and the pursuit of private rights and enjoyment is the order of the day," Hegel was forced to confess that "this reconciliation is merely a partial one, without outward universality. Philosophy forms in this connection a separate sanctuary, and those who serve in it constitute an isolated order of priests, who must not mix with the world, and thus guard the possession of truth. How the temporal, empirical present is to find its way out of this discord, and what form it is to take, are questions that must be left to itself to settle" (PR, 150−51). These are the despairing words of a disillusioned idealist.

The twentieth century must relearn the lessons of the nineteenth century. The theoesthetic whose genesis I have traced implicitly and explicitly informs aesthetic theory as well as artistic and architectural practices down to our own day. A century that begins with utopian expectations

every bit as grand as those of nineteenth-century romantics and idealists is eventually forced to confront the flames of Hiroshima and the ashes of Auschwitz. In the dark light of those flames and the arid dust of those ashes, modernism ends and something *other* begins.

# 3

*I want to expose the Absolute.*

—GEORGES BRAQUE

*If one does not represent things, a place remains for the Divine.*

—PIET MONDRIAN

# ICONOCLASM

*It turned out that nothingness was God, and passing through perfection became nothingness, because this is what it was. "Nothingness" can be neither investigated nor studied, for it is "nothingness"; but in this "nothingness" appeared "something"—man; but since "something" cannot comprehend anything it automatically becomes "nothing"; hence it follows that man exists, or that God exists as "nothingness," as nonobjectivity.*

—KAZIMIR MALEVICH

# 3 □ ICONOCLASM

**T**HREE DISFIGURED FIGURES . . . one play. One play . . . three translations: one Dutch (fig. 3.1); one Russian (fig. 3.2); one American (fig. 3.3). Black-on-white/white-on-black, white-on-white, black-on-black. One-in-three/three-in-one. An empty canvas—black or white. A full canvas—black or white. Disfiguring figures a void that is not void but full. An absence that is not absence but presence. A nothing that is not nothing but the presence of Being. The end of (it) All: a chapel surrounded by dark iconoclastic images and a pool of blood in the artist's studio.

"Everything runs from the past to the future," declares Malevich. "But everything should live by the present. . . . The mire of the past, like a millstone, will drag you into the slough" (EA, 39). Modernity is not only a historical period but is, perhaps more important, the embodiment of a desire—a fundamental desire that is both ancient and primitive. Modern culture expresses a deep and abiding longing for the presence of the present and the present of presence. The word *modern* derives from the Latin *modernus,* which means "just now." As Malevich suggests, the present/presence of the modern is affirmed by the negation of the past. Rupture announces itself in the modernist dictum "Make it new!" In the modern epoch, the effort to make it new usually presupposes an erasure of the past that approximates what Nietzsche labels "creative forgetting." Such erasure, however, always leaves a trace. The forgotten never simply disappears but eternally returns to haunt the present and disrupt presence. Thus modernity remains inseparably bound to the very past against which it struggles to define itself.

In the modern era, the relentless search for the new involves the ceaseless quest for originality. Never derivative, the original is primary rather than secondary. To be original is to be present at an origin or *archē* that is not dependent on or derived from anything other than itself. The pursuit of originality is the quest for the primordial source of creativity. So understood, the desire of modernity not only is primitive and ancient but is, in a certain sense, the desire for the primitive and ancient. Eliot, the most modern of modern poets, writes,

> We shall not cease from exploration
> And the end of all our exploring
> Will be to arrive where we started
> And know the place for the first time.
> . . . . . . . . . . . . . . . . . . . . . . . . . . . . .
> Quick now, here, now, always—
> A condition of complete simplicity
> (Costing not less than everything)
> And all shall be well and
> All manner of thing shall be well
> When the tongues of flame are in-folded
> Into the crowned knot of fire
> And the fire and the rose are one.[1]

3.1 Piet Mondrian, *Composition I-A* (1930). Oil on canvas, 29⅝ × 29⅝ in. Hilla Rebay Collection (1971), Solomon R. Guggenheim Museum, New York. VAGA, New York, 1991. Photograph: David Heald.

3.3 Ad Reinhardt, *Abstract Painting* (1963). Oil on canvas, 20 × 20 in. Gift of Honora and Don Gifford, Collection, Williams College Museum of Art, Williamstown, Massachusetts.

3.2 Kasimir Malevich, *Suprematist Composition: White on White* (1918). Oil on canvas, 31¼ × 31¼ in. Collection, The Museum of Modern Art, New York.

What fire? Which rose? Is this the rose whose naming unleashes an apocalyptic fire? The rose that lends its name to the Rosicrucians whose brotherhood claimed even the founder of modern philosophy—René Descartes? Perhaps. And what of the k/not of fire? How is it to be read? Is it to be ignited or extinguished? When the fire and the rose are one, the Kingdom will have arrived . . . now, here, now, always. Costing not less than everything. But is this price too high? Is the price ash—ash that is the remains of an apocalypse that is a holocaust? The end toward which modernity progresses is the kingdom of spirit—the third *Reich*—envisioned in Hegel's idealistic philosophy. For many people, the dawn of the twentieth century brought with it the promise of unprecedented personal and social renewal. Throughout Europe and Russia, utopian dreams fueled revolutionary political experiments. Leading artists and architects believed they were called to serve as aesthetic educators who were uniquely qualified to lead the masses into the Promised Land. The journey toward the Kingdom of God on earth, however, was neither completely secular nor simply political. The most advanced artists of this century have repeatedly insisted that social change is impossible apart from spiritual transformation. Reversing Hegel's dialectical progression from art through religion to philosophy, artists of widely differing ideological orientations and stylistic persuasions have maintained that in a world where religion seems increasingly irrelevant and philosophy moribund, art alone can refigure humankind's deepest spiritual preoccupations and aspirations.

The theoesthetic formulated in post-Kantian theology and philosophy implicitly and explicitly informs seemingly diverse artistic practices developed throughout this century. As we have seen, the goal of theoesthetics is union with the Absolute or the Real, which underlies or dwells within every person and all phenomena. Since this Absolute is universal, many artists insist that it can be reached only through the activity of abstraction in which particularity and individuality are either negated or suppressed. Such abstraction is, in effect, a ritual of purification that leads to a "condition of complete simplicity." Since this simplicity is the primal or originary state from which all development begins, to reach this end is to return to the beginning. In this archaeoteleological process, Garden and Kingdom—Alpha and Omega—are one and (the) One is God.

The roots of this theoesthetic vision lie deeply buried in the Western tradition. During the opening decades of this century, however, artists turned to fashionable popular religions instead of classical theology and philosophy. The most common source of spiritual inspiration for painters and architects was the often noted but rarely analyzed religious movement known as Theosophy. The influence Theosophy exercised on the founders of modern art and architecture is so great that it is impossible to comprehend their work without an understanding of its basic tenets.[2]

Theosophy constitutes a late chapter in the long history of esotericism. The word *theosophy* designates the wisdom of God that is necessary to salvation. Gnosis, which is usually secret and disclosed only to initiates,

reveals the relation between the individual on the one hand, and, on the other, spiritual beings as well as the impersonal reality underlying all appearances. In one of the earliest appearances of the word, the sixth-century Christian mystic Dionysius the Areopagite uses *theosophy* to designate any knowledge that is salvific. By the time of the Renaissance, the notion of theosophy circulated widely and was associated with religious practices as diverse as alchemy, magic, and Christian Kabbalah. The most important precursor of modern Theosophy is the remarkable sixteenth-century figure Jakob Böhme, whose writings form an integral part of a German mystical tradition that extends from the Middle Ages into the nineteenth and twentieth centuries. One of the most striking features of Böhme's texts is the extraordinarily intricate drawings and etchings that illustrate his ideas. The geometric rigor and symbolic sophistication of an image like *The True Principles of All Things* anticipates modern strategies of abstraction that were developed over two centuries later (fig. 3.4).[3]

**3.4** Jakob Böhme, *The True Principles of All Things.*

Among those who were most deeply influenced by Böhme's tracts were the Jena romantics. During the late eighteenth and early nineteenth centuries, Böhme enjoyed a remarkable revival in Germany. Although critical of his form of expression, Hegel actually went so far as to admit that Böhme's visionary works prefigure his own philosophical system. Hegel's acknowledgment of the continuing significance of Böhme's insight underscores important parallels between speculative theoesthetics and Theosophy. The threefold rhythm articulated in Hegel's philosophy—unity, loss/fragmentation, and return to unity—constitutes the *structural* foundation of all Theosophical systems. In other words, philosophical theoesthetics and Theosophy are *formally* indistinguishable. Moreover, philosophical idealism and Theosophical spirituality agree that the *telos* of the psychocosmic process is the discovery of the implicit identity of the human and divine. In view of such profound similarities, it is possible to understand Theosophy as a popularized version of Hegelian theoesthetics.

The founder of the version of Theosophy that proved so important for modern artists was a Russian woman of noble heritage—Helena Petrovna Blavatsky. Reputed to be possessed of paranormal powers from a young age, Blavatsky traveled throughout Europe, Egypt, and India before settling in New York City and founding the Theosophical Society on November 17, 1875. In subsequent years, she published numerous books, which include three massive works that extensively define and explain the basic tenets of Theosophy: *Isis Unveiled: A Master-Key to the Mysteries of Ancient and Modern Science and Theology* (1877), *The Secret Doctrine: The Synthesis of Science, Religion, and Philosophy* (1888), and *The Key to Theosophy* (1889). In 1879 Blavatsky moved to India, where she led the society she had founded until her death in 1891.

After Blavatsky's death, leadership of the Theosophical Society fell into the hands of an Englishwoman, Annie Besant (née Wood). Besant deserted her clergyman husband in 1873, to become a leading figure in the British labor movement as a strike organizer and union official. Blavatsky's *Secret Doctrine* persuaded her to leave the Fabian Society and join the Theosophical Society. Following in Blavatsky's footsteps, Besant moved to India in 1893, where she extended her political involvement by actively supporting the Indian home rule movement. Besant led Blavatsky's inner circle after her death and was formally elected president of the society in 1907. While in India, Besant met three men who were to change the direction of the Theosophical Society. Charles W. Leadbeater was an Anglican clergyman who claimed to possess clairvoyance. Besant and Leadbeater jointly authored *Thought-Forms*, a work that played a crucial role in Kandinsky's artistic development. It was Leadbeater who convinced Besant that an unassuming fourteen-year-old boy named Jiddu Krishnamurti was the reincarnation of the Lord Maitreya, the World Teacher, who in previous eras had appeared in the guise of exalted figures like Sri Kṛṣna and Jesus. Besant adopted Krishnamurti and supported his education in England. Krishnamurti remained a leading figure in the

Theosophical Society until Besant's death. From 1933 until his own death in 1986, Krishnamurti promoted his independent version of Theosophy.

Besant and Leadbeater's insistence that Krishnamurti was the reincarnation of Jesus led to defection of one of the Theosophical Society's most distinguished members. Rudolf Steiner was born in Hungary, educated in Austria, and spent his adult life in Germany and Switzerland. Steiner played an intriguing role in the complex interrelation of early twentieth-century religion, art, and architecture. Recognized as something of a prodigy, he was invited at the age of twenty-two to edit Goethe's natural scientific writings. Goethe's work left a lasting impression on Steiner.[4] In Goethe's scientific investigations and theoretical reflections on color, Steiner discovered what he regarded as a way to penetrate the surface of appearances imaginatively and to uncover spiritual reality. Goethe, it will be recalled, was a leading figure in the establishment of the Weimar *Kultur* that came to its fullest expression in Jena during the 1790s. Thus Steiner's appropriation of Goethe's insights establishes a direct link between eighteenth- and nineteenth-century theoesthetics and twentieth-century Theosophy.

Steiner remained associated with the Theosophical Society until 1912. After his disagreement with Besant and Leadbeater about the status of Krishnamurti, Steiner established his own organization, which he named the Anthroposophical Society. Anthroposophy (knowledge of humans, or human wisdom) is yet another version of the perennial philosophy represented in Theosophical doctrine.[5] Theosophy and Anthroposophy do not differ significantly in their essential theological and philosophical principles. In contrast to Blavatsky and Besant, however, Steiner tried to develop empirically tested strategies for inducing spiritual vision. The discipline to which Steiner subjected his followers ranged from "biodynamic" methods of soil cultivation to experimental educational practices. The arts played a particularly important role in Anthroposophy's aesthetic education. Steiner's influence on artistic practice was greatest among architects. This was at least in part the result of his own architectural efforts. During the last years of his life, Steiner devoted himself to the design and construction of Goetheanum, which still serves as the headquarters of the Anthroposophical Society in Dornach, Switzerland.

As I have stressed, the crucial figure in the emergence of Theosophy is Blavatsky. The writings of Besant, Leadbeater, and Steiner represent extensions and elaborations of Blavatsky's basic insights. In her encyclopedic books, Blavatsky develops a syncretistic system that weaves strands of Eastern and Western esoteric and exoteric religious and philosophical traditions. While tracing her spiritual lineage back to Alexandrian, Neoplatonic, and Indian philosophy, Blavatsky also recognizes more recent anticipations of her vision. Hegel in particular appears at critical points in Blavatsky's exposition of Theosophy. In the opening pages of *The Secret Doctrine*, she invokes Hegel in an effort to clarify the foundational principles of her position.

(1) The ABSOLUTE; the *Parabrahm* of the Vedântins, or the one Reality, SAT, which is, as Hegel says, both Absolute Being and Non-Being.

(2) The first manifestation, the impersonal, and, in philosophy, *unmanifested* Logos, the precursor of the "manifested." This is the "First Cause," the "Unconscious" of European Pantheists.

(3) Spirit-Matter, LIFE; the "Spirit of the Universe," the Purusha and Prakriti, or the *second* Logos.

(4) Cosmic Ideation, MAHAT or Intelligence, the Universal World-Soul; the Cosmic Noumenon of Matter, the basis of the intelligent operations in and of Nature also called MAHAIBUDDHI.

THE ONE REALITY; its *dual* aspects in the conditioned Universe.[6]

It is obvious that Blavatsky reverses Hegel's translation of *Vorstellungen* into *Begriffe* by attempting to present philosophical ideas in religious language.

The most basic belief of Theosophy is that "all men have spiritually and physically the same origin" (KT, 42). This origin is "THE ONE REALITY," which Blavatsky describes as "Be-ness," "enduring substance," "Universal Spirit," "Nature," "ABSOLUTE," "DEITY," and "GOD." Within Blavatsky's scheme, duality, division, opposition, and fragmentation are apparent rather than real. Those who have been initiated into "the secret doctrine" realize that in its essence human being is a "radiation of the Divine Soul." Recognition of the divine identity of the self is the salvific gnosis that the great World Teachers, East and West, bring to their followers.

Though the principles of Theosophy are quite simple, their elaboration is very complex. For example, the incarnation of the divine in the human is neither immediate nor direct. Blavatsky describes "the septenary nature of man" in which various spiritual and material "layers" conceal the "Absolute Essence" that is the origin and goal of life. The sevenfold nature of human being mirrors the seven planes of reality through which the divine cosmos passes in its evolution and involution. Since God, self, and world are identical, the development of one is the realization of the other. Eternally enacting the creation of the world, the divine-human-cosmic process passes through seven stages: three of descent in which there is a movement from the spiritual to the material, one of "crystallization,"[7] and three of ascent in which there is a movement from the material to the spiritual. Summarizing the loss and return involved in all spiritual development, Blavatsky writes, "We believe in a Universal Divine Principle, the root of ALL, from which all proceeds, and within which all shall be absorbed at the end of the great cycle of Being" (KT, 63). The "great cycle of Being" reinscribes the circular rhythm of Hegel's dialectic. As the "Universal Divine Principle" emanates from the spiritual domain to the material world, lingers, and then returns to its origin, so Hegel's "Absolute Spirit" proceeds from the realm of Logic (*Science of Logic,* which Hegel describes as "the mind of God before the creation of the world"), into nature (*Philosophy of Nature*) and history (*Philosophy of Spirit*), and eventually returns to the sphere of "the Absolute Idea."[8]

There are, nonetheless, two significant differences between Blavatsky's spiritualism and Hegel's idealism, which are extremely important for the

emergence of twentieth-century abstract or nonobjective painting. First, Blavatsky has a much more negative view of matter and materiality than does Hegel. While it is clear that, within the Hegelian system, the material is always sublated by the spiritual, matter is never merely negated but is always preserved as a necessary moment that never completely disappears. For Blavatsky, by contrast, "the objective *material* universe" is "a temporary *illusion* and nothing else." Since matter is illusory, it must be negated or removed in order to reach spirit. Second, the Divine Essence or Universal Spirit is "the Unknown." The unknowability of the Absolute is not, for Blavatsky, a form of ignorance that can be overcome in something like Hegel's Absolute Knowledge. To the contrary, "the absolute Unity" is "the *unknowable* deific essence" (KT, 82). Blavatsky's radically monistic ontology precludes the possibility of the distinction between subjectivity and objectivity that all knowledge presupposes. Rather than establishing a dialectical relation between identity and difference, Blavatsky collapses difference into identity. Thus her Absolute more closely approximates Schelling's *Indifferenzpunkt* than Hegel's differentiated totality. While Hegel struggles to reconcile universality and particularity in individuality, Blavatsky sacrifices the individual to the universal. Individuality, like materiality, is epiphenomenal. It too must pass away before the Kingdom of Light can dawn. But light—white light—harbors a profound darkness.

Many who did not necessarily share Theosophy's complex spiritual vision nevertheless saw in the economic, technological, and social developments of the opening decade of the twentieth century signs of something like a "harmonic convergence" that signaled the birth of a "New Age." "An interlocking world system of imperialism; opposed to it, a socialist international; the founding of modern physics, physiology, and sociology; the increasing use of electricity; the invention of radio and the cinema; the beginnings of mass production; the publishing of mass-circulation newspapers; the structural possibilities offered by the availability of steel and aluminum; the rapid development of chemical industries and the production of synthetic materials; what did all of this mean?"[9]

To a visionary like Apollinaire, who was the leading poet of the cubist movement, the moment of convergence completely transformed both the cosmos and human experience. "For the first time the world as a totality ceased to be an abstraction and became *realizable.*"[10] Within this realized totality, self and world appear to be one. Apollinaire broadcasts the good news:

> I am drunk from having drunk the universe whole.
> I am everywhere or rather I start to be everywhere.
> It is I who am starting this thing of the centuries to come.

Apollinaire's heady words recall Nietzsche's declaration of the death of God: "The madman jumped into their midst and pierced them with his eyes. 'Whither is God?' he cried; 'I will tell you. *We have killed him*—you and I. All of us are his murderers. But how did we do this? How could we

drink up the sea? Who gave us the sponge to wipe away the entire horizon?' "[11] For Nietzsche, the death of God is the divinization of man. When the transcendent creator dies and is reborn in the creative subject, the locus of creativity shifts from heaven to earth. With this reversal, the relation between subject and object, as well as image and reality, is recast.

No longer conceived as an empty mirror reflecting referential data, the modern subject discovers its own generative and productive capabilities. The act of representation shifts from the re-presentation of antecedently constituted entities to the presentation of original forms. Writing in 1912, Albert Gleizes and Jean Metzinger argue that "the visible world can become the real world only by the operation of the intellect" (TMA, 208). This does not imply that the objective world is merely a fanciful projection of the creative subject. The finite creator is more like a Demiurge, who struggles to form unformed matter, than the transcendent Creator, who creates out of nothing. Subject and object are joined in a dialectical relationship that is mutually constitutive. Within this interplay, figure is transformed from a mirror image into an invented artifact. In his "Thoughts and Reflections on Art," Georges Braque concludes that "the senses deform, the mind forms. Work to perfect the mind. There is no certitude but in what the mind conceives" (TMA, 260).[12] Cubism works to perfect the mind by relentlessly exploring the transformed relationship between the painted image and reality.

Cubism, however, would have been impossible without the extraordinary painterly innovations of Paul Cézanne. In their highly influential book *Du cubisme,* Gleizes and Metzinger go so far as to assert that "to understand Cézanne is to foresee Cubism." To render Cézanne understandable, Gleizes and Metzinger distinguish "superficial realism," which includes the work of the impressionists, from "profound realism," which is best exemplified by Cézanne's art. There are, to be sure, notable similarities between the impressionists and Cézanne. Most important, the work of the impressionists reflects the turn to the subject that defines modern philosophy and increasingly informs modern art. "Gradually, in the later works of the Impressionists and Post-Impressionists . . . a painting becomes more a record of the artist's experience than an account of perceived natural facts, until it could be said to have originated in the mind rather than in observed nature."[13] The experience with which the impressionists are most concerned is sensory or perceptual. Impressionists attempt to capture in paint the *presence* of the sensory trace of the fleeting moment. The object depicted is not of intrinsic interest but draws the eye of the artist insofar as it is the occasion for his or her own experience. This experience, like the moment it records, is ever changing. As if to underscore the primacy of fluctuating perception, some of the leading impressionist works represent "the same" object at different moments. The classic example of this strategy is, of course, Monet's series of paintings of the Rouen Cathedral (plate 2). The preoccupation with momentary sensory impressions creates the appearance of deliberate *superficiality.* The im-

pressionists are less concerned with depth than with surface. This is the point Gleizes and Metzinger underscore when they describe impressionism as "superficial realism."

To move from superficial to "profound realism" is to *begin* the journey beneath the surface without leaving behind perception and sensation. In a marvelously succinct remark, Cézanne expresses his admiration for Monet and suggests reservations about his work: "Il n'est qu'un oeil, mais, mon Dieu, quel oeil!" An eye—an extraordinary eye—but *only* an eye. From Cézanne's point of view, the impressionists succumbed to what Robert Hughes describes as "the dictatorship of the eye over the mind." Cézanne's art can be understood as an effort to put the mind back into the eye. At first glance, Cézanne's obsessive painting and repainting of the landscape around Mont Sainte-Victoire might seem to repeat Monet's preoccupation with the Rouen Cathedral and haystacks (plate 3). Cézanne's concerns, however, differ significantly from the interests of Monet. In an oft-repeated remark recorded in a letter to Émile Bernard, Cézanne insists, "You must see in nature the cylinder, the sphere, the cone."[14] For Cézanne, appearances are not superficial impressions but profound figures. Perception is more complex than the impressionists realized. Cézanne gradually discovered what Kant had long known: the mind is never simply passive but is active in all awareness—even in the most rudimentary forms of perception and sensation. The canvases of Cézanne unfold what might be described as a "phenomenology of perception." Maurice Merleau-Ponty argues,

> Cézanne did not think he had to choose between feeling and thought, between order and chaos. He did not want to separate the stable things that we see and the shifting way in which they appear; he wanted to depict matter as it takes on form, the birth of order through spontaneous organization. He makes a basic distinction not between "the senses" and "the understanding" but rather between the spontaneous organization of the things we perceive and the human organization of ideas and sciences. We see things; we agree about them; we are anchored in them; and it is with "nature" as our base that we construct our sciences. Cézanne wanted to paint this primordial world and his pictures therefore seem to show nature pure, while photographs of the same landscapes suggest man's works, conveniences, and imminent presence. Cézanne never wished to "paint like a savage." He wanted to put intelligence, ideas, sciences, perspective, and tradition back in touch with the world of nature that they must comprehend.[15]

As Cézanne patiently probes landscapes and still lifes, cylinders, spheres, and cones slowly begin to emerge from the confusion of sensory flux. Through these forms, Cézanne sees intelligence in nature. The geometry of perception figures the concrete idea.

What Cézanne begins, cubism extends. In a rare comment on his artistic practice, Picasso remarks, "I paint forms as I think them, not as I see them."[16] The movement from Cézanne to Braque and Picasso marks the transition from a phenomenology of perception to a phenomenology of conception. Analytic cubism follows Cézanne from surface to depth and

from exterior to interior. *"Cubism,"* Apollinaire explains, "is the art of painting new structures out of elements borrowed not from the reality of sight, but from the reality of insight" (TMA, 227). In the summer of 1908, Braque literally followed in the footsteps of Cézanne by going to L'Estaque in southern France. The works Braque executed during this sojourn reflect the strong influence of Cézanne (fig. 3.5). Although Picasso did not accompany Braque to L'Estaque, some of the paintings he completed during the summer of 1908 bear a striking resemblance to the works of Cézanne and Braque (fig. 3.6). In these early works, which provoke Matisse's quip ("les petites cubes") from which the name cubism derives, the distinctive characteristics of analytic cubism are already recognizable. The illusion of space gives way to a painted surface that is filled to overflowing with sharply delineated geometric forms presented in muted colors. Though obviously still present, representation has begun its retreat.

Three years later, Braque and Picasso vacationed together at Céret in

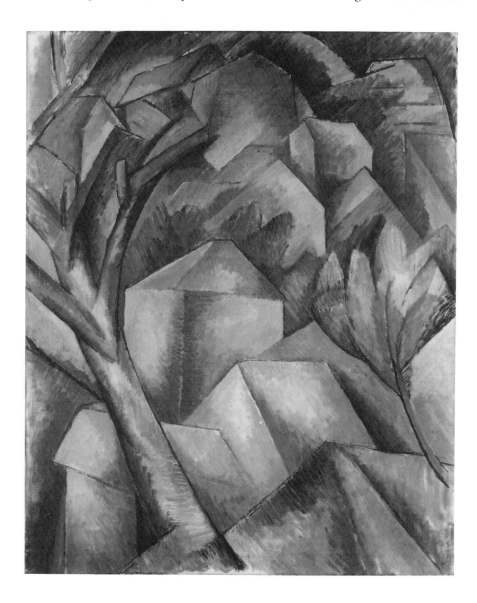

3.5 Georges Braque, *Houses at L'Estaque* (1908). Oil on canvas, 73 × 59.5 cm. Hermann and Margrit Rupf-Stiftung, Kunstmuseum, Bern. © 1991 ARS, New York/ADAGP, Paris.

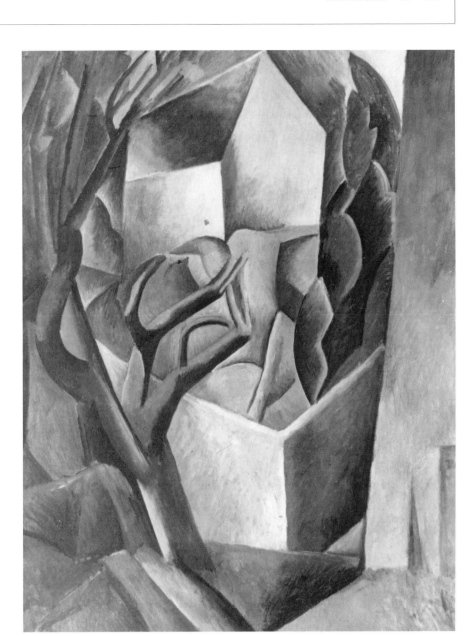

**3.6 Pablo Picasso,** *Cottage and Trees* **(1908). © 1991 ARS, New York/SPADEM, Paris.**

the French Pyrenees. In the works from this period, cubism reached maturity (plates 4, 5).[17] Between 1908 and 1911, Braque's and Picasso's paintings became increasingly abstract until only faint traces of representation remained. Geometric formalism replaced description and mimetic reference. Cubist geometry, however, is not Euclidean. Thus abstraction is not necessarily simplification. As images become more abstract, forms become more complex. The intricacy of these forms reflects Braque's and Picasso's growing appreciation for the complexity of the perceptual and conceptual processes involved in figuration. The apprehension of objects is never the result of a momentary sensory impression but is always the product of a multifaceted creative process.

Under the rigorous dissection of analytic Cubism, objects [lose] their momentary superficial appearance; they [are] made to reveal their existence as

entities plotted in time and space. The new sense of objects conceived in three or even four dimensions seen from many angles [surpasses] the narrow convention which required the single viewpoint of Vitruvian perspective. The limited view of an object seen from one given plane [is] inadequate and the new conception [introduces] two factors of interest: movement on the part of the spectator rather than the object, and knowledge of the object based on more than a limited glance.[18]

Within the shifting perspective of cubism, the object is never simply one thing. Defending cubist practice from the attacks of hostile critics, Gleizes and Metzinger point out that "an object is not one absolute form; it has many: it has as many as there are planes in the region of perception" (TMA, 214). The multiplicity of perspectives constitutive of objectivity renders forms on the cubist canvas forever incomplete. Different angles of vision are juxtaposed to create figures that are strangely disfigured. When occasional fragments can be identified, as in Picasso's *Man with Violin* (1911) or Braque's *Still Life with Harp and Violin* (1912), parts do not coalesce to form a whole. This does not mean, however, that every vestige of an encompassing totality has simply vanished. Rather, the locus of unity has shifted from individual objects to relationships between and among particular entities. During the same years that Saussure formulated the theory of language that became the basis of structural linguistics and anthropology, Braque's and Picasso's artistic experiments led to conclusions that anticipated the seminal insights of contemporary structuralism.[19] In a manner analogous to Saussure's phonemes, the interchangeable elements in a cubist composition display a structure that functions as a grid linking otherwise disassociated fragments. This grid does not exist in objects apart from the cognitive activity through which it is apprehended. The structure exposed by the cubist gaze is the structure of subjectivity itself.

To understand the broader implications of the movement from naive realism, through impressionism and Cézanne's phenomenology of perception, to cubism's phenomenology of conception, it is helpful to note the striking parallels between the cubist project and Edmund Husserl's phenomenology.[20] While the roots of phenomenology can be traced to Hegel's *Phenomenology of Spirit* (1807), Husserl formulated the most important twentieth-century version of phenomenology during the years that Braque and Picasso were developing cubism. Following Hegel, Husserl regards philosophy as a "universal science" that seeks perfect clarity and certainty by uncovering the "absolute foundations" of knowledge. Such apodictic knowledge is the product of phenomenological reflection. Insofar as phenomenology is the science of both "the totality of objectively existing beings" and what Husserl labels "transcendental subjectivity," "phenomenology properly carried through is the truly universal ontology."[21]

In order to avoid misrepresenting Husserl's enterprise, it is necessary to understand exactly what he means by "phenomenon." A phenomenon is an entity *as it appears to consciousness*. The task of the phenomenologist is to *describe* all being as being-for-consciousness. This description entails

a critical reassessment of what Husserl identifies as the "natural attitude" of consciousness. As we have seen, common sense regards objects as existing in the world prior to and independent of the subject. Husserl brackets this natural understanding of experience through what he calls alternatively the "phenomenological reduction" or the "*epochē*." The *epochē* is, in effect, a version of Cartesian doubt through which Husserl tries to turn consciousness from *res extensa* to *res cogitans* in order to reduce objectivity to subjectivity. Natural consciousness is led into error and uncertainty by "forgetting" the origin of its world. Phenomenology involves the effort to recover this lost origin by disclosing the constructive activity of consciousness. Contrary to the natural attitude, Husserl maintains that every object of experience, as well as the world in which these objects appear, is the product of a constituting subject. This subject is the "transcendental ego" that projects the world of experience through its "intentional" activity. All objectivity is, therefore, constructed or constituted by the creative subject. In examining the object of consciousness, the phenomenologist does not look for empirical data (i.e., givens) but seeks the ideal Logos, which, having been constructed by the transcendental subject, constitutes the objectivity of the object. Husserl labels the essential structure of the object its *eidos*. This *eidos* is the unchanging form that secures the spatial and temporal presence of the object. "Eidetic phenomenology," Husserl explains, "is the presentation of invariant structural systems without which perception of a body and a synthetically concordant multiplicity of perceptions of one and the same body as such would be unthinkable."

Though there are subtle and significant differences between their phenomenologies, Husserl's transcendental subjectivity *functions* in a manner analogous to Hegel's Absolute Spirit. Heidegger suggests this association without explicitly drawing the connection: "The transcendental reduction to absolute subjectivity gives and secures the possibility of grounding the objectivity of all objects (the Being of this being) in its valid structure and consistency, that is, in its constitution, in and through subjectivity. Thus transcendental subjectivity proves to be 'the sole absolute being.'" This "absolute being" is the Logos that is the (structural) foundation of the world.

It is obvious that Braque and Picasso did not develop the implications of their artistic practices and experiments in a way that led directly to the conclusions reached by Hegel and Husserl. Several brief cryptic remarks by the artists, however, suggest that they were not unaware of the broader theological and philosophical ramifications of their work. At the time he was struggling to make the transition from Cézanne's phenomenalism to what eventually became cubism, Braque writes, "I couldn't portray a woman in all her natural loveliness. I haven't the skill. No one has. I must, therefore, create a new sort of beauty, the beauty that appears to me in terms of volume of line, of mass, of weight, and through that beauty interpret my subjective impression. Nature is a mere pretext for a decorative

composition, plus sentiment. It suggests emotion, and I translate that
emotion into art. I want to expose the Absolute" (TMA, 259–60). From
the outset, many insightful critics and interpreters recognized in cubism
an idealism that borders on spirituality. As early as 1913, Apollinaire ar-
gued in *Les peintres cubistes,* "Wishing to attain the proportions of the ideal,
to be no longer limited to the human, the young painters offer us works
that are more cerebral than sensual. They discard more and more the old
art of optical illusion and local proportion, in order to express the gran-
deur of metaphysical forms. This is why contemporary art, even if it does
not directly stem from specific religious beliefs, nonetheless possesses
some of the characteristics of great, that is to say, religious art" (TMA,
224). It was left for other leaders in modern art to develop the explicit
religious presuppositions and implications of the new painting. In 1936,
while presenting the fourth cycle of his seminal course on Hegel's *Phe-
nomenology of Spirit* at the École des hautes études, Alexandre Kojève
wrote a fascinating essay on his uncle's art, entitled "Les peintures con-
crètes de Kandinsky."[22]

Kojève's account of Hegel is no mere exposition but a creative reading
that is filtered through his interpretation of Marx and Heidegger. For Ko-
jève, one of Hegel's most important insights is that history has, in some
sense, reached closure. Living and writing over a century after Hegel's
death, Kojève is forced to ask, What remains to be done at the end of
history? Surprisingly enough, in responding to this question, Kojève over-
turns one of the central theses in Hegel's system. Instead of "a thing of the
past," art—"total and absolute painting"—first becomes possible at the
end of history. To support this claim, Kojève develops Kant's analysis of
the inner teleology that defines every beautiful artwork. "Complete,
closed in on itself, and sufficient to itself," the work of art is "purposeless."
This purposelessness reflects the "uselessness" (*inutilité*) of *l'oeuvre d'art.*
Under normal circumstances, this uselessness would provide the occasion
for the criticism of art. But at the end of history, the situation is different.
Purpose has been realized; the future has arrived in the *present* and thus
nothing essential is left outstanding. At this moment—a moment that lasts
forever—the arduous labor of history is over, and the leisurely play of
the Kingdom begins. For Kojève, as for his eighteenth- and nineteenth-
century precursors, self-fulfilling play is most completely embodied in art.

But not just any art will do. Kojève maintains that abstract art best
captures life in the Kingdom. Family pride no doubt led Kojève to insist
that Kandinsky's work is the most adequate expression of "total and
absolute painting." What makes abstract art particularly appropriate at
the end of history is precisely its nonreferentiality, or, more precisely, its
self-referentiality. In contrast to representational art, whose referent is ex-
terior, abstract art, according to Kojève, does not point beyond itself but is
autotelic. Like the Hegelian Idea whose incarnation history enacts, the
abstract work of art concretely embodies the Real by erasing the difference
between image and reality. "Let us take as an example," Kojève writes,

a drawing where Kandinsky incarnates [*incarne*] a Beauty implied in a combination of a triangle with a circle. This Beauty has not been "extracted" or "abstracted" from a real nonartistic object, which would "also" be beautiful— but "at first" still another thing. The Beauty of the picture "circle-triangle" does not exist at all outside of this picture. In the same way, the picture does not "represent" anything exterior to itself, its Beauty is thus purely immanent, it is the Beautiful of the picture, which exists only in the picture.

When immanence swallows transcendence, history is over. From this point of view, the artist is a Nietzschean *Übermensch* who "drinks up the sea."

Kojève's reading of Kandinsky's painting represents a sustained effort to reconcile his own left-wing Hegelianism and his uncle's art. The result is a richly suggestive misprision. There are undeniable similarities between Kandinsky's artistic theories and practice and Hegel's philosophy. But there are no less important differences. Kandinsky does not share Kojève's belief that history has reached its end and, consequently, has a different understanding of the nature and function of art. For Kandinsky, nonobjective art does not signal the realization of the Kingdom but is in the service of realizing a Kingdom that still lies in the future. After the millennium, art will no longer be necessary.

The spiritual vision that lies behind Kandinsky's art is an idiosyncratic mixture of philosophical idealism, Theosophy, and Russian Orthodoxy. Central to each of these traditions is a theology of history that can be traced to early Christian gnostics. Elaborating the Christian doctrine of the Trinity, spiritualists and theologians from Mani and Joachim of Fiore to Hegel and Blavatsky divide history into three stages, which are represented by the eras of the Father, Son, and Spirit. The third age is the time of fulfillment in which the divine *Reich* is completely realized. During the opening decade of the twentieth century, millenarian fervor was running particularly high in Russia. "According to the Russian Orthodox tradition, Constantinople (Byzantium) was the 'Second Rome,' and when that city was conquered by the Muslim Turks in 1453, the succession as the 'Third Rome' passed to Moscow, the new and everlasting capital of Christianity. . . . For the Orthodox, the Old Rome represented the Father; the second Rome, Constantinople, symbolized the Son or the Logos; while the third Rome, Moscow, expressed the conviction that the entire collective life of the nation should be inspired by the Holy Spirit."[23]

Kandinsky shared the apocalyptic hopes of his time. In the 1911 preface to *Der Blaue Reiter*, Kandinsky and his coeditor Franz Marc write, "A great era has begun: the spiritual 'awakening,' in the increasing tendency to regain 'lost balance,' the inevitable necessity of spiritual plantings, the unfolding of the first blossom. We are standing at the threshold of one of the greatest epochs that mankind has ever experienced, the epoch of great spirituality."[24] Kandinsky's paintings from this period make it clear that he believed Moscow occupies a special place in the divine economy. In a work like *The Last Judgment* (1910), an angel blowing a trumpet heralding

the advent of the Kingdom hovers above the image of a resurrected saint (fig. 3.7). In the distance, Moscow appears as the city on the hill that is the site of New Jerusalem. As numerous other paintings from the prewar period make clear, the Kremlin will be the center of the holy city to which Christ returns and from which he will exercise his lordship over the entire world. Though beginning in Kandinsky's own time, the complete realization of the Kingdom of God still lies in the future. Quoting Blavatsky in *Concerning the Spiritual in Art,* Kandinsky observes, "The earth will be heaven in the twenty-first century in comparison with what it is now."[25]

The artist-prophet reveals the way to New Jerusalem by developing an "aesthetic education of man." The course Kandinsky charts passes from "the nightmare of materialism" to "the kingdom of the abstract."

> The more abstract is form, the more clear and direct is its appeal. In any composition the material side may be more or less omitted in proportion as the forms used are more or less material, and for them substituted pure abstractions, or largely dematerialized objects. The more an artist uses these abstracted forms, the deeper and more confidently will he advance into the kingdom of the abstract. And after him will follow the gazer at his pictures, who also will have gradually acquired a greater familiarity with the language of the kingdom.[26]

The goal of Kandinsky's aesthetic education is the discovery of "the 'oneness' of the 'human' and the 'divine.'"[27]

In developing his understanding of the spiritual dimension of art, Kandinsky drew heavily on Annie Besant's and Charles W. Leadbeater's *Thought-Forms.*[28] Besant, as noted above, assumed leadership of the Theosophical Society after the death of Blavatsky. Accepting Blavatsky's basic position, Besant extended the Theosophical system into new areas. In *Thought-Forms,* Besant and Leadbeater argue that distinctive forms and colors express specific thoughts and emotions. They based their analysis on a tripartite anthropology in which the physical body is surrounded by a mental body, which is the locus of cognitive activity, and an astral body, which is the seat of emotions, desires, and passions. The mental and astral bodies interpenetrate to create a "cloud-like substance" or "aura" that can be seen by spiritually advanced individuals who are gifted with clairvoyance. It is important to stress that the difference among the physical, mental, and astral domains is not qualitative. Leadbeater and Besant were thoroughgoing monists. Everything is composed of a single substance, which assumes determinate forms that are more or less subtle.

The activity of the cosmos—physical, mental, and spiritual—is a function of the *vibration* of this subtle substance. The notion of a pervasive cosmic vibration has a long history in the Western tradition. Drawing on Böhme's insights, Schelling describes the "universal heartbeat" as the dynamic oscillation between polar opposites. This vibration or oscillation is the exercise of divine energy. To approach the source of this energy, it is necessary to ascend from the material to the immaterial domain. With this movement, forms become less dense and more refined as the rate of

**3.7 Wassily Kandinsky,** *The Last Judgment* **(1910). The Joseph H. Hazen Collection. © 1991 ARS, New York/ADAGP, Paris.**

the activity of the spiritual essence steadily increases. Each thought or emotion is characterized by a specific rate of vibration, which, in turn, is correlated with a definite color and form. Leadbeater and Besant concisely summarize the conclusions of their analysis: "Three general principles underlie the production of thought-forms: 1. Quality of thought determines color. 2. Nature of thought determines form. 3. Definiteness of thought determines clearness of outline" (TF, 21). They go so far as to establish a color code for thoughts and emotions ranging from sentiments like "High Spirituality" and "Pure Religious Feeling" to base feelings of "Selfishness," "Sensuality," and "Malice" (plate 6). While shades of deep red, dark brown, and muted gray represent emotions such as anger, sensuality, avarice, and depression, light greens, yellows, and pinks express intellect, sympathy, and affection. "The different shades of blue all indicate religious feeling, and range through all the hues from the dark brown-blue of selfish devotion, or the pallid grey-blue of fetish-worship tinged with fear, up to the rich deep clear color of heartfelt adoration, and the beautiful pale

azure of that highest form which implies self-renunciation and union with the divine; the devotional thought of an unselfish heart is very lovely in color, like the deep blue of a summer sky" (TF, 23–24).

Having developed their doctrine of color and its accompanying ontology, Leadbeater and Besant proceed to formulate a theory of communication. Communication takes place through the vibration of the all-pervading subtle substance. Thoughts and emotions can be transmitted from one person to another through appropriate forms and colors. An important part of the spiritual therapy Leadbeater and Besant prescribed involved "sending" helpful thoughts and noble emotions to those in need by way of original drawings and paintings. This spiritual strategy resulted in some remarkable abstract works of art. For Leadbeater and Besant, the highest form of spiritual insight is the apprehension of the one reality of which everything is an embodiment. The image depicted in figure 3.8, which they label *An Aspiration to Enfold All,* was reportedly produced by a person while sitting in meditation. The manifest diversity and latent unity of humankind are expressed in "intricate lines [that] are in reality only one line circling round the form again and again with unwearied patience and wonderful accuracy." The proper name of the psychocosmic principle of unity is "the Logos." In figure 3.9, increasingly complex variations of *The Logos Pervading All* are graphically presented. In the course of decoding these images, Leadbeater and Besant conclude, "In all reli-

**3.8 Annie Besant and C. W. Leadbeater,** *An Inspiration to Enfold All.*

**3.9 Annie Besant and C. W. Leadbeater,** *The Logos Pervading All.*

3.10 Wassily Kandinsky, *Lady in Moscow* (1912). Städtische Galerie im Lenbachhaus, Munich. © 1991 ARS, New York/ADAGP, Paris.

gions there remains some tradition of the great truth that the LOGOS manifests himself through seven mighty channels, often regarded as minor Logoi or great planetary Spirits" (TF, 63). These seven channels direct the evolution and involution of the universal Logos. To understand one's place in this planetary process is to grasp the salvific truth of the Logos.

For Kandinsky, to sound the cosmos is to hear the Logos. The divine Logos that pervades all releases vibrations that resound with harmonic *Zusammenklingen.* The substantial unity of the cosmos creates the possibility of synesthesia. Kandinsky's reflections on the interplay of visual and aural experience were inspired by Rudolf Steiner's *Luzifer-Gnosis,* which he read and carefully annotated between 1904 and 1908. Since color and sound are nothing other than different vibrations of a single reality, colors sound and sounds are colorful. Elaborating Leadbeater's and Besant's spiritual color charts, Kandinsky graphs the expressive and communicative potential of different colors.

Some of Kandinsky's early efforts to depict Theosophical ideas are highly representational and overly literalistic. For example, in *Lady in Moscow* (1912) the central figure is surrounded by a blue aura that suggests her astral body (fig. 3.10). The "pure pale rose" of the cloud by her side represents, in the words of Leadbeater and Besant, "that absolutely un-

selfish love which is possible only to high natures." Though the meaning of the black cloud hovering above the city remains obscure, it seems to depict an ominous thought-form that suggests impending disaster. The brighter side of this disaster appears in the brilliant colors of the Kremlin, which stands on a hill in the distance.

Kandinsky's use of form and color quickly became increasingly sophisticated and more abstract. A mere year after completing *Lady in Moscow,* he painted the stunning *Black Lines No. 189* in which only the vaguest hints of recognizable form remain (plate 7). The development of nonobjective painting represents a further movement away from materiality and toward spirituality. Never an end in itself, abstraction is valued only insofar as it *expresses* spiritual reality. In "On the Question of Form," Kandinsky argues,

> In order to "understand" this kind of painting [i.e., abstraction], the same kind of liberation is necessary as in realism. That is, here also it must become possible to hear the whole world as it is without representational interpretation. Here these abstracting or abstract forms (lines, planes, dots, etc.) are not important in themselves, but only their inner sound, their life. As in realism, the object itself or its outer shell is not important, only its inner sound, its life.
>
> *The "representational" reduced to a minimum must in abstraction be regarded as the most intensely effective reality.* [29]

It is important to stress that nonobjective painting *is not* necessarily non-representational. In Kandinsky's carefully coded art, abstract form and color no longer refer to identifiable objects in the world but do represent definite thoughts, feelings, and emotions. When interpreted through Leadbeater's and Besant's color chart, the brilliant colors of *Black Lines No. 189* become spiritually significant. Green denotes "the divine power of sympathy"; crimson suggests "affection"; pink refers to "unselfish love"; yellow signifies "intellectual gratification"; and blue indicates "genuine religious feeling," which leads to the realization of "the universal brotherhood of humanity." The symphony these colors create is supposed to echo the harmony of the divine cosmos. Works like *Paradise, Improvisation 27 (Garden of Love),* and *Light Painting,* which were completed between 1911 and 1913, illustrate Kandinsky's use of Theosophical color theory to represent visions of idyllic life. In all of these paintings, forms and color serve a "higher reality." "We should never make a god out of form," Kandinsky insists. "We should struggle for form only as long as it serves as a means of expression for the inner sound. Therefore we should not look for salvation in *one* form only." [30]

The outbreak of World War I brought a change in Kandinsky's circumstances that had a significant impact on his artistic style. In August 1914 Kandinsky was forced to leave Germany after sixteen extremely productive years. In 1915 he returned to Russia, where he remained for six years. There he discovered that millenarian fervor had to be transferred from the religious to the political domain. To many it seemed that the kingdom of

harmony and equality that had long been promoted by spiritual visionaries was about to become a social reality. During the early years of the Russian Revolution, political leaders supported the avant-garde and sponsored the restructuring of artistic and cultural institutions. As if following Schiller's prescription for the realization of the aesthetic state, artists, activists, and politicians joined in a struggle to realize their common utopian dream. Kandinsky was among the leading artists called upon to participate in these revolutionary sociocultural changes. In 1918 at the request of Vladimir Tatlin, Kandinsky joined the Visual Arts Section of the People's Commissariat for Enlightenment. This organization was responsible for education and research programs in the museums and publications in the arts. Kandinsky also taught a studio course and directed theater and film for the commissariat. The most significant contribution that Kandinsky made during these years was the establishment of the Moscow Institute of Artistic Culture, where members of the avant-garde met regularly to conduct research and discuss theoretical questions. The program of the institute reflected the position that Kandinsky outlines in his two major theoretical treatises, *Concerning the Spiritual in Art* and *Point and Line to Plane.* [31]

Less than a year after the creation of the research institute, the avant-garde became internally divided, and the ideological tide began to shift against Kandinsky's artistic style. Tatlin and Alexander Rodchenko became increasingly hostile toward abstract art and promoted a utilitarianism in which the artist becomes an engineer and technician who transforms "art into life." The $5 \times 5 = 25$ exhibition of 1921 provided the occasion for Rodchenko to issue art's death notice: "Art is dead! . . . Art is as dangerous as religion as an escapist activity. . . . Let us cease our speculative activity [i.e., painting pictures] and take over the healthy bases of art—color, line, materials and forms—into the field of reality, of practical construction." [32]

Rodchenko's notice signaled that it was time for Kandinsky to move again. Disenchanted with the course of the Revolution in Russia, Kandinsky returned to Germany, where utopian hopes had been reborn in the very place they had originated in the 1790s. The German Revolution of 1918 led to the establishment of the Weimar Republic. In the spring of 1919, the newly empowered Social Democrats established the Bauhaus in Weimar, where an effort was made to revive many of the original ideals of Weimar *Kultur.* Still enjoying the reputation he had established for his prewar contributions, Kandinsky was welcomed as one of the most prominent members of the Bauhaus.

The impact that Kandinsky's experiences in Russia had on his work did not become fully evident until the Bauhaus years. The most notable change between the pre- and postwar paintings is a shift from biomorphic to geometric form. Influenced by the constructivism of Rodchenko, El Lissitzky, and László Moholy-Nagy and the suprematism of Malevich, Kandinsky began to experiment with more sharply delineated forms. The

culmination of these efforts is *Composition 8,* which Kandinsky regarded "as the highpoint of his postwar achievement" (plate 8). This work presents colors reminiscent of his earlier paintings in forms that have become much more sharply defined.

The increased formalism of Kandinsky's postwar work did not involve a lessening of his spiritual concerns. To the contrary, he attempted to refine the spiritual dimension of his art by developing a theory of form to supplement Leadbeater's and Besant's theory of color. In so doing, Kandinsky formulated a grammar of art in which syntax dictates meaning. Within this formal syntax, the foundational structure is binary opposition. The fundamental polarity in this structure is represented by the circle and triangle, whose interrelation is governed by what Kandinsky describes as "the mysterious law of pulsation." Within this play of opposites, the triangle stands for more active and aggressive feelings, and the circle suggests interiorization and spiritual depth. The third originary form, the square, represents peace and calm. In a letter to his contemporary biographer, Will Grohmann, Kandinsky explains his reason for giving the circle primary significance in his art: "The circle is the synthesis of the greatest oppositions. It combines the concentric and the eccentric in a single form, and in equilibrium. Of the three primary forms, it points most clearly to the fourth dimension." [33] When the union of opposites is consummated, the circle collapses into a point that is an *Indifferenzpunkt.* In this point, the invisible becomes visible. "The geometric point is an invisible thing. Therefore it must be defined as an incorporeal thing. Considered in terms of substance, it equals zero. . . . Thus we look upon the geometric point as the ultimate and most singular *union of silence and speech.*" [34] In the synesthesia of Kandinsky's aesthetic, the union of silence and speech is the synthesis of form and formlessness. The dilemma that Kandinsky can never solve is how to figure the unfigurable.

During the years when Kandinsky was developing the principles and practices of nonobjective art, a fellow Theosophist was wrestling with similar spiritual questions and artistic puzzles in the Netherlands. In the opening decades of this century, Piet Mondrian developed neoplasticism, an artistic style that exerted considerable influence on painting and architecture. While Kandinsky's spiritual vision was the product of his unique synthesis of Russian Orthodoxy, philosophical idealism, and Theosophy, Mondrian combined idealistic philosophy and Theosophy with his native Calvinist Protestantism to create his own theoesthetic. Unlike Kandinsky, Mondrian actually joined the Theosophical Society on May 25, 1909. Blavatsky's photograph hung in his studio, and he is reported always to have had the books of Steiner and Krishnamurti by his side. One source that was important for Mondrian, but not for Kandinsky, was the work of the Theosophical mathematician M. H. J. Schoenmaekers. Deeply impressed by his extensive conversations with Schoenmaekers in 1915–16, Mondrian borrowed the name for his artistic style (i.e., neoplasticism) from Schoenmaekers's book *Plastic Mathematics,* published in 1916. In this

work, Schoenmaekers presents mathematical equations that are purported to formalize the structure of the cosmos in terms of basic contraries and oppositions. Mondrian believed that these calculations, as well as modern scientific developments, confirmed Blavatsky's vision of the world.

> There are two paths leading to the Spiritual; the path of learning, of direct exercises (meditation, etc.) and the slow path of evolution. The latter manifests itself in art. One may observe in art the slow growth towards the Spiritual, while those who produce it remain unaware of it. The conscious path of learning usually leads to the corruption of art. Should these two paths coincide, that is to say that the creator has reached the stage of evolution where conscious, spiritual, direct activity is *possible,* then one has attained the ideal art.[35]

Ideal "art advances where religion once led."

Mondrian sought further support for his theoesthetic in earlier philosophical systems. As the above quotation indirectly implies, he believed that there are profound similarities between his artistic point of view and Hegel's philosophical position. Mondrian stressed that, for Hegel, art is a manifestation of spirit. In contrast to Kandinsky, for whom the apprehension of spirit was closely associated with feeling and emotion, Mondrian's Calvinist background left him suspicious of affective life. Following Hegel rather than Schleiermacher, he argues that spirit is essentially *rational.* Pure reason, which is articulated in the science of logic, constitutes the formal foundation of the world of appearances. "Long before the new was manifested determinately in life and in art," Mondrian maintains, "the logic of philosophy had clearly stated an ancient truth: *being is manifested or known only by its opposite.*"

> This implies that *the visible, the natural concrete, is not known through visible nature, but through its opposite. For modern consciousness, this means that visible reality can be expressed only by abstract-real plastic.*
>
> It does not seem very *modern* to illuminate the rationality of a new truth by citing an ancient one, but it only seems so, for new truth is nothing other than a new *manifestation* of universal truth, which is immutable.
>
> This truth, *true* throughout the ages, was already diversely formulated in ancient times. One of the best formulations perfectly defines *the true meaning of art: opposites are best known through their opposites. We all know that nothing in the world can be conceived in or by itself; but that everything is judged by comparison with its opposite* (Philo of Alexandria; Bolland, *Pure Reason*).
>
> Only in our time—with maturing and growing equilibrium between the inward and the outward, the spiritual and the natural—has the artist come to recognize consciously this ancient truth already reemphasized by logical thought (Hegel). The artist came to this awareness *through the way of art, an outward way.*
>
> Art—as one of the manifestations of truth—has always expressed the truth of opposites; but only today has art realized this truth in its *creation.* The division between the old and new painting becomes apparent as soon as we see that naturalistic painting manifested *this truth in a veiled and disequilibrated way,* whereas the new plastic *expresses it determinately and in equilibrium.* [36]

For Mondrian, as for Hegel, Kandinsky, and Schoenmaekers, the structure of spirit is thoroughly dialectical. Every particular entity is constituted by its internal relation to its own opposite. In Mondrian's terms, "all relations are dominated by a single primordial relation, which is defined by the opposition of two extremes." This primordial relation or universal structure, which supports the play of differences, is the divine Logos. As art matures, representation gives way to abstraction in a process of disfiguration that increasingly unveils the Logos. When the artist becomes self-conscious, art becomes ideal. Sounding an utterly Hegelian note, Mondrian contends that ideal art cannot "appear before its proper time."

> If unity is contemplated in a precise and definite way, attention will be directed solely towards the universal, and as a consequence, the particular will disappear from art—as painting has already shown. For the universal cannot be expressed purely so long as the particular obstructs the path. Only when this is no longer the case can universal consciousness . . . which is the origin of all art, be rendered directly, giving birth to a purified art of expression.
>
> This, however, cannot appear before its proper time. For it is the spirit of the times that determines artistic expression, which, in turn, reflects the spirit of the times. (TMA, 323)

Mondrian is convinced that the early years of the twentieth century mark the birth of truly spiritual art.

In the course of developing neoplasticism, Mondrian recapitulated some of the major styles that led to abstract art. His earliest works reflect the influence of traditional Dutch landscape and still-life paintings. As his style becomes more venturesome, it is possible to catch glimpses of previous modern masters. In works like *Canal in the Schinkel Area of Amsterdam* (1898) and *Upright Sunflower* (1908), traces of Van Gogh appear; the symmetrical fruit and dishes in *Still Life with Apples and Plate* (1901) recall Cézanne's geometric fruit; and *Church at Zoutelande* (1909) echoes Monet's impressionistic cathedrals. By 1910–11, Mondrian's canvases were growing more and more abstract. A suggestive self-portrait painted in 1908 marks an important point of transition. Mondrian's self-representation is remarkably Christlike. The piercing eyes of this frontal image render the work darkly mysterious. As one examines the painting carefully, the formal structures that pattern Mondrian's mature work slowly emerge. The oval eyes are surrounded by incipient right angles, formed by the eyebrows and nose, which barely hint at the figure of the cross.

Mondrian's progressive movement toward abstraction can be charted in a series of land- and seascapes that begins with works reminiscent of nineteenth-century romanticism. For example, *Dune V* (1909–10) bears a striking resemblance to Friedrich's *Monk by the Sea* with one noteworthy exception: the solitary human figure has been completely erased. A crucial factor in the evolution of Mondrian's mature style was his encounter with cubism. After seeing the work of Braque and Picasso in an Amsterdam exhibition in 1911, Mondrian journeyed to Paris, where he enjoyed

extensive contact with the cubists. Shortly thereafter, his work displays the clear influence of Braque and Picasso.

Mondrian agreed with Kandinsky's belief that abstraction should never be an end in itself but should be used only in the service of spiritual values. "With the basic tools of Cubism," Michael Govan points out, Mondrian "dissolves the images of natural appearance—of the tree, of buildings, of sea and sky—into the binary marks of vertical and horizontal, not only in an effort to examine the universal code behind the external signifiers of the natural, secular, and religious, but also to equate and relate such representations to the *internal human medium* of insight and to the transformation of understanding toward the universal."[37] The universal, as I have noted, is the divine Logos, whose structure is formed by the dialectical relationship of binary opposites. *The Sea* illustrates the way in which Mondrian appropriates cubist abstraction to express Christian Theosophy (fig. 3.11). The two forms that dominate the painting are the cross and the oval. In addition to its standard Christian meaning, Theosophy views the cross as a prefiguration of the foundational structure of the cosmos. Describing the mystical significance of the cross, Schoenmaekers writes,

3.11 Piet Mondrian, *The Sea* (1914). Charcoal and gouache on wood-pulp wove paper, glued to homosote panel, 35½ × 48⅜ in. Peggy Guggenheim Collection, Venice; Solomon R. Guggenheim Foundation, New York, VAGA, New York, 1991. Photograph: Robert E. Mates.

> The cross is above everything else a construction of nature's reality, vaguely suspected for some time, and finally become visible. . . . The more he will meditate about the construction of the cross, the more exactly the mystic will see reality as a created fact. . . . The body is fundamentally visible as a figurative realization of the intersection of the [vertical] ray and [horizontal] line. . . . The figure, which objectivizes the conception of a pair of absolute entities of the first order, is that of absolute rectangular construction: the cross. It is the figure that represents ray-and-line, reduced to the first order.[38]

The oval outlines the cosmic egg from which the entire universe evolves. The universal Logos is embodied in the natural world as the play of the sexes. According to Mondrian's Theosophic iconography, horizontal lines refer to the female principle and vertical lines to the male principle, both of which emerge from undifferentiated unity. In *The Secret Doctrine*, Blavatsky stresses the universal significance of the egg.

> In their primitive characters these two [i.e., Logos-Soul and Logos-Creator] were the first Cosmic Duad, *Nut*, "space or *Sky*," and *Nu*, "the primordial Waters," the Androgyne Unity, above whom was the *Concealed* BREATH of Kneph. . . . The *immutably* Infinite and the *absolutely* Boundless can neither will, think, nor act. To do this it has to become finite, and *it* does so, by its ray penetrating into the mundane egg infinite space—and emanating from it as a finite god. All this is left to the ray latent in the one. When the period arrives, the absolute will expand naturally the force within it, according to the Law of which it is the inner and ultimate Essence. The Hebrews did not adopt the egg as a symbol, but they substituted for it the "Duplex heavens," for, translated correctly, the sentence: "God made the heavens and earth" would read: "In and out of his own essence as a womb [the mundane egg], God created the two heavens."[39]

As Mondrian unfolded the structural principles of his religious vision, his canvases became ever more austere.

In Mondrian's mature work, Calvinism tempers Theosophy to create an ascetic aesthetic. Abstraction becomes dematerialization in which figurative signifiers are elided to reveal the transcendental signified. In contrast to Hegel, for whom the universal principle underlying all reality is concrete, Mondrian depicts an abstract universal that transcends individuality and materiality. The end result of this process of abstraction is a style characterized by a palette limited to black, white, and the three primary colors and forms that are strictly rectilinear. Mondrian's comment in "Natural Reality and Abstract Reality" is, in effect, a gloss on a signature canvas like *Composition with Red, Blue, and Yellow* (plate 9).

> New plasticism is pure painting: the means of expression still are form and color, though these are completely interiorized; the straight line and flat color remain purely pictorial means of expression.
>
> Although each art uses its own means of expression, all of them, as a result of the progressive cultivation of the mind, tend to represent balanced relations with ever greater exactness. The balanced relation is the purest representation of universality, of harmony and unity which are inherent characteristics of the mind. (TMA, 322)

Mondrian's interpretation of the emergence of universal self-consciousness through the work of art follows the traditional tripartite movement from unity, through division, to reunification, which we have already discovered in romantic theologians, philosophers, and artists as well as in Theosophy and Kandinsky's art. With the emergence of individual consciousness, humankind loses its original "harmony with nature's rhythm" and is plagued by conflict, opposition, and disharmony. The only way for this conflict to be overcome is for individuality to give way to universality. "If today individual consciousness is maturing," Mondrian argues, "then the lost harmony can be rediscovered, for, no longer obstructed by individuality, the *universal (in nature)* can exist *universally—independently, and perceptible* to man. Abstract-real painting gives us an image of this regained harmony."[40]

The harmony that Mondrian sought is social as well as personal. "Plastic vision," he argues, "implies action. . . . The pure plastic vision should set up a new society . . . a society composed of balanced relationships" (E, 40). Artists are charged with the responsibility of leading humankind into this brave new world. Mondrian's belief in the necessity of translating theoesthetic vision into social reality led to his involvement with the architects, designers, and social planners in the de Stijl group. Mystics and militants joined in the struggle to bring together art and technology to create a rational society in which universal values might flourish.

*Composition 1-A* effectively captures the vision of art that moves beyond the canvas to encompass the world (fig. 3.1). Here Mondrian tilts his classic square on end to form a lozenge. Within the white diamond, he paints his typical black square. In this case, however, the square overflows the canvas. The black lines run beyond the border of the work and pass into the surrounding world, thereby creating the sense that the structure represented is not limited to *l'oeuvre d'art*. The two forms that survive Mondrian's abstraction are the square and the triangle, which not only recall Kandinsky's late work but also are the symbols for eternal unity in Blavatsky's cosmic calculus.

But is Mondrian's work successful? The balance and harmony for which he longed forever eluded him. Seeking the reconciliation of opposites, he consistently privileged universality and spirituality at the expense of individuality and materiality. Mondrian never wavered in his belief that "the universal cannot be expressed purely so long as the particular obstructs the path." In this ascetic aesthetic, artistic practice becomes a ritual of purification. When these aesthetic principles become guidelines for social and political action, the sinister side of the strategy of abstraction appears. The individual, it seems, must be sacrificed to the larger totality. Instead of confronting the darkness that shadows the bright colors and pure forms of his art, Mondrian fled to America.

To follow Mondrian from Europe to America, we must take a detour through Russia. Kazimir Malevich prepared the way for postwar abstract

expressionism by extending the process of abstraction beyond the point reached by the cubists, Kandinsky, and Mondrian. Mondrian's christo-Theosophic cross returns in Malevich's work, but there are significant differences. In place of clearly delineated forms and rectilinear angles, Malevich's cross is fuzzy, its angles irregular. In *Suprematist Composition Conveying the Feeling of a Mystic "Wave" from Outer Space*, the floating figure seems to represent the outline of an airplane as much as a religious icon (fig. 3.12). These changes are symptomatic of Malevich's reworking of modernist beliefs and conventions. While sharing a commitment to Theosophy and Russian Orthodoxy, Malevich was also deeply impressed by the futurist program. The First Futurist Manifesto, published in *Le Figaro* in 1900, boldly declares, "We intend to sing the love of danger, the habit of energy and fearlessness. Courage, audacity and revolt will be essential ingredients of our poetry. We affirm that the world's magnificence has been enriched by a new beauty; the beauty of speed" (SN, 43). The fascination with speed was created by the extraordinary technological advances at the turn of the century. As we have seen, the cubists recognized in these changes the possibility of actually realizing the idealistic dream of a universal society and culture. Airplanes and the wireless seemed to draw the world together into a seamless web.

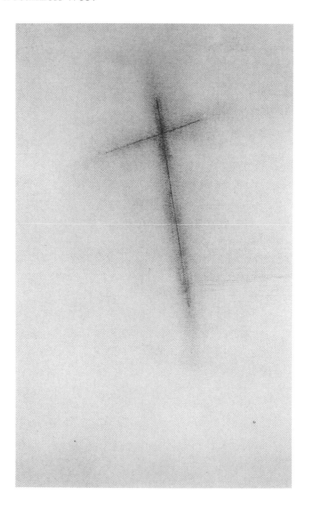

**3.12 Kasimir Malevich,** *Suprematist Composition Conveying the Feeling of a Mystic "Wave" from Outer Space* **(1917).**

Speed quickly became a symbol not only of technical accomplishment but also of humankind's spiritual potential. Ever-increasing rates of speed created the hope of transcending the ordinary experience of space and time and achieving the apprehension of simultaneity. "The aspiration of simultanism is to grasp the moment in its total significance or, more ambitiously, to manufacture a moment which surpasses our usual perception of time and space."[41] In 1912 Henri-Martin Barzun founded a journal in which he published artworks devoted to the development of a theory of simultaneity. Barzun composed a poem praising the unification of the world established by wireless waves emanating from the Eiffel Tower:

> I radiate, invisible, from the summit of the Tower
> Fluid carrying the hope of ships in distress
> Enveloping the earth with my waves
> Proclaiming the Word, the Time of the world.[42]

Apollinaire, who attempted to embody the theory of simultaneity in some of his most experimental poetry, discerned the anticipation of this new experience of space in cubism: "The new painters do not propose, any more than did their predecessors, to be geometers. But it may be said that geometry is to the plastic arts what grammar is to the art of the writer. Today, scientists no longer limit themselves to the three dimensions of Euclid. The painters have been led quite naturally, one might say by intuition, to preoccupy themselves with the new possibilities of spatial measurement, which in the language of the modern studios, are designated by the term: *the fourth dimension*" (TMA, 223). Though neither Braque nor Picasso was particularly interested in non-Euclidean geometry, Maurice Prince, a mathematician who frequented the famed Bateau Lavoir, speculated on the relationship between cubism and the fourth dimension.

The fourth dimension, or, in Linda Henderson's suggestive term, "hyperspace philosophy," can be traced to the late-nineteenth-century writings of the Englishman Charles Howard Hinton.[43] In 1904, one year before Einstein proposed his special relativity theory, Hinton published *The Fourth Dimension*, in which he uses images of brightly colored cubes to evoke a mode of awareness that is not limited to three dimensions. Hinton's association of the fourth dimension with time cleared the way for artists to synthesize geometric speculation and the futurist's exaltation of speed. As speed increases, spatial perception is transformed so as to create the possibility of intuiting infinity.

The spiritual significance of the fourth dimension is most fully developed by the Russian mystic P. D. Ouspensky. A follower of Blavatsky, Ouspensky wrote two books that proved very important for prerevolutionary Russian art: *The Fourth Dimension: A Study of an Unfathomable Realm* (1909), and *Tertium Organum: A Key to the Enigmas of the World* (1911). Combining ideas from thinkers as diverse as Kant, Blavatsky, and Eastern mystics, Ouspensky elaborates a theory of evolution in which human consciousness progressively moves toward infinite awareness.

There is in existence an idea which a man should always call to mind when too much subjugated by the illusions of the reality of the *unreal,* visible world in which everything has a beginning and an end. It is the idea of infinity, the fact of infinity. . . . Let us imagine for a moment that a man begins to feel infinity in everything: every thought, every idea leads him to the realization of infinity.

This will inevitably happen to a man approaching an understanding of a higher order of reality.

But what will he feel under such circumstances?

He will sense a precipice, an abyss everywhere, no matter where he looks; and experience indeed an incredible horror, fear, and sadness, until this fear and sadness shall transform themselves into the joy of sensing a new reality. . . .

This sense of the infinite is the first and most terrible trial before initiation. Nothing exists! A little miserable soul feels itself suspended in an infinite void. Then even this void disappears! Nothing exists. There is only infinity.[44]

Into this infinite void, Malevich ventures.

Malevich's approach to the fourth dimension was gradual, however. His chart depicting the development of modern art, beginning with Cézanne, effectively summarizes Malevich's own aesthetic education (fig. 3.13). Having started with cubo-futurist works that are influenced by Braque, Picasso, and Fernand Léger, Malevich eventually developed his own style, which he labeled suprematism. El Lissitzky underscores the religious and political genealogy of suprematism when he concludes his 1920 essay, "Suprematism in World Reconstruction," "AFTER THE OLD TESTAMENT THERE CAME THE NEW—AFTER THE NEW THE COMMUNIST—AND AFTER THE COMMUNIST THERE FOLLOWS FINALLY THE TESTAMENT OF SUPREMATISM."[45] Malevich distinguishes two basic types of creation: "one, initiated by the conscious mind, serves practical life, so-called, and deals with concrete visual phenomena; the other, stemming from the subconscious or superconscious mind, stands apart from all 'practical' utility and treats abstract visual phenomena" (NO, 11). The primary aim of suprematist art is to provide the occasion for the latter form of awareness in the viewer. The experience of the "ineffable" enables one to overcome the oppositions that plague the world of appearance. "A real work of art," Malevich maintains, "can never be disharmonious because the artist's very purpose is to transform the discord of ostensible reality—the cacophonous din of our surroundings—into a true artistic harmony" (NO, 38–39). In contrast to the *rational* unity of Mondrian's mature work, Malevich searched for a harmony that surpasses consciousness and thus must be experienced affectively rather than cognitively. In this quest, he turned for guidance to the poetry of Alexei Kruchenikh, with whom he collaborated to produce the opera *Victory over the Sun* in 1913. Adapting the samadhi state of awareness described in Swami Vivekenanda's version of the Advaita school of Vedantic philosophy, Kruchenikh developed what he describes as "*zaum* language." Through linguistic innovation, *zaum* is supposed to create altered states of consciousness that transport one "beyond reason and

КРИВАЯ СЕЗАННА      СЕРПОВИДНАЯ КРИВАЯ КУБИЗМА      СУПРЕМАТИЧЕСКАЯ ПРЯМАЯ МАЛЕВИЧА

**3.13 Kasimir Malevich,**
*Analystic Investigation of*
*Form Development in the*
*Pictorial Cultures of Cezanne,*
*Cubism, and Suprematism.*

logic." Though never explicitly claiming to do so, Malevich actually attempted to paint what Kruchenikh tried to write.

Since the awareness of the infinite is sub- or superconscious, it cannot be represented figuratively but must be presented nonobjectively. Many of Malevich's suprematist paintings employ basic forms and primary colors that are reminiscent of Kandinsky and Mondrian. Malevich's original use of diagonals, however, creates a sense of dynamism and vitality that is notably lacking in the work of his predecessors (plate 10). The energy

generated by these lines suggests speed that is capable of transforming the temporal succession characteristic of three dimensions into the simultaneity of the fourth dimension. Past, present, and future fuse to form the "Eternal Now" described by Ouspensky: "A feeling of four-dimensional space. A new sense of time. The live universe. Cosmic consciousness. Reality of the infinite. A feeling of community with everyone. The unity of everything. The sensation of world harmony. A new morality. The birth of a superman." [46] For Ouspensky and Malevich, cosmic consciousness is, paradoxically, an unconscious state in which differences collapse into identity. This original *Indifferenzpunkt* can be figured, if at all, only in the void of an empty canvas.

In 1915, at the 0.10 exhibition in Petrograd, Malevich hung a work entitled *Black Square* in the upper corner of the room that traditionally is reserved for the religious icon in the homes of Russian Orthodox believers. There were precedents for attributing religious significance to a simple black square. In *Utriusque Cosmi,* published in 1617, Robert Fludd presented a black monochrome surrounded on four sides by the phrase *Et sic in infinitum.* For Malevich, the *Black Square* embodies the pure *feeling* of nonobjectivity. Looking back on his attempt to step beyond the world of objective appearance, Malevich describes the anxieties he suffered.

> Even I was gripped by a kind of timidity bordering on fear when it came to leaving "the world of will and idea," in which I had lived and worked and in the reality of which I had believed.
> But a blissful sense of liberating non-objectivity drew me forth into the "desert," where nothing is real except feeling . . . and so feeling became the substance of my life.
> This was no "empty space" which I had exhibited but rather the feeling of non-objectivity. (NO, 68)

But even the emptiness of the black canvas does not mark the end of Malevich's pursuit of the abstract. Beyond the dark "desert" lies a more profound void. "The black square on the white field," Malevich explains, "was the first form in which non-objective feeling came to be expressed. The square = feeling, the white field = the void beyond this feeling" (NO, 76). From 1917 to 1918 Malevich attempted to enter this void in his "White on White" series. In these works, even primary colors disappear. All that remains is the opaque transparency of pure form and the purity of whiteness. With *White Square on a White Background* (1918), suprematism reached its outer limit.

Two years after completing *White Square on a White Background,* Malevich wrote a remarkable essay entitled "God Is Not Cast Down," in which he explains the religious significance of his spiritual journey. "It turned out," Malevich concludes, "that nothingness was God. . . . God exists as 'nothingness,' as non-objectivity" (EA, 222). With a magical flick of the artist's brush, emptiness is transformed into fullness, and absence into presence. According to Malevich, three ways lead to the "Promised Land" of divine nonobjectivity: "religion, science or factory, and art." The

sojourner along each of these paths confidently declares, "I shall build the kingdom of heaven on earth and not in heaven—therefore I am God." The *telos* of the historical process is the union of the most radical opposites: the human and the divine. In Malevich's mystical vision, everything "strives towards God." At the end of this strife, man "will become God." Alpha and Omega become one as the Kingdom restores the harmony of the Garden. At this moment, the creature becomes the creator who, in Malevich's words, proclaims, "I am the beginning of everything, for in my consciousness worlds are created."

But a price must be paid for this reversal; through a dialectical inversion, self-realization becomes "self-annihilation." For Malevich, as for Mondrian, the affirmation of the universal presupposes the negation of the individual. Malevich freely admits that suprematism implies a certain nihilism. "In developing a non-objective idea," he writes, "we are attracting to ourselves a hail of stones; we will be called idealists, mystics, nihilists, utopians" (EA, 186–87). The stones were first hurled by Tatlin and Rodchenko, whose growing impatience was fueled by their desire for a socially productive art. Though Malevich attempted to defend himself by insisting on the social utility of suprematism, he never seemed convinced by his own arguments. He continued to harbor utopian hopes but was reluctant to absolutize any existing or anticipated political system. Contrary to expectation, Malevich ended by agreeing with Rodchenko. Having pushed abstraction to its logical conclusion, he seems to have exhausted art's possibilities. Anticipating Rodchenko's declaration of the death of art, Malevich wrote in 1920, "There can be no question of painting in Suprematism; painting was done for long ago, and the artist himself is a prejudice of the past" (EA, 127). From 1920 to 1927 Malevich literally and figuratively produced nothing. Again taking up his brush in the last years of his career, he resorted to reproducing presuprematist works and backdating them to 1903–10. Abstraction had come to an end.

*An* end but not *the* end. What died in Moscow was reborn several decades later in New York City. Instead of ceasing to paint or returning to a preabstract painterly style, one might attempt to figure the end of art by painting "the last painting." This is precisely the strategy adopted by Ad Reinhardt. From 1954 to 1967, Reinhardt painted a series of seemingly identical 5 × 5–foot "Black Paintings" that ostensibly repeat Malevich's *Black Square.* Though the political context and religious background of Reinhardt and Malevich's work are different, their spiritual concerns are remarkably similar. Both sought immediate union with the Real through a process of abstraction in which the removal of signifiers reveals the *presence* of the transcendental signified.

Postwar America might seem to be an unlikely place for the revival of the radical painting of prewar Europe and Russia. However, from 1935 to 1941, the New York intelligentsia underwent a "slow process of de-Marxization and later depoliticization."[47] While the reasons for this shift of interest were many and complex, one of the major contributing factors

was a deep-going disillusionment with Russia. Many members of the American political and cultural left had pinned their hopes for revolutionary change on Russia. The Moscow trials of 1938 combined with the 1939 Nazi-Russian nonaggression pact and the invasion of Finland to convince American intellectuals and artists that the Russian experiment had failed. Debates in and around the *Partisan Review* reflected the changes in the way artists and critics viewed the relationship between art and politics. Having started as the leading Marxist-Trotskyist journal, *Partisan Review* eventually came to represent the type of formalism that Clement Greenberg misleadingly identifies with modernism.

In addition to disenchantment with Russia, postwar America was also characterized by growing uncertainty about the benefits of modern technology. To survivors of two world wars, the early modernists' confidence in the capacity of technology to bring a better future seemed bitterly ironic. Furthermore, the emergence of totalitarianism on both ends of the political spectrum created suspicions about holistic structures and universal sociopolitical programs. These concerns were deepened by the arrival in New York City of many expatriated artists from Europe and Russia. The response of American artists to the influx of foreign talent was ambivalent. On the one hand, the Europeans and Russians brought with them artistic styles and techniques that were obviously invigorating; on the other hand, Americans were struggling to develop their own cultural and artistic identity and thus were reluctant to perpetuate their colonial status by simply following the lead of Europe.

Political disenchantment did not necessarily mean the disappearance of the preoccupations that had inspired early modern utopianism. No longer confident of the possibility of reforming sociopolitical structures, postwar American artists turned inward. The utopia for which they searched became inner and personal rather than outer and political. With this shift, they extended the spiritual probings of painters like Kandinsky, Mondrian, and Malevich without developing their political agendas. In making this move, artists who eventually were known as abstract expressionists were influenced by surrealism. European surrealists began arriving in New York in 1941. To many American artists struggling to find a way out of representationalism and social realism, the innovations of the surrealists opened a world of new possibilities. The ends of the abstract expressionists, however, differed significantly from their precursors. Whereas early modern Russian and European artists saw individuality as a problem to be overcome on the way to universality, the "New York school" resisted collectivism and cultivated individualism. And yet, paradoxically, the abstract expressionists finally negated what they attempted to affirm. The conclusions reached by European, Russian, and American abstract art do not differ significantly.

Nowhere is the inward turn of art more apparent than in the work of Ad Reinhardt. As if to comment on Malevich's *Black Square,* Reinhardt writes:

DARK

"Black," medium of the mind
. . . . . . . . . . . . . . . . . . . . . .
Leave temple images behind
Rise above beauty, beyond virtues, inscrutable, indescribable
Self-transcendence                           revealed yet unrevealed

Undifferentiated unity, oneness, no divisions, no multiplicity
No consciousness of anything
No consciousness of consciousness

All distinctions disappear in darkness
The darkness is the brilliance        numinous, resonance (AA, 90)

Raised a Lutheran, Reinhardt, like Mondrian, was deeply influenced by Protestant iconoclasm. But Reinhardt did share Mondrian's, Kandinsky's, and Malevich's interest in Theosophy. Through his lifelong friendship with Thomas Merton, Reinhardt developed a religious perspective that blends Eastern and Western mysticism to form what is, in effect, an artistic *via negativa*. Thus Reinhardt's work underscores the close connection between the esoteric religion and philosophy that are so important for early modernists and the Western theologico-philosophical tradition dating back to the Neoplatonists.

To claim that Reinhardt's mature art is an exercise in negative theology is not to impose alien theological categories on an aesthetic undertaking. Throughout the latter part of his career, Reinhardt insisted that his artistic purpose was "to retrieve the spiritual in a secular culture" (AA, 82). The goal of this project was what Meister Eckhart described as "the divine dark." Recapitulating Malevich's movement toward sacred darkness, Reinhardt's "mystical ascent" leads to a nothingness that he too identifies with God.

Mystical ascent    - separation from error, evil
                          -      "      from world of appearances,
                                          sense attractions
                          - "the divine dark"—"luminous
                                     darkness" (AA, 105)

The *telos* of the mystical quest is perfect oneness with "the divine dark." The method Reinhardt uses in his ascent is the process of negation. Reformulating Mies van der Rohe's well-known modernist dictum "Less is more," Reinhardt maintains that "less in art is not less. More in art is not more." To approach the less that is not less but more, it is necessary to effect a separation "from [the] world of appearances" by means of the activity of abstraction. In developing his method of negation, Reinhardt followed the lead of earlier artists for whom abstraction is negation. As we have discovered, abstraction removes every vestige of form and figuration in order to reach the formlessness of the unfigurable or unrepresentable. The erasure of form and figure is supposed to leave the trace of an original oneness. This oneness is lost with the emergence of form and the inscrip-

tion of figure. While the presence of form is the absence of oneness, the absence of form is the presence of oneness. To approach the One that is the *archē* and *telos* of the cosmic as well as the artistic process, it is necessary to negate negation through abstraction.

Reinhardt's use of abstraction as a method of negation repeats one of the most important strategies employed by early Greek philosophers in their search for the original One from which all emerges and to which everything longs to return. Developing insights advanced in Plato's *Parmenides,* Speusippus proposed a novel way of negation that he labeled *aphairesis,* or abstraction. Aphairesis was intended as an alternative to the well-established method of *apophasis.* [48] As the identification of the *via negativa* with apophatic theology suggests, apophasis is the form of negation used in traditional negative theology. Apophasis negates by stating an opposite. *X,* for example, is identified as not-*Y.* Such negation, however, remains somewhat indefinite, for it determines *X* only in relation to a specific entity or quality. Complete identification would require an infinite series of negations. Aphairesis, by contrast, negates by abstracting or subtracting particular qualities from an entity. The penultimate aim of aphairesis is the essence of the entity under consideration; its ultimate aim is the essential One that underlies the many that compose the phenomenal world.

In its early versions, aphairetic negation presupposed an interpretation of the creation of the cosmos through a prolonged process in which layers of reality gradually accumulate. From the time of the Pythagoreans, this creative process was interpreted in terms of mathematics and geometry. The primal One generates numbers, which in turn give rise to points, lines, planes, and eventually volumes. These geometric forms constitute the structural foundation of everything. Each additional layer is, in Pythagorean terms, a supplementary "prosthesis." As the ground of grounds, the One is the absolute origin from which later prostheses derive. Aphairesis reverses this creative process through the removal or stripping away of successive supplements. By progressing from the world of appearances to the realm of forms, and then proceeding from volume to plane to line to point, it is possible to approach the One. Since supplements corrupt the origin, they must be eliminated or at least seen through if the True or the Real is to be discovered. Aphairesis functions like a ritual purification that allows the initiate to draw near the purity of the origin. This origin is the "darkness" that mystics deem divine.

With this darkness, we return to the Black Paintings. Black, for Reinhardt, is the color of the absence of color.

"Black," *Absence of "Color," Colorlessness,* Darkness, *Lightness, "art of Painting"*
vs. Art of Color . . . " Painting is Black, Sculp. is White, Arch. is Color" . . .
"Blacked-out," non-color, Beyond color, shape, line
*Monochrome, monotone . . .*
*Negative* presence, "Darkness," "A getting rid of," "Blowing out"
*Dematerialization,* non-being. (AA, 95)

The absence of color is not, however, mere absence but is at the same time a hidden presence. This absence, which is embodied in black, is actually the result of the absence or total absorption of light. Black, in other words, issues from the *total presence* of light. Indirectly following Malevich, Reinhardt's black on black becomes white on white. When black is white, and white is black, we glimpse the point of indifference in which differences fall into primal identity.

This point of indifference recalls not only Schelling's *Indifferenzpunkt* but also the Parmenidean One for which mystics, theologians, and artists ceaselessly search. As the ground of being, this original One does not exist *sensu strictissimo*. Nor is it simply nonbeing. The One is "beyond being," though it lends being to whatever exists. Inasmuch as this One is the primal origin of everything, it remains implicated in the order of being. This ongoing involvement calls into question the difference between kataphatic theology and apophatic and aphairetic theology. Though apophasis and aphairesis reverse or invert the structure of kataphatic theology, they do not subvert the essential presuppositions of Western theoesthetics.

Reinhardt shared with his religious and artistic precursors the desire to be united with the Origin. If this union is to be consummated, the forms and figures that are the prosthetic supplements separating individuals from the origin must be removed. When abstraction is complete, union is achieved in the total darkness of the black canvas. In a revealing poem entitled simply "One," Reinhardt writes,

> "Formless thou art, and yet
> thou bringest forth many forms, and then
> withdrawest them to thyself."

> "Differentiating itself and yet remaining in itself undifferentiated."

> "By letting go, it all gets done
> the world is won by those who let go!
> But when you try and try
> the world is beyond winning."

> "in the beginning is the end," vice versa

> Ultimate diagram, free space, universal dimension
> Last word, to the end  "mania for totality"
> Triumph over time, death, oblivion "a fragrance of eternity"
> Totality, unity, finality  wordless essence (AA, 93)

The unrepresentable, Reinhardt believed, can be "represented" only in the absence of form and figure. This *absence* of form is the *presence* of divine formlessness. So understood, the end of abstraction truly is the beginning.

Totality . . . unity . . . finality. Though he tried, Reinhardt could not paint the last painting. More precisely, he could paint the last painting only by painting it again and again. As he painted and repainted, however, subtle changes began to emerge. At first glance, Reinhardt's Black Paintings appear to be uniformly colored. But closer inspection reveals differences that are all too easily overlooked. Reinhardt's canvases are not

precisely monochromatic. Rather, each surface is created by the subtle interplay of different hues. Shades of deep reds, browns, blues, and lavenders mingle to produce a darkness that fills the painted surface. When mixed on Reinhardt's palette, black is not merely the negation or absorption of colors. His Black Paintings are not simple but are richly complex. Moreover, as one contemplates the shades of difference on the canvas, shifting patterns begin to form and withdraw. Just as the Black Paintings are not really colorless, so too they are not utterly formless. In the shadows of the dark canvases, subtle geometric patterns can be dimly discerned. In several of the Black Paintings, a startling form emerges from the shades of darkness—it is the figure of a cross. Reinhardt in effect reinscribed Malevich's *Black Cross* on the *Black Suprematist Square.* Instead of being the last painting, the obscure lines of Reinhardt's dark vision create a space that beckons other artists. The question that remains is whether this is the space of resurrection or of crucifixion.

In a conversation with Thomas Hess held at the Guggenheim Museum on May 1, 1966, Barnett Newman commented on his fourteen-piece work entitled *The Stations of the Cross: Lema Sabachthani:* "I was trying to call attention to that part of the Passion which I have always felt was ignored and which has always affected me and that was the cry of *Lema Sabachthani,* which I don't think is a complaint, but which Jesus makes. . . . I felt that to the extent that Jesus was crucified and did physically say *Lema Sabachthani* in relation to that drama, that it was more appropriate for me to be concerned with the Sabachthani ( . . . forsaken me)."[49] Though using conventional titles for the paintings, Newman ignored the traditional meaning of the Stations of the Cross. He restricted his palette to an occasional use of white and a more extensive use of black, which, according to Newman, is the color of tragedy. Each of these abstract works, all of which are 78 × 60 inches, is composed of one or more vertical lines of varying widths on raw canvas. In some cases the lines, or "zips" as they are called, are sharply delineated, and in others they are fuzzy or even ragged. The cold austerity of Newman's works suggests the agony and despair of *Lema Sabachthani.* Following tradition, the series ends with *Fourteenth Station (Entombment)* (1965–66). But Newman does not leave his viewer hanging on Golgotha. As absence becomes presence for Malevich and Reinhardt, so death becomes life for Newman. Beyond *The Stations of the Cross* lies the remarkable work *Be II,* first exhibited under the title *Resurrection,* in which raw canvas is covered by a striking surface painted white and framed on the right by a slender black line and on the left by a border of bright cadmium red. This imageless image of the fullness of being expresses Newman's deepest desire.

From the beginning of his career, Newman insisted on the spiritual significance of art. In a letter to the *New York Times* dated June 7, 1943, Newman, Mark Rothko, and Adolph Gottlieb set out a five-point aesthetic program that concludes: "It is a widely accepted notion among painters that it does not matter what one paints as long as it is well painted. This

is the essence of academism. There is no such thing as a good painting about nothing. We assert that the subject is crucial and only that subject matter is valid which is tragic and timeless." Written in the midst of the suffering and devastation wrought by World War II, this statement under-scores the vacuity of art for art's sake and the futility of empty formalism. For Newman and his colleagues, art is not simply about art but is an expression of transcendent value.

The value that governs Newman's aesthetic is the *sublime*. As we have seen, Kant distinguishes the mathematical from the dynamic sublime. In both of its forms, the sublime is excessive. The dynamic sublime exceeds all form. The phenomenon that Kant cites to illustrate this excess is the overwhelming power of nature. "In what we are accustomed to call sub-lime in nature," Kant maintains, "there is such an absence of anything leading to particular objective principles and forms of nature correspond-ing to them that it is rather in its chaos or its wildest and most irregular desolation, provided size and might are perceived, that nature chiefly ex-cites us in the ideas of the sublime" (CJ, 40). Newman translated the Kan-tian dynamic sublime from nature to culture by reinscribing the power of formlessness in the sensation of paint as such. Though implicit in many of his works, the experience of the sublime is most forcefully presented in *Vir Heroicus Sublimis* (plate 11). This immense canvas (7 feet 11 3/8 inches × 17 feet 9 1/4 inches) is painted in a brilliant red, with five vertical stripes ranging in color from cream and white to shades of pink and crim-son. Newman intended his paintings to be viewed at close range. When one stares at *Vir Heroicus Sublimis* closely, the painting creates a halluci-natory effect in which it seems to engulf the viewer. The sense of direct participation in the redness of the work is enhanced by the absence of a frame. Like many other modern painters, Newman left his canvases un-framed. It is as though he wanted to remove the frame to allow viewer and painting to become one. To experience the perfect union of subject and object is to enjoy the sublime. In Newman's abstract art, "the Sub-lime is Now." In this Now, the presence of the present is re-presented on the nonrepresentational canvas. Newman explains the purpose behind his work:

> We are reasserting man's natural desire for the exalted, for a concern with our relationship to the absolute emotions. We do not need the obsolete props of an outmoded and antiquated legend. We are creating images whose reality is self-evident. . . . We are freeing ourselves of the impediments of memory, association, nostalgia, legend, myth, or what have you, that have been the devices of Western European painting. Instead of making *cathedrals* out of Christ, man, or "life," we are making it out of ourselves, out of our own feelings. The image we produce is the self-evident one of revelation, real and concrete, that can be understood by anyone who will look at it without the nostalgic glasses of history.[50]

As Kant points out, the experience of the sublime is never unambigu-ous but is "a negative pleasure" or even "a feeling of displeasure." The

displeasure of the sublime is a function of the emptiness, which, paradoxically, is at the heart of the feeling of fullness. This is the lesson of the last Station of the Cross. The experience of the formlessness that is plenitude involves loss as well as gain. Newman was, in Harold Rosenberg's telling phrase, "a theologian of nothingness" who attempted to "induce nothingness to exclaim its secrets."[51] This task, however, was more difficult than it first appeared. "Emptiness," Newman discovered, "is not that easy. The point is to produce it."

"The point is to produce it." This statement must be read in at least two ways. First, the goal of Newman's artistic enterprise was to produce the emptiness that is fullness. When Newman "seeks sublimity in the here and now," Jean-François Lyotard explains, "he breaks with the eloquence of romantic art but does not reject its fundamental task, that of bearing pictorial or otherwise expressive witness to the inexpressible. The inexpressible does not reside in an over there, in another work, or another time, but in this: that something happens. In the determination of pictorial art, the indeterminate, the 'it happens' is the paint, the picture. The paint, the picture as occurrence or event, is not expressible, and it is to this that it has to witness."[52] When "the 'it happens' is the paint, the picture," the work of art becomes something like a performative utterance that creates a state of affairs instead of referring to antecedent objects or conditions. In this way, painting is transformed into a technique for "*practicing* the sublime." Through this practice, the artist attempts to provide the occasion for "an experienced moment of totality." To reach such a moment, it is necessary to move beyond the point of abstraction achieved by Kandinsky and Mondrian. Newman observes, "I knew that if I conformed to the triangle, I would end up with a graphic design or *an ornamental image*. I had to transform the shape into *a new kind of totality*."[53] When the last trace of the signifying image is eliminated, the canvas becomes the signified thing—the thing itself that is both True and Real. The absolute identity of signifier and signified is *Onement*. But how is *Onement* to be produced?

"The point is to produce it." Second, the emptiness of plenitude and fullness of emptiness "appears" *in* the point *as* the point. In a manner similar to Reinhardt, Newman followed in the footsteps of aphairetic negative theology. Through the process of abstraction, Newman also moved from volume to plane to line to point. The will-to-abstraction is a will-to-purity, which, in turn, is a will-to-immediacy. The Being-Nothingness for which Newman longed can be experienced only in the immediacy of the present as the immediacy of presence. The point, which is both the end and the beginning, is the One that appears as *Onement I* (1948). At this point—in this point—the Christian iconography of *The Stations of the Cross* becomes indistinguishable from the Jewish Kabbalistic iconography of *Zim Zum I*. Both seem to declare, "Hear, O Israel, Adonai is our God, Adonai is One!" In Newman's last sculpture, *Zim Zum I*, two walls, each consisting of six steel panels set at right angles, are separated by an empty space (fig. 3.14).

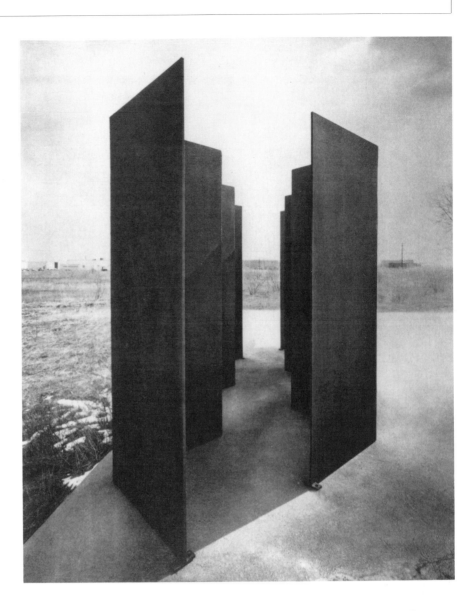

**3.14 Barnett Newman,** *Zim Zum I* **(1969). Cor-ten steel, 8 ft. × 15 ft. × 6 ft. 6 in. Collection Annalee Newman. Courtesy Annalee Newman.**

The void in the midst of these errant walls repeats the zip that rends Newman's canvases. The *Z's* formed by the zig-zagged walls recall the *Z's* of Zim Zum. As one enters the intermediate space of the between, the surrounding "world" seems simultaneously to expand and contract. This place, which is really no place, is *Makom.* "*Makom* is place. *Hamakom* is, literally, '*the* place.' It is also one of the secret names of God and one of the many poetic locutions which the Torah uses to avoid pronouncing His name or spelling out its letters. Thus Moses would not say: 'The Lord spoke to me . . . ' but 'The Place spoke to me.' "[54]

Citing the Kabbalah, the poet Edmond Jabès notes that "when god, *El,* wanted to reveal Himself, He appeared as a point" (EL, 3). But this revelation is also a concealment. In order to allow creation to appear, God, who once filled the entire universe, must withdraw—into a point. Thus the fullness of Being never arrives and Onement is never present. Indirectly admitting the absence of the One that brings unity, Newman paints

*Onement* not once but repeatedly: *Onement I, Onement II, Onement III, Onement IV,* . . . Unlike *The Stations of the Cross,* this series seems open-ended. The withdrawal of the One, which leads to the expansion of *Onement,* does not, however, destroy the hope for sublime unity. Anticipation not only lingers but explodes in the figure of *Dionysus* (plate 12). In the rich green of this painting, the vertical zips joining heaven and earth become horizontal lines, which, like Mondrian's incomplete square, stretch beyond the canvas to encompass the surrounding world. This Dionysian "image" suggests what Hegel describes as the "bacchanalian revel in which no member is sober."

As we have begun to suspect, however, there is a dark side to the modernist search for totality, unity, and immediacy. As Hölderlin maintains in *The Death of Empedocles,* the reason, clarity, and order of ancient Greece conceal an even more ancient irrationality, obscurity, and disorder. This terrifyingly ancient realm is the site of the birth of tragedy to which Dionysus transports his followers. Developing Hölderlin's insights, Nietzsche argues in *The Birth of Tragedy* that Dionysus, god of wine and mystic ecstasy, cannot be understood apart from Apollo. Apollo, god of the sun, music, and poetry is, for Nietzsche, the "god of individuation and just boundaries." He is "the marvelous image of the *principium individuationis*" who embodies the "freedom from all extravagant urges" and the "moral" demands of "self-control." Dionysus, by contrast, incarnates "the shattering of the *principium individuationis*" in an ecstasy "whose closest analogy is furnished by physical intoxication" (BT, 21, 22, 34). It would be a mistake, however, to conclude that Apollo and Dionysus are only opposite. Like Freud's ego and id, they are inextricably interrelated. As "the interpreter of dreams," Apollo represents a form of consciousness that is "but a thin veil hiding . . . the whole Dionysiac realm." Neither Apollo nor Dionysus can exist without the other. Apollo derives energy from Dionysus, and Dionysus requires the guise of Apollo to appear. The perfect unity of Apollo and Dionysus is staged in Attic tragedy.

The question that Nietzsche poses in *The Birth of Tragedy* is, in Heidegger's terms, "the origin of the work of art." In responding to this question, Nietzsche develops a genealogy of Greek tragedy. Following suggestions initially advanced by Schiller, Nietzsche argues that the origin of tragedy can be traced to the satyr chorus.

> The satyr was man's true prototype, an expression of his highest and strongest aspirations. He was an enthusiastic reveler, filled with transport by the approach of the god; a compassionate companion reenacting the sufferings of the god; a prophet of wisdom born out of nature's womb; a symbol of the sexual omnipotence of nature. . . . Here archetypal man was cleansed of the illusion of culture, and what revealed itself was authentic man, the bearded satyr jubilantly greeting his god. (BT, 51–52)

To greet the god is to identify with Dionysus, and to identify with Dionysus is to return to the creative-destructive origin from which all arises and to which everything returns. This is the primal origin figured in New-

man's *Day before One* (1951), where, in Nietzsche's terms, "not only does the bond between man and man come to be forged once more by the magic of the Dionysiac rite, but nature itself, long alienated or subjugated, rises again to celebrate the reconciliation with her prodigal son. . . . Now that the gospel of universal harmony is sounded, each individual becomes not only reconciled to his fellow but actually one with him—as though the veil of Maya had been torn apart and there remained only shreds floating before the vision of mystical Oneness" (BT, 23).

The "original Oneness," which Nietzsche also describes as "the primordial One," is "the ground of Being." This ground is not inert but is the dynamic essence of "the True Subject" that expresses itself in and through all reality. Though omnipresent, this essence remains obscure; it is a dark "chthonic realm" that can never be completely illuminated. In one of his summaries of the difference between Apollo and Dionysus, Nietzsche invokes a particularly revealing image of the primordial One: "Apollo embodies the transcendent genius of the *principium individuationis;* through him alone it is possible to achieve redemption in illusion. The mystical jubilation of Dionysus, on the other hand, breaks the spell of individuation and opens a path to the maternal womb of being" (BT, 97). The Dionysian identifies with the original, primordial One, ground of Being, True Subject, chthonic realm, maternal womb, or Original Mother in which desire and dread meet. When Alpha and Omega coincide, womb becomes tomb. Though joyful, ecstasy is also terrifyingly painful. To be united with the primordial One is to endure "the truly Dionysian suffering of dismemberment." The followers of Dionysus undergo a process of "de-individuation" or "un-selving" that leads to what Mark Rothko defines as the goal of his art: "I don't express myself in my painting. I express my not-self." This "not-self" is the subject of tragedy, and tragedy, according to Rothko, is the only subject worthy of art.

With the work of Mark Rothko, our examination of modern painting comes full circle. Born in Russian-occupied Dvinsk in 1903, Marcus Rothkovitch received a rigorous religious education from an early age. Although his family was Jewish, Rothko, like Kandinsky, was deeply influenced by Russian Orthodoxy. Rothko's interest in Christian issues is evident in an early series of works devoted to the themes of crucifixion and resurrection. By the time he reached maturity, quasi-representational forms disappear, but spiritual concerns persist.[55] The dark hues of Malevich and of Reinhardt's Black Paintings return, and the horizontal lines of Newman's *Dionysus* reappear in Rothko's work. Echoing Malevich's declaration, "I am the beginning of everything," Rothko claims that his aim is to "see objects and events as though for the first time, free from the accretions of habit and divorced from the conventions of a thousand years of painting."[56]

Rothko's transition from figurative to nonfigurative painting was mediated by the influence of surrealism. Through the surrealists' probing of the unconsciousness, Rothko discovered primitive myths, which, he be-

lieved, are universal. The essence of the myths that humankind has developed throughout the centuries is "the tragic-religious drama." This mythic theme forms the substance of Rothko's art. He repeatedly insists that "the exhilarated tragic experience . . . for me is the only source book for art." To pursue the tragic is to venture "into unknown lands which can be traversed only by those who are willing to take the risks."

The risk that tragic art involves is the rupture of the *principium individuationis*. In the early 1950s, Rothko confidently declared, "I have created a new type of unity; a new method of achieving unity." "My own work has a unity like nothing—(I do not mind saying even if I appear immodest)—the world has ever seen." [57] Having arrived at his "new method" by 1949, Rothko devoted the remainder of his career to creating works fashioned by superimposing horizontal rectangles on a monochromatic background. Though reminiscent of earlier abstract art, Rothko's signature paintings differ significantly from the works of artists like Kandinsky, Mondrian, Malevich, Reinhardt, and, to a lesser degree, Newman. In place of clearly defined and sharply delineated geometrical structures, Rothko presented obscure, blurred forms that seem to hover mysteriously above the surface of the canvas. Rothko's self-confidence notwithstanding, there is a hesitancy or uncertainty about these works that is notably lacking in other nonrepresentational art. Rothko was explicitly concerned with the interplay of disclosure and concealment that Newman's works merely imply. The layered effect of the enigmatic painted surface suggests a play of veils in which every revelation is a reveilation. Rothko struggled to capture something that appears by withdrawing and must withdraw in order to appear.

As the years passed, the uncertainty grew. Between 1954 and 1956 there was a decided shift in Rothko's palette. The bright reds, yellows, oranges, greens, and blues gave way to somber wines, browns, grays, and blacks. By 1970, the gaiety of Nietzsche's "joyous affirmation" disappeared in the play of *Black and Grey* (plate 13). In his penultimate project, the Houston chapel, the darkness became overwhelming as the tragic drama approached its final act (fig. 3.15). Recasting Malevich's *Black Square* and Reinhardt's Black Paintings, Rothko created a series of fourteen works that repeat in more ominous tones Newman's *The Stations of the Cross*. This series is placed in an octagonal structure that is modeled after the Russian Orthodox churches that were so important for Kandinsky and other members of the early avant-garde. Sacred or secular . . . presence or absence . . . fullness or emptiness . . . satisfaction or deferral? It remains uncertain. Nearly a decade earlier, Rothko anticipated the uncertainty he would eventually embody in the chapel: "If people want sacred experiences, they will find them here. If they want profane experiences, they'll find those too. I take no sides."

But, of course, Rothko *does* take sides. It is precisely his ardent *desire* for the sacred that renders his doubt and uncertainty so tragic. In a lecture in 1958, Rothko remarked, "I want to mention a marvelous book, Kier-

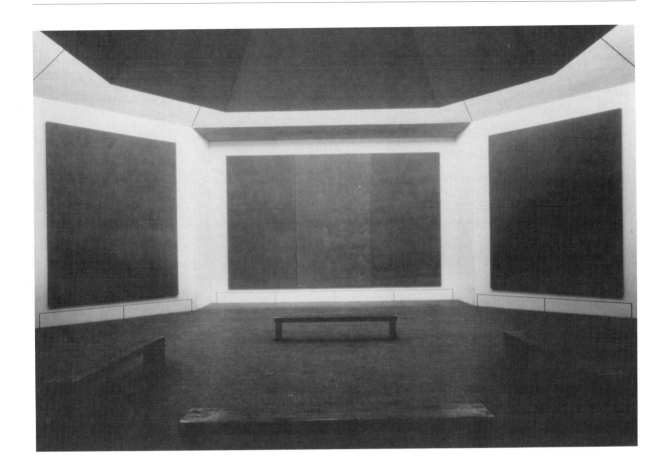

3.15 Mark Rothko, *Chapel*. © 1991 Kate Rothko-Prizel and Christopher Rothko/ ARS, New York.

3.16 Insignia of the Aryan Theosophical Press.

kegaard's *Fear and Trembling/Sickness Unto Death,* which deals with the sacrifice of Isaac by Abraham. Abraham's act was absolutely unique. There are other examples of sacrifice. . . . But what Abraham was prepared to do was beyond understanding. There was no universal that condoned such an act. This is like the role of the artist."[58] Like Abraham, the artist is called upon to make a sacrifice. But unlike Abraham, the artist sacrifices himself rather than another. Twelve years later, the darkness of his own chapel engulfed him. In February 1970, Mark Rothko committed suicide.

Rothko's suicide was the final chapter in his pursuit of the tragic-religious drama. The tragedy of modernity, however, extends far beyond the death of a single individual. What began in the salons of Jena ended on the stage in Bayreuth and on the parade grounds of Nuremberg. It is hardly an accident that Blavatsky's influential book *The Key to Theosophy* was published by the Aryan Theosophical Press, whose insignia is formed by the symbols of eternity: the triangle and the square. Within the square, which is surrounded by the triangle, two additional figures are inscribed: the Star of David and above it a swastika (fig. 3.16). Perhaps only the twentieth century has known the historical significance of the birth of tragedy. When the desire for presence creates a will-to-immediacy that becomes a will-to-purity, the sacrificial fires of purgation spread to become a holocaust. From these still smoldering flames can anything be reborn?

**4**

*I would wish for my house, for everything I write, to have the form of crystal.*
—ANDRÉ BRETON

*Glass brings a new age—*
*Brick buildings are depressing.*
—PAUL SCHEEBART

# P U R I T Y

*There are no architects today, we are all of us merely preparing the way for him who will once again deserve the name of architect, for that means: Lord of Art, who will build gardens out of deserts and pile up wonders in the sky.*
—WALTER GROPIUS

*Modern architecture is surely most cogently to be interpreted as a gospel—as quite literally, a message of good news.*
—COLIN ROWE

# 4 □ P U R I T Y

**B**Y THE SECOND decade of the twentieth century, not all the news was good news. The global network created by modern technology made it possible to wage global war. Gertrude Stein, whose portrait Picasso so carefully painted, described World War I as a "cubist war." "Really the composition of this war, 1914–1918, was not the composition of all previous wars, the composition was not a composition in which there was one man in the center surrounded by a lot of other men but a composition that had neither a beginning nor an end, a composition of which one corner was as important as another corner, in fact the composition of cubism."[1] The war, however, was not only cubist but also futurist. Conflict on a global scale would have been impossible apart from an extraordinary increase in speed that manifested itself in all dimensions of life. As Stephen Kern points out, the crisis of August 1914 would have been "unfathomable to anyone who had lived before the age of electronic communication. In the summer of 1914 the men in power lost their bearings in the hectic rush paced by flurries of telegrams, telephone conversations, memos, and press releases; hard-boiled politicians broke down and seasoned negotiators cracked under the pressure of tense confrontations and sleepless nights, agonizing over the probable disastrous consequences of their snap judgments and hasty actions."[2] The same technological and electronic network that modernists saw drawing the world together also threatened to tear it apart. But not even the horrors of war discouraged a futurist like Filippo Marinetti. To the contrary, war, he insisted, is a "purifying ritual" that will lead to an even brighter future.

> We affirm that the world's magnificence has been enriched by a new beauty; the beauty of speed. A racing car whose hood is adorned by great pipes, like serpents of explosive breath—a roaring car that seems to run on shrapnel—is more beautiful than the Victory of Samothrace.
> We will glorify war—the world's only hygiene. . . .
> We will sing of great crowds excited by work, by pleasure, and by riot; we will sing of the multicolored, polyphonic tides of revolution in the modern capitals. (SN, 43)

While world war would have been impossible apart from the transforming power of speed, the experience of war imposed a sense of homogeneity and simultaneity that altered the way in which time is apprehended. The synchronization of military maneuvers required the establishment of World Standard Time. If troops, trains, and ships were to be moved and campaigns launched on schedule, timetables coordinating distant regions had to be established. Battle also changed the sense of time by creating an "intensified sense of the present." In his popular war novel *Under Fire* (1916) Henri Barbusse captures the splendor and the terror of the present moment in combat: "In the line from left to right fires emerge from the sky and explosions from the ground. It is a frightful curtain

which divides us from the world, which divides us from the past and from the future. We stop, fixed to the ground, stupefied by the sudden host that thunders from every side."[3] The intensification of the present combines with the homogeneity produced by the standardization of time to create a sense of omnipresence and simultaneity. To experience such simultaneity is to approach the enjoyment of the universal presence for which most modernists long. Apollinaire envisions the fullness of temporal presence in his poem *Merveille de la guerre*.

> I leave to the future the story of Guillaume Apollinaire
> Who was in the war and knew how to be everywhere
> In the happy cities behind the front
> In the whole rest of the universe
> In those who died trampling in barbed wire
> In the women in the canons in the horses
> From zenith to nadir to the 4 cardinal points
> . . . . . . . . . . . . . . . . . . . . .
> And without doubt it would be even more beautiful
> If I could suppose that all these things everywhere
> In which I am could also inhabit me
> But in this sense nothing can be done about it
> Because I am everywhere at this hour.

It was left for architects to translate the altered experience of time into a transformed experience of space.

When one turns to the works and writings of early-twentieth-century artists and architects, traces of the war are conspicuously absent. This absence is so overwhelming that it becomes an uncanny presence haunting the will-to-abstraction. Faced with the danger of the imminent collapse of Western civilization, artists and architects turned from the real to the ideal in search of reassuring purity. But this purity is itself a danger. Structures built to cover the ashes of war eventually spark new fires that threaten to run wild. Whence this darkness? Whither this devastation?

In the small Swiss village of Safenwil, an unknown Reformed pastor labored throughout the war to develop a diagnosis of the ills that had led modernity to disaster. In 1918 Karl Barth published a revolutionary book entitled *The Epistle to the Romans*. Like most reformers throughout the history of Christianity, Barth derived his basic insights from the letters of Paul. Unlike his predecessors, however, Barth's rediscovery of Paul was mediated by his interpretation of Kierkegaard. In the preface to the second edition of his work, Barth goes so far as to admit, "If I have a system, it is limited to a recognition of what Kierkegaard called the 'infinite qualitative distinction' between time and eternity, and to my regarding this as possessing a negative as well as a positive significance: 'God is in heaven, and thou art on earth.' "[4] In formulating a theological response to modernity, Barth effectively recast Kierkegaard's critique of Hegel. The position Barth defined, which came to be known as neoorthodoxy, governed theological discourse from 1918 to the 1960s. The orthodoxy in question was Prot-

estant, or, more precisely, Calvinist. Standing in the Reformed tradition, Barth's theological position was rigorously iconoclastic. The devastation wrought by modernity, he maintained, was a function of the idolatry inherent in late-nineteenth- and early-twentieth-century cultural Christianity. Those who insist that the Kingdom of God is dawning on earth commit the sin of absolutizing the finite. In his survey of modern religious thought, Barth argues: "'Absolutism' in general can obviously mean a system of life based upon the belief in the omnipotence of human powers. Man, who discovers his own power and ability, the potentiality dormant in his humanity, that is, his human being as such, and looks upon it as the final, the real and absolute, I mean as something 'detached,' self-justifying, with its own authority and power, which he can therefore set in motion in all directions and without any restraint—this man is absolute man."[5] In the absence of restraint, humans end up negating what they attempt to affirm. Creative power turns destructive in a catastrophe of unprecedented proportions.

To such ruinous idolatry, Barth responds with a resounding *Nein!* Rather than immanent in human life and history, God is "totally other" and thus infinitely transcends self and world. Individuals can do nothing to bridge the abyssal gulf that separates the human and the divine. Radicalizing the Pauline doctrine of salvation by grace rather than works, Barth concludes that *all* activity testifies to our fallen condition. From this point of view, culture appears to be a product of the self-assertion constitutive of sin. Religion, which appears to be humankind's greatest achievement, is in fact the gravest sin.

Since Barth's position is dialectical, his No is not a simple negation but harbors a Yes. "Religion compels us to the perception that God is not to be found in religion. Religion makes us know that we are competent to advance no single step. Religion, as the final human possibility, commands us to halt. Religion brings us to the place where we must wait, in order that God may confront us—on the other side of the frontier of religion. The transformation of the 'No' of religion into the divine 'Yes' occurs in the dissolution of this last observable human thing."[6] To affirm God is to negate self, and to negate self is to affirm God. The delicate balance between affirmation and negation that Barth tries to establish is unstable. Though not precisely a reinscription of the *via negativa,* his dialectical theology presupposes a negativity that always threatens to slip into either an undialectical dualism or a monism.

As the opposition between the divine and the human deepens, God increasingly withdraws from the world. The Kingdom of God and the kingdom of the world are thus set against each other in such a way that loyalty to the former requires negation of the latter. Religious devotion demands an asceticism in which individuals retreat from the world of appearances. The end of this movement is the isolation of the individual and the silence of God that Kierkegaard describes in *Fear and Trembling.* This is the silence that spread over Europe during and after the war; this is the

silence that Rothko heard and painted in his last years; and this is the silence that resounds in Mies van der Rohe's most successful buildings.

Barth insists that silence is not the last word: God speaks! The gap separating humans from God is, however, so great that human beings cannot even hear the Word of God without divine assistance. Barth attempts to resolve this dilemma with his doctrine of the Trinity. God, the Father, reveals himself in the Son, and this revelation becomes effective through the Spirit. In his analysis of the Trinity, Barth's dialectical negation threatens to negate itself and turn into its own opposite. Although he fully endorses Kierkegaard's critique of Hegel, Barth's notion of the Trinity is nonetheless suspiciously Hegelian. Intent on securing the difference between God and self, Barth ends by inadvertently implying their identity. In the play of revelation, human subjectivity and divine activity are finally indistinguishable. God, who first appeared absent, now seems present—here and now. When presence becomes total presence, the transcendent God dies. Those who came after Barth toll the death of the God he praised.

In 1918, the same year *The Epistle to the Romans* appeared and within four days of the signing of the armistice, a book was published by a Swiss contemporary of Barth who was destined to have as revolutionary an impact on architecture as Barth had on theology. Charles-Édouard Jeanneret, who at precisely this moment was in the process of becoming Le Corbusier, wrote a work with Amédée Ozenfant entitled *Après le cubisme*, which defines the principles of a new aesthetic named "purism." Five years later, Le Corbusier developed the innovative implications of this aesthetic in *Towards a New Architecture*.

Le Corbusier's aesthetic program was the product of a complex religious vision formed by a synthesis of radical Christianity, Theosophical spirituality, and idealistic metaphysics. Born in La Chaux-de-Fonds, Le Corbusier was raised a Calvinist Protestant. According to a family legend that fascinated Le Corbusier throughout his life, his ancestors were members of the heretical Christian sect known as Catharism.[7] Catharism (from *cathari*, "the pure") first appeared in Cologne between 1143 and 1144. By the 1150s, it had spread to southern France and northern Italy. In Languedoc, where it was for a time more popular than Catholicism, the Cathari were known as the Albigensians. The church's response to the danger posed by this heresy culminated in the Albigensian crusade, which effectively ended the spread of Catharism.

The Cathari trace their spiritual roots back to early Gnostic heresies. In a letter to Le Corbusier, his brother, Albert Jeanneret, underscores the link between Catharism and Manichaeism: "The Jeannerets, classified as inhabitants of Jura, came to France at the moment of the religious persecution of the Huguenots. I think the Huguenots, like their ancestors the Cathari, were disciples of Manes, living in the southeast of France, against whom the Pope unleashed the cruel Albigensian crusade" (EC, 203). Whether or not the association of the Cathari and the Huguenots is his-

torically accurate, it is extremely important in the development of Le Corbusier's religio-aesthetic. Descended from Gnosticism, Catharism entails an explicit dualism, which, as we have seen in our analysis of Barth, is implicit in Calvinism. According to Cathar theology, creation is divided between the material world, governed by an evil principle, and the spiritual domain, ruled by the absolutely good god. In anticipation of issues to be explored in what follows, it is important to note that some versions of this dualism retain traces of anti-Semitism that go back to Mani (or Manes, as the Romans called him), who identifies the evil principle with the god of the Old Testament and the good principle with the god of the New Testament. Within this dualistic cosmology, the goal of life is to achieve salvation by escaping from the material world. Since the affirmation of the spiritual requires the negation of the material, Catharism sanctions a rigorous asceticism that rejects marriage and imposes dietary requirements that prohibit the eating of any food that is the product of sexual union. As a sign of suspicion of the physical and sensual world, the Cathari remove as many material features as possible from their rituals and places of worship. In Catharism, as in Calvinism, decoration of any kind is strictly forbidden.

Central to the religious activities of Catharism is a prolonged process of purification. The most rigorous ascetic practices are restricted to a "privileged" elite known as "the perfect." After a lengthy probation during which they are subjected to extraordinary physical and psychological demands, the perfect receive the *Consolamentum*. This secret gnosis enables them to assume responsibility for ministering to ordinary believers who are either unable or unwilling to submit to the rigors demanded of the elite.

Le Corbusier's commitment to the fundamental tenets of Calvinism and Catharism was reinforced by two books that he received as he was about to leave his native La Chaux-de-Fonds in the Swiss Jura for what proved to be an extremely important *Wanderjahr*. Charles L'Eplattenier, who had been Le Corbusier's teacher at the local art school, gave his prize pupil two books as a farewell gift in 1907: the first was a Theosophical account of the history of religions, *Les grands initiés: Esquisse de l'histoire secrète des religions* (1889) by Édouard Schuré; the second was a work based upon German idealistic metaphysics and aesthetics, *L'art de demain: Vers l'harmonie intégrale* (1903) by Henry Provensal.

Though Schuré was not as influential as some of the other Theosophists we have considered, his work did have a decisive and lasting impact on the young Le Corbusier. Schuré's spiritual journey began as a child when he had two visions: one while viewing a series of frescoes in Alsace; the other of the risen Christ in the Strasbourg cathedral. Several years later, when visiting the Louvre, the classical sculptures of Venus di Milo and, not insignificantly, Dionysus strengthened Schuré's belief that the divine can be revealed in works of art. The visions occasioned by Christian and Greek art defined the task he sets for himself in *The Great Initiates*.

In order to build a bridge between the lost Paradise and earth plunged in darkness, was it not necessary to reconstruct the living chain of the various religions, to restore to Hellenism and Christianity their original unity, to reconcile once again the whole tradition of East and West? At that instant, as in a flash I saw the Light that flows from one mighty founder of religion to another, from the Himalayas to the plateau of Iran, from Sinai to Tabor, from the crypts of Egypt to the sanctuary of Eleusis. Those great prophets, those powerful figures whom we call Rama, Krishna, Hermes, Moses, Orpheus, Pythagoras, Plato and Jesus appeared before me as a homogeneous group. How diverse in form, appearance, and color! Nevertheless, through them all moved the impulse of the eternal Word. To be in harmony with them is to hear the Word which was in the beginning. (GI, 17)

In the course of his career, three individuals proved very important for Schuré's development. The first was Richard Wagner, whom he met in Munich in 1868. Schuré's 1875 book, *Richard Wagner, son oeuvre et son idée*, played a major role in introducing the works of Wagner to the French public. In August 1876 Schuré went to Bayreuth to attend the first complete performance of *Der Ring des Niebelungen*. While in Bayreuth, he met the second person who was to prove influential: Nietzsche, with whom he had numerous lengthy conversations. In the music of Wagner and the philosophy of Nietzsche, Schuré saw the contemporary rebirth of what he regarded as authentic spirituality. Finally, Schuré's friendship with Rudolf Steiner was of lasting significance. The two men, who became acquainted in 1906 when Steiner was in Paris lecturing on spiritual knowledge, quickly developed a close relationship. Steiner eventually wrote the introduction to the German edition of Schuré's work.

In *The Great Initiates* Schuré attempts to realize his dream of reconciling not only Athens and Jerusalem but virtually all the major religions in the world. Toward this end, he traces the perennial wisdom typical of theosophical spirituality from ancient India, through the Greeks and Hebrews, to the religion of Jesus. Having been influenced by the form and substance of Hegelian idealism, Schuré argues that esoteric doctrine, in a manner analogous to speculative philosophy, discloses the "Truth" that diverse religions represent "in superstitious or symbolic forms." This truth unfolds "in accord with the laws of universal evolution." The longest chapter in the story of the universal evolution of spirit is devoted to the life and thought of Pythagoras.

According to Schuré's version of the tale, Pythagoras returned to Greece, after thirty-four years of wandering in the Near and Far East, to assume the charge of reestablishing the power and prestige of the temple of Apollo. In an argument that bears a certain resemblance to Nietzsche's *Birth of Tragedy*, Schuré insists that Apollo and Dionysus do not embody opposing principles but are

two different revelations of the same divinity. Dionysus represented esoteric truth, the heart and interior of things—accessible to the initiates alone. He held the mysteries of life, of past and future incarnations, of the relationships

between soul and body, the heaven and earth. Apollo personified the same truth applied to terrestrial life and the social order. Inspirer of poetry, medicine, and law, he represented science through divination, beauty through art, the peace of peoples through justice and harmony of soul and body through purification. In a word, for the initiate, Dionysus meant nothing less than the evolving divine spirit of the universe, and Apollo his manifestation to earthly man. (GI, 286)

In order to impart the wisdom of the gods, Pythagoras established an institute, or academy, that served as "a small model city under the direction of a great initiate." The building housing the members of the academy was completely white. In his teachings, Pythagoras attempted to communicate "the unity of the Great Whole," which "anticipates the synthesis of Hellenism and Christianity" that Schuré seeks to establish. Pythagoras discovered "the key to the universe" in the *architecture* of a temple.

> [Pythagoras's] fascinated gaze fixed itself upon the Dorian façade of the temple. The severe building seemed transfigured beneath the chaste rays of Diana. He thought he saw the ideal image of the world and the solution he was seeking. For the base, columns, architrave and triangular pediment suddenly represented to him the threefold nature of man and universe, of microcosm and macrocosm, crowned with divine unity, which is itself a trinity. *Cosmos,* dominated and penetrated by God, formed
>
> > The holy Tetrad, vast and pure symbol,
> > Origin of Nature and model of the gods.
>
> Yes, it was there, hidden in those geometric lines—the key to the universe, the science of numbers, the ternary law which rules the constitution of beings, that of the septenary which controls their evolution. (GI, 275)

This secret key was revealed to the initiates only after they underwent a long process of "purification" in which body and soul were thoroughly cleansed. The master warned his followers, "Do not yield to pleasure except when you agree to be untrue to yourself" (GI, 308). Those who passed the ritual trials were invited into the "inner court" of the academy where Pythagoras disclosed "the science of numbers" recorded in a book entitled *Hieros Logos.* In his description of this secret doctrine, Schuré anticipates the synesthesia that would later prove so important in the color theory advanced by Leadbeater and Besant.

> For numbers, the master taught, contain the secret of things, and God is universal harmony. The seven sacred modes built on the seven notes of the heptachord correspond to the seven colors of light, to the seven planets and to the seven forms of existence, which are reproduced in all the spheres of material and spiritual life, from the least to the greatest. The melodies of these modes, wisely instilled, should bring the soul into harmony, making it capable of vibrating exactly with the breath of truth. (GI, 307–8)

To breathe "the breath of truth" is to be united with the "World Soul." In this monotonous vibration, appearance gives way to reality, opposition to unity, and difference to identity. At the end of the ritual, "Pythagoras lifted his disciples from the world of forms and realities; he erased time and space, causing them to descend with him into the *Great Monad,* into the

essence of the Uncreated Being" (GI, 313–14). In this moment of profound unity, the initiates became "consistent and transcendent idealists" who believed "that the only real and durable things of earth are the manifestations of spiritual Beauty, Love, and Truth" (GI, 337).

The idealism implicit in Pythagorean philosophy becomes explicit in Provensal's aesthetic theory. Provensal indicates what he regards as the goal of life in the subtitle of his book, *L'harmonie intégrale*. In a manner reminiscent of Schiller's *On the Aesthetic Education of Man*, Provensal argues that an artistic elite leads the human race toward union with the Absolute. Describing the responsibility of the artist, he writes, "It is necessary for him to reconcile the truth of yesterday to that of tomorrow and to create from this fact the invisible chain, which, uniting the infinite of the universe to his ego, resolves the equation of the Absolute."[8] The Absolute reveals itself in the divine laws of "unity, number, and harmony" that are embodied in works of art. Reversing Hegel's dialectic of artistic development, Provensal argues that, since architecture is the most abstract art, it most adequately re-presents the Absolute. "Painting and sculpture [must be reoriented] toward a more abstract conception and this will be toward architecture, the dominant art par excellence, where all the intellectual forces of the two major arts will converge in order to realize as exactly and transcendentally as possible the fleeting forms of the absolute."

Several years before Braque and Picasso defined the principles of cubism, Provensal was arguing that "'cubic' forms are the most perfect and universal and thus the most expressive of ideal reality." Drawing on the insights of "Kant, Fichte, Schiller, Schelling, and especially Hegel," Provensal elaborates a notion of *beauté idéale* that "expresses mind and spirit rather than simply appealing to the physical senses" (EC, 19, 17). Though essentially immaterial, the ideal beauty of cubic architecture is prefigured in nature in the form of mineral crystals. "The mineral kingdom offers us in its crystallizations numerous and invariable examples of initial volumes from which architecture can borrow teachings. It is thus in the rational combination of these volumes that all aspiration of art is accomplished, and it is good that nature wants to give us the point of departure. Furthermore, geological formations can incite the artist to adaptations, to architectonic models capable of being inscribed in the bosom of space." For Provensal, as for many Theosophists, the crystal becomes the symbol of the New Age ushered in by artistic educators. By creating beautiful crystalline structures, the architect leads the human race from personal conflict and social strife "vers la vie tout harmonieuse."

In 1901, two years before the publication of Provensal's *Art de demain*, Peter Behrens collaborated with Georg Fuchs, a leader in the movement to reform German theater, to produce the inaugural spectacle for the Darmstadt Artists' Colony. "The ceremony had a tinge of ritual. Between two rows of Priestesses of Art a woman in black brought forward the symbol of crystal—*Das Zeichen*, the sign, the emblem of the New Spirit

bringing the reign of peace into the new unity of the Society of the Elect" (MA, 1:83). For artists and architects working in the early years of this century, glass was an "immaterial material" that is ideally suited to utopian designs. In *Alpine Architecture* (1919) Bruno Taut presented a series of visionary schemes for creating crystal stupas and glass-lined caves in the Italian-Swiss Alps (fig. 4.1). These glass structures were to serve as "spiritual centers" for newly formed utopian communities. Taut's friend and associate Paul Scheebart expressed the millenarian potential of *Glas-architektur* poetically:

> Happiness without glass—
> What an absurdity!
> Bricks pass away
> Glass colors stay.
> The joy of color
> Is only in glass-culture.
> Larger than a diamond
> Is the glass-house's double wall.
> Glass brings a new age—
> Brick buildings are depressing. (SN, 178–80)

For Behrens, the glass crystal was the "symbol of a new spiritual light born—like the diamond—out of the bowels of the earth, invocation to a new power of art, of Life-as-Art uniting *Kunst* and *Sollen*, beauty and duty." In the German Pavilion at the Turin Exposition of 1902, Behrens created a crystalline cavern in which the figure of Zarathustra moves toward the light. An "Apollonian sign of industrial organization," "the crystal invokes a principle of Reason that aspires to impose itself as Absolute Order" (MA, 1:83–84).

In the years following the crystal ceremony, Behrens established one of the most important studios in the history of modern architecture. Le Corbusier, Gropius, and Mies all worked in this studio while Behrens was developing his innovative designs for the German electricity monopoly AEG. In his famous Turbine Factory, Behrens synthesized the form of a Greek temple and a modern factory to create a building in which glass is used in a strikingly original way. Behrens's architecture left a lasting impression on his young protégés.

Shortly before starting to work for Behrens, Le Corbusier read Nietzsche's *Thus Spoke Zarathustra.* He was especially impressed by the description of Zarathustra as a messianic figure who descends from the mountain and undergoes tribulations encountered in his struggle to lead the human race to Truth. At about the same time, Le Corbusier was also reading Joseph-Ernest Renan's humanistic interpretation of Christ developed in *La vie de Jésus.* It is clear from textual notations and later comments that Le Corbusier identified with Zarathustra and Jesus. The architect is the savior who leads his people from the chaos and destruction of the present world to the crystalline purity of the New Age. "Imagine all this junk," Le Corbusier writes, "which till now has lain spread out over

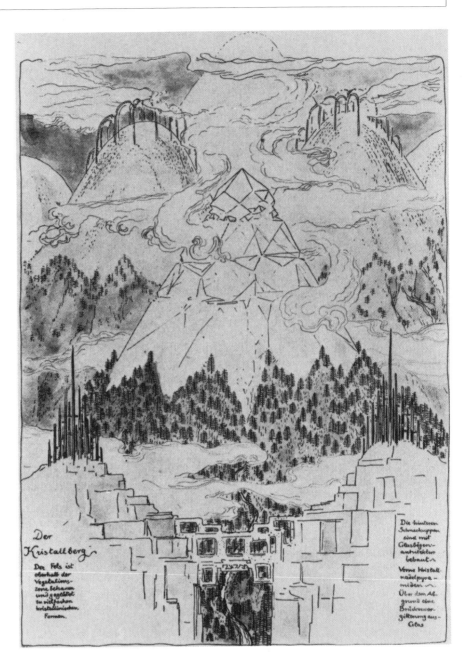

**4.1 Bruno Taut,** *Sketch for Alpine Architecture* **(1919).**

the soil like a dry crust, cleaned off and carted away and replaced by immense clear crystals of glass, rising to a height of 600 feet!" (SN, 188).

In *Après le cubisme*, Le Corbusier and Ozenfant proclaim the dawn of the New Age: "Not fifty years have passed since the birth of industry. Already formidable works have been realized. . . . They bring us the perception of a clear, airy, general beauty. Not since Pericles has thought been so lucid."⁹ *L'art de demain* is no longer deferred or delayed but is present here and now. The aesthetic of this New Age is purism, whose basic tenets were originally defined in ancient Greece. Although Le Corbusier never admits it, the aesthetic principles that inform all of his mature work result from his adaptation of Schuré's account of Pythagoras to the industrial

age. Following the asceticism inherent in Calvinism, Catharism, and Pythagoreanism, Le Corbusier insists that sensuality and sensible experience are inferior to rationality and cognitive reflection. The "divine axis" of the universe leads from the disturbing realm of the senses to the tranquil kingdom of reason. Sensuality is primitive—savage; rationality is modern—civilized. "If, says one mathematician, the Greeks triumphed over the barbarians, if Europe, descended from the thought of the Greeks, dominates the world, it is because the savages love clamorous colors and the noisy sounds of the drum, which only occupy their senses, while the Greeks love the intellectual beauty that is hidden beneath sensible beauty" (AC, 48). Recalling Hegel's dialectical analysis of *Geist*, Le Corbusier argues that history evolves from the senses to reason, and from the material to the spiritual. The *telos* of this process is the programmatic *construction* of the rational idea.

Le Corbusier follows Pythagoras when he maintains that "number is the base of all beauty" (AC, 28). Numbers form the divine laws that constitute the "fatal order" of reality. In a particularly revealing passage, Le Corbusier defines the spiritual essence of art: "Actual spirit is a tendency to rigor, precision, the better utilization of forces and materials, to the least *déchet,* in sum, a tendency to purity. This is also the definition of Art" (AC, 32–33). As the tendency to purity, art wipes away *le déchet:* loss, waste, offal—refuse, rubbish, garbage, cut off parts of butchered animals . . . *la part maudite.* [10] Beneath the pure structures of ideal beauty, mutilated remains remain. In his concluding summary of the principles of purism, Le Corbusier writes, "Purism wants to conceive clearly, execute loyally, exactly, without *déchet;* it turns away from troubling conceptions. . . . *Un art grave* must banish all deceptive techniques for the real value of conception" (AC, 60). Clear conception presupposes the apprehension of "generality," which is the "invariable in form." To reach the general, the particular that is figured in decoration and ornamentation must be negated. For Le Corbusier, as for abstract painters from Kandinsky, Mondrian, and Malevich to Reinhardt, Newman, and Rothko, the production of the authentic work of art involves a process of dis-figuring that removes the traces of representation. Le Corbusier labels this activity of disfiguring "deformation" (*déformation;* AC, 57). Through de-formation, one apprehends "the intellectual beauty that is hidden beneath sensible beauty." Since intellectual beauty is purely formal, deformation, paradoxically, reveals the forms that the architect uses in his or her formations.

Le Corbusier frequently employs linguistic metaphors to explain the work of art. As previously noted, between 1907 and 1911 Saussure was delivering lectures at the University of Geneva that eventually became his *Course in General Linguistics.* Le Corbusier's search for the "universal and invariable" grammar of architecture parallels Saussure's effort to define *la langue* that underlies *la parole.* By turning from the particular, historical, and diachronic to the universal, ahistorical, and synchronic, it is possible to dis-cover "the transcendental signified" that is, in effect, absolute. Ac-

cording to Le Corbusier, this is the proper mission of architecture, which had been forgotten for at least a century: "For a hundred years, architecture has lost its sense of mission; it is no more than a low-level decorative art" (AC, 27). For the purist, even cubism remains "a decorative art, romantic ornamentalism" (AC, 59).

As "superfluous ornament" is stripped away, pure beauty is revealed. This beauty reflects the harmonious accord formed by precise "numerical proportions." Universal harmony "sounds an internal chord in us" that resonates with the "universal divine principle." Though not drawing on Leadbeater and Besant, Le Corbusier reaches a conclusion that is remarkably similar to Kandinsky's color theory.

> At the basis of us, beyond our senses, a resonance, a sort of table of harmony begins to vibrate. Trace of indefinable, preexisting Absolute that establishes our being. This table of harmony that vibrates in us is our criterion of harmony. This must be the axis on which man is organized in accord with nature and, probably, the universe; this axis of organization must be the same as that on which all phenomena and all objects of nature are aligned; this axis leads us to suppose a unity of gestation in the universe, to admit a unique will at the origin.

First apprehended in ancient Greece, the universal harmony echoes through the ages and receives its clearest expression in modern Europe.

In *Towards a New Architecture*, Le Corbusier extends the principles of purism from painting to architecture. If this book is not placed in the context of *Après le cubisme* as well as the theological and philosophical sources of purism, it is easy to miss the spiritual dimensions of the "machine aesthetic." Though the house is, in Le Corbusier's famous phrase, "a machine for living in," the goal of his "engineer's aesthetic" remains to establish a harmonious accord between the individual and the universal laws governing the cosmos. "Architectural emotion exists when the work rings within us in tune with a universe whose laws we obey, recognize and respect. When certain harmonies have been attained, the work captures us. Architecture is a matter of 'harmonies,' it is 'a pure creation of spirit'" (TA, 165, 19). Le Corbusier underscores the ideality of architecture when he insists that "there is a new spirit: it is the spirit of construction and of synthesis guided by a clear conception" (TA, 15). The clear conception that informs architecture is articulated in the "algebraic" plan. The plan numerically formulates the primal structures defined by Pythagoras as well as Cézanne: "cubes, cones, spheres, cylinders, and pyramids." Without an adequate plan, one is left with the "insupportable sensation of shapelessness, disorder, and willfulness" (TA, 48). Since the building re-presents the plan, construction *incarnates* the idea.

In the course of his *Wanderjahr*, Le Corbusier had an experience bordering on the religious that anticipated the direction of much of his mature architecture. While in Florence, he visited the nearby monastery of Ema. In this austere structure, Le Corbusier saw the embodiment of Provensal's "cubic architecture." Predisposed to monastic asceticism by his

Calvinist, Catharic, and Pythagorean background, Le Corbusier glimpsed in the forms on the Italian hillside the outlines of *l'art grave* that would become his signature.

Over twenty years later, monastic severity reappears in what is perhaps Le Corbusier's best-known work, Villa Savoye (1929–31; fig. 4.2). This revolutionary building puts into practice the theory of deformation. Having been stripped of all ornamentation, the structure appears flat, thin, and light. The cubic form is the product of two closely related processes: elementarization and dematerialization. The reductive technique of removing useless detail results in a stark geometric form that is carefully balanced. The loud colors that Le Corbusier associates with savagery are replaced with "civilized" white and traces of black. The elementarism of Le Corbusier's form and color recalls not only Schuré's description of Pythagoras's house but also Mondrian's most austere canvases. But there is a lightness that borders on levity in Le Corbusier's work that is missing in Mondrian's art. The use of empty space and the interruption of the outer walls creates a liberating feeling of openness. The ethereality of the villa is accentuated by its elevation above the ground. The pilotis, or slender pillars, supporting the structure give the sense of a building about to ascend to higher spheres.

The use of reinforced concrete and load-bearing pillars removes the necessity of interior supporting walls. This enables Le Corbusier to create open spaces in which, as Alan Colquhoun suggests, there are "no domestic secrets." There is, however, a tension between the exterior and interior of the building. The straight lines and right angles of the outer structure give way to transecting diagonals and sweeping curves that interrupt the otherwise rigid formalism of the interior space (fig. 4.3). The result is a dynamic tension that increases the vitality of the building. In the works that follow Villa Savoye, Le Corbusier tended to privilege rectilinear structures. Late in his career, dynamic diagonals and organic curvatures returned to create forms that border on the biomorphic (fig. 4.4).[11]

Le Corbusier always used his purist aesthetic in the service of utopianism. Modern architecture, he believed, harbors revolutionary potential. In an often-cited aphorism, Le Corbusier actually proposes architecture as an alternative to revolution: "Architecture or Revolution. Revolution can be avoided." Whether such a claim is interpreted as conservative or as radical depends upon one's political persuasions. Le Corbusier clearly understands his position to be a radical departure from previous forms of social planning and architectural practices. The war did not destroy the optimism that Le Corbusier shared with so many modernists. To the contrary, he was among those who saw war as something like a purifying ritual. *Après le cubisme* opens with a disturbing declaration: "The War is finished, everything is organized, everything is clarified, everything is purified, the factories are risen, nothing is any longer what it had been before the War: the grand Struggle has tested everyone, it has put an end to senile methods and imposed in their place those that the battle has proven the

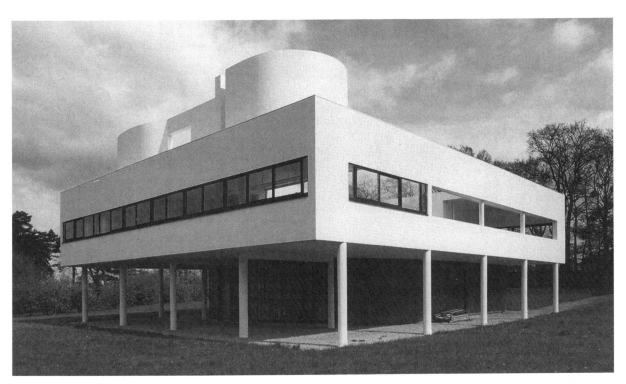

4.2 Le Corbusier, *Villa Savoye* (1929–31). Fondation Le Corbusier, Paris. © 1991 ARS, New York/SPADEM, Paris.

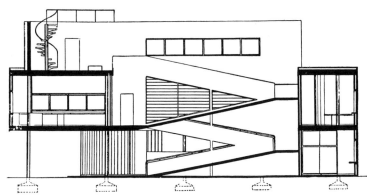

4.3 Le Corbusier, *Villa Savoye*, cross-section. Fondation Le Corbusier, Paris. © 1991 ARS, New York/SPADEM, Paris.

4.4 Le Corbusier, *La Tourette* (1960). Fondation Le Corbusier, Paris. © 1991 ARS, New York/SPADEM, Paris.

best" (AC, 11). In Le Corbusier's idealistic vision, the hand that inflicts the wound offers the cure. The arrival of industrial society holds the promise of a harmonious community in which equality (but not freedom) reigns. The architect must labor to *build* this ideal world.

The exigencies of postwar Europe created a desperate need for mass housing. One of Le Corbusier's most important contributions to solving the social problems of his day was his design of the Dom-Ino Houses (fig. 4.5). This reinforced-concrete structure is made up of six columns, which support the floor and roof slabs, and cantilevered concrete stairs joining different floors. By providing maximum flexibility in inexpensive and easily reproducible structures, this simple design became an early model for low-cost housing projects. When Le Corbusier moved from the housing unit to the city as a whole, he continued to follow the principles of purism. His design for "the 'Contemporary City' is a perfectly symmetrical grid of streets. The right angle reigns supreme [fig. 4.6]. Two great super-

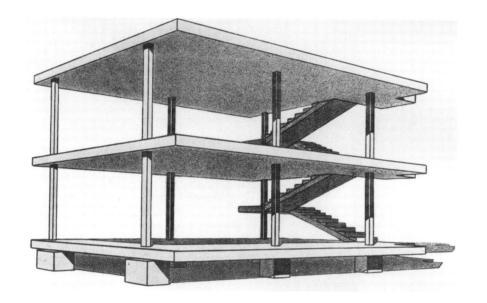

**4.5  Le Corbusier, *Dom-Ino House* (1919). Fondation Le Corbusier, Paris. © 1991 ARS, New York/SPADEM, Paris.**

**4.6  Le Corbusier, *A Contemporary City* (1922). Fondation Le Corbusier, Paris. © 1991 ARS, New York/ SPADEM, Paris.**

highways (one running east-west, the other north-south) form the central axes; they intersect at the exact center of the city."¹² Though not immediately evident, the structure of the city is cruciform. From the spotlessly clean streets arise the "immense clear crystals of glass" that are *das Zeichen* of the New Age. Le Corbusier labels these transparent crystals "unités." The Unité d'Habitation, which was built in Marseilles (1947–52), is virtually an entire city in a single building. Sixteen hundred people live in 337 apartments. Le Corbusier's concern in the Unité is less with individual dwelling than with communal living. The building provides a variety of collective services. *La rue marchande* is moved from outside and street level to the central floor of the building. In its most ideal form, the Unité includes workshops, meeting rooms, day-care centers, restaurants, tennis courts, a gymnasium, and, in one design, even sand beaches. "Le Corbusier envision[s] a society in which men and women would work full-time as equals. He therefore presume[s] the end of the family as an economic unity in which women [are] responsible for domestic services while men work for wages. In the Unité, cooking, cleaning, and child raising are services provided by society."¹³ When such a society is not only imagined as possible but becomes actual, the world is transformed into "the Radiant City."¹⁴ *La ville radieuse* is not a city on the hill but is a city spread out on the flat plain of Le Corbusier's pure grid.

Just as there is a sinister side to the spiritual aspirations of the abstract painters we have considered, so there is a danger in Le Corbusier's quest for purity. Le Corbusier celebrates what he calls "the 'White World'—the domain of clarity and precision, of exact proportion and precise materials, culture standing alone—in contrast to the 'Brown World' of muddle, clutter, and compromise, the architecture of inattentive experience" (SN, 191). Purity vs. danger . . . order vs. chaos . . . reason vs. sensation . . . light vs. darkness . . . white vs. brown . . . art vs. *déchet.* Above the title on the first page of *The Radiant City,* the following inscription appears: "THIS WORK IS DEDICATED TO AUTHORITY, PARIS, MAY, 1933." A year earlier, Le Corbusier had become an editor of the journal *Prélude,* whose board included several well-known pro-Fascists. Though Le Corbusier was initially critical of fascism, he quickly changed his position when Mussolini invited him to Italy to explore the possibility of designing buildings for his regime. Shortly thereafter, Le Corbusier writes in Marinetti's pro-Fascist publication, *Stile futurista,* "The present spectacle of Italy, the state of her spiritual powers, announces the imminent dawn of the modern spirit. Her shining purity and force illumine the paths which had been obscured by the cowardly and the profiteers."¹⁵ It would be easy—all too easy—to dismiss Le Corbusier's action as a gesture of blatant self-interest that remains unrelated to the purism of his aesthetics. But perhaps matters are not so simple. It is possible that certain strands of modernism indirectly provide the architecture of fascism.

Despite the excesses of leading figures like Marinetti and Le Corbusier, the utopian urge remained strong throughout the early decades of this

century. Colin Rowe explains that modern architecture's "aim was never to provide a well-cushioned accommodation for either private or public bourgeois euphoria. Instead, its ideal was to exhibit the virtues of an apostolic poverty, of a quasi-Franciscan *Existenz minimum.* 'For it is easier for a camel to go through a needle's eye, than for a rich man to enter the kingdom of God'; and, with this belligerent and somewhat *samurai* dictum in mind, the austerity of the twentieth century architect must be abundantly explained. He was helping to establish and to celebrate an enlightened and a just society." [16] As we discovered in our investigation of abstract painting, no one was more preoccupied with the aesthetics of "apostolic poverty" than Piet Mondrian. For Mondrian, art provides the aesthetic education that prepares the way for entry into the Promised Land. In Theo van Doesburg, Mondrian found a follower who attempted to translate neoplasticism from the canvas to the world by applying its aesthetic to design and architecture. The aim of this undertaking was the union of art and life. To promote his socio-aesthetic program, van Doesburg founded a journal in 1917, which he entitled *De Stijl.* The painters Mondrian and Vilmos Huszár, the poet Antony Kok, the sculptor Georg Van der Leck, and the architect J. J. P. Oud organized around van Doesburg's publication. This group quickly became one of the leading avant-garde organizations in Europe. De Stijl was not intended to be just any style but was promoted as *the* style of the coming age. Its first manifesto, published in 1918, declares,

> There is an old and a new consciousness of time.
> The old is connected with the individual.
> The new is connected with the universal.
> The struggle of the individual against the universal is revealing itself in the World War as well as in the art of the present day.
> The War is destroying the old world with its contents:
> individual domination in every state.
> The new art has brought forward what the new consciousness contains:
> a balance between the universal and the individual.
> The new consciousness is prepared to realize the individual life as well as the external life. (DS, 12)

The strong influence of the basic principles of Mondrian's neoplasticism is evident in this manifesto. For members of de Stijl, the problems that led to World War I were created by the individualism that had become rampant in Western society and culture. The only solution to personal and social problems appeared to be to move toward more cooperative and collective forms of activity. In an effort to promote such cooperation and collectivization, de Stijl revived the notion of the *Gesamtkunstwerk* that developed in Jena in the last decade of the eighteenth century. Poets, painters, sculptors, and architects joined in an effort to create a "total work of art" that would completely transform the environment in which people live, work, and play.

While van Doesburg remained the driving force behind de Stijl, the success of the movement would have been impossible without the early

interest and support of Mondrian. In a series of articles and tracts written between 1915 and 1924, Mondrian explores the implications of neo-plasticism for design, architecture, and city planning. His commitment to the spiritual principles that inform his aesthetic theory and artistic practice never wavers. In an essay written in 1922, Mondrian summarizes the way in which the realization of the *Gesamtkunstwerk* transforms human life.

> Domination of life's tragedy has come to an end. The "artist" is immersed in an existence as a complete human being. The "non-artist" is his equal: he is equally imbued with beauty. Talent will cause one person to occupy himself with aesthetics, another with science, a third with something else—as a "profession"; each is an equivalent part of the total. Construction, sculpture, painting and crafts will then be merged into architecture, i.e., into our environment. . . . [L]ife movements are then harmonious in themselves. (DS, 92–93)

Although in this text Mondrian argues that the progression of the arts culminates in architecture's concretization of aesthetic principles, he remains critical of anything approaching a facile appropriation of painterly strategies by architects. In a 1917 letter to van Doesburg, he stresses his uneasiness: "Please don't forget that my artistic productions are meant to be paintings—that is, autonomous figurative representations, not constituent parts of architecture" (DS, 93). By the mid-twenties, the differences between Mondrian and van Doesburg had deepened, and the painter and architect formally split. These disagreements in no way diminish the lasting impact that Mondrian had on de Stijl and, through this movement, on modern architecture more generally.

Mondrian's reservations proved no deterrent to van Doesburg. Approaching his task with an idealism that is indistinguishable from religion, van Doesburg announced, "The quadrangle is the token of a new humanity. The square is to us what the cross was to the early Christians" (TMA, 316). For van Doesburg, as for Mondrian and Le Corbusier, the religion behind his aesthetic was Protestantism. J. J. P. Oud describes the neoplasticism of the de Stijl group as a latter-day version of "Protestant iconoclasm." In his early neoplastic paintings, van Doesburg repeated Mondrian's use of basic geometric forms, straight lines, and right angles, with the three primary colors and three "noncolors" (i.e., black, white, and gray; fig. 4.7). In his search for stylistic purity, van Doesburg removed decoration and ornamentation. The abstract structure that remains after the process of disfiguring is supposed to be both reasonable or logical and universal.

Although he began as a painter, van Doesburg was convinced from the outset that architecture represents a synthesis of the arts that is capable of transforming society and culture. The *architecture élémentarisée* that eventually became characteristic of de Stijl developed slowly. In his earliest collaborative effort, van Doesburg worked with Oud in the design and construction of the De Vonk House in Noordwijkerhout, the Netherlands (fig. 4.8). The product of this joint effort is only marginally successful.

4.7 Theo van Doesburg, *Composition XXI* (1920–22). VAGA, New York, 1991.

4.8 Theo van Doesburg and J. J. P. Oud, *De Vonk House* (1920). VAGA, New York, 1991.

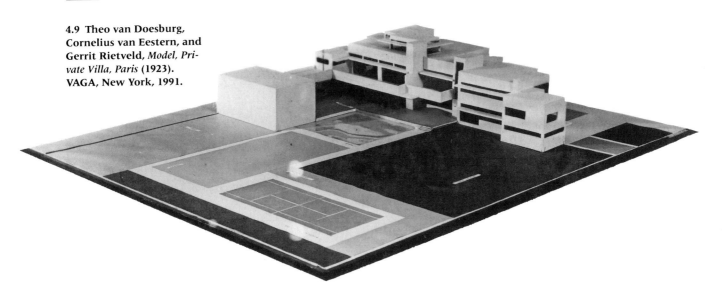

4.9 Theo van Doesburg, Cornelius van Eestern, and Gerrit Rietveld, *Model, Private Villa, Paris* (1923). VAGA, New York, 1991.

4.10 Theo van Doesburg, *Color Construction: Project for a Private House* (1923). VAGA, New York, 1991.

Having been influenced by Frank Lloyd Wright, Oud insisted on using bricks in the construction. But Oud resisted Wright's introduction of the flat roof and retained the pitched roof typical of traditional Dutch architecture. In this early work, van Doesburg's contribution was limited to exterior decoration and interior design. As a critic of needless decoration, van Doesburg faced the impossible task of creating nonornamental ornaments. His attempted solution involves the addition of mosaics executed in neoplastic style above and on both sides of the front door. On the inside of the building, van Doesburg extended geometric patterns and primary colors in floor tiles, doors, and trim. The result is a structure in which the neoplastic elements seem supplemental rather than integral.

This situation changed dramatically when van Doesburg took a more active hand in the actual design of buildings. In 1923 he joined Cornelius van Eesteren and Gerrit Rietveld to develop plans for a private villa that marks a significant departure from established de Stijl design (fig. 4.9). The far-reaching implications of this break did not become fully apparent until the early work of Peter Eisenman four decades later. The villa design dislocates the central structure of the house and distributes it among multiple horizontal planes whose mass is interrupted by long narrow windows. The elongated building stretches horizontally in a way that creates an unprecedented sense of expansive openness.

As he worked with van Eesteren to deepen his knowledge of architecture and refine his design skills, van Doesburg developed several intriguing drawings and models. His most innovative plan is *Color Construction: Project for a Private House* (fig. 4.10). This creative "counter-construction" extends spatial experimentation by using an array of intersecting planes to generate previously unexplored volumes. Although it was not intended to represent an actual structure, this plan exercised considerable influence on architects within and beyond the de Stijl movement. One of the most striking features of this drawing is its novel use of color. Having stripped the structure of ornamentation, van Doesburg applied the colors he had

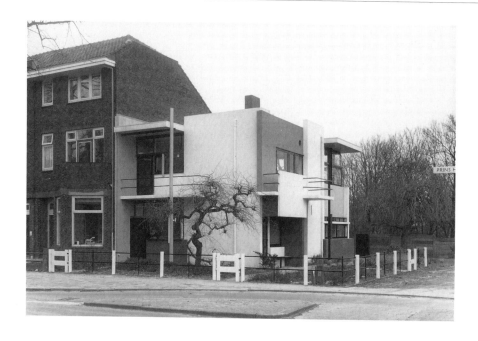

**4.11 Gerrit Rietveld,**
*Schröder House* **(1924).**
**VAGA, New York, 1991.**

used in the mosaics on the De Vonk House to the planes in the axono-
metric projects in an effort to suggest how red, yellow, blue, black, and
gray might be used on white façades. The result is an effective interplay of
primal forms and primary colors in which painting and architecture ap-
proach unity. This synthesis, however, is still on paper or canvas and thus
remains to be built.

The formalism of van Eesteren's architecture and the color of van
Doesburg's paintings and drawings meet in what is perhaps the best ex-
ample of neoplastic architecture: Rietveld's Schröder House in Utrecht
(fig. 4.11). Prior to designing this building, Rietveld was best known for
his creation of the Red/Blue Chair, in which he used primary colors and
flat surfaces to produce a chair that appears better suited to theory than to
comfort. In an extraordinarily bold move, Rietveld simply appended the
Schröder House to an existing series of traditional Dutch row houses.
Commenting on his gesture four decades later, Rietveld wrote, "Without
bothering to adapt the house to some extent to the traditional houses on
the Prins Hendriklaan, we simply attached it to the adjacent house. It was
the best thing we could do—to make it stand out in contrast as much as
possible." The Schröder House shows how far de Stijl architecture pro-
gressed beyond Oud's and van Doesburg's first tentative efforts. No longer
is there any effort to combine modern design and traditional Dutch brick
architecture. To the contrary, Rietveld stressed their differences and dis-
junctions by using modern materials that are painted in accordance with
the principles of de Stijl design to accentuate the formalism of the build-
ing's structure. Paradoxically, this use of color is antidecorative. The exte-
rior walls are painted white and four contrasting shades of gray. The
austerity of these planar surfaces is broken by pipes, window and door
frames, railings, and supports that are painted bright red, yellow, and blue.

"The color of each element seems to have been decided in terms of its material character, shape, and spatial relationship to the whole."[17] The interior of the house exhibits one of the earliest efforts to create what eventually became the typical modern "open plan," which erases the distinction between interiority and exteriority. When taken as a whole, Rietveld's Schröder House serves as a virtual illustration of van Doesburg's description of the basic principles of "the new architecture."

> The new architecture is *anti-cubic,* that is to say, it does not try to freeze the different functional space cells in one closed cube. Rather, *it throws the functional space cells* (as well as overhanging planes, balcony volumes, etc.) centrifugally from the *core of the cube.* And through this means height, width, depth, and time approach a totally new plastic expansion in open spaces. In this way, architecture gets . . . a more or less floating aspect that, so to speak, works against the gravitational forces of nature. (DS, 103)

Van Doesburg's stress on the dynamic element in architecture points to a shift in his aesthetic theory and architectural practice that took place in the mid-1920s. After meeting Lissitzky in 1921, van Doesburg increasingly came under Russian influence. Following his cessation of painting in the early twenties, Malevich, who was Lissitzky's teacher, attempted to respond to the criticisms of constructivists like Tatlin and Rodchenko by calling for an effort to use the principles of suprematism to reorganize the world. Artists, architects, planners, and designers, he argued, must join "to recreate the world in a Suprematist mold." In an effort to show how this might be accomplished, Malevich shifted from a two-dimensional to a three-dimensional approach in which he made drawings and models of buildings, which he named "planits" or "arkhitektons." It is possible that Malevich's experiments with arkhitektons influenced the conception of van Eesteren's and van Doesburg's 1923 villa design (fig. 4.12).[18]

**4.12 Kasimir Malevich,** *Architectonics* **(1922–25).**

The more decisive influence on van Doesburg, however, was Lissitzky. Extending Malevich's utopian explorations, Lissitzky developed a series of drawings that he labeled *Prouns,* which is an acronym for *proetky ustanovleniya (utverzhdeniya) novogo*—projects for the establishment (affirmation) of the new. In a tract entitled "Suprematism in World Reconstruction," Lissitzky explains the practical significance of Malevich's artistic innovations.

> for us SUPREMATISM did not signify the recognition of an absolute form which was part of an already-completed universal system. on the contrary, here stood revealed for the first time in all its purity the clear sign and plan for a definite new world never before experienced—a world which issues forth from our inner being and which is only now in the first stages of its formation. for this reason the square of suprematism became a beacon.
>
> in this way the artist became the foundation on which progress in the reconstruction of life could advance beyond the frontiers of the all-seeing eye and all-hearing ear.[19]

In his contribution to the Greater Berlin Art Exposition of 1923, Lissitzky demonstrated the way in which suprematism transforms the lived environment by translating his Proun drawings into a *Prouenraum* (fig. 4.13). Two features of the *Prouenraum* proved decisive for later architectural developments. First, Lissitzky eliminated the characteristic de Stijl use of primary colors and limited the tonal accents to the "noncolors" white, black, and gray. Second, he applied Malevich's painterly use of the dynamic diagonal to spatial design. Van Doesburg's acceptance of the latter innovation sealed his break with Mondrian, who continued to insist on the exclusive use of straight lines and right angles, and solidified the growing affiliation between Russian constructivism and Dutch de Stijl design.

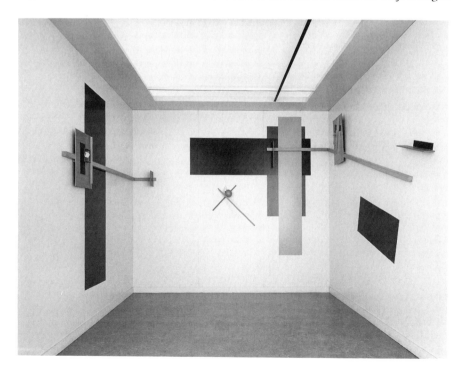

**4.13 El Lissitzky, *Proun Space* (1965 reconstruction of the 1923 original). Wood, 300 × 300 × 260 cm. Municipal Van Abbemuseum, Eindhoven, The Netherlands.**

Van Doesburg's drift away from principles essential to neoplasticism became explicit in 1922, when he joined Lissitzky and others in signing the minority report prepared by the International Faction of Constructivists at the Congress of International Progressive Artists in Düsseldorf. "We insist that today art is no longer a dream set apart and in contrast to the realities of the world. Art must stop being just a way of dreaming cosmic secrets. Art is a universal and real expression of creative energy, which can be used to organize the progress of mankind, it is a tool of universal progress" (DS, 106). In 1926 van Doesburg formalized his break with Mondrian's aesthetic by issuing his "Manifesto of Elementarism." While not completely disavowing neoplasticism, van Doesburg insisted that the doctrinaire use of the geometrical grid must be loosened to allow the introduction of angular lines, planes, and volumes to create a sense of dynamism that better captures the progressive speed of modernity.

Despite van Doesburg's growing misgivings, the impact of neoplasticism on many of the most creative artists, architects, and designers continued to grow throughout the 1920s. Van Doesburg's 1921 visit to the Bauhaus was of decisive importance in setting the artistic direction of the recently transformed Grand Ducal Academy of Art in Weimar. Though usually associated with the modernist machine aesthetic, this design direction was not the original inspiration for the creation of the Bauhaus. In its conception, the Bauhaus was intended to realize the ideals of Weimar *Kultur* defined in Jena in the 1790s. Still clinging to Schiller's vision of artists leading the way to the creation of the concrete *oeuvre d'art* in the form of an organic state, Weimar officials established the Staatliche Bauhaus in 1919 and entrusted its leadership to the young idealistic architect Walter Gropius.

In an early address to the students at the Bauhaus, Gropius expressed the spiritual aspirations and utopian expectations that informed his vision of the *Künstlerkolonie.*

> No large spiritual organizations, but small, secret, self-contained societies, lodges. Conspiracies will form which will want to watch over and artistically shape a secret, a nucleus of belief, until from the individual groups a universally great, enduring, spiritual-religious idea will rise again, which finally must find its crystalline expression in a great *Gesamtkunstwerk.* And this great total work of art, this cathedral of the future, will then shine with its abundance of light into the smallest objects of everyday life.[20]

The "cathedral of the future" is the "cathedral to socialism," which is depicted in the frontispiece to the first manifesto of the Bauhaus, in which Gropius calls for a return to *völkisch* ideals. "Let us create a new guild of craftsmen without the class distinctions that raise an arrogant barrier between craftsman and artist! Together let us desire, conceive, and create the new structure of the future, which will embrace architecture and sculpture and painting in one unity and will one day rise toward heaven from the hands of a million workers, like the crystal symbol of a new faith."[21] The faith in the salvific potential of architecture that Gropius had

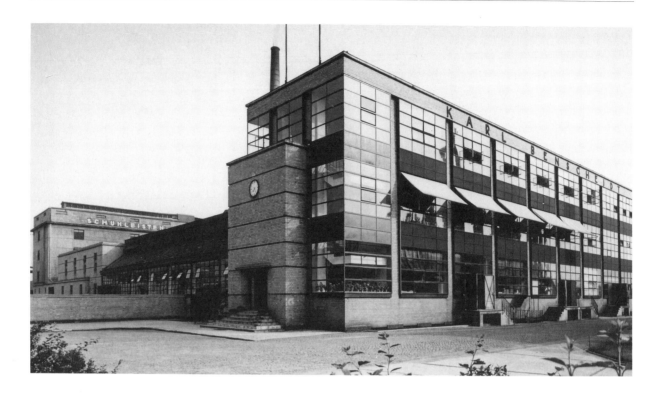

discovered in Behrens's studio resurfaced as *das Zeichen* of the New Age and was reinscribed in a crystal cathedral.

In setting the early direction of the Bauhaus, however, Gropius turned from Behrens's use of industrial design and modern materials to craft methods and traditional materials—especially wood. Though he built the Fagus Shoe-last Factory while under the influence of Behrens's industrial design, by 1919 Gropius was admonishing his students, "The new era calls for the new form. . . . Timber is *the* building material of the present day" (fig. 4.14). While some critics insist that Gropius's reversion from glass, iron, and concrete to wood was necessitated by the unavailability of modern materials in war-torn Germany, the deeper reason for this un-expected change was his lingering idealization of the folk culture that had inspired the romantic visions of poets and philosophers from Hölderlin and Novalis to Schelling and Hegel.

Nowhere was Gropius's commitment to the esoteric spirituality that inspired so many modern artists more evident than in his appointment of Johannes Itten to organize and teach the *Vorkurs* required of all Bauhaus students. Profoundly interested in mysticism and especially influenced by the writings of Jakob Böhme and certain forms of Indian devotional prac-tice, Itten viewed the Bauhaus as a "secret self-contained society" whose members were dedicated to spiritual goals. Long years of meditation con-vinced Itten that religious practices release creative powers that artists can channel in productive ways. Accordingly, he encouraged his students to undergo rituals of purification before entering his classroom. Far from a rigorous or systematic thinker, Itten appropriated fragments of esoterica

**4.14  Walter Gropius,** *The Fagus Shoe-last Factory* **(1911). Royal Institute of British Architects.**

to form a collage of beliefs and practices that is as idiosyncratic as a cubist canvas. When he fell under the sway of the Zurich-based Zoroastrian sect Mazdaznan, Itten imposed his ascetic practices on the entire Bauhaus by persuading the Bauhaus kitchen to convert to a vegetarian diet.[22]

Eventually the eccentricities of Itten's spirituality proved too much for the more practical-minded Gropius. As van Doesburg and Mondrian seem to have been destined to split, so conflict between Gropius and Itten appeared inevitable. Bauhaus painter and teacher Oskar Schlemmer, who also had mystical propensities, describes the source of the disagreement between Gropius and Itten.

> Gropius contends that we should not shut out life and reality, a danger . . . implied by Itten's method. . . . Itten's ideal would be a craftsman who considers contemplation and thought about his work more important than the work itself. . . . Gropius wants a man firmly rooted in life and work, who matures through contact with reality and through practicing his craft. Itten likes talent which develops in solitude, Gropius likes character formed by the currents of life (and the necessary talent). . . . These two alternatives strike me as typical of current trends in Germany. On the one hand, the influence of oriental culture, the cult of India, and also a return in the *Wandervogel* movement, and others like it; also communes, vegetarianism, Tolstoyism, reaction against the war; and on the other hand, the American spirit, progress, the marvels of technology and invention, the urban environment.[23]

Though Schlemmer overstates the contrast between Gropius and Itten, his comment points to differences that became increasingly difficult to ignore. These artistic disagreements did not prevent Itten from accomplishing what was perhaps his most lasting contribution to the life of the Bauhaus—the appointment of Kandinsky and Paul Klee to the faculty.[24] By 1922, however, Gropius felt compelled to remove Itten from the *Vorkurs* and to replace him with the Hungarian constructivist László Moholy-Nagy. This change marked a turning point in both the history of the Bauhaus and Gropius's personal career, which was publicly acknowledged in his exhibition entitled "Art and Technology: A New Unity."

The union of art and technology that Gropius imagined was less a new revelation than a return to the crystalline vision he had glimpsed in Behrens's studio and expressed in his early Fagus Shoe Factory. The transition from Itten's esoteric spirituality and folkish methods to the techniques of modern industrial design coincided with the Bauhaus's move from Weimar to Dessau in 1925. The emergence of a right-wing government in Thuringia forced the Bauhaus to leave Weimar. In Dessau, Gropius expressed renewed hope for the community of artists as well as the rest of society in his design for the new building to house the school (fig. 4.15). Initially, Gropius's rejection of the "immoderation" of Itten's spirituality did not seem to diminish the idealism of his architecture. To the contrary, in his return to glass, iron, and concrete construction, Gropius revived the utopianism typical of Taut and Scheebart's *Glasarchitektur*. In his theoretical essay *The New Architecture and the Bauhaus*, Gropius sounds a nearly Nietzschean note: "As a direct result of

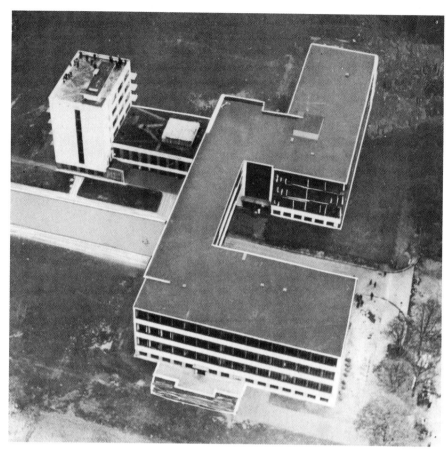

**4.15 Walter Gropius,** *The Bauhaus* **(1926).**

the growing preponderance of voids over solids, glass is assuming an ever greater structural importance. Its sparkling insubstantiality, and the way it seems to float between wall and wall imponderably as the air, adds a note of gaiety to our modern homes." For Gropius, as for his suprematist precursor Malevich, the void is more a sign of presence and plenitude than of absence and emptiness. In this gay wisdom, the unbearable lightness of building creates a liberating sense of levity. "The New Architecture throws open its walls like curtains to admit a plenitude of fresh air, daylight and sunshine. Instead of anchoring buildings ponderously into the ground with massive foundations, it poises them lightly, yet firmly, upon the face of the earth; and bodies itself forth, not in stylistic imitation or ornamental frippery, but in those simple and sharply modelled designs in which every part merges naturally into the comprehensive volume of the whole."[25] While Gropius shared the critique of ornament developed by Le Corbusier, Mondrian, and van Doesburg, his reservations did not grow out of austere Protestant iconoclasm. Gropius saw in the rejection of ornamental excess the possibility of more sophisticated and reasonable pleasures.

The "structural logic" of the "new architecture" presupposes a process of disfiguration in which buildings are *"purified"* of every excess. Such disfiguring dissolves complex structures into basic units that can be effectively rationalized and standardized. "Standardization," Gropius insists,

"is not an impediment to the development of civilization, but, on the contrary, one of its immediate prerequisites." In other words, rationalization entails homogenization in which particular differences are negated and "universal qualities" and "standard types" are affirmed. "The unification of architectural components would have the salutary effect of imparting that homogeneous character to our towns which is the distinguishing mark of a superior urban culture. A prudent limitation of variety to a few standard types of buildings increases their quality and decreases their cost; thereby raising the social level of the population as a whole."[26] Gropius intended his design for the Dessau Bauhaus to promote humankind's progress toward a more civilized life than had been known in the past. By directly and indirectly synthesizing drawings, models, and plans for structures as diverse as Behrens's AEG projects, van Eesteren's and van Doesburg's private villa, Rietveld's Schröder House, and Malevich's architectonics, Gropius created a building that captures the dynamic of lucid rationality characteristic of the machine aesthetic. The building consists of a skeleton of reinforced concrete enclosed by a glass curtain. As Sigfried Giedion points out, "The extensive transparent areas, by dematerializing the corners, permit the hovering relations of planes and the kind of 'overlapping' that appears in contemporary painting."[27] On the interior, Gropius used the open plan to unify public and private space. The governing purpose of the construction was the creation of an integral space that would promote professional cooperation and support communal living. As such, the Bauhaus was supposed to serve as a model of the ideal society that Gropius and his colleagues struggled to create.

As the unity of art and technology grew ever closer, there was a subtle but significant change from a spiritual to an economic justification for the new architecture. Without ever renouncing his utopian principles, Gropius increasingly stressed the efficiency and economy of "purifying . . . architecture from a welter of ornament." As the spirituality and idealism of a latent theoesthetic gave way to the rationality of functionalism, glass latticework appeared to be less the revelation of the Absolute than the reflection of the assembly line.

By emphasizing the economy of reason, Gropius indirectly returned to insights initially advanced by Adolf Loos in his classic essay "Ornament and Crime," published in 1909. Loos, a Czech who lived in Vienna at the turn of the century, worked in Chicago with Louis Sullivan from 1893 to 1896. Though Sullivan used ornament effectively to enrich the structural grid of his buildings, he was keenly aware of the dangers of excessive ornamentation. "It could only benefit us," he observes, "if for a time we were to abandon ornament and concentrate entirely on the erection of buildings that were finely shaped and charming in their sobriety" (SN, 168). Radicalizing Sullivan's reservations, Loos waged a lifelong war against ornamentation, in which civilization itself seems to be at stake. An early participant in the secession movement, Loos joined the revolt against the historical style of much late-nineteenth-century architecture. In an

influential article, published in the secessionist journal *Ver Sacrum*, he condemns Vienna's Ringstrasse "for screening its modern commercial truth behind historical façades."[28] In his architecture, Loos attempted to express the *commercial* truth of modern industrial society.

Loos's criticism of ornament is, in the first place, economic. The production of ornaments requires useless labor that indentures workers. "The producers of ornament," Loos argues, "must work twenty hours to earn the wages a modern worker gets in eight. Decoration adds to the price of an object as a rule, and yet it can happen that a decorated object, with the same outlay in materials and demonstrably three times as much work, is offered for sale at half the price of a plain object. The lack of ornament means shorter working hours and consequently higher wages" (OC, 229). On one level, the crime of ornamentation is a crime against the workers who produce it. But there are other levels of Loos's analysis.

Although there is no evidence of direct influence, it is hardly a coincidence that Loos developed his theory of artistic expression in Vienna at the same time that Freud was promulgating his theory of psychoanalysis. For Loos, as for Freud, "all art is erotic" (OC, 236). Anticipating Mondrian's cosmogonic interpretation of vertical and horizontal lines, Loos maintains that "the first ornament invented, the cross, was of erotic origin. The first work of art, the first artistic act, which the first artist scrawled on the wall to give his exuberance vent. A horizontal line: woman. A vertical line: the man penetrating her" (OC, 226). Loos places the development of artistic expression within an evolutionary scheme with which we have become familiar. Ornamentation is primitive or infantile, and modern design, which is characterized by the absence of decoration, is civilized or mature. "Cultural evolution," Loos concludes, "is equivalent to the removal of ornament from articles in daily use" (OC, 226–27). When repressed ornamentation returns in the modern world, it is a sign of either criminality or degeneracy.

> But the man of our own times who covers the walls with erotic images from an inner compulsion is a criminal or a degenerate. Of course, this urge affects people with such symptoms of degeneracy most strongly in the lavatory. It is possible to estimate a country's culture by the amount of scrawling on lavatory walls. In children this is a natural phenomenon: their first artistic expression is scribbling erotic symbols on walls. What is natural for a Papuan and a child, is degenerate for modern man. (OC, 226)

In this revealing passage, Loos extends the genesis of ornament from the erotic to the scatological realm. As Freud pointed out, the genital and the anal are not two separate physical and psychological domains but are different sites for the release of the same basic drives. Although Loos does not explain or develop his insight, his recognition of the interplay of sexuality and anality uncovers an additional valence to what Le Corbusier eventually labeled the "Brown World," which the "White World" of purist modern aesthetics tries to wipe away. Ornament, Loos concludes, is shit!

In a characteristically witty and ironic essay entitled "The Plumber," Loos goes so far as to suggest that "the plumber is the pioneer of cleanliness. He is the State's top tradesman, the quartermaster of civilization—the civilization that counts today."[29] The text is accompanied by an extraordinary set of drawings that depict an array of bathroom fixtures and plumbing devices, the chief of which is, of course, the toilet. In passages that invoke militaristic images and metaphors, Loos presciently declares that "German civilization has begun its triumphal progress over the whole globe." Contrary to expectation, the plumber is the one who is "the upholder of the Germanic way of life." The Kingdom to which the plumber leads his followers is one in which cleanliness *is* godliness. "The time is nigh, fulfillment awaits us!" decrees Loos. "Soon the streets of the city will glisten like white walls. Like Zion, the holy city, the capital of Heaven. Then, fulfillment will come!" On the streets of this city, there will be no refuse; on the white walls of its buildings, no shit will be smeared. All filth will be underground—in the sewers of the city . . . and of the mind. This is the purified "capital" for which Loos designed his sanitized buildings (fig. 4.16).

Loos's economic and scatological analyses of ornamentation can be understood as alternative versions of a single insight. Freud, after all, claimed that *money* is shit. If ornament is shit, and shit is money, then ornament is money. To remove ornament is to save money. Though Loos insists that his aesthetic *is not* ascetic, he consistently rejects every form of excess. Consequently, there can be no "expenditure without return."[30]

For ornament is not only produced by criminals; it itself commits a crime, by damaging men's health, the national economy, and cultural development. When two people live side by side with the same needs, the same demands

4.16 Adolf Loos, *Steiner House* (1910). Adolf Loos-Archiv, Graphische Sammlung Albertina, Vienna. © ARS, New York/VBK, Vienna, 1992.

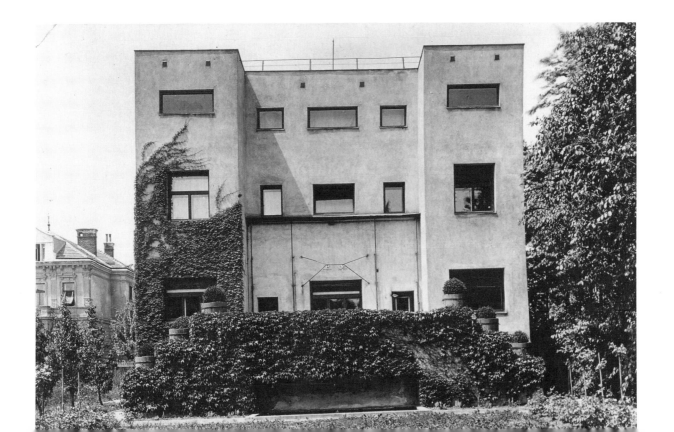

on life and the same income, and yet belong to different cultures, the follow-
ing process may be observed from the economic point of view: the man from
the twentieth century becomes ever richer, the one from the eighteenth ever
poorer. I am supposing that each lives according to his inclinations. The
twentieth-century man can pay for his needs with much less capital and
therefore save. The vegetables he likes are simply boiled in water and then
served with a little melted butter. The other man doesn't enjoy them until
honey and nuts have been added and someone has been busy cooking them
for hours. Decorated plates are very dear, while the plain white china that
the modern man likes is cheap. One man accumulates savings, the other one
debts. (OC, 228)

In this economy, spending costs and saving saves.

So understood, the economy of Loos's architecture re-presents the
economy of industrial capitalism. For this economy to function smoothly,
waste must be *eliminated* and efficiency promoted. Functionalism is more
than an aesthetic; it is a way of doing business and a style of life. "The law
of pure functionality," Theodor Adorno explains, "tolerates no surplus."[31]
The clean lines of the machine aesthetic express an ethic of frugality nec-
essary for the production of the capital required for investment. In contrast
to children and primitives, the prudent capitalist never invests without the
promise of a secure return.

It would be a mistake, however, to insist on a sharp opposition be-
tween the spiritual and economic aspects of early modern architecture.
As Max Weber demonstrated, the spirit of capitalism is inseparably bound
to the Protestant ethic. We have already discovered a link between Prot-
estantism and the emergence of modern architecture in the writings and
buildings of Le Corbusier. As Barth's reinterpretation of the transcendence
of the Calvinist God makes clear, Protestantism harbors a latent suspicion
of nature and history. When this distrust becomes explicit, it can lead to a
negation of the physical, material, and sensual aspects of existence. The
seeds of such asceticism are present in Lutheran doctrine of the two king-
doms. For Luther, as for Barth, the dialectical relation of the kingdom of
earth and the Kingdom of God always threatens to slip into a dualistic
opposition between the realms of darkness and light. Luther consistently
associated the filth of the fallen world with the rule of the Devil. In a
typical passage, he describes the struggle for redemption:

> Thanks be to the good God, who can so make use of the Devil and his wick-
> edness, that it must serve for our good; otherwise (were it up to his wicked
> will) he would quickly slaughter us with his knife, and stink us and stab us
> with his dung. But now God takes him into His hand and says: "Devil, you
> are indeed a murderer and a wicked spirit, but I will use you for my purposes;
> you shall be only my pruning-knife, and the world, and all that depends on
> you, shall be my manure-dung for my beloved vineyard."

While the work of the Devil is "to foul with excrement" (*bescheissen*), "the
function of the grace is to make us clean." "The fundamental aim of
Satan," Norman O. Brown explains, "is the same as the fundamental aim
of capitalism—to make himself *princeps mundi* and *deus huius seculi*. And

Luther sees the final coming to power in this world of Satan in the coming to power of capitalism."[32] From this point of view, to break the power of the Devil it is necessary to resist the spread of capitalism.

But not all Protestants follow Luther's prescriptions and proscriptions. In later versions of Calvinism, the will-to-purity is transferred from the other world to this world to create what Weber labels "worldly asceticism." The purpose of ascetic practice is the "conquest of nature"— human and otherwise. The achievement of this goal requires the constant policing of desire through the creation of a "rational" system of ethics that regulates erotic exchanges. In a remarkable analysis of Dutch Protestantism, which, as we have discovered, played a pivotal role in the development of the de Stijl aesthetic, Weber writes,

> The theater was obnoxious to the Puritans, and with the strict exclusion of the erotic and of nudity from the realm of toleration, a radical view of either literature or art could not exist. The conceptions of idle talk, of superfluities, and of vain ostentation, all designations of an irrational attitude without objective purpose, thus not ascetic, and especially not serving the glory of God, but of man, were always at hand to serve in deciding in favor of sober utility as against any artistic tendencies. This was especially true in the case of decoration of the person, for instance clothing. That powerful tendency toward uniformity of life, which today so immensely aids the capitalist interest in the standardization of production, had its ideal foundations in the repudiation of all idolatry of the flesh. (SC, 169)[33]

Weber joins Freud in anticipating Loos's association of ornament and eros. Puritanical asceticism removes excess, resists surplus, and eliminates waste. As Le Corbusier led us to suspect, the aesthetic of Protestantism is purism.

Purism, however, is not merely an other-worldly ideal. To the contrary, a purist aesthetic expresses the "sober utility" that is extremely *functional* in the modern world of capitalism. By controlling *excessive* expenditure, Puritan ethics and purist aesthetics encourage the efficiency required to make the capitalist machine run.

> The [Puritans'] campaign against the temptations of the flesh, and the dependence on external things, was . . . not a struggle against the rational acquisition, but against the irrational use of wealth. But this irrational use was exemplified in the outward forms of luxury which their code condemned as idolatry of the flesh, however natural they had appeared to the feudal mind. On the other hand, they approved the rational and utilitarian uses of wealth which were willed by God for the needs of the individual and the community. They did not wish to impose mortification on the man of wealth, but the use of his means for necessary and practical things. The idea of comfort characteristically limits the extent of ethically permissible expenditures. . . . Over against the glitter and ostentation of feudal magnificence which, resting on an unsound economic basis, prefers a sordid elegance to a sober simplicity, they set the clean and solid comfort of the middle-class home as ideal. (SC, 171)

The "clean and solid comfort" of the bourgeois home is the reward for work. The Protestant ethic is, of course, the work ethic in which labor

disciplines desire. Though the fundamental tenet of Protestantism is that salvation is granted by God's grace rather than achieved through human works, anxiety about their eternal destiny leads many believers to conclude that successful works can provide proof of one's faith. In this way, worldly success becomes a sign of the believer's other-worldly condition. As these remarks suggest, the place of work in the Protestant economy of salvation is complex. Work is both a means of self-discipline and a way to allay religious anxiety. This ambiguity leads to a paradox that fuels the fires of capitalism. The very struggle to control excess itself becomes excessive, thereby creating an excess that must be invested. The Protestant ethic entails a *prescription* for labor and a *proscription* on enjoyment. "In fact," Weber argues, "the *summum bonum* of this ethic, the earning of more and more money, combined with the strict avoidance of all spontaneous enjoyment of life, is above all completely devoid of any eudaemonistic, not to say hedonistic, admixture" (SC, 53). This coincidence of prescription and proscription is precisely what is required if capitalism is to grow. "When the limitation of consumption is combined with this release of acquisitive activity, the inevitable practical result is obvious: accumulation of capital through ascetic compulsion to save. The restraints which were imposed upon the consumption of wealth naturally served to increase it by making possible the productive investment of capital" (SC, 172). Weber recognizes what Freud was in the process of discovering in Loos's Vienna: the accumulation of a surplus eventually generates the need for expenditure.[34] The repression of eros creates profligacy in unexpected places. Citing the sage of "common sense," Benjamin Franklin, Weber points to what might be described as the "promiscuity of money." "Remember, that money is of the prolific, generating nature. Money can beget money, and its offspring can beget more, and so on. Five shillings turned is six, turned again it is seven and threepence, and so on, till it becomes a hundred pounds. The more there is of it, the more it produces every turning, so that the profits rise quicker and quicker" (SC, 49).

How is such profligacy to be controlled? In the financial world, as in the psychic economy, excess is managed by rational investment strategies. Desire is cathected and recathected; capital is invested and reinvested. The system of production and reproduction expands by absorbing the excess that the system itself creates. What saves the system is the savings of its workers. In other words, work saves and savings work.

But what is the price of such saving? Mies van der Rohe declares, "We will have simplicity, no matter how much it costs." The cost of purity and simplicity, however, can be *very* high. The process of civilization creates discontents that lurk just beneath the clear and clean surfaces and sharp right angles of modern art and architecture. Rational standards and universal norms that are supposed to liberate actually incarcerate. Constructions become prisons in which elegant grids are confining bars. Weber admonishes,

No one knows who will live in this cage in the future, or whether at the end of this tremendous development entirely new prophets will arise, or there will be a great rebirth of old ideas and ideals, or, if neither, mechanized pet-rification, embellished with a sort of convulsive self-importance. For of the last stage of this cultural development, it might truly be said: "Specialists without spirit, sensualists without heart"; this nullity imagines that it has attained a level of civilization never before reached. (SC, 182)

Those who begin as spiritual specialists end as specialists without spirit. The progress of civilization, which is supposed to realize humankind's utopian dreams, culminates in "nullity"—*das Nichts.*

In this purported economy of salvation, dis-figuring does not reveal the absolute or the divine but discovers nothing or almost nothing. For Malevich, Nothing is God. But not everyone shares this supreme faith. Nothing, after all, might be nothing other than nothing. Perhaps transpar-ency allows one to "see" the void that is blinding and "hear" the silence that is deafening. Gropius, as noted above, observes the "growing prepon-derance of voids over solids" in the new architecture. The question that remains is how to build a void that is not a plenum but a trace of *the* void. To fashion such a void would be to construct nothing or *beinahe nichts.*

In 1928 the Bauhaus again came under attack from the local govern-ment that had been supporting it. In an effort to preserve the school, Gro-pius decided to resign as director. The position was offered to Mies van der Rohe who, in the words of his biographer Franz Schulze, "was a man neither of the right nor the left, nor even of the center; he was an artist. Thus he could be expected to keep the political dogs at bay without com-promising the progressive standards of the school" (MR, 175).[35] But Mies declined the offer, and the post was eventually filled by the Swiss architect Hannes Meyer. Meyer's doctrinaire functionalism and unyielding Marx-ism deeply divided the Bauhaus faculty. Schlemmer resigned in 1929, and Kandinsky and Klee contributed less and less to defining and teaching the core curriculum. By 1930 the school's internal disarray had progressed to the point that Meyer was forced to resign. Mies was again offered the directorship and this time accepted the position. Having established his reputation as an architect who designed elegant homes for wealthy cli-ents, Mies's appointment was greeted with open opposition by Meyer's Marxist supporters. When rebellious students interrupted instructional activities, Mies did not hesitate to call on the Dessau police to evict the protesters.

But Mies could not save the Dessau Bauhaus. Weakened by internal dissension, the Bauhaus became susceptible to external pressures. With the growing power of the Nazi party, hostilities between the local govern-ment and the Bauhaus increased until the school was forced to close on October 1, 1932. Later that month, Mies relocated the Bauhaus from Des-sau to Berlin, where it was immediately attacked by the Nazis for alleged ties to the Communist party. On April 11, 1933, the Gestapo closed the

Berlin Bauhaus. Though Mies struggled to reopen the school, his efforts were in vain. On July 20 he conceded defeat and wrote to the Gestapo, "The faculty of the Bauhaus at a meeting yesterday saw itself compelled, in view of the economic difficulties which have arisen from the shutdown of the Institute, to dissolve Bauhaus Berlin" (MR, 186). This effectively marked the end of one of the most important chapters in the history of modern art and architecture.

The vehemence of the Nazi attack on the Bauhaus should not over-shadow the ambivalent relation between national socialism and modern art. "Right-wing *völkisch* sentiment saw the modern arts as pernicious and pathological, the expressions of a rootless *undeutsch* urbanism for which the International Jew was made the most readily fitting symbol. Yet Nazi thought could just as easily identify itself with modernity, with science, and with advanced technology" (MR, 187). Though the taste of the frustrated architect Hitler and his architectural deputy Albert Speer was decidedly classical, both men shared modernism's longing for order and, perhaps more important, desire for purity.[36] The perceived danger of disorder and pollution from within and without led to a "call for order" that resulted in the imposition of strict discipline on all areas of personal and political life. As my investigation of early modern painting and architecture has established, the response of artists and architects to fascism was no less equivocal. Sometimes persecuted and sometimes courted, artists and especially architects maintained ambiguous relations to the political events and movements of their day. Manifest differences between modernism and fascism can easily obscure their deeper affinities. To many who dreamed of personal and social renewal, fascism initially seemed to offer a ray of hope. Even when the brutality of the Nazi regime was exposed, many otherwise intelligent and sensitive people were reluctant to give up their illusions. In the case of architects, the situation was further complicated by their dependence on the government and publicly funded projects for commissions.

Throughout his struggle to preserve the Bauhaus, Mies maintained a complex relation to the Nazi party. Though he clearly rejected much of the Nazis' ideology and resisted the attack on modern art, Mies did not immediately repudiate national socialism. In 1933 he joined the Reichs-kulturkammer, which had been established by the propaganda minister, Joseph Goebbels.[37] Mies's membership in this group, which required proof of "racial purity," resulted in an invitation to submit a proposal to the competition for the German Pavilion at the 1935 Brussels World's Fair. The competition prospectus stressed the chilling aspirations of the government. "The exhibition building must express the will of National-Socialist Germany through an imposing form; it must act as the symbol of . . . National-Socialist fighting strength and heroic will." When Mies submitted his design to the Ministry of Propaganda and Enlightenment of the People, he included the following supporting statement:

> During the last years, Germany has developed a form for its expositions that more and more . . . progressed from exterior embellishment to the essential, to what an exposition should be, to a factual [*sachlich*] but effective visual display of things, to a real picture of German achievements. . . .
>
> Upon entering the German section, one reaches the hall of honor through a forecourt. This hall of honor, defined as it is by freestanding marble walls, serves to accommodate the national emblems and the representation of the Reich. It opens out into a court of honor, which will receive the best works of German art.

Mies's proposal won the competition, but financial difficulties prevented the construction of the building. While it seems unlikely that Mies supported the fundamental tenets of national socialism, there can be no doubt about his willingness to adapt his designs to the requirements of the Nazi regime. Shortly after the World's Fair competition, his public and private commissions came to an end. In 1933 Mies reluctantly left Berlin and resettled in Switzerland, where he lived and worked until he was invited to become the director of the architecture school of the Armour Institute in Chicago. When Mies left Switzerland for Chicago in 1936, architecture's center of gravity shifted from Europe to America.

Mies's circuitous journey to a position of leadership in international architecture began modestly. The son of a stonemason, he was raised in a pious Catholic family in the Rhineland. As a young boy growing up in Aachen, Mies was particularly impressed by the clarity and precision in the design of the local cathedral. In later years, when he attempted to define the task of the architect, Mies frequently returned to religious questions he had first encountered in his youth. "Architectural development depends upon how seriously these questions are stated and how clearly they are answered. Therefore, we hope that these questions will probe deeper and deeper and will be directed more and more towards the essence of things. We must get at the kernel of truth. Questions concerning the essence of things are the only significant questions. The answers a generation finds to these questions will be its contribution to architectural development" (SM, 95). Unlike many other modern artists and architects, Mies did not write much and resisted providing elaborate theoretical justifications for his work. Thus it is difficult to trace specific intellectual influences on the formulation of his ideas. It is obvious, however, that Mies was not drawn to the esoteric philosophy and religion that attracted so many in the early decades of this century. The one thinker who repeatedly returns in Mies's occasional remarks is Thomas Aquinas. While Mies does not seem to have had a very profound grasp of Thomistic theology, a few of Aquinas's basic ideas left a lasting impression on his thought and work. Looking back on his early investigations from the distance of half a century, Mies writes,

> We searched in the quarries of ancient and medieval philosophy. Since we knew that it was a question of truth, we tried to find out what the truth really was. We were very delighted to find a definition of truth by St. Thomas Aqui-

nas: "Adequatio intellectus et rei," or, as a modern philosopher expresses it in the language of today: "Truth is the significance of fact." I never forgot this. It was very helpful and has been a guiding light. To find out what architecture really is took me fifty years—half a century. (SM, 97)

What attracted Mies to Aquinas's theology was its *rationality.* Aquinas's world is thoroughly logocentric. As Franz Schulze points out, the German translation of *Adequatio intellectus et rei* is "die Übereinstimmung des Geistlichen und des Sachlichen." *Geist,* as we discovered in our investigation of Hegel, means both mind and spirit. According to the principles of theoesthetics, rational truth is spiritual and spiritual truth is rational. Thus the "kernel of truth" that reveals the "essence of things" can be cracked only by reason, which is made in the image of God. In Mies's reading, Thomistic theology approaches philosophical idealism. Even though appearances often seem to be irrational, nothing is insignificant. The "significance of fact" is captured in "the philosophical idea." This idea, in turn, is the *structure* that constitutes the foundation of the world. "I must make it clear," Mies explains, "that in the English language you call everything structure. In Europe, we don't. We call a shack a shack and not a structure. By structure we have a philosophical idea. The structure is the whole, from top to bottom, to the last detail—with the same ideas. That is what we call structure" (SM, 97). The task of architecture is to lay bare the foundation of the Real by building this ideal structure.

While creation, ideally, is rational, the architect is not always completely self-conscious. For Mies, as for Hegel, cultural development is guided by "the cunning of reason." Instead of an autonomous creator, the architect is a vessel of a self-surpassing idea that Mies labels "the great form." "To understand an epoch means to understand its *essence* and not everything that you see. But what is important in an epoch is very difficult to find out because there is a very slow unfolding of the great form. The great form cannot be invented by you or by me but we are working on it without knowing it. And when this great form is fully understood, then the epoch is over—then there is something new" (SM, 116). Like the legendary owl of Minerva, the architect takes flight as twilight descends. In this dialectical vision, the eve of one epoch is the dawn of a New Age.

Mies glimpsed this dawning era in the studio of Peter Behrens. Behrens's crystalline structures are, in effect, "temples of labor" that integrate modern technology and New Age idealism. Mies's early effort to create his own "polished crystal" in his contribution to the Turmhaus-AG's competition for a high-rise building near the Friedrichstrasse Station in Berlin not only reflects the influence of Behrens but also carries traces of the *Glasarchitektur* promoted by Taut and Scheebart (fig. 4.17). In contrast to many of his colleagues, however, Mies's interest in religion and philosophy did not lead to utopian hopes and schemes. From the outset, his work was characterized by a detachment that grew ever greater as the years passed. Even more influential than his work for Behrens was his affiliation

**4.17 Ludwig Mies van der Rohe,** *Friedrichstrasse Office Building Project* **(1921). Mies van der Rohe Archive, The Museum of Modern Art, New York.**

in the early 1920s with a remarkable Berlin group that included, among others, Hans Arp, Tristan Tzara, Man Ray, Walter Benjamin, and, most important for Mies, El Lissitzky and Theo van Doesburg. Van Doesburg, in particular, exercised considerable influence on Mies. The rejection of van Doesburg's call for the synthesis of painting and architecture did not prevent Mies from creating designs that bear a remarkable resemblance to certain neoplastic paintings. The 1924 plan for a brick country house reads like a virtual transcription of van Doesburg's *Rhythm of a Russian Dance* (figs. 4.18, 4.19). Later in the same year, Mies organized a German Werkbund exhibition that anticipated much of his mature work. Recalling Loos's influential essay, the title of the exhibition concisely summarizes architectural developments during the first quarter of the century and predicts the direction for the next twenty-five years: *Form ohne Ornament.* Mies had already begun to express his interpretation of "form without ornament" in his celebrated Barcelona Pavilion (fig. 4.20).

**4.18** *Below left* **Theo van Doesburg,** *Rhythm of a Russian Dance* **(1918). Oil on canvas, 53½ × 24¼ in. Edgar J. Kaufman, Jr., Fund, Collection, The Museum of Modern Art. VAGA, New York, 1991.**

**4.19** *Below* **Mies van der Rohe,** *Brick Country House* **(1924). Mies van der Rohe Archive, The Museum of Modern Art, New York.**

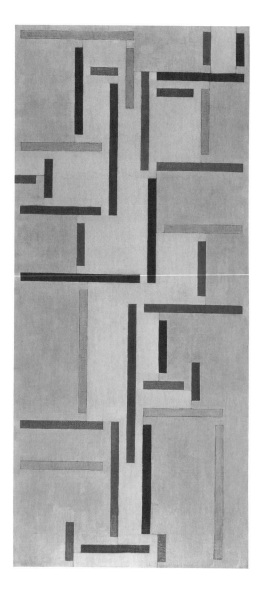

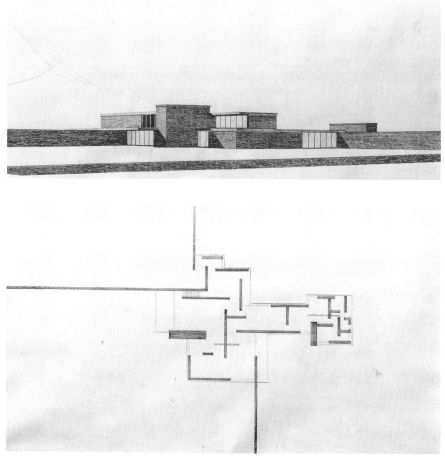

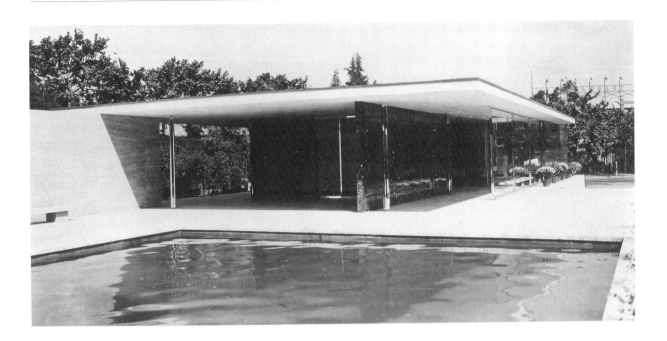

**4.20 Mies van der Rohe,** *German Pavilion at International Exposition* **[Barcelona Pavilion] (1929). Mies van der Rohe Archive, The Museum of Modern Art, New York.**

The pavilion transparently expresses the philosophical idea of structure that Mies regarded as the essence of architecture. The building, asymmetrically situated on a low podium, consists of a flat, cantilevered roof supported by eight steel columns that form three rectangular bays. The unadorned horizontal surface of the roof is repeated in a large uninterrupted vertical plane on the front facade of the structure. Two carefully integrated reflecting pools enrich the design without complicating the building. In the middle of one of the pools stands the bronze figure of a woman. This solitary sculpture, entitled *Evening,* was the work of Georg Kolbe. If the floor plan of the brick country house reflects a van Doesburg painting, the intersecting horizontal and vertical planes of the Barcelona Pavilion recall the formal patterns of some of Mondrian's most successful works. Though resolutely opposed to excessive ornamentation, Mies allowed himself the luxury of using extraordinarily rich materials in the construction of the pavilion. Tinian marble, onyx, travertine, and lightly tinted glass mingle to create an atmosphere in which opacity and transparency became indistinguishable. The building's opulence is enhanced in the free-flowing interior by the use of black carpets and scarlet drapes that frame the glass walls. In this work, Mies's formalist aesthetic created a sense of richness rather than poverty.

The very richness of the Barcelona Pavilion, however, suggests an incipient aestheticism that is concerned more with questions of form than with social problems and practical solutions. A passing acknowledgment of the importance of utility cannot hide the deeper commitments that inspired Mies's later work: "Architecture in its simplest forms is concerned primarily with the useful. But it extends from the almost purely practical, until in its highest forms, it attains its fullest significance as pure art" (SM, 103). When Mies moved to America, his already pure architecture became even purer.

Mies left whatever lingering utopian expectations he might have held in Europe. Two world wars crushed any hope for the imminent arrival of the New Age. As the migration of abstract painting from Europe to America resulted in a turn from outward and social change to inward and personal transformation, so Mies's American work is marked by an aestheticism in which architecture increasingly withdraws from the world. This retreat does not, however, signal the affirmation of an "other" world that is better than this one. Mies's negation is both more radical and more thoroughgoing. Beneath the thin veneer of his elegant structures lurks an unsettling vision of the void. Aestheticism becomes nihilism in an architecture that is, in Mies's own words, "beinahe nichts."

In America, Mies developed two basic building types in which he elaborated the formal structure of the Barcelona Pavilion. The first is vertical, the multistory gridlike structure; the second is horizontal, the single-story clear span. The first "ideal type" is illustrated by Mies's initial large-scale commercial development, which was commissioned by "a rabbinic scholar turned real estate developer, Herbert Greenwald" (MR, 239). The twin towers of Mies's Lake Shore Drive Apartments in Chicago provide the prototype for buildings that changed the cityscape in postwar America and Europe (fig. 4.21). In these two twenty-six–story buildings,

**4.21 Mies van der Rohe,** *Lake Shore Drive Apartments* **(1948–51). Photograph by Hedrich-Blessing (HB-13809). Courtesy Chicago Historical Society.**

**4.22 Mies van der Rohe,** *Farnsworth House* **(1946–51). Photograph by Hedrich-Blessing (14490 U). Courtesy Chicago Historical Society.**

Mies successfully fused the structural skeleton and the glass curtain to create an integrated whole. The transparency of the structure reflects the unity of interiority and exteriority. In the Lake Shore Drive Apartments, Mies realized several of his longstanding aims: "for one, a tall building in steel, its form deriving from the structure—a derivation he had never carried out in detail before, even on paper; for another, a work whose reduction to structural essence expressed the aspiration to universality he had associated with the modern sensibility" (MR, 243).

The second building type characteristic of Mies's American work is epitomized by the Farnsworth House (fig. 4.22). In this construction, Mies carried to completion patterns established in the Barcelona Pavilion. The structure is a rectangular glass box that is elevated five feet above the ground. Not only has all ornament been removed, but the rich materials of the pavilion are replaced by perfectly transparent clear-cut glass planes. The interior is a single open room with a central enclosed area housing bathrooms, kitchen, and a utility space. This is minimalist architecture at its most rigorous. In this case, the dematerialization of the architectural object *is not* its spiritualization. Emptiness is not fullness; absence is not presence. Manfredo Tafuri correctly argues that Mies created a space that is "a place of *absence,* empty, conscious of the impossibility of restoring 'synthesis.' "[38] In the space of this absence, glass, which had been the ideal material for the construction of utopian communities, becomes a barrier that separates rather than unites.

In Mies's later work the clear crystal of the New Age turns dark. As Malevich's "White on White" became a black square that was endlessly repainted in Reinhardt's "last paintings," so Le Corbusier's "White World," constructed to wipe away the "Brown World," and the transparency of Scheebart's *Glasarchitektur* became brown, gray, nearly black in

the Seagram Building (fig. 4.23). Three features of this remarkable structure are noteworthy in this context: its recession from the street, its elevation above ground level, and the materials used in its construction. In contrast to nearby buildings, this 516-foot prismatic skyscraper is set back from Park Avenue. In front of the structure there is a 90 × 150–foot plaza, which, like the Barcelona Pavilion and Farnsworth House, is elevated on a low podium. The open expanse is interrupted by two symmetrical pools with fountains in their midst. The effect of this recession is to create a feeling of isolation by separating the building from the surrounding city. "The plaza," Tafuri observes, "is intended to be the planimetric inversion of the significance of the skyscraper: two voids answering each other and speaking the language of the nil, of silence which—by a paradox worthy of Kafka—assaults the noise of the metropolis. The double 'absent structure' stands aloof from the city in the very act of exposing itself" (MA, 2:312).

The sense of aloofness is deepened by the elevation of the building. As we have seen, the use of elevation to accentuate the separation of structure and surroundings appeared as early as Le Corbusier's Villa Savoye. Mies employed the strategy of elevation with increasing effect in the Barcelona Pavilion and the Farnsworth House. In the Seagram Building, he combined the use of the podium and pilotis to double the building's withdrawal. Rather than an integral part of the city, the lofty prism becomes an aesthetic object that stands in splendid isolation. The materials used in the construction turn the building away from the world and toward itself. When transparent glass is replaced by opaque glass, lucidity becomes opacity. Instead of removing the barrier between interiority and exteriority, the darkness of the glass marks and remarks the margin separating inner and outer. The sober surface of the erect prism silently reflects the world that nosily passes by. Glass becomes a mirror in which reflection is transformed into reflexion. Like the abstract painter who turns from world to self, the architectural object turns away from the city and in on itself. But this inward turn discloses neither the Absolute nor the divine. To the contrary, it reveals nothing. "Here the absoluteness of the object is total. The maximum of formal structurality is matched by the maximum absence of images. That *language of absence* is projected on an ulterior 'void' that mirrors the first void and causes it to resonate. . . . Renunciation—the classical *Entsagung*—is definitive here. To articulate this renunciation, Mies takes a step backward and remains silent. The void as symbolic form—ultimate act of the European myth of Reason—has been reduced to a phantom of itself. Victory over anguish no longer has at its disposal the 'language of the soul,' as in the Kandinsky of the first use of abstract watercolors" (MA, 2:312). Void upon void . . . void reflecting void. Mies builds *the* void. In this void, *beinahe nichts* becomes *das Nichts.*

The language of absence is silence, which is the absence of language. The process of dis-figuring—be it in painting or in architecture—I have

**4.23** Mies van der Rohe, *Seagram Building* (1954–58). Photograph: Ezra Stoller © ESTO.

been arguing, erases signifiers in order to reveal the transcendental signified that is believed to be the Real. Within this ascetic economy, various strategies of negation are penultimate, for they always point to a surpassing affirmation. As abstraction approaches its end, however, an ominous possibility emerges: perhaps what negation affirms is negation itself. To affirm negation, and nothing but negation, is to affirm nothing. If the negation of signifiers ends by affirming that the transcendental signified is nothing, signs are not significant but are left to float freely in a world without security. This is the emptiness over which Mies suspended his buildings. "Where the avant-garde was projecting continuity, Mies designed separations. His architecture isolates itself off: meditation on the impossibility of dialogue, it reduces itself to a montage of signs that have mislaid, with never a trace of nostalgic regret, the universe of significance" (MA, 1:133).

The conclusion of abstraction inscribed in Mies's architecture exposes Rothko's subtle mistake. The author of the book Rothko found so fascinating late in life is not Søren Kierkegaard but Johannes de Silentio. As his name implies, Johannes writes without speaking; his words are the sounds of silence. The silence of the author reflects the silence of the transcendent God—the very same God that Barth rediscovered over half a century later. When God (or the Real), who is the ground of meaning, is "totally other," human discourse becomes insignificant and thus empty. There is no longer any firm foundation to ground our constructions. If radically construed, divine transcendence is indistinguishable from the death of God. This death is enacted in the postmodern world. In the wake of this death, signs are signs of nothing—nothing other than other signs. Those who come after modernism realize that *the danger of purity is nothing*. The questions that remain are, How to speak this silence? How to avoid speaking this absence? How to refigure disfiguring by figuring nothing?

**5**

*After you've painted a white dot on an all-white canvas,*
*where do you go from there?*
—MARC BRASZ

*If there is to be a psychoanalysis of money it must start from the*
*hypothesis that the money complex has the essential structure of reli-*
*gion—or, if you will, the negation of religion, the demonic. The*

# CURRENCY

*psychoanalytic theory of money must start by establishing the*
*proposition that money is, in Shakespeare's words, the "visible god";*
*in Luther's words, "the God of this world."*
—NORMAN O. BROWN

*A descriptive analysis of bank notes is needed. The unlimited satirical*
*force of such a book would be equaled only by its objectivity. For no-*
*where more naively than in these documents does capitalism display it-*
*self in solemn earnest. The innocent cupids frolicking about numbers,*
*the goddesses holding tablets of the law, the stalwart heroes sheathing*
*their swords before monetary units, are a world of their own: orna-*
*menting the façade of hell.*
—WALTER BENJAMIN

*Business art is the step that comes after Art. I started as a commercial*
*artist and I want to finish as a business artist. After I did the thing*
*called "art" or whatever it's called, I went into business art. I wanted to*
*be an Art Businessman or a Business Artist. Being good in business is*
*the most fascinating kind of art.*
—ANDY WARHOL

# 5 □ CURRENCY

**M**ODERNITY PURSUES currency. To "make it new" is to "render it current." To be current is to be of the *moment*—fashionable, up-to-date, in vogue—timely. Not to be current is to be unfashionable, outmoded, passé. For modernity, nothing remains the same; the current is ever-changing, ever-flowing. If modernity is to retain its currency, the new must be repeatedly renewed. Repetition lies at the heart of the new that forms the modern. But repetition is duplicitous, for it not only constitutes but also disrupts and dislocates the moment of modernity.

In the years following the Second World War, abstraction eventually lost its currency. Blank canvases and vacant buildings became nothing but blank and vacant. The spiritual aspirations and utopian expectations that informed the early stages of modernism disappeared in a formalism and aestheticism that increasingly lost touch with concrete personal and social experience. Instead of moving toward a synthesis, art and life were driven apart until art seemed preoccupied with an ideal realm that not only transcended but was irrelevant to historical actuality. This situation created the conditions for a reversal in the strategy of disfiguring. Rather than removing figures to dis-cover transcendent form or pure formlessness, artists began to disfigure the purity of modernist abstraction by refiguring canvases with the seemingly insignificant signs of postindustrial consumer culture.

This alternative strategy of disfiguring resulted from the failure of abstraction. As we have seen, in its first "moment" dis-figuring involves the effort to erase signifiers in order to reveal the transcendental signified. The *telos* of this process is a signified that is completely empty and totally vacuous. Contrary to expectation, the signified that is "wholly other" turns out to be an utterly insignificant sign. In the absence of a transcendental signified that grounds the meaning of signs, what remains are signs that are signs of other signs. No longer obsessed with transcendence, artists become preoccupied with immanence. The currency of the realm is no longer abstraction but (re)figuration in which the presence of the Real appears to be here and now. In the words of Annette Michelson, which I have previously cited, art becomes "a dream of absolute immediacy pervading our culture . . . , which replaces, in a secular age, a theology of absolute presence. The dream is figured on the reverse side of the idealist coin." More precisely, "the dream of absolute immediacy" is not so much a replacement of "a theology of presence" as its reinscription.

"Currency," of course, is also money. "Money," Andy Warhol exclaims, "is the MOMENT to me!" The "reverse side of the idealist" coin is a certain "materialism" that appears in postwar American art. The reasons for this shift are numerous. The emergence of the New York City gallery system for promoting and selling art, the rapidly expanding advertising and mass media industries, and the accumulation of discretionary income

that the middle and upper-middle class can use to purchase art contribute to what is commonly labeled the "commodification of the work of art." Such commodification takes two apparently opposite forms. In the first place, art becomes the repository of excess wealth. Accumulated capital is invested in artworks whose worth thereby increases. No longer the source of spiritual value, *l'oeuvre d'art* becomes a commodity whose worth is established by the forces of the marketplace. Not infrequently, the result of this investment strategy is the removal of the work of art from circulation. As valuable currency, the artwork is deposited safely in a bank vault. In the second place, and conversely, the commodification of the work of art leads not to its withdrawal from the currents of contemporary life, but to the excessive flow of "artistic" signs throughout the culture. Closely related developments in advertising and the mass media lead to the "aestheticization" of culture as a whole. Warhol's prescient observation is a bitterly ironic reversal of the aspirations of modernism. "Business art," he claims, "is the step that comes after Art. . . . Being good in business is the most fascinating kind of art."[1]

As art becomes a business, business becomes an art. These two developments are inseparably interrelated. *The commodification of the work of art* reflects and extends *the aestheticization of the commodity.* In order to appreciate the far-reaching implications of this claim, it is necessary to develop a response to Benjamin's call for "a descriptive analysis of bank notes." The aestheticization of the commodity involves a long and complicated transformation of money that is still underway. The changes associated with this transformation explicitly raise the questions that are implicit in all forms of currency: What does it mean to redeem? Is redemption possible? What redeems? Who redeems? In the wake of abstraction, can appearances be redeemed? Do appearances redeem?

The economy of art and the economy of religion unexpectedly intersect in the question of redemption raised by the problem of currency. As noted above, in his "classic" essay "The Painter and Modern Life," Baudelaire writes, "By 'modernity,' I mean the ephemeral, the fugitive, the contingent, the half of art whose other half is the eternal and the immutable." While high modernists seek "the eternal and immutable" in abstract form, so-called postmodernists turn from the ideal to "the ephemeral, the fugitive, and the contingent." The shift from the transcendent to the immanent *is not,* however, simply a movement away from the religious to the secular. To the contrary, the return of repressed figuration, which disfigures the purity of the abstract work of art, coincides with the death of the transcendent God, who reappears as radically incarnate in natural and, more important, cultural processes. The total presence of God here and now reverses but does not subvert the economy of modernism. The carnality and materialism that seem to mark the closure of modernity and the opening of postmodernity actually extend theoesthetics by establishing an immanent idealism of image. In this inverted economy, the *imago dei* becomes the *deus imaginis.*

It has become a cliché to insist that in modern society money is God. There is, however, more truth in this observation than is usually recognized. Throughout history money and religion share a surprisingly close relationship. Considerable evidence suggests that the origin of money is associated with religious rituals.[2] The word *money* derives from the epithet for Jupiter's sister and wife—Juno Moneta. As the warning goddess, Juno Moneta was best known for three "monitory tales: (1) she advised the Romans to sacrifice a pregnant sow to Cybele, to avert an earthquake; (2) she told them, when they feared for finances in the war against Pyrrhus, that money would never fail those whose cause was just; and (3) the geese that were crated for sacrifice in her temple at the city wall cackled and thus alerted the Romans to the intended surprise attack by the Gauls in 390 B.C.E. Roman coins were first minted in the Temple of Juno Moneta," thereby initiating the ancient practice of associating mints with temples. "The oldest altar to Juno Moneta was located on Mons Albanus, where a bull sacrifice, the central ritual of the Latin confederacy, was annually held."[3]

Other etymological clues suggest a link between money and ritual sacrifice. The German word *Geld* (money), Horst Kurnitzky points out, "means more or less 'sacrifice' [*Opfer*]. *Geld ist Geld, weil es gilt* [Money is money, because it is valid]. But in the eighth century, this verb *gelten* [to be valid] meant 'to sacrifice.' "[4] The Greek word *drachma*, which is the name of a common coin, once was used to designate a handful of sacrificial meat (*oblos*). In Latin *pecunia*, which is the root of the English *pecuniary*, derives from *pecus* (cattle). The association of money with sacrificial animals—especially cattle and bulls—is particularly suggestive. As is well known, the bull was commonly used in ancient ritual sacrifices. In Rome, the Mithraic cult, which was a serious threat to early Christianity, centered on the sacrifice of the bull, and in Greece, the god Dionysus was traditionally represented as a bull. In many of its forms, religion involves an economy of sacrifice in which the relationship between the believer and the god is established by the currency they share.

Within this sacrificial economy, the current flows in two directions: from worshipper to god and from god to worshipper. Ritual practices establish a system of exchange in which devotees offer sacrifices to secure protection and benefits from the gods. In the early stages of religious development, these offerings tended to be either human or animal sacrifices. In time, however, substitutions were introduced. At first, small figures of the sacrificial animals, which usually were made out of precious metals, and, later, coins bearing the images of the animals were offered to the gods. As the rituals were formalized, priests and other religious and political leaders prescribed the terms of exchange. Within this scheme, an established offering "purchased" certain benefits.[5]

A second equally important aspect of the economy of sacrifice is the communal meal. Anthropologists have long recognized the important role that sharing and eating the flesh of the sacrificial animal plays in the constitution of the religious community. The animal is not only an offering *to*

God but also an embodiment *of* the deity. Sacrifice, therefore, involves the death—or more precisely the murder—of God. As Freud maintains in his myth of social origins in *Totem and Taboo,* participants in ritual sacrifice attempt to share guilt and identify with the god by consuming the body of the deity. From this point of view, all culture is consumer culture. The portion of the animal's flesh the communicants receive was determined by each person's social status. An inscription in Attica from 330 B.C.E. defines the rules for distributing the flesh of the sacred bull.

> Five pieces each to the presidents
> Five pieces each to the nine archons
> One piece each to the treasurers of the goddess
> One piece each to the managers of the feast
> The customary portions to others

The practice of sharing sacrificial flesh explains why Moneta is also the name of the goddess Aequitas, who "represents the *equity* or fair apportionment which the state grants to its citizens." [6] It was not uncommon for the share of the bull's flesh to serve as a legal means of payment. At this point, the practice of substitution again intervened. Tokens, which often took the form of coins made of precious metal with the imprint of the sacred animal, replaced animal flesh. Within the sacrificial economy— and every economy is in some sense based on sacrifice—all money is blood money. Community is constituted by an act of "originary" violence in which the god who dies on the sacrificial altar is reborn or, quite literally, becomes incarnate in the social body. [7] The token of divine presence in the community is the coin of the realm that bears the *imago dei.* As Norman O. Brown points out, "The money complex is the heir to and substitute for the religious complex, an attempt to find God in things." [8] God, in sum, dies and is reborn as money.

The most sophisticated analysis of the socioreligious dimensions of money in the modern period was developed by Karl Marx. Though not immediately evident, Marx's interpretation of the origin and function of money bears many similarities to later anthropological studies. Money, Marx argues, is "the bond of bonds" that is "the direct incarnation of all human labor" (C, 92). As on so many other issues, Marx derived the main contours of his argument from Hegel. The Hegelian traces in Marx's analysis lead to an association between money and the Absolute or divine, which commentators and critics have overlooked. In his early essay entitled *Sittlichkeit,* or *System of Ethical Life,* Hegel argues that money represents labor. "The universality of labor or the indifference of all labor is posited as a middle term with which all labor is compared and into which each single piece of labor can be directly converted; this middle term, posited as something real, is *money.*" [9] As the middle term that mediates differences and oppositions, money plays the role that Hegel elsewhere assigns to the Absolute. Hegel's suggestion that money is the representation of the mediation of opposites indirectly points toward Marx's reinterpretation of Hegel's mature system. Marx develops his critique of political

economy by inverting Hegel's speculative idealism to create a dialectical materialism that is grounded in social practices. As Marx unfolds his analysis of money, however, he indirectly reintroduces the very idealism for which he criticizes Hegel. By so doing, Marx suggests, but does not develop, the way in which the commodity is aestheticized.

Money, Marx argues, is related to *surplus* or *excess*. In order to move beyond the level of subsistence existence, primitive social groups must produce more than they consume. The production of an excess results in the differentiation between use-value and exchange-value. For Marx, as for Freud, excess must be expended; what is not used is exchanged. The most rudimentary form of exchange is barter, in which one object is traded for another object. The difficulty with barter arises from what Lester Chandler describes as a "lack of double coincident wants." If one individual does not want the particular object possessed by the other in-dividual, exchange cannot take place. To move beyond a barter economy, it is necessary to find a *mediating third* through which particular products of labor and thus the individuals who possess them can be brought into reciprocal relationship.

The development of this relationship presupposes the implicit or ex-plicit formulation of a notion of representation in which the measure of value shifts from the thing itself to a shared standard of which the thing is a sign. From the time of Aristotle, this "transcendental signified" is labeled the "universal equivalent." Citing the words of Faust with which Freud concludes *Totem and Taboo,* Marx writes, "In their difficulties, our com-modity owners think like Faust: *Im Anfang war die That.* They therefore acted and transacted before they thought. Instinctively they conform to the laws imposed by the nature of commodities. They cannot bring their commodities into relation as values and therefore as commodities, except by comparing them with some other commodity as the universal equiva-lent" (C, 86). The commodity that serves as the universal equivalent is money. Marx uses an image to describe money which, in light of its re-appearance in later religion, art, and architecture, is more suggestive than he ever could have known: "Money is a crystal formed of necessity in the course of exchanges, whereby different products of labor are practically equated to one another and thus by practice converted into commodities" (C, 86).

While Marx never explicitly admits it, his analysis of money is a re-formulation of Hegel's interpretation of the Absolute. As we have seen in our consideration of theoesthetics, the Hegelian Absolute mediates oppos-ites by establishing the unity of differences. For Marx, the universal equivalent is "the unity of differences" that constitutes the medium of exchange.

> Commodities as use-values now stand opposed to money as exchange-value. On the other hand, both opposing sides are commodities, unities of use-value and value. But this unity of differences manifests itself as two opposite poles, and at each pole in an opposite way. Being poles they are as necessarily

opposite as they are connected. On the one side of the equation, we have an ordinary commodity, which is in reality a use-value. Its value is expressed only ideally in its price, by which it is equated to its opponent, the gold, as the real embodiment of its value. On the other hand, the gold, in its metallic reality, ranks as the embodiment of value, as money. Gold, as gold, is exchange-value itself. (C, 104)

Marx might well have used Kant's term for the work of art to describe money: money is *Mittelkraft*. As the mediating third that secures the unity of differences, money is the "metamorphosed shape of all commodities." Through a magic approaching alchemy, different things are, in effect, transformed into gold, which establishes "the equation of the heterogeneous" (G, 163). Marx expresses this equation formulaically:

$$\text{Commodity—Money—Commodity}$$
$$\text{C———M———C}$$

This equation summarizes the two moments of exchange: sale, in which commodity is transformed into money (C—M); and purchase, in which money is transformed into commodity (M—C). The transformational process is made possible by *currency*, which allows opposites to flow into each other.

Marx's logic of exchange reinscribes Hegel's logic of speculation. In *Science of Logic* Hegel describes the structure of the Absolute as a syllogism in which individuality and particularity are mediated and thus united in and through universality. Anticipating Marx, Hegel summarizes his conclusion with a formula:

$$\text{I—U—P}$$
[Individuality—Universality—Particularity]

> The middle term of this syllogism is indeed the unity of the extremes, but a unity in which abstraction is made from their determinateness; it is the *indeterminate* universal. But since this universal is at the same time distinguished as *abstract* from the extremes as *determinate*, it is itself still a *determinate* relatively to them, and the whole is a syllogism whose relation to its Notion has now to be considered. The middle term, as the universal, is the subsuming term or predicate to *both* its extremes, and does not occur once as subsumed or as subject. Insofar, therefore, as it is supposed to correspond, as *species* of syllogism, to the syllogism, it can do so only on condition that when one relation I—U already possesses the proper relationship, the other relation U—P also possess it. (SL, 678) [10]

The *species* of the syllogism is money, and coined money is "specie." "Specie," in turn, can also designate "either of the consecrated elements of the Eucharist." Within the machinations of the Logos, the process of transubstantiation extends from bread and body, as well as wine and blood, to paper and gold. So understood, the speculative economy that grounds both Hegel's idealism and Marx's materialism is essentially sacrificial.

Marx recognizes the incipient idealism of his analysis of currency. He acknowledges that money "as the medium of circulation becomes coin, mere vanishing moment, mere *symbol* of the values it exchanges." "After money is posited really as commodity, the commodity will be posited ideally as money" (G, 790, 80). From Marx's point of view, such idealism is dangerous. There is a "tendency of circulation to convert coins into a mere semblance of what they profess to be" (C, 126). This change begins a process of separation between coin and value, or, in different terms, image and thing, or signifier and signified. The disjunction of appearance and "reality" releases a chain of substitutions through which the expenditure of surplus is repeatedly displaced.

> The fact that the currency of coins itself effects a separation between their nominal and their real weight, creating a distinction between them as mere pieces of metal on the one hand, and as coins with a definite function on the other—this fact implies the latent possibility of replacing metallic coins by tokens of some other material, by symbols serving the same purposes as coins. . . . Silver and copper tokens take the place of gold in those regions of the circulation where coins pass from hand to hand most rapidly, and are subject to the maximum amount of wear and tear. . . . The weight of metal in the silver and copper tokens is arbitrarily fixed by law. When in currency, they wear away even more rapidly than gold coins. Hence their functions are totally independent of their weight, and consequently of all value. The function of gold as coin becomes completely independent of the metallic value of that gold. Therefore things that are relatively without value, such as paper notes, can serve as coins in its place. This purely symbolic character is to a certain extent masked in metal tokens. In paper money it stands out plainly. (C, 126)

The process that Marx charts can be described as the *dematerialization of the token of exchange*. As currency develops, the medium of exchange changes from the thing itself (for example, a bull) to gold, to gold coins, to silver and copper coins, to paper. As Georg Simmel explains in his extraordinary book *The Philosophy of Money*, "Money passes from the form of directness and substantiality in which it first carried out [its] functions to the ideal form; that is, it exercises its effects merely as an idea which is embodied in a representative symbol."[11] This dematerialization or idealization is an aestheticization in which the thing becomes a symbol or image. The threat that Marx sees in the separation of signifier and signified is the possibility of confusing semblance with reality. "The only difference, therefore, between coin and bullion, is one of shape, and gold can at any time pass from one form to the other. But no sooner does coin leave the mint than it immediately finds itself on the high-road to the melting pot. During their currency, coins wear away, some more, others less. Name and substance, nominal weight and real weight, begin their process of separation" (C, 125). Paradoxically, the disappearance of the image from the face of the coin creates the possibility for the image to return as the "thing itself." Several decades later, Nietzsche uses the figure of the worn coin to describe the reversal through which illusory appearances are mistaken for the substance of reality.

> What, then, is truth? A mobile army of metaphors, metonyms, and anthro-
> pomorphisms—in short, a sum of human relations, which have been en-
> hanced, transposed, and embellished poetically and rhetorically, and which
> after long use seem firm, canonical, and obligatory to a people; truths are
> illusions about which one has forgotten that this is what they are; metaphors
> that are worn out and without sensuous power; coins that have lost their
> pictures and now matter only as metal, no longer as coins.[12]

When metaphors and metonymies become the currency of exchange, re-
ality itself becomes aesthetic. Although Marx recognizes the demateriali-
zation of money, he does not develop an account of the aestheticization
of the commodity.

Marx does, however, note that "Robinson Crusoe's experiences are a
favorite theme with political economists" (C, 76). Three years after the
appearance of the second edition of *Capital,* David Wells published a fas-
cinating book entitled *Robinson Crusoe's Money.* Wells's work is a defense
of the gold standard, which is presented in the form of an imaginative
narrative about the experiences of Robinson Crusoe and his fellow
islanders.

In the years following the Civil War, debate about the gold standard
raged throughout the United States. To finance the war, the government
suspended the gold standard that had been established by the Coinage Act
of 1792.[13] Currency issued without gold backing was called "greenbacks,"
which supporters of the gold standard dubbed "fiat money." In one of the
illustrations that Thomas Nast contributed to Wells's book, a coin bearing
the figure of an eagle and the inscription "United States of America . . .
Specie" casts a shadow that is labeled "greenbacks" (fig. 5.1). The caption

**5.1 Thomas Nast,**
*A Shadow Is Not a
Substance.*

to the drawing reads, "A Shadow Is Not a Substance." The substance of currency, according to Wells, is gold. Gold, he insists, is not an arbitrary sign but is the "truth" that secures the value of every signifier. In another sketch, Nast depicts a gold coin superimposed on a crowing cock standing atop a pile of rubbish and heralding the sunrise of "Truth" (fig. 5.2).[14] Wells entitles this illustration "The Survival of the Fittest." Among the debris under the cock it is possible to discern everything from soap, hats, and shoes to laws, acts of Congress, decisions by the Supreme Court, and bluebacks. Most interestingly, near the bottom of the rubbish heap, Nast inserts the skull of a bull. As truth itself, gold, it seems, is the authentic substitute for the (sacrificial) bull.

Within Wells's socioeconomic Darwinism, the value of gold is natural rather than conventional. In contrast to every other token of exchange, gold possess an "inherent" value, which makes it "the object of universal desire."[15] To demonstrate the absolute worth of gold and thus establish the necessity of the gold standard, Wells plots the evolution of the island's economy from a "primitive" to a "civilized" level. As the islanders progress from local trade and barter to commerce with the rest of the world, certain disadvantages of gold become evident. In addition to being cumbersome, gold is susceptible to theft. To protect themselves from the threat of robbery, the islanders develop a monetary system in which bank notes are exchanged instead of gold. For Wells, as for Marx, the introduction of paper currency brings with it unavoidable difficulties. These problems become explicit in the most provocative and humorous chapter of the story, "War with the Cannibals, and What Came of It."

Wells's war is a parody of the Civil War. To lead them in the war against the cannibals, the islanders elect a group of philosophers who, significantly, specialize in oratory and rhetoric. Having recognized the truth of Marx's observation that "the printing press . . . is inexhaustible and works like magic," the philosophers finance the war by printing more money whenever the need arises. From the point of view of the rhetoricians, all money is fiat money that is produced by decree or social convention. Inasmuch as value is imaginative rather than real, money is a fiction. Currency, in other words, is an aesthetic creation, which, in the final analysis, is indistinguishable from the work of art. In a remarkable drawing, Nast represents a hand extending a note to a stuffed doll upon whose belt is written: "INFLATED Humpty Dumpty" (fig. 5.3). On the wall behind the doll various bills are posted that read, "This is not a Rag Baby but a Real Baby by act of congress"; "This is R. R. stock . . . "; "This is money by the act of congress"; "This is money by the act of cannibals." In addition to these bills, there are two other drawings within the drawing. The first is the image of a house that bears the inscription "This is a House and Lot by act of the architect." The second is a picture of a cow surrounded by the words "This is a COW by the act of the artist." On the note that is offered to the doll the following words appear: "This is MILK by act of con." Not an act of Congress, but an act of *con*. Wells's meaning is per-

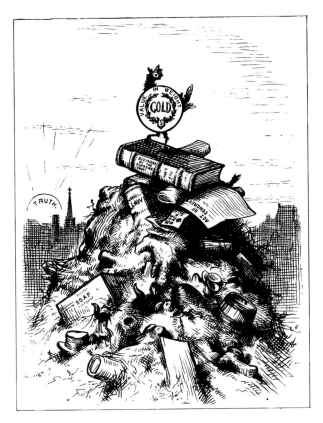

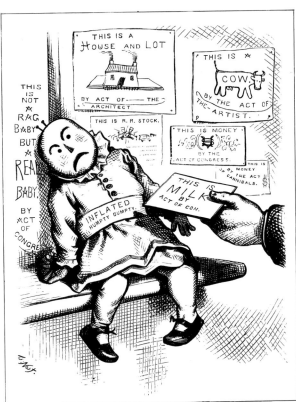

**5.2** *Above* **Thomas Nast,** *The Survival of the Fittest.*

**5.3** *Above right* **Thomas Nast,** *Milk Tickets for Babies, in Place of Milk.*

fectly clear: paper currency involves the aestheticization of the commodity in which the token of exchange becomes a work of art. Money and art meet in the (sacred) cow whose fictive value is established by "the act of the artist." Far from sanctioning the aesthetic strategies of the philosophers, Wells regards the play of signs not secured by gold as an elaborate con game. To avoid the disastrous consequences of mistaking illusions for reality, it is necessary to "get sober" by accepting certain "hard economic truths." The most basic of these truths is the necessity of a return to the gold standard. Only on such a secure foundation, Wells concludes, can a stable economy be built.

In 1879 the United States government accepted the advice of Wells and others and restored the convertibility of paper currency to gold. By 1880 the gold standard had evolved into an international monetary system that was supported by all major countries. With the outbreak of World War I, however, wartime exigencies again led to the suspension of the gold standard by many countries. "The United States maintained gold convertibility of the dollar, but since other currencies were no longer convertible into dollars, the U.S. dollar in effect floated against them."[16] With the collapse of the banking system during the Depression, the United States followed other nations and again revoked the gold standard. The financial chaos that resulted from this action plunged international trade and finance into confusion and decline that were reversed only after the Second World War.

One of the major reasons for the postwar economic recovery was the development of an international monetary system. Several years before the end of the war, England and the United States began negotiations that eventually led to the 1944 Bretton Woods agreement. In an effort to restore a semblance of order to international markets, fixed exchange rates were instituted by linking all major currencies to the United States dollar and establishing the convertibility of the dollar into gold at a fixed price. This arrangement functioned reasonably well until 1971, when in response to international pressures President Nixon ended the convertibility of the dollar into gold.[17] The efforts of the international community to preserve fixed rates of exchange in the absence of any vestige of the gold standard proved futile. In 1973 fixed exchange rates gave way to floating rates of exchange. With this development, it became undeniable that money is not the sign of a stable "transcendental signified" but is really nothing but a sign of a sign. No longer bound to a secure referent, currency is a floating signifier whose value is relative to other floating signifiers. In this groundless economy, currency is the free flow of unanchored signs.

By 1973 the aestheticization of the commodity had progressed far beyond what Marx could have imagined. Not only had currency become unredeemable, but money had become even more immaterial. With the emergence of plastic charge cards in the late 1950s and early 1960s[18] and the introduction of computers into the financial network, money became electronic. Currency, in other words, evolved from electrum (i.e., "the material substance of the ingots of which coins were made"[19]) to electricity. Electronic money is pure image, which is nothing but the play of fleeting figures on a video screen. The current that runs this economy is the fluctuating flow of electricity. The spark of electricity is a trace of the fiery current that the first philosopher of flux identified with the essence of things. "All things," Heraclitus maintains, "are an equal exchange for fire and fire for all things, as goods are for gold and gold for goods."[20] Unlike Heraclitus's flux, the current that runs the electronic economy is not undifferentiated but is structured like a language. Computers can only "speak" a language, which, like Hegel's Absolute and Lévi-Strauss's structures, is patterned in terms of binary oppositions. Even the most current ledgers have only two columns: credit and debit—plus and minus.

When money becomes electronic, the universal equivalent is transformed into the circulation of electric current. Within this flow, currency is, in Marx's terms, a "vanishing moment" that marks the "appearance of disappearance" (G, 790). What disappears in this freely floating currency is the transcendental signified that grounds value. Insofar as gold functions in the economic system in a manner analogous to the way God functions in the religious system, the end of the go[l]d standard is the economic equivalent of the death of God. Without secure backing, value becomes relative, constantly changing, and shifting. Instead of an independent reality of intrinsic worth, the "real"—God, the sacred bull, the

thing itself, gold—is a signifier . . . image . . . figure. Insofar as the real is figural, the figural is, in some sense, real. But in what sense can figures be real? In the absence of standards that are as good as gold, how can appearances be redeemed?

The cover of the 1966 Easter edition of *Time* magazine was a black monotone with three words printed on it in bright red letters: "Is God Dead?" By the mid-sixties, the spread of what Harvey Cox dubbed "the secular city" had begun to raise serious questions about the viability of religious faith in the modern world. Deep-going doubt was not merely an academic affair but a practical concern for a growing number of people. The *Time* article begins by asking,

> Is God dead? It is a question that tantalizes both believers, who perhaps secretly fear that he [*sic*] is, and atheists, who possibly suspect that the answer is no.
>   Is God dead? The three words represent a summons to reflect on the meaning of existence. No longer is the question the taunting jest of skeptics for whom belief is the test of wisdom and for whom Nietzsche is the prophet who gave the right answer a century ago. Even within Christianity . . . a small band of radical theologians has seriously argued that the churches must accept the fact of God's death, and get along without him.[21]

The most important of the radical death-of-God theologians is Thomas J. J. Altizer. The 1966 publication of his *Gospel of Christian Atheism* unleashed a debate that still rages in theological circles. In subsequent articles and books, Altizer continues to develop and refine the position he initially advanced in the mid-sixties. Although consistently described as a "radical theology," Altizer's position is not, in fact, a novel departure from the Western religious tradition. To the contrary, his theological vision represents a reworking of Hegel's most basic insights.

Altizer's program must be understood in the context of the neoorthodoxy that dominated theological discourse during the first half of this century. As we have discovered, Karl Barth initiated a new theological era with the proclamation of the thoroughgoing transcendence of God. When Altizer declares the death of God, it is really the death of the Barthian God that he announces. Altizer's No to Barth's No is at the same time a Yes to a radical immanence in which every vestige of transcendence disappears. In Hegelian terms, the negation of negation issues is a total affirmation that overcomes all traces of unreconciled otherness. Within Altizer's apocalyptic vision, the death of God is the condition of the possibility of the arrival of the Parousia. When the Kingdom of God is at hand, divine presence is totally realized *here and now.*

The title of the *Time* article on the death of God captures the subtext of Altizer's theology: "Toward a Hidden God." For Altizer, the death of God *is not* the mere negation of the divine. To the contrary, the disappearance of the transcendent God is the appearance of the totally immanent divine. Paradoxically, the "hidden" God is the God who appears com-

pletely in and as the appearances of the world itself. For dialectical vision, transparent visibility is perfect invisibility, and vice versa. In the absence of the "wholly other" God, mundane appearances do not point beyond themselves to a transcendent reality that lends them value and significance. Appearances are the appearance of nothing other than themselves. Altizer agrees with Nietzsche's insistence that transcendence effectively negates the importance of the world in which human beings are destined to dwell by situating meaning and value in a beyond that can never be reached. From theologians like Barth to artists like Mondrian and Reinhardt and architects like Le Corbusier and his followers, the belief in transcendent reality results in a nihilistic rejection of material, sensual, and carnal life. According to Altizer, the incarnation reveals that truth is *embodied* in the ever-changing currents of the material and historical world. Altizer's theology is a radical Christology in which the death of the Father is the birth of the Son. Following Hegel, Altizer argues that the truth disclosed in Christ is universal rather than particular. When fully comprehended, the incarnation does not merely involve a single historical figure but is an all-encompassing kenotic process through which the infinite empties itself into the finite. From Hegel's and Altizer's dialectical perspective, the descent of the infinite into the finite is at the same time the elevation of the finite to the infinite. Though the death of God initially seems to be the disappearance of the center and ground of value, which inevitably leads to nihilism, it turns out to be the negation of negation of life that is the *redemption* of appearances. Within Altizer's economy of salvation, the death of God redeems appearances, and appearances are redemptive. In terms that mix the insights of Hegel and Nietzsche, Altizer proclaims the good news of his "gay wisdom."

> This new Dionysian redemptive way is nothing more and nothing less than the proclamation and the dance of Eternal Recurrence. Yet this is a uniquely modern or postmodern identity of eternal recurrence, for it reverses the archaic symbol of eternal return by both apprehending and creating an Eternity or "Being" which *is* the pure immanence of a present and actual moment. That pure immanence dawns only when the Eternity and the Being of our past have been wholly forgotten, only when God is dead. Then and only then is that center everywhere whereby and wherein "Being begins in every Now." [22]

The eternal presence of this Now is the Being for which modernity—even in the guise of a certain postmodernity—longs. [23]

Despite the profound similarities between their positions, Altizer diverges from Hegel on several important points. In this context, the most significant difference concerns the relation of philosophy to religion and art. As we have seen, Hegel maintains that philosophy brings to completion the truth represented first in art and then in religion by rendering artistic and religious images in philosophical concepts. Altizer reverses Hegel's argument by translating speculative wisdom into religious images that reach fulfillment in modern art. Though Altizer frequently alludes to

the importance of the visual arts in the development of humankind's experience and self-consciousness, he offers his most insightful remarks in a brief but important book that bears the revealing title *Total Presence*. In the following passage, Altizer briefly summarizes his interpretation of the development of twentieth-century painting:

> At first glance Cubism seems to be a resurrection of archaic art, but we soon realize that the faces in cubist painting do not embody a primordial presence. The faces of the women of Picasso's *Les Demoiselles d'Avignon,* while exhibiting a progression from naturalistic to violently distorted visages, embody even if in a reverse form the primal impact of an interior and individual center of consciousness. Just as Cubism was made possible by Cézanne, it carries forward the tradition of Western painting, even if the object of that painting is now realized in a truly new form and identity. Perhaps we will someday come to understand that there is no greater distance between Picasso and Leonardo than there is between Leonardo and Giotto, for just as the portraits of the High Renaissance transcend the form established by the human icons of Giotto, modern painting has broken through the forms established by the Renaissance. Yet it is crucial to note that it has broken through them and not simply dissolved them, for if modern art has become a universal art in our world, it nevertheless has never ceased to embody its Western ground and origin. . . . When fully realized, as in the late paintings of Barnett Newman, abstract art seems to pass into nonart, for it dissolves the frame of the easel, passing into the world beyond it, and that world is a purely and totally anonymous world.[24]

For Altizer the development of art and religion is strictly parallel. As the death of God ends the separation between the divine and the mundane by revealing the sacrality of nature and culture, so the end of art as a domain transcending everyday experience leads to the aestheticization of the world. Within the Hegelian dialectic to which Altizer is committed, opposites coinhere in such a way that everything reverses itself in the course of its own development. The infinite becomes the finite and the finite becomes infinite; the sacred becomes profane and the profane becomes sacred; art becomes nonart and nonart is aestheticized. As the above passage indicates, Altizer believes this process culminates in "high" modern art, which comes to completion in abstract expressionism. With the disappearance of the frame from the modern *oeuvre d'art,* art and world become one. Since there is nothing beyond appearances, art embodies figures that are not only real but are the "real itself." In the absence of any beyond, representation becomes presentation.

Altizer's reworking of Hegel's dialectical interpretation of philosophy, religion, and art underscores important developments in modern society and culture. However, his commitment to so-called high modernism and his overt hostility to postmodern consumer culture blinds him to the significant changes that have taken place in the last quarter century. Although Altizer insists on the importance of concrete historical analysis, his unyielding use of speculative dialectics renders his account of cultural development suspiciously abstract. Altizer resists the careful analysis of contemporary society and culture that would force him to revise his

position. It is as if history literally ended in the mid-sixties and every-thing that has transpired since then is nothing but the eternal return of the same.

But the situation is even more perplexing. It is not clear that Altizer fully understands the most significant implications of his own position. This shortcoming is reflected in his failure to recognize the importance of post–abstract expressionist art. At the time Altizer was developing his death-of-God theology, Robert Rauschenberg, Jasper Johns, and Andy Warhol were charting a new course for art. These seemingly disparate theological and artistic innovations are not unrelated. It is not "high" modernism or abstract expressionism but modernist postmodern art that most powerfully figures the death of God. Religious and artistic develop-ments are, of course, mediated by economic transformations that have taken place since the end of World War II. While the death of God is the theological equivalent of the aestheticization of the commodity, the com-modification of the work of art in post–abstract expressionism—and es-pecially in pop art—is the artistic translation of the death of God. It remains to be seen exactly how the religio-economic trends we have been considering are expressed artistically.

In the summer of 1990, the far-reaching implications of the aestheti-cization of the commodity were dramatically displayed at the very site where Marx wrote *Capital.* The British Museum mounted a timely and provocative exhibition entitled "Fake? The Art of Deception." The mate-rials included in the exhibition covered an extraordinary range: from an-cient to postmodern, from visual to verbal, from "high" to "low" culture. In his introduction the editor of the catalogue, Mark Jones, who, it is important to note, is the assistant keeper in the Department of Coins and Medals at the British Museum, suggests the justification for this unusual exhibit.

> *Fake?* is an exhibition about deception, or rather the material evidence of the
> myriad deceptions practiced by men upon their fellows over three millennia.
> It is a record of human frailty, of the deceit of those who made fakes and of
> the gullibility of those who were taken in by them—a curious subject at first
> sight for exhibition in the British Museum. Yet it can be argued that fakes,
> scorned or passed over in embarrassed silence by scholar, dealer, and collec-
> tor alike, are unjustly neglected; that they provide unrivalled evidence of the
> values and perceptions of those who made them, and of those for whom they
> were made.[25]

It is no accident that the question of fakery arises at this particular histori-cal moment. A century that began with the search for authenticity and originality ends in a play of figures, images, and signs that renders prob-lematic the very notions of the authentic and original. An uncertainty pervades the British Museum's exhibition. Its title is, after all, a ques-tion: "Fake?" Indeed, the entire display is a sustained interrogation in which once-stable oppositions begin to oscillate: original/copy, authentic/

fake, genuine/counterfeit, object/interpretation, production/reproduction. David Lowenthal stresses the unprecedented questions that recent technological advances raise about the status of the work of art.

> Several trends combine to give faking and the problem of authenticity their present salience: technical advances; the commodification of culture; the popularisation of art and antiquity; the devaluation of originals and of objective truth; the historicizing of values.
>
> Technology has simultaneously promoted the skills of forgery and of its detection, while ever increasing the numbers of works of art and antiquity come under scrutiny. . . . Improved reproductive techniques also alter attitudes toward fakes. Mass-produced objects detectable as replicas only by scientific analysis invalidate time-honored reasons for preferring originals and raise doubts about the very concept of faking. While unmasking forgeries or confirming attributions, technology also casts doubts on the criteria used to assess authenticity and subverts the traditional primacy of artifacts. In recent museum displays interaction blurs the line between original objects and later interpretations.[26]

Given these developments, it probably was inevitable that faking and counterfeiting eventually would become the subject of art. One of the least conspicuous works in the exhibition poses the question of art in the age of mechanical reproduction in a particularly effective way: J. S. G. Boggs's *$10 Bill* (fig. 5.4).

Three years prior to "Fake? The Art of Deception," the British Museum sponsored an exhibition about money in which the portraits that the Bank of England engravers had copied were displayed beside the paper currency. Boggs recounts his experience while visiting the exhibition.

> The other day, I was at the British Museum. They currently have up an exhibition of British banknote design through the ages, of all things, and it's got some terrific items, including the actual portraits that the Bank of England used as models for the etched portraits on the current bills. So who's copying whom? Anyway, they also have several glass cases filled with wonderful ex-

**5.4 J. S. G. Boggs, *$10 Bill B28021991B* (1991). Ink on basingwerk paper, 18 × 40 in. Photograph: Vrej Baghoomian Gallery, New York.**

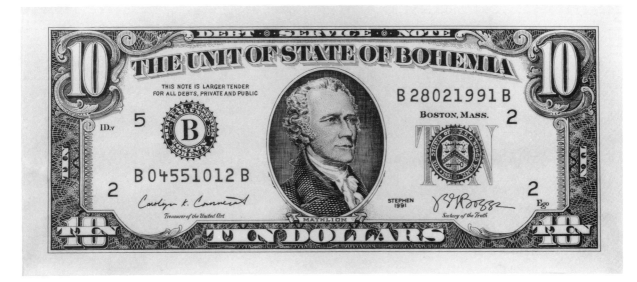

amples of classic, long-abandoned banknotes. I took out my sketching pad and started to draw some of them. Really beautiful things. Suddenly, a woman came over to me and told me I was to cease and desist—it was against the law to draw British currency. I said, "Oh, yeah?" And anyway these bills were two hundred years old, for God's sake. I ignored her and went back to work. About half an hour later, a big bouncer type came over and said, "Hello, Mr. Boggs. We're not supposed to be here are we?" And he proceeded to throw me out. It was as if they'd been expecting me. (BB, 243–44)[27]

At the time this encounter took place, Boggs had achieved considerable notoriety in England. He was about to go on trial on charges of counterfeiting. In October 1986 the police raided the opening of an exhibition at the Young Unknowns Gallery in London and confiscated four of Boggs's drawings—a ten-pound note, a five-pound note, and two one-pound notes. Though the authorities decided not to press charges, the Bank of England initiated private criminal proceedings, which resulted in a trial in November 1987. Despite the best efforts of the bank, Scotland Yard, and a partial judge, Boggs was eventually acquitted of the charges. The trial and the events surrounding it underscore the importance of the issues at stake when art and economics intersect.

Boggs's journey to the dock in Old Bailey began innocently enough. While in a coffee shop in Chicago in 1984, Boggs was absentmindedly doodling on his napkin when a waitress, struck by his sketch of a dollar bill, asked if he would sell her his drawing. Without any premeditation, Boggs refused but offered to pay for his coffee with it. After giving the waitress the napkin, Boggs recalls, "I got up to leave, and she called out, 'Wait a minute. You're forgetting your change.' And she gave me a dime. We smiled and I walked out" (BB, 189). Thus began an artistic strategy that Boggs refined in the following years. The first place his efforts met with widespread success is the home of international finance—Switzerland. The Swiss were so eager to acquire Boggs's bills that "counterfeits" of his "counterfeits" immediately started to appear. Faced with this situation, Boggs and his collectors were forced to find ways to "authenticate" his fake bills.

Following the pattern established with the Chicago waitress, Boggs refuses to sell his drawings of money. Instead of offering his bills for sale, Boggs uses them in economic transactions of precisely the kind conducted in the Chicago coffee shop. He exchanges the drawing of money for goods or services and requires, in addition to the item purchased, the proper amount of change and a "genuine" receipt. It is important to stress that Boggs makes it perfectly clear that what he is offering is a drawing and not "real" money. Not less than twenty-four hours after the exchange, Boggs informs interested collectors that he has conducted a transaction and offers to sell them the receipt and sufficient information to locate the person who possesses the bill. It is then up to the collector and the owner of the drawing to engage in further negotiations. The point Boggs is making by using this complex strategy of exchange is

that the work of art is not the drawn or painted image but the economic transaction. Boggs's art is "the art of the deal," which is fueled by the conjunction of the commodification of art and the aestheticization of the commodity.

In a remarkable coincidence, events in the world economy during the fall of 1987 provided a graphic illustration of the point Boggs attempts to make with his currency drawings. In October 1987, only one month before Boggs's trial, the American stock market crashed, sending shock waves throughout the world economy. The crash resulted in large part from programmed trading that had become possible with the worldwide use of computers in the financial markets. What was traded on that fateful October afternoon were not things or even pieces of gold but numbers that were fleeting images on video terminals. Within a matter of hours, the Dow Jones industrial average plunged over five hundred points and investors lost an estimated half a trillion dollars. But "where had it gone?" What had been lost? "One answer," Lawrence Weschler suggests, "is that it hadn't *gone* anywhere; it wasn't now in some new place, where we would eventually be able to locate it if we just set our minds to it. Rather, it had in a sense never existed in the first place" (BB, 240).

In the course of narrating his fascinating tale about Boggs's bills, Weschler notes another extraordinary coincidence. While taking a break from his research on the origin and function of money, Weschler happened to turn on the radio and hear a report by Robert Krulwich, who is the economics correspondent for National Public Radio and CBS. Summarizing the development of money from cows to gold to paper, Krulwich explains,

> Now one of the things that's interesting is that paper money circulates but that doesn't drive out the gold, just as the gold didn't completely drive out the barter. Everything exists side by side. Then in the 1830s you begin to get checking, which is a method whereby I sign a piece of paper instructing my bank to give you some of their other kind of paper. As usual, this innovation first gets accepted by the elites, but it gradually spreads throughout the society, and meanwhile, paper bills and gold and barter continue right on alongside. Little by little the various backings of the coins get withdrawn—you can no longer redeem your check for a paper bill that you can redeem for gold and silver. Now, all you can exchange your old bill for is a new bill. But by the 1960s, people (again starting with the elites) are using fewer and fewer paper bills and checks anyway: they've started using credit cards, which are just the sequences of numbers splayed onto carbon paper. And now, in the eighties, we're even getting rid of carbons, it's all becoming electronic—my number telling my bank's number to transfer such-and-such an amount to this supplier's bank's number. It's becoming more and more invisible. Nowadays, half a trillion dollars exchanges hands every day—although no hands are involved, and in a sense no dollars either, and not even numbers really. It's just binary sequences of pulses racing between computers.
>
> In the midst of all that, this fellow Boggs has found a way to illustrate, to act out, the essential nature of exchanges and money. He forces us to see, among other things, how it's all a fiction, there's nothing backing it, it's all an act of faith. (BB, 199–200)

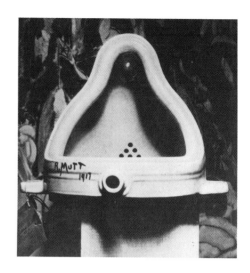

This speculative economy rests on faith in a fiction.

But economy of faith sometimes fails, and the failure of faith interrupts the flow of currency upon which the art of the deal depends. In the corner of one of his bills where the actual pound note says "Bank of England: I promise to pay the bearer on demand the sum of 1 pound," Boggs writes, "I promise to promise to promise." Promise is no more fulfillment than a sign is the "real" itself. Unless, of course, there is no transcendental signified, and thus the sign is always a sign of a sign. In this case, there is nothing more promising than floating signifiers. Though never cited directly, Marcel Duchamp anticipated the direction of Boggs's work. "The painting," Duchamp avers, "is no longer a decoration to be hung in the dining room or living room. We have thought of other things to use as decoration. Art is taking more the form of a sign. . . . This is the feeling that has directed me all my life" (E, 13).

There are other precedents for Boggs's aesthetic strategy: Picasso doodled on many of the checks with which he paid his bills; Klee exchanged art for dinner; Pollock bought drinks with paintings; and Yves Klein sold "immaterial" flakes of gold. Boggs's most interesting and important precursor, however, is Duchamp. On December 3, 1919, Duchamp paid his dentist, Daniel Tzanck, with the drawing of a check for $115.00 (fig. 5.5). Though Duchamp drew the check in Paris, the fictitious bank upon which it was drawn is located in New York: "The Teeth's Loan & Trust Company, Consolidated, 2 Wall Street, New York." Tzanck did not "cash" the check but held it for twenty years, at which point Duchamp bought it back "for a lot more than it says it's worth."[28] From Duchamp, the check circulated to Patricia Matta, Arne Ekstrom, and finally Mary Sisler. Is this check art or money? Money as art? Or art as money? It is still a question of currency.

If the line separating art and money is obscure—if, that is, art is money and money is art, and if all money, in turn, is "fiat money," then all art must be "fiat art." "Fiat art" is art, which, as David Wells suggests,

is art "By the act of the artist." In April 1917—one year before Le Corbusier and Ozenfant announced the advent of purism—Duchamp scandalized the art world by entitling a purely white *pissotière Fountain* and declaring it a work of art (fig. 5.6). Duchamp's aesthetic strategy is every bit as complex as the schemes of Boggs. Already well known for his highly acclaimed *Nude Descending a Staircase*, Duchamp submitted his *Fountain* to the Society of Independent Artists (upon whose hanging committee he served) under the pseudonym of R. Mutt. Duchamp had not, in fact, made the urinal but had purchased it from the J. L. Mott Iron Works. *Fountain* is the most famous example of what Duchamp describes as his "ready-mades." The ready-made is a mass-produced object that Duchamp arbitrarily selected and proclaimed a work of art by fiat. As opposed to the objet trouvé, which is selected for its distinctive aesthetic qualities, the ready-made is indistinguishable from other mass-produced objects. Nothing other than the artist's decree differentiates the artifact. In contrast to other ready-mades like bicycle wheels and snow shovels, the *pissotière* is particularly provocative and evocative. The selection committee of the Society of Independent Artists rejected Duchamp/Mutt's submission. The day after the opening, the organizers of the exhibition published the following disclaimer in the newspaper: "The *Fountain* may be a very useful object in its place, but its place is not an art exhibition and it is, by no definition, a work of art."[29]

The definition of the work of art is, of course, precisely the question that Duchamp's ready-mades were intended to raise. As early as 1913, Duchamp asked, "Can one make works that are not works of 'art'?" In other words, is all construction or fabrication artistic? Is J. L. Mott as much an artist as Richard Mutt? And is Richard Mutt an artist of the same caliber as Marcel Duchamp? Duchamp further complicated these questions by making miniature reproductions of *Fountain*. The original, of course, is not original but is itself a reproduction. The reproduction of the original, therefore, is the reproduction of a reproduction. Duchamp's artistic strategy forces us to reconsider the definition of the work of art by calling into question the opposition between art and nonart. If all production is, in some sense, artistic, then all culture is, in some sense, aesthetic.

The questions Duchamp raised are not original but implicit in cubist collage. As we have seen, analytic cubism moves toward abstraction by analyzing the structure of objects in terms of intersecting lines and planes. As the movement of abstraction progresses, the artwork increasingly withdraws from the world of appearances and eventually enters a realm of pure formalism. Synthetic cubism moves in the opposite direction. The techniques of collage and papiers collés employ everyday objects to interrupt the purity and homogeneity of the painted surface. "The collage revolution," Harold Rosenberg explains, "brings to an end the age-old separation between the realm of art and the realm of things. With collage, art no longer copies nature or seeks equivalents to it; an expression of the advanced industrial age, it appropriates the external world on the basis

that *it is already partly changed into art*" (E, 174). The most common material incorporated into the artwork is newspaper. The inclusion of *le journal* on the surface of the canvas not only draws life into art but also emphasizes the currency of art.[30] In one of his most famous collages, Picasso used an overdetermined trace of a newspaper (JOU) as well as a fragment of an actual object. He glued a piece of oilcloth with a printed design of chair caning, which was used to cover a café table (plate 14). Picasso's choice of material is particularly interesting. Though the work is entitled *Still Life with Chair Caning,* he did not use actual caning. The "real" object that he appropriated (the oilcloth) is also an image (the caning) that is a product of mass manufacture. By using found materials that are already prints, Picasso (re)created a work that is as much a reproduction as a production. The world that appears in the work of art is the fabricated world of industry that is always already figured.

Though Georges Braque and Juan Gris made notable contributions to synthetic cubism in which they extended the methods of appropriation and quotation to everything from sand, sawdust, and iron filings to packaged products, department-store items, and wallpaper, one of the most interesting of the early collage artists is the German Kurt Schwitters. Schwitters made art from the underside of modernism's utopia. He used the junk, waste, garbage, detritus, and refuse that he collected from the streets of Hannover (plate 15). In words that combine Marinetti's extravagance and Dada's outrageousness, Schwitters extols the power of collage.

> Take wheels and axles, hurl them up and make them sing (mighty erections of aquatic giants). Axles dance midwheel roll globes barrel. Cogs flair teeth, find a sewing-machine that yawns. Turning upward or bowed down the sewing-machine beheads itself, feet up. Take a dentist's drill, a meat grinder, a car-track scraper, take buses and pleasure-cars, bicycles, tandems and their tires, and deform them. Take lights and deform them as brutally as you can. Make locomotives crash into one another. . . . Explode steam boilers to make railroad mist. Take petticoats and other kindred articles, shoes and false hair, also ice-skates, and throw them into the place where they belong and always at the right time. For all I care, take the man-traps, automatic pistols, infernal machines, the tinfish and the funnel, all of course in an artistically deformed condition. (SN, 64)

It is clear that Schwitters's deformation is the opposite of the deformation Le Corbusier practiced. For Le Corbusier the process of deformation purifies by removing excessive ornamentation and revealing essential form. Schwitters, by contrast, *disfigured* the austere purity of "high" modernist buildings and canvases with deformed waste products excreted by the ever-expanding industrial machine. In Schwitters's collages, Le Corbusier's "Brown World" returns to smear the "White World." In this return of the repressed, the will-to-purity is transformed into the will-to-impurity.

Schwitters's collages are not, however, completely chaotic. He organized ready-made refuse on a cubist grid to create a sense of incipient

**5.7 Kurt Schwitters,**
*Cathedral of Erotic Misery*
**(ca. 1933). Sprengel Mu-**
**seum, Hannover. VAGA,**
**New York, 1991.**

order in the midst of the confusing currents of modern urban life. Schwitters labeled his compositions "Merz" paintings. The name Merz proves to be prophetic. *Merz* is not a word but the fragment of a word that Schwitters discovered on a shred of paper in one of his collages. The whole from which it was torn is an advertisement for the Kommerz- und Privat-Bank. Art, money, and advertising intersect in the debased Merz paintings.

Schwitters's most ambitious Merz work was not a painting but his house in Hannover—the Merzbau, which was begun in 1923 and destroyed by Allied bombers in 1943 (fig. 5.7). The full name of the Merzbau was Cathedral of Erotic Misery. This fantastic construction probed the depths of the underground of which refuse is the trace.[31] Mixing images of festival and hades, the Merzbau suggested undercurrents that circulate between modern *Kom-merz* and the ancient altars of sacrifice. Schwitters's "Murderers' Cave" and "Sex-Crime Den" insinuate the economy of sacrifice in the midst of the "Radiant City."

One of the words for junk in German is *Kitsch,* which can also mean "rubbish" or "trash." In his classic essay "Avant-Garde and Kitsch," Clement Greenberg's summary of the genesis of the avant-garde raises issues relevant to the developments we have been considering.

It has been in search of the absolute that the avant-garde has arrived at "abstract" or "nonobjective" art—and poetry, too. The avant-garde poet or artist tries in effect to imitate God by creating something valid solely on its own terms, in the way nature itself is valid, in the way a landscape—not a picture—is aesthetically valid; something *given*, increate, independent of meanings, similars or originals. Content is to be dissolved so completely into form that the work of art or literature cannot be reduced in whole or part to anything not itself.

But the absolute is absolute, and the poet or artist, being what he is, cherishes certain relative values more than others. The very values in the name of which he invokes the absolute are relative values, the values of aesthetics. And so he turns out to be imitating, not God . . . but the disciplines and processes of art and literature themselves. This is the genesis of the "abstract." (AGK, 8)

In our consideration of abstract painting and early modern architecture, we have already discovered certain difficulties with Greenberg's formalist account of modern art. In this context, it is necessary to analyze some of the implications of this critical position that Greenberg himself failed to realize.

"Avant-garde culture," Greenberg concludes, "is the imitation of imitation." This representation of representation issues in nonrepresentational art that is totally self-reflexive. The self-reflexive work of art is completely self-contained within a purely formal aesthetic universe. Such nonobjective art is "high art"—the only art that Greenberg believes is worthy of the name. Where there is "high art," there is also, of course, "low art," or in Greenberg's terms "where there is an avant-garde, generally we also find a rear-guard." "True enough—simultaneously with the entrance of the avant-garde, a second new cultural phenomenon appeared in the industrial West: that thing to which the Germans give the wonderful name of *Kitsch*: popular, commercial art and literature with their chromeotypes, magazine covers, illustrations, ads, slick and pulp fiction, comics, Tin Pan Alley music, tap dancing, Hollywood movies, etc., etc." (AGK, 11). The emergence of kitsch was made possible by three interrelated factors: the industrial revolution, the spread of literacy, and the establishment of a bourgeois class with sufficient leisure time and money for art. "To fill the demand of the new market," Greenberg argues, "a new commodity was devised: ersatz culture, kitsch, destined for those who, insensible to the values of genuine culture, are hungry nevertheless for the diversion that only culture of some sort can provide" (AGK, 12). Kitsch is everything that "true" art is not: nonoriginal, inauthentic, undemanding, unedifying, formulaic, repetitive, cheap, counterfeit, fake, popular. In the terms of Walter Benjamin, kitsch is "the work of art in the age of mechanical reproduction." When "high" becomes "low," the "aura" of art disappears. While Benjamin recognizes liberating possibilities in the mechanical reproduction of art, Greenberg insists that kitsch debases artistic currency.

The relationship between "high" and "low" art is, however, more

subtle and complex than Greenberg's polemics suggest.[32] If there is no high without a low (and vice versa) and no avant-garde without a rear-guard (and vice versa), then kitsch is parasitic on high culture. "The precondition for kitsch, a condition without which kitsch would be impossible, is the availability close at hand of a fully matured cultural tradition, whose discoveries, acquisitions, and perfected self-consciousness kitsch can take advantage of for its own ends. It borrows from it devices, tricks, stratagems, rules of thumb, themes, converts them into a system, and discards the rest. It draws its life blood, so to speak, from this reservoir of accumulated experience" (AGK, 12). Greenberg does not understand that the strange logic of parasitism is duplicitous. What is parasitic is not simply exterior but is an "outside" that is "inside" the body it infects. Furthermore, not all parasites are deadly; many, in fact, are necessary to the vitality of the organism they inhabit. This is surely the case in the artistic economy that Greenberg explores. "High art" needs "low art" as much as kitsch needs the avant-garde. Abstract art presupposes what it represses; indeed, it actually constitutes itself in and through an act of repression. There would be no nonfigurative art without figures to disfigure. The "masters" of modernism, I have argued, consistently associate figuration with the primitive, infantile, and mad. By adding yet another layer to this tapestry, Greenberg's argument invites a shift from the psychological to the political register. Figurative art is not only the art of savages, children, and the insane; it is also the art of the masses who, like the unconscious, are always ready to erupt and run wild. Inasmuch as disfiguration is repression—political as well as artistic and psychological—to disfigure dis-figuration is to allow the return of the repressed in a revolution that threatens to spread far beyond the canvas. *This* revolution is what Greenberg fears.

The complicity between "high" and "low" is, however, even more tangled than these remarks suggest. As I have stressed, for Greenberg "avant-garde culture is the imitation of imitating." In its purest form, art is about art. Art, in other words, is the figure of a figure, image of an image, or sign of a sign. Kitsch, by contrast, employs "debased and academicized simulacra." "Kitsch, using for raw material the debased and academicized simulacra of genuine culture, welcomes and cultivates this insensibility. It is the source of its profits. Kitsch is mechanical and operates by formulas. Kitsch is vicarious experience and faked sensations. Kitsch changes according to style, but remains always the same. Kitsch is the epitome of all that is spurious in the life of our times. Kitsch pretends to demand nothing of its customers except their money—not even their time" (AGK, 12).

When understood in this way, the difference between "high" and "low" is really a difference that is no difference. Though the images obviously differ, abstract painting and so-called kitsch both involve what Jean Baudrillard describes as the "precession of the simulacrum." The culture of the simulacrum is thematized in mid-twentieth-century art. What

Greenberg sees as vice, post–abstract expressionists see as virtue. Through a postindustrial revolution, "high" becomes "low" and "low" becomes "high." As one moves from Robert Rauschenberg to Jasper Johns to Andy Warhol, the thing becomes image and image becomes the "thing-in-itself." In this process, the dis-figured canvas of abstract art is disfigured by the refuse of industrial society and the figures of postindustrial culture.

Rauschenberg, Michael Newman argues, "re-opens art to the detritus and imagery of the sinful city in a negation of puritan exclusion and Barnett Newman's Jewish iconoclasm."[33] This development signals a break with abstract expressionism that repeats and radicalizes a typical Duchampian gesture. As Duchamp irreverently disfigures the Mona Lisa by adding a mustache, goatee, and the vaguely obscene letters L.H.O.O.Q., which, when pronounced letter-by-letter in French means "She's got a hot ass," so Rauschenberg disfigures a de Kooning drawing by erasing it. In moving beyond what he regards as the empty formalism of abstract expressionism, Rauschenberg returns to strategies employed in Braque's and Picasso's papiers collés, Duchamp's ready-mades, and Schwitters's *Kitsch* works. Using found objects, which, like Schwitters, he picks up on city streets, Rauschenberg creates "assemblages" or "combines." His best-known combine is *Monogram,* in which a stuffed angora goat, intertwined with a tire, is placed upon an irregular platform that is smeared with different colors of paint (fig. 5.8). Like Duchamp's L.H.O.O.Q., Rauschenberg's goat penetrating the tire carries sexual overtones. In this case, however, homosexual love is suggested.

Rauschenberg observed in 1971 that "there is no reason not to consider the world as one gigantic painting." In his multimedia works, he assembles heterogeneous objects and materials from the everyday world in a way that juxtaposes artifacts of "high" and "low" culture as well as art and nonart objects. As more and more mundane objects grace the canvas, the range of art expands to encompass all of culture. Rauschenberg does not limit his "palette" to found objects but also uses found images. He is one of the first artists to realize the cultural power and aesthetic potential of electronic media. He remarks, "I was bombarded with TV sets and magazines, by the refuse, by the excess of the world. . . . I thought that if I could paint or make an honest work, it should incorporate all of these elements, which were and are a reality. Collage is a way of getting an additional piece of information that's impersonal. I've always tried to work impersonally" (SN, 345). In an age of electronic images, it is no longer adequate simply to glue prefabricated objects and figures to the canvas. New collage techniques must be devised. For Rauschenberg and his followers, the most effective innovation is the introduction of silk-screening. The transfer of the screened image creates a work that is, impossibly, both an original and a reproduction, and neither an original nor a reproduction. Many of Rauschenberg's most memorable works are re-presentations drawn from television images of early-to-mid-sixties

**5.8 Robert Rauschenberg, *Monogram* (1955–59). Various materials, 122 × 183 × 183 cm. VAGA, New York, 1991. Photograph: Statens Konstmuseer, Stockholm.**

America (plate 16). On these "screens," it is impossible to know whether art is imitating life or life is imitating art.

From 1955 to 1960, Rauschenberg shared a studio in New York City with Jasper Johns. During their early years in New York, Rauschenberg and Johns found artistic mentors in John Cage and Merce Cunningham. In later years, Rauschenberg worked with Cage and Cunningham on a variety of projects. In November 1973 Johns met with Samuel Beckett to discuss a possible collaboration. Out of these discussions came the remarkable work *Foirades/Fizzles,* which includes five brief Beckett texts and a series of lithographs by Johns. In this assemblage, texts and images, many of which were not original but recycled, combine in such a way that the question of priority becomes unanswerable. When the result of the collaboration was published in a catalogue several years later, Cage contributed something that approximates an introduction, entitled "Mesostic: Jasper Johns." Cage concludes with the following lines:

My
at thE
Time
tHe space
tIme
iNterests
thinGs
pArt
caN be thrown
anD perhaps
whaT one takes to be
tendency to add tHings is
havE
theN
say aBout
intErests
tImes
somethiNg
move
what one takeS
takEs to be
woRld
move inTo it
how doEs
Does
It
aNd
inTerests me that
thrOwn into
Add
caN
One
Tendency to
sometHing
and
bE
woRld
as it Were
be thrOwn into a
thing oR
suddenLy
Does
Another
the Same
same tIme
iT
World
a wholE can
peRhaps
wEre [34]
A whole can . . . A whole were . . . future . . . or past . . . or
E
R
E

(H)ere . . . (W)ere . . . (Wh)ere. A whole? Perhaps.

In a conversation with Georges Duthuit, Beckett comments,

> B. The only thing disturbed by the revolutionaries Matisse and Tal Coat is a certain order on the plane of the feasible.
>
> D. What other plane can there be for the maker?
>
> B. Logically none. Yet I speak of an art turning from it in disgust, weary of its puny exploits, weary of pretending to be able, of being able, of doing a little better the same old thing, of going a little further along a dreary road.
>
> D. And preferring what?
>
> B. The expression that there is nothing to express, nothing with which to express, nothing from which to express, no power to express, no desire to express, together with the obligation to express.[35]

"Nothing to express, nothing with which to express, nothing from which to express . . . the obligation to express" . . . Nothing. But how can one express nothing? Perhaps with a "No" thing. In 1961 Johns constructed/painted (a) no-thing. Nothing will return.

"No power to express, no desire to express." Johns has no desire to express; he desires to express nothing. The absence of the desire to express, or the presence of the desire to express nothing implies a critique—a radical critique—of both the abstraction and the expression of abstract expressionism.

Johns's work is, among other things, a sustained interrogation of the problem of representation. As we have already ascertained, abstract or nonobjective art is not necessarily nonrepresentational. For modernists, abstraction seems to re-present the Absolute or divine as well as to express one's innermost feelings and experiences. And yet, representation inevitably fails, for it erases precisely what it attempts to record. *Re-presentation is de-presentation.* Representation, therefore, is not the realization of presence but its negation. To escape the economy of representation, abstraction is not sufficient; thus, it is necessary to refigure figuration. Toward this end, Johns turns from the subject of abstract expressionism to the object prefigured in Duchamp's ready-mades and Rauschenberg's combines. In an unusually revealing remark, Johns explains, "I'm interested in things which suggest the world rather than suggest the personality. I'm interested in things which suggest things which *are* rather than in judgments. The most conventional things, the most ordinary things—it seems to me that those things can be dealt with without having to judge them; they seem to me to exist as clear facts without involving aesthetic hierarchy" (JJ, 21).[36]

Although Johns begins with found objects, he does not leave them as he finds them. He writes in his sketchbook,

> Take an object
> Do something to it
> Do something else to it
> " " " " "

Take a canvas.
Put a mark on it.
Put another mark on it.
" "      " " "

Make something
Find a use for it

AND/OR
Invent a function
Find an object. (JJ, 21)

The objects with which Johns starts are thoroughly conventional and utterly mundane: light bulbs, flashlights, beer cans, paint brushes (fig. 5.9). But unlike his predecessors, Johns does not simply appropriate objets trouvés. Rather, he recasts them in sculpmetal, papier-mâché, and in some cases in bronze. The result is an object that throbs with ambiguity. Johns contends that "the object itself is a somewhat dubious concept." "Now the idea of 'thing' or 'it' can be subjected to great alterations, so that we look in a certain direction and we see one thing, we look in another way and we see another thing. So that what we call 'thing' becomes very elusive and very flexible, and it involves the arrangement of elements before us, and it also involves the arrangement of our senses at the time of encountering this thing. It involves the way we focus, what we are willing to accept as being there."[37] The elusive, flexible objects Johns uses are cultural instead of natural. Starting with fabricated artifacts, his art remains unapologetically artificial.

As a refabricator of artificial objects, Johns is a *sign* painter. His objects are signs—literally and figuratively signs. Not just any signs, but the most common, quotidian, banal signs one can imagine. On January 20, 1958,

**5.9** Jasper Johns, *Painted Bronze* (1960). Painted bronze, 13½ × 8 in. Collection of the artist. VAGA, New York, 1991. Photograph: Rudolph Burckhardt.

**5.10** Jasper Johns, *Flag* (1954–55). Encaustic, oil, and collage on fabric mounted on plywood, 42¼ × 60⅝ in. Gift of Philip Johnson in honor of Alfred H. Barr, Jr., Collection, The Museum of Modern Art. VAGA, New York, 1991.

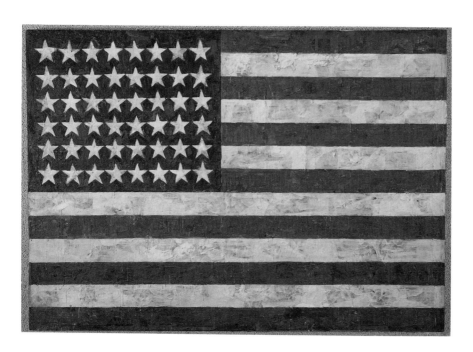

Johns's first one-man show opened, in which he exhibited canvases that bear what were to become his signature images: the American flag, targets, numbers, and letters (fig. 5.10, plate 17). Johns, like Rauschenberg, works with found images to fashion a critique of abstract expressionism. His strategy does not involve an outright rejection of his precursors, however, but entails a subtle subversion of their work. Johns uses the painterly techniques of abstraction to call into question nonobjective painting. Commenting on *Flag* and *Target,* Greenberg writes, "Everything that usually serves representation and illusion is left to serve nothing but itself, that is, abstraction, while everything that usually connotes the abstract or the decorative—flatness, bare outlines, all-over or symmetrical design—is put to the service of representation."[38]

Johns achieves this arresting flatness and all-overness by using encaustic. He paints the image on a collage that includes newspapers, photographs, and other graphic materials embedded in wax. The result is a translucent surface that gives a sense of complexity without suggesting depth. The sign-image typically fills the entire surface of the work. Stressing Johns's importance for postwar art, Robert Morris points out that he "established a new possibility for art . . . The work was looked at rather than into, and painting had not done this before. Johns took painting further toward a state of non-depiction than anyone else. . . . [He] took the background out of painting and isolated the thing. The background became the wall. What was previously neutral became actual, while what was previously an image became a thing."[39] The removal of the background erases perspective, thereby eliminating any sense of illusionistic space. When the image is foregrounded in this way, it becomes absolutely neutral. Such neutrality bespeaks a lack of intention and expression. It would not be incorrect to describe Johns's figures as nonabstract nonexpressionist. Translating Leo Steinberg's insight into semiotic terms, it can be argued that the overwhelming neutrality of the sign "insinuates our absence."

The *absence* of the subject is the *presence* of the object as such. The object does not point beyond itself, for, in Morris's words, the image becomes the thing. As Steinberg observes, "The position of modern anti-illusionism finds here its logical resting place. The street and the sky—they can only be *simulated* on canvas; but a flag, a target, a 5—these can be *made,* and the completed painting will represent no more than what it actually is. For no likeness or image of a 5 is paintable, only the thing itself. A crucial problem of twentieth-century art—how to make the painting a firsthand reality—resolves itself when the subject matter shifts from nature to culture."[40] The firsthand reality is a thing that is a *sign.* In Johns's aesthetic universe, thing is sign and sign is thing. For example, although it is a painting, Johns's bull's eye—and in light of the foregoing analysis of currency, it is important to stress that it is a *bull's* eye—could actually be hung on the wall and used as a target. To illustrate the transmutation of thing into sign and vice versa, Johns superimposes three flags

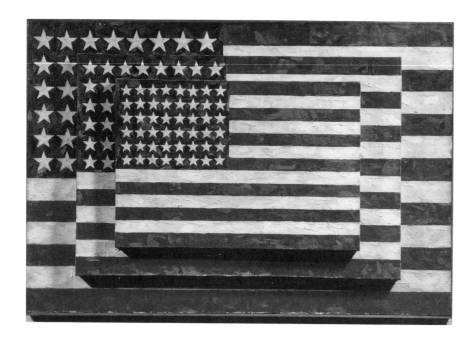

**5.11** Jasper Johns, *Three Flags* (1955). Encaustic on canvas, 30⅞ × 45 × 5 in. Collection, The Whitney Museum of American Art. VAGA, New York, 1991. Photograph: Leo Castelli Gallery, New York.

(fig. 5.11). This work suggests that the image does not rest on anything *hors d'oeuvre* but is always the image of another image.

Johns's most graphic explorations of the sign-thing relationship are his paintings of numbers and letters. We have already discovered that, throughout the Western philosophical and aesthetic tradition, beauty is often interpreted as numerical harmony and proportion. Instead of attempting to construct figures that re-present the ideality of numbers, Johns paints numbers that are beautiful (fig. 5.12). Numbers are not mysterious presences that lurk behind or beneath the surface but are boldly displayed on the canvas as things-in-themselves. Like the things and images with which he works, the numbers and letters in Johns's paintings are "found." Using stencils, Johns reproduces series of numbers and letters that are always regular and sequential. He never deviates from the prototype by modifying, fragmenting, or recombining the numbers and letters. In a particularly interesting group of works, dating from the early sixties to the late seventies, entitled *0 through 9,* Johns repeats the method of superimposition by inscribing the stenciled digits on top of each other. Steinberg records the following exchange with Johns: "Q: Do you use these letter types because you like them or because that's how the stencils come? A: But that's what I like about them, that they come that way" (JJ, 29). The use of stencils results in a grid of numbers and letters that parodies the characteristic modernist grid. Johns's grid does not represent the universal structure underlying and grounding appearances but is indistinguishable from appearance as such. On the surface of Johns's non-expressive canvases, number and thing, word and object, signifier and signified, collapse into each other. As the thing itself becomes a sign, the transcendental signifier disappears. The disappearance of the referent is the appearance of (the) no-thing.

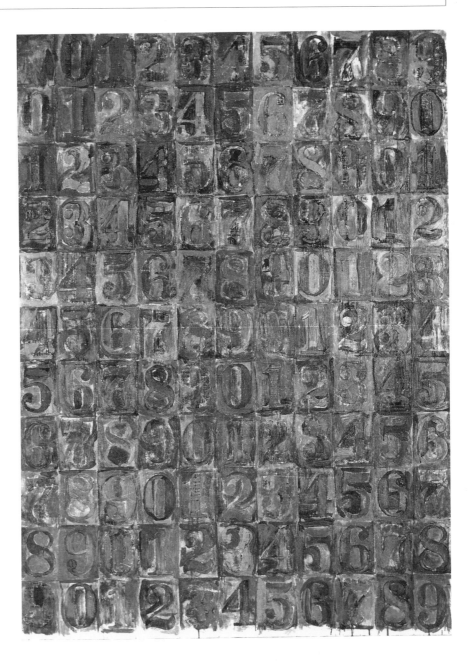

5.12 Jasper Johns, *Gray Numbers* (1958). Encaustic and collage on canvas, 67 × 49½ in. Collection Kimo and John Powers. VAGA, New York, 1991. Photograph: Rudolph Burckhardt.

In *No*, Johns combines encaustic, collage, and sculpture to produce an assemblage that is both figurative and nonfigurative (fig. 5.13). Letters made of pliable metal are suspended above a gray surface by a straightened coat hanger and attached to the canvas with a screw. In the upper left corner of the work, the outline of the base of a bronze reproduction of Duchamp's *Female Fig Leaf* is etched into the paint. The cast for Duchamp's work appears to have been taken from the female genitals.[41] Johns's use of gray in this work and elsewhere is carefully calculated. "I used gray encaustic to avoid the color situation. The encaustic paintings were done in gray because to me this suggested a kind of literal quality that was unmoved or immovable by coloration and thus avoided all the emotional and dramatic quality of color. Black and white is very mislead-

5.13 Jasper Johns, *No* (1961). Encaustic, collage, and sculptmetal on canvas with objects, 68 × 40 in. Collection of the artist. VAGA, New York, 1991. Photograph: Leo Castelli Gallery, New York.

ing. It tells you what to say or do. The gray encaustic paintings seemed to me to allow the literal qualities of the painting to predominate over any of the others" (JJ, 37). Although emphasizing the literal, *No* plays with the figurative to create a work of uncommon ambiguity. How is "No" to be read? How is this no-thing to be interpreted?

*No* is, first of all, a No to abstract expressionism. Carrying abstraction to completion, the abstract expressionists banished not only figures but also words from the canvas. Johns's No disfigures the dis-figured surface of abstraction. But No is not precisely *on* the canvas. It is suspended above, though attached to, the painted surface. The slight distance between figure and ground creates an ever-shifting play of light and shadow in which No is both obscure and superficial. By combining painting and sculpture, Johns also says No to the purported autonomy of different arts that Greenberg identifies with modernism.

But *No* is not only a painted-sculpted thing; it is also a word whose meaning is unclear. "No" is, of course, a term of negation. It is also, however, the abbreviation for "number." When included in the work of art, No is a word that calls into question its status as a word, and a thing that calls into question its status as a thing. More perplexing than Magritte's

*Ceci n'est pas une pipe,* Johns's *No* says, "No, this is not a word. . . . No, this is not a thing." But unlike the pipe, "No" *is* both a word and a thing.

As a word of prohibition, No is the word of the father that bars access to the mother stripped bare by her son. The trace of woman left by the outline of Duchamp's *Female Fig Leaf* is the site of transgression. To this temptation, *No* says "No."

When heard rather than read, *No* is homophonic with *know.* No . . . know. Does *No* represent knowledge or its negation? No . . . k-no-w . . . k-now. Is *No* the presence and/or absence of the now for which modernity longs?

As layers of meaning accumulate and associations proliferate, it becomes clear that *No* stages a play that is something like a Japanese No play.[42] Japan is, in Roland Barthes's words, the "Empire of Signs." Probing "The Three Kinds of Writing," Barthes argues,

> A total spectacle but a divided one, *Bunraku* of course excludes improvisation: to return to spontaneity would be to return to the stereotypes which constitute our "depth." As Brecht had seen, here *citation* rules, the sliver of writing, the fragment of code, for none of the action's promoters can account in his own person for what he is never alone to write. As in the modern text, the interweaving of codes, references, discrete assertions, anthological gestures multiplies the written line, not by virtue of some metaphysical appeal, but by the interaction of a *combinatoire* that opens out into the entire space of the theater: what is begun by one is continued by the next, without interval.[43]

A tissue of interweaving codes and references, Johns's combined paintings are also a *"combinatoire* that opens out into the entire space of the theater." This space is the theater of the No play.

The traditional Japanese No play excludes originality, spontaneity, and individuality by staging highly ritualized reenactments of ancient legends. Actors retreat behind masks in an effort to allow actions to appear *as such.* The "suchness" of the action is *tathata. Tathata* involves appearance rather than essence, surface rather than depth, presentation rather than representation. So understood, *tathata* is the realization of the "absolute hereness" that Steinberg properly discerns in Johns's signs. Like a Japanese No play, Johns's art is more of a presentation than a representation.

As we have come to suspect, however, presentation is never pure. Presence always carries a trace of absence. The overpowering neutrality of Johns's signs presupposes the "realism of absolute impersonality."[44] Although his richly figured canvases are the antithesis of Mondrian's disfigured works, "No" is the word that Johns also repeats to himself again and again and again. With each "No," he withdraws farther behind the mask of his works. The "absolute impersonality" incarnate in the signs of Johns is what Altizer describes as the "new anonymity" that characterizes modernity. For Altizer, the death of God comes to completion in the disappearance of the centered self. As the divine empties itself through an incarnational process in which it becomes one with the world, so the sub-

ject negates itself to become one with the object. Altizer concludes, "The real end or reversal of an individual interior makes possible the actual advent of a universal presence, a presence transcending all interior and individual identity, and presenting itself beyond our interior, and beyond every possible interior, as a total and immediate presence."[45] When understood dialectically, Johns's *No* reverses itself and becomes radically affirmative. *No* is a No to "No" and, as such, is, in Nietzsche's terms, "Yea-saying." By sounding this affirmation, John(s) prepares the way for Warhol.

In an essay entitled "Pop: An Art of Consumption," Baudrillard writes,

> It appears that, on the theme of "Inspiration," Pop artists are in no way inferior to earlier generations. This theme implies, since Werther, the ideality of *Nature* to which it suffices to be faithful in order that it be true. It is simply necessary to awaken it, reveal it. We read in John Cage, musician and theorist-inspirator of Rauschenberg and Jasper Johns: " . . . art should be an affirmation—not an attempt to bring order . . . but simply a way of *waking up* to the very life we are living, which is so excellent, once one gets one's mind and one's desires out of the way and lets it act of its own accord." This acquiescence to a revealed order—the universe of images and manufactured objects shining through to a basic *nature*—leads to professions of a mystico-realist faith: "A flag was just a flag, a number was simply a number."[46]

The world that Warhol represents is the world of postindustrial capitalism. The aestheticization of the commodity and the commodification of *l'oeuvre d'art* join in the "realized utopia" of the culture industry celebrated in Warhol's art. "Making money," Warhol exclaims, "is art!" Anticipating Boggs, Warhol makes money—stacks of it, sheets of it (plate 18). Fresh sheets of money that look like they have just rolled off the printing presses whose "magic" so worries Marx. Warhol offers a concise summary of his artistic career: "I started as a commercial artist and I want to finish as a business artist." He is convinced that the art of finance redeems the currency of modernity—here and now. Preaching a new aesthetic gospel, he declares, "Money is the MOMENT to me" (AW, 136).

Warhol extended and radicalized the critique of abstract or nonobjective art initiated by Rauschenberg and Johns. The first exhibition of what eventually came to be known as pop art was mounted in 1962 in Irving Blum's Los Angeles gallery. The term "pop art" was coined by Lawrence Alloway to describe British art of the 1950s that appropriated images from American advertising and mass media. Before settling on "pop art," critics described the new departure signaled by the explosion of figuration with a variety of terms: new realism, popular image art, common object art, factualism, neo-Dadaism, American dream painting, antisensibility painting, cool art, and sign painting.[47] Reveling in kitsch, pop artists turned from "high" to "low" or popular culture for inspiration. In the 1950s and 1960s, American culture was rapidly becoming a culture of images and signs. Industrial production was quickly being replaced by image production. The media explosion disseminated signs on a level that was previ-

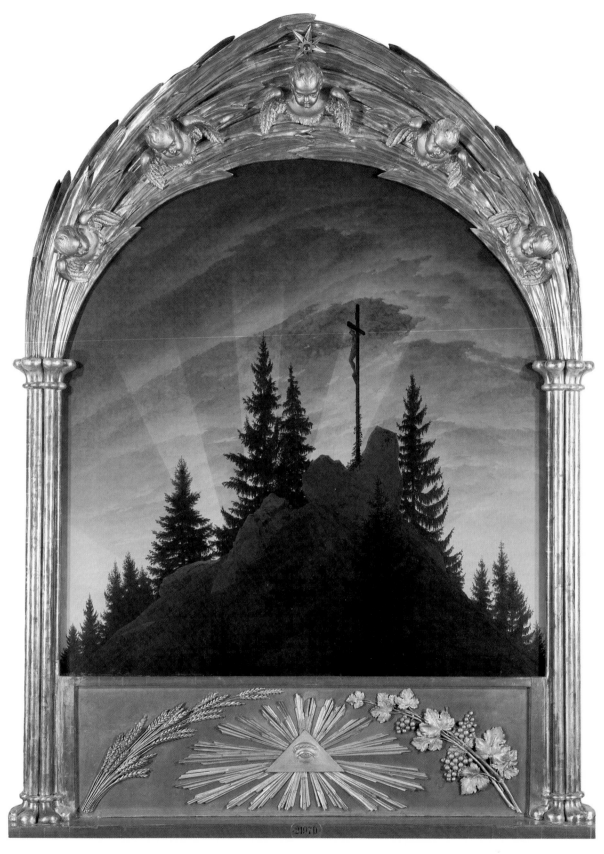

1. Caspar David Friedrich, *The Cross in the Mountains* (1807–8). Oil on canvas, 115 × 110 cm. Staatliche Kunstsammlungen Dresden, Sächsische Landesbibliothek. Photograph: A. Rous, 1991, courtesy Deutsche Fototek.

**2.** Claude Monet, *Rouen Cathedral, the Façade in Sunlight* (1894). Oil on canvas, 41$\frac{13}{16}$ × 29 in. Purchased in memory of Ann Strang Baxter, Sterling and Francine Clark Art Institute, Williamstown, Massachusetts.

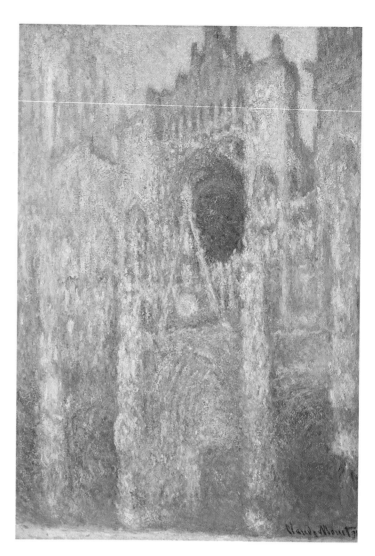

**3.** Paul Cézanne, *Mont Sainte Victoire* (1902–6). Oil on canvas, 22$\frac{1}{4}$ × 38$\frac{1}{8}$ in. Mr. and Mrs. Walter H. Annenberg, The George W. Elkins Collection, Philadelphia Museum of Art.

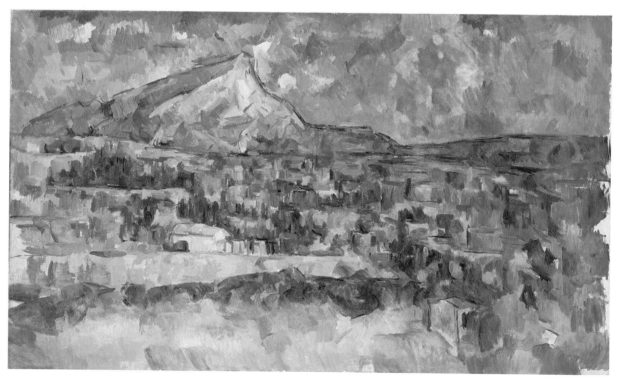

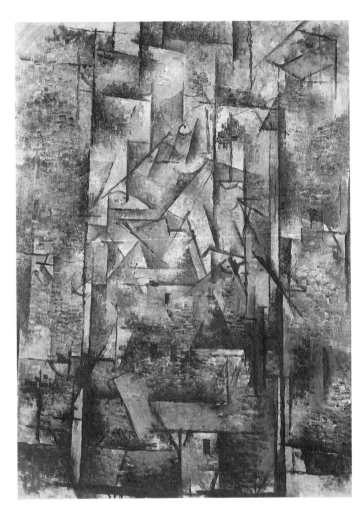

4. Georges Braque, *Rooftops at Céret* (1911).
© 1991 ARS, New York/ADAGP, Paris.

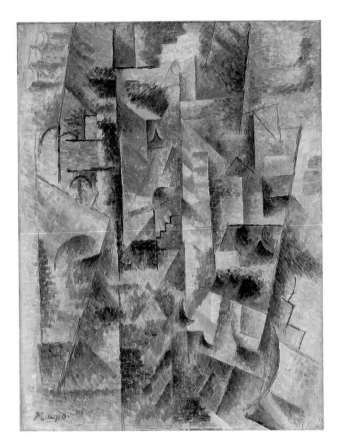

5. Pablo Picasso, *Landscape at Céret* (summer 1911). Oil on canvas, 25⅝ × 19¾ in. Gift of Solomon R. Guggenheim (1937), Solomon R. Guggenheim Foundation, New York. © 1991 ARS, New York/SPADEM, Paris. Photograph: David Heald.

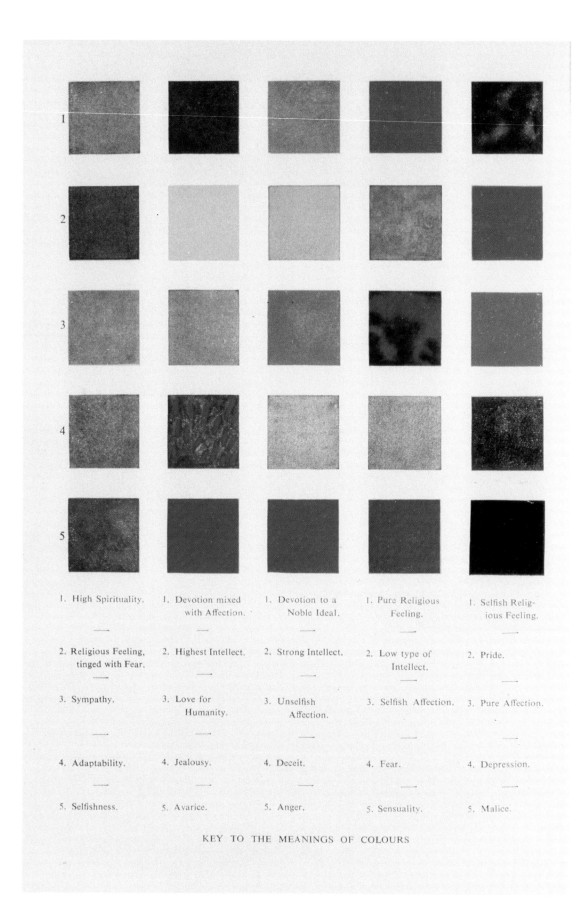

KEY TO THE MEANINGS OF COLOURS

1. High Spirituality.

2. Religious Feeling, tinged with Fear.

3. Sympathy.

4. Adaptability.

5. Selfishness.

1. Devotion mixed with Affection.

2. Highest Intellect.

3. Love for Humanity.

4. Jealousy.

5. Avarice.

1. Devotion to a Noble Ideal.

2. Strong Intellect.

3. Unselfish Affection.

4. Deceit.

5. Anger.

1. Pure Religious Feeling.

2. Low type of Intellect.

3. Selfish Affection.

4. Fear.

5. Sensuality.

1. Selfish Religious Feeling.

2. Pride.

3. Pure Affection.

4. Depression.

5. Malice.

6. **Annie Besant and C. W. Leadbeater,** *Key to the Meanings of Colours* **(1911).**

7. Wassily Kandinsky, *Black Lines No. 189* (December 1913). Oil on
canvas, 51 × 51⅝ in. Gift of Solomon R. Guggenheim (1937), Solomon R.
Guggenheim Foundation, New York. © 1991 ARS, New York/SPADEM,
Paris. Photograph: David Heald.

8. Wassily Kandinsky, *Composition 8* (1923). Oil on canvas, $55\frac{1}{8} \times 79\frac{1}{8}$ in. Gift of Solomon R. Guggenheim (1937), Solomon R. Guggenheim Foundation, New York. © 1991 ARS, New York/SPADEM, Paris. Photograph: David Heald.

9. Piet Mondrian, *Composition in Red, Blue, and Yellow* (1937–42). Oil on canvas, $23\frac{3}{4} \times 21\frac{7}{8}$ in. Collection, The Museum of Modern Art, New York. The Sidney and Harriet Janis Collection. VAGA, New York, 1991.

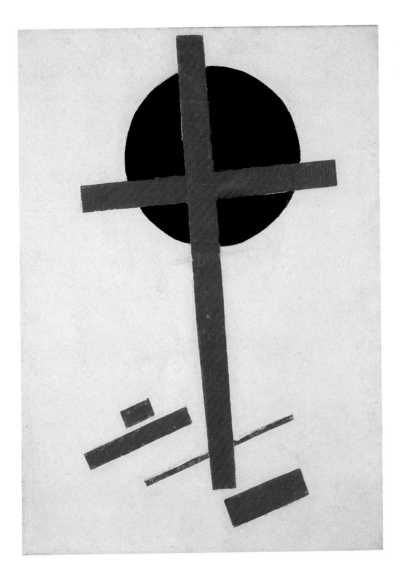

10. Kasimir Malevich, *Suprematist Painting.* Stedelijk Museum, Amsterdam.

11. Barnett Newman, *Vir Heroicus Sublimis* (1950–51). Oil on canvas, 7 ft. 11⅜ in. × 17 ft. 9¼ in. Gift of Mr. and Mrs. Ben Heller, Collection, The Museum of Modern Art, New York. Courtesy Annalee Newman.

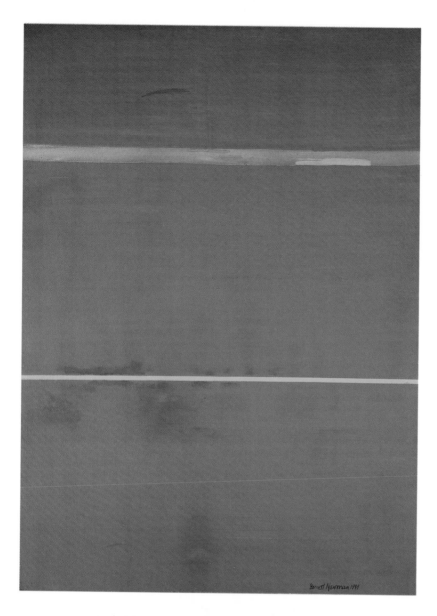

12. Barnett Newman,
*Dionysus* (1949). Oil on
canvas, 67 × 49 in. Gift
of Annalee Newman,
National Gallery of Art,
Washington, D.C. Courtesy
Annalee Newman. Photo-
graph: Richard Carafelli.

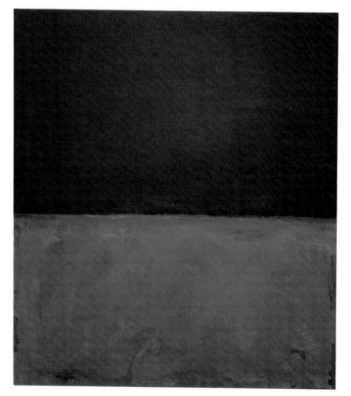

13. Mark Rothko, *Untitled*
(Black and Grey). National
Gallery of Art, Washington,
D.C.; Gift of The Mark
Rothko Foundation.
© 1991 Kate Rothko-Prizel
and Christopher Rothko/
ARS, New York.

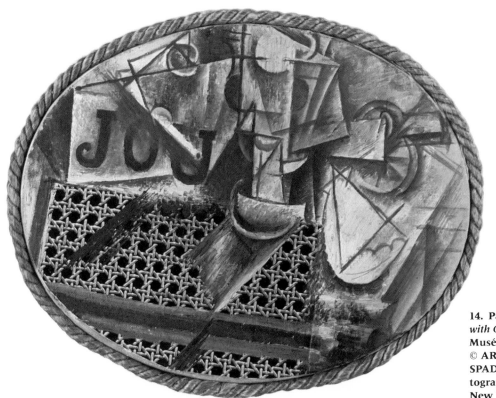

14. Pablo Picasso, *Still Life with Chair Caning* (1912). Musée Picasso, Paris. © ARS, New York/ SPADEM, New York. Photograph: Art Resource, New York.

15. Kurt Schwitters, *Merzbild 32A, "The Cherry Picture"* (1921). Collage of cloth, wood, metal, gouache, oil, cut-and-pasted papers, and ink on cardboard, $36\frac{1}{8} \times 27\frac{3}{4}$ in. Mr. and Mrs. A. Atwater Kent, Jr., Fund, Collection, The Museum of Modern Art, New York. VAGA, New York, 1991.

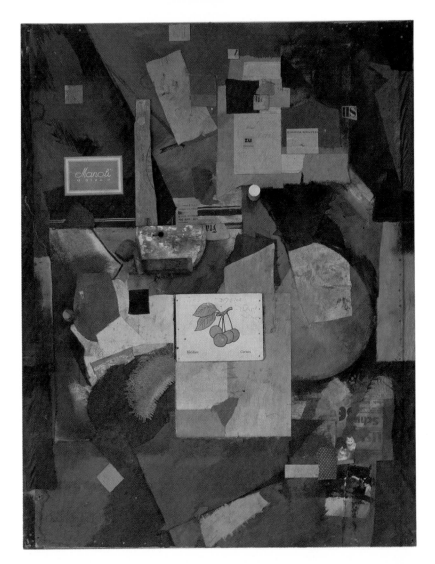

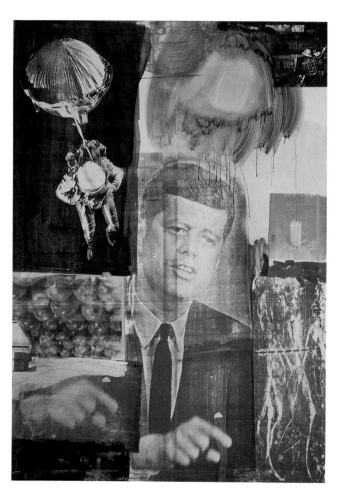

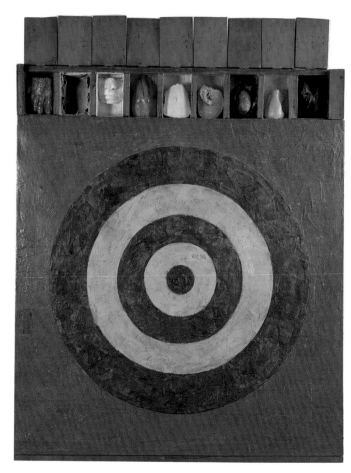

16. Robert Rauschenberg,
*Retroactive I* (1964). Oil on
canvas, 84 × 60 in. Gift of
Susan Morse Hilles, Wads-
worth Atheneum. VAGA,
New York, 1991.

17. Jasper Johns, *Target
with Plaster Casts* (1955).
Encaustic on canvas with
plaster cast objects, 51 ×
44 × 3½ in. VAGA, New
York, 1991. Photograph:
Leo Castelli Gallery.

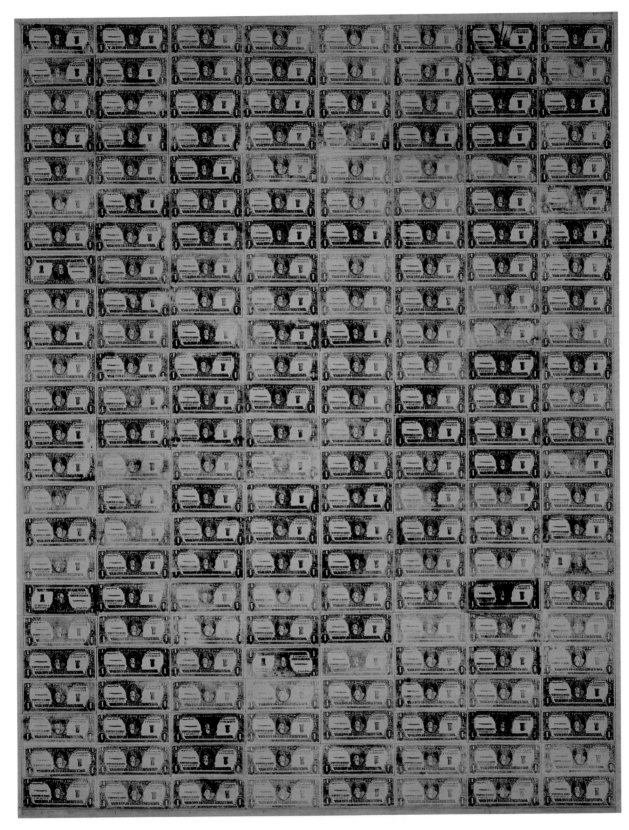

18. Andy Warhol, *192 One-Dollar-Bills* (1962). Collection Marx. © 1991
The Estate and Foundation of Andy Warhol/ARS, New York. Photo-
graph: Heiner Bastian Fine Art, Berlin.

19. Andy Warhol, *Atomic Bomb* (1965). Silk screen on canvas, 104 × 80½ in. © 1991 The Estate and Foundation of Andy Warhol/ARS, New York. Photograph: Saatchi Collection, London.

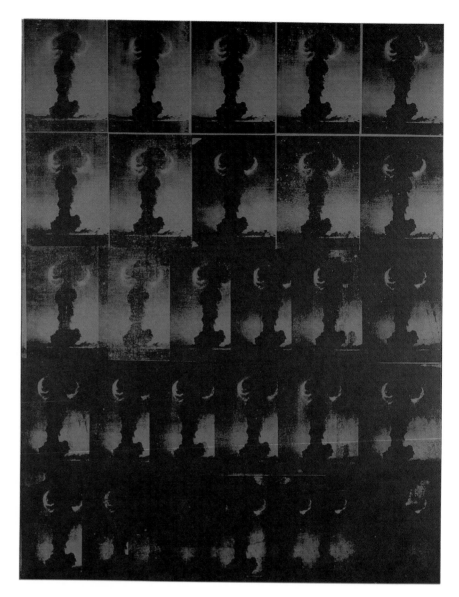

20. James Stirling, *Staatsgalerie, New Building and Chamber Theater* (1977–83). Photograph © Richard Bryant, 1985, ARCAID.

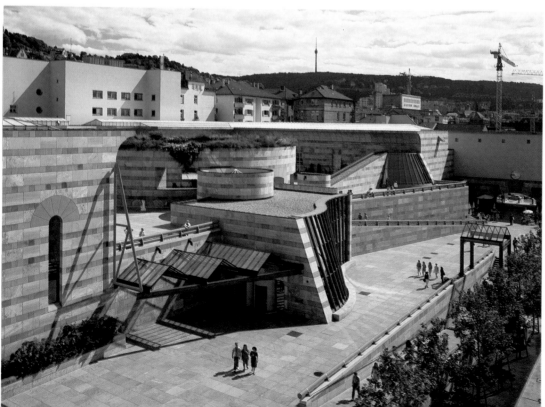

**21. Michael Graves,** *The Portland Building* **(1980), view from Fifth Avenue. Courtesy Michael Graves. Photograph: Proto Acme Photo.**

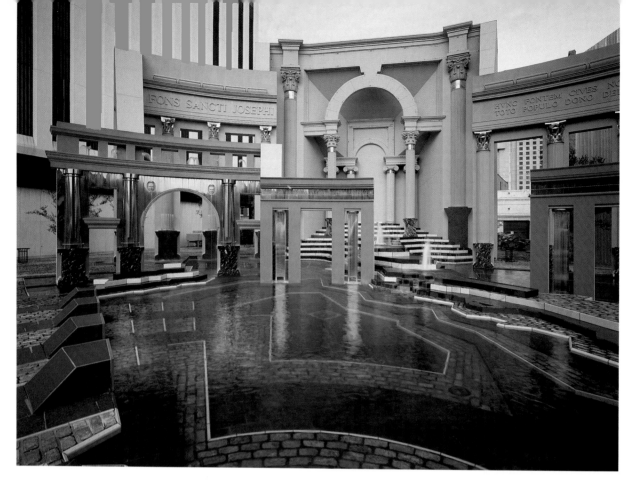

22. **Charles Moore,** *Piazza d'Italia* **(1975–78). Photograph** © **Norman McGrath.**

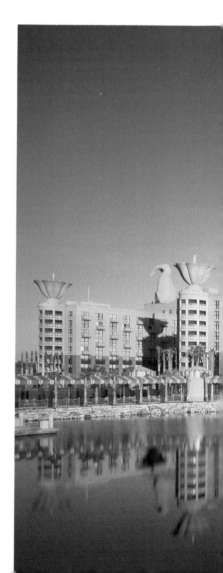

**23. Michael Graves,** *Walt Disney World Dolphin Hotel* **(1987). Courtesy Michael Graves. Photograph: Steven Brooke.**

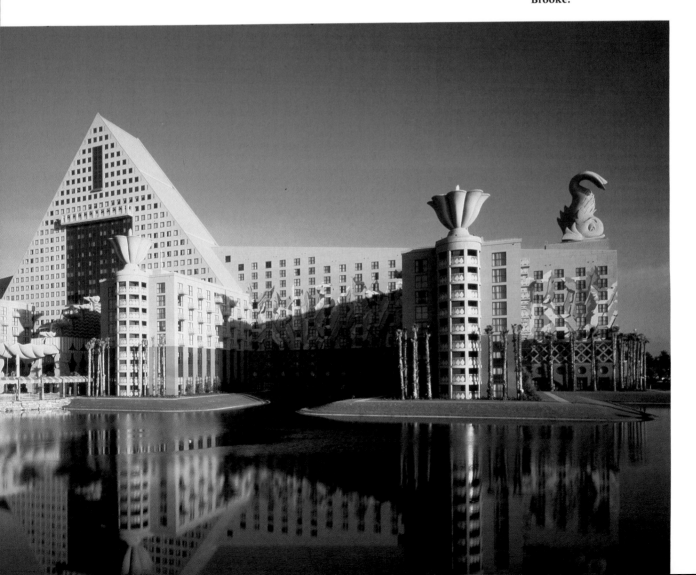

24. Bernard Tschumi, *Le Parc de la Villette.* Courtesy Bernard Tschumi Architects. Photograph: Jean-Marie Monthiers.

25. Peter Eisenman and Jacques Derrida, *Choral Work.* Courtesy Eisenman Architects. Photograph: Dick Frank.

26. Peter Eisenman, *Wexner Center for the Visual Arts,* aerial view. Courtesy Eisenman Architects. Photograph © Jeff Goldberg, ESTO.

27. Peter Eisenman, *Wexner Center for the Visual Arts,* exterior. Courtesy Eisenman Architects. Photograph © Jeff Goldberg, ESTO.

**28.** Michelangelo Pistoletto, *Man Seen from the Back: The Present* (1961).
Varnish, acrylic, and oil on canvas, 200 × 150 cm. Romilda Bollati Collection,
Milan. Photograph: P. Pellion.

29. Michelangelo Pistoletto, *Division and Multiplication of the Mirror (The Divided Table)* (1975–79). Wood and mirror glass, 150 × 200 × 120 cm. Collection of the artist. Photograph: P. Pellion.

30. Michelangelo Pistoletto, *The Time of the Mirror* (1986). Centre National d'Art Contemporain de Grenoble. Photograph: Magasin, Grenoble.

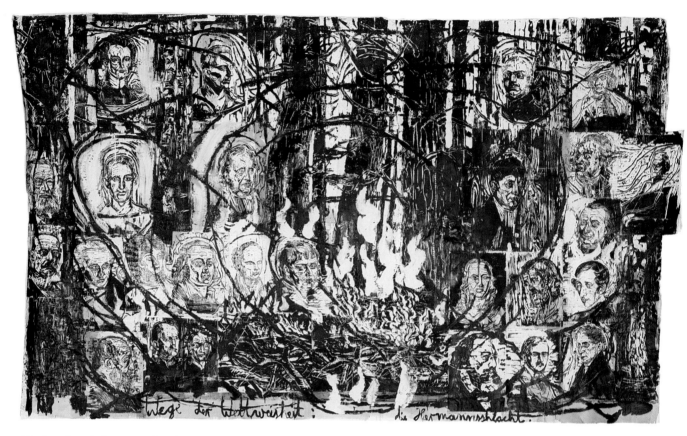

**31.** Anselm Kiefer, *Ways of Worldly Wisdom: Arminius's Battle*. Acrylic, emulsion, and shellac on woodcut, 295 × 483 cm. Reproduced by permission of the artist. Photograph: Marian Goodman Gallery, New York.

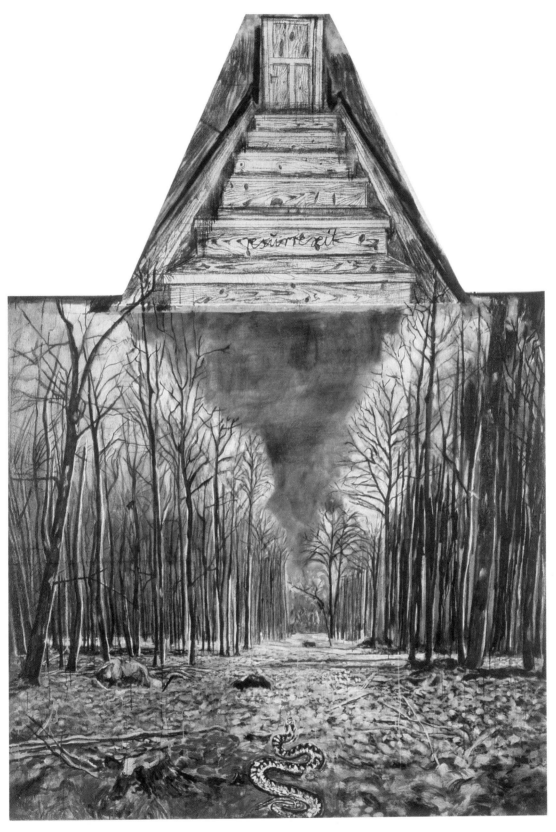

**32.** Anselm Kiefer, *Resurrexit* (1973). Oil, acrylic, and charcoal on
burlap, 114½ × 70⅞ in. Reproduced by permission of the artist. Photograph:
Marian Goodman Gallery, New York.

33. Anselm Kiefer, *Painting = Burning* (1974). Oil on burlap, 220 × 300 cm. Reproduced by permission of the artist. Photograph: Marian Goodman Gallery, New York.

34. Anselm Kiefer, *Father, Son, and Holy Spirit* (1973). Oil on burlap, 165 × 156 cm. Reproduced by permission of the artist. Photograph: Marian Goodman Gallery, New York.

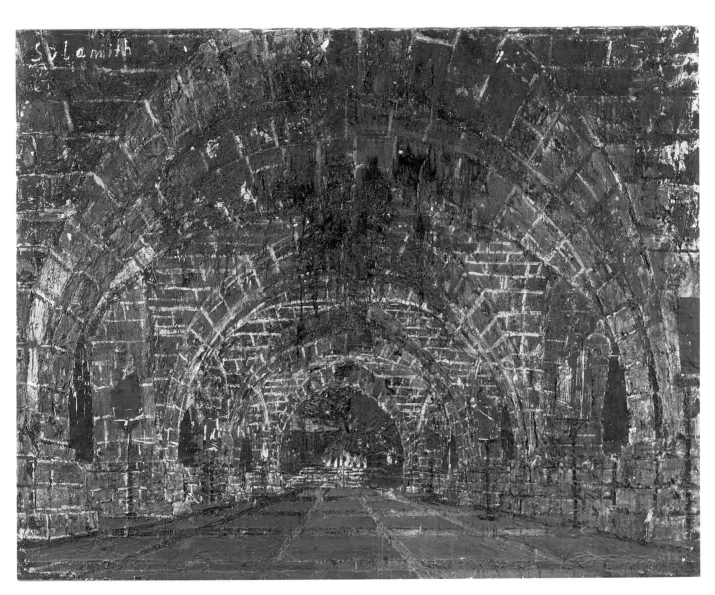

**35.  Anselm Kiefer,** *Shulamite* **(1983). Oil, emulsion, wood-cut, shellac, acrylic, and straw on canvas, 114¼ × 145¾ in. Reproduced by permission of the artist. Photograph: John Webb, courtesy Saatchi Collection, London.**

36. Anselm Kiefer, *Zim Zum* (1990). Oil crayon, ashes, canvas on lead, 149¾ × 220½ in. Reproduced by permission of the artist. Photograph: Jon and Anne Abbott, courtesy Marian Goodman Gallery, New York.

ously unimaginable. For those with eyes to see, it was obvious that circulating images and floating signifiers had become the currency of socio-cultural exchange. Warhol saw all of this clearly and early. In response to the aestheticization of culture, he developed an art whose purpose is, in Barthes's terms, to "stage the Signifier."

For Warhol, as for Johns, the signifier does not point beyond itself to a secure ground outside the structure of signification. To the contrary, signs are de-based and utterly superficial; "reality" is only skin deep. "If you want to know about Andy Warhol," he admits, "just look at the surface of my paintings and films and me, and there I am. There's nothing behind it" (E, 102). *There's nothing behind it.* The surface of the work that stages the signifier also embodies the death of the transcendental signified. In pop art, Barthes points out, "the attempt has been made to abolish the signified, and thereby the sign; but the signifier subsists, persists, even if it does not refer, apparently, to anything."[48] The "mania for signifying" re-figures Johns's No-thing as an irrepressible nothing. With characteristic irony, Warhol confesses, "Some critic called me the Nothingness Himself and that didn't help my sense of existence any. Then I realized that existence itself is nothing and I felt better. But I'm still obsessed with the idea of looking into the mirror and seeing no one, nothing" (AW, 7).

Warhol's reflection absolutizes the signifier. More explicitly than any of his predecessors, he insisted that the sign is always the sign of a sign. When Warhol looked in the mirror, he saw nothing . . . nothing but an image. Paradoxically, this proliferation of signs and images is iconoclastic. "By this I mean the new modern form of iconoclasm, which does not consist of destroying images but of manufacturing images, a profusion of images *in which there is nothing to see.* These are, literally, images that leave no trace. They are without aesthetic qualities as such—except for the professionals in the art world. But, behind each of the images, something has disappeared. That is their secret, if they have one—and that is also the secret of simulation, if it has one. Now, upon reflection, that was the very problem of Iconoclasm in Byzantine times. The Iconolaters were discerning people who pretended to represent God to his greater glory, but who in reality, by simulating God in images, dissimulated as a consequence the very question of his existence. Each image was a pretext for not posing the question of God's existence. But behind each image, in fact, God had disappeared. . . . That is to say, the question of his existence was no longer even posed. The question of God's existence or non-existence was resolved through simulation. But it is possible to think that this was God's own strategy for disappearing, and precisely behind images. God himself makes use of images in order to disappear, by obeying the fundamental drive not to leave any trace. Thus the prophecy is fulfilled: we live in a world of simulation."[49] The disappearance of God, which in recent times is figured as the death of God, is the appearance of radicalized appearances that mark the birth of the world of simulation. In this brave new world, *it's image all the way down.*

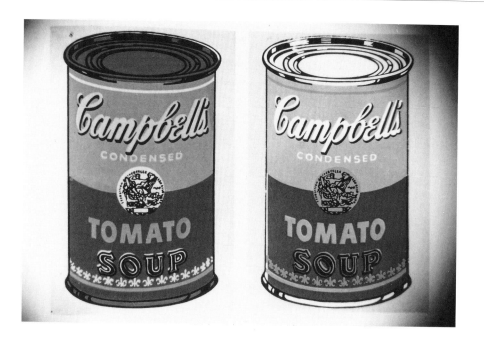

**5.14** Andy Warhol, *Campbell's Soup Cans* (1965). **Silk screen and canvas.** © 1991 **The Estate and Foundation of Andy Warhol/ARS, New York. Photograph: Art Resource, New York.**

Following the lead of Johns or setting the pattern for Johns—in the culture of the simulacrum, the questions of originality and authorship become moot—Warhol used the technique of silk-screening to depict a simulated world. His images are representations of images from newspapers, magazines, advertisements, film, and television. Warhol, however, carried the silk-screen method to extremes never envisioned by Johns. Warhol once declared, "I think somebody should be able to do all my paintings for me." As if to test his suspicion, he established Andy Warhol Enterprises and set up the Factory to reproduce works of art. Taking Benjamin's description as a prescription, Warhol set out to produce works of art in the age of mechanical reproduction by using techniques that mime the procedures of industrial production. Instead of a lonely genius, the artist in the Factory was more like a supervisor who oversees workers on the assembly line, or a film editor who repackages footage shot by others. Within this economy of production, art not only becomes mechanical but the artist becomes a machine, thereby realizing the dream Warhol expressed when he announced, "I want to be a machine." As works like the infamous Campbell's Soup cans and Brillo boxes indicate, the products that roll off the assembly line look like mass-produced objects, photographic snapshots, frames of film, or television screens (fig. 5.14). In this dizzying eruption of images, the identity of the artist is no longer obvious. Warhol ironically attempted to preserve the "aura" of the work of art, or, perhaps more accurately, of the artist, by signing "his" works. But even the proper name seems suspiciously improper, for there is no certainty that Warhol's signature is done by his own hand rather than by another person or even a Kafkaesque "writing machine."

Of all the figures reproduced in his works, Warhol was most enamored of movie and television images. Obsessed with the stars and celebrities of film, he screened and rescreened Liz Taylor, Eddie Fisher, James Cagney, Dennis Hopper, Marlon Brando, Elvis, Ginger Rogers, Heddy Lamarr, James Dean, Joan Crawford, Liza Minnelli, Natalie Wood, Troy Donahue, Warren Beatty, Mick Jagger, and Marilyn—above all, Marilyn Monroe. As the movie screen becomes the television screen, "reality" itself is transformed. For Warhol, television did not represent the real but *was* the real. "I always suspected that I was watching TV instead of living life. People sometimes say that the way things happen in the movies is unreal, but actually it's the way things happen to you in life that's unreal. The movies make emotions look so strong and real, whereas when things really happen to you, it's like watching television—you don't feel anything" (AW, 91).

Life, in other words, is a media event. Eventually subject and object united as Warhol became what he represented—a celebrity. Since an air of electricity always surrounded him, everything became a spectacle. In "the society of spectacle," the speculative philosopher's "struggle for recognition" is realized in the star's confident pronouncement: "I am recognized, therefore, I am." In a gesture that put everything on stage, Warhol lined the Factory with silver foil. When silk screens become all-encompassing silver screens, life becomes a superficial series of flickering images of flowing current. The currency of this realm is electronic.

Warhol's electric spectacle is, in effect, a perverse realization of the utopian dreams of modernity in which art and life become one. Pop art discovers redemption by redeeming appearances. Since signs signify nothing, the play of appearances is not the manifestation of an eternal essence but is the only "reality" we can ever know or experience. Pop art, Baudrillard explains, "signifies the end of perspective, the end of evocation, the end of witnessing, the end of the creative gesture and, not least of all, the end of the subversion of the world and of the malediction of art. Not only is its aim the immanence of the 'civilized' world, but its total integration in this world. Here there is an insane ambition: that of abolishing the annals (and the foundations) of a whole culture, that of transcendence."[50]

In the absence of transcendence, there is no beyond in the name of which to negate, reject, or resist what is. Contrary to popular understanding, pop art is idealistic—it is the *idealism of the image.* Since there is nothing outside the image, the image is (the) "real." Within this specular economy, the "real" is ideal and the ideal is "real." For those who dwell in this utopia of the simulacrum or the simulacrum of utopia, there is nothing for which to hope and *nothing* to fear. Redemption is at hand. "Pop art," Warhol avers, "is liking things." His fellow pop artist Roy Lichtenstein is more explicit: "Pop art looks out into the world; it appears to accept its environment, which is not good or bad, but different—another state of mind. 'How can you like exploitation?' 'How can you like the

complete mechanization of work?' 'How can you like bad art?' I have to answer that I accept it as being there in the world. . . . Pop art has very immediate and of-the-moment meanings which will vanish—that kind of thing is ephemeral."[51] Acceptance . . . nonjudgment . . . immediacy . . . the MOMENT . . . the ephemeral . . . indifference . . . Andy Warhol was the embodiment of Baudelaire's dandy who is nothing—if not fashionable . . . au courant . . . current.

In his stunning essay "Theatrum Philosophicum," Michel Foucault writes of Warhol's art:

> "Here or there, it's always the same thing; what difference if the colors vary, if they're darker or lighter. It's all so senseless—life, women, death! How ridiculous this stupidity!" But in concentrating on this boundless monotony, we find the sudden illumination of multiplicity itself—with nothing at its center, at its highest point, or beyond it—a flickering of light that travels ever faster than the eyes and successively lights up the moving labels and the captive snapshots that refer to each other to eternity, without ever saying anything: suddenly, arising from the background of the old inertia of equivalences, the striped form of the event tears through the darkness, and the eternal phantasm informs that soup can, that singular and depthless face.[52]

Currency: a flickering light that travels ever faster . . . snapshots that refer to each other to eternity . . . nothing at its center, at its highest point, or beyond it.

A certain darkness haunts the relentless pursuit of currency. Nietzsche's Zarathustra recognizes that radical Yea-saying must unavoidably embrace a certain Nay.

> Did you ever say "Yes" to one joy? Oh my friends, then you also said "Yes" to *all* pain. All things are entwined, enmeshed, enamored—
> —did you ever want Once to be Twice, did you ever say "I love you, bliss—instant—flash—" then you wanted *everything* back.
> —Everything anew, everything forever, everything entwined, enmeshed, enamored—oh, thus you love the world—
> —you everlasting one, thus you love it forever and for all time; even to pain you say: Refrain but—come again! *For joy accepts everlasting flow!*[53]

Currency: *everlasting flow.* Warhol was not blind to darkness. Indeed, he was as obsessed with death and disaster as he was with the brightness of stars. Dark images abound: *Five Deaths on Red* (1962), *Five Deaths on Orange* (1963), *Five Deaths Seventeen Times in Black and White* (1963), *Red Disaster* (1963), *Orange Disaster* (1963), *Silver Disaster* (1963), *Lavender Disaster* (1963), *Saturday Disaster* (1964), *Tuna Fish Disaster* (1963), knives, guns, electric chairs—*Big Electric Chair* (1967), *Little Electric Chair* (1965), *Blue Electric Chair* (1963)—suicides, skulls, plane crashes, ambulance crashes, car crashes, hospitals, funerals, and, of course, the ultimate war hole—the bomb—*Atomic Bomb* (plate 19).

Of all the disasters that Warhol recorded, the assassination of John F. Kennedy held a special fascination for him. Shortly after Kennedy's death, Warhol completed several series of portraits of Jackie, which include mov-

ing images of her at her husband's funeral. In 1968 Warhol returned to the theme in a set of silk screens entitled *Flash: November 22, 1963*, which is based on newspaper reports of the assassination. In retrospect, there seems to be something uncannily prophetic in Warhol's preoccupation with Kennedy's death. Warhol eventually achieved the fame for which he longed. On June 4, 1968, his picture appeared on the front page of the *New York Times* under the following headline: "Warhol Gravely Wounded in Studio, Actress is Held, Woman Says She Shot Artist Who is Given a 50–50 Chance to Live." Later that night there was another assassination. The *Times* bore the following headline on June 5: "Kennedy Shot and Gravely Wounded, After Winning California Primary, Suspect Seized in Los Angeles Hotel."

Not even a bullet could shatter the screen on which Warhol saw his life displayed. Recalling the attack in later years, he writes,

> Right when I was being shot and ever since, I knew that I was watching television. The channels switch, but it's all television. When you're really really involved in something, you're usually thinking about something else. When something's happening, you fantasize about other things. When I woke up somewhere—I didn't know it was at the hospital and that Bobby Kennedy had been shot the day after I was—I heard fantasy words about thousands of people being in St. Patrick's Cathedral praying and carrying on, and then I heard the word "Kennedy" and that brought me back to the television world again because then I realized, well, here I was, in pain. (AW, 91)

Though he struggled to repress it, Warhol seems to have realized the emptiness of the spectacle he lived. As early as 1960, he painted *TV $199*, which is the reproduction of a newspaper advertisement. The television screen, like the mirror Warhol dreaded, is empty.

In the years after the attempt on his life, Warhol tried to fill the emptiness and heal his wound with more and more signs. But it was always more of the same. As his art became less interesting, he became more devoted to the cult of celebrity. He once claimed, "Hollywood is everything I wanted my life to be like." The aestheticization of culture ends on the movie lots of Hollywood and playgrounds named Disneyland and Disney World. By the 1980s Warhol devoted most of his time and energy to his magazine, *Interview*, whose stars were Nancy and Ronald Reagan.

In 1985, a quarter century after he had painted the empty TV screen, Warhol—or one of his hired hands—executed another work that is either a television screen or a frame of film. This time there is a figure on the screen. The image is, of course, an ad. Across the top of the screen are four frames that are cast in green as negatives. Below this film strip, the large "positive" frame displays the image of a man and words that declare a revolution: "The new revolutionary collar on Van Heusen Century shirts won't wrinkle . . . ever!" The ad man is Ronald Reagan; the title of the work is *Van Heusen (Ronald Reagan)* (fig. 5.15). Fourteen years earlier, at the height of the war in Vietnam, Warhol said in a conversation with Paul Morrissey:

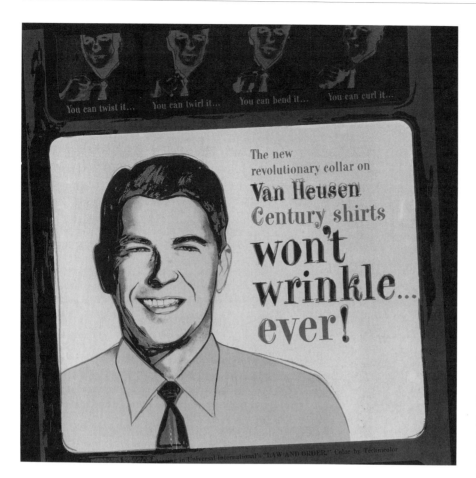

**5.15 Andy Warhol,** *Van Heusen (Ronald Reagan)* **(1985). Silk screen, 38 × 38 in. © 1991 The Estate and Foundation of Andy Warhol/ARS, New York. Photograph © D. James Dee, 1988, courtesy Ronald Feldman Fine Arts, Inc., New York.**

> I don't know much about Reagan. He's denounced for putting down student uprisings, but to me that sounds good. . . . Instead of wandering around taking drugs and not knowing what to do with themselves, American hippie kids should go to a country, colonize it and make a new civilization there. . . . Americanize it, Europeanize it, Irishize it! Certainly to Americanize it would be the best thing: America has the best civilization in the world as far as improvements and everything are concerned. . . . I like what John Wayne says and whenever he talks I find that I agree with him 100 percent.[54]

It would be convenient to attribute such a statement to Warhol's biting irony. But things are not so simple. By the end of his life, it became clear that Warhol's alliance with Reagan was far from accidental. For Ronnie, as for Andy, life *is* television and movies. Though Warhol disavowed political interests, his art is politically charged. His hero Ronald Reagan did not invent the politics of the simulacrum, but he remains its most powerful representative. To discover the architects of the society of spectacle, we must look elsewhere.

**6**

*Television makes me what I am.*
—TALKING HEADS

*And without doubt, our epoch . . . prefers the image to the thing, the*
*copy to the original, the representation to the reality, appearance to*
*being. . . . What is sacred for it is only* illusion, *but what is profane is*
truth. *More than that, the sacred grows in its eyes to the extent that*

# LOGO CENTRISM

*truth diminishes and illusion increases, to such an extent that* the peak
of illusion *is for it* the peak of the sacred.
—LUDWIG FEUERBACH

*The only question in this journey is: how far can we go in the extermi-*
*nation of meaning, how far can we go in the non-referential desert form*
*without cracking up, and, of course, still keep alive the esoteric*
*charm of disappearance?*
—JEAN BAUDRILLARD

*Irony is the infinitely delicate play with nothingness, a playing that is*
*not terrified by it but still pokes its head into the air. But if one takes*
*nothing neither speculatively nor personally seriously, then one obviously*
*takes it frivolously and to this extent not seriously.*
—SØREN KIERKEGAARD

# 6 □ LOGO CENTRISM

**F**ROM TIME IMMEMORIAL, the desert has been the site of exile, nomadism, and erring. A place of awesome inhumanity and frightful indifference, the desert demands austerity, asceticism, and self-denial. "Desert: luminous, fossilized network of an inhuman intelligence, of a radical indifference—the indifference not merely of the sky, but of the geological undulations, where the metaphysical passions of space and time alone crystallize. Here the terms of desire are turned upside down each day, and night annihilates them. But wait for the dawn to rise, with the awakening of fossil sounds, the animal silence" (A, 6). Although many have roamed the desert seeking revelation or searching for Truth, the desert is the place of illusions . . . of mirages.

In southern Nevada, the silence of the desert is broken by the noise of bright lights that darken the barren landscape and reverse the rhythms of life. Lights, millions of lights, turn night into day and transform metaphysical into physical passions. Even in the city, the desert is a place of excess—no longer excessive denial but excessive expenditure; no longer excessive asceticism but excessive consumption. Nonetheless, redemption remains the goal of the desert sojourn. One goes into the desert to try to lose loss.

Whether approached by land or air, Las Vegas rises from the desert like an overwhelming mirage—especially at night. It must have appeared an illusion too good to be true to the Spanish explorers who gave the location its name. In old Spanish, *la vega* designated a fertile lowland plain. Las Vegas has always been an oasis for weary travelers. A verdant grassland fed by natural aquifers, it served as a watering place on the Spanish trail to California. In 1855 Mormon missionaries established a settlement in the area and built a fort to protect travelers on the Salt Lake–Los Angeles Trail. In the course of the last century and a half, the nature of the watering holes has changed, and the illusion of Las Vegas has grown.

Today Las Vegas is a city of *signs*. Everything seems to be the pre-text for signs. Buildings are not autonomous structures but, in effect, billboards that disappear behind the signs they bear. Though the signs take many forms, they are predominantly electric. Las Vegas is a city run by and filled with electricity. In the city's ever-shifting currents, proliferating signs run wild until they become insignificant.

The "center" of Vegas is the Strip. Along the main thoroughfare of this desert city, one discovers huge electric signs that mark the site of The Sands and The Dunes. In the middle of the Strip, between The Sands and The Dunes, an oasis appears, an oasis that is a mirage or, more precisely, The Mirage. Designed by Joel D. Bergman, The Mirage is one of Las Vegas's newest and most spectacular hotels (fig. 6.1). The publicity disseminated by the hotel's public relations office announces, "The new Mirage

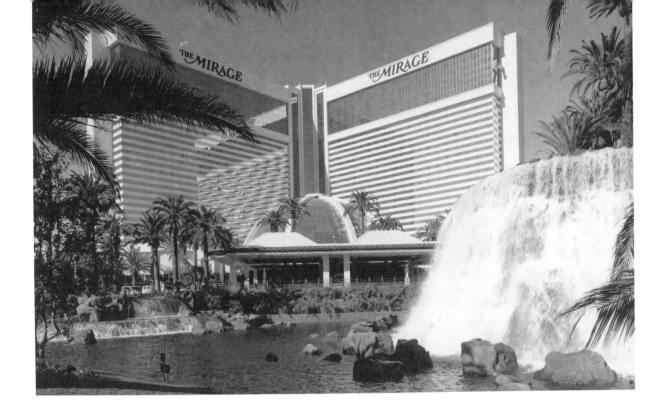

6.1 Joel Bergman, *The Mirage Hotel* (1989).

Resort is a South Seas oasis set in the desert of Las Vegas. The Mirage has been designed with the tropics in mind. Lush foliage, waterfalls and lagoons provide the guests with a serene atmosphere in which to relax. Rich tropical colors and carved teakwood add graceful touches. According to Steve Wynn, chairman of The Mirage, when guests arrive, they enter an enchanted place. . . . 'Our guests will be in paradise.'" An enchanted place . . . Paradise. The mirage begins with an oasis: rushing water cascading, streaming, flowing, tumbling over and around massive rocks. Scattered islands covered with palm trees and lush vegetation. In the midst of the lagoon, a volcano erupts regularly, sending jets of steam and flames a hundred feet into the air. In a sheltered grotto, dolphins frolic as children gleefully play nearby in a tranquil pool.

Behind the oasis, The Mirage rises—a massive thirty-story, 3,049-room hotel. The Y-shaped structure is patterned with alternating horizontal bands of pure white and reflective gold mirrors. Near the entrance to the hotel stands an immense electric sign that heralds Siegfried and Roy, "Masters of the Impossible," whose "magic show of wonder and illusion is guaranteed to mystify." Inside the hotel, the mirage continues. Behind the registration desk is a "coral reef"—a 52-foot, 20,000-gallon saltwater aquarium filled with fish indigenous to the Caribbean, Hawaii, Tonga, Fiji, the Red Sea, the Marshall Islands, the Sea of Cortez, and Australia: sharks, rays, tangs, surgeon fish, triggerfish, puffers, and others. Across from the reef is a luxuriant tropical rainforest under a 90-foot-high atrium: royal palms, orchids, elephant ears, banana trees, canary palms, and bamboo stalks. In the midst of the restaurants and boutiques that line the European Esplanade, there is a glass-enclosed Jungle Palace that is completely white

except for the blue of the pool and the bright colors of a mosaic depicting a jungle scene reminiscent of a Rousseau painting. Two enormous white tigers prowl freely in the palace. A continuously playing tape explains that these are two of the twenty-three white tigers that Siegfried and Roy use in their magic show. In this mirage, nature becomes culture and culture becomes simulacrum.

Beyond the lagoon, the coral reef, the rainforest, and the jungle palace lies the heart of The Mirage: the casinos. Gambling of every conceivable kind abounds—much of it electronic and all of it, like the volcano in the middle of the oasis, computerized.[1]

> The challenge of all the artificial lights to the violence of the sun's rays. Night of gambling sunlit on all sides; the glittering darkness of these rooms, in the middle of the desert. Gambling itself is a desert form, inhuman, uncultured, initiatory, a challenge to the natural economy of value, a crazed activity on the fringes of exchange. But it too has a strict limit and stops abruptly; its boundaries are exact, its passion knows no confusion. Neither the desert nor gambling are open areas; their spaces are finite and concentric, increasing in intensity toward the interior, toward a central point, be it the spirit of gambling or the heart of the desert—a privileged, immemorial space, where things lose their shadow, where money loses its value, and where the extreme rarity of traces of what signals to us there leads men to seek the instantaneity of wealth. (A, 128)

In the light of the simulacrum, things lose their shadows and everything becomes superficial. Even money loses its value as it is expended or consumed. Expenditure . . . consumption: there is no difference in the instantaneity of wealth and the immediacy of the moment. As one wanders through The Mirage, it becomes clear that there is still much to learn from Las Vegas.

In one—but only one—of its inscriptions, postmodernism is logo centrism. *Logo,* derives from the Greek *logos,* which indicates word or speech. More recently, *logo* has been used to designate an emblem, figure, image, or sign—especially one that identifies a product or business for the purposes of advertising. The effectiveness of the logo depends upon its transparency and the immediacy of its meaning. The logo is designed to be grasped in an instant. Logo centrism designates the centrality of the logo—the figure, image, and sign. Within a logo centric economy, signs do not refer to a more basic, fundamental, or essential reality but are signs of signs, figures of figures, images of images. Since everything appears to be image, nothing appears but appearance.

Logo centrism is the reverse side of the logocentrism that constitutes the foundation of the dominant theological, philosophical, and aesthetic tradition in the West. In contrast to logo centrism in which figure, sign, and image are privileged, logocentrism affirms the centrality of the logos—speech, word, or reason. Throughout the history of the Western tradition, the Logos has been interpreted in various ways: Platonic forms, the mind of the creator God, the Son of God, the image of God, Reason, Spirit, Absolute Subject, creative archetypes, numbers, geometric forms, foun-

dational structures, and so forth. In each of its incarnations, the Logos forms the ground and provides the reason for all that exists. From a logocentric perspective, to under-stand anything, one must penetrate appearances and comprehend what stands under the surface. From this point of view, signifiers refer to essential signifieds, images reflect a more fundamental reality, and figures figure a primordial substance. As we have seen, the theoesthetic presupposed by modernism is thoroughly logocentric. Modern art and architecture dis-figure by removing figure from the work of art. Abstract or nonobjective art and formalist architecture seek both to uncover the transcendental signified by erasing signifiers and to discover pure form by eliminating all ornamentation. Though not always explicitly religious, the theoesthetic enterprise is undeniably motivated by spiritual impulses. The goal of modernist aesthetic education is reconciliation with the "reality" that underlies appearances.

By inverting logocentrism, logo centrism not only allows but actually solicits the return of the repressed. Postmodern architecture disfigures the dis-figuration of modern architecture. Figure, sign, image, and representation return with a vengeance. As in the case of painting, however, it is not clear whether the inversion of opposites really changes anything. In important ways, logo centrism is logocentric. As we shall see, though the interpretation of the nature of reality shifts and artistic strategies change, the aim of postmodern aesthetic education remains reconciliation with the "Real."

Beginnings are always a problem, but nowhere more so than in the case of postmodernism. Postmodernism involves a thoroughgoing critique of the belief in origins and originality. For postmodernists, the notion of origin is a fiction that is first constructed and then projected back to a prelapsarian paradise in which everything is still pure and perfect. The concept of originality is no less fantastic. The idea of the creative genius is a reformulation of the notion of the creative God who is the uncaused cause that creates out of nothing. In other words, origin and originality are "theological" notions that ought to have died with the God who is their source. From a postmodern perspective, nothing is original, and thus everything is always already secondary. As Edward Said points out, it is necessary to distinguish "beginning" from "origin."[2] A beginning provides a point of departure without being original.

Though traces of postmodernism can be discerned in high modern architecture, the 1966 publication of Robert Venturi's *Complexity and Contradiction in Architecture* (most of which was written in 1962) marks the nonoriginal beginning of postmodern architecture.[3] Venturi's book, which he describes with disarming irony as "A Gentle Manifesto," is a response to Le Corbusier's highly influential 1923 *Vers une architecture*. There is, in fact, nothing gentle about Venturi's argument; it is a sustained attack on the foundational principles of modern architecture. In the course of his analysis, Venturi defines what in later years became the chief tenets of postmodern architecture.

Venturi insists that the purity and simplicity of modern architecture fail to reflect the complexities of modern society and culture. In his opening salvo, he declares, "I like complexity and contradiction in architecture. I do not like the incoherence or arbitrariness of incompetent architecture nor the precious intricacies of picturesqueness or expressionism. Instead, I speak of a complex and contradictory architecture based on the richness and ambiguity of modern experience, including that experience which is inherent in art. . . . Everywhere, except in architecture, complexity and contradiction have been acknowledged" (CC, 16). The abstract geometric formalism of modern architecture, Venturi maintains, takes cubism and abstract expressionism as its model. Mies van der Rohe captures the gist of the modernist aesthetic with his often-cited quip "Less is more." For Venturi, less is not more but is "a bore." By midcentury the formalism of architecture had become, for many, utterly empty and completely detached from and opposed to the changing currents of contemporary life. In an effort to revitalize architecture, Venturi turned to pop art. The architectural use of pop art underscores the parallel I have been pursuing in previous chapters: whereas modern architecture extends the disfigurative strategy of abstract and nonobjective painting, postmodern architecture appropriates the figurative style of pop art. As we have seen, when figure returns in pop, it returns with a difference. The sign is, in a certain sense, insignificant, for it always figures another sign. When this situation is recognized and artfully thematized, architecture, like painting, becomes the art of simulation. Simulation, according to Baudrillard,

> is no longer that of a territory, a referential being or a substance. It is the generation by models of a real without origin or reality: a hyperreal. The territory no longer precedes the map, nor survives it. Henceforth, it is the map that precedes the territory—PRECESSION OF SIMULACRA—it is the map that engenders the territory and if we were to revive the fable today, it would be the territory whose shreds are slowly rotting across the map. It is the real, and not the map, whose vestiges subsist here and there, in the deserts that are no longer those of the Empire, but our own. *The desert of the real itself.* (S, 2)

The desert to which Venturi turned to re-cover the "real" is Las Vegas.

The far-reaching implications of Venturi's "Gentle Manifesto" became explicit several years later with the publication of *Learning from Las Vegas: The Forgotten Symbolism of Architectural Form.* Begun as a research project at Yale in the fateful year 1968 and published in 1972, *Learning from Las Vegas* proposes an aesthetic of tolerance and acceptance rather than exclusion and repression. "Architects," Venturi and his colleagues note, "are out of the habit of looking nonjudgmentally at the environment, because orthodox Modern architecture is progressive, if not revolutionary, utopian, and puristic; it is dissatisfied with *existing* conditions. Modern architecture is anything but permissive: Architects have preferred to change the existing environment rather than enhance what is there" (LV, 3). When Venturi turns his purportedly "nonjudgmental" eye to the world around him, he sees a culture of the simulacrum comprising cities of signs.

In the late 1960s, as in the early 1990s, Las Vegas is *the* city of the sign and, as such, is completely logo centric. The Strip, Venturi observes, "is virtually all signs." Indeed, "if you take the signs away, there is no place." Along the Strip, which Venturi regards as a microcosm of the contemporary world, "the sign is more important than the architecture" (LV, 9, 18, 13). He attributes the predominance of the sign to two important cultural shifts. First, in contrast to the modernists, Venturi insists that the relevant revolution in the latter half of the twentieth century is not industrial but electronic. The culture of the simulacrum reflects a postindustrial society in which the currency of exchange is figure rather than thing, representation instead of object. Second, and not unrelated to the first point, contemporary culture rests upon a consumer economy that encourages the production of insubstantial, changeable products. Change is not only a cultural value but an economic necessity. To encourage consuming expenditure, advertising and entertainment industries have emerged to transform the commodity into an image. Even when we purchase things, we buy (into) image. In postindustrial consumer society, everything becomes a *spectacle*. While speculative philosophy attempts to mediate reality conceptually, the society of spectacle *mediaizes* "reality" figuratively. The difference between mediation and mediaization is not, however, as great as it first appears. As we have discovered in our consideration of pop art, the precession of the simulacrum involves an idealism of the image that is the functional equivalent of the conceptual idealism inherent in speculative philosophy.

Having committed himself to a nonjudgmental ethic of tolerance, Venturi actively affirms and embraces logo centrism. Against modernity's exclusive principle of either/or he sets postmodernity's inclusive principle of both/and: "I am for richness of meaning rather than clarity of meaning, for the implicit function as well as the explicit function. I prefer 'both-and' to 'either-or,' black and white, and sometimes gray, to black or white. A valid architecture evokes many levels of meaning and combinations of focus: its space and its elements become readable and workable in several ways at once" (CC, 16). To establish the scope and significance of his architectural "revolution," Venturi has developed a list of binary opposites that are intended to summarize the differences between modernism and postmodernism. Of the multiple contrasts he defines, seven are important for charting the course of subsequent architectural tendencies: image/ form (or representational art/abstract expressionism, symbolism/abstraction); ordinary/original (or conventional/creative and unique); superficial/ integral; high *and* low art/high art (or cheap/expensive, awful/nice); mixed media/pure architecture, heterogeneous images/the image of the middle class; and historical/modern (or evolutionary, using historical precedent/ revolutionary, progressive, antitraditional).[4]

First and foremost, Venturi calls for a return to figure, image, ornament, and sign. Rejecting the aniconicity of modernism, he proposes an architecture that "emphasize[s] image—image over process or form." To

underscore the importance of the use of figures and images, Venturi has developed his now classic distinction between the duck and the decorated shed. "Where the architectural systems of space, structure, and program are submerged and distorted by an overall symbolic form," we have a *duck*. In the *decorated shed*, by contrast, "systems of space and structure are directly at the service of program, and ornament is applied independently of them" (LV, 87). While the duck pervades modern architecture, only the decorated shed is appropriate in the society of the sign.

The figures, representations, and signs used to decorate insubstantial sheds should be ordinary and conventional instead of original or unique. Sounding a theme that has become a cornerstone of many later versions of postmodernism, Venturi declares that "copies . . . are more interesting than the real." In stressing reproduction at the expense of production, he takes his cue from pop art. Like Warhol industriously turning out Campbell's Soup cans and Brillo boxes, Venturi flaunts cliché and privileges the commonplace. The figures with which Venturi decorates are—like Rauschenberg's and Johns's images, Schwitters's junk, and Duchamp's ready-mades—found rather than made, borrowed or stolen instead of invented or created. If the sign is always the sign of a sign, no sign can ever be original.

When art becomes a cliché, it is undeniably superficial. For Venturi, superficiality is not a shortcoming that can be surmounted by digging deeper but a virtue that allows us to defeat the sense of gravity that all too often weighs upon us. Buildings should be neither profound nor integral but two-dimensional signs. "The forms of the buildings are visible but remain secondary to the signs in visual impact and symbolic content. The space of urban sprawl is not enclosed and directed as in traditional cities. Rather, it is open and indeterminate, identified by points in space and patterns on the ground; these are two-dimensional or sculptural symbols in space rather than buildings in space, complex configurations that are graphic or representational" (LV, 116–17). In the case of decorated sheds, the façade is all-important. Indeed, appearances to the contrary notwithstanding, structure is nothing but façade. What appears to be the back of an edifice is another front, and what seems to be a deep structure is a supplementary surface.

It should be obvious that Venturi's principle of inclusion cannot incorporate modernity's principle of exclusion. Consequently, he rejects modernism's rejection of low art without excluding so-called high art. Resisting every form of purism, Venturi contends,

> Architects can no longer afford to be intimidated by the puritanically moral language of orthodox Modern architecture. I like elements which are hybrid rather than "pure," compromising rather than "clean," distorted rather than "straightforward," ambiguous rather than "articulated," perverse as well as impersonal, boring as well as "interesting," conventional rather than "designed," accommodating rather than excluding, redundant rather than simple, vestigial as well as innovating, inconsistent and equivocal rather than direct and clear. I'm for messy vitality over obvious unity. (CC, 16)

The mess that Venturi seeks to create requires the use of mixed media. In place of Greenberg's insistence on the autonomy of different art forms, Venturi proposes an architecture that mixes but does not match media. Architecture, in other words, must become a multimedia art.

Venturi's endorsement of mixed media involves an eclecticism that leads to a reconsideration of the appropriateness of historical reference. While modernism's search for the new leads to a dismissal or repression of the past, postmodernism regards historical traditions as rich resources for contemporary architecture. Venturi's criticism of modernity on this point involves both a different aesthetic sensibility and an alternative interpretation of historical development. While orthodox modern architecture tends to associate the primitive with the sensual, fanciful, and figurative, and the modern with the rational, abstract, and nonfigurative, Venturi regards the primitive as the simple, elementary, and orderly, and the modern as complex, contradictory, and figurative. He cites August Heckscher in support of this point: "The movement from a view of life as essentially simple and orderly to a view of life as complex and ironic is what every individual passes through in becoming mature" (CC, 16). To enrich their constructions, architects are free to draw on the entire repertoire of figures, forms, and styles developed in the course of human history. With complexity and contradiction come paradox and ambiguity in which univocality inevitably gives way to equivocality. For Venturi, polysemy and polymorphism are marks of a richness to be cultivated and not of a poverty to be eliminated.

It would be a mistake to think that Venturi's concerns in his critique of modernism are merely aesthetic. His proposal for a postmodern architecture is also informed by ethical interests. Though modern architecture begins as an ethically inspired effort to realize a better social world, it ends as a corporate authoritarianism that seeks to establish and secure both aesthetic and social order by repressing sociocultural diversity. Modern architects, Venturi argues, "reject the very heterogeneity of our society that makes the social sciences relevant to architecture in the first place. As Experts with Ideals, who pay lip service to the social sciences, they build for Man rather than for people—this means, to suit themselves, that is, to suit their own particular upper-middle-class values, which they assign to everyone" (LV, 154). Having lost its social concern, modernism comes to represent precisely the values it should be resisting. In calling for an ethic of tolerance, Venturi sounds a populist note that is intended to support democratic values of equality and diversity. Heterogeneous images reflect and encourage a heterogeneous society. Venturi's ethical concerns do not create a sense of seriousness and gravity that is typical of many early modern artists and architects. To the contrary, Venturi never loses his sense of humor and always insists on the importance of irony. Inasmuch as he uses "irony and . . . a joke to get serious, the architect becomes a jester" (LV, 161). Venturi realizes what most crusading reformers fail to recognize: humor is a most effective means of social criticism.

Having established the principles of his critique of modernism, Venturi proceeds to call into question the very basis of the oppositions he formulates. Recalling, without citing, Adorno's observation that Bauhaus design is "just as ornamental as the basic structures of Cubism,"[5] Venturi argues that modern architecture, "while rejecting explicit symbolism and frivolous appliqué ornament, has distorted the whole building into one big ornament" (LV, 103). From this point of view, the distinction between modernism and postmodernism is not the difference between the rejection and acceptance of figure and ornament but the difference between the implicit and explicit use of figure and ornament. Modern architecture is every bit as figurative as postmodern—even if its figures are, according to Venturi, "dry, empty, and boring." Appropriating the iconography of modern industry, modern architecture *symbolizes* "the brave new world of technology."[6] Even Mies, who, as we have seen, seems to be the most rigorous nonfigurative architect, used ornament, while denying that he was doing so.

> Less may have been more, but the I-section on Mies van der Rohe's fire-resistant columns, for instance, is as complexly ornamental as the applied pilaster on the Renaissance pier or the incised shaft in the Gothic pier. (In fact, less was more work.) Acknowledged or not, modern ornament has seldom been symbolic of anything non-architectural since the Bauhaus vanquished art deco and the decorative arts. More specifically, its content is consistently spatial and technological. Like the Renaissance vocabulary of the Classical orders, Mies' structural ornament, although specifically contradictory to the structure it adorns, reinforces the architectural content of the building as a whole. If the Classical orders symbolized the "rebirth of the Golden Age of Rome," modern I-beam represents the "honest expression of modern technology as space"—or something like that. Note, however, that it was "modern" technology of the Industrial Revolution that was symbolized by Mies, and this technology, not current electronic technology, is still the source for Modern architectural symbolism today. (LV, 115)

Venturi's point is important, for it suggests the way in which modern architecture is, in a sense, already postmodern. Its "purity" is infected from within by precisely what is supposed to be repressed. Venturi might have supported his point by a further consideration of Mies's Seagram Building. As we have seen, the Seagram Building is the quintessential modern building in which ornament is eliminated to reveal structure. But the clarity of the structure and the purity of the functionalism are illusory. The exposed I-beams that appear to be structural and functional are actually decorative. The real supports are inside the building. The use of structural elements for decorative purposes is even more explicit in a work like the John Hancock Building in Chicago (fig. 6.2). The austere geometricism of the typical modern high rise is interrupted by the building's taper and the display of diagonal braces. In such gestures, the line separating structure and form from figure and ornament is erased.

Although Venturi does not make the case, it is possible to argue that one of his oppositions implies the inextricable interrelation of modernism

6.2 **Skidmore, Owens, and Merrill,** *John Hancock Building* **(1969). Photograph: Alan Thomas, 1992.**

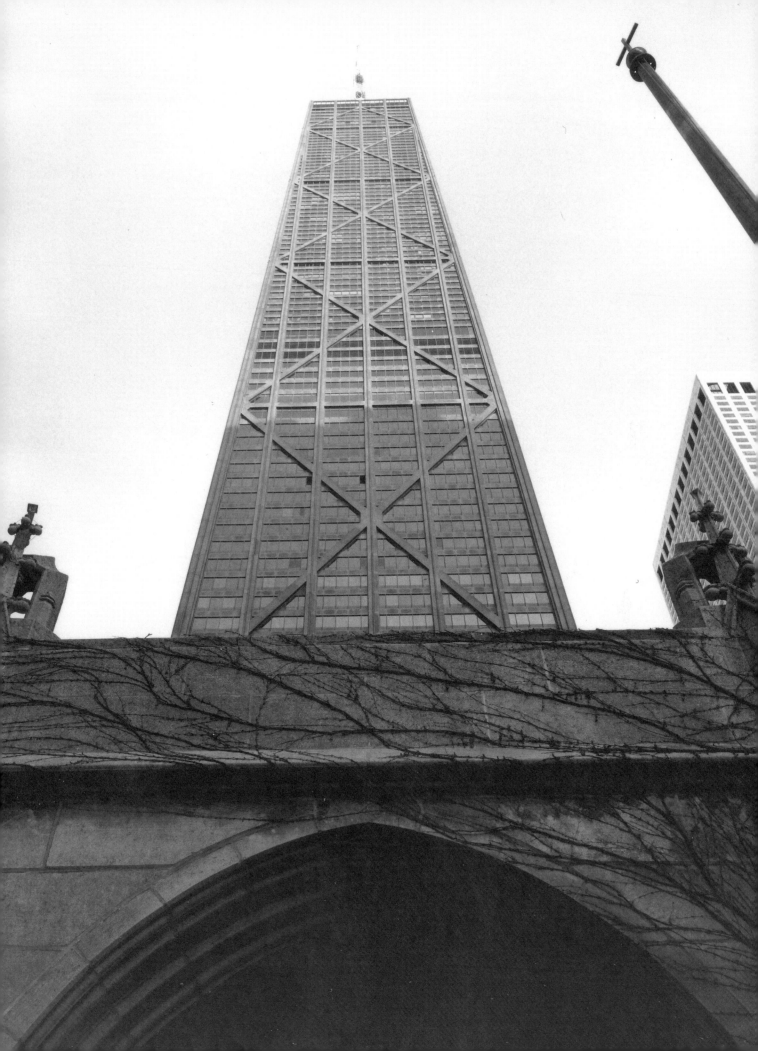

and postmodernism. He sets "Historical Styles" against "Modern Style." We have already noted the important role that historical reference plays in postmodernism's critique of modernism. In this context, the distinction between *styles* and *style* deserves comment. While postmodernism is stylistically pluralistic, modernism endorses a single style—that of abstraction or formalism. Nevertheless, modernism is a *style* and, as such, is undeniably figurative. Though the style of modernism was evident from the beginning, it was not explicitly recognized as such until Philip Johnson, whose career provides what is, in effect, a concise summary of the shifting currents in twentieth-century architecture, and Henry-Russell Hitchcock introduced the "New Architecture" to America. The title of the catalogue accompanying their 1932 exhibition at the Museum of Modern Art is, significantly, *International Style: Architecture since 1922.* The introduction of "international style" suggests that a fundamental change took place in modern architecture. Johnson's and Hitchcock's description of this new style conforms to what we have come to expect of modern architecture: "one dominant style," "absence of ornament," "functionalism," "principle of order," and, most important, "the formal simplification of complexity." "The finest buildings built since 1800," Johnson and Hitchcock conclude, "were those least ornamented" (IS, 69). There is, however, a significant difference between Johnson's and Hitchcock's reading of modern architecture and the self-understanding of the architects themselves. In what seems to be a passing aside, they comment, "The fact that there is so little detail today increases the decorative effect of what there is. Its ordering is one of the chief means by which consistency is achieved in the parts of a design" (IS, 70). This interpretation of modern architecture not only anticipates Venturi's insistence on its ornamental quality but signals a fundamental shift in the modern movement as it travels from Europe to America. When modernism became stylish, its purpose and function were transformed. We have already discovered that when abstract painting crossed the Atlantic after the Second World War, the search for a social utopia became the quest for personal salvation. A similar, though more radical, transformation took place when modern architecture was imported. Having begun in Europe as an ethically motivated struggle to establish a more just and equitable world by providing adequate housing and recreational space for the urban masses, modernism in postwar America became the preferred style of corporations and the upper-middle class. As Tom Wolfe points out in a bitterly ironic twist, what had started as worker housing became the symbol of wealth and prosperity. Postmodern architecture completes what modernism began.

As these remarks imply, if modern architecture is, in some sense, already postmodern, Venturi's postmodernism is, in important ways, still modern. The most telling opposition that Venturi defines is "the difficult whole vs. the easy whole." The whole of modernism is easy because it *excludes* what is contradictory, complex, heterogeneous, and messy. A whole that excludes, of course, is not whole but partial, torn, and rent.

Venturi's criticism of the modern purist aesthetic is that it is not holistic enough. His ideal remains a whole or totality that assembles and unites more than it separates and divides. Venturi's effort to translate the exclusion of either/or into the inclusion of both/and is essentially a Hegelian gesture in which the principle of noncontradiction is supplanted by the principle of contradiction according to which everything contains its own opposite. In a statement that might have been proffered by Hegel, Venturi claims, "But an architecture of complexity and contradiction has a special obligation toward the whole: its truth must be in its totality or its implications of totality. It must embody the difficult unity of inclusion rather than the easy unity of exclusion" (CC, 16). It is not insignificant that Venturi cites the most Hegelian of poets—T. S. Eliot—in the opening paragraph of his manifesto. Furthermore, the literary critics upon whom he relies are representatives of so-called New Criticism. The guiding principle of New Criticism is that the work of art is a self-referential totality that must be considered in its own terms and not in relation to anything *hors-texte*—for example, authorial intention and historical circumstance. New Critics place particular emphasis on the "organic unity" of structure and meaning. Every successful work of art finally reconciles tensions, ironies, and paradoxes in an equilibrium of opposed forces. Venturi cites Cleanth Brooks to elaborate one of the most important critical principles of his architectural theory.

> Yet there are better reasons than that of rhetorical vainglory that have induced poet after poet to choose ambiguity and paradox rather than plain discursive simplicity. It is not enough for the poet to analyze his experience as the scientist does, breaking it up into parts, distinguishing part from part, classifying the various parts. His task is finally to unify experience. He must return to us the unity of the experience itself as man knows it in his own experience. . . . If the poet . . . must perforce dramatize the oneness of the experience, even though paying tribute to its diversity, then his use of paradox and ambiguity is seen as necessary. He is not simply trying to spice up, with a superficially exciting or mystifying rhetoric, the old stale stockpot. . . . He is rather giving us an insight which preserves the unity of experience and which, at its higher and more serious levels, triumphs over the apparently contradictory and conflicting elements of experience by unifying them into a new pattern. (CC, 20)

It would be hard to imagine a more Hegelian argument. Like the philosopher, the goal of the artist-architect is to establish unity in the midst of diversity. For Venturi, as for Hegel, disunity and irrationality are epiphenomenal. "Apparent irrationality of a part will be justified by the resultant rationality of the whole, or characteristics of a part will be compromised for the sake of the whole. The decisions for such valid compromises are one of the chief tasks of the architect" (CC, 25). The whole is the synthetic totality in which opposites are reconciled and differences united. Since Hegel is the modern philosopher par excellence, Venturi's indirect and apparently unwitting espousal of Hegel's speculative idealism extends and does not subvert modernism. Venturi never calls into question the struc-

tures of order, reason, meaning, unity, wholeness, and totality. His logo centrism, therefore, remains thoroughly logocentric. While never admitting it, his position implies that the problem with modernism is that it is not modern enough. Thus, postmodernism must become more consistently modern than modernism.

When one turns from writings to architecture, Venturi's work is considerably less innovative. His lingering attachment to basic tenets of modernism results in a certain tentativeness in the buildings he designs. Although he reintroduces ornament, his use of figure both contradicts and reinforces form. In what is probably his best-known work, his house for his mother, the advances and limitations of Venturi's architectural practice are evident (fig. 6.3). The planar style typical of modernism is interrupted by unexpected gaps, disruptive asymmetry, irregular windows, decorative moldings, and colored façades. The most striking feature of the house is the oversized pediment, which anticipates a detail that attracted Venturi's attention in Las Vegas, that is, "the sign for the Motel Monticello, a silhouette of an enormous Chippendale highboy, . . . visible on the highway before the sign itself" (LV, 8). At the time of its construction, the unapologetic eclecticism of the Vanna Venturi House offended the sensibilities of many architects and critics who had grown accustomed to the simplicity of the international style.

In later works, Venturi elaborates themes defined in his writings and extends the innovations proposed in his mother's house. A building like

**6.3** Robert Venturi, *Vanna Venturi House* (1963–65). **Courtesy Venturi, Scott Brown and Associates, Inc. Photograph: Rollin R. La France.**

Gordon Wu Hall on the Princeton University campus gives evidence of Venturi's characteristic preference for traditional building materials (bricks and limestone) and his insistence on ornamentation (fig. 6.4). His use of figure, however, remains suspiciously modern. The superficial geometric forms of solid white and gray marble and granite that decorate the building are closer to an abstract canvas than to a work of pop art. It was left for others to develop and radicalize the possibilities that Venturi identifies. In the years following the publication of *Complexity and Contradiction in Architecture* and *Learning from Las Vegas*, there has been a proliferation of figuration, representation, signs, and images, a growing use of quotation, citation, and appropriation, increased emphasis on superficiality, greater openness to the cheap, low, banal, and popular, and more frequent and obvious historical reference. In sum, architecture has become thoroughly heterogeneous and eclectic. Committed to complexity and contradiction, architects have become less and less concerned about integration, harmony, unity, and totality.

Few have done more to popularize postmodern architecture than has Philip Johnson. There is a certain irony in this, for, as we have seen, Johnson was instrumental in launching the modern movement in America. His

**6.4 Robert Venturi, Denise Scott Brown, John Rauch,** *Gordon Wu Hall* **(1982–84). Courtesy Venturi, Scott Brown and Associates, Inc. Photograph: Tom Bernard.**

early work is thoroughly informed by the principles of modernism. Many of the buildings he designed in the late 1940s and 1950s are every bit as formal as Mies's most abstract structures. While his 1949 Glass House recalls Mies's Barcelona Pavilion and Farnsworth House, his contribution to the campus of the University of St. Thomas might have been lifted from Mies's Illinois Institute of Technology (figs. 6.5, 6.6). But even during his most formalist stage, Johnson remained open to the use of figuration. By the 1960s, Johnson grew disenchanted with the abstraction of the international style and was increasingly drawn to the resources of figure and ornament suggested by pop artists. His wildly popular New York State Pavilion for the 1964 World's Fair foreshadowed things to come. In what appeared to be an effort to advertise the migration of the avant-garde from

**6.5** *Below* **Philip Johnson,** *Glass House* **(1949). Courtesy John Burgee Architects.**

**6.6** *Bottom* **Philip Johnson,** *University of St. Thomas* **(1957). Courtesy John Burgee Architects.**

6.7 Andy Warhol, *Thirteen Most Wanted Men.* © 1991 The Estate and Foundation of Andy Warhol/ARS, New York.

6.8 Philip Johnson, *New York State Pavilion* (1964). Courtesy John Burgee Architects. Photograph: Ezra Stoller © ESTO.

Europe to New York, state officials arranged a collaboration between Johnson and the leading postwar American artist—Andy Warhol. Ever the provocateur, Warhol developed his notorious multifigured portrait *Thirteen Most Wanted Men* to adorn Johnson's building (fig. 6.7). This gesture proved too much for Governor Nelson Rockefeller, who ordered Warhol's work to be covered and painted white. Rockefeller's whitewash could not, however, erase the gay eccentricity of Johnson's construction (fig. 6.8). The central open-air structure consists of a brightly colored oval

roof supported by sixteen split columns. The main entrance is flanked by the low circular white building for which Warhol designed his silk screen and a two-tiered column with circular observation decks on top. In addition to dazzling colors and bright lights, the inside of the pavilion is decorated with three dominant images: above the main entrance, the state insignia or sign is suspended; on the floor, a huge map of the state of New York is drawn; and below the map, there is a large Texaco logo. The removal of *Thirteen Most Wanted Men* did not obscure the influence of pop art on Johnson's architecture.

After he joined John Burgee in 1967, the extent of Johnson's departure from the principles of the international style became obvious. This shift was, no doubt, less significant for Johnson than for many of his supporters and detractors. As we have seen, Johnson regards modernism as a *style*. Throughout all of the twists and turns of his extraordinary career, Johnson's approach remains consistently aesthetic. Consequently his move from modernism to postmodernism does not represent a substantial change of direction but simply reflects fluctuating fashions. From 1979 to 1985, with few exceptions (e.g., Sugerland Office Park, Houston; Nieman-Marcus Store, San Jose; Cleveland Play House; College of Architecture, University of Houston), Johnson's and Burgee's commissions were high-rise office buildings. Some of the economic tendencies we have been considering suggest the importance of the fact that many of these buildings were joint ventures with speculative real estate developers.[7]

In spite of their stylistic diversity, Johnson's buildings are all characterized by eclecticism and historicism. These tendencies are evident in the Republic Bank Center in Houston, where Johnson uses a three-tiered gable roof design to generate an effect reminiscent of the traditional Dutch façades that fascinated Oud and van Doesburg (fig. 6.9). Swedish granite replaces reinforced concrete, steel, and a glass curtain to create a rich exterior. Multiple copper gables, capped with lead-coated obelisks, add decorative flourishes. The entrance is a massive 80-foot arch that opens to vaulted arcades and a central hall that is 120 feet high. The heaviness of the interior columns and arches surrounding the hall is offset by the brightness of the colors and lighting as well as the openness of layered latticework on the walls and ceiling. The overall effect is one of luxurious grandeur rather than austere formalism.

Johnson's most obvious use of historicism to date is the PPG Corporate Headquarters in Pittsburgh (fig. 6.10). The neo-Gothic design of this six-building complex creates a cathedral for corporate capitalism. The central forty-story tower is surrounded by a thirteen-story tower and four five-story towers, one of which houses a large skylit atrium. The plaza, which is encircled by upscale boutiques, is decorated with a geometric pattern in cream, gray, and pink granite that recalls the decorated façade of Venturi's Gordon Wu Hall. In the center of the plaza stands a 44-foot-high pink granite obelisk. Johnson successfully combines black glass, framed in sleek silver, with multiple obtuse, acute, and right angles to form a daz-

zling play of mirrors in which the building repeatedly reflects itself. The traditionalism of the neo-Gothic design is offset by the use of modern glass and steel, and by the art deco effect created by the use of fluorescent lights inside the top corner spires. On the interior, the structural and chromatic uniformity is interrupted by diagonal panels of opaque red glass. As one contemplates this remarkable building, it seems obvious that the work's primary historical reference is Charles Barry's Houses of Parliament in London. It is hard to believe that the same architect designed the PPG building who, twenty-five years earlier, was building Miesian glass boxes.

While Johnson's works are numerous and various, he is best known for the AT&T Corporate Headquarters in New York City (fig. 6.11). The distinguishing characteristic of this instant landmark is the five-story Chippendale pediment that indirectly cites the Motel Monticello in Las Vegas and repeats Venturi's use of this motif in his mother's house. There is, however, an important difference between Venturi's and Johnson's use of the Chippendale design. When the pediment of the house is redrawn in the skyscraper, straight lines and right angles become diagonals, circles, and curves. In making such changes, Johnson's work becomes more faithful to the principles of postmodernism than does Venturi's own building.

If, as Venturi insists, postmodernism is characterized by both the recognition of the importance of the electronic revolution rather than the industrial revolution, and an appreciation for pop instead of abstract art, then the client and the location of the so-called first postmodern skyscraper could not be more appropriate. Commissioned by the leader in

electronic communications and located on Madison Avenue in the heart of the advertising industry that gave birth to pop art, Johnson's building is a monument to the postmodern corporate "reality" that continues to transform the world into its own image. The thirty-seven–story tower is a classical three-part structure. Beneath the crowning decorative pediment is a middle section that consists of a vertical steel frame covered with a thin granite veneer. The cathedral-like base consists of a giant arch, under a circular window, surrounded by tall supporting columns. Throughout the structure, Johnson attempts to simulate traditional stonemasonry that is rich in sculptural detail. Employing illusory strategies fitting for Madison Avenue, he mixes real and false joints and creates large circular openings that suggest thick stone instead of the actual applied granite facing. Here, as elsewhere, apparent depth is really superficial.

The cavernous vaulted lobby and the adjacent 60-foot-high loggia form a space that, like the PPG building, is the functional equivalent of a latter-day cathedral. In the center of the Romanesque lobby, standing on a tall granite plinth and silhouetted against a 20-foot oculus, is a golden statue of the god of AT&T's electronic revolution—the *Genius of Electricity,* which was executed by Evelyn Beatrice Longman in 1916 and taken from the top of the company's previous corporate headquarters (fig. 6.12). As

6.11 *Above left* **Philip Johnson,** *AT & T Corporate Headquarters* **(1979–84). Courtesy John Burgee Architects.**

6.12 *Above* **Philip Johnson,** *AT & T Corporate Headquarters,* **lobby. Courtesy John Burgee Architects.**

Charles Jencks observes, ''Ironically, this Nietzschean superman, who has in this chapel displaced the suffering Christ, is a fey Golden Boy, an overgrown *putto* with wings'' (PM, 231). It is not clear whether Johnson appreciates the complexity of his multiple historical quotations. What is clear, however, is that he makes no effort to disguise his fascination with artifice. Johnson freely admits that his art is fake, and thus he does not try to deceive. To the contrary, an essential part of his play is to display artifice as such. Although Johnson extends the practice of postmodern architecture beyond the point reached by Venturi, his chef d'oeuvre is nonetheless a typical New York skyscraper with decorative supplements.

Something quite different emerges in the eclecticism of James Stirling. Stirling's richly complex and contradictory work presupposes an aesthetics of heterogeneity that extends into the realm of building the principles that inform art from cubist collage to Rauschenberg's combines and assemblages. Although his early work exhibits the influence of classical modernism, Stirling from the outset resists the purity and austere formalism of the modern masters. His Engineering Building at the University of Leicester marks a significant development in postwar architecture (fig. 6.13). Stirling simultaneously uses and suspends pure forms. Furthermore, he freely mixes traditional and modern building materials by com-

**6.13** James Stirling, *Engineering Building* (1959–63). Courtesy ARCAID. Photograph © Richard Einzig.

bining bricks with steel and glass. The result is a collage of forms and materials whose fragile foundation and tenuous balance are suggested by the slender glass column that seems to support the main tower. While the beauty of this structure does not represent classical regularity, neither is it simply irregular. Dissimilar parts join to form a whole that is still coherent. The Engineering Building is no longer modern but not yet postmodern.

Stirling crosses the thin line separating (and joining) the modern and the postmodern in the Staatsgalerie New Building and Chamber Theater in Stuttgart (plate 20). By the late 1970s, Stirling was less interested in preserving coherence than in generating creative tensions by juxtaposing opposites. Commenting on the Staatsgalerie in a 1981 lecture, he implicitly invoked Venturi's inclusive principle of both/and: "In addition to Representational and Abstract, this large complex, I hope, supports the Monumental *and* Informal; also the Traditional *and* High Tech."[8] In practice, Stirling's inclusive architecture results in complexities and contradictions that surpass anything either Venturi or Johnson has achieved. Stirling combines traces of Greek, Roman, and Egyptian architecture with references to Schinkel's Altes Museum, and brightly colored high-tech ornamentation (which explicitly recalls the Beaubourg in Paris) to create a dramatic building that is extremely controversial. Praised as the most advanced example of postmodernism and damned as a revival of totalitarian or neo-Fascist architecture, the Staatsgalerie continues to provoke heated debate among critics as well as the public at large.

Despite its innovative style, Stirling managed to remain sensitive to the context of the building. Not only did he preserve all existing structures, but the U-shaped plan reflects the neoclassical design of the 1837 gallery. The fourth side, which is open to the street, is traversed by intersecting entrances, piazzas, and plazas. In the center of the complex is a large sunken sculpture garden that is circular in shape. Instead of Johnson's stylishly colored red and pink granites, Stirling uses sandstone set in travertine. The masonry constructions employ a variety of classical forms and arches. Juxtaposed to these traditional elements are structures and details that represent the latest design and technology. Gone are right angles, regular lines, and flat planes, and in their place are irregular angles, wavy lines, and undulating planes. Crystalline stasis gives way to a vital flow in which the unexpected displaces the controlled (fig. 6.14).

Stirling's use of decorative color is more daring than anything ventured by Venturi or Johnson. Le Corbusier's white world disappears not in subtly muted pinks, browns, and grays but in bright, even gaudy, reds, blues, greens, and yellows. Stirling brandishes decoration and ornamentation without becoming ostentatious. As if to mock imposing façades and grand entrances, the main approach to the Staatsgalerie is a skeletal structure that resembles one of Venturi's "ghost" constructions. A tissue of quotations and citations, this supplemental entrance surpasses what Jencks describes as "double coding" and becomes polycoded. Outlining what might be anything from a primitive dwelling to a Greek temple, the

**6.14 James Stirling, *Staats-galerie, New Building*, detail. Courtesy ARCAID. Photo-graph © Richard Bryant, 1985.**

gateway to the museum is built with modern construction techniques, using fully displayed steel I-beams that are painted bright red and blue. This remarkable collage simultaneously evokes the primitive, classical, modern, and postmodern. In the center of the museum, an open sculpture court recalls the Pantheon without a dome. Directly across from the main stairs leading to the bottom of the circular opening, there is a sunken, truncated Doric portico that suggests a religious altar and hence evokes a sense of sacred space. But unlike Johnson, Stirling leaves the center empty. He explains, "It's no longer enough to do classicism straight; in this building the central pantheon, instead of being the culmination, is but a void—a room like non-space instead of a dome—open to the sky." [9] At the precise center of the sculpture court, which, in turn, is the center of the whole structure, there is a reference to electricity that is considerably less grand than the monumental *Genius of Electricity* employed by Johnson. With biting irony, Stirling comments, "The center is a drain and the three circles represent not the Trinity, but the cross-section of an electric cable" (PM, 272). The center, which traditionally is deemed sacred and, as such, provides life with meaning, order, and direction, is not precisely missing but has become the site of refuse and waste.

It is impossible to provide a comprehensive summary of the Staats-

galerie because it is complex without being whole. Through strategies of juxtaposition and superimposition, Stirling creates paradoxes that are not resolved. If this work is a collage, it is not synthetic; if it is an assemblage, it holds apart as much as it brings together; if it is a combine, the fragments it combines remain fragmentary in their free associations. Stirling's work effectively reflects the irreducible discontinuity of contemporary experience. To underscore the fragility of the baseless structures within which we dwell, Stirling adds an inconspicuous, though important, detail. In one of the walls of the parking garage, several large stones appear to have fallen to the ground, leaving an unrepaired hole. In a certain sense, this fissure or fault ruins the work by exposing the illusion of even the most seemingly substantial structures. The stonework of the building is as superficial as the decorative ornaments. The gap in the wall reveals that the sandstone and travertine are only one inch thick. Within the economy of the simulacrum, every secure foundation is finally imaginary.

Less inventive architects relax the oppositions that Stirling leaves unresolved. Two of the most influential postmodern architects in America, Michael Graves and Charles Moore, concentrate on contrasting moments of the antitheses that Stirling refuses to synthesize. While Graves's work spanning the decade extending roughly from the mid-1970s to the mid-1980s emphasizes the "monumental" and "traditional," his most recent buildings as well as the designs of Moore extend "informality" to the point of fancy. When taken together, the work of Graves and Moore exposes the problematic implications of the most commonly recognized version of postmodern architecture.

A charter member of the New York Five,[10] Graves, like most of the other first-generation postmodernists, was deeply influenced by high modern architecture. Though his earliest designs reflect a cubist sense of space and form, he has never accepted modern architecture's resistance to color. Moreover, Graves has always been willing to use discordant styles without seeking an overarching synthesis. In one of his first projects, a 1969 addition to the Benacerraf House, Graves repeats the gesture of Rietveld's Schröder House by appending a highly abstract modern structure to a nondescript stucco suburban house (fig. 6.15). The use of bright colors (red, yellow, blue, and green) for trim on the otherwise white addition anticipates Stirling's palette in the Staatsgalerie and foreshadows Graves's later chromatic innovations. In addition to the use of color, Graves departs from orthodox modernism by breaking volumes and planes asymmetrically.

These tendencies quickly became more pronounced. By the early 1970s, Graves's use of color was more extensive and his forms virtually ran riot. In the Snyderman House he pushed the intricacies of form to the breaking point (fig. 6.16). Proliferating planes and forms are split to generate multiple intersecting façades. Soft pastel colors counterbalance the sense of disruption and confusion created by irregular spaces.

> Throughout the design, there is an interaction of opposed elements—flat and
> curved, interior and exterior, public and private—which is derived from an

**6.15 Michael Graves,** *Bena-cerraf House* **(1969), view of addition. Courtesy Michael Graves. Photograph: Laurin McCracken.**

**6.16 Michael Graves,** *Sny-derman House* **(1972). Courtesy Michael Graves.**

understanding of the house in its natural setting. The interaction between the man-made and the natural occurs at a metaphorical level and also permeates the built composition. The 'natural' is taken to mean that which shows the attributes of nature—irregularity, lyricism, movement. Similarly, 'man-made' becomes synonymous with idealized form, geometry, stasis. (MG, 51)

All of Graves's later work is governed by the struggle to reconcile opposites within his architecture and to overcome the fundamental opposition between the human and the natural environments.

Graves prefaces a 1982 book devoted to his buildings and projects undertaken between 1966 and 1981 with a revealing essay, "A Case for

Figurative Architecture." Like Venturi, Graves formulates his criticism of modernism by turning to analogies between language and literature, on the one hand, and, on the other, architecture and design. Though he does not seem to be fully aware of it, a careful reading of the essay shows that his argument rests on a series of binary oppositions that are parallel to the contrasts with which Venturi distinguishes the modern and the postmodern: standard/poetic, intrinsic/extrinsic, machine/man, inhuman/human, technical and utilitarian/cultural and symbolic, abstract/representational, and nonfigurative/figurative. In each case, modern architects privilege the former, while Graves calls for a return to the latter. From Graves's point of view, the machine aesthetic is essentially inhuman. "In its rejection of the human or anthropomorphic representation of previous architecture," he argues, "the Modern Movement undermined the poetic form in favor of nonfigural, abstract geometries. These abstract geometries might in part have been derived from the simple internal forms of machines themselves" (MG, 11). Rather than realizing a utopia in which human beings can reach fulfillment, the inhumanity of modern architecture both reflects and creates a sense of alienation. Graves relates this alienation to the absence of figure in architecture: "This lack of figural reference ultimately contributes to a feeling of alienation in buildings based on such singular presuppositions" (MG, 13). In this simplistic calculus, abstract = alienated, and figural = reconciled. The purpose of Graves's postmodern ar-

**6.17 Michael Graves,** *Plocek Residence* **(1982). Courtesy Michael Graves. Photograph: Proto Acme Photo.**

chitecture is to overcome alienation by making people feel at home in the world. For Graves, as for Venturi, the problem with modernism is not so much its goals as the means by which it attempts to achieve them.

If the sense of alienation is to be mastered, it is necessary to fill both Mies's glass void and the emptiness of Stirling's center. Opposing modern abstraction, which negates the individual subject and affirms anonymous presence, Graves attempts to return "man" to his *proper* place. "We habitually see ourselves," he claims, "if not at the center of our 'universe,' at least at the center of the spaces we occupy. This assumption colors our understanding of the differences between center and edge" (MG, 12). While other more radical and interesting versions of postmodernism insist that the center is irrecoverable and only edge, margin, and border remain, Graves insists that the center, which provides meaning, order, and direction to life, can be recovered by returning to what he describes as "the anthropomorphic attitudes of culture." "Poetic forms in architecture are sensitive to the figurative, associative, and anthropomorphic attitudes of a culture. If one's goal is to build with only utility in mind, then it is enough to be conscious of technical criteria alone. However, once aware of and responsive to the possible cultural influences on building, it is important that society's patterns of ritual be registered in the architecture" (MG, 11). As students of religion have long maintained, ritual is inseparably bound to myth. Accordingly, Graves proceeds to argue that it is "crucial that we reestablish the thematic associations invented by our culture in order to fully allow the culture of architecture to represent the mythic and ritual aspirations of society" (MG, 13).

The basic aspiration expressed in myth and ritual is the longing for wholeness and reconciliation in which every trace of personal and social fragmentation is overcome. Myth and ritual are mnemonic strategies through which individuals attempt to return to the eternal origin of their being for renewal and regeneration. Re-membering is supposed to overcome the dis-memberment inevitably suffered in the course of time. Within the world of myth and ritual, to arrive at the origin is to return to the sheltering home that we have never really left. When understood in this light, Graves's return to figure, history, and tradition assumes proportions that are rarely recognized. Architecture becomes the search for an *archē* that can serve as a secure foundation for human existence. Graves's traditional aspirations become clear in his work dating from the mid-1970s.

The Plocek Residence, which was designed in 1977 and built in 1979–82, marks a turning point in Graves's career (fig. 6.17). Departing decisively from stylistic propensities he shared with other members of the New York Five, this structure defines the design that has become Graves's signature. Though the Plocek Residence differs significantly from the Snyderman House, the two buildings share Graves's desire to reconcile the human and the natural.

> All architecture before the Modern Movement sought to elaborate the themes of man and landscape. Understanding the building involves both association with natural phenomena (for example, the ground is like the floor), and anthropomorphic allusions (for example, a column is like a man). These two attitudes within the symbolic nature of building were probably originally in part ways of justifying the elements of architecture in a prescientific society. However, even today, the same metaphors are required for access to our own myths and rituals within the building narrative. (MG, 12)

If, as Graves contends, we moderns are alienated, one of the most pervasive conflicts we suffer is the opposition to the natural environment. To counteract modern architecture's insensitivity to nature, Graves attempts to *root* the house in the ground. In the Plocek Residence, building and landscape are thoroughly interdependent. The main approach to the house stresses the continuity between land and dwelling by integrating the gently sloped garden with stepped earth-tone walls that unite more than they separate. The carefully crafted gardens surrounding the house extend the continuity between nature and culture. The structure itself recalls an ancient Egyptian temple or tomb as much as the modern designs of Aldo Rossi and Leon Krier. The Plocek Residence is, in every sense of the word, a monument. The three stories of the house conform to the classical tripartite division of basement, piano nobile, and attic, which, in Graves's anthropomorphic iconography, correspond to lower limbs, body, and head. The house itself is not a whole but is an integrated part of a more encompassing totality. "In the composition, house and landscape are made formally interdependent. Along the primary entrance axis, a gate relating to the basement story is pulled away from the front façade while the study pavilion in the garden is seen as the keystone removed from the mass of the upper portion of the house. The relationship of the house to the site is clarified by the understanding that these elements have been displaced and are located along the processional axis of the house. Furthermore, a series of stepped walls, one of which engages the study pavilion, forms the outer edge of the rear garden, whose figure is completed by the garden façade of the house itself. As the house can be now seen as a fragment within this total organization of building and landscape, the thematic dialogue between the two is both understood and enriched" (MG, 43). When nature and culture are one, the house becomes a home.

The main entrance to the house is through a split column. As Graves stresses, the front and back, home and garden, are drawn together by the displaced keystone, which is relocated in the garden pavilion behind the house. Within the structure proper, inside and outside as well as height and depth are drawn together by the open stair column and skylight located at the point of intersection of the two principal axes. The interior design of the Plocek Residence gives the impression of a *Gesamtkunstwerk* that equals anything achieved at the Bauhaus. However, whereas the mod-

ern *Gesamtkunstwerk* is supposed to be the product of communal labor, Graves's total work of art is his own creation. He designed not only the building but also the furniture, lamps, rugs, sculpture, even tea sets, china, and the jewelry worn by his clients. Graves's practice reinforces Venturi's claim that "'total design' comes to mean 'total control'" (LV, 149).

As is so often the case, a seemingly insignificant detail discloses what Graves achieved in the Plocek Residence. In the living room, above the richly colored marble fireplace, which repeats the columnar design of the exterior, Graves placed one of his own paintings. The tones of the painting reflect the subtle natural hues of the interior and exterior design. This unabashedly representational work depicts Graveslike buildings and monuments integrated within a peaceful natural setting. The title of the painting is *Archaic Landscape*. This is precisely what Graves attempted to recreate in the Plocek Residence. But his work is, of course, a similacrum. Graves's "archaic landscape" is as much a mirage as are the oasis, jungle, and rainforest located in the midst of The Mirage.

Graves does not restrict his critique of modernity to the individual house. If myth and ritual are to revitalize society, they must be effective in the public as well as the private sphere. In his celebrated Portland Building, Graves extends the principles of the Plocek Residence to the public domain (plate 21).

> The design of the building addresses the public nature of both the urban context and the internal program. In order to reinforce the building's associative or mimetic qualities, the façades are organized in a classic three-part division of base, middle or body, and attic or head. The large paired columns on the main façades act as a portal gate and reinforce one's sense of passage through the building along its main axis. . . . The most publicly accessible activities are placed in the base of the building, which is colored light green in reference to the ground. The base of the building also reinforces the importance of the street as an essential urban form by providing a loggia on three sides and shopping along the sidewalk on the fourth. The city services are located in the middle section of the building, behind a large window of reflective glass which both accepts and mirrors the city itself and which symbolizes the collective, public nature of the activities held within. The figure of Lady Commerce from the city seal, reinterpreted to represent a broader cultural tradition and renamed "Portlandia," is placed in front of one of the large windows as a further reference to the city. (MG, 195)

While the finished building does not include all of the figurative detail initially envisioned, it is obvious that Graves's use of historical reference and ornamentation is not frivolous but is carefully calculated to evoke symbolic associations that encourage civic responsibility.

Unlike the typical modern high rise, the Portland Building is a twenty-story cube. The simulated masonry construction suggests the façade of an Egyptian pyramid or Aztec temple. The colossal six-story pilasters with trapezoidal capitals and the decorative garlands draped on the sides of the building add to the monumentality of the structure. As the very image of

stability, the Portland Building recalls an earlier time when the center of the polis was known with certainty and its foundation seemed secure. Whether this past represents the future of the postmodern megalopolis remains doubtful.

There is a seriousness about Graves's monumental architecture that renders it heavy. The weight of the architecture reflects the gravity of the task at hand: to restore meaning—both personal and collective—by revitalizing myth and ritual. But the work belies its purpose. Despite his efforts to revivify symbols, Graves's structures remain hollow. His buildings seem more like stage sets for a Cecil B. DeMille extravaganza than the sanctified setting for shared rituals. At this point in Graves's career this irony—indeed, any irony—was unintended. As we shall see, he eventually lightened up and his work became less grave.

The architecture of Charles Moore is characterized by a very different mood. Moore delights in levity, humor, and irony, which, in Heinrich Klotz's apt phrase, reflect his "vast tolerance." The lightness of Moore's touch is captured in the title of an essay in which he summarizes his differences with the principles of modernism: "The Yin, the Yang, and the Three Bears."

> I have believed for some time that sense might be made of the opposing views in terms of "yin" and "yang," the Chinese diagram of opposites complementing one another. If our century's predominant urge to erect high-rise macho objects is nearly spent, I thought we might now be eligible for a fifty-year-long respite of yin, of absorbing and healing and trying to bring our freestanding erections into an inhabitable community. I like that, but am growing impatient with fifty-year-swings, and wonder whether a more suitable model for us might be Goldilocks, of Three Bears fame, who found some things (Papa Bear's) too hot or too hard or too big, and other things (Mama Bear's) too cold, too soft, or too small, but still other things (Baby Bear's) just right, inhabitable, as we architects would say. The early modern polemicists disliked the world they saw and expected the opposite to be an improvement (like Goldilocks part way through her testing); but their panacea turned out to have its drawbacks, too, and it seems more accurate to note that, even as humans have yearnings—for place, for roots, for changing sequences of light and space, for order and clarity, for reverie—just so, when each of these yearnings is satisfied, we can feel surfeit, and seek to head another way, to mobility, or ambiguity, or surprise. (CM, 46)

Mobility, ambiguity, and surprise are not "signposts to some Architectural Utopia or some Big Revelation," but point the way to a "gay wisdom" in which play and frivolity are privileged moments (CM, 15). As Moore points out, "Buildings, I have insisted for a long time, can and must speak to us, which requires that we grant them freedom of speech, the chance to say things that are unimportant, even silly, so when they are grave or portentous we can tell the difference. I have taken as my particular mission to emphasize the light and sunny moments. I'm calling some of the projects *Frivolous and Serious Play;* I think the two are not inimical, and that both can be joyous. These are all places where people are meant to have a good time" (CM, 18).

To fulfill this mission, Moore appropriates the figurative strategies of pop art. He resurrects the "unimportant, even the silly," by turning from "high" to "low" culture. With greater consistency than Venturi, Stirling, or Graves, Moore develops an architecture of the sign. While historical references are certainly not absent from Moore's work, he shows a decided predilection for the signs of the postmodern culture of the simulacrum. In an aphorism written to accompany a collection of fanciful "Memory Palaces" that he constructed for an exhibition celebrating the opening of the addition to the Williams College Museum of Art, Moore characteristically turns his wit on himself.

> Donlyn Lyndon has noted that the way I design a building is rather like eating an ice cream cone on a hot day, licking frenziedly at the drips that threaten to spill. Maybe that is why I keep looking for buildings that honor the images of the chocolate, or even the hot fudge sundae. The image is a top-heavy one, of course, of roofs and chimneys and dormers and bays, all bigger than the chaste and smaller base on which they tumble and slide. A very few medieval towns do this, as their buildings search upward for light. A Spanish castle at Coca does it, or some drawings by Paul Klee. But mostly the chocolate sundae is an image for the future. Do not confuse it with mashed potatoes, which start the same, heaped to overflowing, but then are made centripetal by a crater filled with gravy. The mashed potato image does not have the generosity or the potential for surprise that good architectural images require.

Without a secure foundation, Moore's architecture is always on the verge of collapsing. He realizes this, of course, and makes a joke out of it. Not everyone appreciates his relentless irony and humor, however. When Moore suggested to one of his clients the utterly Warholesque gesture of placing an oversized five-dollar bill on the façade of a proposed bank, the company's board of directors promptly dismissed his recommendation. But Moore persists, and the result of his perseverance is an "architecture of play" in which everything becomes fanciful.

While all of his buildings are witty and playful, Moore's vision of the postmodern condition is best portrayed in his most imaginary works. In his proposal for an amusement park, named Indiana Landing, Moore attempts to create what he describes as "a place like Tivoli Gardens in Copenhagen, full of fun, and beautiful things as well" (CM, 19; fig. 6.18). Moore's Copenhagen is obviously that of Hans Christian Andersen rather than Søren Kierkegaard. By repeating the universal grid that runs throughout the state of Indiana within the confines of the amusement park, Moore creates the sense that everything expands from a single point. As one proceeds through the park, things grow larger, thereby giving one the feeling of becoming smaller. As one shrinks, one becomes Alice lost in a marvelous Wonderland. Unfortunately, this Wonderland was never built.

Shortly thereafter, however, Moore did build a Wonderwall (fig. 6.19). Having been commissioned to design the Centennial Pavilion for the 1984 New Orleans World's Fair, Moore was unable to restrict his play to the fair-

**6.18** *Above* **Charles Moore,** *Indiana Landing* **(1980–82). Courtesy Moore/Andersson Architects.**

**6.19** *Left* **Charles Moore,** *Wonderwall* **(1982–84). Photograph: R. Greg Hursley.**

grounds. His fantasy overflows into the streets of the city. In a description of the circumstances surrounding the beginning of the Wonderwall, Moore inadvertently suggests one of the most important aspects of the unspoken agenda that informs his style of postmodern architecture: "When an issue arose about burying one-half mile of unsightly high-tension lines along the main boulevard of the fair site for 11 million dollars, I offered to stage an architectural tantrum vivid enough to take attention away from the lines for a third the amount. The gauntlet was picked up and Bill Turnbull and I architected the one-half-mile-long Wonderwall. . . . The Wonderwall did seem to bring an otherwise dreary street alive" (CM, 19). Fantasy, it seems, is constructed to cover the "otherwise dreary" circumstances of contemporary life. But, as we shall see, the repressed returns to haunt Moore's "Memory Palaces" and to fault his fantastic Wonderwall.

Moore's most acclaimed fantasy work is an earlier New Orleans project: Piazza d'Italia (plate 22). Originally conceived as a public space for the festivals and celebrations of New Orleans's Italian-American community, the piazza embodies what Robert Stern describes as Moore's "aggressive playfulness." The light-hearted spirit that Moore projects for communal rituals of renewal differs significantly from the anticipated solemnity of Graves's civic ceremonies. If Graves's buildings are only accidentally stage sets, Moore's Piazza d'Italia resembles nothing so much as the garish backdrop for a third-rate Hollywood movie. Moore revels in the theatricality that Michael Fried associates with the essential corruption of the modern aesthetic. Moore's Italy is a fantasy; the piazza a dreamscape.

The two entrances to the piazza are marked by structures that are historically allusive without being monumental. On the Lafayette Street side, Moore places a triumphal arch decorated with mosaics in the Italian national colors (red, white, and green). The main entrance, which is along Polydras Street, is marked by an irregular campanile cast in modern materials, as well as the skeleton of a temple that is remarkably similar to the entrance to Stirling's Staatsgalerie. E. J. Johnson, who is one of Moore's most insightful interpreters, notes the "sonotube temple, its concrete columns laid out in a false perspective whose vanishing point is the point in front of the fountain from which it is best viewed. Here ancient forms and Renaissance perspective, both native to the Italian tradition, combine to focus on a Pop version of the Italian Baroque, with the Italian Middle Ages rising, in the form of the campanile, just a few steps away" (CM, 79).

As one proceeds through the entrance to the center of the piazza, the tricks continue, indeed, proliferate. Moore freely mixes materials—expensive and inexpensive, traditional and modern: marble, granite, cobblestones, slate, stucco, steel, stainless steel, ceramic tile, and neon. The center of the plaza is a fountain, reminiscent of the eighteenth-century Fontana di Trevi in Rome, which is placed in the midst of concentric circles that look like a Jasper Johns target. Moore explains,

> Here in a fountain built by New Orleans citizens of Italian descent, the contours form Italy. Sicily becomes the speaker's rostrum, and waters flow down

the mirrored surfaces of the Arno, the Tiber, and the Po. The (Italian) classical orders of architecture appear insofar as we could manage, in water, with volutes, acanthus leaves, flutes, and fillets, as well as egg-and-dart moldings all formed with jets. But the explicit references . . . will only reinforce the excitement of the water, the marble, and the stainless steel, for the celebration is first of all one of the senses, and then for the mind and memory.[11]

While modern masters stress the exercise of reason at the expense of the senses, this postmodern humorist prefers sensation to rationality.

The central element in the background of the fountain is a large arch supported by two Corinthian columns. The more carefully one inspects the arch and columns, the more obvious it becomes that everything is displaced. Moore's quotations are never straightforward but always ironic. He circles the top of the central columns and outlines the arch with an incongruous touch of art deco in the form of neon lights. The Ionic capitals of the adjacent columns are steel, and their bases are covered with a thin marble veneer. Instead of trying to hide his artifice, Moore boldly announces the play of simulacra he stages. In this play, humor abounds. Just in case we still do not get the joke, Moore's collaborators (unbeknownst to him) tricked him by slipping in two reliefs in which the smiling face of the architect playfully spits at the viewer.

There is not a trace of nostalgia in Moore's Piazza d'Italia. He realizes that in the postmodern world, myths and rituals can be revived only as theatrical spectacles. The effort to return home is inevitably a fantasy, which does not necessarily imply that it can no longer be enacted. After all, it might be impossible to avoid myth and ritual, even if they can only be lived as imaginative fictions.

One of Venturi's polarities that I have until now overlooked is piazza/Disneyland. Whereas modern architects build piazzas, Venturi argues, postmodern architects fabricate Disneylands. But Charles Moore upsets Venturi's neat and tidy contrast. In Piazza d'Italia, Disneyland becomes a piazza, and public space is transformed into a Disney World. As early as 1964, Moore observes that "in as unlikely a place as could be conceived, just off the Santa Ana Freeway, a little over an hour from Los Angeles City Hall, in an unchartable sea of suburbia, Disney has created a place, indeed a whole public world, full of sequential occurrences, of big and little drama, of hierarchies of importance and excitement" (CM, 36). To complete the image of the world projected by postmodern architecture, Disney's vision must be translated into reality by figuring "reality" as a pleasurable fantasy.

In 1987 the *New York Times* Sunday magazine carried a headline, "The Significance of Classical Structures," with the byline "Michael Graves," followed by a brief text. The piece is not an article on the current state of architecture but an advertisement for Dexter Shoes. The conjunction of architecture, advertising, and the media is neither accidental nor innocent. The Dexter ad renders explicit certain developments that had been

unfolding for nearly a decade. In the course of the 1980s, leading post-modern architects achieved a celebrity status usually reserved for media stars and entertainers. In fact, architects became entertainers. The consequences of this unlikely turn of events for architecture are considerable. When Madison Avenue displaces the Bauhaus as the site for "advanced" architectural practice, the logocentrism of modern design gives way to the logo centrism of designer architecture.

At the time Graves appeared in the Dexter ad, he was in the midst of what remains his largest project to date: the Walt Disney World Swan Hotel and Dolphin Hotel. These hotels transform the magic of Siegfried and Roy into the main attraction. In this Magic Kingdom, fierce tigers become as tame as kittens who lie down peacefully with swans and dolphins. A publicity release distributed by the Disney public relations office declares, "Michael Graves brings fantasy architecture to Walt Disney World Swan. . . . Fantasy architecture characterizes Disney's belief that the architecture outside the boundaries of Disney's theme parks should embody the same fantasy and sense of place as that within." An article describing the Dolphin Hotel invokes a different term for Disney architecture: "Walt Disney World Dolphin features architecture as entertainment." Fantasy architecture is entertainment, and entertainment architecture is a fantasy. Disney's aim is to transform the entire world into a Magic Kingdom. The one chosen to lead us to this kingdom is Michael Graves. Disney advertisements proclaim the good news:

> The postmodernist style and whimsical approach of the architect Michael Graves are evident everywhere in the buildings' design and decor. The hotels are works of art in themselves, with larger-than-life murals painted on their façades, giant sculptures on their roofs, and fanciful fountains in strategic locations. Chandeliers incorporating monkey and cockatoo cutouts, giant palm tree columns, expansive hand-painted murals, and thousands of paintings and prints by artists as diverse as Matisse and David Hockney are displayed throughout the buildings' public areas and in the guest rooms.

The central feature of the 1,059-room lakeside Dolphin Hotel is a twenty-seven–story triangular-shaped structure that is flanked by two long gently sloping wings that are capped by a pair of six-story statues of dolphins (plate 23). Four nine-story extensions protrude into a fifty-acre lagoon. The entrance to the hotel is dominated by another large dolphin statue and a waterfall cascading nine stories into a 56-foot clamshell. Publicity statements released at the time of the hotel's opening summarize its appearance and capture its mood.

> The *Walt Disney World Dolphin* blends the practical with the fanciful and the familiar with the unique, creating a tropical fantasy land with all of the amenities of the world's finest resorts.
> Designed by internationally acclaimed architect Michael Graves, the award-winning hotel radiates the Disney tradition of lighthearted fun and entertainment. From its coral and turquoise façade covered with giant banana leaf murals and crowned with twin six-story dolphins to the wealth of

expansive, hand-painted murals and giant three-dimensional hand-painted cutouts displayed in every public area, the *Walt Disney Dolphin* earns the distinction of a colossal work of art.

"Both inside and out, the hotel was designed to echo the tropical Florida landscape, as well as the fun and whimsy of the nearby Disney theme parks," says Graves. "And the array of artwork is an integral element of the grand scheme, infusing the hotel with an aura of fantasy that appeals to guests of all ages."

If ornament is a crime, Graves is the most dangerous of criminals.

Facing the Dolphin Hotel across the crescent-shaped lake is the equally ornate Swan Hotel (figs. 6.20, 6.21). The twelve-story Swan Hotel is organized around a courtyard with an octagonal lobby that connects the wings of the hotel with restaurants, entertainment facilities, and the causeway that crosses the lake to the Dolphin Hotel. The exterior is painted in sun-washed coral and waves of turquoise. On top of the gently arched main structure, two 47-foot swans are perched, and on the adjacent wings stand two massive clamshells.

The interior of the hotels is even more elaborate than the exterior. Everything from carpets and wallpaper to towels and toilet paper is decorated with dolphin and swan logos. Murals and sculptures, fountains and mobiles abound. In the Dolphin Hotel alone, there are more than forty-five hundred prints of "classic paintings by the artists who most influenced Graves' style." In addition to reproductions, Tom Marchisotto, first vice president of architecture for Tishman Hotel Corporation, stresses that "few hotels in the world boast such a wealth of original art, especially created on such a grand scale." These are, however, strange "originals." Disney officials explain that "Michael Graves had creative control over every aspect of the hotel, from steward's uniforms to room keys. To achieve his vision, Graves produced small renderings for each mural and series of murals, then Tishman commissioned artists to follow these renderings and execute the paintings."

To complete his extraordinary *Gesamtkunstwerk,* Graves set up a factory worthy of Warhol. In a 4,000-square-foot studio beneath the Manhattan Bridge in Brooklyn, shifts of eight artists worked around the clock to transform Graves's miniature drawings and paintings into huge murals measuring anywhere from 21 × 29 feet to 9 × 129 feet and 3.5 × 242 feet. On the production line of this factory, one artist did not complete a single work; painters labored in teams with each individual responsible for a different part of the murals. Not only is the "original" a reproduction, but the creative artist disappears into his surrogates.

Toward what end is this "colossal work of art" constructed? As I have suggested, Disney and Graves are quite clear on this point: the purpose of architecture is "lighthearted fun and entertainment." Such whimsy might seem more characteristic of Charles Moore than of Michael Graves. But even in his most solemn moments, Graves's goal remains to overcome the alienation that modern architecture both mirrors and extends by reconcil-

**6.20** *Above* **Michael Graves,** *Walt Disney World Resort Hotels,* **model (1986). Courtesy Michael Graves.**

**6.21** *Right* **Michael Graves** *Walt Disney World Dolphin Hotel* **(1987). Courtesy Michael Graves. Photograph: William Taylor.**

ing individuals and groups to their postmodern condition. Between the
Portland Building and the Disney World hotels, Graves realized what Ven-
turi had discovered a quarter of a century earlier: since everything is im-
age, nothing appears but appearance. Accordingly, the task of the
architect is to reconcile people to the culture of the simulacrum. This
seems to be what we have learned from Las Vegas. The good news of the
Magic Kingdom is still spreading—Graves and his fellow postmodern ar-
chitects are now designing Euro Disneyland.[12]

The Walt Disney Company has not undertaken the production of Dis-
ney World alone. The Theme Park and EPCOT Center are jointly spon-
sored by MGM Studios. The corporate unity of Disney and MGM is hardly
inconsequential. Entertainment architecture developed by celebrity archi-
tects and promoted by the entertainment industry reflects a world in
which "reality" has become mediaized. In his insightful and provocative
reading of America, Baudrillard observes, "The cinema here [i.e., in
America] is not where you think it is. It is certainly not to be found in the
studios the tourist crowds flock to—Universal, Paramount, etc., those sub-
divisions of Disneyland. If you believe that the whole of the Western world
is hypostatized in America, the whole of America in California, and Cali-
fornia in MGM and Disneyland, then this is the microcosm of the West"
(A, 55). When the "real" is thoroughly mediaized, we enter the culture of
the simulacrum in which everything is always already image. In terms
previously invoked, since the sign is always a sign of a sign, the sign is, in
effect, the thing (in) itself, and, conversely, the thing (in) itself is a sign.
Elsewhere Baudrillard explains,

> Disneyland is there to conceal the fact that it is the "real" country, all of
> "real" America, which *is* Disneyland. . . . Disneyland is presented as imagi-
> nary in order to make us believe that the rest is real, when, in fact, all of Los
> Angeles and the America surrounding it are no longer real, but of the order
> of the hyperreal and of simulation. It is no longer a question of a false rep-
> resentation of reality (ideology), but of concealing the fact that the real is no
> longer real, and thus of saving the reality principle. (S, 24)

The real is no longer real because everything is always already figured. Con-
trary to the canons of high modernism, figuration is inescapable—though
not necessarily all-encompassing. Rejecting every strategy of abstract or
nonrepresentational art, postmodern architecture disfigures modern dis-
figuring by reveling in signs, images, representations, and figures that do
not point beyond themselves but stage an endless play. If there is nothing
beyond the image, reality is logo centric.

Postmodern logo centrism appears to involve the rejection or negation
of the logocentrism that informs the theoesthetic of modernism. But any
simple opposition between logo centrism and logocentrism is misleading,
for they are really contrasting expressions of a single impulse. Both logo
centrism and logocentrism seek immediate union with the real. Within
this similarity, an important difference emerges: contrasting interpreta-
tions of reality lead to alternative aesthetic strategies. While logocentrism

struggles to erase signifiers in order to arrive at the pure transcendental signified, logo centrism attempts to extend the sign to infinity by collapsing the signified in the signifier. Union with the real—regardless of how the real is understood—holds out the promise of overcoming alienation and achieving reconciliation. In the utopianism characteristic of modernity, the Kingdom is regarded not only as realizable but is believed, in some sense, to be already real. Appearances to the contrary notwithstanding, modern theoesthetics implies a realized eschatology, which becomes explicit in Hegel's speculative philosophy where the real is ideal and the ideal is real. Logo centricism shares this modern belief in realized eschatology. Like pop art, upon which it depends, postmodern architecture presupposes an idealism of the image in which the Kingdom of God on earth becomes a Magic Kingdom where wishes are immediately fulfilled. According to Colin Rowe, this fanciful kingdom is "a symbolic American utopia." "Disney World deals with the crude and the obvious: and this is both its virtue and its limitation. Its images are not complex: and, thus, Disney World's Main Street is not so much an idealization of the real thing as it is a filtering and packaging operation, involving the elimination of unpleasantness, of tragedy, of time and of blemish." [13] This postmodern utopia is an unwitting—and not even a particularly witty—parody of the utopias of modernism. In Disney World, utopia becomes kitsch and kitsch becomes utopia. The Magic Kingdom is, in Louis Marin's terms, the "degenerate utopia" of what Adorno and Horkheimer label "the culture industry." [14]

The culture industry represents the third and most recent stage in the development of the capitalist economy. As Fredric Jameson persuasively argues, capitalist expansion begins with market capitalism in which industrial capital grows by establishing national markets, and develops into monopoly capitalism in which nation-states extend markets internationally by means of imperialism and colonialism. In the third phase of its development, multinational capitalism spreads rapidly by means of international corporations that are not bound to any particular nation or political regime. [15] Multinational capitalism involves a postindustrial economy that is characterized by what Jameson and others describe as "the commodification of representation." The commodification of representation entails what I have described as the twofold development of the aestheticization of the commodity and the commodification of art.

When culture is commodified and commodities are aestheticized, society becomes a "Society of Spectacle." In his highly influential book *Society of Spectacle*, the French Marxist Guy Debord argues,

> The spectacle is the other side of money: it is the general abstract equivalent of all commodities. But if money has dominated society as the representation of the central equivalence, namely as the exchangeable property of the various goods whose uses remained incomparable, the spectacle is its developed modern complement, in which the totality of the commodity world appears as a whole, as a general equivalence for what the totality of the society can

be and do. The spectacle is the money that *one only looks at,* because in the spectacle the totality of use is already exchanged for the totality of abstract representation. (SP, 49)

As I have argued, in the postmodern world the currency of exchange, that is, Marx and Debord's general equivalent, is the sign or the image. The architects of the society of spectacle display consumption by figuring the currency of the realm *in* signs and images *as* signs and images. Within this speculative economy, figures, signs, and images are not only what is consumed but are all-consuming. This spectacle, Debord insists, "says nothing more than 'that which appears is good, that which is good appears'" (SP, 12).

So understood, the postmodern society of spectacle is a consumer society. Society *needs* consumption and therefore must make its members *want* to consume even when they do not need to do so. If consumption lags, the economy falters. To insure ongoing productivity, the objects of consumption, which are not the things themselves but their representations, must be ephemeral, insubstantial, and constantly changing. By creating a "religious fervor for the commodity," the society of spectacle transforms spiritual aspirations into the immaterial materialism of the figure. "Philosophy, the power of separate thought and the thought of separate power, could never by itself overcome theology. The spectacle is the material reconstruction of the religious illusion. Spectacular technology has not dissipated the religious clouds where men had placed their own powers detached from themselves; it has only tied them to an earthly base. . . . It no longer throws into the sky but houses within itself its absolute denial, its fallacious paradise" (SP, 20).[16] This "fallacious paradise" might seem to be the antithesis of the pure utopia for which modernists long. But once again appearances are deceiving. Compulsive consumption and rigorous asceticism are not merely opposites but are alternative strategies directed toward the same end. "The spectacle," Debord points out, "is the elimination of the limits between self and world" (SP, 219). In other words, the spectacle concretely realizes the goal of speculative philosophy by reconciling subject and object. While the ascetic seeks union with the Real by self-denial, the consumer seeks union with the Real by self-indulgence. As Hegel suggests in his *Science of Logic,* emptiness is fullness.

But what neither speculative ascetics nor spectacular consumers are willing to admit is that fullness is emptiness. Paradise is always a "fallacious paradise." In the postmodern world, this illusion is, as we have seen, the Magic Kingdom. The Mirage returns in Disney World. After erasing the barrier separating Disneyland and the postmodern world, Baudrillard, who formulates his position by combining the insights of Debord and Georges Bataille, proceeds to argue that "the US is utopia achieved." The citizens of this so-called utopia live in "a perpetual present" (A, 75–77). When life becomes an endless play of simulacra, experience is fragmented and dissipated in a series of dissociated moments. Postindustrial capitalism

and a certain kind of schizophrenia are, as Gilles Deleuze and Félix Guattari maintain, inseparably related.[17] Jameson summarizes this important point in his account of postmodernism and consumer society:

> I believe that the emergence of postmodernism is closely related to the emergence of this new moment of late, consumer or multinational capitalism. I believe that its formal features in many ways express the deeper logic of that particular system. I will only be able, however, to show this for one major theme: namely the disappearance of a sense of history, the way in which our entire contemporary social system has little by little begun to lose its capacity to retain its own past, has begun to live in a perpetual present and in a perpetual change that obliterates traditions of the kind which all earlier social formations have had in one way or another to preserve.[18]

With the (eternal) return of the perpetual present, postmodernism seems to collapse into modernism. In Baudelaire's classic definition, to which I have already had recourse, modernity is defined as "the ephemeral, the fugitive, the contingent, the half of art whose other half is the eternal and the immutable." While abstract art and modern architecture seek the eternal and the immutable, pop art and postmodern architecture are immersed in the ephemeral, the fugitive, and the contingent. This emphasis on presence and the present might seem to be more characteristic of modernism than postmodernism. After all, we have discovered that postmodern architecture turns toward the past from which modern architecture turns away. It is, however, necessary to take a closer look at the way in which the past appears in postmodern architecture. The title of the 1980 Venice Biennale devoted to postmodern architecture is "The *Presence* of the Past." The question that remains concerns the nature of this presence.

The *use* of the past in postmodern architecture involves acts of appropriation and expropriation. As Walter Benjamin stresses in his analysis of the origin of German tragic drama, "Just as a man lying sick with fever transforms all the words which he hears into the extravagant images of delirium, so it is that the spirit of the present age seizes on the manifestations of past or distant spiritual worlds, in order to take possession of them and unfeelingly incorporate them into its own self-absorbed fantasizing" (LA, 64). The self-absorbed fantasy of the society of spectacle does not break with the self-reflexive fantasy of speculative philosophy and its corresponding theoesthetic. Even when disguised as postmodernism, representation remains within a metaphysics of presence and an economy of presentation. Modernism and postmodernism, *as it is usually figured in architecture,* both reflect the subject defined in modern philosophy. In the course of establishing its identity, this subject attempts to negate every difference that stands against it. Such a subject is a thetic subject for whom all activity is, in the final analysis, self-activity, and all positing self-positing. Inasmuch as every other is a moment in its own being, this subject sees itself everywhere. For the speculative subject, the other is the mirror in which it sees *itself* reflected. In Foucault's terms, the self-constituting

activity of the panoptical subject results in the homogenization of all heterogeneity. Not only nature but also history becomes a standing reserve at the disposal of the masterful subject. Postmodern architecture is an expression of this subject. Tradition returns as the past that is an inexhaustible archive or memory bank available for instant recall in the present. The presence of the past as decorative figure is little more than an embellishment of the present. Since everything is subject to representation, an unrepresentable past, a past more ancient than any present and all presence, is simply unthinkable.

From the time of Venturi's apparent critique of modern architecture, irony has been recognized as one of the distinguishing features of postmodernism. However, neither supporters nor critics have examined the philosophical and theological presuppositions and implications of irony. Consequently, the deep complicity between modernism and postmodernism has gone unnoticed. The subject for whom the past is an archive to be exploited is undeniably ironic. It is again Hegel who presciently identifies the issue relevant to any adequate analysis of postmodern architecture. Commenting on Fichte's argument, which provides the philosophical underpinnings for romantic notions of irony, Hegel writes,

> Now insofar as concerns the closer connection of Fichte's propositions with one tendency of irony, we need in this respect emphasize only the following points about this irony, namely that [*first*] Fichte sets up the *ego* as the absolute principle of all knowing, reason, and cognition, and, in this way, the *ego* remains throughout abstract and formal. *Second,* this *ego* is, therefore, in itself just simple, and, on the one hand, every particularity, every characteristic, every content is negated in it, since everything is submerged in this abstract freedom and unity, while, on the other hand, every content which is to have value for the *ego* is only posited and recognized by the *ego* itself. Whatever is, is only by the instrumentality of the *ego,* and what exists by this instrumentality I can equally well annihilate again. (FA, 64)

While the ego of the modern architect is heroic, the ego of the postmodern architect is ironic. When philosophically understood, these two egos are not as different as they initially seem to be. The use of the past in postmodern architecture is never direct but is always indirect and in some sense ironic. The standpoint of the ironist differs significantly from the perspectives of the historical figures whose productions he or she appropriates. The ironist knows things his or her precursors could not have known and thus embodies a "higher" form of self-consciousness. Most important, the ironist "knows" that what appeared to be true in the past is illusory and what once seemed fact is fiction. For the ironist, reality itself is nothing other than a "supreme fiction." The poet Wallace Stevens effectively captures the gist of ironic self-consciousness when he writes, "The final belief is to believe in a fiction, which you know to be a fiction, there being nothing else. The exquisite truth is to know that it is a fiction and that you believe in it willingly."[19] An implicit contradiction in Stevens's claim underscores the inescapable instability of irony. When one *knows* a fiction to be a fiction, irony vanishes. Fictive awareness always threatens

to undercut itself by denying its own fictiveness. In different terms, irony resists self-ironization and thus tends to become *the* all-encompassing viewpoint instead of one perspective among many. In this way, irony does not break with the modern philosophy of self-consciousness but becomes its highest expression.

Insofar as irony is, in terms Kierkegaard borrows from Hegel, "infinite absolute negativity," it entails a certain nihilism. Through endless nega-tion, the ironist becomes completely indifferent to everything. *Nothing matters.* When nothing matters, however, negation negates itself and be-comes a form of radical affirmation. Kierkegaard, who understands irony better than any other theologian or philosopher in the history of the West, argues,

> In the last analysis, the ironist must always posit something, but what he posits in this way is nothingness. Now it is impossible to take nothingness seriously without either arriving at something (this happens when one takes it speculatively seriously), or without despairing (this happens when one takes it personally seriously). But the ironist does neither of these, and to this extent, one may say he is not really serious about it. Irony is the infinitely delicate play with nothingness, a playing that is not terrified by it but still pokes its head into the air. But if one takes nothingness neither speculatively nor personally seriously, then one obviously takes it frivolously and to that extent not seriously.[20]

The frivolity of the ironist allows him or her to embrace anything and everything. Tolerance—absolute tolerance—becomes the highest virtue. If logocentrism is coterminous with the regime of God, then logo centrism marks the epoch of the death of God when anything is possible.

> Thus perhaps at stake has always been the murderous capacity of images, murderers of the real, murderers of their own model as the Byzantine icons could murder the divine identity. To this murderous capacity is opposed the dialectical capacity of representations as a visible and intelligible mediation of the Real. All of Western faith and good faith was engaged in this wager on representation: that a sign could *exchange* for meaning and that something could guarantee this exchange—God, of course. But what if God himself can be simulated, that is to say, reduced to the signs that attest to his existence? Then the whole system becomes weightless, it is no longer anything but a gigantic simulacrum—not unreal, but a simulacrum, never again exchanging for what is real, but exchanging in itself, in an uninterrupted circuit without reference or circumference. (S, 10–11)

Such weightlessness is the unbearable lightness of nonbeing.

As an extension of speculative philosophy, the society of spectacle stages an "uninterrupted monologue." In this play of spectacular con-sumption, desire "knows" no other, for "the spectacle wants to get nothing other than itself" (SP, 14). The purpose of the all-consuming monologue, which sometimes appears to be an open-ended dialogue, is the mainte-nance and justification of the existing order or system. When the Kingdom arrives, criticism ends and resistance disappears. What is, is what ought to be. If the real is ideal, and the ideal is real, there is, as Duchamp once observed, "no solution because there is no problem." The labor of history

complete, true play begins for the first and last time. The Magic Kingdom is a carnival that knows no darkness, a festival that harbors no tears. Only at this moment might one dare to proclaim, "It is finished." Nothing remains to be done. Everything is accepted; nothing is refused. *Nothing* is refused.

It was a beautiful late fall afternoon when I finally had the opportunity to visit the Piazza d'Italia. Having just arrived from the prematurely cold North, I found the warmth of the southern afternoon refreshing and invigorating. As I left the French Quarter and made my way through the streets of New Orleans, my pace quickened. Turning onto Polydras Street, I caught my first glimpse of the piazza. I was immediately struck by the spectacular play of reflection that danced on the mirrorlike surfaces of the elegantly austere modern high rises surrounding the plaza. The juxtaposition of Moore's quasi-modern campanile and ironic white skeletal temple created the sense of frivolity and levity that I had come to expect from postmodern architecture.

But as I passed through the entrance, the mood of the piazza changed suddenly and unexpectedly. Not only did the piazza remain incomplete, but it was thoroughly disfigured. Weeds were growing between the cobblestones; trash littered the ground; refuse overflowed baskets and cans; a broken fence failed to secure the boundary between the plaza and a vacant parking lot and nearby dilapidated buildings. The center of the piazza was in no better shape. The fountain and neon lights were not working; scattered debris floated in the water; tiles were broken and falling from the relief map of Italy; once bright façades were faded, chipped, and cracked; the mosaics on the triumphal arch were crumbling; and a torn plastic banner bearing the interrupted advertisement: "Italian Days, September . . . " dangled in the gentle breeze. In the midst of all of this, Charles Moore's two faces were still smiling, even if they could no longer spit at me.

The piazza was deserted except for three homeless people, all of whom were clutching tattered plastic bags in which they carried all their worldly possessions. One slouched on a bench, staring vacantly into space; another lay on the ground, bottle in hand, in a drunken stupor. The silence of the scene was shattered only by the din of distant traffic and an unsettling laugh that was *not* that of Charles Moore or any of his associates. The third homeless man sat, with back turned, at the edge of the piazza. For as long as I stayed, he laughed loudly and uncontrollably. His laugh was not funny, for it was no ordinary laugh but the laugh of a madman. The playground had become a desert haunted by a strange laugh . . . a different laugh . . . an other laugh. Perhaps this was the laugh of a certain other that postmodern architecture cannot figure. Perhaps. I lingered until dusk fell and then left with the laugh of the madman still ringing in my ears. Strange folly. Uncanny follies. Follies I realized I could no longer refuse.

**7**

*I received life like a wound.*
—LAUTRÉAMONT

*Universal existence, eternally unfinished and acephalic, a world like a bleeding wound, endless creating and destroying particular finite beings: it is in this sense that true universality is the death of God.*
—GEORGES BATAILLE

# R E F U S E

*Residual space is sometimes awkward. Like structural poché, it is seldom economic. It is always leftover, inflected toward something more important beyond itself.*
—ROBERT VENTURI

*Overlaid by the entire history of architecture and laid open to the hazards of a future that cannot be anticipated, this other architecture, this architecture of the other, is nothing that exists. It is not a present, the memory of a past present, the purchase or pre-comprehension of a future present.*
—JACQUES DERRIDA

# 7 □ REFUSE

**A** CHANGE OF SCENE that changes little: from South to North—New Orleans to New York—from the piazza to 42nd Street.

MT 2

"Border Crossing . . . Derelict piers and luxury hotels, junkies and detectives, cheap whorehouses and gleaming skyscrapers had all been part of his world. . . . THE STREET." (MT, 24)

In the wake—the interminable wake—of modernism and modernist postmodernism, questions of refuse and refusing arise. Suppose carnival and festival always harbor darkness . . . suppose Dionysus's "bacchanalian revel" is the mask of tragedy . . . suppose the death of God is not the arrival of the Parousia but the mark of the impossibility of its arrival . . . suppose presence is never present . . . suppose reconciliation is a mirage . . . suppose the utopia has not arrived . . . the Kingdom is delayed . . . perhaps infinitely deferred. If all of this and more, much more, is so, then should everything be embraced or should some things be refused? Questions proliferate: What does it mean to refuse? What does it mean to re-fuse? Can one refuse? Can one avoid refusing? What is refuse? In the name of what does one refuse? Who or what calls one to refuse?

To begin to probe these questions—questions that will remain unanswered—it is necessary to refigure disfiguring. In the first two epochs we have explored, we have discovered contrasting strategies of disfiguring. While abstract painting and modern architecture dis-figure by removing figures, modernist postmodernism disfigures modern dis-figuring by defacing abstract forms and pure structures with superficial figures. As we have discovered in our investigation of postmodern architecture, the movement from the modern to the postmodern can be interpreted as a shift from the exclusive logic of either/or to the inclusive logic of both/and. In spite of these noteworthy differences, modernism and modernist postmodernism remain committed to an archaeoteleological process that is supposed to culminate in a reconciliation with the "Real." Thus, neither the logocentrism of modernism nor the logo centrism of postmodernism calls into question the assumptions and conclusions of theoesthetics.

I have argued, however, that there is a third reading of "disfiguring" that points to a different version of postmodernism. In its third guise, disfiguring neither erases nor absolutizes figure but enacts what Freud describes as the process of "denegation," through which the repressed or refused returns. Neither simply an affirmation nor a negation, de-negation is an un-negation that affirms rather than negates negation. The affirmation of negation by way of un-negation subverts every effort to negate negation. When interpreted in terms of denegation, disfiguring figures the impossibility of figuring in such a way that the unfigurable "appears" as a disappearing in and through the faults, fissures, cracks, and tears of figures.

The epoch released by the third "moment" of disfiguring can be comprehended neither linearly nor dialectically. If it comes "after" modernism and postmodernism, it is as a certain "before" that always already haunts their presence and disrupts their present. Such a nondialectical third entails the strange alogic of the neither/nor, which can be figured by *neither* modernism's either/or *nor* modernist postmodernism's both/and. This neither/nor opens the space and creates the time for an *other* postmodernism, a *different* postmodernism in which otherness and difference remain irreducible to identity and sameness. The other that eludes the logic of either/or and both/and implies an altarity that retraces theoesthetics as a/theoesthetics. With the approach of a/theoesthetics, refusal becomes not only possible but unavoidable.

In exploring various artistic strategies that have been deployed in the search for an alternative to modernism and modernist postmodernism, it is necessary to concentrate on particular artists, architects, and works instead of inclusive schools. The impossibility of discerning unified patterns in this epoch is not simply the result of our lack of historical distance. The work of the artists and architects who are preoccupied with a disfiguring that neither erases signifiers to reveal a transcendental signified nor collapses the transcendental signified into the play of signifiers calls into question the very notions of unity, coherence, and continuity upon which interpretations of artistic movements and historical development are based. Accordingly, my approach in this chapter and the next will be less comprehensive and more fragmentary than in the rest of the book.

The absence of unity and coherence in life as well as art does not remove the desire to create continuity where there is none. In June 1988 Philip Johnson attempted to bring a semblance of order to the disorder of contemporary architecture by mounting an exhibition at the Museum of Modern Art entitled "Deconstructivist Architecture." The show included exemplary work by seven architects: Frank Gehry, Daniel Libeskind, Rem Koolhaas, Zaha Hadid, Coop Himmelblau, Bernard Tschumi, and Peter Eisenman. In his introductory essay for the catalogue, Johnson is tempted to draw a parallel between the deconstructivist show and the exhibition devoted to international style architecture, which he and Henry-Russell Hitchcock sponsored in the same museum sixty years earlier. But Johnson wisely resists the temptation, for he realizes that "Deconstructivist architecture represents no movement; it is not a creed. It has no 'three rules' of compliance. It is not even 'seven architects.'"[1] In the absence of clearly defined concepts that unify the works he includes in the exhibition, Johnson resorts to two figures or images that capture the difference between "the old International Style" and "the new Deconstructive architecture." He contrasts the image of a ball bearing, featured on the cover of the Museum of Modern Art's 1932 "Machine Art" exhibition, and a photograph taken by Michael Heizer of an 1860s springhouse in the Nevada desert. "Both icons," Johnson explains, "were 'designed' by anonymous persons for purely nonaesthetic aims. Both seem significantly beautiful in

their respective eras. The first image fitted our thirties ideals of machine beauty of form, unadulterated by 'artistic' designers. The photo of the springhouse strikes the same chord in the brain today as the ball bearing did two generations ago. . . . Think of the contrasts. The ball bearing form represents clarity, perfection; it is singular, clear, platonic, severe. The image of the springhouse is disquieting, dislocated, mysterious. The sphere is pure; the jagged planks make up a deformed space. The contrast is between perfection and violated perfection."[2]

In their exploration of "violated perfection," the architects assembled by Johnson reject the pure formalism of modernism as well as the frivolous figuration of postmodernism. Each in his or her own way seeks a third course that is neither modern nor postmodern. But beyond this common quest, they share very little. They are not even all interested in the philosophical style of critical analysis that lends the show its name: Derridean deconstruction. What "Deconstructivist Architecture" displays is more of a nonmovement than a movement. Perhaps for this reason, the exhibition was something of a nonevent. It is possible, however, that precisely this failure is its lasting success.

Of the architects included in the Museum of Modern Art show, only two demonstrate serious and sustained interest in deconstruction: Bernard Tschumi and Peter Eisenman. But even here, differences outweigh similarities. While Tschumi reads deconstruction through Bataille, Eisenman approaches deconstruction with Derrida. These alternative deconstructions lead to different architectures. Although Tschumi and Eisenman both seek a third way *between* modernism and postmodernism, Eisenman's refusal is more disruptive than Tschumi's re-fusal.

Modernism's perfection is always a "violated perfection"; its purity is impure from the beginning, indeed, before the beginning. Modernity is infected by an other it both refuses and cannot refuse. One of the figures of this irrefutable other is figuration. Modernism's disfiguring is not only an aesthetic strategy; it is, as we have seen, a moral crusade. The struggle between figuring and disfiguring is the strife between madness and civilization. Inasmuch as it re-presents sensuousness and irrationality, figuration represents the primitive, infantile, feminine, and mad that modern civilization is constructed to refuse. The refused, however, never goes away. Constituting itself in and through acts of refusal, modernity needs what it nonetheless cannot bear. The refused eternally returns to disrupt and dislocate the structures constructed to control it.

At its height, modernism's search for purity is violated by the eruption of surrealism. In his 1924 "Manifesto of Surrealism," André Breton declares,

> We are still living under the reign of logic. . . . But in this day and age, logical methods are applicable only to solving problems of secondary interest. The absolute rationalism that is still in vogue allows us to consider only facts relating directly to our experience. Logical ends, on the contrary, escape us. It is pointless to add that experience itself has found itself increasingly

circumscribed. It paces back and forth in a cage from which it is more and more difficult to make it emerge. . . . Under the pretense of civilization and progress, we have managed to banish from the mind everything that may rightly or wrongly be termed superstition, or fancy. . . . It was, apparently, by pure chance that a part of our mental world that we pretended not to be concerned with any longer—and, in my opinion, by far the most important part—has been brought back to light. For this we must give thanks to the discoveries of Sigmund Freud. . . . If the depths of our minds contain within them strange forces capable of augmenting those on the surface, or of waging a victorious battle against them, there is every reason to seize them. (MS, 9–10)

The goal of surrealism is to reclaim the rights of the imagination by releasing the strange forces that inhabit the mind. These uncanny powers constitute madness in the midst of civilization and folly at the heart of reason. By soliciting the return of the refused, surrealism attempts to subvert modernism's repressive puritan ethic. For the surrealist, excess displaces restraint in expenditure without return.

Although he was never formally affiliated with surrealism, Bataille shared many of its aims. In contrast to the poets and painters in the surrealist group, Bataille's concerns were never simply artistic. A person of unusually wide interests, he moved freely among fields as diverse as philosophy, theology, art, literature, psychology, sociology, and anthropology. From 1937 to 1939, Bataille was the leader of an informal organization known as the Collège de sociologie. This college, which traced its roots to the pioneering work of Marcel Mauss and Émile Durkheim, brought together a group of highly influential artists and writers. At one time or another, Roger Callois, Michel Leiris, Pierre Klossowski, Denis de Rougement, Georges Dethuit, and Jean Wahl addressed the college.[3] One of the primary concerns of the participants in the Collège de sociologie was the exploration of the nature and function of religion. In one of his most suggestive essays, Bataille argues that, appearances to the contrary notwithstanding, "Surrealism is a religion" (RS). The force of Bataille's claim becomes evident in his revisionary interpretation of religion.

Bataille's analysis of religion rests upon what he regards as the fundamental difference between the sacred and the profane. He develops this distinction by rethinking Freud's contrast between consciousness and unconsciousness and, more important, Nietzsche's notions of the Apollonian and Dionysian.[4] The profane, Bataille contends, designates the "real order," which is characterized by "discontinuity." Discontinuity is the condition in which contrasting objects, various subjects, and subjects and objects are clearly differentiated. The profane world is the world of reason and work. Through reason, we articulate the differences and distinctions necessary for clear consciousness and transparent self-consciousness. Work is utilitarian activity in which desire is repressed and gratification deferred for the sake of what is regarded as useful production. In every profane economy, reason is productive and production is reasonable. When understood in this way, the modern economy is essentially profane. As we discovered in our analysis of the functionalism of modern

architecture, if the economy is to function *properly,* extravagant or excessive behavior must be avoided at all cost. But the cost proves to be too high and hence alternative compensation must be sought elsewhere.

The "real" world of reason and labor, according to Bataille, is not original but emerges from an obscure primal "world" that is sacred. Always carrying a faint recollection of the archaic world that has been left behind and yet dwells within, modern people long to return to the ground from which they originally arose. Religion addresses this primal desire through myths and rituals designed to bind believers back to the sacred origin. In his *Theory of Religion* Bataille argues,

> Man is the being that has lost, and even rejected, that which he obscurely is, a vague intimacy. Consciousness could not have become clear in the course of time if it had not turned away from itself looking for what it has itself lost, and what it must lose again as it draws near to it. Of course, what is lost is not outside it; consciousness turns away from the obscure intimacy of consciousness itself. Religion, whose essence is the search for lost intimacy, comes down to the effort of clear consciousness that wants to be a complete self-consciousness: but this effort is futile, since consciousness of intimacy is possible only at a level where consciousness is no longer an operation whose outcome implies duration, that is, at the level where clarity, which is the effect of the operation, is no longer given. (TR, 56–57)

In contrast to the differentiations of the profane world, the sacred is the domain of intimacy or "immanence" where clear differences and articulate distinctions are lacking. Recalling Nietzsche's Dionysian realm, Bataille claims that "the immanent immensity, where there are neither separations or limits . . . , has the passion of an absence of individuality" (TR, 24). The erasure of the individual entails a violence that provokes terror. Violence and the sacred join in sacrifice.[5]

As an excessive act that is neither reasonable nor useful, sacrifice breaks with the entire profane order. In sacrifice, one performs a deed of "uncalculated generosity"—a deed, in other words, that involves an "expenditure without return."[6] While reason demands a return on every investment (be it philosophical, economic, or psychic), religion requires extravagant prodigality. In developing his account of sacrifice, Bataille brings together Mauss's influential interpretation of the gift (*le don*) and Nietzsche's account of art. A genuine gift must be given selflessly, that is, without self-interest or in the absence of any prospect of personal profit or benefit. From this point of view, every gift is, in effect, a self-sacrifice. The most radical form of sacrifice is the sacrifice of the self. Accordingly, Bataille concludes that sacrifice is incomplete unless it ends in death. "Paradoxically, intimacy is violence, and it is destruction, because it is not compatible with the positing of the separate individual. If one describes the individual in the operation of sacrifice, he is defined by anguish. But if sacrifice is distressing, the reason is that the individual takes part in it. The individual identifies with the victim in the sudden movement that restores it to immanence (to intimacy)" (TR, 51). Repeating and extending Nietzsche's interpretation of Greek tragedy, Bataille maintains that sac-

rifice is a substitute for the literal dismemberment of the individual. By identifying with the victim, one vicariously experiences the return to intimacy without actually dying. But the forces released in sacrifice cannot always be controlled. The sacred is "contagious" and thus sometimes runs wild, thereby creating what Bataille describes as a "prodigious effervescence." This release takes place during festivals, which do not involve harmless play but entail pain and suffering, which are, contrary to expectation, pleasurable. "The festival," Bataille avers, "is the fusion of human life. For the thing and the individual, it is the crucible where distinctions melt in the intense heat of intimate life" (TR, 54). The heat that transforms differences into identity is generated by transgressive acts that violate the boundaries separating individual subjects and things. Forever beyond good and evil, "crimes" of violence and eroticism open the realm of divine intimacy. In *Death and Sensuality: A Study of Eroticism and the Taboo*, Bataille claims that "the final aim of eroticism is fusion, all barriers gone."[7] This fusion is a *coincidentia oppositorum* in which eros is thanatos, and death is life.

> Death actually discloses the imposture of reality, not only in that the absence of duration gives the lie to it, but above all because death is the great affirmer, the wonder-struck cry of life. The real order does not so much reject the negation of life that is death as it rejects the affirmation of intimate life, whose measureless violence is a danger to the stability of things, an affirmation that is fully revealed only in death. The real order [i.e., the reality principle] must annul—neutralize that intimate life and replace it with the thing that the individual is in the society of labor. But it cannot prevent life's disappearance in death from revealing the *invisible* brilliance of life that is not a *thing*. (TR, 46–47)

When life is death and death is life, one passes beyond the limits of reality into the surreality of the sacred.

Surrealism solicits the refused that realism refuses. Like Bataille, surrealists are obsessed with refuse—trash, rubbish, junk, debris, detritus . . . the discarded, rejected, worthless. Against modernism's preoccupation with purity, order, rules, reason, clarity, and function, surrealists set impurity, disorder, transgression, irrationality, and uselessness. Such concerns are hardly reasonable; indeed they are folly—"les folies les plus vives." Forever incomprehensible in any system—be it philosophical, religious, or economic—the folly of surrealism is the "non-knowledge" that Bataille associates with the ecstasy of "inner experience." "If the proposition (non-knowledge lays bare) possesses a sense—appearing, then disappearing immediately thereafter—this is because it has the meaning NON-KNOWLEDGE COMMUNICATES ECSTASY" (IE, 52). Through the work of art, surrealists seek a return of the agonizing ecstasy that was once present in religious ritual. Art, in other words, re-presents what religion once presented.

The strategy that the surrealists adopt to facilitate the return of the refused is automatic writing and, by extension, automatic drawing and

painting. Automatic writing, drawing, and painting are artistic adaptations of the method of free association that Freud developed for the analysis of dreams. In his first "Manifesto of Surrealism," Breton goes so far as to identify surrealism with automatic expression. By letting go of the control of mental functioning, the individual attempts to un-negate the negation of consciousness. This denegation allows the return of the refused. Commenting on Breton's method of automatic writing, Bataille explains, "The one who is seated comfortably, who maximally forgets what is in order to write by chance on blank paper *les folies les plus vives* that pass in the head, is able to arrive at nothing according to the plan of literary value. . . . What he has done is essentially an act of insubordination, in the sense that he has done a sovereign act; at the same time, he has accomplished what, in the sense of religions, would appear as predominant—he has accomplished the destruction of the personality" (RS, 387–88). The accomplishment of the destruction of the personality is the realization of the intimacy that Bataille deems sacred. "The sacred," he explains, "is tied to all that has been analyzed by philosophy under the form of participation. It is evident that when surrealism advances the idea of myth, it responds to a nostalgia living in the spirit of actual men, living not only since Nietzsche but even since German romanticism. Moreover, what constitutes religion is the liaison with myth and rites" (RS, 386). The myths and rites that Bataille associates most closely with surrealism are those of Dionysus.

Bataille's Dionysus is not only Greek but, more important, Nietzschean. If modernists are preoccupied with the rationalism of classical Greece, surrealists are possessed by the more ancient irrationalism of preclassical Orphic Greece. During the years when the Collège de sociologie was meeting, Bataille organized another secret society named Acéphale. As Michel Camus explains, this group "close[d] itself off from the exterior in order better to open itself to *l'expérience intérieur*." [8] The possibility of this disruptive inner experience presupposes that the self is never simply itself but is always at the same time self and other. In Bataille's terms, "man is something other than man"—"l'homme est l'autre chose que l'homme." The members of Acéphale cultivate rather than refuse this interior otherness in an effort to become other—*tout autre.*

In an admittedly self-contradictory gesture, Bataille's "secret society" published a journal entitled simply *Acéphale.* Between 1936 and 1939 three issues appeared, devoted to "La conjuration sacrée," "Nietzsche et les Fascistes," and "Dionysus." Articles by Bataille, Pierre Klossowski, Jean Wahl, and Roger Callois and reprinted essays by Karl Jaspers, Karl Löwith, and Nietzsche explore issues that range from ancient Greek myths, rituals, and pre-Socratic philosophy to modern politics and religion. The cover of each issue bears the extraordinary image of a headless man, with outstretched arms, clutching a dagger and a burning heart (fig. 7.1). In a brief essay entitled "The Sacred Conspiracy," Bataille comments on this disfigured figure:

**7.1 André Masson,**
*Acéphale.* © **1991 ARS, New**
**York/SPADEM, Paris.**

> Man has escaped from his head just as the condemned man has escaped from
> his prison. He has found beyond himself not God, who is the prohibition
> against crime, but a being who is unaware of prohibition. Beyond what I am,
> I need a being who makes me laugh because he is headless; this fills me with
> dread because he is made of innocence and crime; he holds a steel weapon
> in his left hand and flames like those of a Sacred Heart in his right. He re-
> unites in the same eruption Birth and Death. He is not a man. He is not a god
> either. He is not me but he is more than me: his stomach is the labyrinth in
> which he has lost himself, loses me with him, and in which I discover myself
> as him, in other words as a monster. (VE, 181)

Neither god nor man, Acéphale, in whose image we all are made, is a
monster whose birth is the death of modern man. The impossible union
of eros and thanatos that makes reason lose its head is figured in the skull
that displaces the genitals.

The artist who created the figure of Acéphale is André Masson. Ba-
taille and Masson had a long and productive relationship. In the years
following the publication of the first "Manifesto of Surrealism," Masson
persuaded Breton, who initially had been suspicious of transferring sur-
realistic practices from the verbal to the visual arts, that painting could be
genuinely surrealistic. Until their break, which was publicly announced
in the "Second Manifesto of Surrealism," Breton praised Masson as the
leading painter in the surrealist movement.[9] Masson had been using the
technique of automatic drawing and painting for several years before he
met Breton. Noting the parallel between drawing and writing, Masson
describes his approach to art: "(a) The first condition was to make a clean
slate. The mind freed from all apparent ties. Entry into a state of trance.
(b) Surrender to the interior tumult. (c) Speed of writing."[10]

This is not the way Masson started to paint. Deeply influenced by
cubism, his earliest work displays the care and control necessary to articu-
late the forms and structures that underlie the flux of the world. But Mas-
son's wartime experiences discredited the viewpoint that informed not
only cubism but all versions of abstract modern art. After two years in the
trenches, Masson was severely wounded in the 1917 offensive at the
Chemin des Dames. Medics were unable to evacuate him, and he had to
remain in a foxhole until the following morning. That night changed Mas-
son's life and transformed his art. His account of the experience vividly
captures the moment.

> The indescribable night of the battlefield, streaked in every direction by bright
> red and green rockets, striped by the wake and the flashes of the projectiles
> and rockets—all this fairytale-like enchantment was orchestrated by the ex-
> plosions of shells which literally encircled me and sprinkled me with earth

and shrapnel. To see all that, face upward, one's body immobilized on a stretcher, instead of head down as in the fighting where one burrows like a dog in the shell craters, constituted a rare and unwonted situation. The first nerve-shattering fright gives way to resignation and then, as delirium slips over you, it becomes a celebration performed for one about to die.[11]

In the aftermath of this indescribable night, Masson took up Baudelaire's charge: "Plonger au fond du gouffre, Enfer ou Ciel qu'importe! Au fond de l'Inconnu pour trouver de nouveau!"

In pursing his new artistic vocation, Masson took as his guide Bataille and, through Bataille, Heraclitus and Nietzsche. After years of reflection, Masson recounts his point of view in a brief idiosyncratic text entitled *Anatomy of My Universe,* which, not insignificantly, is dedicated to "My Friend, Dr. Jacques Marie Lacan."[12] On the opening page of this work, Masson records the source of his artistic vision.

> Whence come these imagined forms? They come from my impassioned meditation, an attitude that poses an object, even in its first movement when it seems to be completely sunk in the undermined. But soon, as in the process of dream-inducing hallucination, or after a first stage composed uniquely of vortical schemas, there appear forms already plastic like dreams and this meditative disposition calls up forgotten sensations, buried dreams. It is their polymorphous play that I orchestrate in their becoming.[13]

In these few lines, Masson summarizes both the method and substance of his art. Pursuing what Lucy Lippard describes as "oneiric realism," Masson simulates the mechanisms of dream work identified by Freud: displacement, condensation, and juxtaposition. The polymorphous play released by the relaxation of censorship embodies what Masson believes is Bataille's "most difficult and profound" idea: "the identification of eroticism and death." Masson's universe is governed by sexuality and violence—eros and thanatos. The anatomy of this monstrous world of Acéphale, where transgression opens rather than closes the sacred, is thoroughly Nietzschean and, thus, completely Dionysian.[14]

To underscore the difference between his artistic mission and all forms of abstract or formal art, Masson contrasts the philosophies of Husserl and Heraclitus. While Husserl attempts to escape worldly vicissitudes by uncovering ideal structures and timeless forms, Heraclitus drives us ever more deeply into the flux from which there is no exit. "Heraclitus," Masson concludes, "remains for me the essential philosopher." Accordingly, the impossible task of the artist is to figure the flux, or in Michel Leiris's felicitous phrase, "to make fast the absence of fixity."[15] The ceaseless flux of experience cannot be figured in crystalline forms that are clearly delineated and sharply differentiated. To the contrary, the absence of fixity can be fixed only by disfiguring figures. "My work," Masson confesses, "is an errant one." With "errant lines" (Gertrude Stein), he de-limits the sur-reality that abstract works of art repress. Masson criticizes abstract artists for "refusing to represent not only dreams, but the instincts that are the root of being: hunger, love, and violence."[16] As Freud insists, however,

these instincts cannot be expressed directly but must be misrepresented through a certain disfiguring. Masson's disfiguring results in imagery that is hallucinatory, violent, and monstrous. In a work like *The Labyrinth*, he disfigures the surrealist figure for the unconscious—the Minotaur—in a grotesque image that turns everything inside out (fig. 7.2). The intestinal

**7.2  André Masson**, *The Labyrinth*. © 1991 ARS, New York/SPADEM, Paris.

labyrinth of Acéphale reappears in the midst of the Minotaur. Floating eyes and dismembered members are juxtaposed to create a terrifying maze in which loss seems unavoidable. The head of the monster is filled with the image of a sacrificial altar reminiscent of the Aztec and Mayan structures that fascinated Bataille. As one contemplates Masson's dis-figure, it becomes clear that his work not only results from, but also results in, "le dérèglement de tous les sens."

By de-limiting the limits of form and structure, Masson approaches what Julia Kristeva labels the "borderline state" in which the symbolic order is interrupted by traces of the presymbolic. Masson's work neither represents limits nor re-presents de-limitation but represents the unrepresentable by representing the impossibility of representation. His work is painting/drawing-as-experience-of-limits, which figures the unfigurable by disfiguring figures. Kristeva's description of *écriture* suggests an illuminating reading of Masson's art: "What is unrepresentability? That which, through language, is part of no particular language: rhythm, music, instinctual balm. That which, through meaning, is intolerable, unthinkable: the horrible, the abject."[17] The intolerable, unthinkable, horrible, and abject make up the refuse that abstract artists refuse. This refuse litters, contaminates, pollutes, and corrupts Masson's art. Nowhere is this corruption more evident than in his drawings.

In a brief essay entitled "I Draw," Masson remarks, "To an art of presentation—indeed, of apparition—will be opposed a mode of sensing where the point of equilibrium will be found at the moment when appearance and disappearance are confounded."[18] The lines of Masson's drawings close as much as they open, thereby allowing a certain disappearance to appear. The third issue of *Acéphale* includes one of Masson's most extraordinary drawings: the figure of Dionysus (fig. 7.3). In the midst of the classical Greek temple that intrigues Le Corbusier and his followers, the headless Dionysus explodes. Masson's distorted image conjures up the repressed Orphism, hidden behind Greek classicism, which modern artists and architects refuse to acknowledge. In his right hand, Dionysus clutches a dagger with which he inflicts a gaping wound; in his left hand, he holds the fruit of the vine that recalls a "bacchanalian revel" that is hardly Hegelian. In place of the phallus, there appears the skeletal head of Medusa, oozing serpents that entangle the limbs of the monstrous god. This apparition suggests a terror that cannot be figured. Although published in 1937, Masson completed *Dionysus* four years earlier, near the end of a period of unusual personal instability. Between 1931 and 1933, he drew almost nothing but massacres. Though they vary in size and configuration, all these drawings are remarkably similar. In each case, male figures assault female figures with daggers (fig. 7.4).[19] The crazed play of lines creates dizzying images that express phantasmagorical desire in which eros and thanatos mingle.

During the years immediately prior to beginning his massacre drawings, Masson spent much of his time wandering through the slaughter-

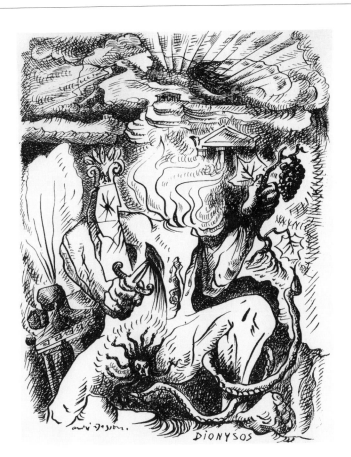

7.3  André Masson, *Dionysus.* © 1991
ARS, New York/SPADEM, Paris.

7.4  André Masson, *Massacre.* © 1991
ARS, New York/SPADEM, Paris.

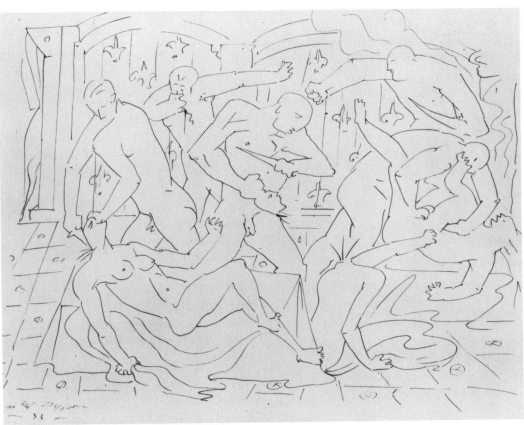

houses surrounding Paris. His fascination with the slaughter of bulls eventually resulted in a series of drawings entitled "Sacrifices: The Gods Who Die," in which the depictions of Mithra, the Minotaur, and the Crucified feature the sacrifice of the sacred bull.[20] In a text written to accompany the publication of Masson's drawings, Bataille associates sacrifice with rending ecstasy. "In the course of the ecstatic vision, at the limit of death on the cross and of the blindly lived *lama sabachthani,* the object is finally unveiled as *catastrophe* in a chaos of light and shadow, neither as God nor as nothingness, but as the object that love, incapable of liberating itself except outside of itself, demands in order to let out the scream of lacerated existence" (VE, 134). Although the temples of sacrifice seem to have disappeared, Bataille insists that their traces can still be discerned at the limit of modern society. In one of his most memorable trips to the edge of Paris, Masson accompanied Eli Lotar, who, at the time, was completing a series of photographs of the slaughterhouses to accompany Bataille's article on *l'abattoir* in the surrealist "Succinct Dictionary of Eroticism." Bataille's entry consists of a single paragraph that begins with the association of violence and the sacred. "The slaughterhouse is linked to religion insofar as the temples of by-gone eras (not to mention those of the Hindus in our own day) served two purposes: they were used both for prayer and for killing. The result (and this judgment is confirmed by the chaotic aspect of present-day slaughterhouses) was certainly a disturbing convergence of the mysteries of myth and the ominous grandeur typical of those places in which blood flows."[21] The location of *l'abattoir* that Bataille analyzes and Masson draws is La Villette. Almost half a century later, La Villette became the site of Bernard Tschumi's Follies.

Heralded and attacked as "the first deconstructive structure ever built," the Parc de La Villette is, in the words of its architect, "the largest discontinuous building in the world." The park, Tschumi explains, "can be seen to encourage conflict over synthesis, fragmentation over unity, madness and play over careful management" (CF, vii). Tschumi's architecture is guided by the notions of discontinuity, distortion, fragmentation, repetition, transference, rupture, interruption, and dislocation. By disfiguring modern forms and postmodern figures, Tschumi probes the uncanny "place" where "space mingles with the unconscious." If Bataille's texts perform writing-as-experience-of-limits, and Masson's art embodies painting/drawing-as-experience-of-limits, then Tschumi's deconstructions stage architecture-as-experience-of-limits. The site of this liminal architecture is the border that is approached in "borderline states." In the seventh of his "Architectural Manifestoes," Tschumi writes, "BORDER CROSSING. Architecture will define the places where reality meets fantasy, reason meets madness, life meets death. (Border crossing is erotic)" (AM, 7). The site of the park is the edge of an edge, margin of a margin, and border of a border of Paris. "La Villette," Tschumi points out, "is right on the edge of one of the walls, with the suburbs just beyond" (CV, 26). But the park is not only *on* a border; it *is* a border that joins and

**7.5 Bernard Tschumi,** *Le Parc de la Villette,* **aerial view (1985). Courtesy Bernard Tschumi Architects.**

disjoins two cities within the city. The Parc de La Villette is suspended between the Cité de la Musique and the Cité des Sciences et de l'Industrie (fig. 7.5).

Begun in 1983 as one of the *grands projets d'urbanisme parisien,* Le Parc de La Villette is located on a 125-acre site in the northeast corner of Paris. In response to the program's charge to create an "urban park for the twenty-first century," La Villette contains cultural and entertainment facilities ranging from art galleries, music halls, and open-air theaters, to restaurants, computer displays, and playgrounds. The Cité de la Musique, designed by Christian de Portzamparc, is situated at the southern entrance to the park. When completed, this complex will house the Nouveau conservatoire supérieur de la musique de Paris, as well as a museum of music, a technical laboratory for the analysis and restoration of musical instruments, and ample instructional and performance space. In the midst of the Cité de la Musique stands the Grande Halle that provides space for temporary exhibitions and performances. The literature distributed by the park's information center unwittingly describes the hall in Bataillean terms: "Constructed in 1867 by Jules de Mérindol, student of Louis Janvier, the Grand Hall was, from 1869–1974, the 'Temple' of the sale of beef in the area of the cattle market de la Villette."

The northern entrance to the park is dominated by the imposing Cité des Sciences et de l'Industrie (fig. 7.6). Adrien Fainsilber's construction

clearly expresses the principles of modern science and technology it is designed to exhibit. Combining references to classical Greece with the most advanced technology and industrial materials, Fainsilber creates a structure that is not merely modern but is futuristic. The multiform and interactive interior offers a variety of settings for an extraordinary array of exhibitions devoted to the natural and physical sciences. Perhaps as a result of Jean-François Lyotard's enormously popular and influential 1985 exhibition at the Centre Georges Pompidou entitled *Les immatériaux,* the city's permanent displays include an extensive array of the most recent electronic media and a section devoted to languages and communication. When one passes through the gates of this city, one enters a world that approaches the realm of science fiction.

Between the Cité de la Musique and the Cité des Sciences et de l'Industrie Tschumi located his park. The dominant feature of the park is a series of red cubes 10 meters on a side, which are symmetrically placed on 120-square-meter plots. These are La Villette's famed Follies. Each Folly is a distinctive variation of the common cubic structure. The Follies that have been completed provide space for the information center, a post office, a café, video studios, and playrooms for children. Between the Follies are open lawns, occasional gardens, and waterways. Numerous walkways transect the park on different levels. Complex and apparently unstable support systems complement an undulating 15-foot-wide cantilevered canopy that transforms parts of the park into a labyrinth (plate 24).

At the border of the park, along the margin where reason meets folly and civilization encounters madness, there looms the *Géode,* a giant sphere 36 meters in diameter that encloses *la salle de spectacle.* This massive reflective sphere recalls a similar structure that is the logo for the Magic Kingdom of the society of spectacle—EPCOT Center. The pristine surface

**7.6 Adrian Fainsilber,** *La Cité des Sciences et de l'Industrie* **(1986).**

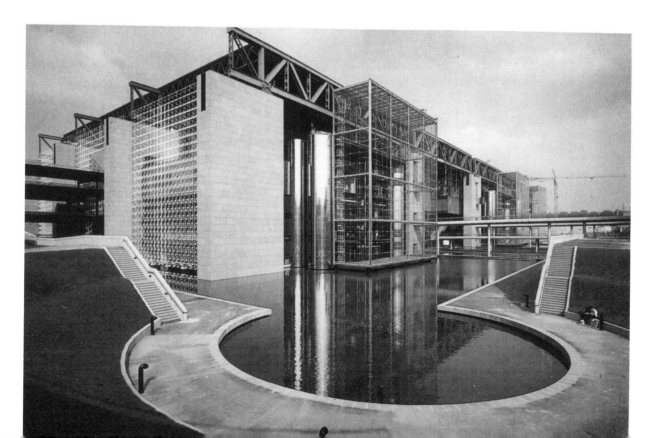

of the sphere, which gathers earth and sky by mirroring each in the other, comprises 6,433 triangular plaques. Neither precisely solar nor lunar, the *Géode* appears to be a brilliant silver sun whose superficial triangles recall the monuments of the Egyptian god Râ. In "The Obelisk," Bataille describes the ancient response to the death of the pharaoh.

> Each time death struck down the heavy column of strength the world itself was shaken and put in doubt, and nothing less than the giant edifice of the pyramid was necessary to reestablish the order of things: the pyramid let the god-king enter the eternity of the sky next to the solar Râ, and in this way, existence regained its unshakable plenitude in the person of the one it had *recognized*. The existing pyramids still bear witness to this calm triumph of an unwavering and hallucinating resolve. . . . The great triangles that make up their sides "seem to fall from the sky like the rays of the sun when the disc, veiled by the storm, suddenly pierces through the clouds and lets fall to earth a ladder of sunlight." . . . In their imperishable unity, the pyramids—end-lessly—continue to crystalize the mobile succession of the various ages, . . . they transcend the intolerable void that time opens under men's feet, for all possible movement is halted in their geometric surfaces. (VE, 216)

Such pyramids are built to cover the abyss over which (the) all is suspended. The crystalline geometry of abstract constructions represents the desire to find an exit from the labyrinth of death and decay by stopping time.

But Bataille describes another pyramid that is a labyrinth rather than its negation—"The Pyramid of Suleri." While walking along the lake of Silvaplana, Nietzsche's gaze lit upon "a powerful pyramidal rock not far from Suleri." The sight of this pyramid triggered his ecstatic vision of the eternal return. Bataille comments on Nietzsche's experience,

> In order to represent the decisive break that took place, . . . it is necessary to tie the sundering vision of the "return" to what Nietzsche experienced when he reflected upon the explosive vision of Heraclitus, and to what he experi-enced later in his own vision of the "death of God. . . . " TIME is the object of the vision of Heraclitus. TIME is unleashed in the "death" of the One whose eternity gave Being an immutable foundation. And the audacious act that represents the "return" at the summit of this rending agony only wrests from the dead God his *total* strength, in order to give it to the deleterious absurdity of time. (VE, 220)

When time is unleashed in death, ecstasy becomes Dionysian. Following Nietzsche, Bataille maintains that in Dionysus's tumultuous revel, Cronus is honored.

> Cronus, the very "human" god of the golden age, was celebrated in satur-nalia; Dionysus, whose coming into the world depended on the murder of his mother by his father—the criminal Zeus striking down Semele in a blast of lightning—this tragic Dionysus, broken in joy, started the sudden flight of the bacchantes. And the least explained of the "mysteries," TRAGEDY, like a festival given in honor of horror-spreading time, depicted for gathered men the signs of delirium and death whereby they might recognize their true na-ture. (VE, 218)

This is the delirium Tschumi seeks to unleash in his Follies.

In an important essay entitled "Questions of Space: The Pyramid and the Labyrinth (or the Architectural Paradox)," Tschumi contrasts modern architecture with his version of deconstructive architecture through the images of the pyramid and the labyrinth.[22] While the pyramid represents reason and civilization, the labyrinth is the sign of folly and madness. For modernists, Tschumi argues, architecture is the creation of the rational mind in which every trace of irrationality and sensuality is refused. In designing their "dematerialized" buildings, proponents of modernism endlessly manipulate linguistic models in an effort to discover ideal forms and essential structures that resist the corrosive effects of time and history. Tschumi insists that modernism's "white crusade" involves a hygienic search for "absolute truth" in which the material and sensual aspects of life are purged. In their flight from death, however, modernists rush into its arms. Whether explicitly or implicitly, structures that repress eros are devoted to thanatos.

In contrast to the death-defying pyramid, the labyrinth entangles us in time ever more deeply. For Tschumi, the labyrinth figures the empirical dimension of space that affects the senses before reason. The opposition between the pyramid and the labyrinth repeats Nietzsche's distinction between Apollonian and Dionysian forms of art.

> Beyond such opposites lie the mythical shadows of Apollo's ethical and spiritual mindscapes versus Dionysus' erotic and sensual impulses. Architectural definitions, in their surgical precision, reinforce and amplify the impossible alternative: on the one hand, architecture as a thing of the mind, a dematerialized or conceptual thing, with its topological and morphological variations, and on the other hand, architecture as an empirical event that concentrates on the senses, on the experience of space.[23]

This opposition, according to Tschumi, is insurmountable, and hence architecture is irreducibly paradoxical. He does not try to resolve or dissolve this paradox by collapsing one side into the other but contends that "the definition of architecture may lie at the intersection of logic and pain, rationality and anguish, concept and pleasure" (MT, 9). To redress the imbalance created by modernism's repressive Apollonian approach, Tschumi develops a Dionysian architecture that is guided by the pleasure principle.

In what appears to be a claim designed to provoke, Tschumi insists that "architecture is the ultimate erotic 'object.'"[24] Following Bataille, Tschumi argues that "eroticism is not the excess of pleasure, but the pleasure of excess."[25] The excess that gives pleasure is the remainder or refuse refused by systems and structures constructed to dominate and control everything that is unruly. By soliciting the repressed, Tschumi attempts to subvert modernism's purist aesthetic and puritan ethic. When understood in this way, the practice of architecture is inseparable from transgression. Tschumi's 1976 manifesto underscores the interplay of eros and transgression in architecture: "If you want to follow architecture's first rule, break it. Transgression. An exquisitely perverse act that never lasts. And like a

caress is almost impossible to resist. Transgression" (AM, 3).[26] By stress-
ing its transgressive nature, Tschumi insists that the pleasure of architec-
ture does not result from the absence of rules but from their infraction.
Rules, which are represented in forms and structures, are not simply
destroyed but are preserved *as faulty.* Instead of covering faults and mend-
ing tears, the architect who seeks perverse pleasure opens wounds that
never heal by deconstructing structures that once seemed whole. The
pleasure of Tschumi's folly is not the salvific pleasure that comes from a
return to the Garden or the realization of the Kingdom, but the rending
of Dionysian pleasure that arrives with the confession there is no escape
from "the deleterious absurdity of time."

In the Parc de La Villette, Tschumi attempts to construct his de-
construction of modern architecture by means of a method he labels "super-
imposition." Superimposition is a "strategy of differences" that counters
modernism's totalizing syntheses with the dissociation and dis-integration
of de-structured structures. In the park Tschumi superimposes three dif-
ferent systems—points, lines, and surfaces—without making any effort to
unify or integrate them (fig. 7.5). In superimposition, Tschumi explains,
"the principle of heterogeneity—of multiple, dissociated and inherently
confrontational elements—is aimed at disrupting the smooth coherence
and reassuring stability of composition, promoting instability and pro-
grammatic madness ('a Folie'). Other existing constructions (e.g. the Mu-
seum of Science and Industry, the Grande Halle) add further to the
calculated discontinuity" (CF, vi). In the system of surfaces, a variety of
textures corresponds to needs that arise from activities as different as
sports, walking, mass entertainment, and shopping. The network of lines
traces pedestrian movements along "1) two coordinate axes, or covered
perpendicular galleries, 2) a meandering 'cinematic' promenade that re-
lates various parts of the Park in a sequential manner, 3) alleys of trees
linking the key activities of the site" (CF, 6).

Although Tschumi maintains that his design is rigorously non-
hierarchical, the point grid actually dominates the other two systems. The
grid both imitates the abstract plan of Paris and plots the pattern of the
park. Tschumi's appropriation of the grid, which plays such an important
role in modern art and architecture, is subversive. By turning the grid
against itself, he uses it to open rather than to close structure. "Just as [the
grid] resisted the humanist claim to authorship," he argues, "so it opposed
the closure of ideal compositions and geometric dispositions. Through its
regular and repetitive markings, the grid defined a potentially infinite field
of points of intensity: an incomplete, infinite extension, lacking center or
hierarchy" (CF, vi). While the grid traditionally has been used to center
and ground structures by providing a secure foundation, Tschumi employs
the grid to create a decentered structure that is "utterly discontinuous and
often unpredictable." Indirectly invoking Foucault, whose work informs
so much of the park, Tschumi notes that the grid "suggests the bars of the
asylum or prison, introducing a diagram of order in the disorder of re-

ality."[27] But the repressed returns to disrupt and disorder systems and structures of control. The point of (no) return is (the) folly.

There is, of course, a long tradition of follies in architecture. The word *folly* implies the eroticism that Tschumi associates with deconstructive architectural practice. *Folly* derives from the stem *beu* (swelling, flowing, flowering), which it shares with the Greek "phallos; phallus, ithyphallic (ithy: erect; carried at festivals of Bacchus [who is also known as Dionysus])."[28] Follies historically have been associated with parks and gardens that serve as Arcadian retreats. By providing an escape from the regulations that police routine behavior, follies become associated with sites of pleasure, excess, and transgression. In the recessive grottoes of these gardens of delight, the refused resurfaces. But, as we have seen, eros cannot be separated from thanatos. Follies often include ruins that mark the site where Dionysus meets Cronus. Gardens, as Jean Starobinski maintains, "teach us that we are ephemeral, that we pass on as generations before us have passed on, that wisdom lies in the acceptance of passing seasons and the vicissitudes of life. . . . Nature . . . leads us in ecstasy to the idea of ruin and the decay of matter. Our final delight is in abandoning ourselves to death, an exaltation that anticipates the darkness into which we will vanish."[29]

It was not, however, until the Age of Reason that the folly became "the figure of unreason." "As epitomizing a gamut of negative qualities, the folly took on the essential nature of the opposite pole, of extreme undesirability, of absolute contradiction. As the emblem of foolish luxury, it offered a warning to spendthrifts and unproductive investors; as totally without function, it provided a specter of emptiness and uselessness without which function itself was meaningless; as close to madness, it described the realm and embodied a visual metaphor that decorated and domesticated an otherwise awesome concept, one that was readily incarcerated behind nonsignifying walls; as a vehicle for all sorts of fashionable literary notions, from the sublime to the picturesque, the folly exhibited them in a kind of museum of meditative objects. Thus, within a tamed space, the folly closeted such difficult and nonbourgeois ideas as horror, terror, and decay. In every sense, the folly represented, in pictorial or figurative form, a necessary evil. Without the folly, rationalism, progress and faith in a perfective mankind would have been empty concepts—mere fictions of good without tangible antagonisms with which to tangle."[30]

Tschumi's Follies reflect and extend the encounter between madness and civilization that begins in the Enlightenment. Folly inhabits rational structures as the refuse through whose repression reason constitutes itself. While the park's Follies recall works of the Russian constructivists, their function in Tschumi's overall scheme is deconstructive (fig. 7.7). Neither inside nor outside the grid, the Follies dislocate the structure within which they are inscribed. In contrast to modernist postmodern architects, who disfigure by adding ornaments and figures to abstract forms, Tschumi's disfiguration deconstructs formal structures by dislocating them from

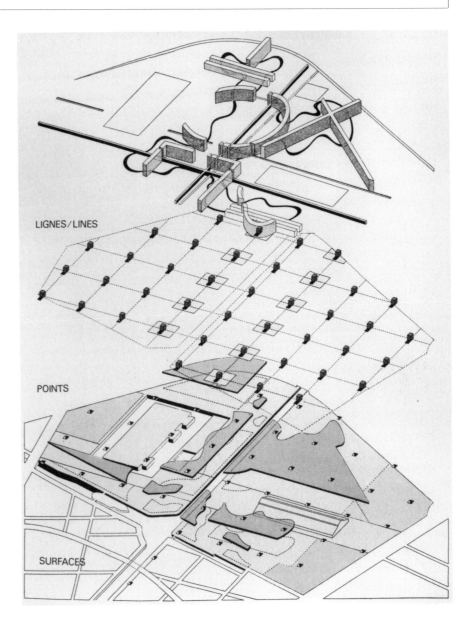

**7.7 Bernard Tschumi,** *Superimposition: Points/Lines/ Surfaces* **(1982). Courtesy Bernard Tschumi Architects.**

within. Each Folly begins as a cube, which then is transformed through a process that Tschumi names "deviation." "Deviation is both the excess of rationality and irrationality. As a norm, it contains the components of its own explosion. As a deviation, it frees them. Normality tends towards unity, deviation towards heterogeneity and dissociation" (CF, 27). The Folly is the site of dissociation, which, in Derrida's terms, "gathers together what it has just dispersed; it reassembles it *as* dispersion." Never integrated totalities but always divisible in themselves, the Follies are points of "rupture, discontinuity, disjunction" (CV, 15). As the juncture of disjunction, the Follies explode structure. The deconstructed cubes are "points of intensity" where forces that come together fly apart and forces that fly apart come together.[31]

In a certain sense, the Follies are useless; they are pointless points. The "explosion" of structure releases a latter-day potlatch in which expen-

diture without return becomes consumption that knows no end. In a 1974 manifesto entitled "Fireworks," Tschumi declares, "Good architecture must be conceived, erected and burned in vain. The greatest architecture of all is the fireworkers': it perfectly shows the gratuitous consumption of pleasure" (AM, 1). The pleasure of architecture cannot be reappropriated in any productive system, for it remains utterly useless. Rather than a weakness, this uselessness is a strength in a society governed by the principle of profit. Tschumi's architecture works by not working. In other words, when it works, it fails.

The pointlessness of Tschumi's architecture points not only to its uselessness but to its meaninglessness. Although the Follies are sensual, they are not sensible; their sense is non-sense. Modern architects, Tschumi insists, are obsessed with the idea of *presence* in the form of the presence of the idea. For the modernist, the architect is the master of meaning who constructs significant forms. Since knowledge is power, to master meaning is to gain control. One of the most important aspects of Tschumi's deconstruction of modernism and modernist postmodernism is his critique of knowledge and meaning. In one of his descriptions of the park, Tschumi offers his most concise summary of his differences with modern and postmodern architecture.

> The project takes issue with a particular premise of architecture, namely, its obsession with presence, with the idea of a meaning immanent in architectural structures and forms which directs its signifying capacity. The latest resurgence of this myth has been the recuperation, by architects, of meaning, symbol, coding, and "double coding," in an eclectic movement reminiscent of the long tradition of "revivalisms" and "symbolisms" appearing throughout history. This architectural postmodernism contravenes the reading evident in other domains, where postmodernism involves an assault on meaning or, more precisely, a rejection of a well-defined signified that guarantees the authenticity of the work of art. To dismantle meaning, showing that it is never transparent but is socially produced, was a key objective in a new critical approach that questioned the humanist assumptions of style. Instead, architectural postmodernism opposed the style of the modern movement, offering as an alternative another more palatable style. Its nostalgic pursuit of coherence, which ignores today's social, political and cultural dissociations, is frequently the avatar of a particularly conservative architectural milieu. The La Villette project, in contrast, attempts to dislocate and de-regulate meaning, rejecting the "symbolic" repertory of architecture as a refuge of humanist thought. . . . La Villette is a term in constant production, in continuous change; its meaning is never fixed but is always deferred, differed, rendered irresolute by the multiplicity of meanings it inscribes. (CF, vi–vii)

To stimulate rather than repress multiple meanings, Tschumi attempts to erase the preprogrammed program by shifting the locus of the production of meaning from the masterful architect to a plurality of readers. This gesture enacts what Roland Barthes describes as "the death of the author."

Barthes's essay "The Third Meaning: Research Notes on Some Eisenstein Stills" indirectly illuminates the nonsense of Tschumi's Follies. In

contrast to the informational and symbolic levels, Barthes's third meaning is not obvious but is "obtuse." "Obtuse meaning," Barthes explains, "is not directed towards meaning . . . does not even indicate an *elsewhere* of meaning. . . . It outplays meaning—subverts the whole practice of meaning. . . . Obtuse meaning appears necessarily as a luxury, an expenditure with no exchange." In light of the importance of Bataille for Tschumi's architectural theory, it is noteworthy that Barthes explicitly draws on Bataille's interpretation of the carnival to develop his notion of obtuse meaning. "The obtuse meaning appears to extend outside culture, knowledge, information; analytically, it has something derisory about it: opening out into the infinity of language, it can come through as limited in the eyes of analytic reason; it belongs to the family of pun, buffoonery, useless expenditure. Indifferent to moral or aesthetic categories (the trivial, the futile, the false, the pastiche), it is on the side of carnival." The exteriority of Barthes's nonsynthetic third is, however, a strange exteriority. Obtuse meaning "is outside (articulated) language while nevertheless within interlocution." Barthes designates this outside that is inside "the filmic." "The filmic," he explains, "is that in the film which cannot be described, the representation which cannot be represented. The filmic begins only where language and metalanguage end."[32]

As if to screen Barthes's filmic, Tschumi constructs a "cinematic promenade" that snakes through the park. This serpentine path extends the practice of superimposition by appropriating Eisenstein's method of montage for architectural purposes. Since the master architect does not impose meaning on form, each element in the park is an "empty slot"—*une case vide*—where meaning must be produced instead of discovered.[33] Strolling along the cinematic promenade, one frames and reframes scenes in an alternating sequence: gap/closure/gap/closure/gap . . . At each point along the way, the meaning of the fragments shifts and slides until it becomes completely undecidable. Tschumi explains his filmic strategy: "The Park is a series of cinegrams, each of which is based on a precise set of architectonic, spatial, or programmatic transformations. Contiguity and superimposition of cinegrams are two aspects of montage. Montage, as a technique, includes such other devices as repetition, inversion, substitution, and insertion. These devices suggest an art of rupture, whereby invention resides in contrast—even in contradiction" (CF, vi). Tschumi's cinematic techniques are not only polymorphous; they are perverse. Their aim—insofar as they have an aim—is not meaning but its lack. In what is perhaps his most revealing comment on the park, Tschumi confesses, "La Villette, then, aims at an architecture that means *nothing*, an architecture of the signifier rather than the signified—one that is pure trace or play of language" (CF, vii).

The point—the point that means nothing—is not Tschumi's but Bataille's point, or Tschumi's refiguration of Bataille's point. The point of the Parc de La Villette is to reissue Bataille's call to summon all of man's tendencies into a point.

*To summon all of man's tendencies into a point, all of the "possibles" that he is, to draw from them at the same time the harmonies and the violent oppositions, no longer to leave outside the laughter tearing apart the fabric of which man is made, on the contrary, to know oneself to be assured of insignificance as long as thought is not itself this profound tearing of the fabric and its object—being itself—the fabric torn (Nietzsche had said: "regard as false that which has not made you laugh at least once . . ."), in this respect, my efforts recommence and undo Hegel's Phenomenology. Hegel's construction is a philosophy of work, of "project." The Hegelian man—Being and God—is accomplished, is completed in the adequation of the project. The only obstacle in this way of seeing . . . is what, in man, is irreducible to project: non-discursive existence, laughter, ecstasy, which link man—in the end—to the negation of the project that he nevertheless is—man ultimately ruins himself [s'abîme] in a total effacement—of what he is, of all human affirmation. Such would be the easy passage from the philosophy of work—Hegelian and profane—to sacred philosophy, which the "torment" expresses. (IE, 80–81)*

This is the passage Tschumi plots in the park he superimposed on the site of the Paris slaughterhouses.

The red of La Villette is the trace of the blood of sacrifice. The Follies are what Didi-Huberman describes in another context as "the torn-rent image" of "an Acéphelic god." As we have seen, this god is the tragic god of ecstasy. Dionysian ecstasy is madness, which is both overwhelmingly terrifying and irresistibly attractive. Eurydice is another guise of madness, Orpheus another mask of the architect whose quest leads him to the underworld. In his folly, Tschumi, like Orpheus, transgresses the prohibition against "looking at the point where life touches death." In "Architecture and Transgression," Tschumi willfully embraces an important passage from the opening pages of Breton's "Second Manifesto of Surrealism." "Everything tends to make us believe that there exists a certain point of the mind at which life and death, the real and the imagined, past and future, the communicable and the incommunicable, high and low cease to be perceived as contradictions" (MS, 123). This is the point toward which Tschumi's architecture is directed. His refusal of modern architecture expresses the *desire* for a re-fusal with what is, in effect, the sacred. The point of the Follies, like the point of Bataille's writing and Masson's painting and drawing, repeats Schelling's *Indifferenzpunkt*. Although Tschumi insists that re-fusal is infinitely deferred, he continues to long for the oneness that modernism promises but cannot deliver.

There is, however, another way to read the nonsense of the point. A few pages after dismissing Schelling's *Indifferenzpunkt* as "the night in which all cows are black," Hegel begins his analysis of the experience of consciousness by examining what seems to be a sensible point—the *hic et nunc* of sense-certainty. As the point of departure, this point is the limit of the Hegelian system. But no sooner has Hegel begun than he loses his point. From the beginning, indeed, before the beginning, the systematic exposition of consciousness seems pointless. The presence of the *hic et nunc* disappears; the point of departure turns out to be the departure of the point. Preoccupied with the certainty of sense, Hegel finds the nonsense of the point unbearable. With a flick of his dialectical wand, he tries

to translate the nonsensical absence of the point into sensible presence. But his effort fails and thus his labor remains pointless. The evasion of the point allows presence to appear while at the same time inscribing an inevitable disappearance in the very midst of presentation. This withdrawal points toward a different refusal. Speaking to this point, Edmond Jabès writes, *"God refused image and language in order to be Himself the point. He is image in the absence of images, language in the absence of language, point in the absence of points"* (EL, 15).

The *absence* of the point is present in the midst of Tschumi's park. Something is missing from his project. It is planned but has not been constructed. Along the cinematic promenade, one of the gardens that remains absent is Choral Work, whose architects are Peter Eisenman and Jacques Derrida (plate 25). By deconstructing modernism and modernist postmodernism differently, Choral Work disrupts the Parc de La Villette as if from within. Perhaps it is no accident that Choral Work has not been constructed; perhaps it cannot be constructed; perhaps La Villette cannot contain it; perhaps Tschumi cannot bear it. Perhaps. But such speculation is pointless.

To begin again, we must return to the nonsense of the point—not Tschumi's but Hegel's point. Hegel's systematic effort to recover presence (here) in the present (now) of the point is bound to fail. The presentation of spatial and temporal presence presupposes something that is never present and yet is not absent. Neither present nor absent, this strange third allows appearance to appear by disappearing. The presence of the present and the present of presence are always dislocated as if from within by something that eludes the economy of presence and thus remains irreducibly unrepresentable. This dislocation disrupts presence by spacing the present and interrupts the present by timing presence. Derrida names this becoming-space of time and becoming-time of space *différance*.

> An interval must separate the present from what it is not in order for the present to be itself, but this interval that constitutes it as present must, by the same token, divide the present in and of itself, thereby also dividing, along with the present, everything that is thought on the basis of the present, that is, in our metaphysical language, every being, and singular substance or the subject. In constituting itself, in dividing itself, in dividing itself dynamically, this interval is what might be called *spacing*, the becoming-space of time and becoming-time of space (*temporization*). And it is this constitution of the present, as an "originary" and irreducibly nonsimple (and therefore, *stricto sensu*, nonoriginary) synthesis of marks, or traces of retentions and protensions . . . that I propose to call archi-writing or archi-trace. Which (is) (simultaneously) spacing (and) temporization.[34]

Never present without being absent, the site of *différance* is a certain nonsite. The impossible task of Eisenman's deconstructive architecture is not simply to build differently but to construct *différance*.

This venture cannot be approached alone; it must be a joint undertaking. To build deconstructively is, in effect, to construct a joint whose origin is not (the) one. Choral Work is such a joint project. Duplicity be-

gins with the title. Choral Work is both a text with a strange architecture and an architectural project that is textual. The origin of Choral Work is at least double—Derrida and Eisenman. Although they cooperate, these two never become one. In a certain sense, the title *is* the work. Recalling his first meeting with Eisenman, which was arranged by Tschumi, Derrida writes,

> I insisted, and Eisenman fully agreed, on the need to give our common work a title, and an inventive title at that, one that not only does not have as its sole function the endowment of collective meaning, the production of those effects of legitimizing identification that one expects from titles in general. On the contrary, precisely because what we were making was not to be a garden (the category under which the administration of La Villette ingeniously classified the space that was confided to us), but something else, a place yet without name, if not unnameable; it was necessary to give it a name, and with this naming make a new gesture, a supplementary element of the project itself, something other than a simple reference to a thing that would exist in any case without its name, outside the name.[35]

As Derrida has long insisted, the strange logic of the supplement can be captured by neither the either/or of Aristotelian logic nor the both/and of Hegelian logic. The supplement implies (but does not represent) "something else"—something so different that it is "unnameable." This unnameable is figured in the disfiguring of Choral Work.

The title frames the work. But "where does the frame take place. Does it take place. Where does it begin. Where does it end. What is its internal limit. Its external limit. And its surface between the two limits" (TP, 63). The "place" of the frame is the edge, margin, border, or limit that delimits the work. As a framing device, the title is the *hors d'oeuvre,* which, though neither inside nor outside the work, opens the space in which the work is inscribed. Commenting on the work in which Hegel framed his philosophical system—*Phenomenology of Spirit*—Derrida underscores the strange place of the title: "This residue of writing remains anterior and exterior to the development of the content it announces. Preceding what ought to be able to present itself on its own, the preface [or title] falls like an empty husk, a piece of formal refuse, a moment of dryness or loquacity, sometimes both at once" (D, 9). This excessive refuse cannot be incorporated or eliminated. It is a lingering remainder that subverts every purported re-fusal.

Whose title is Choral Work: Derrida's or Eisenman's? The answer, it seems, is neither one nor the other. At the time of their first encounter, Derrida was writing a text on Plato's *Timaeus* entitled "Chora." In the course of the dialogue between Derrida and Eisenman, the suggestion emerged—it is not clear from whom—that they form a title for the joint work by introducing yet another supplement: the addition of an *L* to "Chora" to form Choral Work. This supplement is far from innocent. As we shall see, it haunts the margins of Derrida's most sustained interrogation of art, *The Truth in Painting,* and is Eisenman's signature. Derrida

and Eisenman underscore the multiple meanings and associations of Choral Work.

> Derrida: It is musical.
> Eisenman: Yes, and there is togetherness. For me, it means corral as enclo-
>   sure, coral as stone and coral as color, choral as a group musical work,
>   and choral as of chora.
> Derrida: It reminds me also of 'firework'—choral work, fire work, something
>   work. (CW, 3)

The fireworks of Choral Work are not, however, the same as the fireworks of Tschumi's Follies. The madness embodied in the Follies reflects poly-semy run wild. In such plurivocality, the double coding characteristic of postmodernism is multiplied but not interrupted. The undecidable title "Choral Work" *disseminates* meaning. "The difference between discursive polysemy and textual dissemination is precisely *difference* itself, 'an im-placable difference' " (D, 351).

This "implacable difference" can be heard *between* the lines of Derrida and Eisenman's conversation. They repeatedly misunderstand each other. The effect is often comic, sometimes *almost* tragic. Even when they seem to concur, agreement is provisional and not final. Their dialogue stages what Jean-Luc Nancy describes as "le partage des voix"—a sharing that is parting and a parting that is shared. Blanchot's account of *le pas au-delà* effectively describes the exchange or nonexchange between Derrida and Eisenman: "Behind discourse speaks the refusal to discourse, as behind philosophy would speak the refusal to philosophize: the non-speaking speech, violent, concealing, saying nothing and suddenly crying."[36] This cry of refusal is the echo of chora.

In his analysis of the place or, more precisely, the nonplace of chora in Plato's *Timaeus,* Derrida refigures his "nonconcept" *différance.* Chora, Derrida argues, "is the spacing that is the condition for everything to take place, for everything to be inscribed" (CW, 3). In other words, chora is the margin of the between that articulates the differences constitutive of identity. Derrida glimpses this different difference in the midst of Plato's myth of origins. In *Timaeus,* the world originates through the activity of an architect-Demiurge who fashions changing matter in the image of eter-nal forms. After summarizing the myth, Derrida concludes, "So, we have two kinds of being: the eidos, which is eternal and unchanging, and the becoming-world, the sensible. Two kinds of being, one the copy of the other. Now Plato says—and there is something very strange here—that there is something else, the third element, *triton geno.* This third kind, or genus, is neither the eternal eidos nor its sensible copy, but the place in which all those types are inscribed—*chora*" (CW, 3). This third is not di-alectical or synthetic. Neither sensible nor intelligible, it eludes the stric-tures of classical Western ontology. And yet, it is inextricably entangled in structures that cannot include it. Inasmuch as it is "the spacing that is the condition for everything to take place," chora is, in a certain sense, ante-cedent to all that exists. However, as the condition of the possibility of

existence, chora itself does not exist. Nor is it nothing. Chora is "more ancient" than being or nonbeing. The past of this "ancient of ancients" has never been present; it is an absolute past whose perpetual withdrawing opens the space for all presence to appear and creates the time for every present to transpire. Emmanuel Levinas labels this radical past "an-archie." "Incommensurable with the present, unassemblable in it," *anarchie,* Levinas argues, "is always 'already in the past' behind which the present delays, over and beyond the 'now' that this exteriority disturbs and obsesses."[37] The *archē* of an-archie *is not* the traditional *archē* of architecture but is the *archē* of the archi-trace. This trace produces a certain anarchy by faulting the foundation of classical and modern architecture: form, structure, presence, meaning, origin, synthesis, unity, and so forth.

According to Eisenman, the history of architecture from classicism *through* modernism is governed by what he, following Heidegger and Derrida, describes as "the metaphysics of presence." Eisenman divides this history into four chapters that are organized around the shifting relations among what Kant identifies as the three regulative ideas that guide all reflection: God, self, and world. Eisenman's story of Western architecture is not continuous but is punctuated by at least three ruptures. Prior to the fifteenth century, God mediated between man and world, thereby establishing order and insuring meaning. Human thought and action sought to re-present the truth established by the divine architect of creation. With the Renaissance, anthropocentrism replaced theocentrism. "Whereas the architecture of the theocentric world had been a celebration of God, the anthropocentric world now celebrated man. The vertical datum—the wall, the hearth as a center, the chimney as a backbone—all began to be metaphoric of man's vertebrate and upright stature, and architecture began to be scaled to man's bodily proportions rather than to some transcendent perfection. Architecture became anthropomorphic" (HC, 170). The third chapter in Eisenman's story began in the nineteenth and ended in the twentieth century. "With the advent of mass technology and the development of the relativistic human sciences—biology, sociology, psychology, and anthropology—man could no longer maintain his anthropocentric focus or take for granted his centric position and, correspondingly, the 'naturalness' of his social organizations. In the face of the recognition of this fundamental human estrangement, man's sense of himself came into crisis" (HC, 170). Modern architecture arose in response to this crisis. Technology, the modernist believed, would make it possible to realize the utopian future that neither God nor man had delivered. But the dream of modernity was short-lived; it ended in a nightmare in the Second World War.

> Modernism was well into a confrontation with the contingency of its vision and consequently futility of its optimism when, in 1945, it received its final blow. With the scientifically orchestrated horror of Hiroshima and the consciousness of the human brutality of the Holocaust, it became impossible for man to sustain a relationship with any of the dominant cosmologies of his

past; he could no longer derive his identity from a belief in a heroic purpose and future. Survival became his only "heroic" possibility. The technocratic model, which was really just a disguise for the anthropocentric one, brought down the entire cosmological matrix. For the first time in history, man was faced with no way of assuaging his unmediated confrontation with existential anxiety. (HC, 170–72)

Eisenman's architecture is calculated to deepen the "existential anxiety" he believes is endemic to the postmodern world.

Like other members of the New York Five, Eisenman's early work was deeply influenced by modernism. In a series of houses, most of which were never built, Eisenman extends modern formalism by adapting Noam Chomsky's transformational grammar to architectural practice (fig. 7.8). The procedure Eisenman follows in these houses is not unlike Tschumi's treatment of the Follies. Beginning with a cube, Eisenman programs variations on this basic structure. Unlike Tschumi, he tries to generate an "autonomous architectural object" by devising transformational processes that are not controlled by the creative subject. The goal of these "syntactic" investigations is to identify the "structural essence" of architecture. It should be clear that this search for an architectural eidos is thoroughly logocentric. But even in these early works, it is possible to discern anticipations of Eisenman's eventual break with modernism. Instead of integral structures, the houses are interrupted by disturbing elements that serve no practical function: stairs lead nowhere, columns support nothing, cracks appear in inconvenient places, and bright colors disfigure the purity of white surfaces. Eisenman insists that in contrast to the work of his erstwhile colleague Michael Graves, the purpose of these houses is to "shatter the sense of comfortable complacency" by "alienating people from their environment." Nonetheless, he realizes that his early houses remain un-

**7.8** Peter Eisenman, *House No. III.* **Courtesy Eisenman Architects. Photograph: Dick Frank.**

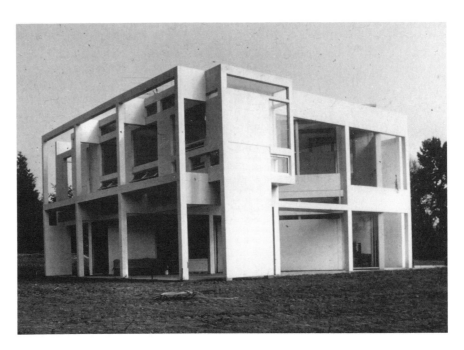

deniably modern. "The attempt at autonomy," he admits, "was a dream of illusory presence, of the denial of absence, of the 'other'" (HC, 182).

After reading Derrida, Eisenman gave up his dream of presence. A passage in the draft of "Misreading Peter Eisenman," which is conspicuously missing from the published version of the essay, suggests a shift away from architectural principles that presuppose a metaphysics of presence.

> The current work expands on the concept of architectural figure in the narrow sense of representation, such as that characteristically used in the work of many current architects. It considers such a use of figuration to be but a method of writing a text of origin and therefore center, thereby suppressing the presence of absence. On the other hand, figure in the larger rhetorical sense, in the sense of analogy, metonymy or metaphor, as the fundamental constituent of text is at the very heart of the current work. Figure in such a sense is none other than the manifestation of absence through presence, the presence of absence, the very strategy of dislocation.

To realize his strategy of dislocation in which formal presence is disrupted by recessive absence, Eisenman is developing a *textual* architecture. His notion of text is thoroughly Derridean. The text, Eisenman explains, "'is no longer something complete, enclosed in a book or its margins, it is a differential network. A fabric of traces referring endlessly to something other than itself.' . . . It is not a 'stable object' but a process, a 'transgressive activity' that disperses the author as the center, limit and guarantor of truth" (TB, 71). Within this differential network, meaning is a function of the relationship between and among signs. Since everything is always already coded and signs always refer to other signs, there is no-thing in itself. In contrast to speculative or imaginal idealism, however, this network is not self-contained but is put in play by "something other than itself," which can never be re-presented. This other is the ever-withdrawing point of nonidentity that renders every integrative synthesis impossible. In the absence of wholeness and integrity, the text becomes a "tissue of superpositions" in which differing strands intersect to dislocate space and time.

In his important article "Architecture as a Second Language: The Texts of Between," Eisenman illustrates his understanding of textuality with David Lynch's film *Blue Velvet*. What fascinates Eisenman about the film is Lynch's use of detail to create a sense of temporal dislocation. The most notable instance of Lynch's technique is the lack of temporal coincidence between the narrative and the soundtrack. While the film is set in a small North Carolina town in the 1950s, the version of the song "Blue Velvet" that plays in the background did not appear until a decade later. "Blue Velvet" was first sung by Tony Bennett in 1951, recorded in 1960 by the Statues, and finally recorded again by Bobby Vinton in 1963. Lynch uses Vinton's rendition to create a space between the time of the narrative and the time of the music. Other details exacerbate the sense of temporal discontinuity. For example, Lynch also includes Roy Orbison's 1963 song "In Dreams" and uses a 1968 Oldsmobile convertible. Though

7.9 Peter Eisenman, *Romeo and Juliet* (1986). Courtesy Eisenman Architects. Photograph: Dick Frank.

these might seem to be insignificant details, Eisenman is convinced that they are actually the point of the film.

> While those images and sounds are present so are their displacements. In other words, the text of the film is about something else. And yet, the film is crafted so as to render the gap between these disjunctions as virtually natural. This is an example of a text of "between." . . . One does not know what the "truth" of these sounds and images is. They do not appear to be related to the narrative but to something other than the narrative, some other structure of relationships outside the film's structure. This "something other" than the narrative is the text between. (TB, 72)

Eisenman's analysis of Lynch's film is particularly helpful, for it indirectly provides his clearest explanation of his complex strategy of "scaling." Scaling is a means of introducing time into the space of architecture. The time that preoccupies Eisenman is no ordinary time but a time that, though it allows presentation to occur, is itself never present and thus disrupts every form of presence. Scaling traces the anachronistic time of *différance*. In his *Romeo and Juliet* project, developed for the 1986 Venice Biennale, Eisenman uses the process of scaling to generate a complex architectural scheme. The text in which this project is presented is entitled *Moving Arrows, Eros, and Other Errors* and consists of thirty superimposed plastic transparencies that bear a narrative explanation and drawings done to different scales (fig. 7.9). The "origin" of this architectural text and textual architecture is not one but multiple; in other words, it is already divided and dispersed. There are at least three versions of *Romeo and Juliet:* one by Da Porto, one by Bandello, and one by Shakespeare. Eisenman weaves different strands of these texts together to form a site that is "a palimpsest and a quarry." But the narratives not only constitute the site,

the site also shapes the narratives. "Each narrative," Eisenman points out, "is characterized by three structural relationships, each having its own physical analogue: division (the separation of the lovers symbolized in physical form by the balcony of Juliet's house); union (the marriage of the lovers symbolized by the church); and their dialectical relationship (the togetherness and apartness of the lovers as symbolized in Juliet's tomb). The three structural relationships that pervade the narrative also can be found to exist at a physical level in the plan of the city of Verona: the cardo and decumans divide the city; the old Roman grid unites; and the Adige River creates a dialectical condition of union and division between the two halves."[38] By juxtaposing different narratives and superimposing contrasting scalings, Eisenman produces a labyrinth from which there is no exit. For example, in one scaling, he relocates Verona within the castle of Romeo to represent Romeo's effort to unite the city, which had been divided by the feud between the Capuletti and Montecchi families. The failure to achieve union is depicted by another scaling in which the tomb of Juliet is enlarged and superimposed on the cemetery of Verona in such a way that the entire city becomes the grave of the young lover. Multiple texts and sites are put into play in such a way that synthesis—dialectical or otherwise—becomes impossible. The death of Juliet marked by the tomb/city figures the impossibility of union. Eisenman summarizes his conclusion in this project: "Here, for the first time, there was a text of between; a fabric of images referring to something other than itself in order to create a dislocation in time and space. Traditional textuality . . . is ultimately projected to return the system to closure. The textuality of the *Romeo and Juliet* project is as a set of fragments that are internally incomplete. They signal the impossibility of a return to more traditional forms of text in architecture such as the relationship of type or form to man" (TB, 73).

The strategy of scaling is developed further in Choral Work. In their contribution to Tschumi's park, Eisenman and Derrida "attempt to bring into figuration an idea of chora." This undertaking, however, is impossible, for, as Derrida insists, "chora cannot be represented" (CW, 8). The architectural task, then, becomes to represent the impossibility of representation. Toward this end, Eisenman and Derrida develop a way of disfiguring that is neither modern nor postmodern.

In Choral Work, three texts again generate the project (plate 25). In this case, the textual web is even more tangled, since, as Eisenman notes, each text is on another text: "Bernard's [text] can be seen as a text on mine for Venice; mine will be a text on Jacques Derrida's; his a text on Plato's *Timaeus*" (CW, 8). As Choral Work has developed, its intertextuality has become even more complex. Derrida and Eisenman superimpose their work on Tschumi's La Villette plan. But Tschumi's work is superimposed on Derrida's theory and, it appears, on Eisenman's strategy of scaling, which, in turn, is also superimposed on Derrida's notion of deconstruction. Eisenman suspects that Tschumi stole his notion of scaling

and transformed it into his own method of superimposition. Eisenman's appropriation of Derrida's reading of textuality is calculated to compound the problem of authorship and origin. He superimposes two additional texts on Tschumi's point grid: the *Romeo and Juliet* project with its intricate layering of texts and signs, and his unrealized plan for a housing project on Cannaregio, a small island near Venice. In developing his Cannaregio design, Eisenman appropriates the point grid scheme Le Corbusier had used in his plan for a hospital that was to have been built on the site of the island's abattoirs. Apparently dismissing any concern about Tschumi's unacknowledged appropriation of the strategy of scaling, Eisenman stresses the intricacy of the site he devises in La Villette.

> I want to reiterate that I make no claim to prior authorship. In fact, my project was inspired by an unrealized project for a hospital on Cannaregio by Le Corbusier, which was to be located directly on the site of the old abattoir at the northern end of the island. I merely extend his grid to my site, and so it is more proper to say that both Tschumi and I used Le Corbusier's grid system. Furthermore, Tschumi is Swiss and Le Corbusier was Swiss, so go the parallels for the story we are inventing. Our deconstruction of the linear time of narrative is also a deconstruction of the tradition of precedent and authorial priority. (CW, 19)

But Eisenman protests too much. It is precisely the question of authorship that he is raising. This extraordinarily complex question is, in the final analysis, inseparable from a theological problematic. Inasmuch as the author-architect is made in the image of God, the death of God implies the disappearance of the author-architect, and vice versa. It is possible, however, that the death of God does not result in the mere absence of presence but implies an altarity that cannot be figured in terms of being and nonbeing. This third alternative is suggested by a detail relevant to the Cannaregio project about which Eisenman remains silent. Cannaregio was not only the site of slaughterhouses but also the island where the Jewish population of Venice once lived. In Choral Work Eisenman and Derrida, who are both Jewish, call into question the incarnational theology that implicitly informs the work of Tschumi and his surrealist precursors. I shall return to this theological issue in what follows.

As I have noted, Choral Work has not been built. Promises continue but fulfillment is deferred. To find a deconstructive construction, we must look elsewhere. In the course of his dialogue with Derrida, Eisenman remarks, "What is interesting for me as I read the 'chora' text is that I feel that I was actually making 'chora' before I knew about it" (CW, 8). Nowhere is Eisenman's deconstruction *avant la lettre* more evident than in his most acclaimed building, Wexner Center for the Visual Arts, located on the campus of Ohio State University (plates 26 and 27). Wexner Center is neither modern nor postmodern but something else, something other. In an interview with architectural theorist Jeffrey Kipnis, Eisenman explains that this building "wavers between process object and aesthetic object; between figuration and abstraction. It is caught in a moment that is

between. In terms of my work, it marks a movement from a geometric formalism, a certain uncompromising avant-gardism in the houses, to something other. But in that something other, there is another level of displacement. It engages context, history, and figuration as a displacing force."[39] The displacements effected by Wexner are multiple: it is a center without a center; a museum that calls into question the metaphysics and ideology of the museum; a structure that is poststructural; a construction that is deconstructive. Oscillating between abstraction and figuration, Wexner Center disfigures otherwise than either modernism or post-modernism. Here, as elsewhere, everything begins along the margin, border, edge . . . with the tear, wound, cut.

Eisenman begins by disfiguring. Before the beginning, there seemed to be One—one building. But this "original" one was actually two: Mershon Auditorium and Weigel Hall. Eisenman cuts the link, severs the cord joining them, and thereby opens the time-space of the between in which his building is suspended. Wexner Center is a (w)edge driven between two other buildings. Actually, it is not one but many wedges; wedges within and without create an irreducibly open structure that "is" nothing but edge. When read in this way, Wexner Center prefigures Choral Work.

Along the edge of the between, in what Venturi describes as "residual

**7.10 Peter Eisenman,** *Wexner Center for the Visual Arts,* **interior (1989). Photograph © Jeff Goldberg, ESTO.**

**7.11 Peter Eisenman,** *Wexner Center for the Visual Arts,* **aerial view. Courtesy Eisenman Architects. Photograph © Jeff Goldberg, ESTO.**

space," Eisenman inserts a series of galleries, performance spaces, studios, a fine arts library, and administrative offices. This structure is difficult but not whole. Its spaces are demanding and frustrating for artists, curators, and visitors. Wexner Center does not conform to expectations of what a museum should be. The galleries are interrupted by pillars and posts, some of which are themselves interrupted (fig. 7.10). Eisenman exploits this marginal site in a way that critically engages both modernism and postmodernism. He does not attack the formalism of modernism or the ornamentalism of postmodernism from without but uses structure and figure against themselves to dislocate modern and postmodern architecture as if from within.

Eisenman's deconstruction of modernism is most obvious in his use of the grid in Wexner Center. In addition to serving as Eisenman's logo in his early work, the grid, as we have discovered, is an essential structure for modern artists and architects. In her classic essay "Grids," Rosalind Krauss argues that "one of the most modernist things about [the grid] is its capacity to serve as a paradigm or model for the antidevelopmental, antinarrative, and antihistorical."[40] In all of its modern variations, the grid is the figure of essential form and eidetic structure that remains when figures and ornaments are erased. Eisenman subverts the modern notion of the grid and the metaphysics of presence that it presupposes by using grids ornamentally to reintroduce time into space. The grids that structure and ornament Wexner Center assume multiple forms: exterior and interior scaffolding, window, door, floor, wall, and ceiling patterns, mirrors, ladders, catwalks, stairs, buckeye trees. . . . As grids double and redouble, they repeatedly shift, oscillate, and alternate until it becomes impossible to locate stable axes that provide orientation. Layered grids function like moiré patterns that tremble ever so slightly (fig. 7.11).

The superimposition and intersection of the grids opens the "center" by allowing the outside in and turning the inside out until the gridwork points beyond (the) structure both spatially and temporally. Through a careful orchestration of grids, Eisenman links Wexner Center with the rest of the campus, the university's gridiron, the city of Columbus, the state of Ohio, and even the rest of the world by way of the Columbus airport. The result is not simply one more postmodern effort to recontextualize buildings but something far more complex. In this structure, time invades the space of the grid to open a gap that never closes. In situating Wexner Center spatially, Eisenman invokes traces of the past. Through his method of scaling, he superimposes the Jefferson and Olmsted grids on the Wexner site to create the trace of another trace—the Greenville Trace. The territory of Ohio was initially plotted by two teams of surveyors: one working from north to south, the other working from south to north. One of the aims of the surveyors was to integrate the traditional Jefferson grid with smaller, more localized grids. The grids were supposed to meet on an axis that passes through Columbus. But the surveyors failed; they missed the mark, and thus the grid was disrupted by a gap. This gap is named the Greenville Trace. Eisenman figures this trace in the labyrinth of gardens that falls between Wexner's ornamental grid and the streets of Columbus (fig. 7.12). In one of the walls of this underground that is above ground, there is a fissure that disfigures what is supposed to be an all-inclusive grid. This figureless figure is a trace of the spacing of time that can never be re-covered.

The unrecoverable past also returns in Wexner Center's explicit deployment of figure. In contrast to typical postmodern uses of ornamentation, Eisenman refigures the past in such a way that the very possibility of re-presentation is called into question. The figures that supplement Eisen-

**7.12 Peter Eisenman,** *Wexner Center for the Visual Arts,* **exterior passage. Courtesy Eisenman Architects. Photograph © Jeff Goldberg, ESTO.**

man's dis-integrated structures were taken from the armory that was on the site until 1958. But just as Eisenman turns structures against modernism, so he turns figures against postmodernism. The trace of the past is "present" as "absent" in Wexner Center. As is so often the case, an accident proved productive—more productive than the original intention. In the plan for the site, Eisenman preserved what remained of the original foundation of the armory. By mistake, however, workmen removed the remains of the foundation. Committed to inscribing the trace of the past in the present, Eisenman reconstructed the outline of the armory's foundation. Like the fragile lines of a text, this faint outline traces the site of the withdrawal of the original foundation. What appears to commemorate the presence of a solid foundation turns out to mark the absence of a grounding structure. Although apparently a representation by which the past enriches the present, Eisenman's "textual" supplement is a depresentation through which the inaccessibility of the past hollows out the present. By following Eisenman's nonfoundational outline, we can read modernism's desire for clarity and transparency, as well as postmodernism's ironic play with the past, as two versions of nostalgic longing for an impossible presence.

The remote proximity of the inaccessible past is figured in the disfigured tower (plate 27). As we have seen, "the separation effected by temporalization" generates a "spacing" that splits stable structures. When structures crack, the tower, which is supposed to be the site of (panoptical) surveillance, becomes a blind spot that is the locus of a lapse. The lapse of time exposes the opening of space that never was, is, or will be closed. Intended to be a symbol of security, the faulty tower can now be read as a sign of inescapable insecurity. From a certain perspective, the tower appears to be whole. But as one shifts one's angle of vision, things fall apart. More precisely, one discovers that the whole was never whole but was "originally" a fragment. That which is (always already) rent cannot be made whole. The pieces simply do not fit together. Lines that appear to converge do not meet; walls that seem complete break off; the grid etched in brick abruptly ends; perpendiculars become diagonals; rectangles and squares are cut to form wedges. As one walks around the tower, the circle disappears in a ceaseless play of edges that figure and refigure Eisenman's coup.

Something is forever missing from Derrida's texts and Eisenman's architecture. They are always writing and building something else—something that cannot be written or built but can only be traced by a certain disfiguring. To figure the trace that figures the unfigurable, we must retrace our thoughts by returning to the supplement that transforms "chora" into "Choral Work": *L*. Not one *L* but two—one is the *L* of Derrida, one the *L* of Eisenman. Edmond Jabès indirectly poses the question poetically.

EL

LE

L

Stages of experience from fore-book to absent book. (EL, 71)

How is L . . . ELLE . . . EL to be read? What is *L?* Who is *L?* Where is *L?*

Derrida's *L* is at least double. *L* is ELLE, or so it appears. Throughout his "Chora" essay, Derrida repeatedly notes that Plato figures chora as feminine—"the mother, the matrix, or the nurse." And yet, these "names" are improper, for chora is neither masculine nor feminine but a third genre that approximates the neuter. "So chora is not mother, not the nurse who nurtures infants" (CW, 3). The supplemental *L* of Choral Work is, but is not, not ELLE, and thus is something el-se.

*L* appears el-sewhere in the Derridean corpus. *The Truth in Painting* is not a seamless book but a torn text. The first section of this work, which is entitled "Parergon," is repeatedly interrupted by the figure of a disfigured *L:*

$$\lfloor \underline{\phantom{xx}}$$

This faulty *L* is something like a frame within a text that is devoted to the question of the frame. In "Parergon" Derrida reframes Kant's Third Critique by reading it in a way that calls theoesthetics into question. As the margin of difference between the First and Second Critiques, *The Critique of Judgment* is a nonsynthetic third that cannot be figured within the economy of ontotheology. This different difference creates the opening for an other postmodernism in which the religious can be thought otherwise. "If modernism distinguishes itself by striving for absolute domination," Derrida argues, "then postmodernism might be the realization or experience of its end, the end of the plan of domination. This postmodernism could develop a new relationship with the divine that would no longer be manifest in the traditional shapes of the Greek, Christian, or other deities, but would still set the conditions for architectural thinking."[41] The "historical figure" of this other religion, Derrida suggests, is "a certain Judaism" (TP, 134).

Eisenman refigures the *L* that marks the margin of Derrida's text in a seemingly insignificant supplement to his textual architecture—a detail that is suspended above a threshold that is supposed to open doors. It is a door handle in the shape of an *L,* or, more precisely, in the shape of three *L's* that intersect in a point (fig. 7.13). The *L* is repeated many times on the plate supporting the handle. Once recognized, the *L* appears everywhere in Eisenman's work—early as well as late, in drawings as well as buildings. Every house that is not a home is, in effect, "House El." And yet, Eisenman never talks or writes about the significance or insignificance of *L.* It is as if the letter (if it is a letter) were unpronounceable, unspeakable. Why?

El, the head of the Canaanite pantheon, was the creator and father of the other gods. It appears that El was something of an architect, for one of his most common epithets in Ugaritic literature is "Builder of Things Built." El, architect of the universe, had a Dionysian streak that sometimes led to grotesque excess. In one ancient text, he "is portrayed as drinking himself into a stupor and wallowing in his own excrement and urine."[42]

**7.13 Peter Eisenman, *Door-handle*. Courtesy Eisenman Architects. Photograph: Dick Frank.**

Philo of Byblos, a Greek historian, identifies El with Cronus—the same Cronus with whom Derrida associates Dionysus.⁴³ In this guise, El appears to be the god whose bacchanalian revel is celebrated in Bataille's writings, Masson's paintings and drawings, and Tschumi's architecture.

But elsewhere El appears otherwise. El is also the "name" of Yahweh. Though usually hostile to Canaanite gods and goddesses, Israel identified Yahweh with El. Thus, "El" is a substitute for "Yahweh." But "Yahweh" is itself a substitute for the ineffable name of God. As a substitute for a substitute, El "names" that which is absolutely unnameable. During their first meeting, Eisenman confessed to Derrida, "Through your work directly, and indirectly through such writers as Susan Handelman and Mark Taylor, I have recently begun to consider Hebraic thought and its implications for architecture. There were no graven images in the temple, and, as I understand it, the Hebrew language contains no present tense of the verb 'to be'—only 'was' and 'will be.' Thus Hebraic thought deals more with absence than presence" (CW, 1). No present tense . . . only "was" and "will be" . . . For Eisenman, presence is never present and thus the utopia never arrives. To believe in (its) presence is madness—sheer folly. In the absence of presence, all re-fusals—be they archaeological or teleological, gardens or kingdoms—must be refused. Every habitation is uninhabitable, every *Heim, unheimlich*. Always displaced by an other that cannot be domesticated, architecture unsettles rather than settles, dislocates rather than locates. In the wake—the interminable wake—of modernism and modernist postmodernism, only exile remains. Exile with no hope of return. The nonplace of exile is the desert—the desert where a certain disaster lurks. This is Eisenman's point, and it marks a point of no return.

*"I shall tell you of the sea, Sarah, of all the points of the horizon," wrote Yukel.*
*"I shall tell you of the sea, Yukel, of all points, my prison," wrote Sarah.*
*"I shall tell you of the sea, Yaël, of the salt and foam of the sea, Elya's loose shroud, Aely's infinite wake."*
*The desert, our future foretold.* (EL, 30)

# 8

*The atmosphere of chora is naked; there is no love, no story; it's desert.*

—JACQUES DERRIDA

# D E S E R T I O N

*It is no longer the myths that need to be unmasked . . . , it is the sign
itself that must be shaken; the problem is not to reveal the (latent)
meaning of an utterance, of a trait, of a narrative, but to fissure the very
representation of meaning, is not to change or purify the symbols but to
challenge the symbolic itself.*

—ROLAND BARTHES

*And what is the desert if not a place denied its place, an absent
place, a non-place?*

—EDMOND JABÈS

*Our experience of the divine is our experience of desertion.
It is no longer a question of meeting God in the desert: but of this—
and this* is the desert—: *we do not encounter God, God has
deserted all encounter.*

—JEAN-LUC NANCY

# 8 □ DESERTION

"*WHEN ALL IS SAID, what remains to be said is the disaster. Ruin of words, demise of writing, faintness faintly murmuring: what remains without remains (the fragmentary)*" (WD, 33)

What remains . . . remains to be said, written, figured is fragmentary. Not fragments that once were whole, not fragments that might become whole, but fragments that are irreducibly fragmentary. Three *oeuvres* that are not one, three *oeuvres* that cannot be synthesized—dialectically or otherwise. What remains are scattered fragments that imply a beyond that is not the beyond of theoesthetics.

There is an other desert. A different desert. Different Sands, different Dunes, an other Mirage. The other desert is the place or displace where nothing occurs or almost occurs. Across a continent, across an ocean eight years earlier, during our first conversation, Edmond Jabès paused for what seemed an interminable moment and then proceeded to speak in animated though measured words: "You do not go into the desert to find identity but to lose it, to lose your personality, to become anonymous. You make yourself the void. You *become* silence. It is very hard to live with silence. The real silence is death and this is terrible. It is very hard in the desert. You must become more silent than the silence around you. And then something extraordinary happens: you hear silence speak." How can one become more silent than silence? How can one hear silence speak and see the silence of the desert?

As the helicopter slowly lifted off the ground and headed down the Strip, hotels and casinos sank beneath us. A sharp right turn to the northeast and we were quickly out of the city and over the desert. The flat expanse of sand and sage gradually gave way to massive rock outcroppings and sandstone hills among which wild burros, mustangs, and bighorn sheep roamed freely. The faces of the rocks and hills were etched with traces of ancient geological epochs. Seen from a height of 600 feet, the land stretched below like a taut canvas covered with subtle patterns painted in rich earth tones. Deeper in the desert, hills became mountains erupting like petrified waves out of some prehistoric sea. As the copter nearly brushed the top of the highest peak, the Valley of Fire burst before us in a stunning array of brilliant reds, oranges, ambers, and lavenders. Monumental memorials to the immemorial appeared awesome even from the sky. In the distance, the Mormon Mesa rose from the valley floor. As we passed over the mesa and approached its far rim, the utter flatness, evenness, and horizontality of the land were broken by a rent edge. The copter banked sharply to the left and began to follow the tattered and torn margin of earth as it zigged and zagged, rose and fell as far as the eye could see.

Then suddenly, with an abruptness that was jarring, an other cut—a different cut—appeared on the surface of the mesa. This cut was not ragged but precise—surgically precise. Neither exactly one nor two, the duplicitous cut was a carefully crafted slit that extended from one edge of the mesa to the other. Whether a single cut interrupted by a certain absence or two symmetrical cuts joined by a certain presence, the middle remained empty. Absolutely empty (fig. 8.1).

Reversal: from above to below, to below to above. This was not my first view of *Double Negative*. Two days earlier, I had approached it from a different direction. To reach *Double Negative*—if, indeed, it can be reached— it *is* necessary to go past everything. The drive from Las Vegas to Overton passes through eighty miles of desert. The mineral landscape appears more stark and cruel from the road than from the air. This desert is unforgiving. The height of Mormon Mesa looms larger when driving up the twisting and turning red dirt road that leads to its top. From ground level, the barrenness of the earth's surface is violated not only by scrub sage but also by tracks of errant vehicles. Even people who know their way get lost in this terrain. We roamed for a long time but could not find *Double Negative*. All tracks and traces seemed to lead nowhere. With darkness approaching, our search became more agitated. We drove ever closer to the mesa's precipitous edge. At every turn, the cut seemed to appear. But as we drew near, the illusion of the cut's presence was broken, and the mi-

**8.1 Michael Heizer, *Double Negative* (1969–70). 240,000-ton displacement in rholite and sandstone, 1500 × 50 × 30 ft. Gift of Virginia Dawn, Collection, Museum of Contemporary Art, Los Angeles. Courtesy Michael Heizer.**

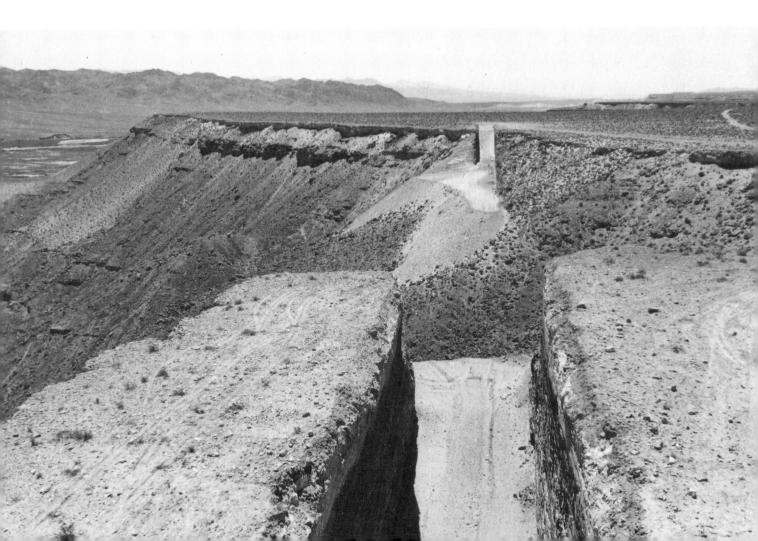

rage lifted. Making a final sweep, the cut or cuts unexpectedly opened in front of us.

Neither a sculptural nor an architectural object but something else—something other—*Double Negative* is a tear that beckons to approach, indeed, to enter. This work of art cannot be appreciated from without but must be viewed from within. To enter the tear, I had to descend the steep and uneven slope of the rent earth. Only beneath ground level did the stunning proportions of this extraordinary work clearly emerge. The sculpture measures 1,500 feet long. The two cuts, which are 50 feet deep and 30 feet wide, are surrounded by walls of 90 degrees and ends pitched at 45 degrees. The 240,000 tons of sandstone displaced to create the opening cling to spill slopes far below that are at least 45 degrees. From the bottom of the cut, the precision of the lines, surfaces, and planes dissolves. The work is eroding. Its walls crumbling and floor littered with refuse and debris from ancient eons, the *Negative* is a constantly changing ruin. This work of art was not constructed to escape time but to embed us in it ever more deeply. As I passed below the surface, I realized the profound truth of what I had long suspected: to dig down is to go back . . . back through layers and layers of space and time to an *archē* that is, perhaps, "older" than the beginning of our world, the world, any world.

The walls of tear display vast murals, rich collages, assemblages, and combines of unspeakable beauty. Colors and shapes, forms and figures too intricate and complex to have been crafted by any human hand suggest a haunting anonymity, a terrifying impersonality, an inhuman intelligence. Enduring yet fragile sediments release a disturbing fossilized murmur. At the edge of the work, the ground grows even more insecure. Loose sand and gravel fell from beneath my feet, adding to the ever-changing shape of the spoil. The work of art continues.

The late afternoon light of the gray winter day created a somber mood. In the distance, the Virgin River wound its way along the base of the Arizona mountains. Gazing across the canyon to the far side, the cleavage seemed to separate as much as unite. At this edge, on this margin, the void was truly unavoidable. As I turned from the unsettling emptiness of space to the expansive corridors of time, silence unexpectedly rushed toward me. Not just any silence but an overwhelming silence that pressed palpably on my ears, creating a pressure that was almost unbearable. But I did not flee; rather, I paused to linger with the *Negative* in the faint hope that I might become more silent than the silence around me. Then something extraordinary happened: I heard silence speak. At this moment silence became visible. *Nothing appeared.*

*Double Negative* is the strangest of works. Frustrating the expectations we have for the work of art, this negative not only inverts but *subverts* the opposites that support the edifice of Western religion, philosophy, and art: primitive/modern, nature/culture, permanence/change, one/many, purpose/chance, placement/displacement, completion/incompletion, active/passive, time/space, speech/silence, sense/nonsense, visible/invisible,

appearance/disappearance, form/formlessness, figure/ground, presence/absence, being/nothing, positive/negative. . . . Like a gift from some long lost civilization, this overwhelming petroglyph cannot be decoded but must be read and reread without end.

With the question of negation, we return to our point of departure without having come full circle. Modernity, we discovered, is obsessed with negation. More precisely, modernity is obsessed with discovering ways in which negation can serve as an indirect means of affirmation. Transcendence is negated to affirm immanence; essence is negated to affirm appearance; the modern is negated to affirm the primitive; individuality is negated to affirm universality; the objective is negated to affirm the nonobjective; form is negated to affirm formlessness; ornament is negated to affirm structure; figuration is negated to affirm abstraction. Each of these gestures can, of course, be reversed. What unites these disparate strategies of negation is a complex dialectic in which negation is affirmation and affirmation is negation. The goal of this dialectic is, in the final analysis, the negation of negation. From this point of view, modernity is inseparable from a preoccupation with what might be described as the double negative.

Hegel, I have argued, presents the most complete account of the modern notion of negation. Indeed, his entire systematic philosophy is based upon a complex analysis of negativity. According to Hegel, negation, which is the foundation of all determinate identity, can be properly conceived only when it is grasped as double negation. Double negation, in turn, is the structure that underlies all reality. As such, the double negative is nothing less than the *ground* of being.

When the ground of being is understood as double negation, it is the "Absolute Ground." In *Science of Logic* Hegel explores the "Absolute Ground" by examining three polarities: "Form and Essence," "Form and Matter," and "Form and Content." "Ground," he explains, "is essence that in its negativity is identical with itself" (SL, 447). Negativity is identical with itself insofar as it relates to nothing other than itself. Since all determination is negation, the relation of particular entities presupposes negativity's relationship to itself. To clarify this point, it is helpful to consider the determination of the Absolute Ground that has been crucial not only for philosophy but also for art: form and matter. According to the principles of classical philosophy, form and matter are opposites that are not inherently associated with each other. Thus their relationship must be constituted by an extrinsic third. Hegel rejects all previous accounts of the synthesis of form and matter. Following the principles of his dialectical logic, he reasons that form and matter are not simply antithetical but are inextricably bound in a relationship that is mutually constitutive. "Matter," he argues, "is that which is indifferent to form, but this indifference is the *determinateness* of self-identity into which form withdraws as into its basis. Form *presupposes* matter in the very fact that it posits itself as sub-

lated and consequently relates itself to this, its identity, as to an other. Conversely, form is presupposed by matter; for the latter is not simple essence, which is immediately itself absolute reflection, but it is essence determined as the positive, that is, essence that only is as sublated negation" (SL, 451). The relation of form and matter conforms to the structure of double negation. Since form is the absence of matter (nonmatter) and matter is the absence of form (nonform), each is the negation of its own negation. When negation is doubled, it is no longer merely negative but becomes positive. According to the logic of *Aufhebung,* negation is both negated and affirmed.[1] In such dialectical affirmation, however, negation is affirmed *as negated.* By negating negation, the power of double negativity reconciles opposites in a totality that appears to be harmonious. In this way, speculative philosophy overcomes the dismemberment—*die Zer-riss-enheit*—that plagues both nature and history. Within Hegel's all-encompassing system, no *Riss*—no rift, cleft, crevice, crack, breach, rupture, split, fissure, or gap—remains. Thus, *nothing is rent.*

But is nothing rent? Or does a certain nothing rend? The negative is more profound than even Hegel realizes, for it refuses negation. To move beyond modernity, to resist the affirmation of the postmodern society of spectacle, one must linger in the Negative with a patience that neither Hegel nor his followers could muster. For Michael Heizer, such lingering is the rending work of art.

Heizer is obsessed with negation. More precisely, he is obsessed with discovering ways in which negation can be affirmed without negating it. The question that pervades Heizer's work is how to render the rending of the negative. His interrogation starts on canvas. In a series of early paintings, deeply influenced by minimalism, Heizer begins to explore negative space. These "paintings," however, are not merely paintings. From the outset, Heizer's work has a sculptural dimension. *Negative Painting,* for example, embodies a play of positive and negative space that falls between painting and sculpture (fig. 8.2). Throughout the late 1960s, Heizer experimented with a variety of media, ranging from paint to earth, and multiple artistic strategies. He cuts canvases, breaks planes, interrupts lines, carves earth, displaces ground, and replaces stone. His tools are both traditional and untraditional: paint, brushes, hammers, chisels, saws, picks, shovels, trucks, bulldozers, cranes, motorcycles, blasting powder, even his own body. As Heizer has refined his methods, the desert has become his preferred site. Some of his most innovative works from this period are earthworks executed in the deserts of California and Nevada. In all of these works, the space of the negative, which is not necessarily negative space, is opened by a certain rending. One of his most suggestive early earthworks, entitled *Rift,* consists of nothing more than an errant line cut into the cracked earth of a Nevada lake bed (fig. 8.3). The tear that rends the torn earth seems to come from and lead nowhere. It is not, however, until *Double Negative* that the scope and scale of Heizer's undertaking becomes clear.

*Double Negative* is not precisely a *work* of art. It is a work that is a

8.2 Michael Heizer, *Negative Painting* (1966). Vinyl lacquer on canvas, 8 × 12 × 1 ft. Courtesy Michael Heizer.

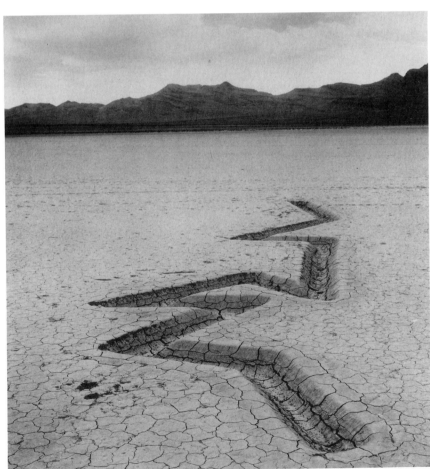

8.3 Michael Heizer, *Rift* (1968), deteriorated. 1.5-ton displacement in playa surface, 52 ft. × 1 ft. × 1 ft. 6 in. Courtesy Michael Heizer.

nonwork—a work that works by not working. "In *Double Negative*," Heizer explains, "there is the implication of an object or form that is not actually there. In order to create this sculpture, material was removed rather than accumulated. The sculpture is not a traditional object sculpture. The two cuts are so large that there is an implication that they are joined as one single form. The title *Double Negative* is a literal description of the two cuts, but it has metaphysical implications because a double negative is impossible. There is nothing, yet there is still a sculpture."[2] Neither simply present nor absent, *Double Negative* is the presence of an absence that is the absence of presence. And vice versa. Heizer does not attempt to negate or sublate absence in order to affirm or re-present presence. His art is nonrepresentational in a way different from any earlier art. In Heizer's case, the erasure of representation does not re-present something more original or primordial than superficial figuration. For example, the removal of figure does not reveal the presence of a structure that is deemed absolute, an essence that is considered transcendent, or a form that is believed pure. To the contrary, Heizer's work presents and re-presents the *impossibility* of presence and thus the failure of re-presentation. The work of art (impossibly) *represents nothing*. Paradoxically, this failure is its success.

To represent nothing without ceasing to represent, Heizer must recast the ground of figuration by refiguring the figure-ground relation. Hegel, we have seen, attempted to establish and secure the Absolute Ground of all appearances. In contrast to Hegel and all his followers, Heizer seeks to remove the ground on which we—indeed, on which everything—stand. "*Double Negative* is a reversal of issues," he insists, "since the earth itself is thought to be stable and obvious as 'ground,' I have attempted to subvert or at least question this." Heizer's subversion of stable ground is not only figurative; it is also literal. To create *Double Negative*, he "accumulates nothing," but "removes ground." The *Negative* is first and foremost a cut or two cuts, tears, rifts, fissures, faults. Its construction is, in a certain sense, a deconstruction. The absence of ground is figured by the removal of earth. As ground withdraws or is withdrawn, figure appears. The shape of the work is formed by subtraction instead of addition. In this incalculable zero-sum game, figure figures the absence of ground, and the ground that grounds figure is groundless. The absence of ground is not, however, a simple absence. The groundless ground that releases figure is, in Blanchot's terms, a "nonabsent absent absence" that nonetheless is not a presence.

The play of figure and ground staged in *Double Negative* creates a clearing that allows disappearance to appear. This appearance of disappearance transpires not only in the *between* marked by the walls of the cut but also in the midst of the empty center between which the two tears are suspended (fig. 8.4). The deeper one digs, the more negation proliferates. The rifts themselves are rent. "Double Negative" names the two cuts that rend the sides of the mesa, as well as the gap that breaks the line traced by the

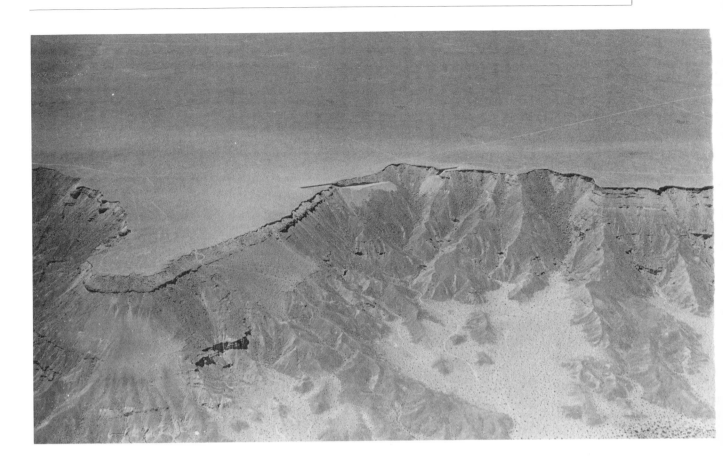

**8.4 Michael Heizer, *Double Negative* (1969–70), aerial view. Courtesy Michael Heizer.**

two symmetrical cuts. Clearly *Double Negative* is not one; it is at least two, for the double negative that it opens (and that opens it) is itself doubled. This endless duplicity marks the site of what Heidegger labels "the origin of the work of art." "And yet—beyond what is, not away from it but before it, there is an other that occurs. In the midst of beings as a whole, there is an open place. There is a clearing, a lighting. Thought of in relation to what is, to beings, this clearing is in a greater degree than are beings. This open center, therefore, is not surrounded by what is; rather, the lighting middle itself encircles all that is, like the nothing we hardly know" (PLT, 53). The clearing that is the origin of the work of art is not a secure foundation that underlies appearances but a groundless abyss. This open place is a no-place that is unfigurable. The unfigurable is—but, of course, it is not—the nothing we hardly know.

In order not to avoid nothing, the void itself must appear. If the void is to appear *as void* and not as implicit plenitude, it cannot be represented by the mere removal of representation. Perfect emptiness is indistinguishable from perfect fullness, even as pure nonbeing is identical with pure being. The unavoidable void, which neither is nor is not, must be rendered by a figuring that is a disfiguring. Disfiguring breaks figures without breaking with figuration. In terms previously invoked, disfiguration uses figure against figure to figure what cannot be figured.

Heizer disfigures the ground. He cuts it; he tears it; he rends it; he

mars it; he scars it. His work of art is nothing other than a complex process of disfiguring. In contrast to the strategy of abstraction in which disfiguration is simply the removal of figures, Heizer's disfiguration allows figures to appear. Subtraction adds and erasure inscribes. Rending creates the space in which forms become articulate. The intermediate space of disfiguring is a cleavage that simultaneously holds apart and brings together opposites whose strife is ceaseless. *To cleave* (from the Greek *glyphein,* "to cut with a knife or carve," and the Latin *glubere,* "to peel") means "to part or divide by a cutting blow, to split, to intersect, to fissure, to separate." *Cleavage* is "the action of cleaving or splitting crystals and certain rocks along their lines of natural fissure; or the state of being so cleft." A *cleavage* is "the fissile structure in certain rocks," or "the direction in which a crystal or rock may be split." But there is another rhythm to the word *cleave.* *Cleave* means not only "divide, separate, split, and fissure," but also "adhere, stick, and cling." Cleaving, therefore, simultaneously divides and joins, separates and unites. To clarify this point, consider the operation of cleaving in *Double Negative.* The walls of the cuts stand in a state of tension that is created and supported by the emptiness of the between. If the work is not to fall to the ground, its walls can neither fly apart nor collapse together. Furthermore, the two cuts assume their artistic proportions by the proximity and distance created by the space of the canyon. The entire work is suspended in the void by the alternating rhythms of cleaving.

Cleaving repeats the strange alogic of chora. As the operation in and through which opposites emerge and remain suspended, cleaving cannot be defined or expressed in terms of the identities and differences that characterize ordinary cognitive activity. Eluding the either/or of classical logic and the both/and of dialectical logic, cleaving entails a neither/nor that is not negative without being positive. In a certain sense, cleaving is unthinkable. But this unthinkable is not simply the absence or negation of thought. To the contrary, cleaving is *both* the condition of the possibility *and* the condition of the impossibility of thought. In other words, that which makes thought possible cannot itself be thought *sensu strictissimo.* It can, however, be figured, if only by disfiguring.

To sculpt (*sek,* "cut") is to cleave, and to cleave is to rend. Formation is never peaceful but always involves a struggle . . . a strife. Inasmuch as it enacts an undecidable alternation between differences and oppositions, the strife that rending releases is endless. Since formation is a function of the strife of rending, the work of art, the labor of production, is unavoidably painful. "But what is pain?" asks Heidegger.

> Pain rends [*reisst*]. It is the *Riss*—the tear, cleft, crevice, fissure, gap, break, crack, flaw, breach, rift, rupture, split, *rent.* But it does not rend into dispersive fragments. Pain indeed tears asunder, it separates, yet in such a way that it at the same time draws everything together to itself. Its rending, as a separating that gathers, is at the same time that drawing, which, like the predrawing [*Vor-riss*] and sketch [*Auf-riss*], draws and joins together what is held

apart in separation. Pain is the joining in the rending [*Reissen*] that divides and gathers. Pain is the joining or articulation of the rift. The joining is the threshold. It delivers the between, the mean of the two that are separated in it. Pain articulates the rift of the difference. Pain is dif-ference itself.

Pain has turned the threshold to stone. (PLT, 204)

Stone bears the work of the sculptor. "Dif-ference itself"—which harbors a certain rending (*unter*, "under, below, amongst" + *scheiden*, "to separate, part, depart, sever")—is not *a* difference. Nor is it the opposite of identity. Dif-ference cuts more deeply; it is a more "primordial" difference, a more "originary" difference that clears the space and creates the time for every identity and all differences. As such, it seems to play the role once assigned to the Creator. Although his labors are solitary, the artist does not work alone, for he is always haunted by an other he cannot name. Which other? What other?

Never an omnipotent Creator, the artist is as passive as he is active. Heizer realizes that he does not control the forces he unleashes. Explosives and bulldozers "begin" a process that something else continues. Spills grow; spoils accumulate; cuts expand and contract. Sun and heat, wind and rain, frost and snow extend the work of art. Indeed, the elements are always already continuing the work of art. Through this process, the work is not completed but becomes ever more incomplete. It is rendered an unmendable fragment . . . an irreparable ruin. Heizer remarks, "I am sure that I learned as much about art in obscure locations as I have from commonly available sources such as museums. Perhaps my exposure to remnants and fragments and the respect accorded them because of the information they contain has affected my view of so-called nonclassic form. Fragments and forms of evidence interest me more than works of art that are intact." The fragments that fascinate Heizer are not parts of what once was whole. Since art "originates" with cleaving, it is always already rent. The question the artist perpetually faces is how to render rather than repress this rent.

*Double Negative* is a tear that beckons one to approach, indeed, to enter. As I descended the steep and uneven slope of the rent earth, the walls seemed to expand and contract, first approaching, then withdrawing. One moment too near, the next moment too far. At the bottom of the tear, I discovered an inside that is not inside but outside, an exteriority that is not exterior but interior. Contrary to Hegel, this outside, this exteriority can be neither inwardized (*er-inner-n*) nor remembered (*erinnern*). By entering an "inside" that is "outside," I fell into an "outside" that is "inside." With this "inside," *I share nothing*. This "exteriority" was terrifying, yet alluring. Its attraction—"the attraction of (pure) exteriority or the vertigo of space as distance, fragmentation that only drives us back to the fragmentary." Dividing us from each other and from ourselves, this fragmentary exterior disrupts, dislocates, and displaces. The place of *Double Negative* is the displacement that appears when the ground (of being) disappears. Displaced . . . Replaced . . . Displaced . . . The process is endless.

To suffer displacement is to undergo exile. And the (dis)place of exile is the desert.

The dream of the West—and not only the West—is to wipe away the tear, to mend the tear that rends human life. Rending can only be overcome if negation can be negated. To negate negation would be to overcome exile by finding a way out—the Way out—out of the desert and into the kingdom that is the Radiant City. But the desert is the place of mirages and illusions. And no mirage is more powerful than the mirage of a way out, no illusion harder to overcome than the illusion that the desert can be escaped.

Michael Heizer does not believe in mirages. Through his art, Heizer struggles to dispel rather than create illusions. His works lead us ever deeper into the desert. In the midst of the desert, Heizer deserts us. He leaves us on our own, which is not to say alone. Winds scatter the sands, erasing the traces of the Way, any way, every way. The negative, Heizer insists, *cannot* be negated. In its irreducible duplicity, *Double Negative* refuses to negate negation. This work opens rather than closes the rift in which we dwell. Heizer's art offers no cure for the wounds we suffer. That which is rent cannot be made whole. His lesson—if he has a lesson—is to teach us to linger patiently with the Negative.

Michelangelo Pistoletto explores the space opened by the *difference* between abstraction and figuration. By so doing, he pushes art to the limits of reflection. The space and time of Pistoletto's art are marked by the tain that lies behind the mirror. His "paintings," which are not precisely paintings, solicit their viewers, "Come! Enter the space of the mirror." "By walking into the space behind me, I enter the space of the mirror, because by moving away from the mirror, I inevitably enter the mirror itself. I have a twofold dimension: I walk in one direction in order to enter into the other. I look at the past in order to enter the future, or else I look at the future in order to move in an entirely new dimension, in which no one has ever moved" (P, 14). This new dimension is a strange space . . . an uncanny space in which I am no longer simply myself. To accept Pistoletto's invitation is to "experience the shattering of our minds," which he insists is "the drama of our decomposition."

The drama Pistoletto's art stages decomposes the philosophy of speculation that marks the closure of Western metaphysics. This decomposition effectively deconstructs reflection by figuring the refused underside of theoesthetics. As Rodolphe Gasché points out in *The Tain of the Mirror: Derrida and the Philosophy of Reflection,* figuring the unfigurable "implies a breaking through of the tinfoils of the mirrors of reflection, demonstrating the uncertainty of the speculum. In this first step of the deconstruction of reflection and speculation, the mirroring is made excessive in order that it may look through the looking glass toward what makes the speculum possible."[3] That which makes the speculum possible, however, cannot itself be comprehended by reflection. In turning back on itself, reflection

discovers that its fault is an unavoidable lack. The lack that shadows re-flection renders every mirror image duplicitous.

Pistoletto is fully aware of the duplicity of reflection. In a section en-titled "The Speculation" in his 1967 essay, "The Last Famous Words," he observes,

> Man has always attempted to double himself as a means of attempting to know himself. The recognition of one's own image in a pool of water, like recognizing oneself in a mirror, was perhaps one of the first real hallucina-tions that man experienced. And a part of man's mind has always remained attached to that reproduction of himself. With the passage of time, this dou-bling, this process of duplication came to be used in ways that were ever more systematic, and ever more convinced. The mind created representation on the basis of the reflection of the self. And art has become one of the specialties of this representation. (P, 72)

The doubling inherent in reflection creates a distance that separates the self from itself. This space is the opening in which art works.

> When my need to understand things began to face up to the consideration of life itself, I instinctively understood all of the conflicts in this system of dou-bling, all of the things of the universe. Looking at works of art, I felt the force with which I was constrained to oscillate between one dimension of experi-ence, which was abstract and mental, and another dimension, which was concrete and physical. And it was in the fact of representation that I discov-ered the poles that were in simultaneous attraction and repulsion, my literal presence as proposed by the mirror and my intellectual presence as proposed by my painting. These two presences of myself were the two lives that were at one and the same time tearing me in two and calling me with urgency to the task of their unification. (P, 72)

Unlike nonrepresentational painters and pop artists, Pistoletto resists re-laxing the tension between the abstract and mental on the one hand, and, on the other, the concrete and physical. Instead of erasing the concrete to expose the abstract or collapsing the mental into the physical, he attempts to develop artworks that stage the ceaseless oscillation of the opposites between which human experience is suspended.

Pistoletto explores the complex interplay of reflection, speculation, and representation in a series of mirror works that began nearly thirty years ago and has yet to reach closure. In 1962 he executed a "self-portrait" by applying painted tissue paper to a polished stainless steel mirror, which, in turn, was mounted on a canvas. This *Self-Portrait* recalls a work com-pleted a year earlier entitled *The Present*. *The Present*, which is done in a more-or-less traditional painting style using acrylic and plastic varnish on canvas, is, in fact, double. Pistoletto presents two images: *Man Seen from the Front: The Present* and *Man Seen from the Back: The Present*. In the first, a man dressed entirely in black stares directly at the viewer; in the second, what appears to be the same man has turned away from the viewer and stares into a beyond that seems to lie before or behind the painted surface (plate 28). In both versions of *The Present*, the central figure is surrounded by a dark void in which obscure shadows flicker. The varnished surface of

the paintings momentarily records fleeting images that quickly appear and disappear. In *Self-Portrait* the obscure black of the shiny varnish is transformed into a highly polished reflecting surface. When confronted with this "painting," it is impossible to refuse Pistoletto's invitation to "enter the space of the mirror." In the face of this work of art, we realize that we are always already caught in the play of reflection.

Pistoletto uses the technique developed in *Self-Portrait* in numerous works. His mirror images create an effect that is deeply disturbing. Directly drawing me into the "painting," Pistoletto turns me back on myself, thereby making reflection unavoidable. In contrast to traditional painting where the gaze is one-directional, Pistoletto forces me to look at myself looking at myself looking at his work. The pictorial space he creates marks a place I cannot escape. In some sense, Pistoletto has always already "painted" me. The space into which he thrusts me is both obscure and elusive. Looking at myself looking at myself, I seem to stand *behind* the surface of the "painting." Furthermore, I appear to be able to see what, in fact, I can never see. Standing behind the painting, I gaze at its surface as if from behind. It is as though the two moments of *The Present* were superimposed to create a different time and space.

Repeatedly refusing to collapse opposites into identity, Pistoletto struggles to hold together contraries that tend to drift apart. The time of the work of art is neither the *nunc stans* of pure form nor the immediate instant of the fluctuating image. The play of Pistoletto's mirrors records a *coincidentia oppositorum* in which the fleeting and the abiding mingle without uniting.

> In the mirror painting we have the ephemeralness of the moment, which is, however, detained in the duration of time. The figure that I fix endures in the present; in this case, it is the ephemeral that makes the static, the past, endure. . . . The ultimate consequence of all of this is a range of considerations from spiritual to philosophical ones. We have a conception of "absolute," which has created spiritual definitions, and we also have a condition of the "relative," "relativity," which undermines the condition of the absolute, making it more and more precarious down to our time. . . . My work demonstrates that without the absolute, the relative flees, it slips through our fingers; hence, it does not become a work, it does not become thought, it does not become our possession. (P, 32)

The figure stuck to the surface of the mirror freezes a moment in the otherwise ceaseless flow of images. The mirror itself functions as a recording surface that recalls Freud's mystic writing pad. Pistoletto's mirror, however, is even less substantial than Freud's tablet. In contrast to the malleable surface of the Freudian pad, Pistoletto's mirrors retain no trace of the images they momentarily record. Forever empty, the mirror receives everything but retains nothing. The tain of the mirror is a film that fails to record. This filmic is even more elusive than that of Barthes and Tschumi.

To encounter the nothingness that shadows reflection is to glimpse a specularity that is not Hegelian. Hegel, we have noted, defines spirit as "*pure* self-recognition in absolute otherness." The circuit of reflection is

complete when I discover *myself* reflected in the I's/eyes of others. It is, of course, always possible that the experience of self in other will fail to issue in self-recognition. Jacques Lacan probes this moment of non-self-recognition in his analysis of "the mirror stage." In contrast to Hegel's polished speculum, Lacan's mirror is faulty, its reflection impure. Forever plagued by "a certain dehiscence at the heart of the organism, a primordial Discord," the individual discovers wholeness and integrity not in himself or herself but in an image reflected in the gaze of the other.[4] This image is not my image but is an *other's* image of me. In the Lacanian moment of reflection, I meet myself in the other *as other* and hence *not* as myself. In contrast to Hegel's "pure self-recognition in absolute otherness," Lacan posits impure non-self-recognition in absolute otherness. The altarity reflected in the gaze of the other is irrepressible. It eternally returns to dislocate the self from itself or, in Lacan's terms, to expose the "split" (*Spaltung*) that the subject inevitably undergoes. It is precisely such self-division that Pistoletto struggles but fails to overcome in his play of mirrors.

Paradoxically, the way to unity seems to pass through division. In "Division and Multiplication of the Mirror: Art Takes on Religion," Pistoletto explains, "I realized I had to divide the mirror in two, in order to give it its double. I cut the mirror together with the frame in which I had set it so that two halves of the frame, sticking to two mirrors, testified to their original oneness" (P, 152). This strategy repeats the classical way of dealing with the problem of multiplicity and fragmentation in Western philosophy and theology. In order to deny or repress division, opposition is interpreted as secondary to a more primordial unity. "Individuals," according to Pistoletto, "come from a division of the unitary entity that started with the multiplication of descendants" (P, 152). Though names vary and metaphors change, the One that ultimately grounds the many is actually God. When "art takes on religion," it becomes clear that the mirror is the image of God. In the late seventies, Pistoletto replaced a painting with a mirror in a baroque frame over the altar at Santa Sicario. Commenting on the installation he writes,

> So a mirror, over an altar or elsewhere but anyhow in some artistic context, becomes a meeting point of the human mirroring and reflecting phenomenon and the universal reality that the mirror itself is able to reflect. A mirror is a way between the visible and the invisible, as it extends sight beyond its seemingly normal faculties. Mirrors, in a room or over an altar, widen the characteristics of the eye and the faculties of the mind so that it offers a vision of totality. I think that there is only one mirror, divided and multiplied, in every available mirror. (P, 152)

With this conclusion, we seem to have returned to the closed economy of the society of spectacle. The medium of reflection reflected in the mirror appears to reveal the one that unifies the many. But Pistoletto wavers and oscillates. He remains uncertain whether the unification of opposites is possible or even desirable. The self-reflexivity figured in the mirror

can imprison as well as liberate. In *The Cage* (1962–74) and *The Cage of the Mirror* (1978–82), Pistoletto suggests the trap of reflection. To gaze into these works is to observe oneself caught in a web of self-reflection from which there seems to be no exit (fig. 8.5).[5] When I see myself everywhere, I become a captive of my own subjectivity. In this cage, every other is really the same, and every difference is finally indifferent. Reflection, which promises fulfillment, brings terrifying emptiness. *The Cage of the Mirror,* however, can be read in other ways. From a different angle of vision, the bars of the cage mark the tear that blinds the I/eye of the subject. In Lacanian algebra, "the barred subject ($)" is the self that can never return to itself. The divisive bar fragments the self by interrupting its recovery of the one. Gazing at myself through these bars, I am forced to admit that discord is "primal" and unity a supplementary phantasm that never was, is, or will be real. With this confession, reflection reaches its limit, and the mirror shatters. The broken mirror exposes "the Hole of History."

In an interview with Germano Celant, published under the title "The Hole of History," Pistoletto recalls, "I once said: let us experience the shattering of our minds, between a negative and a positive condition, between an abstract and a figurative condition; let us experience the drama of our own decomposition" (P, 119). *Between* positivity and negativity; *between* abstraction and figuration. Whence this space? Whither this time? The space-time of the between is the spacing-timing that Derrida "names" with the improper name *différance.* As we have discovered, one of the

8.5 Michelangelo Pistoletto, *The Cage of the Mirror* (1978–82). Iron, 230 × 600 cm. Rivetti Art Foundation, Turin. Photograph: P. Pellion.

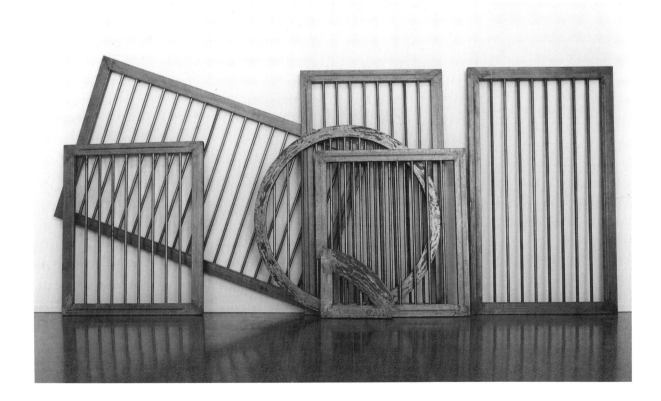

traces of this recessive edge is the frame. The frame, Derrida contends, figures an unfigurable lack.

> What does the lack depend on? What lack is it? And what if it were the frame. What if the lack informed the frame of the theory. Not its accident but its frame. More or less still: what if the lack were not only the lack of a theory of the frame but the place of the lack in a theory of the frame.
>
> Edge [*arête*]/lack. (TP, 41–42)

This edge/lack is the opening in which the drama of our decomposition is staged.

During the latter half of the seventies, Pistoletto repeatedly returned to the theme of the mirror. His mirrors from this period, however, differ significantly from his mirrors in the sixties. The more recent mirrors are empty; they bear no images other than the reflections of the figures that pass before them. Whereas the "paintings" of the sixties are characteristically modern in lacking frames, most of the mirrors of the seventies are framed. The substance and style of the frames vary from undecorated iron (*The Cage of the Mirror*) and wood (*Drawing of the Mirror*, 1979) to ornate gilded frames (*The Shape of the Mirror*, 1975–78). Moreover, some of these frames are fractured; they appear to have been carefully and strategically cut. While Pistoletto's early "paintings" always involve a single surface, his later works include mirrors of different sizes and shapes. Finally, and most important, many of the mirrors are broken or fragmented. In some works, a framed mirror is split in half; in others, a corner is cut off and left standing beside a larger mirror; in several cases, all the mirrors appear to have been carved from larger wholes; in the more complex works, mirrors overlap in such a way that it is difficult to know whether they are whole or part. Clean breaks create mirrors that are geometrical: squares, rectangles, triangles, and occasionally a circle.

Pistoletto gathers several of his most interesting studies of the mirror under a common title, *Division and Multiplication of the Mirror*. Although these works mirror each other, they do not coalesce to form a coherent totality. To the contrary, they constitute a heterogeneous collection in which divisions and oppositions generate new images, which in turn divide and multiply to create new images, and so on ad infinitum. The effect of these intricate mirror works is extraordinary. Gazing into faulted mirrors, I see myself shatter before my eyes. The fragmentation of the subject can be simple or complex. For example, in a 1975 version of *Division and Multiplication of the Mirror*, Pistoletto cuts a gold-framed mirror into two equal pieces, mounted in a way that makes it obvious that they had once been parts of a single object. In *Broken Mirror* (1978), the lower right corner of the mirror is severed and left leaning on the wall below the hanging mirror from which it has been separated. When the viewer looks at these works, her own imago falls apart—her figure is utterly disfigured. Pistoletto seems to have captured Lacan's mirror stage in such a way that the splitting of the subject is performed or enacted every time someone gazes at the artwork. In these mirrors, Pistoletto explains, "the relation-

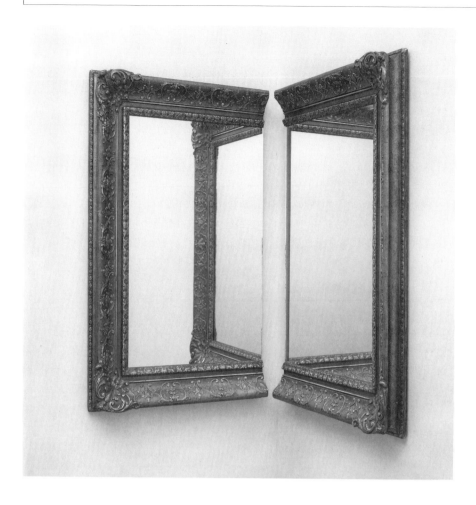

8.6 Michelangelo Pistoletto, *Division and Multiplication of the Mirror* (1979). Mirror glass and gilded wood frame, L: 30¾ × 52 cm.; R: 30 × 52 cm. The Menil Collection, Houston. Photograph: Hickey-Robertson, Houston.

ship between me and myself [is] constantly disrupted'' (P, 149). This disruption deepens in a second 1975 inscription of *Division and Multiplication of the Mirror* (fig. 8.6). This time Pistoletto does not mount the two pieces flat against the wall but places them at equal angles in such a way that they extend from the wall into the space of the gallery. The two parts of the mirror are separated by a gap. This space allows the mirrors to set up a play of images in which they *seem* to extend *behind* the wall on which they hang and thus appear to reflect what lies on the hidden side of the mirror. From one angle, the parts of the mirror seem to fold back on and reverse themselves. From another angle, each part of the mirror appears to extend directly into the wall. This doubling effect creates a shifting image of a cross with an empty space in its middle. When I enter the space of these mirrors by inserting myself between them, a dizzying proliferation of images is released. It is impossible to arrest this reflective/reflexive flux.

Despite the disruption experienced in these works, a trace of unity lingers in the midst of division. It is obvious that these broken mirrors once were whole. This vestige of unity disappears in other mirror works from this period. In *Division and Multiplication of the Mirror* (1976), Pistoletto supplements a divided mirror with two right-angled fragments that do not seem to be parts of any larger whole. In *Drawing of the Mirror*

(1979), there is no longer one mirror but several. Mirrors, some of which are split and some of which are whole, overlap and interplay in such a way that no unity can be discerned in the midst of multiplicity. Though not immediately evident, the title implies not only artistic representation but also painful division. "Draw" is a polyvalent word, which can mean, among other things, to sketch or draft (a picture), to attract, as well as to eviscerate or disembowel, as in "draw and quarter." It is precisely such evisceration that the all-knowing I and all-seeing eye undergo as they are drawn into Pistoletto's mirror "drawings."

In what is perhaps his most disturbing mirror "painting," *The Shape of the Mirror* (1975–78), Pistoletto superimposes three rectangular mirrors with ornate frames and one unframed circular mirror. While this over-lapping divides all the mirrors, at least two (and maybe more) of the surfaces are actually split (fig. 8.7). The effect of this work is utterly disorienting. As I look at myself looking at myself looking at the work, I am not simply split but scattered and resplit. The work of art is not only disfigured but disfigures anyone who gazes at it. The angles of the mirrors cast back my reflections in such a way that I am not where I think I ought to be and I

**8.7  Michelangelo Pistoletto,** *The Shape of the Mirror* **(1975–78). Giorgio Persano Collection, Turin.**

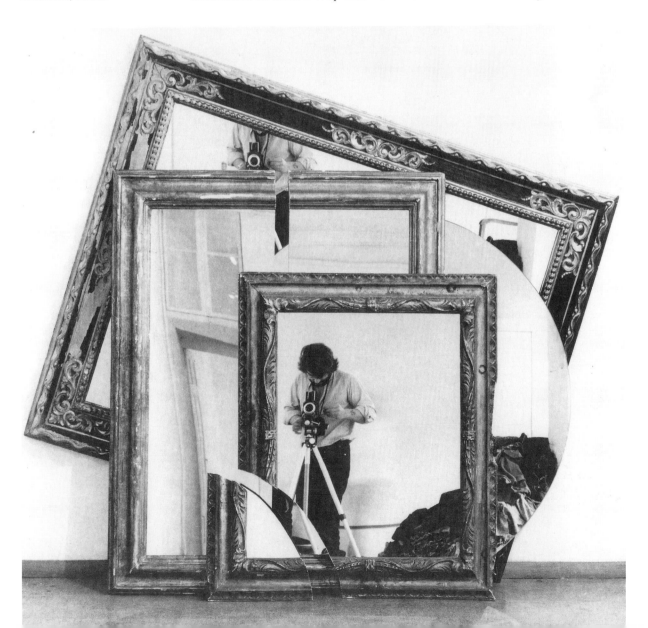

am where I think there is no way I can be. Pistoletto comments on his accomplishment, "I destroyed the concept of subjective style, of a language of identity—whether an identity of form or of personal combination—in order to shatter the individual for the benefit of infinite and countless personalities. The individual became sacred in our century, counteracting an earlier sacredness of styles. Now the individual is fragmented in all senses—philosophical, economic, social, and in communications" (P, 151).

Staring at myself from behind the mirror, I discover the blindness that has always been inherent in my insight. To know myself, I must reflect on myself by returning to myself from my exile in others. My unity, in other words, is not originary but is secondary to the reflection that is impossible apart from the I's/eyes of others. Pistoletto forces me to realize that these others scatter rather than consolidate an I that was never one in the first place. Drawn into the draw of the mirror, I gradually realize that I never have been, am, or will be one. Rather, *I am no one.*

The fault of the mirror reflected in the others I regard harbors an altarity I can never face. This Other cannot appear as such but only approaches by withdrawing in a movement that turns toward me by turning away from me. Altarity forever deserts and thus sends every subject into "internal" exile. This other Other is what is "at play in the subject, while being absolutely irreducible to some subjectivity (that is to say, to any objectivity whatsoever); what, in the subject, 'deserts' (as always already deserted) the subject *itself,* and which, prior to any 'self-possession' (and following another mode than that of dispossession), is the dissolution, the defeat of the subject in the subject or *as* the subject: the (de)constitution [or decomposition] of the subject, or the 'loss' of the subject—if it were possible, that is, to conceive of the loss of what one has never had, a kind of 'originary' loss (of 'self')." [6] The site of the desertion of the subject is the desert. But which desert? Whose desert?

Religious preoccupations are never far from Pistoletto's work. Titles like *The Rocking Temple* (1982) and *Crown of Mirrors* (1973–76) suggest both his concern with and criticism of traditional religious belief and practice. Despair over the viability of institutional religion, however, should not be confused with the dismissal of spiritual matters *tout court.* "In the mirror," Pistoletto avers, "man and God get into the same dimension but get out of the dogma" (P, 152). This tantalizing assertion raises more questions than it answers: Which God? Whose God?

Two images that do not make one: *The Tables of the Law* (1979) and *Division and Multiplication of the Mirror (The Divided Table)* (1975–79). In the first, two symmetrical mirrors, whose shape recalls the traditional form of the Mosaic tablets, are placed side by side. Like the fractured mirrors, these unframed mirrors are separated by a small gap that fissures every image flickering on them. In the second, a table with a mirror surface is cut into asymmetrical pieces that form three variously shaped triangles (plate 29). The pieces of the broken table are situated in such a way

that images reflect other images in a play that fragments without reassembling representations. In the face of the shattered table(t), the self itself becomes (a) mosaic. "The wandering of time," Celant observes, "makes linearity explode. We plunge into a black hole where identity hurries and shatters into a thousand fragments. . . . Hence, your identities are diverse, and they follow impulses and moments; they change according to the events and the course of development; they draw a portrait made of so many mosaic tiles, personality images, so many of which can be discovered in the course of a life" (P, 120). So many mosaic tiles . . . so many images . . . errant images.

The errancy of images opens a time behind the mirror. *The Time of the Mirror* (1986) is an installation in the vast space of Centre National d'Art Contemporain in Grenoble (plate 30). In the midst of overwhelming dark forms stands a single mirror whose surface reflects wavering, oscillating images. The emptiness of this space creates a sense of desertion. *The Time of the Mirror* leads to a space that recalls a desert where light becomes darkness. In this deserted space, icons obscure as much as they illuminate. *The Time of the Mirror* is part of Pistoletto's most recent work, which he describes as "Art of Squalor." He begins "Hard Poetry," a brief text devoted to an explanation of the premises of "Art of Squalor," by writing,

> Art of squalor, parasitic art, art of mortification. Surface of desolation, obtuse surface. A repulsive art that represents nothing. . . . An immobile, viscous, worn-out art.
> Grayish, blackish that tends towards yellowish.
> Mass of triturated ideas, of pulverised objects, of meanings that are smashed, rotted, softened, and compressed.
> Fragments of instruments and concepts. (P, 196)

Hard poetry indeed. "A repulsive art that represents nothing." This art marks the return of the repressed that modernism and modernist postmodernism refuse.

"Art of Squalor" pushes beyond *Division and Multiplication of the Mirror*. Its somber forms and distorted shapes bring into sharp relief the darkness that haunts broken mirrors. Behind the mirror . . . at the limits of reflection lies catastrophe.

> The slowness of vast distances in the soaked color of squalor, that is not sham but thickness.
> Subterranean energy of dense skies in the depth of the sea with no solution of continuity.
> Flat to the eyes, dark, reddish, far from everything and everyone; alone.
> A terrible detachment, a definitive otherness. (P, 196)

To capture the rhythm of squalor requires "a grave . . . art, which achieves the maximum distance and maximum slowness, without being grazed by the infinity of immobility. The motion is slow like the catastrophic motion of the universe" (P, 196).

Pistoletto's catastrophe approaches Blanchot's disaster. Always eluding the reflection it nonetheless makes possible, "the disaster is unknown; it is the unknown name for that in thought itself that dissuades us from

thinking of it, distancing us, by proximity. Alone, in order to expose one-self to the thought of the disaster that undoes solitude and overflows every space of thought, as the intense, silent and disastrous affirmation of the outside" (WD, 14). This is the outside inscribed "inside" Pistoletto's art as the tain of the mirror that re-marks the limits of reflection. To approach this space, which Pistoletto makes unavoidable, is to wander "far from everything and everyone, alone. A terrible detachment, a definitive otherness" (P, 196).

"The era is defined," according to Heidegger, "by the god's failure to arrive, by the 'default of God.'" "Because of this default, there fails to appear for the world the ground that grounds it. The word for abyss—*Abgrund*—originally means the soil and ground toward which, because it is undermost, a thing tends downward. But in what follows, we shall think of the *Ab-* as the complete absence of the ground. The ground is the soil in which to strike root and to stand. The age for which the ground fails to come, hangs in the abyss" (PLT, 91–92). *Abgrund* . . . abyss . . . rending, catastrophic abyss . . . The absence of ground is the absolute desertion that is the desertion of the Absolute. How can this desertion be figured?

My first encounter with the work of Anselm Kiefer was in February 1989 at the much maligned and widely misunderstood Guggenheim exhibition entitled "Refigured Painting: The German Image, 1960–1988." This show brought together the work of a heterogeneous group of artists who have been labeled *die neuen Wilden* and neoexpressionists.[7] While hardly representing a coherent movement, the artists included in the Guggenheim exhibition shared a critical attitude toward late modernist abstraction, minimalism, and performance art. Though Georg Braselitz's brightly colored distorted and inverted figures dominated the show, there was a wide range of figurative strategies on display: from Hermann Albert's Hopperlike figures and Gerhardt Richter's hyperreal landscapes to caricatures bordering on cartoons by C. O. Paeffgen and Sigmar Polke. It was, however, a work by Anselm Kiefer that I found most arresting: *Ways of Worldly Wisdom: Arminius's Battle* (plate 31). This large woodcut, with acrylic and shellac, depicts leading German cultural figures arranged around the obscure image of a forest with a fire in its midst. Superimposed on the faces, trees, and flames is the outline of a form that approximates a palette. As I studied the images, I detected the faces of Heidegger, Kant, Hölderlin, Böhme, and others. Intrigued, I explored further and discovered that a previous version of this work, *Ways of Worldly Wisdom* (1976–77), also includes the faces of Rilke, Fichte, and Schleiermacher. In a still earlier painting, *Germany's Spiritual Heroes* (1973), which is different in style but similar in theme, Kiefer inscribes the names but not the images of Hegel, Feuerbach, Marx, Schopenhauer, Wagner, Jung, Heidegger, and Nietzsche.[8] The muted tones of Kiefer's work stood in marked contrast to

the bright colors of many of the paintings in the exhibition. His "portraits," which were drawn from either dictionaries or books about the Third Reich, were reminiscent of Warhol's celebrity portraits and *Thirteen Most Wanted Men.* Despite the resemblance, it was clear to me that Kiefer's art probes issues that Warhol's work assiduously avoids.

In the weeks and months following the Guggenheim exhibition, I pursued Kiefer's work. The more I saw and studied, the more fascinated I became. The dark but not oppressive colors of his paintings—lavenders, purples, yellows, browns, ochers, ambers, and blacks—are strangely alluring. While exploring spiritual questions, Kiefer's canvases flaunt their materiality. His paint is so thick that it cracks. Straw, sand, earth, lead, iron, burlap, and cardboard are freely mingled with oils and acrylics. Rejecting the modernist prescription of autonomy, Kiefer mixes painting, photography, sculpture, and graphics to form works that are not incoherent, though they do not form integrated wholes. His canvases are monumental yet fragile. Rather than clean and pure, they are dirty, almost contaminated; rather than shadowless, they are shady; rather than self-referential and self-reflexive, they are fragmented, almost torn to shreds. Bringing together opposites that are not reconciled, these extraordinary works create an atmosphere of uncertainty and undecidability.

Kiefer's paintings enact a return of the refused with a power and on a scale I had never before encountered in the visual arts. Although postmodern architecture and logo centric artists return to history and figure, Kiefer's retrieval of history and use of figuration differ significantly from postmodernism's ironic appropriations. As the names and faces of *Ways of Worldly Wisdom* suggest, Kiefer is concerned with the complex relationship between the German philosophical, theological, literary, and artistic tradition and the harrowing events of the twentieth century. He forces his viewers to confront a past they have long been repressing. This past, however, is not only the history of Germany. As we have seen, the theoesthetic developed in Jena during the last decade of the eighteenth century and refined throughout the nineteenth century forms the very foundation of modern and modernist postmodern artistic and architectural practices that extend far beyond the borders of Germany. The history Kiefer probes is, in the final analysis, our own. Behind the events of the past century, he glimpses a more ancient past that is portrayed in the myths, stories, and rituals of Greece, Rome, Scandinavia, Babylon, the Hebrew Bible, the New Testament, Jewish and Christian mysticism. As the layers of his work accumulate, Kiefer's art becomes a tissue of traces that struggle to figure something that can be figured only by disfiguring.

Kiefer's works *are* disfigured—horribly and terribly disfigured. Debris is peeled away to expose ever more refuse. Holes are left uncovered, rifts left unclosed, wounds left gaping. These canvases seem to have been tortured; they are burnt, scorched, and charred. The trace they bear is ash . . . always ash. There is no utopia here—or elsewhere. The scene is one of devastation and desertion.

The site of desertion is the no-place of a certain withdrawal. Something is always slipping away, always missing in Kiefer's art. Beyond history, beyond even myth, Kiefer pursues or is pursued by something other that is neither near nor far, neither immanent nor transcendent. Its distance is proximate and its proximity distant. Never present without being absent, this beyond that is ever near is the unfigurable that Kiefer struggles to figure. The ash that remains on the canvas is the trace of an immemorial disaster. Kiefer paints the disaster that Blanchot writes.

> The disaster ruins everything, all the while leaving everything intact. It does not touch anyone in particular; "I" am not threatened by it, but spared, left aside. It is in this way that I am threatened; it is in this way that the disaster threatens in me that which is exterior to me—an other than I who passively become other. There is no reaching the disaster. Out of reach is he whom it threatens, whether from afar or close up, it is impossible to say: the infiniteness of the threat has in some way broken every limit. We are on the edge of disaster without being able to situate it in the future: it is rather always already past, and yet we are on the edge or under its threat, all formulations that would imply the future—that which is yet to come—if the disaster were not that which does not come, that which has put a stop to every arrival. (WD, 1)

On the edge of disaster . . . always on the edge. The dis-place of disaster is the desert.

Kiefer is obsessed with the desert. Not the desert of the simulacrum, the shadowless desert of bright lights, but the shadowy desert that begins in the Middle East, or perhaps beyond, and spreads to the West—first Europe, then America, and perhaps beyond. Kiefer's paintings do not represent the desert; rather, *they become the site of desertion.* His haunting disfigures (impossibly) figure the withdrawal of the unfigurable.

In 1966, at the age of nineteen, Kiefer withdrew to the monastery at La Tourette, which was designed by Le Corbusier. Kiefer had just given up the study of law and was poised to begin his artistic career. The site of his withdrawal was carefully chosen. Mark Rosenthal explains that "the young German intended to study the methods used by the architect to give a concrete material appearance to abstract, religious ideas" (AK, 10). Along with Notre-Dame-du-Haut, Ronchamp, La Tourette is the outstanding example of Le Corbusier's postwar architecture in which austere geometricism gives way to vital biomorphism. In these buildings, the errant lines, odd angles, and hermetic symbols that Corbusier's puritan aesthetic had long led him to repress return to create vibrant structures. Tafuri's analysis illuminates the unexpected turn in Corbusier's late work that is of interest to Kiefer:

> Not to be submerged by the wave of the momentary flow that shapes the metropolis was the goal of Le Corbusier in attempting to dominate that flux intellectually. In the end, however, the intellect found itself reduced to impotence. But from that checkmate it learned that it could speak. Its battle languages still had something to communicate, but only by taking refuge in mystic spaces, monasteries, the foothills of the Himalayas—withdrawing from the metropolitan reality that it had mistakenly believed could be rec-

onciled with itself. . . . Extended to its limits, language—which has placed its own mortgage on the real—incessantly fractures its own unity, refusing to make peace with what has obliged it to accept exile. (MA, 2:324)

The fracture of unity that sends everything and everyone into exile creates the space for Kiefer's artistic venture. After living in a monastic cell and participating in daily rituals with the Dominican monks for three weeks, Kiefer left La Tourette and returned to Freiburg, where he began to study art. Throughout his career, Kiefer has remained concerned with the creative and destructive resources of religion. In a 1985 interview, he describes the strange gods that pursue him, which, no doubt, would have been unrecognizable to the monks at La Tourette. "For me, it is, indeed, not clear that we represent the middle point of the world. We have spoken about gods who are unhappy without mortals. It is perhaps possible that gods exist who have no relationship with humans. As an artist, it is my belief that it is possible to perceive something, to sense a force, which has no reference to human beings."[9] How can such a difference be conceived without negating its altarity?

Though Kiefer developed a significant body of work during the late 1960s and early 1970s, he was not well known until the 1980 Venice Biennale. When widespread recognition finally arrived, it turned out to be a mixed blessing. His work provoked hostile criticism and heated controversy among his compatriots. Many accused Kiefer of reviving the past in order to glorify the fatherland. Some critics went so far as to accuse him of being a neo-Nazi. These charges are bitterly ironic, for Kiefer's return to Germany's past involves a critical reassessment of what people had refused to confront. As I have suggested, Kiefer is especially interested in the role philosophy, theology, literature, and art played in creating the conditions for the disasters of the twentieth century. Directly facing the devastation in whose wake we still live, Kiefer refuses every utopia—be it the imminent utopia of modernism or the immanent utopia of modernist postmodernism. His unfailing realism does not lead to despair but to a relentless interrogation of the forces that release disaster and of the role that art can play in a world that is undeniably postmodern.

Kiefer's 1973 painting *Resurrexit* is characteristic of his early work and anticipates many of issues he probes in his later work (plate 32). This highly representational image consists of two distinct parts. The main section of the painting depicts a winter scene typical of the Black Forest and Oden Forest where Kiefer lives and works. In the midst of the forest, a path has been cleared, creating a woodland way similar to the *Holzwege* along which Heidegger loved to roam. At the bottom of the painting, near the beginning of the clearing, is a snake. The serpent, which appears frequently in Kiefer's work, carries multiple associations—from biblical stories of Paradise and the staffs of Moses and Aaron, to the epics of Gilgamesh and Edda, as well as the poetry of Paul Celan. Overdetermined in a way that makes decidable meaning impossible, Kiefer's serpents sometimes imply evil, other times good; sometimes destruction, other

times creation; sometimes ignorance and foolishness, other times knowledge and wisdom. In *Resurrexit* the head of the serpent directs the gaze of the viewer to the vanishing point on the horizon where the forest path gives way to the sky, which ascends like a funnel-shaped cloud to meet a wooden staircase. The shape of the stairs recalls Hegel's reference to a pyramid that "has its very tip knocked off," which Derrida appropriates as a figure of the silent *A* of *différance*. [10] At the bottom of the stairs, Kiefer has written *resurrexit;* at the top of the stairs, there is a closed door. What lies beyond this door?

The wooden, hand-hewn interior, which appears in many of Kiefer's works from this period, is drawn from the converted schoolhouse in the Oden Forest that served as his studio at this time. The stairs, in other words, lead to the door of the artist's atelier. By inscribing *resurrexit* on the stairs to his studio, Kiefer raises the question of the redemptive role of art. He seems to be asking whether art can provide an exit from the nightmare of modern history. Is the artist the prophet or even the messiah who can lead his people from the desert to the Promised Land?

We have found that following the appearance of Schiller's *On the Aesthetic Education of Man,* the artist assumes prophetic, if not messianic, proportions. Furthermore, the salvific power of art is a basic tenet of theoesthetics. No one believed more strongly in the capacity of art to redeem than did Kiefer's onetime teacher Joseph Beuys. "Only art," Beuys declares, "is capable of dismantling the repressive effects of a senile social system that continues to totter along the deathline" (AK, 56). Kiefer is far less confident of art's potential to heal personal wounds and cure social ills. Indeed, the archaeology of disaster leads him to conclude that, when art becomes religion, it fuels the flames of destruction.

Kiefer's fascination with alchemy reflects his abiding interest in the question of the salutary power of art. In many of his works he uses lead, which is the base material from which the alchemist attempts to make gold. Historically, alchemy has been closely related to certain Eastern and Western esoteric and mystical traditions. In the myths and rituals associated with these traditions, the value of gold is its purported capacity to provide a universal remedy for ills and to serve as an elixir of immortality. Gold, in other words, holds out the promise of *resurrexit*—the escape from the labyrinth of death and destruction through the mastery of time. The means by which base metal is transformed into gold is *fire*. Fire purges lead of its impurities and turns it into pure gold.

Numerous Kiefer canvases seem to enact something like an alchemical process. Molten lead, clinging to the scorched surface, appears to be on the point of turning into something else. But ash rather than gold invariably appears. Having learned the lessons of modernity's will-to-purity, Kiefer realizes that the fires that purge also destroy. Far from providing a universal cure, art harbors destructive power that binds one ever more firmly to time and history. In *Painting = Burning,* the white outline of a palette is superimposed on the charred remains of a scorched landscape

**8.8 Anselm Kiefer, *Icarus: March Sand* (1981). Oil, emulsion, shellac, sand, photograph (on projection paper) on canvas, 114¼ × 141¾ in. Reproduced by permission of the artist. Photograph: Saatchi Collection, London.**

(plate 33). As Andrew Benjamin points out, "All that is revealed [in this painting] is that which refuses representation; the Holocaust, nuclear annihilation, the remains of the after war. They are not events in history, for they have called into question the very process that is the making of history. The means of representation—the palette—becomes a mere outline announcing the impossibility of placing on the canvas that which the burning removed. It is the emptiness of the palette that announces in advance the vacuity of history."[11]

*Icarus: March Sand* makes the same point somewhat differently (fig. 8.8). "March Sand" suggests the March Heath in the Brandenburg region, southeast of Berlin, which is rich in historical associations and plays an important role in Kiefer's iconographic repertoire. "The area is happily recalled for many Germans in Theodor Fontane's *Walking-Tours through the Brandenburg March,* written in the nineteenth century; but the Brandenburg territory has had great importance in Prussian history since the early 17th century, and the Brandenburg March became a frequently fought-over prize, which in this century was lost first to Russia and later

to East Germany." In addition to this, *"Märkischer Heide, märkischer Sand, an old patriotic tune of the region, became a marching song for Hitler's army"* (AK, 35). Icarus, of course, is the son of Daedalus, who with wings of wax attempted to escape from the labyrinth but flew too close to the sun and thus fell into the sea. In Kiefer's work, the winged Icarus, whose head is shaped like a palette, is either ascending from or falling toward the burning sand of March Heath. Kiefer comments, "The palette represents the art of painting; everything else that can be seen in the painting—for example, the landscape—is, as the beauty of nature, annihilated by the palette. You could put it this way: the palette wants to abolish the beauty of nature. It is all very complicated, because it actually does not become annihilated at all" (AK, 60). *Icarus: March Sand* figures a disaster that is not merely historical. Behind the disaster played out on the Brandenburg heath lies a more profound "disaster [that] ruins everything, all the while leaving everything intact." When art traces this disaster, it offers no cure and promises no redemption. The purgatorial fires burning on the sands of the deserted heath lead to no resurrexit. The door to the artist's studio at the top of the stairs is closed—closed tightly.

In my consideration of Tschumi's appropriation of Bataille's interpretation of the relation between the pyramid and the labyrinth, I stressed that in one of its guises, the pyramid is the figure for the escape from the labyrinth of time. From this point of view, pyramids are built to cover the abyss over which (the) all is suspended. As such, the triangular sides of the pyramid point the way from time to eternity. When translated from the Egyptian to the Christian context, the figure of the triangle becomes the image of the trinitarian God. Kiefer's *Father, Son, and Holy Spirit* repeats the form and substance of *Resurrexit* with several important differences (plate 34). The work no longer depicts merely a winter scene but portrays the burnt remains of evergreen trees, which traditionally symbolize eternity. More important, the closed door is opened to reveal a room that contains three chairs with burning flames. Along the border that joins and separates the scorched evergreens and the attic room, three words are written, *Vater, Sohn,* and *hl. Geist.*

Given the rustic setting, as well as the importance of Freiburg and Germany's forests for Kiefer, it is difficult to resist the temptation to relate these flames to certain aspects of Heidegger's philosophy. This association is not entirely arbitrary, for in 1975 Kiefer dedicated a book to Heidegger. Furthermore, the figure of Heidegger, I have noted, appears in *Ways of Worldly Wisdom: Arminius's Battle* and *Ways of Worldly Wisdom*. In his remarkable account of Heidegger's relation to national socialism, Derrida repeatedly stresses that within the Western ontotheological tradition, which Heidegger both extends and deconstructs, "*Geist* is flame." Bringing his analysis to a close, Derrida argues, "A circle draws this *Frühe* from the day before the day before up to that morning that has not yet come, and this circle is not— not yet or already no more—the circle of European metaphysics, or the eschatologies, the messianisms or apocalypses of all sorts. I did not say that

the flame was *something other or opposite* than pneumatological or spiritual breathing, I said that it is on the basis of flame that one thinks *pneuma* and *spiritus* or, since you insist, *ruah*, etc."[12] The association of fire with the spirit of metaphysics is as old as philosophy itself. For Heidegger's favorite philosopher, Heraclitus, fire is the material manifestation of the Logos. In Hebrew and Christian scriptures, fire is the sign of God's presence. The history of the twentieth century demonstrates beyond any reasonable doubt that these images and metaphors are hardly inconsequential.

In *Germany's Spiritual Heroes* the fire of spirit spreads, in good Hegelian fashion, from *heiliger Geist* to the founding fathers of the modern West. Kiefer reinscribes the divine Trinity in the names Hegel, Feuerbach, and Marx (fig. 8.9). Moreover, the upper room expands to become a vast memorial hall, along whose sides open flames burn above the written names of Germany's spiritual heroes. The singed lower border of the work indicates that the entire wooden structure is about to burst into flames.

Flames and forest meet in the burning center of *Ways of Worldly Wisdom: Arminius's Battle.* The title of this work is borrowed from a 1924 apology for Catholicism by Bernard Jansen. In the 1976 oil version, the fire is missing, and the roots of the trees appear to be subterranean serpents ensnaring historical figures in a demonic web of intrigue. Arminius is the name of a German chieftain who, in 9 C.E., defeated three legions of Roman soldiers that were commanded by Quintilius Varus in the Teutoburg Forest. The Nazis frequently used this event to inspire hatred of foreign influences among the German people (AK, 49, 51). Kiefer's painting plays on multiple registers to underscore the entanglement of cultural tradition and political reality. The ways of worldly wisdom, it seems, lead to world destruction. By including the images of philosophers, theologians, poets,

**8.9** Anselm Kiefer, *Germany's Spiritual Heroes* (1973). Oil and charcoal on canvas, 121 × 268½ in. Collection of the Eli Broad Family Foundation, Santa Monica. Reproduced by permission of the artist. Photograph: Douglas M. Parker Studio.

and artists such as Hegel, Kant, Fichte, Hölderlin, Schleiermacher, Nietzsche, Wagner, and Heidegger, Kiefer implies that the theoesthetic tradition must be held accountable for the excesses of the twentieth century. The genesis of transgression, Kiefer believes, is idolatry.

I have argued that one of the products of speculative philosophy is the idealism of the image that characterizes the Magic Kingdom of the society of spectacle. For Kiefer, this idealism amounts to what Baudrillard labels "iconolatry." From Kiefer's point of view, the society of spectacle is not a realized utopia but is a desert where temptation lurks. Since the time of Aaron, the desert has been associated with the temptation of idolatry. Kiefer is fascinated by Aaron and has done several works in his name. In his most important painting devoted to this prominent figure in the Hebrew Bible, *Aaron* (1984–85), Kiefer presents a typically charred landscape to which he attaches thin lead strips numbered to represent the twelve tribes of Israel. In the lower center of the canvas is a dark, lead-covered opening over which Aaron's staff is suspended. The staff is the miraculous rod that enabled Moses and Aaron to visit plagues upon the Egyptians and to turn water into blood. Moreover, the staff is associated with serpents. In response to the pharaoh's demands for a portent, Aaron threw his staff on the ground, and it turned into a serpent. When the pharaoh's wise men and sorcerers did likewise, Aaron's staff swallowed all the others. It is, however, with the incident of the golden calf that Aaron's name is most closely associated. Through a process approximating alchemy, Aaron fashioned "the image of a bull-calf" from the gold jewelry of the people. When Moses descended from the mountain and encountered the wild celebrations in honor of the sacred bull, he shattered the tablets bearing the writing of God. In this fleeting moment, the original text was lost forever.

Every artist is, in some sense, a descendent of Aaron, who succumbs to the lure of image worship. Indeed, it is precisely this temptation to which the logo centric world of postmodernism falls prey. Kiefer realizes that idolatry is not only a religio-aesthetic issue but, perhaps more important, a political problem. In *Bilder-Streit*, or *Iconoclastic Controversy*, he uses the aesthetic strategies of modernist postmodernism to reassess critically the idealism of the image (fig. 8.10). This work consists of oil, emulsion, shellac, and sand on a photograph, mounted on canvas with a woodcut. The photograph of three toy tanks confronting each other on what looks like a desert was taken in Kiefer's studio. The wooden floor bordering the sand recalls the memorial halls of his earlier works. Superimposed on this desertscape is the ubiquitous outline of the artist's palette. Unlike postmodern pastiche, Kiefer's layered images do not suggest the self-reflexivity of the symbolic order but imply something the figures cannot represent. In the midst of the tanks, there is a hollow that is reminiscent of Michael Heizer's only German work, *Munich Depression*. The earth is fissured and torn—like the desert earth of Heizer's *Rift*. On the parched pages of his pictographic book entitled *Spaltung* (split, crack, cleavage, fissure), Kiefer

**8.10** Anselm Kiefer, *Icono-clastic Controversy* (1980). Mixed media, 290 × 400 cm. Museum Boymans van Beuningen, Rotterdam. Reproduced by permission of the artist.

effectively captures the rending of the desert in the context of his struggle to represent nuclear disaster. In *Iconoclastic Controversy,* the disaster is the Holocaust. On the surface of the palette, flames from battles, sacrifices, funerals, ovens, or something else erupt. "The holocaust," as Edith Wyschogrod maintains, "is itself intrinsic to postmodern sensibility in that it forces thought to an impasse, into thinking a negation that cannot be thought and upon which thinking founders."[13] Kiefer's artistic wager is that what cannot be thought can be figured by a certain disfiguring.

Kiefer's strategy of disfiguring is neither modern nor postmodern. He neither erases nor absolutizes figure but uses figure with and against itself to figure the unfigurable. His canvases become the site of an unsettling dis-placement where the refused is not repressed but is allowed to return. In a manner similar to Freud's *Entstellung,* Kiefer's disfiguration is an un-negation that affirms rather than negates negation. His rent images are what Didi-Huberman describes as "bleeding traces," which, in Roland Barthes's terms, "fissure the very representation of meaning."[14] This fault is opened by an exteriority that "cannot be interiorized through the process of signification." Lyotard's analysis of figure illuminates Kiefer's strategy of disfiguration:

> The position of art is a refusal of the position of discourse. The position of art
> marks a function of figure that is not signified, and this function is around
> and through discourse. It indicates that the transcendence of the symbol is
> figure, that is to say, a spatial manifestation that linguistic space cannot in-
> corporate without being disrupted; it is an exteriority that linguistic space
> cannot interiorize as signification. Art is defined in terms of alterity, as plas-
> ticity and desire . . . with respect to invariability and reason, it is diacritical
> space. . . . The enigma is that there remains . . . a between-world [*entremonde*]
> that is the reserve of visions and that all discourse is dissipated before it is
> resolved. The absolute other is probably this beauty of difference.[15]

The absolute Other opens "in" figure the trace of something that is "out-
side" figure. Rejecting modern abstraction and postmodern figuration,
Kiefer claims, "Art about art is tautological, one has no leverage; one can
only really work from the outside."[16] Though not immediately apparent,
this outside is the rift of the crypt.

The flames of *Iconoclastic Controversy* are rekindled in *Shulamite* as a
memorial to the immemorial that is not eternal but is more archaic than
time itself (plate 35). "The immemorable, the unknown that has no pres-
ent," is, as Blanchot argues, "the unforgettable Other" (WD, 117). *Shu-
lamite* repeats the single-point perspective of *Resurrexit* in a scene that
reinscribes the memorial hall of *Germany's Spiritual Heroes*. In this case,
however, there is no forest scene and no hand-hewn hall. What appears
is a massive dark crypt that is modeled after Wilhelm Kries's Funeral Hall
for the Great German Soldiers in the Hall of Soldiers (Berlin, 1939). Dur-
ing the early 1980s, many of Kiefer's works include images of Nazi archi-
tecture. The most provocative paintings from this phase of his career are
included in a series entitled "To the Unknown Painter." In these works,
Kiefer outlines a palette, mounted on a stand, which is located in the place
of honor in the middle of the grand classical structures that were admired
by Hitler and his followers. Although many critics read these paintings as
a glorification of national socialism, Kiefer's gesture seems less celebratory
than accusatory of both art and politics.

The memorial hall portrayed in *Shulamite* is charred—as if it were a
monstrous oven. Along the sides of this obscure space, where the flames
memorializing Germany's spiritual heroes once burned, there are dark-
ened windows covered with burnt woodcut fragments. The gray grid on
the floor is not a modernist figure of the Absolute but a dark net that
ensnares anyone who dares to enter. At the vanishing point, flames ap-
pear—not one but seven—to form the faint trace of a menorah. Shula-
mite, a woman of legendary beauty, appears only once in the Bible—in
the Song of Songs 6:13.

> Come back, come back, Shulammite maiden,
> come back, that we may gaze upon you.
> How you love to gaze on the Shulammite maiden,
> as she moves between the lines of dancers!

In these richly suggestive verses, Shulamite is presented as the object of
the male gaze. If this specular relation is read in a Lacanian rather than a

Hegelian way, it is possible to interpret the figure of Shulamite as interrupting the circuit of reflection in a manner not unlike Pistoletto's fragmented mirrors. Furthermore, Shulamite seems to be somewhat marginal, for the place of her appearance is "between the lines." The question Shulamite poses is, among other things, a question of how to read and how to represent what cannot be said directly but always appears *between* the lines.

Kiefer repeatedly returns to the figure of Shulamite. Though certainly aware of her role in the Bible, Shulamite's significance for Kiefer derives from Paul Celan's poem *Todesfuge* (Death fugue), written in a concentration camp in 1945—the year of Kiefer's birth. In *Todesfuge* Celan establishes a contrast between Shulamite and Margarete.

> Black milk of daybreak we drink you at night
> we drink in the morning at noon we drink you at sundown
> we drink and we drink you
> A man lives in the house he plays with the serpents he writes
> he lives when dusk falls to Germany your golden hair Margarete
> your ashen hair Shulamith we dig a grave in the breezes there one lies
> unconfined . . .
>
> Black milk of daybreak we drink at night
> we drink you at noon death is a master from Germany
> we drink you at sundown and in the morning we drink and we drink you
> death is a master from Germany his eyes are blue
> he strikes you with leaden bullets his aim is true
> a man lives in the house your golden hair Margarete
> he sets his pack on to us he grants us a grave in the air
> he plays with the serpents and daydreams death is a master from Germany
>
> your golden hair Margarete
> your ashen hair Shulamith [17]

Master/slave, day/night, country/city, blue/black, golden/ashen. Ashes . . . serpents . . . bullets . . . grave . . . ashes. Margarete and Shulamite figure unreconciled opposites that continue to rend postmodern experience.

In a series of paintings— *Your Blond Hair, Margarete* (1981), *Your Ashen Hair, Shulamite* (1981), *Your Golden Hair, Margarete* (1981)—Kiefer depicts the veiled image of Shulamite but only hints at Margarete with small bundles of straw. Margarete is, of course, a richly suggestive figure. Her blond hair and blue eyes not only represent the Aryan ideal, but her flaxen hair recalls the soil of the motherland for which so much blood has been spilled. This blood points to the dark side of Margarete's light hair. In Goethe's *Faust* Margarete, who is also known as Gretchen, is led by her love for Faust to deceive her mother and kill her daughter. In a painting entitled simply *Margarete,* Kiefer indicates the darkness that lies at the heart of modernity with the faint light of flames that burn the straw representing beautiful blond hair. Beyond the lines of Celan's troubling poem, Margarete and Shulamite meet in ashes spread on Kiefer's dark canvases.

Ash is the remainder of the flame of spirit, spirit that is deemed Holy Spirit, Absolute *Geist,* which is the guiding spirit of the West. In an essay

devoted to Celan's poetry, "Shibboleth," Derrida claims that ash is "the name of what remains of what doesn't remain" (SB, 334). He cites Celan's "Chymisch":

> Great, gray,
> like all that is lost near
> Sisterly shape
>
> All the names, all the
> names burn up
> with the rest. So much
> ash to bless. So much ash
> to bless.

As the "remains that don't remain," ash "inscribes itself only to efface itself." This self-effacing trace is a memorial to the immemorial—"a cipher that commemorates what was destined to be forgotten, destined to become a name, nothing, no one, ash" (SB, 333). The name turned to ash is the trace of something that is both unnameable and immemorable, which, it seems, is always forgotten.

The forgetting of this unnameable, however, is a strange forgetting. The immemorial is not simply forgotten but is inseparable from a remembering that is not a re-membering and a recollection that is not a re-collection. The memorial to the immemorial recalls a lapse of memory that dis-members. This lapse, this lack is the ashen hole that disfigures Kiefer's canvases. "I tell stories in my pictures," Kiefer explains, "to show what's *behind* the story. I make a hole and go through."[18]

To pass through this hole is to approach a past that was never present. This past is "the absolute past—that is, the immemorial or unrememberable, with an archive that no interiorizing memory can take into itself" (M, 67). As we discovered in the rift of Derrida's chora, the faults of Eisenman's structures, the tear of Heizer's ground, and the fragments of Pistoletto's mirrors, this anarchic *archē* is the "terrifyingly ancient," the "unrepresentable before" that disfigures all figures. At this point, in this point, which is a non-sensical *point de folie* other than the points made by Tschumi, we are "called to recall what we must *think:* thought is not bereaved interiorization; it thinks at boundaries, it thinks the boundary, the limit of interiority. And to do this is also to think the art of memory, as well as the memory of art" (M, 71).

Inasmuch as the art of memory struggles to take into itself what it cannot interiorize, the memory of art necessarily entails something like an impossible mourning. As traditionally understood, mourning is a healing process in which an individual works through the experience of loss. The end of mourning is the sublation of absence through which the self is reconciled to loss as well as to itself. There is, however, an other mourning that mourns an altarity with which reconciliation is impossible. Derrida contrasts these two mournings: "Is the most distressing, or even the most deadly infidelity, that of a *possible mourning,* which would interiorize within us the image, idol, or ideal of the other who is dead and lives only

in us? Or is it that of the impossible mourning, which, leaving the other his alterity, respecting thus his infinite remove, either refuses to take or is incapable of taking the other within oneself, as in the tomb or the vault of some narcissism?" (M, 6). The mourning of the unreconcilable Other is endless, for this Other is not merely outside but is "inside" as an "outside" that cannot be interiorized. As Pistoletto's fractured imago implies, exile is also an "internal" affair. Not all deserts are outside.

The dis-place of mourning is the deserted crypt. A dark, ashen crypt that sometimes is lighted by a memorial flame that burns dimly. But what is a crypt?

> No crypt presents itself. The grounds are so disposed as to disguise and to hide: something, always a body in some way. But also to disguise the act of hiding and to hide the disguise: the crypt hides as it holds. . . . The crypt is thus not a natural place, but the striking history of an artifice, an *architecture*, an artifact: of a place *comprehended* within another but rigorously separate from it, isolated from the general space by partitions, an enclosure, an enclave. So as to purloin *the thing* from the rest. Constructing a system of partitions, with the inner and outer surfaces, the cryptic enclave produces a cleft in space, in the assembled system of various places.[19]

The "cleft in space," which is the opening of the crypt, is the disfigure of the *Abgrund* that appears when the ground disappears. The figure of this disfigure is ash. The darkness of ash appears when the twilight of the idols falls after the desertion of the gods.

> Ash.
> Ash. Ash.
> Night.
> Night-and-Night. (S, 336)

Kiefer figures this night not only in Shulamite's ashen hair but with the ashes that darken the crypt named *Shulamite.* Behind the seven flames that mark the vanishing point, a darker darkness withdraws. In this darkness *To the Supreme Being* appears (fig. 8.11). This painting brings together, inter alia, *Germany's Spiritual Heroes* and *Shulamite* to form an image that is utterly cryptic. At the far end of a structure that could be a memorial hall, a cathedral, or something else—in the place where one would expect to find the altar—there are three black panels.[20] The flames of both the Trinity and the menorah have been extinguished, and only darkness remains. This obscure triptych recalls Reinhardt's Black Paintings. But there is an important difference. Whereas Reinhardt's black canvases extend the promise of an emptiness that is a fullness, Kiefer's dis-figured images suggest the impossibility of fulfillment. The dark altar in *To the Supreme Being* marks the point where altarity withdraws. This desertion does not leave in its wake mere absence, nor does it promise the arrival of presence. Kiefer's darkness figures the point Jabès describes.

> A point beats in space. Listen.
>
> (*You arrive at a certain point, you leave, you return immediately: same place, same point, but you do not know where.*

8.11 Anselm Kiefer, *To the Supreme Being* (1983). Musée National d'Art Moderne, Centre Georges Pompidou. Reproduced by permission of the artist.

*Imagine everything beginning with this point. Around it, no cry that is not the last, no sound that is not the last to be uttered, no breath that is not the last breath.*
*From this point on, we should be able to write and speak without words, from this point on that probably lies on the far side of gesture, agreement or truth, in the mute space death has hollowed out at the end of the book.)*

The freedom of the spirit, O tense emptiness, depends on ruling out any point of support. (EL, 20)

The point that offers no support is the vanishing point. The vanishing of the point marks the disappearance that allows appearance to appear. *Everything turns on this point: the point neither exists nor does not exist; it "is" neither present nor absent, neither being nor nonbeing.* This seemingly pointless point dislocates the entire economy of theoesthetics. This is the point of chora—this is the point of *Zim Zum* (plate 36).

*Zim Zum* is, in my judgment, Kiefer's most magnificent and most troubling work. In this painting he pushes art to the point where something that is not and yet is not nothing "appears" by disappearing. His strategies are those with which we have become familiar. The image of scorched earth is framed and reframed by strips of battered and torn lead. Charac-

teristic earth tones are interrupted by hints of yellow, red, and orange that seem to be lingering traces of a devastating fire. In the middle of the burned land, a large gray hole opens to expose the void over which the earth is suspended. Ground that seems secure is but a brittle shell that fails to cover the emptiness it surrounds. In the Kabbalah, we have seen, "Zim Zum" is the name of the point into which God withdraws to allow the world to appear. God's withdrawal is creative. In Kiefer's rendering, or, perhaps more precisely, rending, of Zim Zum, the withdrawal of God is an act of desertion that leaves the world lacking. Unlike the Being beyond being implied by the between of Newman's *Zim Zum I* (fig. 3.14), the *retrait* enacted on Kiefer's canvas inscribes a nonabsent absence that is always lacking and, thus, leaves everything incomplete. This unavoidable lack is terrifying for all who desire the presence of fulfillment or the arrival of salvation.

And yet, despite this terror, or perhaps because of it, *Zim Zum* intimates an uncanny sublimity. Kiefer's sublime is neither Kant's dynamic sublime that fascinates abstract painters nor the mathematical sublime that obsesses logo centric artists. In Kiefer's work, the sublime does not erupt with either the removal or the proliferation of figures. Rather, the sublime withdraws in and through the strife of images. All art involves *Bilder-Streit*. In this disfiguring struggle, "the imagination is thus destined to the beyond of the image, which is not a primordial (or ultimate) presence (or absence) that images would represent, or that the images would present as not being (re)presentable. But the beyond of the image, which is not 'beyond,' which is at the limit, is in the *Bildung* of the *Bild* itself, . . . and the trace of the figure, the tracing, the separating-uniting incision."[21] The separating-uniting incision opens the space and releases the time of representation. As the condition of the possibility of all representation, this *Riss* is itself unrepresentable. It can be figured only by disfiguring. In *Zim Zum*, Kiefer's disfigured canvas brings art to the limit where it trembles with the approach of an Other it cannot figure. Faults, fissures, rifts, and tears clear an other space, a strange space that "opens something up, outside of all places, it makes a spacing out. If we are in it, we do not stand in it: there is no place there—but we ourselves are opened up there, parted from ourselves, from all our places and all our gods."[22]

A final figure: *Departure from Egypt* (fig. 8.12). This work, which is part of a series, "Auszug aus Ägypten" (1984–85), consists of a huge photograph of the desert upon which Kiefer superimposes brush strokes, which look like wood grain, and a gray cloud, which resembles dripping lead. From the top of the work dangles a thread with a noose at its end. Along the base of the desert mountain runs a road that seems to come from and lead nowhere. On the far side, the Way disappears into, or appears out of, a vanishing point. On the near side, the Way fades into a void. No one follows this way. The desert is deserted—completely deserted. There is no resurrexit here or elsewhere. Only Ash . . . Ash . . . Ash . . . Night . . . Night-and-night.

Night
White, sleepless night
Such is the disaster:
The night lacking darkness,
But brightened by
No light.

For Kiefer, as for Heizer and Pistoletto, the work of art is rending. To be opened by the tears of art is to suffer a wound that never heals. "This experience," Blanchot explains, "is the experience of art. Art—as images, as words, and as rhythm—indicates the menacing proximity of a vague and empty outside, a neuter existence, null, without limit, sordid absence, a suffocating condensation where being ceaselessly perpetuates itself as nothingness" (L, 242–43).

As an end approaches that brings nothing to a close, we are left to ask again, "Where has art led us?" Perhaps, as Blanchot insists, art that is no longer modern has led us "to a time before the world, before the beginning. It has cast us out of our power to begin and to end; it has turned us toward the outside without intimacy, without place, without rest. It has led us into the infinite migration of error. . . . It ruins the origin by returning it to the errant immensity of an eternity gone astray" (L, 244).

The end of art: Desert . . . Desertion . . . The errant immensity of an eternity gone astray is the desert in which we are destined to err endlessly.

**8.12  Anselm Kiefer,** *Departure from Egypt* **(1984–85). Synthetic polymer paint, charcoal, and string on cut-and-pasted photograph and cardboard, 43¼ × 33¾ in. Gift of Denise and Andrew Saul Fund, Collection, The Museum of Modern Art, New York. Reproduced by permission of the artist.**

totality of which we are all integral members. Schleiermacher maintains that this unity cannot be understood but must be *immediately* experienced in an intuition that is at once religious and aesthetic. Hegel, by contrast, argues that immediacy is always conceptually mediated and thus can never be experienced as such. The inaccessibility of immediacy does not, however, entail the impossibility of unity. By abstracting from the immediacy of the sensuous moment, it is possible to discover the universal structure that draws everything together in an intricate web. This dialectical structure, which is the substance and ground of reality, cannot be directly experienced but must be rationally comprehended. When properly grasped, divine reality is present here and now. This presence is the end toward which history has been progressing since its beginning.

In Kierkegaard's scheme, Schleiermacher and Hegel never pass beyond the aesthetic stage of existence. What Schleiermacher regards as the highest form of human experience is what Kierkegaard describes as aesthetic immediacy, and what Hegel interprets as the culmination of the world historical process is nothing but a reflective aestheticism that is utterly fantastic. In Schleiermacher's religio-aesthetic feeling, the individual dissolves in the passing moment of sensation, and in Hegel's religio-speculative knowledge, the individual disappears in the universal structure of reason. From Kierkegaard's perspective, ethical existence extends rather than resolves these difficulties. While controlling desire by subjecting idiosyncratic inclination to the moral law, the ethicist takes as his or her obligation the negation of individuality and the affirmation of universality. What seems to be a universal moral law is actually nothing other than a sociocultural construction that reinforces the existing structures from which it arises.

The two rhythms of Kierkegaard's aesthetic stage effectively summarize the styles of artistic and architectural disfiguring that characterize the first two epochs we have considered. The movement from the particular or the individual to the general or universal, which defines reflective aesthetic and ethical existence, prefigures the strategy of abstraction in nonobjective painting and classical modern architecture. Abstraction—be it painterly or architectural—involves a suspicion of the sensuous and a faith in the formal. The goal of modernist disfiguring is union with the Logos that is identified with the Real. When carried to completion, abstraction becomes empty formalism that is utterly vacuous. This emptiness creates the conditions for the return of the refused. Sensuousness reemerges in figures that disfigure the purity of dis-figured canvases and buildings. Figuration—be it painterly or architectural—involves a suspicion of abstraction and a faith in the image. The goal of modernist postmodern disfiguring is union with the logo that is identified with the Real. Whether regarded as immediate or mediated, modernists and their postmodern followers believe this reunion with the Real is realizable. The purpose of aesthetic education is to make this faith a reality.

But what if the Real is unrealizable? What if reunion is impossible?

What if the dream of theoesthetics is nothing but a dream? Or perhaps a nightmare—even *the* nightmare of the twentieth century? What if aesthetic education promises no cure other than the cure of the desire for a cure? What if religion is not a rebinding (*re-ligare*) that gathers together what has fallen apart but a rebinding that creates a double bind that can never be undone?

Kierkegaard's religious stage opens with the interruption of an Other that disrupts aesthetic immediacy and eludes the structures of the universal moral law. Incomprehensible in any system, this Other resists all totalization. The very otherness of the Other, however, poses a dilemma: Can the Other be thought *as other* without reducing it to same? Kierkegaard realizes that the Other as other is unthinkable, or is thinkable only as unthinkable. The impossible task he sets for himself and his reader is to think the unthinkable. Such thinking or unthinking cannot be straightforward but must be indirect. Consequently, Kierkegaard develops a writerly strategy of indirection in what he describes as his "aesthetic" authorship. The purpose of Kierkegaard's aesthetic education is to lead the reader to the limit of human experience. At this point, which is a vanishing point, something Other approaches. Throughout the pseudonymous authorship, Kierkegaard refuses to speak in his own name; he always writes as an other. Never identifying with any of his personae, the author forever withdraws. In this withdrawal, an other Other (impossibly) "speaks" by *not* speaking. Kierkegaard's aesthetic education does not reveal the presence of the divine here and now but stages an unrepresentable *retrait* that leaves everyone gaping.

This withdrawal engenders a paradox that eventually becomes absolute. The withdrawal of the unspeakable is the condition of the possibility of speaking. Thus to speak is always, in some sense, to speak not. Every word is shadowed by an uncanny double that faults it. This fault is both unavoidable and irredeemable. In the nonabsent absence of the trace of this fault, all saying is unsaying. Indirect communication says the unsayable in and through the *failure* of language. The "name" of this failure is the unnameable and the pseudonym of the unnameable is "God." As Blanchot argues,

> The name God signifies not only that what is named by this name does not belong to language in which this name intervenes, but that this name, in a manner difficult to determine, would still be a part of it [i.e., language] even if this were set aside. The idolatry of the name or simply the reverence that makes it unpronounceable (sacred) is related to this disappearance of the *name* that the name itself makes appear, and that forces language to rise up where it conceals itself until forbidding it. Far from lifting us to all the lofty significations that theology authorizes, it gives rise to nothing that would be proper to it: a pure name that does not name, but is rather always about to name, the name as name, but in that way not at all a name, without nominative power, hung on language, as if by chance and thus passing on to it its (devastating) power of nondesignation that relates it to itself.[8]

The devastating power of nondesignation incites the passion of understanding. Understanding pushes itself to its limits by struggling to think what it cannot think. This paradoxical gesture is unavoidable, for understanding constitutes itself by inscribing "within" itself a limit it cannot comprehend.

> The paradoxical passion of the understanding is, then, continually colliding with this unknown, which certainly does exist but is also known and to that extent does not exist. The understanding does not go beyond this; yet in its paradoxicality, the understanding cannot stop reaching it and being engaged with it, because wanting to express its relation to it by saying that this unknown does not exist will not do, since just saying that involves a relation. But what, then, is this unknown, for does not its being the god merely signify to us that it is unknown? To declare that it is the unknown because we cannot know it, and that even if we could know it we would not express it, does not satisfy the passion, although it has correctly perceived the unknown as boundary [*Grænse*]. But a boundary is expressly the passion's torment, even though it is also its incentive. And yet, it can go no further, whether it risks a result through *via negationis* or *via eminentiae*. [9]

The *Grænse*—the boundary, border, limit—that delimits understanding marks the nonsite of a different difference and an other Other, which Kierkegaard describes alternatively as "infinitely and qualitatively different" or "qualitative heterogeneity." Since this radical heterogeneity is neither positive nor negative, it can be figured neither through the *via negationis* nor the *via eminentiae*. In *Philosophical Fragments* the pseudonym Johannes Climacus probes this unsettling neither/nor.

> What, then, is the unknown? It is the boundary that is continually arrived at, and therefore when the determination of motion is replaced by the determination of rest, it is the different, the absolutely different. But it is the absolutely different in which there is no distinguishing mark. Defined as the absolutely different, it seems to be at the point of being disclosed, but not so, because the understanding cannot even think the absolutely different; it cannot absolutely negate itself but uses itself for that purpose and consequently thinks the difference in itself, which it thinks by itself. It cannot absolutely transcend itself and therefore thinks as above itself only the sublimity that it thinks by itself. If the unknown (the god) is not solely the boundary, then the one idea about the different is confused with the many thoughts about the different. [10]

"Absolute difference" is not *a* difference among others but *the* difference of the between that opens the time and space for specific differences to emerge and pass away. If absolute difference were not always differing from itself, it might be called "difference itself." But such a name would be improper.

By pushing understanding to its limit, Kierkegaard glimpses an unnameable limit that he names "the absolute difference." This extraordinary heterogeneity exceeds the economy of theoesthetics. Indeed, theoesthetics is constructed *not* to think this unthinkable difference. By trying to think the unthinkable, Kierkegaard refuses the refusal of theo-

esthetics. In fashioning his aesthetic education, he attempts to figure an Other he himself does not comprehend. The neither/nor of absolute difference keeps slipping away in an either/or that inverts but does not subvert the both/and of theoesthetics. But the other Other that Kierkegaard solicits returns over a century later in the disfigures of Derrida's chora, Eisenman's *L*'s, Heizer's cuts, Pistoletto's fragments, and Kiefer's ashes.

In the work of artists and architects who strive to figure the unfigurable in a disfiguring that is neither modern nor modernist postmodern, a previously unthought a/theoesthetic is beginning to emerge. A/theoesthetics does not involve the outright rejection of the program of theoesthetics. Any such direct opposition merely repeats the binary or dialectical structure that theoesthetics presupposes. Rather, in a manner similar to Kierkegaard's critique of Hegel, a/theoesthetics attempts to undo theoesthetics as if from within by figuring what it leaves unfigured. Thus a/theoesthetics does not break with theoesthetics in order to introduce something that is supposed to be totally new. To the contrary, a/theoesthetics borrows artistic strategies from the theoesthetic tradition to recall something that is terribly old. Though neither eternal nor divine, this immemorial borders on what might be refigured as the religious.

While theoesthetics defines the parameters of modern theology, a/theoesthetics creates the possibility of a postmodern a/theology. A/theology explores the space *between* the alternatives that define the Western ontotheological tradition. Thus, a/theology is neither theistic nor atheistic; it can be encompassed by neither positive nor negative theology. If it must be described in classical terms, it might be defined as something like a nonnegative negative theology that nonetheless is not positive. A/theology pursues or, more precisely, is pursued by an altarity that neither exists nor does not exist but is beyond both Being and nonbeing. This unthought and unthinkable beyond is suspended between the poles that constitute twentieth-century theology.

Appearances to the contrary notwithstanding, modern theology remains thoroughly traditional. In the Western tradition, theology is in the service of religion. Accordingly, the task of theology is to announce salvation or reconciliation by proclaiming the negation of every form of negation. In this century, the theological effort to negate negation has taken two seemingly opposite forms. As we have observed, twentieth-century theology begins with Karl Barth's negation of every form of immanence. Nature, history, and culture, Barth argues, are fallen. God cannot be found in time and space but is radically transcendent to the entire created order. To affirm one's relation to God, therefore, it is necessary to negate one's relation to natural, historical, and cultural processes. Though Barth often hesitates to push his argument to its logical conclusion, he cannot disguise his conviction that salvation is essentially otherworldly.

Barth's most persuasive critics argue that his insistence on transcendence is, in the final analysis, nihilistic. From this point of view, the Barthian belief in transcendence embodies what Hegel describes as "unhappy

consciousness." Inwardly and outwardly sundered, unhappy conscious-
ness seeks to flee beyond the personal and social conflicts that are en-
demic to history. For many, the only way to overcome this unhappiness is
to follow Nietzsche by declaring yet again that God is dead. This is pre-
cisely the course followed by proponents of the second leading twentieth-
century theological option: so-called death-of-God theology. As we have
seen, in Thomas Altizer's "gospel of Christian atheism" the disappearance
of transcendence issues in a radical immanence that negates every vestige
of alienating otherness. This atheism is, in effect, a negation of Barth's
negation of negation. The differences between these two alternatives is not
as great as it first appears. In both cases, negation is negated, and thus
reconciliation is affirmed. While Barth negates immanence to affirm tran-
scendence, Altizer negates transcendence to affirm immanence. Through
inverse dialectical negations, Barth affirms his belief that the Kingdom is
*present* elsewhere, and Altizer expresses his conviction that the Kingdom
is *present* here and now. What neither Barth nor Altizer confronts is the
possibility of the impossibility of the presence of the Kingdom—here or
elsewhere, now or then. Consequently, neither thinks the negative radi-
cally enough.

Part of the burden of the foregoing chapters is to suggest that major
artistic and architectural practices running throughout the twentieth cen-
tury parallel the dominant tendencies in modern theology. The disfiguring
of abstract painting and modern architecture seeks a purity of form that
transcends the vicissitudes of sensual and historical experience. The dis-
figuring of pop art and postmodern architecture, by contrast, attempts to
escape the vacuity of pure form and abstract structure by total immersion
in the immanence of the image. Though the tactics of abstraction and
figuration differ significantly, they both remain utopian. For the abstract
artist and modern architect, the Kingdom is *present* elsewhere. For the pop
artist and postmodern architect, the Kingdom is *present* here and now.
What neither of these alternatives confronts is the possibility of the im-
possibility of the Kingdom—here or elsewhere, now or then. This impos-
sibility is figured in a/theoesthetics and refigured in a/theology.

A postmodernism that is no longer modernist must give up the hope
of utopia. In theological terms, this means that we must let go of the
dream of salvation. This is no easy task, for the denial of utopia can be-
come utopian and the loss of the dream of salvation can become a salva-
tion. The impossibility of reconciliation means that there is no resurrexit
here or elsewhere, now or in the future. The door is closed, closed tightly;
there is no upper room.

Postmodernism that is not a disguised modernism does not involve a
return to traditional religion or the emergence of a secular religion that
would make it possible to bind back together everything that has fallen
apart. To the contrary, postmodernism *sensu strictissimo* creates the pos-
sibility of thinking religion otherwise. In the absence of reconciliation, we
discover that we are caught in a double bind from which there is no es-

cape. We are bound to and by structures—religious, psychological, political, social, cultural, and historical—that are both inescapable and forever deficient. The inadequacy of structures is a function of their unavoidably repressive character. A structure that does not repress is not a structure. Not all structures, of course, are equally repressive or repress in the same way. And yet, repression, regardless of its form, must be resisted. To resist, however, is not merely to negate. Simply rejecting repressive structures is as utopian as merely embracing them.

A/theology involves an ethic of resistance in which irreconcilable differences are repeatedly negotiated. If religion no longer is conceived as leading to salvation, it becomes possible to rethink *re-ligare* as a double binding that involves what Kierkegaard describes as a "double movement" that is neither merely positive nor merely negative. The aim of the negotiation of this double movement is to minimize repression. Though the elimination of repression is a utopian dream, and, thus, the Kingdom will never arrive, despairing or cynical resignation is not the only response available to us. Faced with the double bind of structures that are unavoidable yet inadequate, we are called to enact an irreducibly nondialectical double movement that does not negate negation but requires us to linger with the negative by forever resisting the repression that structures inevitably inflict. Since repression eternally returns, the struggle of resistance is endless.

But who or what calls for resistance? In the name of whom or what do I resist? Upon what ground can I resist? These questions remain unanswerable. The unsettling call for resistance approaches from the proximate distance of an Other I can never know. One of the improper "names" of this unnameable Other, I have suggested, is "altarity." To think the unthinkable Other, erroneously named altarity, it is necessary to unthink all we have thought with the name "God"—as well as what Nietzsche describes as "the shadows of God": One, Being, identity, essence, substance, subject, presence. . . . As we undertake the demanding task of this unthinking, recent developments in art and architecture can serve as our guide.

A/theology involves an aesthetic education that subverts theoesthetics. This education does not teach the resignation to what is, nor does it promote transcendent spirituality. There is nothing beyond the unfigurable figured in the disfiguring work of art. A/theological aesthetic education does not disfigure this disfiguring by repeating the classical religio-philosophical gesture of translating figures and images into ideas and concepts. To the contrary, traditional religious and philosophical concepts must be disfigured by refiguring the disfiguring of postmodern art and architecture. Altarity can be rendered—if at all—only in a text that is rent. The wounded word is the bleeding trace in and through which altarity approaches by withdrawing and withdraws by approaching. Fragments within fragments are not unified or synthesized but come together by being held apart in their differences. The text woven from these traces is an

*allograph*, which, in its failure—in its gaps and fissures, its faults and lacks—inscribes an Other it cannot represent. Though never present, the unrepresentable is unavoidable. It is the unsaid in all our saying that undoes all we do.

To live in the wake of modernity is to live without the hope of resurrexit. We need not travel far to find the desert, for it always approaches us where we are, to dislocate us as if from within. In the desert that has become our world, there is only exile—chronic exile—without beginning and without ending. Beginning never begins and ending never ends. Thus, all time is the meantime of the always already, and all space is the nonsite of the between that is no where. Forever under way in the absence of the Way, every arrival is a departure and every location a dis-location.

Who calls . . . what calls, "Come! Wander, err elsewhere . . . always elsewhere?" No response is possible, for our questions are as infinite as the displacement that feeds them. The word of the call is never truly present; it echoes and reechoes from the beyond of a terrifyingly ancient that forever approaches as a future that never arrives to disrupt the present that never is. To heed this unspeakable word is to be mortally wounded—"wounded from behind"—by the unrecoverable immemorial that dismembers. To be open to . . . to be opened by the bleeding trace of the wounded word is to suffer a disfiguring for which there is no cure

.

.

.

fragile nontruth
rending nontruth
of disfiguring
haunted
forever haunted by
the Truth that
cures
the incurable Truth that
cures
not

.

.

.

# ABBREVIATIONS
# AND EDITIONS

| A | Jean Baudrillard, *America*, trans. Chris Turner (New York: Verso, 1988). |
|---|---|
| AA | Ad Reinhardt, *Art-as-Art: The Selected Writings of Ad Reinhardt*, ed. Barbara Rose (New York: Viking Press, 1975). |
| AC | Charles-Édouard Jeanneret and Amédée Ozenfant, *Après le cubisme* (Torino: Bottega d'Erasmo, 1975). |
| AE | Friedrich Schiller, *On the Aesthetic Education of Man in a Series of Letters*, trans. Reginald Snell (New York: Frederick Ungar, 1977). |
| AGK | Clement Greenberg, "Avant-Garde and Kitsch," in *The Collected Essays*, ed. John O'Brian, vol. 1 (Chicago: University of Chicago Press, 1986). |
| AK | Mark Rosenthal, *Anselm Kiefer* (Philadelphia: Philadelphia Museum of Art, 1987). |
| AM | Bernard Tschumi, *Architectural Manifestoes* (London: Architectural Association). |
| AS | Josef Chytry, *The Aesthetic State: A Quest in Modern German Thought* (Berkeley: University of California Press, 1989). |
| AW | Andy Warhol, *The Philosophy of Andy Warhol* (New York: Harcourt Brace Jovanovich, 1975). |
| BB | Lawrence Weschler, *Shapinsky's Karma, Boggs's Bills, and Other True-Life Tales* (San Francisco: North Point Press, 1988). |
| BT | Friedrich Nietzsche, *The Birth of Tragedy*, trans. Francis Golffing (New York: Doubleday and Co., 1956). |
| C | Karl Marx, *Capital: A Critique of Political Economy*, trans. Samuel Moore and Edward Aveling, vol. 1 (New York: International Publishers, 1967). |
| CC | Robert Venturi, *Complexity and Contradiction in Architecture* (New York: Museum of Modern Art, 1988). |
| CF | Bernard Tschumi, *Cinégramme folie: La Parc de La Villette* (Princeton: Princeton Architectural Press, n.d.). |

CJ          Immanuel Kant, *The Critique of Judgment,* trans. James Meredith (New York: Oxford University Press, 1973).

CM          Charles Moore, *Buildings and Projects, 1949–1986,* ed. E. J. Johnson (New York: Rizzoli, 1986).

CPR         Immanuel Kant, *Critique of Pure Reason,* trans. Norman Kemp Smith (New York: St. Martin's Press, 1965).

CV          Bernard Tschumi, *La case vide* (Landeer, England: Architectural Association, 1985).

CW          Jeffery Kipnis, ed., *Choral Work,* forthcoming.

D           Jacques Derrida, *Dissemination,* trans. Barbara Johnson (Chicago: University of Chicago Press, 1981).

DS          Hans L. C. Jaffé, ed., *De Stijl, 1917–1931: Visions of Utopia* (New York: Abbeville Press, 1982).

E           Harold Rosenberg, *Art on the Edge* (New York: Macmillan, 1975).

EA          Kazimir Malevich, *Essays on Art, 1915–1928,* trans. X. Glowacki-Prus and A. McMillan, vol. 1 (Copenhagen: Borgen, 1968).

EC          Paul Turner, *The Education of Le Corbusier: A Study of Le Corbusier's Thought, 1900–1920* (New York: Garland Publishing Co., 1977).

EL          Edmond Jabès, *The Book of Questions: El, or the Last Book,* trans. Rosmarie Waldrop (Middletown, CT: Wesleyan University Press, 1984).

FA          G. W. F. Hegel, *Aesthetics: Lectures on Fine Art,* trans. T. M. Knox, vol. 1 (New York: Oxford University Press, 1975).

G           Karl Marx, *Grundrisse: Foundations of the Critique of Political Economy,* trans. Martin Nicholaus (New York: Random House, 1973).

GI          Edouard Schuré, *The Great Initiates: A Study in the Secret History of Religions,* trans. Gloria Rasberry (New York: Harper and Row, 1961).

HC          *PETER EISENMAN HOUSE OF CARDS* (New York: Oxford University Press, 1987).

IE          Georges Bataille, *Inner Experience,* trans. Leslie Boldt (Albany: State University of New York Press, 1988).

IS          Philip Johnson and Henry-Russell Hitchcock, *The International Style: Architecture since 1922* (New York: W. W. Norton and Co., 1932).

JJ          Richard Francis, *Jasper Johns* (New York: Abbeville Press, 1984).

KT          H. P. Blavatsky, *The Key to Theosophy* (Point Loma, CA: Aryan Theosophical Press, 1913).

L           Maurice Blanchot, *The Space of Literature,* trans. Ann Smock (Lincoln: University of Nebraska Press, 1982).

LA    Philippe Lacoue-Labarthe and Jean-Luc Nancy, *The Literary Absolute: The Theory of Literature in German Romanticism* (Albany: State University of New York Press, 1988).

LV    Robert Venturi, Denise Scott Brown, and Steven Izenour, *Learning from Las Vegas: The Forgotten Symbolism of Architectural Form* (Cambridge: MIT Press, 1988).

M    Jacques Derrida, *Memoires for Paul de Man,* trans. Cecile Lindsay, Jonathan Culler, and Eduardo Cadava (New York: Columbia University Press, 1986).

MA    Manfredo Tafuri, *Modern Architecture,* vols. 1 and 2 (New York: Rizzoli, 1976).

MG    *Michael Graves: Buildings and Projects, 1966–1981,* ed. Karen Vogel Wheeler, Peter Arnell, and Ted Bickford (New York: Rizzoli, 1982).

MR    Franz Schulze, *Mies van der Rohe: A Critical Biography* (Chicago: University of Chicago Press, 1985).

MS    André Breton, *Manifestoes of Surrealism,* trans. Richard Seaver and Helen Lane (Ann Arbor: University of Michigan Press, 1969).

MT    Bernard Tschumi, *The Manhattan Transcripts* (London: Architectural Design, 1981).

NO    Kazimir Malevich, *The Non-objective World* (Chicago: Paul Theobald and Co., 1959).

OC    Adolf Loos, "Ornament and Crime," in *The Architecture of Adolf Loos* (New York: Arts Council, n.d.).

P    *Pistoletto: Division and Multiplication of the Mirror,* curated by Germano Celant and Alanna Heiss (New York: Institute for Contemporary Art, 1981).

PA    F. W. J. Schelling, *The Philosophy of Art,* trans. Douglas Scott (Minneapolis: University of Minnesota Press, 1988).

PLT    Martin Heidegger, *Poetry, Language, Thought,* trans. Albert Hofstadter (New York: Harper and Row, 1971).

PM    Charles Jencks, *Post-modernism: The New Classicism in Art and Architecture* (New York: Rizzoli, 1987).

PR    G. W. F. Hegel, *Lectures on the Philosophy of Religion,* trans. E. G. Speirs and J. B. Sanderson, vol. 3 (New York: Humanities Press, 1968).

PS    G. W. F. Hegel, *Phenomenology of Spirit,* trans. A. V. Miller (New York: Oxford University Press, 1977).

RS    Georges Bataille, "La religion surréaliste," in *Oeuvres complètes,* vol. 7 (Paris: Gallimard, 1976).

S        Jean Baudrillard, *Simulations,* trans. Paul Foss, Paul Patton, and Philip Reitchman (New York: Semiotext[e], 1983).

SB       Jacques Derrida, "Shibboleth," in *Midrash and Literature,* ed. Geoffrey Hartman and Sanford Budick (New Haven: Yale University Press, 1986).

SC       Max Weber, *The Protestant Ethic and the Spirit of Capitalism,* trans. Talcott Parsons (New York: Charles Scribner's Sons, 1958).

SL       G. W. F. Hegel, *Science of Logic,* trans. A. V. Miller (New York: Oxford University Press, 1969).

SM       Peter Carter, "Sayings of Mies van der Rohe," *Architectural Design* (1961).

SN       Robert Hughes, *The Shock of the New* (New York: Alfred Knopf, 1967).

SP       Guy Debord, *Society of the Spectacle* (Detroit: Black and Red Press, 1970).

SR       Friedrich Schleiermacher, *On Religion: Speeches to Its Cultured Despisers,* trans. Richard Crouter (New York: Cambridge University Press, 1988).

TA       Le Corbusier, *Towards a New Architecture,* trans. F. Etchells (London: Architectural Press, 1987).

TB       Peter Eisenman, "Architecture as a Second Language: The Texts of Between," *Restructuring Architectural Theory, Threshold* 4 (Spring 1988): 71–75.

TF       Annie Besant and Charles W. Leadbeater, *Thought-Forms* (Wheaton, IL: Theosophical Publishing House, 1917).

TMA      Herschel B. Chipp, ed., *Theories of Modern Art: A Source Book by Artists and Critics* (Berkeley: University of California Press, 1968).

TP       Jacques Derrida, *The Truth in Painting,* trans. Geoffrey Bennington and Ian McLeod (Chicago: University of Chicago Press, 1987).

TR       Georges Bataille, *Theory of Religion,* trans. Robert Hurley (New York: Zone Books, 1989).

VE       Georges Bataille, *Visions of Excess: Selected Writings, 1927–1939,* trans. Alan Stoekl, Carl Lovitt, and Donald Leslie (Minneapolis: University of Minnesota Press, 1985).

WD       Maurice Blanchot, *The Writing of the Disaster,* trans. Ann Smock (Lincoln: University of Nebraska Press, 1986).

# NOTES

## CHAPTER ONE

1. Paul Tillich, "On the Theology of Fine Art and Architecture," in *On Art and Architecture,* ed. John Dillenberger and Jane Dillenberger (New York: Crossroad, 1987), 204. In this volume, the Dillenbergers have collected Tillich's most important writings on the visual arts. Tillich's discussion of art in his *Systematic Theology* is limited by the restriction of his remarks to the role art plays in the life of the church. See *Systematic Theology* (Chicago: University of Chicago Press, 1967), 3:197–201.

2. There are several noteworthy exceptions to this general rule. Geradus van der Leeuw develops a phenomenological analysis of the religious implications of different artistic forms in *Sacred and Profane Beauty: The Holy in Art,* trans. D. E. Green (London: Weidenfeld and Nicholson, 1963). John Dillenberger, who was one of Tillich's students, has written what amounts to a theologically informed historical survey of religion and the visual arts (*A Theology of Artistic Sensibilities: The Visual Arts and the Church* [New York: Crossroad, 1986]). Though Thomas J. J. Altizer presents extensive analyses of the theological import of modern literature, passing comments make it clear that he also recognizes the religious significance of modern painting. See, inter alia, Altizer, *Total Presence: The Language of Jesus and the Language of Today* (New York: Seabury Press, 1980). More recently, Gregor Goethals has presented a timely analysis of the religious import of electronic images (*The Electronic Golden Calf: Images, Religion, and the Making of Meaning* [Cambridge, MA: Cowley Publications, 1990]).

3. Clement Greenberg, "Modernist Painting," in *The New Art: A Critical Anthology,* ed. Gregory Battcock (New York: E. P. Dutton and Co., 1966), 101, 102.

4. Michael Fried, "How Modernism Works: A Response to T. J. Clark," in *Pollock and After: The Critical Debate,* ed. Francis Frascina (New York: Harper and Row, 1985), 67.

5. Clement Greenberg, "Towards a Newer Laocoon," in Frascina, *Pollock and After,* 43.

6. I have begun to develop the notion of a/theology in several previous books. See *Deconstructing Theology* (New York: Crossroad, 1982); *Erring: A Postmodern A/theology* (Chicago: University of Chicago Press, 1984); *Altarity* (Chicago: University of Chicago Press, 1987); and *Tears* (Albany: State University of New York Press, 1990). I shall extend and expand my interpretation of a/theology in chapter 9 of this book.

7. As will become apparent, my primary focus is on painting and architecture. Many of the most innovative interpretations of art in recent years have moved from painting to sculpture and various forms of performance art. While I have learned much from these critical strategies, I am not convinced that painting is as regressive as many critics insist. To the contrary, critical insights developed in relation to art forms other than painting can be productively turned back on painting itself.

8. *Aesthetic* derives from the Greek *aisthetikos,* which means "pertaining to sense perception."

9. Terry Eagleton, *The Ideology of the Aesthetic* (Cambridge, MA: Basil Blackwell, 1990), 13.

10. In contrast to the dearth of theological and philosophical studies of modern

art, the relationship between religion and aesthetics has received considerably more attention. The most extensive study of the theological implications of aesthetics is Hans Urs Von Balthasar, *Seeing the Form,* trans. Erasmo Leiva-Merikakis (New York: Crossroad, 1983).

11. These definitions are from *The Oxford English Dictionary* and *The American Heritage Dictionary of the English Language.*

12. J. Laplanche and J.-B. Pontalis, "Distortion" (*Entstellung*), in *The Language of Psycho-Analysis,* trans. Donald Nicholson-Smith (New York: W. W. Norton, 1973), 124.

13. *Dénégation* is the standard French translation of *Verneinung.*

14. Georges Didi-Huberman, *Devant l'image* (Paris: Éditions de Minuit, 1990), 178.

15. Roger Shattuck, *The Banquet Years: The Origins of the Avant-Garde in France, 1885–World War I* (New York: Random House, 1968), 26.

16. James Joyce, *Finnegans Wake* (New York: Viking Press, 1976), 628.

17. Charles Baudelaire, *The Painter of Modern Life and Other Essays,* trans. Jonathan Mayne (New York: Da Capo Press, 1964), 12.

18. Annette Michelson, "Art and the Structuralist Perspective" (manuscript, photocopy in my possession), 56.

19. Roland Barthes, "The Eiffel Tower," in *A Barthes Reader,* ed. Susan Sontag (New York: Hill and Wang, 1982), 237.

20. Tom Wolfe, *The Painted Word* (New York: Bantam Books, 1975), 4–5.

21. Arthur Danto, *The Philosophical Disenfranchisement of Art* (New York: Columbia University Press, 1986), 111.

22. Walter Benjamin, "The Work of Art in the Age of Mechanical Reproduction," in *Illuminations,* ed. Hannah Arendt (New York: Schocken Books, 1969), 217–51.

23. Douglas Crimp, "The End of Painting," *October* 16 (1981): 77.

24. I use the term "nonabstract" at this point to call attention to the problems involved in the commonplace opposition between abstract (or nonobjective) and representational art. Painting can resist abstraction without becoming representational.

25. Robert Morris, "Three Folds in the Fabric and Four Autobiographical Asides as Allegories (or) Interruptions," in *Critical Relations* (Williamstown, MA: Highgate Art Trust, 1989), 6.

26. The most insightful recent analyses of the relationship between language and image include W. J. T. Mitchell, *Iconology: Image, Text, Ideology* (Chicago: University of Chicago Press, 1986); Roland Barthes, *Image—Music—Text,* trans. Stephen Heath (New York: Hill and Wang 1977); and Jean-François Lyotard, *Discours, Figure* (Paris: Éditions Klincksieck, 1985).

27. Maurice Merleau-Ponty, *L'oeil et l'esprit* (Paris: Gallimard, 1964), 23.

## CHAPTER TWO

1. Robert Rosenblum, *Modern Painting and the Northern Romantic Tradition: Friedrich to Rothko* (New York: Harper and Row, 1975), 14–15.

2. Thomas Moore, *The Letters of Thomas Moore,* quoted in Rosenblum, *Modern Painting,* 19–20.

3. Rudolf Otto, *The Idea of the Holy: An Inquiry into the Non-rational Factor in the Idea of the Divine and Its Relation to the Rational,* trans. John Harvey (New York: Oxford University Press, 1958). Otto was deeply influenced by Schleiermacher's account of religion in terms of feeling as well as by Kant's analysis of the sublime.

4. William Wordsworth, "Lines Composed a Few Miles above Tintern Abbey on Revisiting the Banks of the Wye during a Tour. July 13, 1798," in *The Norton Anthology of English Literature,* ed. M. H. Abrams (New York: W. W. Norton and Co., 1962), 2:78–79. In his essay "Nature," Ralph Waldo Emerson gives the classic American statement of Wordsworth's point: "Standing on the bare ground,—my head bathed by the blithe air, and uplifted into infinite space,—all mean egotism vanishes. I become a transparent eye-ball; I am nothing; I see all; the currents of the Universal being circulate through me; I am part or parcel of God" (*Nature: Addresses and Lectures* [Boston: Houghton, Mifflin, and Co., 1903], 10).

5. Josef Chytry points out that in 1785 the duchy of Weimar, which consisted of Weimar proper, Eisenach, and Ilmenau, had a population of 106,000. Jena had a mere 4,000 inhabitants (AS, 40).

6. August 18, 1771, entry. Quoted in Rosenblum, *Modern Painting,* 18.

7. M. H. Abrams, *Natural Supernaturalism: Tradition and Revolution in Romantic Literature* (New York: W. W. Norton and Co., 1971), 199.

8. Quoted in Alec R. Vidler, *The Church in an Age of Revolution* (Baltimore: Penguin, 1971), 31. Religion is discussed in relation to romanticism usually to show the regression of politically concerned artists who turn away from social revolution and toward the Catholic church. Though this pattern is undeniable in the careers of some of the Jena romantics, it should not obscure the way in which less traditional forms of religious belief contribute to revolutionary social and political vision.

9. Schleiermacher lectured on aesthetics at the University of Berlin in 1819. These lectures were not published until 1842.

10. At one point, Schleiermacher describes this "immediate consciousness" as "childlike passivity" (SR, 102). The association of the child with the primitive is a recurrent theme in modernism.

11. Immanuel Kant, *On History,* trans. Lewis White Beck (New York: Bobbs-Merrill, 1965), 3.

12. I borrow this term from Philippe Lacoue-Labarthe and Jean-Luc Nancy (LA, 35). It should be clear that Schleiermacher's organic totality also conforms to the structure of this system-subject.

13. Josiah Royce, *Lectures on Modern Idealism* (New Haven: Yale University Press, 1964). Although Royce's remarks are made in the context of his consideration of theoretical reason, Kant's account of practical reason leads to the same conclusion.

14. Richard Kearney, *The Wake of Imagination: Toward a Postmodern Culture* (Minneapolis: University of Minnesota Press, 1988), 170.

15. Ibid., 191.

16. Martin Heidegger, *Kant and the Problem of Metaphysics,* trans. J. S. Churchill (Bloomington: Indiana University Press, 1962), 173, 169.

17. Kant's analysis of *Zweckmässigkeit ohne Zweck* and his correlative account of disinterestedness form the philosophical basis of the doctrine of art for art's sake that developed in the latter half of the nineteenth century.

18. Jacques Derrida, "Economimesis," *Diacritics* 11 (1981): 9.

19. John Sallis, *Spacings—of Reason and Imagination in the Texts of Kant, Fichte, and Hegel* (Chicago: University of Chicago Press, 1987), 91.

20. Jean-Luc Nancy, "L'offrande sublime," in *Du sublime* (Paris: Éditions Belin, 1988), 50.

21. Winckelmann's "gaiety" is a precursor of Nietzsche's "gay science." Indeed, Nietzsche's interpretation of Greek culture is a product of the tradition that Winckelmann inaugurated.

22. *Aufgehoben* is, of course, the term that Hegel uses to define the operation of his speculative dialectic. When opposites are sublated, they are simultaneously negated and preserved.

23. Friedrich Hölderlin, *Grosse Stuttgarter Ausgabe,* ed. Friedrich Beissner (Stuttgart: Cotta, 1946–77), 4:216.

24. Hegel is equally critical of his colleague Schleiermacher. Responding to Schleiermacher's analysis of religion in terms of intuition, Hegel argues that if religion is essentially a matter of feeling, the most religious creature would be a *dog!* The point of Hegel's critique of Schelling and Schleiermacher is basically the same: they both fail to grasp the dialectical relation between unity and multiplicity. From Hegel's perspective, any such position is finally nihilistic. By collapsing difference into identity, the meaning and value of the world of appearance are negated. One of the fundamental aims of Hegel's philosophy is to reinvest appearance with essential significance.

25. G. W. F. Hegel, *The Difference between Fichte's and Schelling's Systems of Philosophy,* trans. H. S. Harris and Walter Cerf (Albany: State University of New York Press, 1977), 89, 91.

26. G. W. F. Hegel, "Earliest System-Programme of German Idealism," in H. S.

Harris, *Hegel's Development toward the Sunlight, 1770–1801* (New York: Oxford University Press, 1972), 511. After a meticulous reconstruction of the debates surrounding the question of the authorship of this fragment, Harris writes, "My conclusion, therefore, is that the fragment *eine Ethik* is indeed a piece of Hegel's own work, and not something that he copied; and that he wrote it in Berne—or more precisely at Tschugg—in the summer of 1796" (257). Chytry, by contrast, attributes the *System-program* to Hölderlin (AS, 125–28). On this issue, I find Harris's argument persuasive. Regardless of the identity of the author, this brief statement accurately summarizes the general position that Hegel, Hölderlin, and Schelling held during the mid-1790s.

27. Hegel, "Earliest System-Programme of German Idealism," 509, 510.

28. See *Hegels theologische Jugendschriften,* ed. Herman Nohl (Tübingen: J. C. B. Mohr, 1907). A selection of these essays has been translated into English by T. M. Knox: G. W. F. Hegel, *Early Theological Writings* (Philadelphia: University of Pennsylvania Press, 1971).

29. Hegel, *Early Theological Writings,* 196.

30. The notion of the Trinity is the product of a long religious development that repeats in a different register the moments in the evolution of art. Hegel analyzes this progression in *Lectures on the Philosophy of Religion.* For a consideration of Hegel's treatment of religion, see Mark C. Taylor, *Journeys to Selfhood: Hegel and Kierkegaard* (Berkeley: University of California Press, 1980), especially 105–22, 141–62, and 181–228.

31. Derrida contends that the brief phrase *in seinem Anderen* expresses the heart of Hegel's dialectic: "'*in seinem Anderen.*' The 'its other' is the very syntagm of the Hegelian proper; it constitutes negativity in the service of the proper, literal sense" (*Glas,* trans. John Leavey and Richard Rand [Lincoln: University of Nebraska Press, 1986], 83).

32. G. W. F. Hegel, *The Logic of Hegel,* trans. W. Wallace (New York: Oxford University Press, 1968), 285.

## CHAPTER THREE

1. T. S. Eliot, "Little Gidding," in *The Norton Anthology of English Literature,* 4th ed. (W. W. Norton and Co., 1979), 2:2292, lines 241–44, 254–61.

2. As I noted in the opening chapter, interest in formal matters has long obscured the spiritual and religious dimensions of modern art. In recent years, this has begun to change. One of the major factors contributing to this shift in critical perspective was the remarkable exhibition mounted in 1986–87 by the Los Angeles County Museum of Art. The catalogue for this show, *The Spiritual in Art: Abstract Painting, 1890–1985* (New York: Abbeville Press, 1986), is a rich resource that deserves serious attention.

3. Böhme's use of illustrative figures is neither unique nor original. In "Hidden Meanings in Abstract Art," the opening essay of *The Spiritual in Art,* Maurice Tuchman presents an impressive collection of Theosophical images.

4. See Rudolf Steiner, *A Theory of Knowledge Implicit in Goethe's World Conception* (Spring Valley, NY: Anthroposophic Press, 1968).

5. For a summary of Anthroposophy, see Rudolph Steiner, *An Outline of Occult Science* (Spring Valley, NY: Anthroposophic Press, 1972).

6. H. P. Blavatsky, *The Secret Doctrine: The Synthesis of Science, Religion, and Philosophy* (Covina, CA: Theosophical University Press, 1925), 1:16. More interested in free associations than in careful analysis, Blavatsky elsewhere writes, "The Hegelian doctrine, which identifies *Absolute Being* or 'Be-ness' with 'non-Being,' and represents the Universe as an *eternal becoming,* is identical with Vedânta philosophy" (2:449 n. 948).

7. The image of the crystal, which appears repeatedly in Theosophical reflections, is appropriated by many modern artists and architects and still plays an important role in New Age religions.

8. Though Hegel repeatedly uses the metaphor of the circle to describe his philosophical method, nowhere is the significance of this image clearer than in his closing

remarks in *Science of Logic:* "[S]cience exhibits itself as a *circle* returning upon itself, the end being wound back into the beginning, and the simple ground, by the mediation; this circle is moreover a *circle of circles,* for each individual member as ensouled by the method reflected into itself, so that in returning into the beginning it is at the same time the beginning of the new member" (SL, 842). For Hegel, as for Eliot, "the end of all our exploring / Will be to arrive where we started / And know the place for the first time."

9. John Berger, "The Moment of Cubism," in *The Sense of Sight: Writings of John Berger,* ed. Lloyd Spencer (New York: Pantheon Books, 1985), 160.

10. Ibid., 163.

11. Friedrich Nietzsche, *The Gay Science,* trans. Walter Kaufmann (New York: Random House, 1974), 181.

12. In a highly persuasive argument, Jean-Joseph Goux examines the socio-historical conditions underlying this change in the understanding of the subject. See Goux, *Symbolic Economies: After Marx and Freud,* trans. Jennifer C. Gage (Ithaca: Cornell University Press, 1990).

13. George Heard Hamilton, *Painting and Sculpture in Europe, 1880–1940* (New York: Penguin Books, 1981), 16.

14. Quoted in Roland Penrose, *Picasso: His Life and Work,* 3d ed. (Berkeley: University of California Press, 1981), 153.

15. Maurice Merleau-Ponty, *Sense and Non-sense,* trans. Herbert L. Dreyfus and Patricia A. Dreyfus (Evanston: Northwestern University Press, 1964), 13–14.

16. Quoted in Hamilton, *Painting and Sculpture in Europe,* 15.

17. Though Picasso usually has been regarded as the leader in the emergence of cubism, the Museum of Modern Art's revisionary exhibition *Picasso and Braque: Pioneering Cubism* (September 24, 1989–January 16, 1990) demonstrated previously unacknowledged aspects of the originality of Braque's contributions. While the impact of Picasso's revolutionary *Les demoiselles d'Avignon* (1907) on Braque is undeniable, it is clear that the discovery of cubism was a joint affair in which Picasso and Braque were *nearly* equal partners.

18. Penrose, *Picasso,* 196. I shall consider the notion of the fourth dimension in the context of my analysis of Malevich's work.

19. Though Saussure taught Sanskrit, Gothic, and Old High German at the École pratique des hautes études in the late 1880s, there is, to my knowledge, no evidence that he had any contact with or influence on Braque and Picasso.

20. Edward Fry and Guy Habasque also stress the parallel between cubism and Husserl's phenomenology. See *Cubism* (New York: McGraw-Hill, 1985), 39; and "Cubisme et phénoménologie," *Revue d'esthétique,* April–June 1949, 151–61. For a suggestive analysis of perception that uses the example of apprehending a cube, see Maurice Merleau-Ponty, *Phenomenology of Perception,* trans. Colin Smith (London: Routledge and Kegan Paul, 1962), 203–6. Merleau-Ponty's remark underscores the shared concerns of phenomenology and cubism.

21. The text from which these citations are drawn is Edmund Husserl, "Phenomenology," in *Deconstruction in Context,* ed. Mark C. Taylor (Chicago: University of Chicago Press, 1986), 121–40.

22. Kojève's course on Hegel is, in my judgment, among the most important events in twentieth-century French intellectual history. His analysis of Hegel set the intellectual agenda from his day to our own time. Those who participated in the course include, among others, Jean-Paul Sartre, Maurice Merleau-Ponty, Georges Bataille, Jacques Lacan, Raymond Aron, and Raymond Queneau. Kojève's lectures have been published under the title *Introduction à la lecture de Hegel* (Paris: Gallimard, 1968). Selections from this volume have been translated into English: *Introduction to the Reading of Hegel,* trans. James Nicholas, ed. Allan Bloom (New York: Basic Books, 1969).

Born in Russia, Kojève fled his homeland in 1920 at the age of twenty. After a brief incarceration in a Polish prison, he traveled to Berlin and Heidelberg, finally arriving in Paris in 1927, where he remained until his death in 1968. For a fuller account of Kojève's career, see Michael S. Roth, *Knowing and History: Appropriations of Hegel in Twentieth-Century France* (Ithaca: Cornell University Press, 1988), 83–146.

"Les peintures concrètes de Kandinsky" appears in *Revue de métaphysique et morale* 90, no. 2 (1985): 149–71. The passages I quote from Kojève can be found in this essay.

23. Marit Werenskiold, "Kandinsky's Moscow," *Art in America* 77 (March 1989): 98.

24. Wassily Kandinsky and Franz Marc, *The Blaue Reiter Almanac*, ed. Klaus Lankheit (New York: Viking Press, 1974), 250.

25. Wassily Kandinsky, *Concerning the Spiritual in Art*, trans. M. T. H. Sadler (New York: Dover Publications, 1977), 14.

26. Ibid., 2, 32.

27. Wassily Kandinsky, *Point and Line to Plane*, trans. Howard Dearstyne and Hilla Rebay (New York: Dover Publications, 1979), 21.

28. Sixten Ringbom has developed the most extensive analysis to date of Kandinsky's debt to Theosophy in *The Sounding Cosmos: A Study in the Spiritualism of Kandinsky and the Genesis of Abstract Painting* (Helsinki: Abo Academi, 1970).

29. Wassily Kandinsky, "On the Question of Form," in Kandinsky and Marc, *Blaue Reiter Almanac*, 164–65.

30. Ibid., 149.

31. I have gathered this information from Clark V. Poling's outstanding work *Kandinsky: Russia and the Bauhaus Years, 1915–1933* (New York: Solomon R. Guggenheim Museum, 1983), 12–19.

32. Quoted in Camilla Gray, *The Russian Experiment in Art, 1863–1922* (New York: Henry Abrams, 1962), 249.

33. Quoted in Poling, *Kandinsky: Russia and the Bauhaus Years*, 54.

34. Kandinsky, *Point and Line to Plane*, 25.

35. Robert P. Welsh and J. M. Joosten, *Two Mondrian Sketchbooks, 1912–1914* (Amsterdam: Meulenhoff, 1969), 33–35.

36. Piet Mondrian, *The New Art: The New Life*, ed. Harry Holzman and Martin James (Boston: G. K. Hall and Co., 1986), 44.

37. Michael Govan, "Plato to Plastic: Mondrian and the Representation of the Modern Ideal," in *Mondrian e de Stijl: L'ideale moderno* (Milan: Electa, 1990), 14.

38. Quoted in H. L. C. Jaffé, *De Stijl, 1917–1931: The Dutch Contribution to Modern Art* (Amsterdam: Meulenhoff, 1956), 57.

39. Blavatsky, *Secret Doctrine*, 1:353–54.

40. Mondrian, "The New Plastic in Painting," in *New Art*, 49n.

41. Shattuck, *Banquet Years*, 345.

42. Quoted in Stephen Kern, *The Culture of Time and Space, 1880–1918* (Cambridge: Harvard University Press, 1983), 72.

43. Linda D. Henderson's book, *The Fourth Dimension and Non-Euclidean Geometry in Modern Art* (Princeton: Princeton University Press, 1983), is the most complete study of the impact of geometrical and mathematical speculation on early-twentieth-century art. It is interesting to note that the movement into the fourth dimension was a favorite theme of science fiction writers like E. A. Abbott, H. G. Wells, and others. Abbott's *Flatland: A Romance of Many Dimensions by a Square* was particularly popular at the end of the last century.

44. Quoted in Roger Lipsey, *An Art of Our Own: The Spiritual in Twentieth-Century Art* (Boston: Shambhala, 1988), 143.

45. El Lissitzky, "Suprematism in World Reconstruction," in *Russian Art of the Avant Garde: Theory and Criticism, 1902–1934*, ed. John E. Bowlt (New York: Thames and Hudson, 1988), 158.

46. Quoted in Charlotte Douglas, "Beyond Reason: Malevich, Matiushin, and Their Circles," in *Spiritual in Art*, 187.

47. Serge Guilbaut, *How New York Stole the Idea of Modern Art: Abstract Expressionism, Freedom, and the Cold War*, trans. Arthur Goldhammer (Chicago: University of Chicago Press, 1983), 2. Guilbaut presents a richly documented analysis of the political and social context of postwar American art.

48. In developing the following remarks, I have been guided by Raoul Mortley's *Word to Silence: The Rise and Fall of the Logos*, vols. 1 and 2 (Bonn: Hanstein, 1986).

49. Thomas B. Hess, *Barnett Newman* (New York: Museum of Modern Art, 1971), 99.

50. Barnett Newman, "The Sublime Is Now," in *Abstract Expressionism: A Critical Record,* ed. David Shapiro and Cecile Shapiro (New York: Cambridge University Press, 1990), 328.

51. Harold Rosenberg, *Barnett Newman* (New York: Henry Abrams, 1978), 42.

52. Jean-François Lyotard, "The Sublime and the Avant-Garde," in *The Lyotard Reader,* ed. Andrew Benjamin (Cambridge: Basil Blackwell, 1989), 199.

53. Quoted in Rosenberg, *Barnett Newman,* 59.

54. Hess, *Barnett Newman,* 73. Hess presents the most complete analysis of the Kabbalistic dimensions of Newman's art.

55. In her fine study of Rothko, Anna Chave attempts to draw a direct line between the early religious art of a painter like Bellini and Rothko's abstract work. Although the argument is strained at this point, there is clearly a continuity of interest between traditional Western religious art and Rothko's abstract expressionism. See Anna C. Chave, *Mark Rothko: Subjects in Abstraction* (New Haven: Yale University Press, 1989), chapter 7.

56. Quoted in ibid., 50.

57. Ibid., 80, 191.

58. Ibid., 197.

## CHAPTER FOUR

1. Gertrude Stein, *Picasso* (New York: Charles Scribner's Sons, 1939), 11.

2. Kern, *Culture of Time and Space,* 259–60.

3. Quoted in ibid., 293. In developing these remarks on the homogeneity and simultaneity of temporality, I have followed Kern's insightful analysis. On page 295, Kern quotes the lines from Apollinaire that I cite below.

4. Karl Barth, *The Epistle to the Romans,* trans. Edwyn C. Hoskyns (New York: Oxford University Press, 1968), 10.

5. Karl Barth, *Protestant Thought: From Rousseau to Ritschl,* trans. Brian Cozens (New York: Simon and Schuster, 1969), 14.

6. Barth, *Epistle to the Romans,* 242.

7. Paul Turner presents the most complete analysis of Le Corbusier's educational background in *The Education of Le Corbusier: A Study of the Development of Le Corbusier's Thought, 1900–1920* (New York: Garland Publishing Co., 1977). Turner's account has provided valuable guidance in developing my interpretation of Le Corbusier's religious training.

8. Since Provensal's *L'art de demain* seems to be available only at Fondation Le Corbusier in Paris, I have had to rely on passages cited in Turner's *Education of Le Corbusier.* All the quotations from Provensal that I cite can be found in the first chapter of Turner's book. The translations are my own.

9. Charles-Édouard Jeanneret and Amédée Ozenfant, *Après le cubisme* (Torino: Bottega d'Erasmo, 1975), 27. In the following pages, references to this work are cited in the text. The translations are my own.

10. *La part maudite* is the title of one of Georges Bataille's most important works. I shall return to Bataille when I analyze Bernard Tschumi's critique of modern architecture in chapter 7.

11. The two buildings in which this development is most evident are the Monastery of La Tourette and the chapel of Ronchamp. I shall return to these structures in chapter 8.

12. Robert Fishman, *Urban Utopias in the Twentieth Century: Ebenezer Howard, Frank Lloyd Wright, and Le Corbusier* (Cambridge: MIT Press, 1982), 190.

13. Ibid., 232.

14. For a thorough discussion of different aspects of this issue, see Le Corbusier, *The Radiant City: Elements of a Doctrine of Urbanism to Be Used as the Basis of Our Machine-*

*Age Civilization* (New York: Orion Press, 1967). The broader political aspirations that inform Le Corbusier's vision of the Radiant City are suggested in his plans for the League of Nations Palace. Like most utopian believers, the city he imagines is universal. The League of Nations Palace is designed to serve as the seat of world government.

15. Quoted in Fishman, *Urban Utopias,* 240. Fisher provides a helpful account of Le Corbusier's political involvements; see especially chapters 25–27. In this context, it is important to note that in the early 1940s Le Corbusier held a position in the Vichy government.

16. Colin Rowe and Fred Koetter, *Collage City* (Cambridge: MIT Press, 1978). Rowe is one of the few critics who has noted the importance of Hegel for modern architecture. He observes, "But the approach of Hegel, whose ideas are surely an indispensable component of the early-twentieth-century utopia, is attended with the most massive difficulty—with pain. Historical inevitability, historical dialectic, the progressive revelation of the Absolute in history, the spirit of the age or the race or the people: we are dimly aware of how much these outcroppings of a theory of society as growth and, also, of how much less visible is their influence than that of theories of purely classical or French provenance" (27).

17. Nancy J. Troy, *The De Stijl Environment* (Cambridge: MIT Press, 1983), 117.

18. For further consideration of Malevich's influence on architecture, see Christina Lodder, *Russian Constructivism* (New Haven: Yale University Press, 1983), chapter 5; and Marcel Otakar, "The Black Square and Architecture," *Art and Design* 5/6 (1989): 59–63.

19. Lissitzky, "Suprematism in World Reconstruction," 153.

20. Walter Gropius, "Address to the Students of the Staatliche Bauhaus, Held on the Occasion of the Yearly Exhibition of Student Work in July 1919," in *The Bauhaus,* ed. Hans M. Wingler (Cambridge: MIT Press, 1986), 36.

21. Walter Gropius, "Program of the Staatliche Bauhaus in Weimar," in *Bauhaus,* 31.

22. Lipsey, *Art of Our Own,* 202.

23. Ibid., 202.

24. See Poling, *Kandinsky: Russia and the Bauhaus Years.*

25. Walter Gropius, *The New Architecture and the Bauhaus,* trans. P. Morton Shand (Cambridge: MIT Press, 1989), 29, 43–44.

26. Ibid., 37–38.

27. Sigfried Giedion, *Space, Time, and Architecture: The Growth of a New Tradition* (Cambridge: Harvard University Press, 1969), 495.

28. Carl Schorske, *Fin-de-Siècle Vienna: Politics and Culture* (New York: Random House, 1981), 339.

29. Adolf Loos, "The Plumber," in *Spoken into the Void: Collected Essays, 1897–1900,* trans. Jane O. Newman and John H. Smith (Cambridge: MIT Press, 1982), 49.

30. I borrow this phrase from Georges Bataille.

31. Theodor Adorno, *Minima Moralia: Reflections from a Damaged Life,* trans. E. F. N. Jephcott (New York: Verso, 1989), 40.

32. Norman O. Brown, *Life against Death: The Psychoanalytical Meaning of History* (New York: Random House, 1959), 226, 221. The passage from Luther cited above is quoted by Brown on page 226. For a brilliant psychoanalytic account of the relation between Luther's anality and the emergence of capitalism, see chapters 14–15 of Brown's work.

33. Though recent sociological analyses have uncovered factors Weber overlooks, his analysis of the impact of Protestantism on capitalism remains extremely helpful.

34. In this context, it is important to recall that Freud repeatedly uses economic metaphors to describe psychic processes. The three most interesting readings of the dynamics of the Freudian economy that thus far have been developed are Brown, *Life against Death;* Gilles Deleuze and Félix Guattari, *Anti-Oedipus: Capitalism and Schizophrenia,* trans. Robert Hurley, Mark Seem, and Helen Lane (New York: Viking Press, 1977); and Paul Ricoeur, *Freud and Philosophy: An Essay on Interpretation,* trans. Denis Savage (New Haven: Yale University Press, 1970).

35. In developing the following summary of the late life of the Bauhaus, I have been guided by Franz Schulze's careful analysis in *Mies van der Rohe: A Critical Biography* (Chicago: University of Chicago Press, 1985), 175.

36. See Alex Scobie, *Hitler's State Architecture* (University Park: Pennsylvania State University Press, 1990).

37. In formulating these comments, I have followed Schulze's careful reconstruction of Mies's political involvements. See especially chapter 5, "Depression, Collectivization, and the Crisis of Art, 1929–1936." The following quotations are from pages 198–99.

38. Manfredo Tafuri, *The Sphere and the Labyrinth: Avant-Gardes and Architecture from Piranesi to the 1970s,* trans. Pellegrino d'Acierno and Robert Connolly (Cambridge: MIT Press, 1987), 111.

## CHAPTER FIVE

1. Quoted in Benjamin H. D. Buchloch, "The Andy Warhol Line," in *The Work of Andy Warhol,* ed. Gary Garrels (Seattle: Bay Press, 1989), 55.

2. In developing my analysis of the relationship between money and religion, I have drawn on the following works: William H. Desmond, *Magic, Myth, and Money: The Origin of Money in Religious Ritual* (New York: Free Press, 1962); Paul Einzig, *Primitive Money in Its Ethnological, Historical, and Economic Aspects* (London: Eyre and Spottiswoode, 1948); Pierre Klossowski, *La monnaie vivante* (Paris: Eric Losenfeld, n.d.); *Museum des Geldes: Über die seltsame Natur des Geldes in Kunst, Wissenschaft, und Leben* (Düsseldorf: Städtische Kunsthalle, n.d.); Dennis W. Richardson, *Electric Money: Evolution of an Electronic Funds-Transfer System* (Cambridge: MIT Press, 1970); Lawrence Weschler, *Shapinsky's Karma, Boggs's Bills, and Other True-Life Tales* (San Francisco: North Point Press, 1988); and Jacques Le Goff, *Your Money or Your Life: Economy and Religion in the Middle Ages* (New York: Zone Books, 1988).

3. Joseph T. Shipley, *The Origins of English Words: A Discursive Dictionary of Indo-European Roots* (Baltimore: Johns Hopkins University Press, 1984), 248; Desmond, *Magic, Myth, and Money,* 124.

4. Horst Kurnitzky, "Das liebe Geld: Die wahre Liebe," in *Museum des Geldes,* 39.

5. While it is obvious that this economic relationship continues to inform religious practice, the close connection between pecuniary offerings and ritual sacrifice is less often recognized. The intersection of economics and sacrifice can be seen most clearly in economic theories of the Atonement. Anselm's account of salvation in terms of the payment of a ransom is the classic example of this symbolic exchange. See *Why God Became Man: A Scholastic Miscellany,* ed. Eugene Fairweather (Philadelphia: Westminster Press, 1966), 100–183.

6. Desmond, *Magic, Myth, and Money,* 104–5, 124.

7. For instructive extensions of Freud's analysis of ritual sacrifice, see René Girard, *Violence and the Sacred,* trans. Patrick Gregory (Baltimore: Johns Hopkins University Press, 1981), and *The Scapegoat,* trans. Yvonne Freccero (Baltimore: Johns Hopkins University Press, 1986); and Eric Gans, *The Origin of Language: A Formal Theory of Representation* (Berkeley: University of California Press, 1981).

8. Brown, *Life against Death,* 240.

9. G. W. F. Hegel, *System of Ethical Life,* trans. H. S. Harris and T. M. Knox (Albany: State University of New York Press, 1979), 154. Hegel makes the same point in his mature philosophy: "Money is not one particular type of wealth amongst others, but the universal form of all types so far as they are expressed in an external embodiment and so can be as 'things'" (*Philosophy of Right,* trans. T. M. Knox [New York: Oxford University Press, 1969], 194–95).

10. I—U—P is the third form of the syllogism that Hegel considers. He summarizes the two forms that lead up to it as I—P—U and P—I—U. Only at the third stage does the universal emerge in its "proper" role as the mediator of differences.

11. Georg Simmel, *The Philosophy of Money,* trans. Tom Bottomore and David

Frisby (London: Routledge and Kegan Paul, 1978), 148. Simmel's monumental work has received far less attention than it deserves.

12. Friedrich Nietzsche, "On Truth and Lie in an Extra-moral Sense," in *The Portable Nietzsche,* ed. Walter Kaufmann (New York: Penguin Books, 1980), 46—47.

13. This act actually instituted a bimetallic standard of gold and silver. For all practical purposes, however, the United States adhered to a monometallic gold standard throughout the first half of the nineteenth century.

14. Nast's choice of image of the cock is especially suggestive. If the insights of Marx and Freud are read through Jacques Lacan's psychoanalytic theory, it is possible to interpret money and the phallus as alternative embodiments of the universal equivalent. For an elaboration of this line of argument, see Goux, *Symbolic Economies,* especially chapter 1.

15. David Wells, *Robinson Crusoe's Money; or, The Remarkable Financial Fortunes and Misfortunes of a Remote Island Community* (New York: Harper and Brothers, 1876), 53. There is a pedagogical as well as a polemical purpose behind Wells's tale. He attempts to make the economic debates of his day comprehensible to laypeople by integrating quotations from economic theorists in an engaging adventure story.

16. F. L. Rivera-Batiz and C. Rivera-Batiz, *International Finance and Open Economy Macroeconomics* (New York: Macmillan, 1985), 518.

17. It should have been obvious at the time that this change signaled a significant decline in American economic power and prestige. During the entire postwar period, America's economic power had been the foundation of the world economy. With the emergence of floating exchange rates, the economic system was decentered and power dispersed. It is important to note that these developments took place at the precise moment that America was suffering military defeat in the jungles of Southeast Asia.

18. While banks began experimenting with credit cards in the early 1950s, they were not widely used until the mid-1960s. Charge-account banking was initiated by the Franklin National Bank of New York in 1952. The charge card as it is known today first appeared when the Bank Americard was introduced in California in 1959. For a summary of the development of the credit card industry, see Richardson, *Electric Money,* chapter 6.

19. Marc Shell, *Money, Language, and Thought: Literary and Philosophic Economies from the Medieval to the Modern Era* (Berkeley: University of California Press, 1982), 1. Shell is primarily concerned with the relationship between economics and literature. Nonetheless, some of his insights shed light on the visual arts. Other relevant studies of literature include Walter Benn Michaels, *The Gold Standard and the Logic of Naturalism: American Literature at the Turn of the Century* (Berkeley: University of California Press, 1987); and Gayatri Chakravorty Spivak, "Speculation on Reading Marx: After Reading Derrida," in *Poststructuralism and the Question of History,* ed. Derek Attridge, Geoff Bennington, and Robert Young (New York: Cambridge University Press, 1987), 30—62.

20. *Fragmente der Vorsokratiker,* ed. H. Diels (Berlin, 1934), fragment 90.

21. "Toward a Hidden God," *Time,* April 8, 1966, 82.

22. Thomas J. J. Altizer, *History as Apocalypse* (Albany: State University of New York Press, 1985), 230. The concluding quotation in this passage is from Nietzsche's *Thus Spoke Zarathustra,* section 3, "The Convalescent."

23. In recent years, Altizer has attempted to incorporate postmodernism within his modernist dialectic. This strategy both reflects and extends confusions about important differences between the modern and postmodern. As we shall see in what follows, postmodernity *sensu strictissimo* insists that the presence that modernists seek never arrives or is perpetually deferred.

24. Altizer, *Total Presence,* 32—33.

25. Mark Jones, introduction to *Fake? The Art of Deception,* ed. Mark Jones (London: British Museum, 1990), 11.

26. David Lowenthal, "Forging the Past," in *Fake?* 18—19.

27. I have drawn extensively on Lawrence Weschler's highly engaging and unusually insightful essay in developing my account of Boggs's work.

28. Quoted in Thierry de Duve, "Marcel Duchamp, or *The Phynancier* of Modern Life," *October* 52 (Spring 1990): 71. In his fascinating study, de Duve follows the wanderings of Duchamp's check.

29. Ibid., 65. De Duve points out that to complicate matters further, Duchamp "publishes an unsigned editorial in his little satirical review, *The Blind Man,* an editorial called 'The Richard Mutt Case,' which, taking up the defense of Mr. Mutt, reveals his first name" (63).

30. Patricia Leighten has analyzed the content of the newspaper clippings Picasso uses and concludes that they are very carefully chosen to reflect his anarchist political position. See Leighten, *Re-ordering the Universe: Picasso and Anarchism, 1897–1914* (Princeton: Princeton University Press, 1989).

31. It is obvious that Schwitters's Cathedral of Erotic Misery anticipates many of the themes of surrealism. In chapter 7 I shall consider surrealism.

32. For the most recent examination of these issues, see Kurt Varnedoe's and Adam Gopwich's catalogue for the Museum of Modern Art's exhibition, *High and Low: Modern Art and Popular Culture* (New York: Museum of Modern Art, 1991).

33. Michael Newman, "Revising Modernism, Representing Postmodernism: Critical Discourses of the Visual Arts," in *Postmodernism: ICA Documents,* ed. Lisa Appignanesi (London: Free Association Books, 1989), 101.

34. John Cage, "Mesostic: Jasper Johns," in *Foirades/Fizzles: Echo and Allusion in the Art of Jasper Johns* (Los Angeles: University of California, 1987), 28–29.

35. Quoted in Rosalind Krauss, "Jasper Johns: The Functions of Irony," *October* 2 (Summer 1976): 99.

36. Elsewhere Johns elaborates, "I have attempted to develop my thinking in such a way that the work I've done is not me—not to confuse my feelings with what I produced. I didn't want my work to be an exposure of my feelings. Abstract-Expressionism was so lively—personal identity and painting were more or less the same, and I tried to operate the same way. But I found I couldn't do anything that would be identical with my feelings. So I worked in such a way that I could say that it's not me" (Vivien Raynor, "Jasper Johns," *ArtNews* 72 [March 1973]: 22).

37. Quoted in Rolf-Dieter Herrman, "Johns the Pessimist," *Artforum* 16 (October 1977): 26–27.

38. Clement Greenberg, "After Abstract Expressionism," in *New York Painting and Sculpture, 1940–1970,* ed. Henry Geldzahler (New York: E. P. Dutton, 1969), 365.

39. Quoted in Max Kozloff, *Jasper Johns* (New York: Meridian Books, n.d.), 13.

40. Leo Steinberg, "Jasper Johns: The First Seven Years of His Art," in *Other Criteria: Confrontation with Twentieth-Century Art* (New York: Oxford University Press, 1972), 28.

41. Fred Orton, "Present, the Scene of . . . Selves, the Occasion of . . . Rules," in *Foirades/Fizzles,* 178.

42. This association is not completely arbitrary, for Fred Orton reports, "There's a story to the effect that Johns was amused with the idea that 'no' in Japanese means 'of,' and that in *No* the suspended 'no,' its imprint, and shadows, are shadows are '*of*' the canvas and each other" (ibid., 177). Orton does not, however, develop the connection between "no" and the No play.

43. Roland Barthes, *Empire of Signs,* trans. Richard Howard (New York: Hill and Wang, 1982), 55.

44. Steinberg, "Jasper Johns," 52.

45. Altizer, *Total Presence,* 107.

46. Jean Baudrillard, "Pop: An Art of Consumption?" in *Post–Pop Art,* ed. Paul Taylor (Cambridge: MIT Press, 1989), 37–38.

47. Sidra Stich, *Made in U.S.A.: An Americanization in Modern Art, in the '50s and '60s* (Berkeley: University of California Press, 1987), 2.

48. Roland Barthes, "That Old Thing, Art . . . ," in Taylor, *Post–Pop Art,* 27.

49. Jean Baudrillard, "Beyond the Vanishing Point," in Taylor, *Post–Pop Art,* 187–88.

50. Baudrillard, "Pop: An Art of Consumption?" 35.

51. G. R. Swenson, "What Is Pop Art?" *ArtNews* 62 (November 1963): 25, 63.

52. Michel Foucault, *Language, Counter-memory, Practice,* ed. Donald Bouchard (Ithaca: Cornell University Press, 1977), 189.

53. Friedrich Nietzsche, *Thus Spoke Zarathustra,* ed. Marianne Cowan (Chicago: Henry Regnery Co., 1957), 334–35.

54. Quoted in Buchloch, "Andy Warhol Line," 60.

## CHAPTER SIX

1. On the lawn that borders the lagoon, there are signs that read, "The Volcano Erupts after Dark Every 15 Minutes until 1:00 AM except Days When the Red Light Is Blinking." The blinking red light signals that the computer controlling the volcano is down, and thus no eruptions can occur.

2. See Edward Said, *Beginnings: Intention and Method* (New York: Basic Books, 1975).

3. It is important to stress at the outset that "postmodernism" is not a term privileged by Venturi. Since his critique of modernism defines the terms of what comes to be known as postmodern architecture, however, I shall use this term to describe Venturi's own position.

4. For a complete list of Venturi's binary opposites, see LV, 102, 118.

5. Adorno, *Minima Moralia,* 39.

6. In previous chapters we have discovered that modern art and architecture represent more than modern industry and technology. Venturi does not acknowledge the abiding spiritual significance of the work he examines.

7. As Carleton Night points out, Johnson's willingness to work with developers marks an important departure in the architectural profession. "In the past, few architects worth their reputations as designers would undertake buildings for developers. But Johnson and Burgee, working initially with Gerald D. Hines Interests, altered that and in so doing helped to create what is almost an entire new profession" (*Philip Johnson/John Burgee: Architecture 1979–1985* [New York: Rizzoli, 1985], 6).

8. Peter Arnell and Ted Bickford, eds., *James Stirling: Buildings and Projects* (New York: Rizzoli, 1985), 260.

9. Ibid., 258.

10. The other members of this informal but highly influential group were Richard Meier, John Hejduk, Charles Gwathmey, and Peter Eisenman. I shall consider Eisenman's work in chapter 7.

11. Quoted in Gerald Allen, *Charles Moore* (New York: Granada, 1980), 110.

12. See Ross Miller, "Euro Disneyland and the Image of America," *Progressive Architecture* 10 (1990): 92–95.

13. Rowe and Koetter, *Collage City,* 45–46.

14. Louis Marin, "Disneyland: A Degenerate Utopia," *Glyph* 1 (1977): 50–66; Max Horkheimer and Theodor Adorno, *Dialectic of Enlightenment,* trans. John Cumming (New York: Continuum, 1987). It is important to note that Horkheimer and Adorno were in southern California when they wrote this book. Much of their analysis is based on their interpretation of the Hollywood entertainment industry. In contrast to Baudrillard, many of whose arguments they anticipate, Horkheimer and Adorno remain committed to an aesthetic theory that reflects the principles of high modernism. See Theodor Adorno, *Aesthetic Theory,* trans. C. Lenhardt (New York: Routledge and Kegan Paul, 1984).

15. Fredric Jameson, "Postmodernism, or the Cultural Logic of Late Capitalism," *New Left Review* 184 (1984): 53–92. For a very helpful account of these economic developments, see David Harvey, *The Condition of Postmodernity* (Cambridge, MA: Basil Blackwell, 1989), especially part 2, "The Political-Economic Transformation of Late Twentieth-Century Capitalism," 121–197.

16. While Debord advances beyond Marx in his recognition of the pervasive power of the symbolic order, his analysis is limited by his retention of classical Marxist oppositions like material/immaterial, earth/heaven, physical/mental, real/ideal, etc.

17. See Gilles Deleuze and Félix Guattari, *Anti-Oedipus,* and *A Thousand Plateaus: Capitalism and Schizophrenia* (Minneapolis: University of Minnesota Press, 1987).

18. Fredric Jameson, "Postmodernism and Consumer Society," in *The Anti-aesthetic: Essays on Postmodern Culture,* ed. Hal Foster (Port Townsend, WA: Bay Press, 1983), 125. Although Jameson insists that the schizophrenia of the fleeting moment is a form of experience characteristic of contemporary consumer society, in chapter 9 I shall argue that Kierkegaard's analysis of the aesthetic form of life describes precisely such immediacy.

19. Wallace Stevens, "Adagia," in *Opus Posthumous: Poems, Plays, Prose,* ed. Samuel French Morse (New York: Random House, 1982), 163.

20. Søren Kierkegaard, *The Concept of Irony with Constant Reference to Socrates,* trans. Lee Capel (Bloomington: Indiana University Press, 1968), 286–87.

## CHAPTER SEVEN

1. Philip Johnson, preface to *Deconstructivist Architecture,* ed. Philip Johnson and Mark Wigley (New York: Museum of Modern Art, 1988), 7.

2. Ibid., 8. In the course of his introduction, Johnson draws a direct line from Russian constructivism—especially the work of Malevich, Lissitzky, and Tatlin—to deconstructivist architecture. While there are obvious similarities between the work of some of the constructivists and some of the deconstructivists, their differences are far more significant. Johnson's reading of deconstruction in terms of stylistic antecedents repeats the very notion of artistic development of which deconstruction is suspicious. I shall consider the work of Heizer in chapter 8.

3. Denis Hollier has collected a selection of the college's proceedings in a volume entitled *The College of Sociology, 1937–1939* (Minneapolis: University of Minnesota Press, 1989). It is significant that during these same years, Alexandre Kojève was delivering his lectures on Hegel. Much of the work of the members of the college can be understood as an extended dialogue with and criticism of Hegel.

4. For a summary of Nietzsche's account of this distinction in *The Birth of Tragedy,* see chapter 3.

5. *Violence and the Sacred* is, of course, the title of René Girard's most discussed book. When compared with the richness of Bataille's analysis, Girard's argument appears both limited and superficial. The shortcomings of Girard's work are, at least in part, the result of the Christian apologetic interests that inform his reading of myth and ritual.

6. In his interpretation of Bataille, Derrida focuses on the notion of expenditure. See "From Restricted to General Economy: A Hegelianism without Reserve," *Writing and Difference,* trans. Alan Bass (University of Chicago Press, 1978), 251–77. For a fuller account of Bataille and Derrida, see Taylor, *Altarity,* chapters 5 and 9.

7. Georges Bataille, *Death and Sensuality: A Study of Eroticism and the Taboo* (New York: Arno Press, 1977), 129.

8. Michel Camus, "L'Acéphalité ou la religion de la mort," *Acéphale* 1 (1936): i.

9. After his break with Masson, Breton embraced Salvador Dali's "paranoiac" style of painting.

10. Quoted in William Rubin, *André Masson* (New York: Museum of Modern Art), 107. In later years, Masson came to recognize similarities between his painting method and certain religious practices. He was particularly intrigued by Zen Buddhism.

11. Ibid., 30–31.

12. Though Lacan was never a member of the surrealist group, he knew many of its members well and followed artistic developments with interest. He and Bataille were particularly close. In view of these relations, it is not implausible to interpret Lacanian psychoanalysis as a surrealistic rereading of Freud.

13. André Masson, *Anatomy of My Universe* (New York: Curt Valentin, 1943), II.

14. For a provocative elaboration of this notion of transgression, see Foucault's homage to Bataille, "A Preface to Transgression," in *Language, Counter-memory, Prac-*

*tice*, 30–52. Foucault, who was deeply influenced by Bataille, edited his *Oeuvres complètes*.

15. Michel Leiris, *André Masson: Line Unleashed* (London: South Bank Center, 1987), 53.

16. André Masson, "Origines du cubisme et du surréalisme," in *Le rebelle du surréalisme: Écrits*, ed. Françoise Will-Levaillant (Paris: Hermann), 21.

17. Julia Kristeva, "Postmodernism?" in *Romanticism, Modernism, Postmodernism*, ed. Harry Garvin, Bucknell Review Series (Lewisburg, PA: Bucknell University Press), 141. For further elaboration of Kristeva's analysis of the presymbolic, see *Desire in Language: A Semiotic Approach to Literature and Art*, trans. L. S. Roudiez (New York: Columbia University Press, 1979), and *Powers of Horror: An Essay on Abjection*, trans. L. S. Roudiez (New York: Columbia University Press, 1980).

18. André Masson, "Je dessine," in *200 dessins* (Paris: Musée d'Art Moderne de la Ville de Paris).

19. Masson consistently associates women with violence. When they are not depicted in his drawings and paintings as helpless victims, they usually appear as all-devouring creatures represented by the *vagina dentata*.

20. In this context, it is instructive to recall the relationship between money and sacrifice that I considered in chapter 5.

21. Georges Bataille, "Slaughterhouse," *October* 36 (Spring 1986): 11. In light of Bataille's insistence on the relation between eroticism and death, it is interesting to note that, in the vernacular, *slaughterhouse* refers to working-class houses of prostitution.

22. Bernard Tschumi, "Questions of Space: The Pyramid and the Labyrinth (or the Architectural Paradox)," *Studio International*, September/October 1975, 136–42. In developing the reading of Bataille that informs his architectural theory, Tschumi was deeply influenced by Denis Hollier's *Prise de la concorde*. In the English translation of this book, Hollier underscores the importance of the slaughterhouses of La Villette for Bataille and, by extension, for Tschumi. See Hollier, "Bloody Sundays," in *Against Architecture: The Writings of Georges Bataille*, trans. Betsy Wing (Cambridge: MIT Press, 1988), ix–xxiii.

23. Bernard Tschumi, "The Pleasure of Architecture," *Architectural Design* 3 (1977): 215.

24. Bernard Tschumi, "Architecture and Transgression," *Oppositions* 7 (Winter 1976): 59.

25. Tschumi, "Pleasure of Architecture," 217.

26. Tschumi freely admits that transgression involves violence. In an essay entitled "Violence of Architecture" he argues, "The integration of the concept of violence into the architectural mechanism—the purpose of my argument—is ultimately aimed at a new pleasure of architecture. Like any form of violence, the violence of architecture also contains the possibility of change, of renewal. Like any violence, the violence of architecture is deeply Dionysian" (*Artforum* 20 [September 1981]: 44).

27. Bernard Tschumi, "Madness and the Combinative," *Precis*, Fall 1984, 150. This comment recalls Max Weber's characterization of modern reason as a "cage," which I considered in my account of high modern architecture. See chapter 4.

28. Shipley, *Origins of English Words*, 24.

29. Quoted in Michel Saudan and Sylvia Saudan-Skira, *From Folly to Follies: Discovering the World of Gardens* (New York: Abbeville Press, 1987), 195. This amply illustrated work provides a very helpful history of gardens and follies.

30. Anthony Vidler, "History of the Folly," *Follies: Architecture for the Late Twentieth Century*, ed. B. J. Archer (New York: Rizzoli, 1983), 10.

31. Though Tschumi does not cite Lyotard, Deleuze, or Guattari, he clearly borrows his notion of "points of intensity" from their work. See Jean-François Lyotard, *Des dispositifs pulsionnels* (Paris: Christian Bourgois, 1980), and *Économie libidinale* (Paris: Éditions de Minuit, 1974); Gilles Deleuze and Félix Guattari, *Anti-Oedipus* and *Thousand Plateaus*.

32. Roland Barthes, "The Third Meaning: Research Notes on Some Eisenstein Stills," *Image—Music—Text*, 62, 55, 61, 64. As we shall see in what follows, Eisenstein is also very important for Tschumi.

33. *La case vide* designates the empty box in a chart or an unoccupied square on a chessboard. As such, it marks the site of the indeterminate and unexpected.

34. Jacques Derrida, *Margins of Philosophy,* trans. Alan Bass (Chicago: University of Chicago Press, 1982), 13.

35. Jacques Derrida, "Why Peter Eisenman Writes Such Good Books," manuscript, 7.

36. Maurice Blanchot, *Le pas au-delà* (Paris: Gallimard, 1973), 158.

37. Emmanuel Levinas, *Otherwise Than Being or Beyond Essence,* trans. Alphonso Lingis (Boston: Martin Nijhoff, 1981), 100.

38. Peter Eisenman, *Moving Arrows, Eros, and Other Errors* (London: Architectural Association, 1986), 6–7.

39. Peter Eisenman, "Interview," *a + u,* January 1990, 181.

40. Rosalind E. Krauss, "Grids," in *The Originality of the Avant-Garde and Other Modernist Myths* (Cambridge: MIT Press, 1986), 22.

41. Jacques Derrida, "Architetture ove il desiderio può abotare," *Domus* 20 (1986).

42. *Harper's Bible Dictionary,* ed. Paul Achtemeier (New York: Harper and Row, 1985), 252.

43. See Derrida, *Glas,* 231–32.

## CHAPTER EIGHT

1. For an analysis of Hegel's notion of sublation, see chapter 2.

2. Throughout this chapter, Heizer's comments are from unpublished texts that the artist has kindly made available to me.

3. Rodolphe Gasché, *The Tain of the Mirror: Derrida and the Philosophy of Reflection* (Cambridge: Harvard University Press, 1977), 238.

4. Jacques Lacan, "The Mirror Stage as Formative of the Function of the I as Revealed in Psychoanalytic Experience," in *Ecrits: A Selection,* trans. Alan Sheridan (New York: W. W. Norton and Co., 1977), 4.

5. Another Pistoletto work that provides a powerful image of the infinite self-enclosure of reflection is *A Cubic Meter of Infinity* (1966). This work is a cube (120 × 120 × 120 centimeters), comprising six mirrors turned inward and bound together with a string. There is no opening to the cube. Since the interiority of the construction is sealed off from any exteriority, the play of reflection is presumably uninterrupted.

6. Jacques Derrida, "Desistance," introduction to Philippe Lacoue-Labarthe, *Typography: Mimesis, Philosophy, Politics,* ed. Christopher Fynsk (Cambridge: Harvard University Press, 1989), 16.

7. See *Refigured Painting: The German Image, 1960–1988,* ed. Thomas Krens, Michael Govan, and Joseph Thompson (New York: Solomon R. Guggenheim Museum, 1989).

8. For a complete list of the names and faces in these works, see AK, 157.

9. Quoted in Thomas West, "The Energy of Broken Images," *Art International* 2 (Spring 1988): 75.

10. See Derrida, "Différance," in *Margins of Philosophy,* 4.

11. Andrew Benjamin, "Deconstruction and Art / The Art of Deconstruction," in *What Is Deconstruction?* ed. Andrew Benjamin and Christopher Norris (New York: St. Martin's Press, 1988), 53. Benjamin's articles are, in my judgment, among the most insightful analyses of Kiefer's work that have yet appeared.

12. Jacques Derrida, *Of Spirit: Heidegger and the Question,* trans. by Geoffrey Bennington and Rachel Bowlby (Chicago: University of Chicago Press, 1989), 112.

13. Edith Wyschogrod, "Hasidism, Hellenism, and Holocaust: A Postmodern View," unpublished paper.

14. Barthes, *Image—Music—Text,* 167.

15. Lyotard, *Discours, Figure,* 13.

16. Thomas West, "Interview at Diesel Strasse," *Art International* 2 (Spring 1988): 65.

17. Paul Celan, *Poems,* trans. Michael Hamburger (New York: Persea Books, 1981), 50–53.

18. Quoted in Steven Madoff, "Anselm Kiefer: A Call to Memory," *ArtNews* 86, no. 8 (1987): 128.

19. Jacques Derrida, "*Fors:* The Anglish Words of Nicolas Abraham and Maria Torok," trans. Barbara Johnson, in Nicolas Abraham and Maria Torok, *The Wolf Man's Magic Word: A Cryptonymy* (Minneapolis: University of Minnesota Press, 1986), xiv.

20. John Gilmour underscores the religious dimension of Kiefer's imagery in this work by developing an ingenious comparison between *To the Supreme Being* and Leonardo da Vinci's *Last Supper.* See *Fire on the Earth: Anselm Kiefer and the Postmodern World* (Philadelphia: Temple University Press, 1991), chapter 2. This is the highpoint in an otherwise disappointing book. A confused and misleading reading of post-modernism plagues Gilmour's interpretation of Kiefer's art.

21. Nancy, "L'offrande sublime," 61.

22. Jean-Luc Nancy, "Of Divine Places," *Paragraph* 7:44.

## CHAPTER NINE

1. Søren Kierkegaard, *Fear and Trembling,* trans. Howard Hong and Edna Hong (Princeton: Princeton University Press, 1983), 14.

2. I have considered Kierkegaard's work in more detail elsewhere. See, inter alia, *Kierkegaard's Pseudonymous Authorship: A Study of Time and the Self* (Princeton: Princeton University Press, 1975); *Journeys to Selfhood; Altarity,* chapter 10; and *Tears,* chapter 11.

3. Søren Kierkegaard, *Either-Or,* trans. David Swenson and Lillian Swenson (Princeton: Princeton University Press, 1959), 1:95.

4. Ibid., 165.

5. See Søren Kierkegaard, *The Sickness unto Death,* trans. Howard Hong and Edna Hong (Princeton: Princeton University Press, 1980), 29–42.

6. Kierkegaard, *Fear and Trembling,* 54.

7. Ibid., 68.

8. Blanchot, *Le pas au-delà,* 69–70.

9. Søren Kierkegaard, *Philosophical Fragments,* trans. Howard Hong and Edna Hong (Princeton: Princeton University Press, 1985), 44.

10. Ibid., 44–45.

# INDEX

Aaron, 293, 298
Abraham, 95, 310
Abrams, M. H., 20
abstract expressionism, 13, 78, 157, 158, 168, 171, 176, 191
Acéphale, 236–38, 240
Adorno, Theodor, 128, 194, 223
aesthetic education, 12, 20, 23, 31, 33, 38, 45, 55, 66, 80, 105, 114, 189, 294, 313, 314, 316, 318
Age of Reason, 248
Albigensians, 101
alchemy, 53, 149, 294, 298
altarity, 9, 231, 261, 283, 288, 293, 302, 303, 310, 316, 318
Altizer, Thomas J. J., 155–58, 177, 178, 317
analytic cubism, 59–61, 163
Anthroposophy, 55, 341
Apollinaire, Guillaume, 11, 57, 60, 64, 79, 99
Apollo, 92, 93, 103, 104, 246
Aquinas, Thomas, 133, 134
archē, 35, 50, 86, 211, 256, 272, 302
*architecture élémentarisée*, 115
Arp, Hans, 136
art deco, 194, 203, 218
Attic tragedy, 92
Auschwitz, 47
automatic drawing, 235, 237
automatic writing, 235, 236
avant-garde, 4, 21, 31, 71, 94, 114, 142, 165–67, 200

Barbusse, Henri, 98
Barry, Charles, 203
Barth, Karl, 2, 99–102, 128, 142, 155, 156, 316, 317
Barzun, Jacques, 79
Bataille, Georges, 224, 229, 232–38, 240, 242, 245, 246, 251, 252, 267, 296
Bateau Lavoir, 79

Baudelaire, Charles, 1, 10, 11, 145, 182, 225, 238
Baudrillard, Jean, 167, 178, 181, 185, 190, 222, 224, 298
Bauhaus, 20, 71, 121–23, 125, 131, 132, 194, 212, 219
Baumgarten, Alexander Gottlieb, 5, 31
Bayreuth, 20, 95, 103
Beaubourg, 206
Beckett, Samuel, 169, 171
Behrens, Peter, 105, 106, 122, 123, 125, 134
Bergman, Joel D., 186
Berlin, 18, 23, 46, 120, 131–34, 136, 295, 300
Berlin Academy, 18
Besant, Annie, 54, 55, 66–70, 72, 104, 109
Beuys, Joseph, 294
Blanchot, Maurice, 12, 255, 276, 289, 292, 300, 307, 309, 314
Blavatsky, Helena Petrovna, 54–57, 65, 66, 73, 76, 79, 95
Blum, Irving, 178
Boggs, J. S. G., 159–63, 178
Brandenburg, 295, 296
Braque, Georges, 49, 58–63, 74, 75, 79, 80, 105, 164, 168
Braselitz, Georg, 290
Brasz, Marc, 143
Breton, André, 97, 232, 236, 237, 252
Bretton Woods, 154
British Museum, 158, 159
Brooks, Cleanth, 197
Brown, Norman O., 67, 113, 126, 128, 139, 143, 147, 164
Burgee, John, 202
Burke, Edmund, 18

Cage, John, 131, 169, 178, 233, 284, 285
Cagney, James, 181
Callois, Roger, 233, 236

Calvinism, 76, 102, 108, 129
Camus, Albert, 236
Cannaregio, 261
capitalism, 128–30, 143, 178, 202, 223–25
catastrophe, 100, 242, 289
Catharism, 101, 102, 108
Celan, Paul, 293, 301, 302
Celant, Germano, 284, 289
Centre Georges Pompidou, 244
Chandler, Lester, 148
Chemin des Dames, 237
Chomsky, Noam, 257
chora, 254–56, 260, 261, 265, 266, 269, 278, 302, 304, 316
Choral Work, 253–55, 260–62, 265, 266
collage, 123, 163, 164, 168, 173, 175, 205–8
Congress of International Progressive Artists, 121
constructivism, 71, 120
counterfeit, 159, 166
Crawford, Joan, 181
Crimp, Douglas, 13, 14
Cronus, 245, 248, 267
crystal, 97, 105, 106, 121, 122, 134, 139, 148, 278
cubism, 58–64, 74, 75, 79, 98, 105, 109, 157, 163, 164, 190, 194, 237
cubo-futurist works, 80
culture industry, 178, 223
currency, 143–46, 149–54, 159–62, 164, 166, 173, 178, 179, 181, 182, 191, 224

Danto, Arthur, 13, 14
Darmstadt Artists' Colony, 105
*Das Zeichen*, 105, 113, 122
Debord, Guy, 223, 224
deconstruction, 232, 247, 250, 260, 261, 263, 276, 280
Deconstructivist architecture, 231, 232
deformation, 7, 108, 110, 164
Deism, 19
de Kooning, Willem, 168
Deleuze, Gilles, 225
dematerialization, 76, 86, 110, 139, 150, 151
Derrida, Jacques, 26, 229, 232, 249, 253–56, 258, 260, 261, 265–67, 269, 280, 284, 285, 294, 296, 302, 309, 316
Descartes, René, 10, 52
Dessau, 123, 125, 131
de Stijl, 77, 114, 115, 117, 118, 120, 129
Dethuit, Georges, 233
Didi-Huberman, Georges, 7, 252, 299
*différance*, 253, 255, 259, 284, 294

Dionysius the Areopagite, 53
Dionysus, 92, 93, 102–4, 146, 230, 236, 240, 245, 246, 248, 267
Disneyland, 183, 218, 222, 224
Disney World, 183, 218, 219, 222–24
Duchamp, Marcel, 162, 163, 168, 171, 175, 177, 192, 227
Durkheim, Émile, 233
Düsseldorf, 121, 351

Eckhart, Meister, 85
ecstasy, 92, 93, 235, 242, 245, 248, 252
eidos, 63, 255, 257
Eiffel Tower, 11, 79
Einstein, Albert, 79
Eisenman, Peter, 117, 231, 232, 253–67, 302, 316
Ekstrom, Arne, 162
electricity, 57, 106, 154, 181, 186, 204, 207
elementarism, 110, 121
Eliot, T. S., 197
Enlightenment, 3, 21, 23, 71, 132, 248
eros, 129, 130, 235, 237, 238, 240, 246, 248, 259
eroticism, 10, 235, 238, 242, 246, 248
Euro Disneyland, 222
Eurydice, 252
excess, 30, 89, 124, 127, 129, 130, 145, 148, 168, 186, 233, 246, 248, 249, 266
expenditure, 127, 129, 130, 150, 186, 188, 191, 233, 234, 251

Fabian Society, 54
Fainsilber, Adrien, 243, 244
fascism, 12, 14, 113, 132
Feuerbach, Ludwig, 185, 290, 297
Fludd, Robert, 82
fourth dimension, 72, 79, 80, 82
free association, 236
French Revolution, 11, 24
Freud, Sigmund, 7, 92, 126, 127, 129, 130, 147, 148, 230, 233, 236, 238, 282, 299
Fried, Michael, 3, 217
Friedrich, Caspar David, 18
Fuchs, Georg, 105
functionalism, 125, 128, 131, 194, 196, 233

Gasché, Rodolphe, 280
Gehry, Frank, 231
*Geist*, 38, 42, 108, 134, 296, 297, 301
*Gesamtkunstwerk*, 20, 114, 115, 121, 212, 213
Gideon, Sigfried, 125
gift, 102, 234, 273
Glasarchitektur, 106, 123, 134, 139

Gleizes, Albert, 58, 59, 62
Gnosticism, 102
Goetheanum, 55
gold standard, 151–54
Govan, Michael, 75
Graves, Michael, 208–15, 217–20, 222, 257
Greater Berlin Art Exposition, 120
Greece, 38, 92, 103, 107, 109, 146, 236, 244, 291
Greenberg, Clement, 3, 4, 14, 23, 84, 165–68, 173, 176, 193
Gris, Juan, 164
Grohmann, Will, 72
Gropius, Walter, 97, 106, 121–25, 131
Guattari, Félix, 225
Guggenheim Museum, 88

Habermas, Jürgen, 3
Heckscher, August, 193
Hegel, G. W. F., 37–47
Heidegger, Martin, 26, 29, 35, 63, 64, 92, 256, 277, 278, 290, 293, 296–98
Heizer, Michael, 231, 274, 276–80, 298, 302, 307, 316
Hejduk, John, 358
Henderson, Linda, 79
Heraclitus, 154, 238, 245, 297
Hess, Thomas, 88
Hinton, Charles Howard, 79
Hitchcock, Henry-Russell, 196, 231
Hitler, Adolf, 132, 296, 300
Hölderlin, J. C. F., 20, 34, 38, 92, 122, 290, 298
holocaust, 12, 52, 95, 256, 295, 299
Horkheimer, Max, 223
Hughes, Robert, 59
Husserl, Edmund, 62, 63, 238
Huszár, Vilmos, 114

iconolatry, 298, 312
Impressionism, 10, 59
International Faction of Constructivists, 121
International Style, 9, 196, 198, 200, 202, 231
Interview, 183, 261, 284, 293
irony, 11, 13, 179, 184, 185, 189, 193, 199, 207, 214, 215, 226, 227
Isaac, 95, 310
Itten, Johannes, 122, 123

Jabès, Edmond, 91, 253, 265, 269, 270, 303, 309
Jameson, Fredric, 223, 225
Jansen, Bernard, 297
Jeanneret, Albert, 101
Jeanneret, Charles-Édouard. *See* Le Corbusier

Jena, 20, 21, 37, 46, 54, 55, 95, 114, 121, 291
Jencks, Charles, 205, 206
Jesus, 11, 44, 54, 55, 88, 103, 106
Joachim of Fiore, 65
Johns, Jasper, 158, 168, 169, 171–80, 192, 217
Johnson, E. J., 217
Johnson, Philip, 196, 199, 201–4, 231
Juno Moneta, 146
Jupiter, 146

Kabbalah, 53, 91, 305
Kandinsky, Wassily, 54, 64–66, 69–75, 77, 78, 81, 84, 85, 90, 93, 94, 108, 109, 123, 131, 141
Kant, Immanuel, 21–33
Kennedy, John, 182, 183
Kern, Stephen, 98
Kiefer, Anselm, 290–305, 307
Kierkegaard, Søren, 6, 9, 99–101, 142, 185, 215, 227, 309–16, 318
Kipnis, Jeffrey, 261
kitsch, 165–68, 178, 223
Klee, Paul, 123, 131, 162, 215
Klossowski, Pierre, 233, 236
Kojève, Alexandre, 64, 65
Kok, Anthony, 114
Kolbe, Georg, 137
Koolhaas, Rem, 231
Krauss, Rosalind, 263
Kremlin, 66, 70
Krier, Leon, 212
Kries, Wilhelm, 300
Krishnamurti, 54, 55, 72
Kristeva, Julia, 240
Kruchenikh, Alexei, 80, 81
Krulwich, Robert, 161
*Künstlerkolonie*, 121
Kurnitzky, Horst, 146

labyrinth, 237, 239, 240, 245, 246, 260, 294, 296
Lacan, Jacques, 238, 283, 285
Lacoue-Labarthe, Philippe, 21
Las Vegas, 186–88, 190, 191, 198, 199, 203, 222, 271
Lautréamont, 229
Leadbeater, Charles, 54, 55, 66–70, 72, 104, 109
Le Corbusier (Charles-Édouard Jeanneret), 101, 102, 106–10, 112, 113, 115, 124, 126, 128, 129, 139, 141, 156, 163, 164, 189, 206, 240, 261, 292
Léger, Fernand, 80
L'Eplattenier, Charles, 102
*Les immatériaux*, 244
Levinas, Emmanuel, 256, 364

Lévi-Strauss, Claude, 11, 154
Libeskind, Daniel, 231
Lichtenstein, Roy, 181
Lippard, Lucy, 238
Lissitzky, El, 71, 80, 119–21, 136
logocentrism, 188, 189, 219, 222, 227, 230
logos, 43, 56, 63, 65, 68, 69, 74–76, 104, 149, 188, 189, 220, 297, 313
Longman, Evelyn Beatrice, 204
Loos, Adolf, 125–30, 136
Lotar, Eli, 242
Lowenthal, David, 159
Löwith, Karl, 236
Lynch, David, 258, 259
Lyotard, Jean-François, 90, 244, 299

machine aesthetic, 109, 121, 125, 128, 210
madness, 232, 233, 242, 244, 246–48, 252, 255, 267
Malevich, Kasimir, 49, 50, 71, 77, 78, 80–85, 87, 88, 93, 94, 108, 119, 120, 124, 125, 131, 139
Manichaeism, 101
Marc, Franz, 65, 143
Marchisotto, Tom, 220
Marin, Louis, 223
Marinetti, Filippo, 98, 113, 164
Marx, Karl, 64, 147–52, 154, 158, 178, 224, 290, 297
Marxism, 131
Masson, André, 237–43
Matta, Patricia, 162
Mauss, Marcel, 233, 234
Merleau-Ponty, Maurice, 59
Merton, Thomas, 85
metaphysics of presence, 225, 256, 258, 263
Michelson, Annette, 11, 144
Mies van der Rohe, Ludwig, 85, 101, 106, 130–34, 136–39, 141, 142, 190, 194, 200, 211
minimalism, 274, 290
mirror stage, 283, 285
Mithra, 242
modernity, 1, 10, 12, 21, 46, 50, 52, 95, 99, 100, 121, 132, 144, 145, 156, 177, 178, 181, 191, 192, 193, 213, 223, 225, 232, 256, 273, 274, 294, 301, 311, 319
Moholy-Nagy, László, 71
Mondrian, Piet, 49, 72–78, 80, 81, 83–85, 90, 92, 94, 108, 110, 114, 115, 120, 121, 123, 124, 126, 137, 156, 177
money, 127, 130, 143–54, 159–62, 165–67, 178, 188, 223, 224
Moore, Charles, 208, 214, 218, 220, 228

Morris, Robert, 14, 173
Morrissey, Paul, 183
Moscow, 65, 66, 69–71, 83, 84
Moscow Institute of Artistic Culture, 71
Mozart, Wolfgang Amadeus, 311
Museum of Modern Art, 196, 231
Mussolini, Benito, 113
mysticism, 85, 122, 291
myth, 89, 141, 147, 211, 213, 214, 218, 236, 242, 250, 255, 292

Nancy, Jean-Luc, 21, 29, 183, 255, 269
national socialism, 132, 133, 296, 300
New Age, 11, 57, 97, 105–7, 113, 122, 134, 138, 139
New Criticism, 197
Newman, Barnett, 88–91, 93, 94, 108, 157, 168, 305
Newman, Michael, 168
New York Five, 208, 211, 257
Nietzsche, Friedrich, 2, 50, 57, 58, 92–94, 103, 106, 150, 155, 156, 178, 182, 233, 234, 236, 238, 245, 246, 252, 290, 298, 317, 318
nihilism, 83, 138, 156, 227
non-knowledge, 235
nonobjective painting, 57, 70, 173, 190, 313
nonrepresentational art, 94, 166, 222
Novalis, 20, 21, 122

objet trouvé, 163
ornamentation, 4, 108, 110, 115, 117, 125–27, 137, 164, 189, 199, 206, 213, 264
Orpheus, 103, 252
Orphism, 240
other, the, 1–6, 26–30, 39–41, 43–45, 87–89, 92–95, 128–31, 144–50, 152–54, 161–64, 181–83, 223–29, 234–37, 245–47, 270–74, 279–81, 283–89, 292–94, 300–303, 313–16, 318
Otto, Rudolph, 19
Oud, J. J. P., 114, 115, 117, 118, 202
Ouspensky, P. D., 79, 82
Ozenfant, Amédée, 101, 107, 163

Paeffgen, C. O, 290
papiers collés, 163
Paris World's Fair, 11
Parmenides, 86
parousia, 155, 230
*Partisan Review,* 84
People's Commissariat for Enlightenment, 71
Petrograd, 82
Picasso, Pablo, 59–63, 74, 75, 79, 80, 98, 105, 157, 162, 164, 168

Pistoletto, Michelangelo, 280–90, 301–3, 307, 316

Plato, 2, 86, 103, 254, 255, 260, 266

pleasure principle, 246

Polke, Sigmar, 290

Pollock, Jackson, 162

pop art, 9, 158, 178, 179, 181, 182, 190–92, 199, 202, 204, 215, 223, 225, 317

presence, 7, 10–13, 58, 59, 63, 86–90, 94, 101, 144–45, 155–57, 173, 177–78, 230–31, 252–53, 258–59, 265, 271, 276, 281, 297, 305, 311, 317

primitive, the, 34, 35, 50, 76, 93, 108, 126, 148, 152, 167, 193, 206, 207, 232, 272, 273

Prince, Maurice, 79

Protestant ethic, 128–30

Protestantism, 72, 115, 128–30

*Prouns*, 120

Provensal, 102, 105, 109

psychoanalysis, 126, 143

purism, 2, 101, 107–9, 112, 113, 129, 163, 192

Puritans, 2, 129

pyramid, 213, 245, 246, 294, 296

Pythagoras, 86, 103, 104, 107–10

Queneau, Raymond, 343

Rauschenberg, Robert, 158, 168, 169, 171, 173, 178, 192, 205

Ray, Man, 76, 132, 136

ready-mades, 163, 164

Reagan, Ronald, 183, 184

reality principle, 222

redemption, 93, 128, 145, 156, 181, 186, 296

Reinhardt, Ad, 83–88, 90, 93, 94, 108, 139, 156, 303

Renan, Ernst, 106

repetition, 144, 242, 251

Richter, Gerhardt, 290

Rietveld, Gerrit, 117–19, 125, 208

Ringstrasse, 126

Rodchenko, Alexander, 71, 83

Rome, 30, 65, 146, 194, 217, 291

*Romeo and Juliet*, 259–61

Rose, Barbara, 13, 14, 18, 46, 50, 52, 69, 270

Rosenberg, Harold, 90, 163

Rosenblum, Robert, 18

Rosenthal, Mark, 292

Rossi, Aldo, 212

Rothko, Mark, 88, 93–95, 101, 108, 142

Rouen Cathedral, 58, 59

Rowe, Colin, 97, 114, 223

Royce, Josiah, 24

Russian Orthodoxy, 65, 72, 78, 93

Russian Revolution, 71

sacred, the, 10, 18, 32, 85, 94, 104, 147, 153, 154, 157, 185, 207, 233–38, 242, 252, 288, 298, 314

sacrifice, 95, 146, 147, 165, 234, 235, 242, 252, 310

Said, Edward, 189

Satan, 128, 129

Saussure, Ferdinand de, 8, 62, 108, 343

Scheebart, Paul, 97, 106, 123, 134, 139

Schiller, Friedrich, 12, 20, 21, 23, 31–33, 35–38, 42, 45, 46, 71, 92, 105, 121, 294

Schinkel, K. F., 74, 206

Schlegel, Friedrich von, 20, 21

Schleiermacher, Friedrich, 10, 18–23, 25, 34–36, 46, 73, 290, 298, 310, 312, 313

Schlemmer, Oskar, 123, 131

Schoenmaekers, M. H. I., 72–75

Schopenhauer, Arthur, 290

Schulze, Franz, 131, 134

Schuré, Edouard, 102–4, 107, 110

secession movement, 125

Shakespeare, William, 143, 259

Shattuck, Roger, 10

Shulamite, 300, 301, 303

silence, 72, 100, 101, 131, 141, 142, 158, 186, 228, 270, 272, 310

Simmel, Georg, 150

spectacle, 105, 113, 177, 181, 183, 184, 191, 223–25, 227, 244, 274, 283, 298

speed, 78, 79, 82, 98, 121, 237

Speer, Albert, 132

Speusippus, 86

Starobinski, Jean, 248

Stein, Gertrude, 98, 238

Steinberg, Leo, 173, 174, 177

Steiner, George, 55, 69, 72, 103

Stern, Robert, 217

Stevens, Wallace, 226

Stirling, James, 205–8, 211, 215, 217

structuralism, 62

sublime, 18–20, 29–31, 36, 42, 89, 90, 92, 248, 305

Sullivan, Louis, 125

suprematism, 71, 80, 82, 83, 119, 120

surrealism, 84, 93, 23, 232, 233, 235–37, 252

Swami Vivekenanda, 80

Tafuri, Manfredo, 139, 141, 292

Talking Heads, 185

Tatlin, Vladimir, 71, 83, 119

Taut, Bruno, 106, 123, 134, 270

teleology, 27, 28, 40, 64, 312

television, 168, 180, 181, 183–85

thanatos, 235, 237, 238, 240, 246, 248
theoesthetics, 17, 46, 52, 54, 55, 87,
   134, 145, 148, 223, 230, 231, 266,
   270, 280, 294, 304, 309, 310, 312,
   314–18
Theosophical Society, 54, 55, 66, 72
Theosophy, 52–57, 65, 72, 75–78, 85,
   95
Third Reich, 52, 291
Tillich, Paul, 2, 3
Timaeus, 254, 255, 260
time, 4–5, 40, 42, 62–63, 74, 86–87,
   98–99, 113–14, 125–27, 148–50,
   155–56, 158–60, 182–83, 233–34,
   242, 252–54, 256–65, 278–82, 284–
   86, 311–12, 315–16, 353–54
tragedy, 88, 92, 93, 95, 103, 115, 223,
   230, 234, 245
transcendence, 2, 65, 85, 128, 142, 144,
   155, 156, 181, 273, 300, 316, 317
transgression, 177, 235, 238, 246–48,
   252, 298
Tschumi, Bernard, 231, 232, 242, 244–
   55, 257, 260, 261, 267, 282, 296, 302
Tzanck, Daniel, 162
Tzara, Tristan, 136

University of Leicester, 205
utopia, 12, 84, 164, 178, 181, 196, 210,
   214, 223, 224, 230, 267, 291, 293,
   298, 317

Van der Leck, Georg, 114
van Doesburg, Theo, 114, 115, 117–21,
   123–25, 136, 137, 202

van Eesteren, Cornelius, 117–19, 125
Van Gogh, Vincent, 10, 74
Vedantic philosophy, 80
Venturi, Robert, 189–94, 196–99, 202,
   203, 205, 206, 210, 211, 213, 215,
   218, 222, 226, 229, 262
via negativa, 85, 86, 100
violence, 19, 147, 188, 234, 235, 238,
   242

Wagner, Richard, 103, 290, 298
Wahl, Jean, 233, 236
Warhol, Andy, 143–45, 158, 168, 178–
   84, 192, 201, 202, 220, 291
waste, 108, 128, 129, 164, 207
Weber, Max, 128–30
Weimar Kultur, 20, 31, 37, 55, 71, 121
Weimar Republic, 71
Wells, David, 151, 162
Weschler, Lawrence, 161, 351
Winckelmann, Johann Joachim, 31–33
Wolfe, Tom, 13, 196
Wordsworth, William, 19, 20
World War I, 70, 98, 114, 153
World War II, 89, 158
Wright, Frank Lloyd, 117
Wyschogrod, Edith, 299

Yahweh, 2

Zim Zum, 90, 91, 304, 305
Zeichen, Das, 105, 113, 122